Farewell to an idea . . . The cancellings,
The negations are never final. The father sits
In space, wherever he sits, of bleak regard,

As one that is strong in the bushes of his eyes.
He says no to no and yes to yes. He says yes
To no; and in saying yes he says farewell.

Wallace Stevens, "The Auroras of Autumn"

T.J. Clark

Farewell to an Idea

Episodes from a History of Modernism

Yale University Press
New Haven and London

Designed by Gillian Malpass

Printed in Singapore

Library of Congress Cataloging-in-Publication Data

Clark, T. J., 1943–
 Farewell to an idea : episodes from a history of modernism / T. J.
Clark.
 p. cm.
 Includes bibliographical references and index.
 ISBN 0-300-07532-4 (cloth : alk. paper)
 1. Modernism (Art) I. Title.
N6490.C58 1999
709'.04–dc21 98-49433
 CIP

A catalogue record for this book is available from
The British Library

Endpapers: Jackson Pollock: *Lavender Mist* (detail of fig. 182)

Frontispiece: Paul Cézanne: *The Large Bathers* (detail of fig. 76)

NOTE: Dimension of illustrations are given in centimeters,
height before width.

Contents

Acknowledgements

In the course of writing this book, I was lucky enough to receive a Guggenheim Memorial Foundation Fellowship, a National Endowment for the Humanities Research Fellowship, and a University of California President's Research Fellowship in the Humanities. I am grateful for all three. Above all I want to thank the University of California, Berkeley for its generous support, in the form of two Humanities Research Fellowships, and currently a Chancellor's Professorship. The book could not have been done without them.

Some of the book's chapters have appeared previously in preliminary form. Chapters 1 and 3 are revised and expanded from my "Painting in the Year Two," *Representations*, 47 (Summer 1994) and "Freud's Cézanne," *Representations*, 52 (Fall 1995). Chapter 7 sticks fairly close to my "In Defense of Abstract Expressionism," *October*, 69 (Summer 1994). Chapter 6 is based on my "Jackson Pollock's Abstraction," in Serge Guilbaut, ed., *Reconstructing Modernism* (Cambridge, Mass. and London, 1990).

When a book tries to pull together the work and teaching of three decades, as this one does, it is obviously impossible to thank all those who helped along the way. I have acknowledged specific debts, chapter by chapter, in the footnotes. But there are others, of a more general and pervasive kind. The group of colleagues I had at the University of Leeds – in particular Terry Atkinson, Fred Orton, and Griselda Pollock – helped shape my thinking about modernism in fundamental ways. The friends made through Monroe Engel's and Leo Marx's reading group in Boston kept the book's questions alive at a difficult moment. Here in Berkeley, the individuals associated with Iain Boal and *Retort* – especially Jim Brook, Chic Dabby, Joseph Matthews, Sanjyot Mehendale, Dick Walker, and the unstoppable Iain himself – have mattered, and helped, in all sorts of ways. So have Jenny and Greil Marcus. I shall always be thankful to Serge Guilbaut for goading me first into writing on Pollock, something I was thoroughly afraid of doing. Gail Day did much the same service in the case of El Lissitzky. Patricia Boyer, Anna Indych, Peter Nisbet, Kirk Varnedoe, Gabriel Weisberg, and Julie Wolf were especially generous in the search for illustrations. Particular readings, comments, and criticisms from Caroline Arscott, Yve-Alain Bois, Benjamin Buchloh, Thomas Crow, Whitney Davis, Brigid Doherty, Hal Foster, Francis Frascina, Charles Harrison, Christina Kiaer, Howard Lay, Michael Leja, John O'Brian, Alex Potts, Jennifer Shaw, Lisa Tickner, Kathryn Tuma, Jonathan Weinberg, Christopher Wood, Marnin Young, and members of the *Representations* editorial board, remain in my mind as fruitful. Then there has been the example of Michael Fried. My footnotes tell part of the story: time and again over the years, looking at pictures in Fried's company, or absorbing his reactions to what I had to say in lecture or article form, has pushed my thinking forward and reminded me of what writing about painting is about. His opposition has been true friendship.

Michael Rogin's reading of the manuscript was typically generous, searching, and constructive – he and Ann Banfield have made Berkeley a better place. (I promise, Mike, to read Andrey Biely's *St. Petersburg* one of these days.) Donald Nicholson-Smith gave the whole book a real going-over, of the kind I've come to rely on. He has been a friend, a touchstone, in good times and bad – without him there would not have been enough laughter and anger in the world.

I want to thank those at Yale University Press who worked hard to turn an unwieldy manuscript into a book – especially Laura Church, Sheila Lee, Sally Nicholls, and Abby Waldman. Above all, I am indebted to Gillian Malpass, my editor, whose enthusiasm for the book really mattered, and whose patience and energy drove the whole process on.

Finally, the reading, and the friendship, that always went deepest – to the heart of the matter – was Anne Wagner's. This book is hers through and through; though I know she will want to share it with Sam, Hannah, and Ruby Clark. Modernism is not exactly a cheery subject, but looking at it in this company – maybe even defending it to this company – has been a good cure for modern life.

Introduction

Gebrochen auf dem Boden liegen rings
Portale, Giebeldächer mit Skulpturen,
Wo Mensch und Tier vermischt, Centaur und Sphinx,
Satyr, Chimäre – Fabelzeitfiguren.

(Broken on the ground lie round about/Portals, gable-roofs with
sculptures,/Where men and animals are mixed, centaur and
sphinx,/Satyr, chimera – figures from a legendary past.)

Heine, "Für die Mouche"

For a long time, writing this book, I had a way of beginning it in mind.
I wanted to imagine modernism unearthed by some future archaeologist, in the
form of a handful of disconnected pieces left over from a holocaust that had
utterly wiped out the pieces' context – their history, the family of languages they
belonged to, all traces of a built environment. I wanted Adolph Menzel's
Moltke's Binoculars (fig. 2) to have survived; and John Heartfield's *A New Man
– Master of a New World* (fig. 3); and Picasso's *Italian Woman* (fig. 4); and
Kasimir Malevich's *Complex Presentiment (Half-Figure in Yellow Shirt)* (fig. 5).
The questions that followed from the thought-experiment were these. What
forms of life would future viewers reconstruct from this material? What idea of
the world's availability to knowledge would they reckon the vanished image-
makers had operated with? What imaginings of past and future? Or of part and
whole? Would it be just the archaeologists' fancy that the surviving images had
ruin, void, and fragmentariness already written into them, as counterpoint to
their hardness and brightness? The repetition of *neuer* and *neuen* in the
Heartfield might strike the interpreters as keys to all this, but the words
themselves would mean nothing. Likewise the writing on the back of the
Malevich, elaborate and careful, presumably in the painter's hand. Our archae-
ologists would not know it read: "The composition coalesced out of elements of
the sensation of emptiness, of loneliness, of the exitlessness [*besvykhodnosti*] of
life."[1] And even if by some fluke they deciphered it, how far would that get them
in making sense of Malevich's (modernism's) tone? The painting is ostensibly
jaunty, almost flippant. Its man, house, and landscape have the look of toys. But
in what sort of game? Played by which wanton children? Was it the same game
as Heartfield's (or even Moltke's)?

I find it hard to imagine any human viewer, even on the other side of
Armageddon, not responding to the tenderness and punctiliousness of Picasso's
modeling in *Italian Woman* – the shading of eyes and mouth, the different
sheens and textures of what the woman is wearing, the pressure of hand on lap

1 El Lissitzky: Detail of
fig. 147 (larger than
actual size)

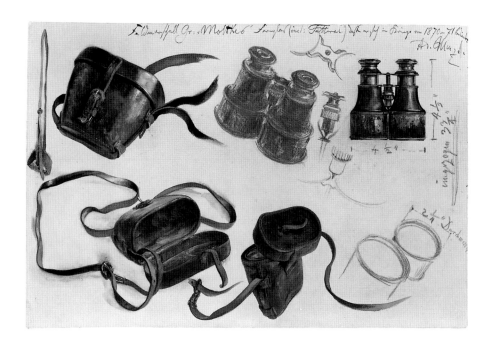

2 Adolph Menzel: *Moltke's Binoculars*, pencil and gouache on paper, 26 × 40, 1871 (Kupferstichkabinett, Staatliche Museen, Berlin)

– and understanding they were offerings of love. But beyond that, this world of persons and sexualities would be opaque. (Would future viewers sense that Picasso's woman is wearing fancy dress? Would they take their cue from the clouds in the sky?) Is the male in *Complex Presentiment* being teased for his phallic dutifulness – those two little buttons! that drawstring at the waist! – or are these his last shreds of humanity? I have no more idea than the archaeologists. Are Field Marshal Moltke's binoculars wonderful or silly? Here they are, snug in their carrying case! And here is the case empty, with magenta lining visible. And here it is shut tight and buckled. And this is how the focus screw works. "Is there an object for which the nineteenth century did not invent a case or a holder? It had them for watches, slippers, egg-cups, thermometers, playing cards. And if not cases and holders, it invented envelopes, housings, loose covers, dust sheets."[2] It is as if an object did not properly exist for this culture until it sat tight in its own interior; and one is hard put to say – certainly on the evidence of Menzel's gouache – whether this was because the object was felt to need protection from the general whirl of exchange (or bullets), or whether it was thought to be so wonderful in its own right that a separate small world should be provided for it, like a shell or calyx. Heartfield's new man, photographically grimy, is similarly encased – touched on two sides by blast furnaces, cooperative apartment blocks, tractors, trucks full of soldiers, the new Baku Palace of the Press. He looks to the future, eyes airbrushed full of tears.

Now that I sit down to write my introduction, I realize that what I had taken for a convenient opening ploy – the fragments, the puzzling scholars, the intervening holocaust – speaks to the book's deepest conviction, that already the modernist past is a ruin, the logic of whose architecture we do not remotely grasp. This has not happened, in my view, because we have entered a new age. That is not what my book title means. On the contrary, it is just because the "modernity" which modernism prophesied has finally arrived that the forms of representation it originally gave rise to are now unreadable. (Or readable only

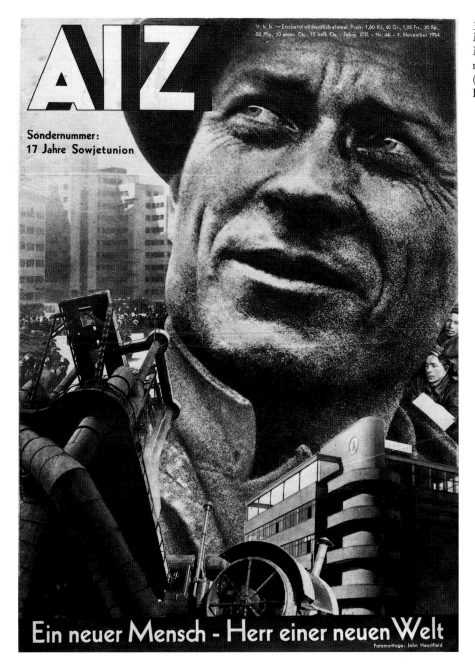

under some dismissive fantasy rubric – of "purism," "opticality," "formalism," "elitism," etc.) The intervening (and interminable) holocaust was modernization. Modernism is unintelligible now because it had truck with a modernity not yet fully in place. Post-modernism mistakes the ruins of those previous representations, or the fact that from where we stand they seem ruinous, for the ruin of modernity itself – not seeing that what we are living through is modernity's triumph.

Modernism is our antiquity, in other words; the only one we have; and no doubt the Baku Palace of the Press, if it survives, or the Moltke Museum, if it has not been scrubbed and tweaked into post-modern receptivity (coffee and biscotti and interactive video), is as overgrown and labyrinthine as Shelley's dream of Rome.

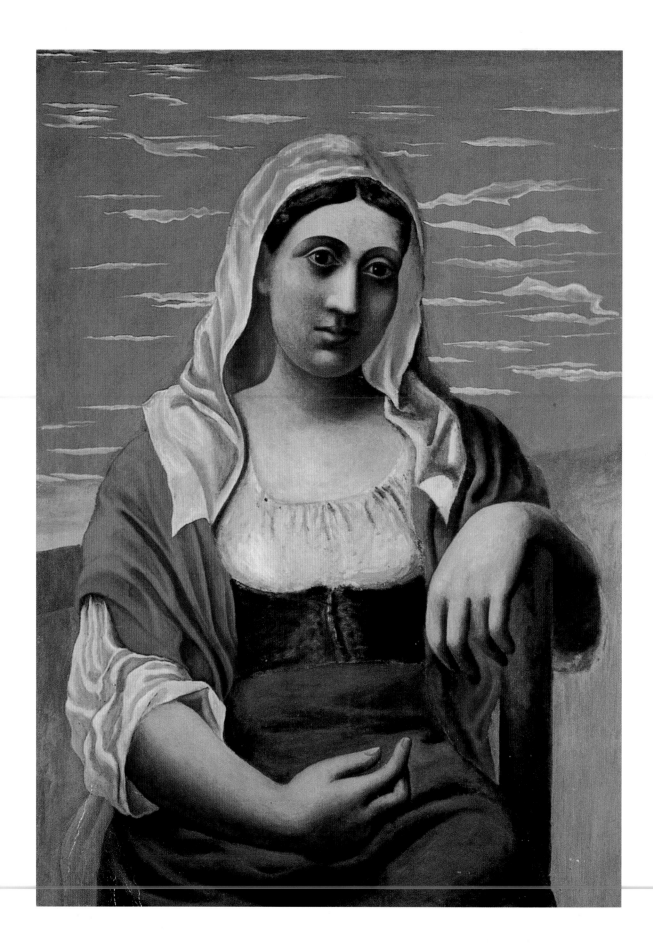

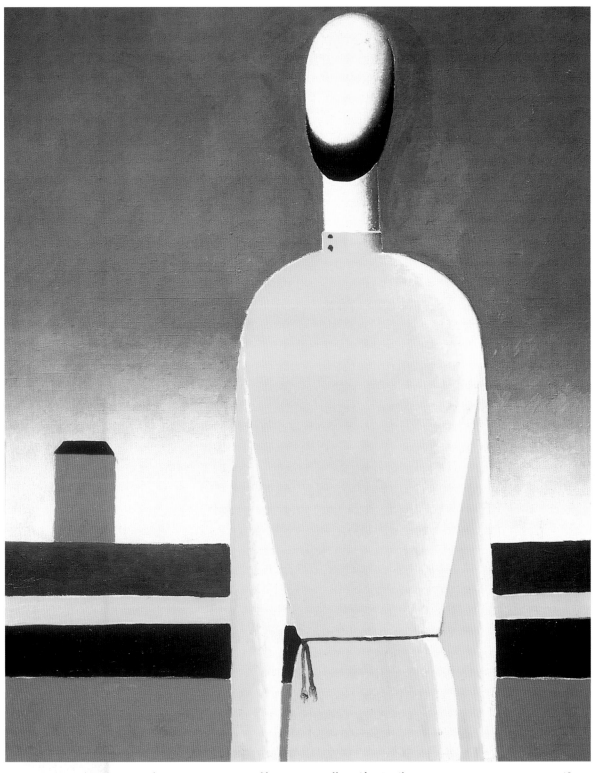

5 Kasimir Malevich: *Complex Presentiment (Half-Figure in Yellow Shirt)*, oil on canvas, 99 × 79, 1928–32 (State Russian Museum, St. Petersburg)

4 (*facing page*) Pablo Picasso: *Italian Woman*, oil on linen, 98.5 × 70.5, 1919 (Private collection)

This Poem was chiefly written upon the mountainous ruins of the Baths of Caracalla, among the flowery glades, and thickets of odoriferous blossoming trees, which are extended in ever winding labyrinths upon its immense platforms and dizzy arches suspended in the air. The bright blue sky of Rome, and the effect of the vigorous awakening spring in that divinest climate, and the new life with which it drenches the spirits even to intoxication, were the inspiration of this drama.[3]

The tears in the eyes of Heartfield's new man will soon be as incomprehensible as scratches on Mousterian bone. And as for Menzel's passion for binoculars! His careful measurements in inches, his depthless swivelling of things to reveal their visual truth, his dreaming of state-formation in terms of a gadget in a battle-worn case . . . This is a world, and a vision of history, more lost to us than Uxmal or Annaradapurah or Neuilly-en-Donjon. We warm more readily to the Romanesque puppets on God's string, or the kings ripping blood-sacrifice from their tongues, than to workers being read to from *Izvestia* or *El Machete* (fig. 6).[4]

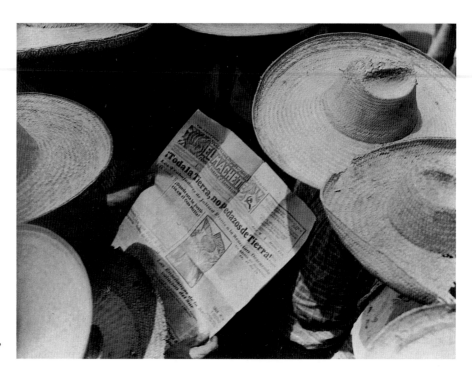

6 Tina Modotti: *Men Reading "El Machete,"* photograph, 17.1 × 23.5, 1924 (Private collection)

These are the reasons I could not escape in writing this book from the dangerous (and no doubt absurd) idea that it was addressed to posterity. Of course this was fantasy, not prediction: it was a way of writing, or dreaming of writing; and from it derives much of the book's basic form – its brokenness and arbitrariness, and the accompanying effort at completeness of knowledge, at least in the few test cases I do present. I think of them as core samples, or preliminary totalizations. The modernist arrogance of that ambition is precisely why I could not let it go. (Not that I am claiming that this is how the book proceeds all through. Chapters vary in length and tactics. "Completeness" is not the same as comprehensiveness. But the chapters and moments the book hinges on – Pissarro in 1891, UNOVIS in 1920, David in Year 2, Picasso in the

first flush of Cubism – are turned in the hand, I hope, as fiercely as Moltke's binoculars. They are items from a modernist dig.)

Addressed to posterity, then – but posterity meaning us.

No one expects books on Romanticism, Dada, or the Scientific Revolution to come up with capsule definitions of their subjects. Why modernism has been the exception here is a story in its own right. I shall operate with a loose and capacious notion of modern art, and spend a lot of my time (not all) on limit cases; the assumption being that in these the pressures and capacities of a particular mode of representation (maybe we should call it a family of modes) will tend to be clearest, just because the capacities are pressed to breaking point. "Limits" in this case does not mean edges. I want to avoid thinking of modernism in spatial terms, even in terms of conceptual space. I want modernism to emerge as a distinctive patterning of mental and technical possibilities. Limit cases, like Pissarro in 1891 or Malevich in 1920 or Pollock from 1947 to 1950, seem to me characterized by a thickening or thinning of those patterns – by kinds of simplification or overload, stabs at false immediacy or absolute muteness, ideas of beginning again or putting an end to representation, maybe moving finally from representation to agency (from art to politics, or from sign to trace, or to signs whose meanings only the future will grasp).

As for the word "modernity," it too will be used in a free and easy way, in hopes that most readers know it when they see it. "Modernity" means contingency. It points to a social order which has turned from the worship of ancestors and past authorities to the pursuit of a projected future – of goods, pleasures, freedoms, forms of control over nature, or infinities of information. This process goes along with a great emptying and sanitizing of the imagination. Without ancestor-worship, meaning is in short supply – "meaning" here meaning agreed-on and instituted forms of value and understanding, implicit orders, stories and images in which a culture crystallizes its sense of the struggle with the realm of necessity and the reality of pain and death. The phrase Max Weber borrowed from Schiller, "the disenchantment of the world," still seems to me to sum up this side of modernity best. Or the throwaway aphorism of Paul Valéry: "The modern contents itself with little [*Le moderne se contente de peu*]." (And of course it is no argument against Weber's thesis to say that "we live in the middle of a religious revival," that Marxism became a grisly secular messianism in the twentieth century, that everyday life is still permeated by the leftovers of magic, and so on. The disenchantment of the world is horrible, intolerable. Any mass movement or cult figure that promises a way out of it will be clung to like grim death. Better even fascism than technocracy: there is a social id in most of us that goes on being tempted by that proposition.)

"Secularization" is a nice technical word for this blankness. It means specialization and abstraction; social life driven by a calculus of large-scale statistical chances, with everyone accepting (or resenting) a high level of risk; time and space turned into variables in that same calculus, both of them saturated by "information" and played with endlessly, monotonously, on nets and screens; the de-skilling of everyday life (deference to experts and technicians in more and more of the microstructure of the self); available, invasive, haunting expertise; the chronic revision of everything in the light of "studies." I should say straight-away that this cluster of features seems to me tied to, and propelled by, one central process: the accumulation of capital, and the spread of capitalist markets into more and more of the world and the texture of human dealings. I realize this is now a minority view, and will be seen by many readers as a vestige of the early twentieth-century messianism I just tried to put at a distance. If I

cannot have the proletariat as my chosen people any longer, at least capitalism remains my Satan.

Let me try to strike a bargain with the reader over this. Could we agree on the following, which I think may be a necessary, or at least helpful, hypothesis if what we are trying to do is understand why modernity and modernism go together? Leaving the word "capitalism" aside, is it not the case that the truly new, and disorienting, character of modernity is its seemingly being driven by merely material, statistical, tendential, "economic" considerations? We know we are living a new form of life, in which all previous notions of belief and sociability have been scrambled. And the true terror of this new order has to do with its being ruled – and obscurely felt to be ruled – by sheer concatenation of profit and loss, bids and bargains: that is, by a system without any focusing purpose to it, or any compelling image or ritualization of that purpose. It is the blindness of modernity that seems to me fundamental, and to which modernism is a response: the great fact, to go back to Adam Smith's insight, is the hiddenness of the "hidden hand"; or rather, the visibility of that hiddenness – the availability to individual consciousness of more and more "information" (a ludicrous, lobotomizing barrage of same) pointing to the purposelessness of social action.

Blindness, purposelessness, randomness, blankness; pictures built out of statistical accumulations of thrown marks, or touch after touch of pure surfaceness, pure sensation; but equally, pictures clinging to a dream of martyrdom, or peasant leisure, or naked intensity in the woods; and pictures fantasizing themselves the voice – the image, the plan – of a post-human calculus in the making. "I declare Economy to be the new fifth dimension, the test and measure of all creative and artistic work." "THE FACTORY BENCHES ARE WAITING FOR YOU. LET US MOVE PRODUCTION FORWARD."[5] Modernism is caught interminably between horror and elation at the forces driving it – between "Less Is More" and "NO CHAOS DAMN IT." It takes its own technicality and specialization as guarantees of truth. But at the same time it knows these qualities are potentially smug and philistine, always threatening to turn into a Bauhaus- or École de Paris-orthodoxy. Modernism's disdain for the world and wish for a truly gratuitous gesture in the face of it are more than just attitudes: they are the true (that is, agonized) form of its so-called purism. Wilde and Nietzsche are this agony's spokesmen, Rimbaud's its exemplary life. And yet the thought of belonging and serviceability (of Economy as an ideal) haunts modernism, all the more so because belonging and serviceability are sensed to be modernity's true opposites – the dimensions to experience it most ruthlessly outlaws or travesties. These antinomies of modern art, and their relation to a history it invents and resists and misrecognizes, are what this book is mainly about.

The book was written after the Fall of the Wall. That is, at a moment when there was general agreement, on the part of masses and elites in most of the world, that the project called socialism had come to an end – at roughly the same time, it seems, as the project called modernism. Whether those predictions turn out to be true, only time will tell. But clearly something of socialism and modernism has died, in both cases deservedly; and my book is partly written to answer the question: If they died together, does that mean that in some sense they lived together, in century-long co-dependency?

Socialism, to remind you, was the idea of "the political, economic and social emancipation of the whole people, men and women, by the establishment of a democratic commonwealth in which the community shall own the land and

capital collectively and use them for the good of all."[6] Co-dependency, we know to our cost, does not necessarily mean mutual aid or agreement on much. Modernism was regularly outspoken about the barrenness of the working-class movement – its politics of pity, its dreary materialism, the taste of the masses, the Idea of Progress, etc. But this may have been because it sensed socialism was its shadow – that it too was engaged in a desperate, and probably futile, struggle to imagine modernity otherwise. And maybe it is true that there could and can be no modernism without the practical possibility of an end to capitalism existing, in whatever monstrous or pitiful form.

Monstrous or pitiful. We are back in Heartfield territory. You will see in what follows that I interpret the terms "socialism" and "working-class movement" broadly. Two of my main cases are Jacobinism and the sans-culottes in 1793, and anarchism in the early 1890s. Even my third test case, War Communism in Russia in 1919 and 1920, is deliberately extreme: it is maybe as close as any modern society has come to a wholesale dismantling of the money economy, but of course the dismantling was largely involuntary – and where deliberate, doctrinaire and foolhardy – with results that were truly horrible. I make no apology for my strange trio. The Jacobin moment is foundational (sadly) for the imaginings of mass politics that followed. Anarchism is an aspect of socialism (among many others) that those of us wishing socialism, or some comparable form of resistance, to survive will have to think about again, this time without a prearranged sneer. War Communism was utopia as well as horror and abyss, and it leaves us with the question, which we should not allow the enemies of anti-capitalism to monopolize, whether a utopian form of opposition to the present is always in practice infernal. "Modernity, the time of hell," reads one of Walter Benjamin's jottings.[7] There was a kind of socialism that toyed with, and in the end realized, the possibility of making that hell actual. In hopes of the fire being purgative. This has a ghastly attractiveness for modernists, we shall see. UNOVIS tried to get on the bandwagon/tumbril. Modernism regularly joins hands with socialism when socialism is in extremis. That is another reason for my choice of examples.

Socialism was one of the forces, maybe *the* force, that made for the falsely polarized choice which modernism believed it had before it – between idealism and materialism, or *Übermensch* and lumpen, or esoteric and popular. Between the cultic and the utterly disenchanted. Between the last exacerbation of individuality and its magical disappearance into pure practice or avant-garde collectivity. I sense that what lay between those mad alternatives was above all socialism – again, broadly construed. (Revolution, or the cult of class consciousness, would be other words for much the same cluster of images and actions.) Socialism occupied the real ground on which modernity could be described and opposed; but its occupation was already seen at the time (on the whole, rightly) to be compromised – complicit with what it claimed to hate. This is not meant as excuse for the thinness and shrillness of most of modernism's occupation of the *un*real ground. There could have been (there ought to have been) an imagining otherwise which had more of the stuff of the world to it. But I am saying that modernism's weightlessness and extremism had causes, and that among the main ones was revulsion from the working-class movement's moderacy, from the way it perfected a rhetoric of extremism that grew the more fire-breathing and standardized the deeper the movement bogged down on the parliamentary road.[8]

Modernism had two great wishes. It wanted its audience to be led toward a recognition of the social reality of the sign (away from the comforts of narrative and illusionism, was the claim); but equally it dreamed of turning the sign back to a bedrock of World/Nature/Sensation/Subjectivity which the to and fro of

capitalism had all but destroyed. I would be the last to deny that modernism is ultimately to be judged by the passion with which, at certain moments, it imagined what this new signing would be like. Cézanne and Cubism are my touchstones, and Pollock in the world of his drip paintings. But at the same time I want to say that what they do *is* only imagining, and fitful imagining at that – a desperate, marvellous shuttling between a fantasy of cold artifice and an answering one of immediacy and being-in-the-world. Modernism lacked the basis, social and epistemological, on which its two wishes might be reconciled. The counterfeit nature of its dream of freedom is written into the dream's realization: this is an argument that crops up several times in the book. The chapter on UNOVIS may show the link between counterfeit and the modern artist's social isolation more specifically than the chapter on Cubism can. But the link is essentially the same. Some avant gardes believe they can forge a place for themselves in revolution, and have real truck with languages in the making; others believe that artists can be scientists, and new descriptions of the world be forged under laboratory conditions, putting aside the question of wider intelligibility for the time being. I do not see that either belief is necessarily (logically) misguided. It is just that in the actual circumstances of modernism – in modernity, that is – they have so far proved to be.

A book about nineteenth- and twentieth-century culture will inevitably turn on the question of money and the market, and their effect on artmaking. This book does so three times: in its dealings with the Terror and War Communism, and with Pissarro in 1891. Again, two of the three cases are extreme. In 1793 in France and 1920 in Russia the very relation between markets and money seemed, for a while, to be coming to an end. We shall see that certain Bolsheviks looked back to Year 2 explicitly, and exulted in the notion of the socialist state's being able now to drown its enemies in a flood of paper. It was a fantasy, but not an entirely empty one. Money is the root form of representation in bourgeois society. Threats to monetary value are threats to signification in general. "Confidence in the sign" was at stake, to quote one historian of Jacobinism, talking of inflation in 1793 and the role of new banknotes.[9] In their different ways David and Malevich confronted that crisis of confidence, I think, and tried to give form to its enormity. In coming to terms with money, or with money seemingly about to evaporate as a (central) form of life, modernism at moments attained to true lucidity about the sign in general.

I did say "at moments." I am not forgetting the a priori emptiness of most of modernism's pronouncements on matter and the production of meaning. Of course modernism usually vacillated between a crude voluntarism and an equally crude positivity ("in the nature of materials" and so on). But again, limit cases reflect back on normal ones. What modernism thought was possible when the whole signifying basis of capitalism went into free flow – what it thought it might do with the opportunity – may tell us something about where the crude voluntarism and positivism were always meant to be going, even when modernity was as solid as a rock.

A word that has come up already, and will do so again, is "contingency." It points to the features of modernity I began with: the turning from past to future, the acceptance of risk, the omnipresence of change, the malleability of time and space. What it does not mean, I should stress, is that modern life is characterized by an absolute, quantitative increase in uncontrolled and unpredictable events. Tell that to societies still in the thrall of Nature, meaning

floods, famine and pestilence. Tell it to parents coping with pre-modern levels of infantile mortality. Obviously modern society offers the majority of its citizens – we could argue about the precise size of that majority – safer and more humdrum lives. But it is this very fact, and the stress put on the achievement in modern society's endless self-apology, that makes the remaining and expanding areas of uncertainty the harder to bear. Again, the capitalist market is key. Markets offer hugely increased opportunities for informed calculation and speculation on futures. That is why they rule the world. But they do so only if players are willing to accept that conduct *is* calculus and speculation, and therefore in some fundamental sense hit or miss. Markets are predictable and risky. Human beings are not used to living their lives under the sign of both. (Or of either, in a sense. Pre-modern social orderings were not "predictable." They were the very ground of experience as such – of having and understanding a world – confirmed and reconfirmed in the rituals of everyday life.[10] Pre-modern natural disasters were not experienced as risk. They were fury or fate. The very idea of natural disaster is a modern one, an invention of actuaries, aiming to objectify a previous congeries of terrors.)

This is what "contingency" means. It is an issue of representation, not empirical life-chances. And using the word is not meant to imply that modern societies lack plausible (captivating) orders of representation, or myths of themselves – how could anyone living the triumph of late-twentieth-century consumerism, or watching ten-year-olds play computer games, have any illusions on that score? Contingency is good business. It may even turn out to be good religion. (It remains to be seen if the ten-year-olds grow up and get born again. When I said a few pages ago that modern societies were ruled "by a system without any focusing purpose to it, or any compelling image or ritualization of that purpose," I knew my vocabulary would seem old-fashioned, at least to some. Maybe focus and purpose are things human beings can do without. Maybe not.) All I want to insist on is the novelty of our current ways of understanding self and others, and the fact that for modernism, risk and predictability were felt to be endlessly irresolvable aspects of experience (and of artmaking), endlessly at war. Modernism could not put contingency down. But the forms it gave it – think of Seurat's identical, mechanical, all-devouring paint atoms, or Pollock's great walls of accident and necessity – were meant to be ominous as well as spellbinding, and even after a century or half-century still register as such. Sit in the room full of Pollock's pictures at MoMA, and listen to visitors protest against both sides of the equation. "Risk" here, in their view, is randomness and incompetence, and "predictability" lack of incident, lack of individuating structure. A child of five could do it. Or a painting machine.

Seurat and Pollock are unfair examples, of course. They are as close as modernism comes to embracing contingency and making it painting's structural principle. By and large modernism's relation to the forces that determined it were more uneasy, as I said before, more antagonistic. Contingency was a fate to be suffered, and partly to be taken advantage of, but only in order to conjure back out of it – out of the false regularities and the indiscriminate free flow – a new pictorial unity. Out of the flux of visual particles would come the body again (says Cézanne) – naked, in Nature, carrying the fixed weaponry of sex. Out of the shifts and transparencies of virtual space (says Picasso) would come the violin and the mandolin player. Tokens of art and life. Modernist painters knew the market was their element – we shall see Pissarro in 1891 half-railing, half-revelling in its twists and turns – but by and large they could never escape the notion that art would absolve or transfigure its circumstances, and find a

way back to totality. Call it the Body, the Peasant, the People, the Economy, the Unconscious, the Party, the Plan. Call it Art itself. Even those moments of modernism that seem to me to have understood the implications of the new symbolic order (or lack of it) most unblinkingly – Malevich and Pollock are my chief examples – are torn between exhilaration and despair at the prospect. I call the exhilaration nihilism, and the despair unhappy consciousness. But I do not pretend they are easy to tell apart.

One further concession. I realize that my view of modernism as best understood from its limits makes for some notable silences in the book, or for hints at a treatment I do not provide. Matisse is a flagrant example. Above all there is an ominous leap in what follows from 1793 to 1891. Partly this is accident: I have had my say in previous writings on aspects of nineteenth-century art that would connect most vividly to the story I am telling (Courbet's attempt to seize the opportunity of politics in 1850, for example, or the pattern of risk and predictability occurring in paintings of Haussmann's new Paris), and I saw no way to return to them properly here. In any case, I want Pissarro and anarchism to stand for the nineteenth century's best thoughts on such topics. I believe they do stand for them. The true representativeness of 1891 and Pissarro is one of my book's main claims. But I know full well the claim is disputable, and that some readers will see my leap over the nineteenth century as the clue to what my argument as a whole has left out. I cannot bear to face, they will say, the true quiet – the true orderliness and confidence – of bourgeois society in its heyday, and the easy nesting of the avant garde in that positivity. I will not look again at Manet because I do not want to recognize in him the enormous distance of modern art from its circumstances, and the avant garde's willingness to seize on the side of secularization – the cult of expertise and technicality – that seemed to offer it a consoling myth of its own self-absorption.

Of course I bring on this sceptical voice because one side of me recognizes that it points to something real – how could anyone looking at Manet fail to? But equally, I am sure this view of Manet and the nineteenth century is wrong. I have no quarrel with the words "enormous distance" and "self-absorption" with reference to Manet's achievement. What I should want to insist on, though, is the terrible, inconsolable affect which goes with the look from afar. In general I think we have barely begun to discover the true strangeness and tension of nineteenth-century art, lurking behind its extroversion. Michael Fried's books have opened the way.[11] And do not make the mistake of believing that extremism is Manet's and Courbet's property exclusively, with maybe Seurat and van Gogh as co-owners. Ingres is more ruthless and preposterous than any of them. Cézanne around 1870 exists at, and epitomizes, the century's mad heart. Even Corot is a monster of intensity, pushing innocence and straightforwardness to the point where they declare themselves as strategies, or magic against modernity in general. His gray pastorals grapple head on (not even defiantly) with the disenchantment of the world. They aim to include the disenchantment in themselves, and thus make it bearable. Sometimes they succeed. (Pissarro in 1891 is still trying out variants on his master Corot's tactic.) Even Monet's art is driven not so much by a version of positivism as by a cult of art as immolation, with more of the flavor of Nerval and Géricault to it than of Zola and Claude Bernard. "I plunge back into the examination of my canvases, which is to say the continuation of my tortures. Oh, if Flaubert had been a painter, what would he ever have written, for God's sake!"[12] All of the nineteenth century is here.

Friends reading parts of this book in advance said they found it melancholic. I have tried to correct that as far as possible, which in the circumstances may not be very far. Melancholy is anyway an effect of writing; which is to say, this particular practice of writing – green-black words tapped nearly soundlessly into screen space at fin de siècle. The reason I write history is that I am interested in other practices, less cut off and abstract, which once existed and might still be learned from. I hope this proves true of Pissarro and El Lissitzky. Modernism may often have been negative; it was rarely morose. It is the case that many, maybe most, of my chapters come to a bad end. Trust the beginnings, then; trust the epigraphs. Trust Freud, and Stevens, and Frank O'Hara. So cold and optimistic, modernism. So sure it will get there eventually.

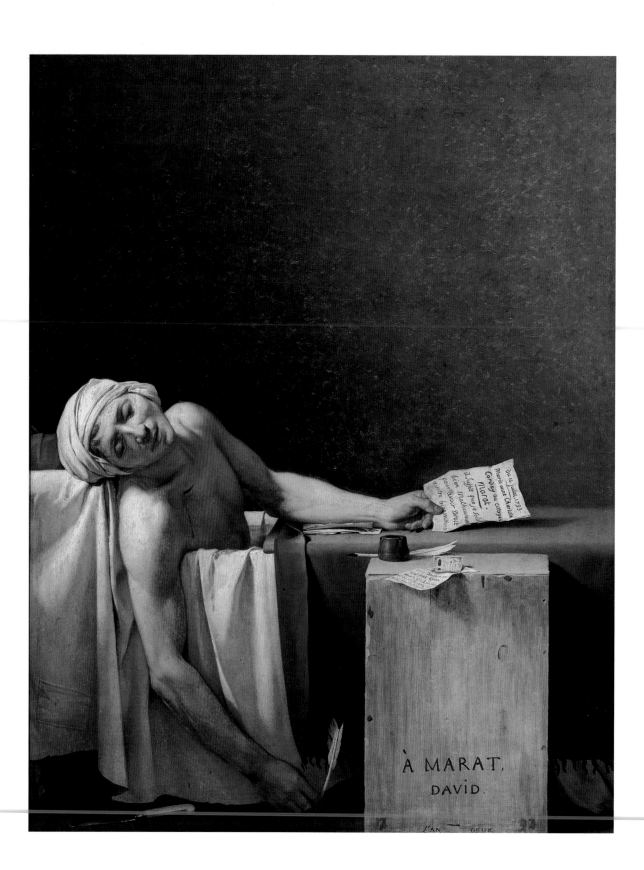

1 Painting in the Year 2

History has too often been no more than a tale of the actions of wild beasts, among whom from time to time one makes out a hero; we are entitled to hope that we are beginning the history of mankind.

Mirabeau, 1789[1]

Books about modernism tend to go in for inaugural dates. It all began in the 1820s, they say, or with Courbet setting up his booth outside the Exposition Universelle in 1855, or the year *Madame Bovary* and *Les Fleurs du Mal* were put on trial, or in room M of the Salon des Refusés. "An important component in historical sequences of artistic events," writes George Kubler,

is an abrupt change of content and expression at intervals when an entire language of form suddenly falls into disuse, being replaced by a new language of different components and an unfamiliar grammar. An example is the sudden transformation of occidental art and architecture about 1910. The fabric of society manifested no rupture, and the texture of useful inventions continued step by step in closely linked order, but the system of artistic invention was abruptly transformed, as if large numbers of men [*sic*] had suddenly become aware that the inherited repertory of forms no longer corresponded to the actual meaning of existence . . . In art the transformation was as if instantaneous, with the total configuration of what we now recognize as modern art coming all at once into being without many firm links to the preceding system of expression.[2]

My candidate for the beginning of modernism – which at least has the merit of being obviously far-fetched – is 25 Vendémiaire Year 2 (16 October 1793, as it came to be known). That was the day a hastily completed painting by Jacques-Louis David, of Marat, the martyred hero of the revolution – *Marat à son dernier soupir*, David called it early on[3] – was released into the public realm (fig. 7).

A few minutes after midday on 25 Vendémiaire, Marie-Antoinette was guillotined. Michelet tells us that her death, so long demanded by Hébert and the Paris wards (the so-called *sections*), in the event went off quietly.[4] People's minds were on other things – the scandal of Précy's escape from Lyon, for example, and the news, mostly bad, from the Army of the North. They knew a great battle was brewing. The cart carrying the queen to the scaffold may well have passed directly under the windows of David's apartment in the Palais du

7 Jacques-Louis David: *Death of Marat*, oil on canvas, 165 × 128, 1793 (Musées royaux des Beaux-Arts de Belgique, Brussels)

Louvre; in any case we have a pen-and-ink drawing in David's hand of the queen in her final regalia, seemingly done on the spot (fig. 8). "Sinister jotting," its first owner called it.[5] The queen died bravely. Her last fear was that her dead body would be torn limb from limb by the crowd. It did not happen.

A few hours later there was a second ceremony in the streets – some of them the same streets Marie-Antoinette had been wheeled along on her way from the Conciergerie to the place de la Révolution. The printed *Ordre de la Marche* for the afternoon's events survives, and we have one or two other reminiscences of the day's final setpiece in the Cour du Louvre. Albert Soboul, in his *Les Sans-Culottes parisiens en l'an deux*, puts together the following description of what happened:

On the afternoon of 16 October, the Museum section marched in procession along the quai de l'École, the rues de la Monnaie, Saint-Honoré, and Saint-Nicaise, then stopped in the place de la Réunion to burn the act of indictment against Marat [that is, a copy of the charges drawn up by the Girondins against Marat the previous April], marched on along the quai du Louvre as far as the rue des Poulies, and went into the great courtyard of the Louvre through the colonnade. At the head of the column were ten ranks of drums and riflemen marching in strict order, then a detachment of the armed forces; after them the popular societies with their standards, the sections "preceded by their banners," and various corporate bodies; a detachment of troops came next, flag and drums in the lead, then the whole Museum section passed by en masse; a "corps of musicians" ahead of a deputation from the Conven-

tion, and following them a group of young conscripts, oak branches in their hands, carrying in their midst the busts of Marat and Lepeletier [sic]; behind them the citoyennes of the section dressed all in white, holding their children by the hand and bearing flowers to deck Marat's tomb; and then bringing up the rear a detachment of the section's own armed forces. In the courtyard of the Louvre, sarcophagi had been erected, and on top of them pictures, painted by David, of the two martyrs of liberty [the other picture, of the regicide Michel Le Peletier de Saint-Fargeau, killed by a Royalist on the morning of the King's execution, no longer exists]; a funeral service was held in front of them, with hymns and speeches. As in the ceremonies of the Catholic church, all the arts contributed their magic to the exaltation of the faithful; the sans-culottes communed in the memory of their martyrs.[6]

It is not often that we know so much about the circumstances in which a painting was first shown to the public. But then, it is not often that the circumstances are so carefully stage-managed. No one can be sure that it was David himself who decided who went where that day carrying what. The Ordre de la Marche is signed, for form's sake, by the Museum section's president and secretary. But it would not be surprising if David were responsible. He was the Republic's great expert on matters of mass choreography. He was one of the section's most important Jacobins. And two days previously he had gone before the Convention to announce that the picture of Marat was completed, and to ask his colleagues, "before offering it you, to allow me to lend it to my fellow citizens of the Museum section, as well as that of Lepelletier [sic], so that both can be present, in some sense, at the civic honors paid them by their fellow citizens."[7] Naturally the Conventionnels were not to be excluded from this special event. They could come see their pictures if they wanted to. Even march in the procession. "I invite you to be the first to come view them at my quarters in the Louvre, starting next Saturday."

The Convention seems to have agreed to David's proposal without much discussion. Among other things, it would probably have struck them as no bad thing for the afternoon of Marie-Antoinette's execution – she was appearing before the Revolutionary tribunal on the day David made his request – to have one or two rival attractions on offer.

I did say "among other things." By which I mean other possible purposes – other meanings and messages that may have been on the organizers' minds, and maybe even on the participants', as they let their pictures out in public or made their way toward the sarcophagi. I believe that David's procession belongs to its moment – to the days and weeks surrounding 25 Vendémiaire – in ways not necessarily written on the surface. And that the picture of Marat only truly makes sense if its belonging to the same moment is taken seriously, even at the risk of setting an empiricist historian's teeth terminally on edge. For of course the Marat was not done with the procession in view. The procession was thrown together in October. It was part of that month's specific politics. The painting had been under way since July. It had been ordered by the Convention, to be seen in situ by Conventionnels. And so it would be in due course – for a while behind the tribune in the Salle des séances, and later, when Marat's fortunes waned, somewhere in an outer office.

But it is never the case that we interest ourselves in the circumstances of a picture's first showing because we believe the picture was done for that showing. That showing could only have been imagined, or perhaps phantasized, by the painter as he or she was at work in the first place. And always inaccurately. David, I guess, never had the idea while he did the painting that eventually his Marat and Le Peletier would be "present, in some sense, at the

civic honors paid them by their fellow citizens." But the fact that they were, and that in the end he went to such lengths to dictate the terms of their inclusion in the event, tells us something about the nature of David's presuppositions as an artist – his active imagining of what he was doing painting Marat at all. Something decisive: that is my hunch. For my feeling is that what marks this moment of picture-making off from others (what makes it inaugural) is precisely the fact that contingency rules. Contingency enters the process of picturing. It invades it. There is no other substance out of which paintings can now be made – no givens, no matters and subject-matters, no forms, no usable pasts. Or none that a possible public could be taken to agree on anymore. And in painting – in art in general – disagreement most often means desuetude.

Modernism, as I have said, is the art of these new circumstances. It can revel in the contingency or mourn the desuetude. Sometimes it does both. But only that art can be called modernist that takes the one or other fact as determinant.

But what contingency, precisely? And entering the picture how?

Let me go back to the procession on 25 Vendémiaire. The first thing to say about it is that it was, at least on one level, profoundly ordinary. Events much like it had happened elsewhere in Paris in the preceding days, and many more were to come. The Sections de la Halle-au-Bled et de Guillaume Tell Réunies, for example, had gathered on 6 October *Pour l'Inauguration des bustes de Brutus, Michel Lepelletier et Paul Marat, martyrs de la liberté, et la déclaration des droits de l'homme, gravée sur une pierre de la Bastille.*[8] They published extracts from the speeches made that day. The Section de Piques was equally proud of the address *Prononcé à la Fête décernée . . . aux mânes de Marat et de Le Pelletier, par Sade, citoyen de cette section, et membre de la société populaire.* They brought it out in pamphlet form on 29 September. Citizen Sade, unsurprisingly, had things to say about Marat's murderer, Charlotte Corday:

> Soft and timid sex, how can it be that delicate hands like yours have seized the dagger whetted by sedition? . . . Ah! your eagerness now to come throw flowers on the tomb of this true friend of the people makes us forget that Crime found a perpetrator among you. Marat's barbarous assassin, like one of those hybrid creatures to whom the very terms male and female are not applicable, vomited from the jaws of hell to the despair of both sexes, belongs directly to neither. Her memory must be forever shrouded in darkness; and above all let no one offer us her effigy, as some dare do, in the enchanting guise of Beauty. O too credulous artists – break this monster in pieces, trample her underfoot, disfigure her features, or only offer her to our revolted gaze pursued by Furies from the underworld.[9]

Presumably the speeches at a similar ceremony the week before, on 23 September, *Dans la Section des Gardes-Françoises, pour l'inauguration des bustes de Lepelletier et Marat,* had had less of a personal subtext. On 22 September the Section du Panthéon gathered to hear one Gavard – he seems to have made no other mark in history – deliver a funeral oration to Marat alone. And so on. These are only the occasions that left a written record behind them.[10]

The show put on by the Museum section was ordinary, then, in the sense of being one of a series. (I am not denying that individual items in the series are as far out of the ordinary as you could dream up. They look like figments of Goya's or Baudelaire's imagination. Year 2 is the nightmare from which all later sadists borrow their imagery.) The show was likewise ordinary in its language, its organization. If the procession of 25 Vendémiaire really followed the instructions set out in the *Ordre de la Marche* – and any militant worth his or her salt

knew things were likely to be a bit ragged on the afternoon – then even an unsympathetic spectator would have been impressed, at least by an imagery of force. The People marched through the streets to the Louvre. At the heart of the procession, and by the look of things its single biggest element, was the rank and file of the Museum section, passing by "en masse, unarmed." But the mass was padded and sandwiched by *corps constitués* of all sorts: delegations from Piques and Panthéon and Guillaume Tell, clubs and popular societies lined up beneath their insignia, representatives of the courts and offices of the Revolutionary government, those Conventionnels who had accepted David's invitation of two days before, women in white leading their children. Conscripts carrying the busts of the martyrs "with the respect inspired by Virtue in those who have vowed to vanquish for the fatherland or die."[11] Marching bands, drums and more drums, and everywhere – at the head of the column, in the middle, making up the rear – *détachements de la force armée*. Nothing is accidental here. Everything is in its proper political and natural place. When the column stopped in the place de la Réunion to set fire to the Girondins' act of accusation against Marat, the crowds were meant to remember the Girondin deputies then awaiting trial in the Conciergerie, and harden their hearts. The trial began a week later. Brissot, Vergniaud and the rest were executed the week following, on 10 Brumaire.

It is a pity, given the amount of detail surviving, that more was not said by contemporaries about how the Marat and Le Peletier paintings were set up at the end of the route. On two sarcophagi, this much is certain. Under some kind of temporary covering. One witness from the early nineteenth century recalls it as a "mortuary chapel."[12] Another talks of the paintings being put "in a kind of funeral crypt, where they were admired over the course of six weeks."[13] Perhaps (here historians start extrapolating from other such floats and festival scenery, of which there were many at the time) they were put inside a halfshell of branches and tricolor drapery. That would agree with David's aesthetic.

Apparently there were four lines of verse by David's friend Gabriel Bouquier pinned to the sarcophagus:

> Peuple, Marat est mort; l'amant de la Patrie,
> Ton ami, ton soutien, l'espoir de l'affligé
> Est tombé sous les coups d'une honte flétrie.
> Pleure! Mais souviens-toi qu'il doit être vengé.

(People, Marat is dead; the lover of the Fatherland,/Your friend, your supporter, the hope of the afflicted/Has fallen under the blows of blighted infamy./Weep! But remember that he must be avenged.)[14]

We shall find Bouquier's basic moves here – his terms of address and instruction to the viewer, and above all his sense of who the viewer was – repeated a hundred times in the following months.

Many of the individual bits and pieces of information about 25 Vendémiaire are vivid, not to say tear-jerking, yet I am still left wondering what the whole occasion was meant to do. Whose occasion was it? Why did David and others think it worth investing their energies in, when so much else demanded their attention? What did they take it to signify?

Soboul, who had his reasons for wanting to believe that a new actor, the *menu peuple* of Paris, had stepped onto the world-historical stage in Year 2, treated the procession we have been looking at as one of the year's great moments of class self-discovery. If he had known of the verses stuck to the

sarcophagus he would have quoted them with relish. "Les sans-culottes communiaent dans le souvenir de leurs martyrs." The body and blood they partook of in the Cour du Louvre, so Soboul believed, was essentially their own. Come unto me all that travail and are heavy laden. David's asking permission to show off the *Marat* and *Le Peletier* to his fellow *sectionnaires* was interpreted in a similarly exalted vein. "Art was no longer reserved for a privileged minority."[15]

I suppose I am more inclined than most to take Soboul's hypothesis seriously. Something was being played out in summer and fall 1793, in and around the strange cult of Marat, which no one historical actor was able to control completely – not the Jacobins, not the Hébertists, not the followers of poor Jacques Roux and Claire Lacombe, not the militants in the Cordeliers or the *sectionnaires* with their banners, not David, not Robespierre, not Citizen Sade. I shall speak to this lack of control in a moment. But for the time being, let me just point out that Soboul himself, in his bran-tub of a book, gives us the clue that I think casts doubt on his best-case interpretation.

The day after the procession, he reports, the Société sectionnaire du Muséum – that is, the hard core of popular activists who ran the section as a political entity – solicited for affiliation to the Jacobin Club. Their spokesman seemed to know what metaphors would do the trick. "The republicans making up the popular society of the Museum section come to ask their mother for the sustenance necessary for their patriotism to grow. Could a tender mother rebuff a virtuous child? You are the mother society of all in the Republic. Add to your family by adopting us."[16] The section's wish was granted; though not, as the Jacobin newspaper assured its readers the next day, until after the membership had undergone "the *most rigid* examination." For had not the Jacobins decided, three weeks before, that they would recognize as true popular societies "only those where the revolutionary committee, first having purged its ranks, now formed the society's core, and where all members had had to pass a vote of this same committee on their credentials"?[17] Soboul may be right in saying that the very severity of this party diktat produced a backlash from the societies themselves. Certainly we have instances of some of them asking for affiliation, being declared not pure enough, and going their separate ways (for as long as the Terror let them). But not the Museum section: that is the point. They were the purest of the pure. It is my guess that the whole episode of 26 Vendémiaire, in fact – milky metaphors and all – was meant as a kind of template for other such bindings and purgings to come.

So are we entitled to look back on the procession of 25 Vendémiaire with what happened the next day in mind? Not necessarily. Sometimes in history strings are really not being pulled behind the scenes. Revolutions are untidy. Coincidences do happen. Politicians have more important things to worry about than pictures and hymns.

But David *was* a politician. My hunch is that the afternoon's events had been conceived, and orchestrated, as a kind of proof of the Museum section's orthodoxy. Popular festivity – the sans-culottes "communing in the memory of their martyrs" – was under control. It had got itself the requisite stiffening. Especially of armed force.

Or maybe we should say that the procession was a kind of reward, from the party, for a purge which had already taken place. "Rigid examinations," after all, are not performed on the spur of the moment in the body of the hall. What the Museum section was, or had made itself, was no doubt known to the players that mattered long before anyone turned up at the assembly point on 25 Vendémiaire. Maybe this is why the Conventionnels allowed their pictures out in the first place.

Historians agree that September 1793 was a turning point in the Jacobins' relations with the sans-culottes. (What is meant by the final, hyphenated word here will emerge gradually, I hope, as the chapter proceeds. For now just take it to indicate, or claim to indicate, the Parisian masses.) Even François Furet, who is more sceptical than most of an account of revolutionary politics impelled by class tension, sees September as "probably the crucial period in the formation of the Revolutionary government." His reasons have a Soboulian ring to them. "The Mountain had needed the sans-culottes to defeat the Gironde in the spring of 1793, and wished to keep them as allies but without giving up any important powers."[18] That proved difficult. A summer of agitation in the streets and clubs culminated, on 5 September, with the sections' armed forces surrounding the Convention, demanding the setting up of an *armée révolutionnaire* for use against the Republic's enemies at home, a purge of the Committees of Public Safety and General Security, and mass arrests.

Furet's phrase is a trifle bland: "The Convention gave ground but retained control over events." On 5 September it agreed that Terror was now "the order of the day." On 9 September it set up the *armée révolutionnaire*. Two days later it fixed maximum prices for grain and flour. Another fortnight and the maximum was extended, at least in theory, to wages and prices for all commodities. (This is one of the reasons why associating the Terror with a not-yet-born socialism is so tempting.) It put the Revolutionary tribunal on a war footing on the fourteenth, passed the Law of Suspects on the seventeenth, told local revolutionary committees to draw up lists of the revolution's enemies. And immediately it turned its new weapons against the most dangerous representatives of those who had asked for them in the first place. The grass-roots activist Jacques Roux, who had made trouble for the Jacobins throughout the year, was finally imprisoned the very day the armed sections ringed the Tuileries.[19] Other so-called *enragés* followed. Their newspapers sputtered into silence. On 9 September the Convention agreed to pay a small wage to needy citizens for attendance at their *assemblées sectionales*, but only if the sections gave up their habit of meeting daily (and monitoring the Convention's doings). Twice a week, or better still, twice every ten days, would be sufficient.[20] It was the beginning of a whole series of moves by the Jacobins that hemmed in, and eventually put an end to, the sections as an independent force. This is the context in which the events of 26 Vendémiaire should be understood. September is the month, I think, when David took the key decisions in his painting of Marat.

I realize I have rubbed my reader's nose in the detail of politics in 1793. And that is as it should be. My claim, you remember, is that the detail of politics is what David's *Marat* is made out of.

Politics, I should say, is the form par excellence of the contingency that makes modernism what it is. This is why those who wish modernism had never happened (and not a few who think they are firmly on its side) resist to the death the idea that art, at many of its highest moments in the nineteenth and twentieth centuries, took the stuff of politics as its material and did not transmute it. I think of Géricault's *Raft of the Medusa* and Delacroix's *Liberty Guiding the People*, of Courbet in 1850 and Manet in 1867, of Morris, Ensor, and Menzel, of *Pressa* and *Guernica*, of Rude's *Marseillaise* and Saint-Gaudens's *Shaw Memorial*, of *Medals for Dishonor*, *Monument to the Third International*, Berlin and Vitebsk, Cologne and Guadalajara. No one but a fool, of course, would deny that politics provided the occasion for art in some or all of these cases. The disagreement turns on the words "occasion" and "material," and

especially on the claim that in some strong sense modernist art not only is obliged to make form *out of* politics, but also to leave the accident and tendentiousness of politics in the form it makes – not to transmute it, in other words. (Otherwise the claim is harmless. For we know full well that Rubens and Velázquez operated as a matter of course with materials that had politics grossly inscribed in them. The *Surrender at Breda*, the *Triumphs of Marie de Medici*. Painters were providers of political services. But of a special, duly allotted kind – there is the difference from modernism. The service they performed was to transmute the political, to clean it of the dross of contingency, to raise it up to the realm of allegory, or – subtler performance for deeper sophisticates – to make its very everydayness quietly miraculous. Surrender at Breda equals Entry into Jerusalem.)

I am not saying that an effort at raising and transfiguring simply ceased on or about Vendémiaire Year 2. The effort, we shall see, is still palpable in David's *Marat*. And in the *Raft* and the *Liberty*. I dare say all three artists would have been happy with the idea of themselves as a new Velázquez. But I believe that in practice they were not able to be any such thing, and that their pictures' articulation of that impossibility is what makes them unprecedented in the history of art. Modernism turns on the impossibility of transcendence.

This last is a simple, not to say obvious, idea which you would have thought anyone interested in the texture of modernity would find it easy to accept. But that would be to underestimate the doubleness of the term "modernism" in the proposition. Modernism is Art. And Art, or a certain cult of Art, is exactly the site (for some) on which the impossibility of transcendence can be denied. Perhaps it is the one site we have left. So defend it by any means necessary.

Modernism's brokenness and ruthlessness, say its enemies, are willed, forced, and ultimately futile. We may even have escaped from them at last. Modernism's extremity, say its false friends, is just surface appearance, beneath which the real matter of art – not just the delights of manufacture, but what those delights have always given onto, moments of vision, here-and-now totalities, a whole usable past – is kept in being, no doubt against the odds. When I say "false friends" it is not that I doubt the passion of their defense, or even that its rhetoric corresponds to much that modernists said of themselves. But modernism, we shall see, is a process that deeply misrecognizes its own nature for much of the time. How could it not be? It is *Art*. And for Art to abandon what Art most intensely had been, and nonetheless to proceed, nonetheless to go on imagining the world otherwise – just otherwise, not epitomized or complete – is not likely to happen without all kinds of reaction-formation on the part of artists.

The case remains to be proven, I know. And the verdict is not meant to apply across the board. I am not saying anything as sweeping as that "modernism – all or any modernism – is political," or trying idiotically to demote the careers of (among others) Corot, Monet, and Matisse. My argument is that the engagement of modernism with politics at certain moments tells us something about its coming to terms with the world's disenchantment in general. Corot, Monet, and Matisse had their own ways of dealing with the same situation. I should say that they recognized the world's disenchantment in terms (with a sense of what was at stake) that put them alongside Courbet, Manet, and Malevich – as opposed to Théodore Rousseau, Renoir, and Derain, for

example, to choose difficult points of comparison. The fact that their art had nothing to say about the Dreyfus affair, or that Madame Matisse decided not to disturb her husband's dreamworld by telling him she was working for the Resistance, is not apropos. There are dreamworlds and dreamworlds. Anyone not capable of seeing that Matisse's tells us more than anyone else's in the last hundred years about what dreaming has become had better give up on modernism right away.

I have to show what I mean, then, by saying that David's *Marat* "turns on the impossibility of transcendence" and shows us politics as the form of a world.

On 28 July 1793, a Sunday, there was a ceremony having to do with Marat in the Club des Cordeliers – at that moment the other great center of Jacobin politics besides the *société-mère* itself. A series of orators stood before a small altar erected to Marat's sacred heart. Marat had used the Cordeliers as a base for his political operations, and the altar contained the very relic, extracted from his body just a fortnight before. The murder had taken place on 13 July.

Later writers about David's picture have been fond of making the comparison between it and a Pietà. Sometimes they seem to think the comparison disposes of the case. And there is nothing new to the linkage, or to the ideological work the linkage is meant to do: that is, to save Marat from a realm where what he was, and what he meant, remains an open question. The main speechmaker on 28 July had this to say (I have combined two accounts of the occasion, from rather different kinds of witness):

> O thou Jesus, o thou Marat! O sacred heart of Jesus, o sacred heart of Marat, you are both equally deserving of our homage . . . Let us compare the Son of Mary's works to those of the friend of the People: as I see it, the apostles are the Jacobins and the Cordeliers, the Publicans are the shopkeepers, and the Pharisees are the aristocrats. Jesus, in a word, was a prophet. But Marat is a god.

> Like Jesus, Marat loves the people and no one but them. Like Jesus, Marat detests the nobles and the priests, the rich and the swindlers. Like Jesus, he never stops fighting those plagues of society. Like Jesus, he led a pure and frugal life [a point, we shall see, which David's picture goes to extraordinary lengths to emphasize]. Like Jesus, Marat was extremely tender-hearted and humane [ditto] . . .[21]

Presumably the orator thought he was on safe ground. But he was wrong. Almost immediately he ran into trouble with part of his audience, including some of Marat's most dedicated supporters. A sans-culotte called Brochet for one, who had just reported to the club on his efforts to find a suitable container for the sacred heart (it was eventually hung from the ceiling in a sort of vial), appears as follows in notes taken on the occasion:

> Brochet, after paying homage to the orator's great talents, finds fault with the parallel he drew: Marat, he says, is not to be compared with Jesus of Nazareth; that man, turned into God by priests, sowed the seeds of superstition on earth, he defended Kings. Marat on the contrary fought against fanaticism and declared war on the throne. Let's hear no more talk of this Jesus! Brochet shouted. [In another account: There ought never to be any talk of this Jesus – it's all foolishness. The seeds of fanaticism and all such fiddle-faddle have disfigured Liberty ever since she was born (*Des germes de fanatisme et toutes ces fadaises ont mutilé la Liberté dès son berceau*).]

Philosophy – yes, nothing but philosophy! – should be the Republicans' guiding star. They shall have no other God but Liberty![22]

Supposing David had been in the audience on 28 July (which is not improbable), whose side would he have been on? Or to put it less crudely, to what extent did the disagreement between Brochet and the orator – that is, the possibility of such a disagreement, even among those who thought Marat a good thing – inform the making of Marat's picture in the weeks that followed? Given that everybody agrees that some kind of analogy between Christ and Marat was intended on 25 Vendémiaire – by both the picture and the whole set-up in the Cour du Louvre – then what kind? And could the picture actually make the analogy – I mean make it stick, make it plausible even to viewers like Brochet?

To begin to answer these kinds of questions we have to try to reconstruct what the exchange in the Cordeliers was about. What was at stake in it? I talked of David possibly ending up on Brochet's or the orator's side. But whose sides were they, ultimately? In what sort of battle?

Very little in 1793 is simple. Brochet, for example, is typically hard to pin down. We know he was linked to François Vincent, the leading light of the Cordeliers at this moment, and perhaps later to Hébert and his newspaper, the *Père Duchesne*. He may have paid for the association. Richard Cobb says he was condemned to death on 12 Germinal, as part of the Jacobins' settling of accounts with the Hébertists. Soboul has him surviving into the Year 3, only to be arrested as a "terrorist" on 25 Frimaire.[23]

Even if we knew for certain how Brochet ended up, that would still not let us assign him any cut-and-dried political position – let alone class-political position – in the chaos of summer and fall 1793. He seems to have been at times a kind of honest broker, or maybe frontman, between the Cordeliers and the Jacobins. It was Brochet I quoted previously as insisting in the Club des Jacobins on 23 September that the popular societies purge themselves before being bound closer to the Party; Brochet who acted as a moderating influence within his own Section Marat, bringing in a better class of artisan and small shopkeeper to sit on the *comité révolutionnaire*[24]; Brochet who was put up as figurehead president of the Cordeliers once the club had been marginalized.[25] And so on.

Brochet's is a representative voice, in other words; representative in its very uncertainty about where the revolution was. His being sure in July that Marat – the figure and memory of Marat – had to be at the center of revolutionary self-definition is nothing special. Everyone from Saint-Just to Jacques Roux chimed in with that, at least for a while. Nor is his being so vehement about the precise terms in which the self-definition had to be done – *these* terms, *my* terms (Marat's terms), not yours. If Saint-Just and Jacques Roux had been in the room together, they would have fallen to arguing in much the same way.

Marat was a martyr of liberty. He was the people's friend. "In the state of war we are in, it is only the people – the little people, the people so scorned and so little deserving of scorn – who are capable of imposing [liberty] on the enemies of the revolution. Only the people can make them do their duty, force them into silence, reduce them to that state of salutary terror so indispensable if the great work of the constitution is to be consummated [and] the State organized wisely . . ."[26] Marat had been a constant enemy of the *accapareurs*,

the *agioteurs*, the *ouvriers de luxe* (among whom he numbered artists). That is, of monopolists and speculators, and the culture they spawned. "The people lack everything in their fight against the upper classes who oppress them [*Tout manque au peuple contre les classes élevées qui l'oppriment*]."[27] Ever since 1789 he had argued that sooner or later the revolution would stand in need of violence to survive. Sometimes he can be found arguing this almost on physical-scientific grounds (before the revolution he had practiced medicine in London and written books against materialism): "It is with our Revolution as with a crystalline solution that is agitated by shaking it violently: at the beginning all the crystals scattered through the liquid are set in motion, dispersing and mingling at random, then they move with less vivacity, by degrees they draw closer together, and in the end they take up their original combination again . . ."[28] Only a series of new shocks would prevent the social mixture from hardening once and for all. "It is by violence that liberty must be established, and the moment is come" – this one (of many) is in April 1793 – "to organize momentarily the despotism of liberty so as to crush the despotism of kings." The French here is especially chilling: "C'est par la violence qu'on doit établir la liberté, et le moment est venu d'organiser momentanément le despotisme de la liberté pour écraser le despotisme des rois."[29]

Of course there is much in this that would likely appeal to the Jacobins as they stood on the verge of Terror. Marat had often been of their party in the disputes of the previous months. When the Girondins had asked for his arrest in early April, David himself had rushed to the tribune shouting: "I demand that you put me to death, I too am a virtuous man . . . Liberty will triumph."[30] By the time of his death Marat was largely reconciled with the emerging powers. Michelet has a sardonic subheading for June 1793: "Robespierre and Marat, guardians of order."

But look again at the phrases from *L'Ami du Peuple* quoted above. Their content, and above all their rhetorical temperature, are typical of Marat's journalism. And these are enough to suggest that, reconciled or not, Marat promised to go on being a mixed blessing for Revolutionary government – certainly for governors of Robespierre's vision and personal style. It was not just Marat's habit of adopting the wildest and bloodiest form of words, even when what he was recommending was a fairly ordinary extension of the state's monopoly of force. (Let us not call it a War Cabinet or an Emergency Powers Act, let us call it a despotism of liberty.) Nor was it merely that he stood in the minds of the Jacobins' enemies as a symbol of everything the Jacobins were but did not dare declare themselves. (The Girondins had far from given up on Marat after the failure of their April campaign against him. He was the monster who had given the signal for the September Massacres. Blood was still on his head. Charlotte Corday was part of a Girondin circle in Caen where such talk was commonplace.) It was also that Marat's unswerving identification with the *petit peuple* of Paris – one-sided as the identification may have been, since his links with the popular clubs and societies were tenuous – led him time and again to give voice to positions on the "social question" that all other parties agreed were beyond the pale.

In 1791, for example, he had been more or less alone in opposing the *lois Le Chapelier* which put an end to workers' associations; not that he disapproved of removing obstacles to free trade – that would have been to reimagine his whole *philosophe* inheritance from the ground up, which certainly he was incapable of doing – but that he thought preventing workers from gathering to discuss their interests was, in a time of trouble, one more way of depriving the revolution of support.[31] And this is the typical trajectory of Marat's politics. A terrible determination to forge or preserve those weapons that (in his opinion)

the revolution might need combines with a wish to speak for the despised and rejected. No one is claiming that the combination led to a specific or consistent politics, or to one that put him usually at odds with the Jacobins. A lot of the time in 1793 it is more a question of his seeming to push the Jacobins to do what was necessary to annihilate their enemies, even if – maybe in Marat's case, especially if – the enemies also claimed to be speaking in the *petit peuple*'s name. Marat called early on for an end to Jacques Roux and the *enragés*.[32] But here too the logic of Terror led back to the same set of insoluble class paradoxes. The *enragés* must be destroyed because they are a faction. The revolution has no room for factions because it is one and indivisible. Because its great terms are Nation and People, singular and sovereign. But if the People is singular and sovereign, then does that mean that those who actually make up the majority of its members *are* the People – for some reason as yet not properly represented? And could there be such a representation without the whole current panoply of the state – the necessary armor of the revolution in difficulties – being thrown into the melting pot? No answers to these questions emerged in Year 2. The questions themselves were raised only dimly and fitfully. But at least Marat's writing seems to have impelled him toward the point where, in however garbled and pseudo-ferocious a form, the questions came up.

Marat was close to the Jacobins, then. In my view he was distinct from them – the image of politics he stood for exceeded Robespierre's and David's in crucial ways – and it should not come as a surprise that after his murder, plenty of people thought the time had come to make the distinction absolute. The *enragés*, for a start: three days after Marat's assassination, on 16 July, Jacques Roux published issue 243 of Marat's newspaper, *Le Publiciste de la république française par l'ombre de Marat, l'ami du Peuple*. What gave him the right to do so, he claimed, was the hatred he had earned "of the royalists, the federalists, the egoists, the moderates, the hoarders, the monopolists, the speculators, the intriguers, the traitors and bloodsuckers of the people"[33] – the more comprehensive the list, the better his title to Marat's legacy. (Unlike the people in power, was the implication, who had discovered that moderates and monopolists have their uses.) Another *enragé*, Théophile Leclerc, followed suit with a new run of *L'Ami du Peuple* in summer and early fall. Hébert, in the *Père Duchesne*, rushed to assure his readers that no change of masthead was necessary: the mantle of Marat fell on him.

These signs need not necessarily have amounted to much. They could have been a version of the usual jockeying for position after a leader dies, especially if he or she dies in harness – part of the spume of politics, in other words, with no very deep or permanent interests in play. But I do not think they were. Two things argue otherwise. First, there is the elaborateness of the Jacobins' efforts to counter the *enragés*' bid for ownership, and make Marat their totem. And second, the fact that Marat's shadow kept spreading and transmuting in late summer, in ways that clearly exceeded any one party's or interest's doing. There was a cult of Marat in Year 2. Soboul is not alone in thinking it had, for a while, the first glimmerings of true religiosity about it. It was a cult in the strong sense, then – the French (or Durkheimian) sense. People gathering, that is, to give form to their collective will. And investing their fears and hopes in a single figure, like and unlike themselves.

Let me begin my description of this process with what the Jacobins did. Obviously no very clear line can be drawn between Party instigation (or effort

at containment) and pressure from below. I think the Jacobins were often trying to draw some such line, and failing. Maybe they were on 25 Vendémiaire. Equally, the scene at the end of July in the Cordeliers had some of the hallmarks of an official occasion. The orator may well have thought he was speaking a Jacobin script, or one they would approve of. But that does not mean we are entitled to take Brochet as delivering the *enragés*' lines, or Hébert's. Maybe he was. More likely he thought he was right at the revolution's center. It was one thing to go shopping, as he had done the day before, for an urn to contain Marat's sacred heart, and another to glory in the analogy between the new cults and those they were supposed to displace. "Philosophy – yes, nothing but philosophy! – should be the Republican's guide." What would Robespierre find to disagree with in that?

The Jacobins found themselves negotiating with too many things – too many interests and energies – calling themselves Marat. This is part of the tension that makes David's picture so spellbinding. But it does not follow that anyone's Marat was grist to the Jacobin mill. Lines got drawn, quickly and brutally. Robespierre brought Marat's widow, Simone Evrard, before the bar of the Convention on 8 August, and had her specifically denounce Jacques Roux and Théophile Leclerc – "scoundrelly writers . . . who claim to continue his journals and make his spirit speak, in order to outrage his memory and lead the people astray."[34] "Now that he is dead, they are trying to perpetuate the parricidal calumny which made him out to be a crazed apostle of disorder and anarchy."[35] On 22 August Jacques Roux was arrested for the first time. On 5 September he was jailed for good. Leclerc disappears from the historical record as the fall proceeds. He had seen the writing on the wall. Hébert was soon fighting unsuccessfully for his life.

Marat was too important and volatile a political sign, then, to share with one's enemies; especially those who wanted his ghost to do little more than repeat the question he had asked in June, and by implication often before: "What have they *gained* from the Revolution?" – "they" being the People, naturally.[36] But the question would not be robbed of its edge simply by pretending Marat had never asked it, or exterminating those who said he had. Marat must go on asking the question, with his characteristic vehemence, but giving it a Jacobin answer. The category "People" had to have something be its sign. Among the signifying possibilities on offer in 1793, "Marat" seemed one of the best. At least in him the category was personified. That might mean that the welter of claims, identifications, and resentments wrapped up in the word could at least be concentrated into a single figure – and therefore shaped and contained. It would take some doing.

Of course I am not saying that Robespierre and his henchmen sat down one day in August and worked all this out. "– Job for you, Citizen David." Nobody knew what was going to happen next in the summer of 1793. Forward planning was a mug's game. But equally, I do think that David's painting a picture of Marat in August and September was steeped in – informed by – the battle over Marat's legacy. Otherwise I would not have bothered to describe it in such detail. What marks my account off from conspiracy theory is not so much an a priori judgement that history does not work like that – too much of the time it does – as a feeling that in this case, with these materials, no such computing of advantage was possible. I make a distinction, in other words, between the sort of manipulation I think was behind the procession on 25

Vendémiaire (and its connection with the purge of the section next day) and the more extended, more intuitive Jacobin effort to have Marat signify in their terms. It is David's effort in particular that concerns me, but also the wider Jacobin negotiation with the Marat cult. And most of all, the implication of David's painting in the negotiation. Soboul is right. The situation is out of control. Surely never before had the powers-that-be in a state been obliged to improvise a sign language whose very effectiveness depended on its seeming to the People a language they had made up, and that therefore represented their interests. (It is the combination of democracy and headlong improvisation, and the pretense by leaders that they are truly ventriloquizing their subjects' thoughts and desires, that mark Robespierre's Paris off from Pericles's Athens.) No doubt it is easy to say in retrospect that the new language did nothing of the sort. But that is not the point. What matters to the historical imagination, at least in the first instance, is how the actors – especially the Jacobins – saw things. I conceive them as wavering hopelessly between conspiracy and self-deception, between calculus of effects and belief in their own symbols. No one more hopelessly (therefore productively) than David.

The question I posed a few pages back was: Supposing David had been present in the Cordeliers, would he have been on Brochet's or the orator's side? And what would he have taken the argument between them to be about, essentially? Representing whose interests?

At least by now we have established what stands in the way of a cut-and-dried answer to any of the above. But the David I imagine is not discouraged by his inability to give an answer – more likely galvanized by the fact. It is the uncertainty of level in the debate that is its chief fascination, and makes him most want to join in. He knew that picturing Marat was a political matter, part of a process of "freezing" the revolution (Saint-Just's unforgettable metaphor) and making it Jacobin property. He was aware of the steps Robespierre had taken to hurry the process on, and why the steps had been necessary. He would

9 Anonymous:
*Robespierre Entering
Marat's Apartment,*
engraving, 1793 (Musée
Carnavalet, Paris)

10 Anonymous: *Obelisk with Cameos of Le Peletier and Marat*, wood and gilt, 39.5 high, 1793 (Private collection)

be on the lookout for danger signals. But of course he took the evening's rhetoric at face value. He believed that a new world was under construction. No doubt he saw in the cult of Marat the first forms of a liturgy and ritual in which the truths of the revolution itself would be made flesh – People, Nation, Virtue, Reason, Liberty. How could he not have thrilled, as the summer and fall went on, to the glamorous details of Marat's deification? News of twenty-nine towns and villages calling themselves after the martyred saint.[37] Of Marat becoming a favorite anti-Christian name for newborn babies. Of church after church, in Brumaire and Frimaire especially, taking down the crucifix and Virgin and putting up Marat and Le Peletier in their place – one historian counts fifty such ceremonies in Paris alone.[38] "That the building previously serving as a church become a hall for sessions of the *société populaire*, and in consequence, that busts of Marat and Le Peletier be put in place of statues of Saint Peter and Saint Denis, its one-time patron saints, and that the village of Mennecy-Villeroy henceforth be named Mennecy-Marat."[39] Of processions and speeches and apotheoses, many of them – particularly in August – with much less of a stage-managed look than the one David would be involved in. Of women going in for "hairdos à la Marat."[40] Of Montmarat replacing Montmartre. Of *déchristianisateurs* perfecting a suitably modernized sign of the cross, to be accompanied by the impeccable murmur, "Le Peletier, Marat, la Liberté ou la Mort."[41] Of prints and broadsides and terra-cotta shrines for sans-culottes' mantelpieces (figs. 9 and 10). Of militants on 11 October, just five days before the Museum procession, dragging the portraits of kings and princes out of the

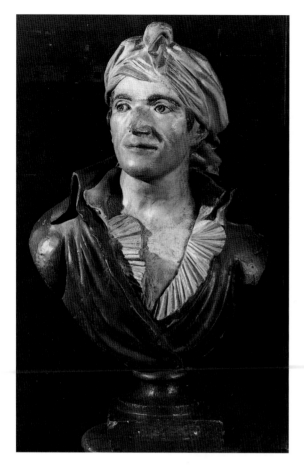

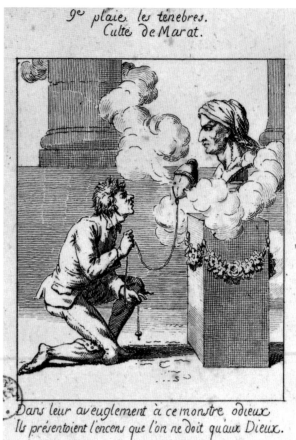

9ᵉ plaie. les ténebres.
Culte de Marat.

Dans leur aveuglement à ce monstre odieux
Ils présentoient l'encens que l'on ne doit qu'aux Dieux.

11 (*above left*) Anonymous: *Marat*, painted plaster, 1793 (Musée Carnavalet, Paris)

12 (*above right*) Anonymous: *Plagues of Egypt*, plate 9, engraving, whole sheet 24.6 × 29.4, 1794 (Bibliothèque Nationale, Paris)

Palais du Fontainebleau and burning them in front of Marat's image (figs. 11 and 12). Smoke from the portrait of Louis XIII by Philippe de Champaigne, it was said, "was wafted toward the bust. It was the most agreeable incense we could offer."[42]

These details, as I say, are glamorous; and perhaps for that reason misleading. There is a quality of farce or factitiousness to many of them, and time and again one is on the verge of dismissing the lot (as Richard Cobb did, for instance) as a series of ludicrous or vengeful stunts, which cut no ice with ordinary men and women. And then one comes across the report of a ceremony, or a petition from a village, or a phrase or two from a *sectionnaire*'s speech, which is suddenly free of the standard forms or the activists' overkill, and in which one thinks one overhears the struggles – maybe the ludicrous struggles – of a new religion being born. There are many other Brochets taking part in the process. Even the crowd outside the Palais du Fontainebleau deserves to figure in the record as more than a mob of peasant dupes egged on by a handful of vandal/professionals. Who are we to say what it must have been like to see the pompous encampment in the forest at last getting its come-uppance? What group of men and women had more of a right to pre-echo Walter Benjamin's: "There is no document of civilization which is not at the same time a document of barbarism." Barbarism had been their daily bread. Maybe it took a burning Philippe de Champaigne to convince them it need not be any longer.

The more one looks at the cult of Marat, the less clear it becomes what kind of phenomenon one is studying. Which history is it part of? Of popular religion or state-formation? Of improvisation by the *menu peuple* or manipulation by

elites? The question applies to the episode of de-Christianization as a whole. And the answer obviously is both. The cult of Marat exists at the intersection between short-term political contingency and long-term disenchantment of the world. Maybe in its latter guise it often looks like a rear-guard action against the loss of the sacred. But here too its forms were unstable and ambivalent. We know of orators staging the Jesus-Marat comparison in 1793 so as to prove that the priests had captured and neutralized "Jesus the sans-culotte" by pretending he was something more than a man.[43] Or others (besides Brochet) making the comparison to Jesus Christ's disadvantage.[44] We know that even in the best-managed section – even in August – things could happen which reminded all concerned that the cult's basic premise was far from secure:

> It is only too true that there were discovered, in the general assembly of the Butte-des-Moulins section [the voice here is that of the *sectionnaires* themselves, responding to an accusation from their neighbors at Arcis], citizens so villainous and perverse as to applaud the murder of Marat, incorruptible Friend of the People. Much the greater part of the assembly was seized with indignation at the occurrence and, to do it justice, decided that the appalling fact should be recorded in the minutes, and . . . reported to the public prosecutor of the revolutionary Tribunal so that he could uncover the perpetrators and punish them . . . Many citizens who had been led astray by intrigue – real anarchists, as you say – now acknowledge their errors. That testifies to the purity of our intentions.[45]

Is it any wonder that Robespierre finally drew back from the whole farrago with a shiver of disgust? Was not trying to make a saint out of Marat, of all people, ultimately playing into one's enemies' hands? Had not the process led – I mean the whole mad, exalted search for a religion of the revolution – to the bishop of Paris, no less, being brought to the bar of the Convention on 17 Brumaire and solemnly abjuring his faith? And three days later to the scandalous (marvelous) Fête de la Raison in Notre-Dame? News was coming in of the *armées révolutionnaires* in the countryside, making bonfires of statues and riding priests out of town on a rail.

> By what right did men who till now had counted for nothing in the course of the Revolution look round, in the midst of these events, for ways . . . to lure even good patriots into false measures, and sow confusion and discord in our ranks? By what right did they threaten freedom of worship in the name of freedom, and battle fanaticism with fanaticism of a new kind! What gave them the right to pervert the solemn homage paid to Truth in all its purity, and make it an everlasting laughing-stock! Why did we let them dally in this way with the people's dignity, and tie jester's bells onto the very scepter of philosophy?[46]

Atheism is *aristocratic*, says Robespierre. Even that argument was not enough to put an end to de-Christianization straight away. Still less to the cult of Marat. As late as 25 Floréal (14 May 1794, two months or so before Robespierre's fall) the Section Marat can be found asking the Committees of Public Safety and General Security's permission to march through Paris in honor of its patron, drums playing, choirs singing, three of its daughters dressed as Liberty, Equality, Fraternity. The committees were unimpressed.

> They are far from considering this project worthy of so great an object, or likely to realize it satisfactorily. They consider the idea of the three divinities represented by three women as contrary to the principles that the French people have just proclaimed by way of the Convention [that is, Robespierre's Cult of the Supreme Being], and against all notions of good sense.

An order banning the procession was issued on 3 Prairial.[47] A month or so before, a police spy had picked up the whisper: "If Marat was still alive at this moment, he would have been indicted and maybe guillotined."[48]

This is to leap forward too far. For the purpose of understanding David's picture, what matters is August and September, and the relation of the Jacobins in those months to the popular movement they had helped bring into being. Outright suppression of the cult of Marat – and of many other demands and images dear to the militants and the *menu peuple* – was not possible, and doubtless not wanted (yet) by Robespierre and co. They thought they could ride the whirlwind. And part of the riding would be to take the demands and images, even those (particularly those) most open to day-to-day political distortion, and give them Jacobin form. If that could be done with the maximum price, for example (which had its origins in pure workshop resentment), then certainly it could be done with Marat. For Marat was their own man, essentially. He needed only be rid of the veils and shadows cast on him by the revolution's enemies. "Give us back Marat whole [*Redonne-nous Marat tout entier*]," as Audouin shouted to David in the Convention.[49]

On one level I think Audouin and David would have understood that request quite literally. We know that David had originally planned, in the wild days following Marat's assassination, to stage a kind of tableau vivant using the martyr's embalmed body, showing him in the attitude struck at the moment of death. What had stood in the way of doing so was the body. It was not entire in the first place.

> On the evening of Marat's death, the Jacobin Society sent us, Maure and myself [the speaker is David, to the Convention on 15 July], to gather news about him. I found him in an attitude that struck me deeply. He had a block of wood next to him, on which were placed paper and ink, and his hand, sticking out of the bathtub, was writing his last thoughts for the salvation of the people. Yesterday, the surgeon who embalmed his corpse sent to ask me how we should display it to the people in the church of the Cordeliers. Some parts of his body could not be uncovered, for you know he suffered from leprosy and his blood was inflamed. But I thought it would be interesting to offer him in the attitude I first found him in, "writing for the happiness of the people."[50]

I get the feeling the embalmer was already trying to talk David down from his first idea of a scene straight out of the morgue; but David was nothing if not stubborn (as well as impressionable) and it was not till next day, after consulting with *sectionnaires* from Théâtre-Français, that he admitted defeat. "It has been decided that his body be put on show covered with a damp sheet, which will represent the bathtub, and which, sprinkled with water from time to time, will prevent the effects of putrefaction."[51]

Surely one main thing the painting of Marat was meant to do was make up for the disappointment in July. It would restore what had been missing. It would be imperishable. Instead of metaphor and stage business, it would be transparent to the facts.

We shall not get the measure of David's ambition for his *Marat*, in other words, unless we understand the depth of his commitment to literalness and

completeness in painting. He is still full of the idea in his presentation speech to the Convention on 24 Brumaire. "The people demanded its friend once more, its grief-stricken voice made itself heard, it provoked my art, it wanted to see its faithful friend's features again . . . I heard the voice of the people, I obeyed." Everywhere else in translating I have made *peuple* plural, as is usual in English, but in this case David's melodramatic singular goes to the heart of the matter. "Le peuple redemandoit son ami, sa voix désolée se faisait entendre, il provoquoit mon art, il voulait revoir les traits de son ami fidèle . . . J'ai entendu la voix du peuple, j'ai obéi."[52]

Partly the stress on literal recreation here has to do with the fiction, which seems to drive David's whole proceeding, that what he has made is the people's image – asked for by them, addressed to them, of one of their number. "He met his death, this friend of yours, giving you his last morsel of bread; he died without even having enough money for his own funeral." "Come gather round, all of you! mothers, widows, orphans, downtrodden soldiers – all you he defended, to his own peril. Approach! and contemplate . . ." For pictures, in the people's eyes, are miracles, where what everyone thought was lost, or maybe just subject to time and fevers, comes back forever into the world. To call this illusionism seems to me to trivialize it. It is conjuration, necromancy, made possible by the force of collective will.

It would take us too far from our subject to discuss how much this view of painting's powers diverged from David's own. Obviously David was a bookish and elaborate painter, sometimes playful in a lugubrious sort of way. But I should say that even at his most grandly discursive – in the *Intervention of the*

13 Jacques-Louis David: *Intervention of the Sabine Women*, oil on canvas, 385 × 522, 1799 (Musée du Louvre, Paris)

Sabine Women, for example (fig. 13) – what is most special about his art is the way the discursiveness coexists with such an all-or-nothing sense of the real. The great bodies lumber into narrative and symbolic position, finally, but as it were in spite of the weight of their illusionistic armor. It is this double-sidedness of David's pictorial imagination – the effort to signify so often at odds with the passion for embodiment – that is the clue to his work's inimitable pathos.

But of course the *Marat* is special. That is because the idea of complete and concrete rendering in art is subtended here by a specific politics of transparency. And therefore given a hectic (inaugural) force. Virtue was what stood up to the light of day. Vice – the very existence of which explained why the revolution, of all things, met with resistance – sought the shadows. All the revolutionary needed to do was lift high Diogenes's lamp. "In vain do you surround yourselves with shadows; I shall shine light into the inmost recesses of your heart, I shall uncover the secret springs of your conduct, and I shall stamp on your brow the hideous character of the passions that move you": this is David fighting for his life in May 1794, in a public indictment of his accusers.[53] I doubt there is a sentence in his writings that brings us closer to the heart of his aesthetic.

"Approach! and contemplate..." One orator at Marat's funeral in July had imagined Marat in turn opening his eyes and returning the people's gaze. "O man beloved of patriots ... open your eyes to the light once again and see the sovereign who surrounds you [*ouvre encore les yeux à la lumière et vois le souverain qui t'entoure*]."[54] I am reminded of the passage in Walter Benjamin where the characteristic of the work of art in the age before mechanical reproduction is said to be that it looked back at its spectators. Of course this illusion rested "on the transposition of a response common in human relationships to the relationship between the inanimate or natural object and man."[55] It was a quality of the work of art imagined by its users. Art as a practice still bore the marks of its beginnings in magic.

Maybe it is true that in the end these kinds of cultic investments in artworks were (or will be) destroyed, as Benjamin has it, by "the desire of contemporary masses to bring things closer spatially and humanly, which is just as fierce as their wish to overcome the uniqueness of every reality by accepting its reproduction."[56] Spatial and human closeness is insisted on with unique passion in David's painting of Marat. And that fact is bound up, you will gather, with the fiction of address to "contemporary masses." But nothing I have found suggests that this undermined the work's magical address – its ability to look back – to those who saw it in Year 2. If anything it reinforced it. Art's having to imagine that it was done for the people (Soboul's "Art was no longer reserved for a privileged minority") leads, at least initially, to a reinvention of its cult value – all the more urgently because the stakes were once again seen to be high. Art had come out (been dragged out) of the Palais du Fontainebleau. That did not mean it was ready to understand its place in the disenchantment of the world. The whole history of modernism could be written in terms of its coming, painfully, to such an understanding.

"Closeness," in the case of the *Marat*, is a specific form of what I have been calling contingency. Another modernist word for it is "immediacy." And one thing the picture of Marat demonstrates is that dwelling on these qualities does not necessarily mean that the work of art exits from the realm of magic. Any quality, however earthbound, is ripe for artistic transfiguration. In late Monet, immediacy takes on metaphysical depth. In most early twentieth-century art, contingency is fetishized as accident or arbitrariness, and invested with sinister

glamor. Modernism, as I say, is always part rearguard action against the truths it has stumbled on.

David's picture was done in two and a half months, in time left over from a political career.[57] I do not think it helps to call the picture "unfinished," for reasons I go on to explain, but obviously it was done at speed, and is full of the signs of a master technician economizing on means. A lot of Marat's body is worked straight out of the initial underpainting with a minimum of fuss. The hand that holds the quill pen, for example; most of the forearm above it; the chest and neck. Sometimes, looking at the picture, one even hankers after a bit more definition. The fingers and knuckles of the writing hand can strike one as perfunctory. (But maybe the perfunctoriness is a way of suggesting the fingers' letting the pen go, or hanging onto it automatically, at the moment of death. The same kind of maybe applies to Marat's knifewound. The fact that it adheres so imperfectly to his chest – its being brought closer spatially, to use Benjamin's phrase – seems to tally with the way more and more features of the painting are pulled forward onto the picture plane, lining up next to it or echoing its orientation. That is the painting's way of focusing and separating its main objects, thereby opening them to contemplation.) Even where the body emerges from shadow and is worked into something more definite – in the face, above all – it is less and less clear, the closer one looks, how the definiteness was done. The eyes especially are a baffling improvisation, with underdrawing and ground both recruited to the surface in the search for the final effect – of skin puffy and fragile, like a half-healed sore, dry and yet soft to the touch. (Marat's raging skin disease, which apparently would have put paid to him in a matter of months even if Charlotte Corday had not intervened, is condensed and displaced onto this one feature; and as a result made easier to look at. Though maybe the overall range of color that David used for Marat's skin – a grimy white, incandescent grays and browns, a tinge of green, even – is another way of hinting at the same condition.)

None of this adds up to unfinish, in my view. (For the time being let us leave aside the picture's empty upper half.) But the kind of finish the painting has – the hardness and clarity it insists on for the things that matter – was clearly often pulled off at the last minute. A great deal of chopping and changing went on, for instance, in and around the top edge of Marat's left forearm – the one resting on the improvised desktop – and the space just above it. It is the picture's crucial (polarized) opposition of light and dark. Contour and color were subject to what look like late alterations, maybe afterthoughts. There are dabs of a separate dark brown, close to the color of the empty background but quite distinct from it, put in along the line of the forearm so as to cancel a previous contour, which time has made visible again.

I am not saying these are great risks or unusual displays. Fixing a picture's light-dark fulcrum, for instance, is often done when work is almost over, when its place in the balance of tones can be seen for real. I just want it established that talking of sharpness and severity in the *Marat* – Jacobin qualities, which David worked hard to achieve – is not the same as pointing to clarity, still less straightforwardness, in technique.

"Give us back Marat whole." Naturally there were other painters besides David in Year 2 who responded to that request. And if we compare David's painting with its most peculiar rival, by a Toulousain named Joseph

Roques (fig. 14) – it is safe to assume that Roques's painting derived from David's, but his treatment of the subject is different in all sorts of ways – then at least we shall get a clearer idea of what David took the request not to mean.

Roques, we could say, took Audouin's words at face value. Offering the body whole, for him, meant giving it a fair amount of space to occupy. It involved putting the viewer back a certain distance from the bath and orange boxes, having the pavement rake upwards in readable perspective, and the bath be seen from a high enough vantage point for its front and back sides, as well as the bloodstained water, to be clearly visible. (It is not that such things are simply absent in the David, but information about them is kept to a minimum.) Of course decorum, and maybe verisimilitude, decreed that much of a male body in a bath was going to be hidden. But what there is of it on show – almost exactly as much as in the David – is as true to death as a Tussaud's waxwork. The chest and ribcage catch the light, and the blood from the wound looks only half clotted. Roques's Marat is all skin and bones. His flesh is an oily gray. Over the collarbone it seems stretched almost to bursting. Mouth and jaw are set in something too much like rigor mortis. Black hair falls out of the turban. The chest has a nipple. Fingers are bony and prehensile. In a word, this body belongs (too much) to a possible world. It is too much undressed as opposed to naked. The cloak on the wall behind and the hat on the back of the chair – a swank Jacobin hat, with tricolor sash and feathers – are just the last straw. Even without them Marat would have had too much the look of someone surprised by death, and not given time to compose himself for it. Now might I do it pat . . .

None of this, as far as I can tell, is the result of some reservation on Roques's part about Marat and the revolution. His painting was presented on 16 Prairial to the Club des Jacobins in Toulouse, a gift from the *commissaire* Desbarreaux.[58] Hard to imagine a more orthodox pedigree. But all the same, the features I have been pointing to put the subject at risk, I think. They miss the point of David's elisions.

In David's painting, Marat's body is maneuvered into a state of insubstantiality. This is not to say that the arms and torso, which are what we mainly see, are hidden or even made difficult to read. But they do not elicit the kind of scrutiny – repelled, but for that very reason fascinated – that we find ourselves giving the corpse in Roques. They do not detain the eye in the same way. This is partly because so much of the body in the David is kept in shadow, and one which in David's treatment of it seems to make Marat much the same substance – the same abstract material – as the empty space above him. The wound is as abstract as the flesh. And the blood coming out of it as impalpable as thread. (Of course the economy here is chilling.) Even these signs of violence would be enough to call the body back to its death throes had its arms and head not fallen into such strict, almost mathematical order. Never have horizontals and verticals been so settled. The laws of gravity have spoken once and for all. So that whatever might have been obtrusive and particular about the body – all the untidy specifics of its martyrdom, all Roques's dishevelment – is quietly set aside. A face put at ninety degrees to its normal orientation, and perfectly frontal, by that fact alone exists at an infinite distance from the world we know, where faces return our gaze. We do not look to it for emotions we can recognize. The face is further estranged by being miniaturized by the turban. (And why a turban, anyway?) Miniaturized, and robbed of the normal signs of masculinity. Fragile as an eggshell, but of course invulnerable. How touching the wisps of hair on the forehead! How heavy the eyelids and delicate the mouth! How accidental your kindest kiss.

Saint-Just blurts out a fear at one point in his *Esprit de la Révolution*, lest

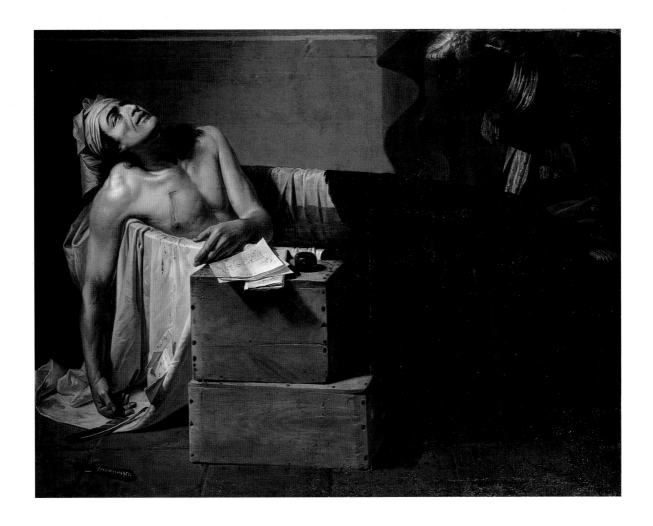

"perhaps our children will blush at the effeminate pictures of their fathers [*nos enfants rougiront peut-être des tableaux effeminés de leurs pères*]."[59] But he agrees that "the revolutionary is implacable toward the wicked, but he is a man of feeling ... Marat was gentle in his own home, he terrified only traitors."[60] The qualities here are hard to balance. Saint-Just's speeches are partly about that. But I cannot help feeling he would have thought the composure of David's revolutionary bought at the cost of making him too little a man.

14 Joseph Roques:
Death of Marat, oil on
canvas, 125 × 161, 1794
(Musée des Augustins,
Toulouse)

I remember talking on one occasion about the *Marat*, and someone's saying when I finished that I had gone on at length about everything in the picture except Marat himself – his dead body, his physical presence. It struck me at the time as a true observation, and somewhat crushing; and it was only later I realized that what I had left out, the picture in a sense left out too. The body is not there in the *Marat* in the same way as the other main objects David has gone to such pains to make real. It is left as a generality: a kind of scaffolding on which other particulars – attributes, writings, instruments of the passion – are hung. Or a machine to hold and display them. If it holds them properly they will bring the machine back to life.

Three times in his presentation speech David returned to the idea that what he had done in his picture was make Marat's features – his traits – visible again. "The people demanded its friend once more ... it wanted to see its faithful

37

friend's features . . ." "May his vanquished enemies grow pale again seeing his disfigured features . . ." "As your eyes run across Marat's livid and blood-stained features, what you see will remind you of his virtues [*Vos regards, en parcourant les traits livides et ensanglantés de Marat, vous rappelleront ses vertus*] . . ." Obviously I am not pretending that blood and disfigurement are simply conjured out of sight in the picture. But I do think they are overshadowed by the play of other signs that catch the light more strongly, or reach forward into our physical and conceptual space. And given the depth of David's commitment to an aesthetic of bodily revelation, this should strike us as a problem. "In vain do you surround yourselves with shadows; I shall shine light into the innermost recesses of your heart."

It is not that I now aim to turn David's recommended procedure on him. God forbid. But I do want to know what it was in Marat that could not be written on or with the body, however much David may have wanted to (may have believed he was doing); but had instead to be given us literally to read.

On one level the answer is easy. It is implicit in the material presented so far about Marat's place in politics. Marat could not be made to embody the revolution because no one agreed about what the revolution was, least of all about whether Marat was its Jesus or its Lucifer. David's picture – this is what makes it inaugural of modernism – tries to ingest this disagreement, and make it part of a new cult object. David spells this out in his presentation speech. He knows he is making an image of Marat against many (maybe most) other images of Marat in circulation. The picture is addressed, somehow over the heads of that current imagery, to posterity or humanity. "Posterity, you will be his avenger . . . Humanity, you will say to those who called him bloodthirsty, that never did Marat, your darling child, give you cause to weep [*Postérité, tu le vengeras . . . Humanité, tu diras à ceux qui l'appeloient buveur de sang, que jamais ton enfant chéri, que jamais Marat, ne t'a fait verser des larmes*]." But of course the tears and accusation are there in the sentence that denies them. And David is fully aware of this, and of the special pressure it puts on picturing. "You, even you, I conjure up, execrable calumny [*Toi même, je t'évoque, exécrable calomnie*] . . ." – one can almost hear David gasping at his own (necessary) daring. For how on earth will it be possible to secure an image of Marat's saintliness if one has to find form for his demonization at the same time – in the same canvas – and show the deadlock of truth and lie as now constitutive of Virtue?

This is what I meant before by talking of contingency entering the image, or of painting being forced to include the accident and tendentiousness of politics in its picture of the world – not just in the things it shows, but in its conception of what showing now is. The carrier of truth and lie in David's picture, needless to say, is writing. Isn't it always? But writing infects the picture's whole economy of illusion. That is what is new. Its procedures overtake those parts of the picture that are, or ought to be, unwritten and objective – empty, factual, unoccupied, material, merely and fully present – all of those words we have for the parts of a world where words seem like afterthoughts. Writing swallows up the figurative in general.

Item one, Charlotte Corday's letter. Written in a brave, square, super-legible hand. Two pages long. Well lit. The first thing we look at in detail (fig. 15).

"du 13 juillet, 1793." it says. (The revolutionary calendar would not start

until October.) "Marie anne Charlotte / Corday au citoyen / Marat." Addresser and addressee. The basic components or circumstances of the speech act. Then a bold line before the letter proper begins. The kind compositors call a dagger. "il suffit que je sois / bien Malheureuse [capital M] / pour avoir Droit [even more formal capital D] / à votre bienveillance." "It suffices that I am truly Unfortunate for me to have a Right to your benevolence."

Of course the letter, quite apart from its contents, is a tour de force of illusionism, calling to mind the scrap-of-paper signatures in Bellini or Zurbaran. Page two, just visible, is pure pathos, of the kind that still life painting specializes in. The shadow on the green baize cover is exquisite. Even the blood is like pollen or smoke. A gray, almost green, thumbnail holds onto *bienveillance* like grim death. The paper crackles under its pressure. I know of few moments in painting that so insist on the strange thing that writing is – childlike, formal, perfidious, entrancing. Marat's not letting go of it even in death seems the key to his vulnerability.

The phrases in the letter come, so contemporaries tell us, from one found on Charlotte Corday after her arrest. She had thought the better of using it to gain access to Marat, and instead wrote another offering to name counter-revolutionaries in her native city, Caen. That was guaranteed to do the trick. One sees why David opted for the alternative.

"Il suffit que je sois bien Malheureuse." The picture turns on a statement that is true propositionally – the picture as a whole is out to show its truth – but of course duplicitous in intent, considered as a performative. It is hard to know how close a reader David expected his viewer to be. Someone less trusting than Marat in 1793 might even have been put on guard by the fact of Charlotte Corday's using *votre* to address a singular *citoyen* – just at the moment when such matters were on revolutionaries' minds. "If *vous* is suitable for *Monsieur*, *toi* is suitable for *Citoyen*," to quote the *Chronique de Paris* in October 1792. "*Tu* is the language of truth, and *vous* the language of the compliment."[61]

I am not sure. Again, the problem is that sensitivities of this kind changed so fast in the course of 1793 that it is unclear if David would have thought he could play upon them. Certainly by the time he was finishing the Marat, the parts of speech were thoroughly politicized. On 10 Brumaire a deputation from the *sociétés populaires* came before the Convention to ask for *tutoiement* to be written into law. And the Convention agreed. *Tu* was henceforth the official form of the French language: the Committees of Public Safety and General Security were to use it in their acts and correspondence.[62] There was even a move some weeks later to have spoken *vousvoyement* made a thing of the past. The Cité-Variétés theater cashed in on the issue of the moment with a play entitled *Le Vous et le toi*. The Théâtre National followed up with one called *La Plus Parfaite égalité; ou le tu et le toi*.[63]

But the case is complicated. *Tutoiement* was a sans-culotte idea. Presumably the Convention's accepting it on 10 Brumaire was part of its general "giving ground but retaining control over events." Robespierre never seems to have used the second person singular from the rostrum. Thuriot put paid to the idea of altering spoken parlance with a sentence or two whose lofty sarcasm seems to me typical of Jacobinism – that is, of Jacobinism's other (most often hidden) side. "It goes without saying that *vous* is absurd, and that it is a grammatical error to speak to a single person as one would to two or several – but is it not also contrary to liberty for citizens to be told how they must express themselves? Speaking French badly is not a crime [*Ce n'est pas un crime de parler mal le français*]."[64]

We shall probably never know how deeply ingrained in Corday's grammar untruth was meant to be. But it is certain her letter establishes truth and falsehood as what the picture mainly turns on. That is why the letter has to be so visually spellbinding. Once we are drawn to it, we are expected to think about where and how falsehood is visible. Corday's words are all true. It is what is in them, or behind them, that has to be rooted out – what may be hiding in their shadow. If you do not root it out soon enough you die. These are the tropes of the Convention in the summer, repeated ad nauseam in debate after debate. They are what eventually made Terror the order of the day.

The paradox of the revolutionary situation, as Furet has reminded us, is that the obsession with lying and hiding exactly did *not* lead to a distrust of language in general, or even to a sense of its practical limits. The worse one's opponents' linguistic perfidy, the more sure one became that language, once rid of their attentions, might still be the locus of good. Discourse swept the warring factions on. No one dreamt of a space outside it.

Marat is just as much a writer as Charlotte Corday. He still has pen in hand. Another pen is ready when that one wears out. His left forearm rests on a pile of paper. And there, if we look, are his last words, put at the point in the picture where closeness, again in Benjamin's sense, becomes positive crossover from the space of illusion to the space of the real: on top of the orange box, perched unstably on its forward edge, reaching out beyond the box's weatherbeaten face (which already seems, by the looks of its lower reaches, hard up against the picture plane), and casting a shadow upon it.

This letter is also legible, but only just. The eye has to strain for a reading, mainly because the whole thing is offered in acute foreshortening, and at a diagonal, but also because it seems to have been scratched out in a hurry, with none of Corday's deliberation. We cannot be sure who is addressing whom. The top half of the letter, long and thin, is hidden by another scrap of paper, and we pick up what is written on it seemingly in midflow – maybe not even at the start of a sentence. The first word – one hopes this time it is genuinely plural – is *vous*: "*vous Donnera* [or maybe *vous Donnerez*, which would be grammatically more comprehensible, even if the form of the word's final letter does not really fit the case; the capital D, by the way, is touchingly clumsy compared with Corday's] *cet/assignat à cette/mere de 5 enfans/et dont le mari est* [here things start to get difficult: the handwriting gets more perfunctory, as if the ink were running out, and the paper begins to curl slightly upwards]/*parti* [or is it *mort*?] . . . *pour la deffense* . . . [*pour la deffense* of what, precisely? . . ./*de la patrie*, maybe? . . . *de la France*?]" "You will give this banknote," is one possible reading, "to this mother of five children whose husband is off defending the fatherland." But is there a final phrase at all? Of course there looks to be something; but it is so scrappy and vestigial, an extra few words where there really is no room left for anything, that the reader continually double-takes, as if reluctant to accept that writing, of all things, can decline to this state of utter visual elusiveness. Surely if I look again – look hard enough – the truth will out. For spatially, this is the picture's starting point. It is closeness incarnate. No reader or viewer is ever quite going to accept that it is also the point where eyesight fails.

No reader, and come to that, not many painters. When David had his studio do a second version of the *Marat* some time over the winter – we know it was done under David's supervision, and presumably meant to be an exact replica – what got tidied up was exactly this petering-out of Marat's writing. Everything on the piece of paper was opened just a little more to the viewer, partly because the paper was allowed to droop down a trifle lower from the lip of the

15 David: Detail of fig. 7

Du 13. Juillet, 1793.

Marie anne Charlotte

Corday au citoyen

Marat.

il suffit que je sois

bien Malheureuse

pour avoir Droit

a votre bienveillance.

À MARAT,

DAVID.

orange box. In particular, the last three words, *de la patrie*, are this time clear as day.

Who can blame the poor copyist? Something about the fact of the picture's most salient point being also its moment of illegibility is deeply counterintuitive. Especially in a picture so spare and sharp-focused – and when so much depends on the contrast of texts. So that we want the contrast to be cut and dried. We want to be literal readers. But here, where the picture offers us the figure of "grasping" as the very form of reading and understanding – grasping the text, and therefore surely the meaning too? – writing and illusionism suddenly turn on each other like a Möbius strip. Reading becomes viewing; but that kind of viewing (that determinant human activity) in which what we see is always already lost (but why do we say lost?) in what we know. Maybe David himself came not to appreciate what he had done here. Why set up a system of writing at all, if not to tie down what Marat must have meant? Is not that what writing (as opposed to picturing) is supposed to do? I can imagine him a month or so later, back in his role as teacher and administrator, telling Wicar or Serangeli – they seem to have been the pupils who did the job – to give the viewer *patrie* after all.[65]

As for Roques, what gets left out of his version of David (as opposed to put in) is precisely writing. He puts Corday's letter in place of Marat's on the front edge of the orange box. Only now that front edge has been set back safely in the space of illusion. Roques certainly expects his viewers to thrill to the letter *as* illusionism. A few drops of bathwater have spilled on it from Marat's hand. Light is reflected off them. Their transparency is marvelously done. Only the first word of the letter – *Citoyen*, naturally – is legible. It is upside down. The rest is rendered in a confident generalization of how handwriting looks.

This is a painting of writing, in other words, as opposed to painted writing, which is what David's picture is struggling with. That is to say, Roques's paintmarks show off their own technical, visual difference from the sign-language they portray. Whereas the point of David's manipulations, as I see them, is that they enact the lack – or loss – of just such difference. Painted writing becomes the figure of the picture's whole imagining of the world and the new shape it is taking. There is a moment at which the descriptions "painted writing" and "written painting" seem largely interchangeable, and both appropriate to everything we see. The boundaries between the discursive and the visual are giving way, under some pressure the painter cannot quite put his finger on, though he gets close. Large questions occur, about seeing and understanding in general. Modernist questions. Is it (ever) possible to say what we are looking at, or see what we are saying? Are there parts of a world to which the judgements "true" or "false" – linguistic judgements, on the face of it – are not applicable? Do bodies (ever) do anything besides write, or hold up writings after they are dead? And so on. We shall find questions of this kind recurring all through the following two centuries, regularly generalized by an ominous "ever." I think of El Lissitzky brooding on the words *Rosa Luxemburg* in 1920 (fig. 1). Or De Chirico's *Politics* of 1916 (fig. 16). The "ever" is regularly what gives modernism its flavor of madness.

Let me look one last time at Marat's and Corday's letters, and the contrast intended between them. Marat's letter was presumably dashed off to accompany the piece of paper money that holds it in place, and its purpose at least is clear. It describes, or recommends, the unfortunate widow to whom the

16 Giorgio de Chirico: *Politics*, oil on canvas, 32.7 × 26, 1916 (Private collection)

assignat should be given. (Could the widow even be Charlotte Corday, in her guise as *malheureuse*?)

Both letters, that is, pose the problem of politics and the people in 1793 in terms of benevolence. Marat's being a friend of the people is most vividly a matter of self-sacrifice. Bare room, orange-box desk, acts of charity. "He met his death, this friend of yours, giving you his last morsel of bread." This is part of what I see as David's strict Jacobin construction of Marat, and it gives us a clue to what the Jacobins conceived popular politics to consist of – what its proper discursive forms were, who were the actors and who the acted-upon. When David had originally promised to show Marat as he had found him, "writing his last thoughts for the safety of the people," he could not have known that those thoughts – or at least the last published version of them, in *Le Publiciste* on 14 July – were an attack on no less than the Committee of Public Safety. A double edit, then: of Corday's promise to swell the list of suspects, and of Marat's inveighing against "plotters on the committee of public safety whom *I shall soon unmask*."[66]

This, if you like, is the picture's ideological ground-bass. I have been suggesting that the test of Marat's writing being truthful – truly benevolent – is its closeness and illegibility, its being offered to us as a thing among things. I have tried to show that the offer doubles back on itself in perplexing ways. In that, I think, the picture enacts the contingency of claims to truth and falsehood at the moment it was made. This is its modernism, so to speak. But we get the picture utterly wrong if we see it as accepting, let alone reveling in, these kinds of self-doubt. They are doubts foisted on it by the very urgency of its effort to guarantee truth, to show it inhering in the world. Marat's letter, the picture wants us to believe, is not writing at all – not like Charlotte Corday's patient

17 Caravaggio: *Saint Matthew and the Angel*, oil on canvas, 295 × 195, 1602 (San Luigi dei Francesi, Rome)

establishment of every grammatical coordinate – but a piece of the real which happens to be readable. And for that reason incompletely. We shall never be sure who says what to whom. The letter is an act. It begins in mid-sentence, so that we do not know – or need to know – whether its first *vous* is subject or object of the verb that follows. The sentence's voice is unfixed: in a sense it is hardly Marat's at all: it is the voice of benevolence, the genuinely plural voice of collective concerns and loyalties. Or so the illusion tries to persuade us.

Someone might object at this point that I have made out Marat's letter to be a more unusual object in the history of painting than in fact it is. For Western art since the Renaissance is full of such paradoxical moments, when an object seemingly escapes from the picture space to become part of ours. Sometimes the offer is made with a flourish, like the leg of the stool in Caravaggio's *Saint Matthew*, as if to confirm the whole picture's being larger and more unstable than life (fig. 17). Sometimes it is quiet. A knife or a cluster of grapes in a Chardin still life pokes out over the forward edge of the shelf on which objects rest (fig. 18). Again the front face of the shelf seems pressed right up to the picture plane. The painter's ability to set up a situation where objects come forward even beyond that notional boundary is meant, I take it, to lead us to think about the specialness of illusionism in general.

The last thing I am saying is that Marat's letter is wholly unlike these precedents, any more than Charlotte Corday's letter is wholly unlike Bellini and Zurbaran. But I do want to speak to the way it differs, ultimately. In Chardin and Caravaggio, as I see it, the picture sets up a series of transitions, from light to dark, from vegetable to mineral, from animate to inanimate, from focused to generalized, which is meant to reconcile the final, incidental excess of reality

with the painting's overall view of things. I think the opposite happens in David. The excess of reality, and the fact that the excess is writing, are only the strongest signs of a general uncertainty about what picturing now is.

Consider, above all, the weird disparity in the painting between its insistence on matter and its treatment of where matter is not. Of course Marat's letter partly possesses the force it does because it is one among a panoply of objects: the pens and inkwell, the patched sheet, the bone-handled knife, the bath, the orange box. The picture goes in for Marat's "things," as we know his devotees did in general. It insists on the specific forms matter took in this instance. And yet the single most extraordinary feature of the picture, I should say, is its whole upper half being empty. Or rather (here is what is unprecedented), not being empty, exactly, not being a satisfactory representation of nothing or nothing much – of an absence in which whatever the subject is has become present – but something more like a representation of painting, of painting as pure activity. Painting as material, therefore. Aimless. In the end detached from any one representational task. Bodily. Generating (monotonous) orders out of itself, or maybe out of ingrained habit. A kind of automatic writing.

This is one of those points – more and more of them will occur as this book goes on – where perception and interpretation of a painting turn on features that are specially difficult to put into words. The task is difficult not just because the effect is subtle, but because the subtlety is of a kind that is meant to leave it open to doubt whether what we are looking at is an effect at all. Much less an effect that puts the mechanics of picturing at risk. It is open to the viewer, that is to say, to see the upper half of the *Marat* as satisfactorily empty, or sufficiently like a wall. And equally, the visibility of the painter's personal handwriting here can be brought under a whole set of comfortable (normalizing) technical descriptions. What we see is scumbling. It is a kind of brilliant unfinish – maybe in this case more brittle and perfunctory than usual – with

18 Jean-Baptiste-Siméon Chardin: *Grapes and Pomegranates*, oil on canvas, 47 × 57, 1763 (Musée du Louvre, Paris)

45

which the better class of viewers in the eighteenth century would be perfectly at home.

I am being a bit dismissive in my presentation of these alternatives because in the end I think they avoid the visual issue. They offer ways not to look (of which art history is prodigal). But I am not denying they are alternatives. And the best I can do to persuade readers to take my readings seriously is just to go on insisting on the failure of language – other people's language, that is, normative and normalizing descriptions of these features as part of a world of objects and/or techniques – to come to terms with what we are looking at. Look at the scumbled wall, I say, as it occurs in rough proximity to the triumph of objecthood in Charlotte Corday's letter. Look at the distance traveled, in terms of the kind of attention invited to the business of illusion-making, between the grain on the surface closest to us – the face of the orange box – and that on the surface furthest away. And is "surface" the right word here? Is not the very metaphorics of distance on which my sentence pivots – of distances traveled, between front and back, near and far, arm's length and stone's throw – itself a way of evading the upper half's placelessness? Its not being anywhere and not being made of anything. So that "grain" for its texture is about as far off beam as "furthest away" for its occupation of space.

All I am doing, I realize, is inventing different ways of saying: Trust me, the visual is a far weirder thing than language (and looking with language) will ever know. This is a topos of modernist criticism. Sometimes one thinks it is about all modernist writing on the visual arts has to say. And its tone is regularly mystagogic or worse. Lately it has come in for a lot of merited methodological flak. Therefore I do not like doing it. I know the bad company I am keeping. I do it (and shall do it again in what follows) because it seems to me true to the visual facts of the case. The modernist facts, that is. As to why modernism felt drawn to these particular areas of visual experience – ones where language has minimal purchase, where the understanding is regularly in doubt as to whether it has been offered anything, or enough, for the interpreting mind to work on – I hope some kind of answer to that question will emerge in what follows. As to whether art's coming to depend on its exploration of such areas was a good or bad thing, ditto.

I should try to offer a plausible account of David's intentions here – of what would have led him to leave the upper half of his picture empty in the first place. There is no great mystery to the set-up. The emptiness is of a room, perhaps a wall. (No hats and cloaks hung on this one.) It signifies Marat's austerity and self-denial. It makes him one of the people – it and the orange box and the patch on the sheet. As the eye moves right, the emptiness gradually becomes less dark and absolute. We know David was a great believer in the light of history.

This kind of account may be simple-minded, but I am sure it leads to the heart of David's beliefs and purposes, and of the revolution's. We would not need Furet to remind us that "in order to perceive the Revolution's deepest sources, one must grasp the most extraordinary and novel aspect of its nature, namely, the People's entry onto the stage of power."[67] This chapter's first twenty-five pages or so were essentially an effort to grasp that aspect again, as it might have affected David. And I mainly wanted to suggest that because it was so extraordinary and novel, it changed the circumstances of picturing for good. It is, in my view, the deepest cause of modernism; which is exactly not to say that modernism has usually recognized its cause. Why should it? It is enough, most of the time, if it represent effects.

The question of the People is a question about representation. The great nineteenth-century historians of the revolution, if we are to believe Furet, were great above all because they "attached central importance to the Revolution's symbolic investment in a new image of power." The People was that image. Edgar Quinet "understood that if the Revolution was a kind of annunciation [the Christian terminology chimes in with our object here] it was not because it was supposed to change society but because it was supposed to put the People in place of the King."[68] That is to say, it tried to put one kind of sovereign body in place of another. And the body had somehow to be represented without its either congealing into a new monarch or splitting into an array of vital functions, with only an instrumental reason to bind them together.

Hence, at a symbolic level, the careering toward direct democracy in 1793. (In my view, putting this kind of stress on symbolism does not necessarily conflict with a history which points to the Jacobins' calling the people on stage as actual, temporary allies in a class politics. Here as elsewhere, political contingency is the circumstance that symbolic actions strive to contain. "Contingency" is just a way of describing the fact that putting the People in place of the King cannot ultimately be done. The forms of the social outrun their various incarnations.) The Jacobins were the People represented. "In other words, a People unanimous by definition and therefore subject to constant self-purification, designed to eliminate enemies hidden within the body of the sovereign and thus to reestablish an imperiled unity."[69]

From the point of view of those trying to represent it, that is, the body of the People was always sick. It needed some radical purging. And ultimately there was only one way to do this. It had to be killed in order to be represented, or represented in order to be killed. Either formulation will do. Marat is the figure of both.

Marat, I said before, had to be made to stand for the People. By now the enormity of the task should be clear: not just that Marat was such a disputed object, pulled to and fro by the play of factions (though this indeed is part of the problem), but that at a deeper level any body was inadequate to what had now to be done. Or any technique of representation. That representation was henceforth a technique was exactly the truth that had not to be recognized.

To put it another way. Marat had to be shown to be one of the people. This was difficult not only because his image might so easily be captured by other competing notions of People/poverty/popularity and so on, but because the Jacobin notion of these entities or qualities was empty. They were defined by pure discursive opposition, to the *riches*, the *aristocrates*, the idle and unproductive. And the categories themselves had better be kept free from empirical detail, lest the actual distinctions and tensions that existed within the people's ranks take on political form.

This is the framework in which David's instantiation of "People" in his picture's upper half might come to make sense. It embodies the concept's emptiness, so to speak. It happens upon representation as technique. It sets the seal on Marat's unsuitability for the work of incarnation. "Some parts of his body could not be uncovered, for you know he suffered from leprosy and his blood was inflamed."

I talked earlier on about the empty upper half's effect on the picture in general. I see it as putting paid to the viewer's last vestige of certainty as to the picture's representational logic. Now I can say what I mean by this.

David was committed to an aesthetic of completeness and realization, never more so than here. The job of the painter, in his opinion, was to conjure Marat back from the realm of the dead, and make his body and attributes present. I have been arguing that the offer of presence on which the picture turns is a piece of writing, reaching forward into our space. Reading and seeing are strangely conflated at this point, the one term consuming the other. But even this need not have been fatal, if only the picture had engineered an absence – of the kind Caravaggio and Chardin provide, in their different ways – as ground and foil to the world of things. Presence in painting, so the Western tradition seems to assume, is ultimately dependent on the painter's securing an opposite term for it: a place where representation can efface itself, because in it there is little or nothing to represent. A wall or void or absence of light. (These questions will come up again apropos of Cubism.)

Something that ought on the face of it to be such an absence looms large in the *Marat*. It fills half the canvas. But instead of guaranteeing the illusion by its simple negativity it turns out instead to be a positive of sorts; and not just another particular, like the unobtrusive wall in Chardin, but something abstract and unmotivated, which occupies a different conceptual space from the bodies below it. This produces, I think, a kind of representational deadlock, which is the true source of the *Marat*'s continuing hold on us. No painting ever believed in illusionism more fiercely. No objects were ever offered the viewer as beguilingly as Corday's and Marat's letters. But the objects are writing. And up above them, ironizing or overshadowing them, is another kind of script: the endless, meaningless objectivity produced by paint not quite finding its object, symbolic or otherwise, and therefore making do with its own procedures.

In a sense, then, I too am saying that the upper half is a display of technique. But display is too neutral a word: for the point I am making, ultimately, is that technique in modernism is a kind of shame: something that asserts itself as the truth of picturing, but always against picturing's best and most desperate efforts. It asserts itself where the picture most wants truth, and thinks truth can finally be materialized – imagined as part of a world. Modernists in the early twentieth century sometimes spoke of what they were doing as attempting "truth to materials." Perfect misrecognition. For "materials" in modernism are always the site of untruth, or the site where questions of truth and lie disappear into the black hole of practice. The fact that this happens in the David where "People" ought to appear, as a kind of aura or halo, is similar to its happening in Matisse, say, where "Pleasure" ought to be, as a kind of ground or immediacy to experience conjured up by the sheer force of color. As does happen, time after time.[70]

There is, I think, one further small piece of the picture which might have the power to reconcile the warring parties. Up to now I have brushed it aside. I mean the scrap of paper whose tiny weight keeps Marat's letter eternally balanced on the edge of the orange box. It is an *assignat*, a piece of revolutionary paper money – writing which stands for property.

I have to say something, in consequence, about what the *assignat* was. Many of the issues concerning it are for experts, and leave me as far behind as they left most revolutionaries. Marat was notably bone-headed on the subject. But one or two things are clear. The *assignat* was a form of paper currency first issued in January 1790, partly in response to the flight of gold and coin which had

followed the storming of the Bastille.[71] It only gradually became a mainstay of government finance. There was considerable scepticism about the whole idea of paper money, which was thought to be an English sort of thing. In theory the notes were guaranteed by land. Inscribed on each was the legend: "Mortgaged on the National Estates." That is to say, on the wealth generated from the sale of crown and church properties, and later from the lands and belongings of *émigrés*, *émigrés'* relatives, and foreigners. From a Jacobin point of view, this rootedness of the paper in the earth was an important ideological consolation. For they were no great believers in the *arbitraire du signe* in general, and in particular money made them nervous. Saint-Just can be found playing the role of Jeremiah in November 1792: "I no longer see anything in the State but misery, pride, and paper." The three were roughly equivalent, that is, but at least somewhere behind the banknotes was a memory, or promise, of Germinal and Fructidor.

In the end, in 1794 and 1795, the new form of money collapsed. The government was forced to conspire against its own currency – buying up the paper in secret and burning it, as a desperate hedge against inflation. But in 1793 that still lay in the future. No one would call the economic policy of Robespierre and co. exactly a success, but it did have one paradoxical result for a while: it managed to stabilize the value of its multiplying paper. This was no small feat for a nation at war. Between the fall of the king and the fall of Robespierre, the state put 11 billion livres' worth of new notes in circulation. 3.686 billion in 1793, 4.190 billion in the first months of 1794. Depreciation set in. By September 1793, the *assignat* was changing hands at fifty per cent of its face value. Many atrocious things followed when Terror was made the order of the day. But the value of the *assignat* actually rose, slowly – to sixty-five per cent of face value by Thermidor. The American ambassador in Paris wrote admiringly to Jefferson that the revolution had managed the "feat of a paper money which goes up in value while the amount of bills printed is actually increasing."[72]

And how had they done it? By Terror, of course. By forcing the pace of expropriations, by seeking out and melting down hidden gold and metal coinage, by a general and ruthless *cours forcé*. David himself, in his capacity as member of the Committee of General Security (one of the two reliable Robespierrists on it before it was properly purged), was repeatedly involved in the detail of duress all through summer. His signatures survive to prove it.[73]

Marat's *assignat* is densely coded, then. Of course I am not claiming it possesses the kind of visual weight that belongs to the other main objects in the scene. One might almost argue it is meant to be overlooked. But only in the way of Poe's Purloined Letter. And we know that some at least of the picture's first viewers did pick it up, and appreciate its signifying power. A writer in the *Feuille de Salut public*, for example, had this to say on 8 Brumaire (he was most likely reacting to the picture on display in David's studio):

> The assignat for five livres which was all Marat possessed is placed by David on the block of wood represented next to the bathtub. This idea is really a stroke of genius, and an answer once and for all to those fools who accused the Friend of the people of being a pen for hire. In any case, who could have paid him what his pen was worth![74]

Not great criticism, but it does give a hint of the audience's viewing habits in Year 2. It confirms that one of the issues the picture was taken to turn on was

Marat's poverty. And that interpreters were able and willing to invest the smallest sign with meaning.

Wishing to be as tendentious a viewer as the one in the *Feuille de Salut public*, therefore, I shall take the *assignat* to sum up Marat's (and David's) world as follows. Those involved in making the revolution in 1793 believed profoundly that they were doing Nature's bidding. If human life could be rid of artifice, they thought, Virtue would reassert itself; because artifice was invariably the work of power. It was a set of ways to keep men (maybe even women) in subjection. Tyranny, fanaticism, custom, superstition, time immemorial: they were all names for the same spirit of misrule. Hence the utopianism of the revolution when it came to the symbolic order: the institution of the calendar, the dividing of the country into *départements* decreed by facts of geography as opposed to history, the rationalization of measurement (a meter being exactly one millionth of the distance between north and south poles), even the effort to alter grammar. And behind all this, the belief that power itself had been naturalized, in the form of the People's body.

Some of these moves look captious and thin. We have seen that the Jacobins themselves recoiled from them or their consequences on occasion – as with the war against *vousvoyement*. But the same verdict applies here as in the case of de-Christianization. Because the actions taken were often strained, and most of them did not stick, does not mean that the deepest meanings and functions of the revolution were not at stake. The revolution is anticipatory, of a history that is still far from ended. Its project is the disenchantment of the world.

This is the ultimate source of that desperation which seems to me most distinctive of Jacobinism as a political style – the blend of impatience, purity, and self-distrust. To believe in oneself as ushering in Nature's kingdom, and to think there was no time to lose if it was to be secured against its enemies; and yet to know in one's heart of hearts that what was being built was just another form of artifice, as wayward and unpredictable as the rest. Another arbitrariness. Another law for the lion and the ox.

"When I use a word," Humpty Dumpty said, in rather a scornful tone, "it means just what I choose it to mean – neither more nor less." "The question is," said Alice, "whether you can make words mean so many different things." "The question is," said Humpty Dumpty, "which is to be master – that's all." This is the kind of conversation David must have got quite used to in the Committee of General Security. Let Alice be Saint-Just, and Humpty Dumpty Robespierre. Let "word" equal *assignat* – plus *malheureuse* and *bienveillance* and *droit* and *deffense* and *patrie*. And *People* scrawled in the paint above the lot of them, though unfortunately not quite legible. "There's a nice knock-down argument for you!"

The French Revolution was made by the bourgeoisie. By that I mean roughly what Burke meant at the time, when he said that "the moneyed men, merchants, principal tradesmen, and men of letters . . . are the chief actors in the French Revolution,"[75] though obviously I differ from Burke in thinking that the coming to power of such men was part of an irreversible change in the social and symbolic order. "Part of" is sufficient here. Not "caused by" or "expression of." I am not interested in a narrative of causes. All I want or need to do, for my present purpose, is insist on the oddity of the word "People" in a revolution of this social character.

An image will do better than a thousand words. There is a picture in Le Mans Museum that for years was thought to be by David himself, and that I think must have come from someone in his inner circle (fig. 19). It is rightly held to

19 Anonymous: *Family Portrait*, oil on canvas, 162 × 130, ca. 1795–1800 (Musée de Tessé, Le Mans)

be one of the most poignant documents to come down to us of the change that the revolution wrought in personal style. Nothing I can say will rob, or is meant to rob, the man in the center of the picture of his plain dignity. It is massive and touching. But for that very reason I think we should attend to the contrast between the father's careful symbolic *déshabillé* and the costumes of his sons and daughter, the china on the mantleshelf (one looks about for a terra-cotta Marat), the glimpse of picture-covered walls, the well-turned furniture, the spinet and the young girl's music lessons, the power to order this painting in the first place. These people and their painter are anonymous, as I say. But I take them to be representative of the political actors we have been looking at.

Compare, for example, the sans-culotte militant François-Pierre Beaudouin, president of the *comité révolutionnaire* of the Gravilliers section in winter Year 2 (we know about him from his will).[76] Master decorative painter, employing six skilled workers, in charge of the section's war production, and leaving behind at his death in 1795 a fine apartment on the rue Phélippeaux: several large rooms opening onto a terraced garden, a kitchen with two ovens, walnut cabinets, inlaid hardwood floors, copper plumbing, crystal chandeliers and goblets, settings in porcelain (terra-cotta Marats long since disposed of), tables of oak and marble. Remember that Beaudouin existed quite far down Jacobin ranks, and in a sense outside them. He was a "popular" leader. To quote the verdict of the historian who discovered him, a leadership comprised of men like Beaudouin "was bourgeois in its social aggregate, and absolutely by comparison with the population it ruled. It was so by its manufacturing and commercial capital, by its real properties and salaried incomes, by its skills in literacy, manipulation of ideological formulae, and governance. It had the power to command labor on a large scale and to create dependencies, allegiances, and constituencies."[77] These were the kinds of men who rang the changes on David's cry before the Convention: "I heard the voice of the people, I obeyed."

Of course the point is not to convict them of hypocrisy or even lack of self-knowledge. I for one am sure David was horribly sincere. It is to wonder what might have been involved for bourgeois individuals – what kinds of inventiveness, what sources of knowledge and ignorance – when they began to represent those whose labor they commanded.

Maybe I was wrong to back away at the start of this chapter from the idea of modernism's having begun at a particular moment. For ultimately I do believe it began with the French Revolution. This chapter has tried to show why. Of course modernism also ended with the revolution, and began again when the revolution began again, and so on. (The cycle continues.)

If I wanted to argue more fully for the 1790s and early 1800s being the decades that usher in a decisive new structuring of time, I think my best evidence would be music. Naturally, since this is the art that feeds most deeply on a culture's imagining of temporality – its sense of sequence and repetition, or of discontinuity and inauguration. Beethoven for me is David's brother. I imagine the *Sabines* dancing (better than Wagner did) to the last movement of the Seventh Symphony. And Marat agonizing to the closing bars of the Fifth.

"À MARAT," finally it reads on the orange box, "DAVID. L'AN DEUX." Dedication, signature, date. And even here language is not transparent. For what does the capital À mean, precisely? What kind of connection do it and the following comma intend between Marat and his image, or Marat and his

maker? *For* Marat, presumably. But also aspiring *to* Marat, reaching out to him physically. And in a sense *his*, belonging to him or done for him by proxy – as we might say, "le tableau à Marat." And where are the words supposed to be spatially (illusionistically)? I wrote that they were "on the orange box." I guess that is one interpretation. It is as Marx once had it, talking of the commodity: that maybe its power derived from us not being able to tell "where the commodity is." This gets to be true of more things (more signs) in David's picture the longer we look.

More, but not all. The *Marat* is not a picture that shows us shifts and uncertainties ending up swallowing the world, or making the concept "world" redundant. (It leaves that to later brands of modernism.) A pen is a pen, a knife is a knife. Goose feathers catch the light like this, and their vanes grow separate and sticky with use just so. Blood on a bone handle looks one way, on steel another, in water a third. Matter is stubborn, or at least predictable, and goes on resisting the work of modernity. Even the proud inscription "YEAR TWO" is provisional. The numbers 17 and 93 are still there to left and right of it, only half erased, seemingly stuck to the wood of the orange box, as if David had tried to make them vanish but been defeated by his own materials. Technique is a perfidious thing, says the painter, but at least a hedge against the future. The time of revolution is short. *Anno domini* will doubtless return.

2　We Field-Women

How it rained
When we worked at Flintcomb-Ash,
And could not stand upon the hill
Trimming swedes for the slicing-mill.
The wet washed through us – plash, plash, plash:
How it rained!

How it snowed
When we crossed from Flintcomb-Ash
To the Great Barn for drawing reed,
Since we could nowise chop a swede. –
Flakes in each doorway and casement-sash:
How it snowed!

How it shone
When we went from Flintcomb-Ash
To start at dairywork once more
In the laughing meads, with cows three-score,
And pails, and songs, and love – too rash:
How it shone!

Thomas Hardy, "We Field-Women"

20　Camille Pissarro: *Two Young Peasant Women*, oil on canvas, 89 × 165, 1892 (The Metropolitan Museum of Art, New York, Gift of Mr. and Mrs. Charles Wrightsman, 1973)

Camille Pissarro's *Two Young Peasant Women* (fig. 20) was first shown to the public in late January 1892.[1] It was part of a wide-ranging exhibition of Pissarro's past and recent work – the kind we would now call a retrospective – put on at the Durand-Ruel Gallery, in a fashionable shopping street just off the boulevard des Italiens. The catalogue for the show invited the visitor to look at Pissarro's paintings chronologically, or with a sense of how paintings done in the previous few months matched up to those from ten or twenty years earlier. There were fifty oil paintings and a score of gouaches: eleven oils from the 1870s, and a hard core of twenty or so landscapes and peasant figures from the great years 1881 and 1883. The year of each cluster of pictures was set off in the catalogue in bold capitals.

All of this had something of a new-fangled flavor in 1892. One or two critics of the exhibition managed the word "retrospective," but never as a noun.[2] Pissarro himself, writing to Monet a fortnight before the opening, opted for the slightly bemused, or maybe even apologetic, formula, "a more or less general exhibition of my works."[3] Thinking of pictures as primarily episodes in an individual's career – as opposed to, say, contributions to a public dialogue in the Salon, or responses to moments like Vendémiaire Year 2 – was to become

55

natural to modernism in the years that followed. The retrospective is one of modernism's main language-games. It teaches artists to view their work, proleptically, as part of a singular, continuous past; and therefore to produce work to fill the bill. I am not saying that these habits of mind were non-existent in 1892 – if only the history of bourgeois individualism were divisible into such neat "befores" and "afters"! – but it does matter, to modernism and Pissarro, that they were still a bit foreign and fragile. *Two Young Peasant Women* (*Deux Jeunes paysannes*) was number 50 in the Durand-Ruel catalogue, the last painting listed for the current year. We know from Pissarro's letters that it was still under way on 13 January, and shipped to Paris with just days to spare.[4]

By Pissarro's standards *Two Young Peasant Women* is distinctly a big work. "Ma grande toile," he called it in the 13 January letter. That may seem stretching things a little as regards square footage. The canvas is just over 35 inches high and just under 46 inches wide. By Salon standards, small beer. But Pissarro was thinking of formats he had made his own over twenty-five years, and established as the sufficient (deliberately modest) sizes of modern painting, whether landscape or figure; and in those terms he was not exaggerating. There are no more than a dozen pictures, in the over-a-thousand Pissarro did in his lifetime, that are even roughly as big as *Two Young Peasant Women*; and no other painting in which more than one figure looms this large in relation to the whole pictorial field. (There are, of course, portraits, including several of peasants. But it is of the essence of *Two Young Peasant Women* that it is not portrait-like, nor even like a portrait multiplied by two. Or maybe we should say that multiplying a portrait by two in this case produces something anomalous, not quite monumental figure painting and not quite scene from everyday life. The anomaly seems to fascinate Pissarro. His picture is partly about the quiet dissonance of categories inherent in a certain scale and set-up.)

Looking at *Two Young Peasant Women*, then, we should never lose sight of its strange relation to Pissarro's own norms; all the more so as the first context in which the picture appeared reminded the spectator so powerfully of what those norms had been. The most exquisite of the paintings from the 1870s included in the 1892 show was *Banks of the Oise* (fig. 21), dated 1873 – more than one critic singled it out as a touchstone.[5] It measures 26 by 32 inches. And even this is one of Pissarro's larger sizes for the decade. Just as representative would be a picture like *The Oise on the Outskirts of Pontoise* (fig. 22), which packs its reflection on landscape and industry (and even the other, more unsullied *Banks of the Oise* has a train racing by in the background) into 18 by 22 inches. As for pictures from the 1880s treating *Two Young Peasant Women*'s subject-matter specifically, there were half a dozen in the retrospective. The peasant figure was meant to be seen as standing at the heart of Pissarro's career. It is not always easy to be sure, from the brief titles and formulaic descriptions in the press, which peasant figures were actually hung. But I have a feeling (from a description by Gustave Geffroy which is a little less formulaic than most) that one of them was *Peasant Women Minding Cows* (fig. 23).[6] It makes a good comparison with "ma grande toile." It is half the size – 25 by 32 inches. The same format, essentially, as *Banks of the Oise*.

Pissarro knew only too well in 1892 that whatever he did in the present would be looked at comparatively, and put to the test of the 1870s. In that sense the retrospective only compounded a process – a verdict – that was already built into the structure of the modern art market. The market put cash value on the past. It very soon gave a career a characteristic profile, with a rise and fall like

21 Camille Pissarro: *Banks of the Oise*, oil on canvas, 65 × 81, 1873 (whereabouts unknown)

22 Camille Pissarro: *The Oise on the Out-skirts of Pontoise*, oil on canvas, 45 × 54, 1873 (Sterling and Francine Clark Art Institute, Williamstown, Mass.)

23 Camille Pissarro: *Peasant Women Minding Cows*, oil on canvas, 65 × 81, 1882 (Collection of Mr. and Mrs. Paul Mellon, Upperville, Virginia)

bar columns on a graph. It made a Pissarro that Pissarro was obliged to live with.

In April 1890, for example, Pissarro came across an old picture of his from a year spent in London in 1871, the *Church at Sydenham*. Partly the encounter was bitter. The painting was hanging in Durand-Ruel's showroom, and in 1890 (and for most of 1891, we shall see) Pissarro and Durand-Ruel were at odds, with the dealer refusing to buy works in Pissarro's latest manner. All the same, *Church at Sydenham* looked good. "It is in admirable condition and a lot better than I thought the picture was back then; there is an effort at unity in it which filled me with delight, it is almost what I am after at present, minus the light and brightness."[7] *Church at Sydenham* was borrowed back from its owner – it had evidently sold fast – for the 1892 show. In June 1890 Durand-Ruel pushed the price of another 1871 canvas, *The Rocquencourt Road*, to 2,100 francs at auction.[8] By December 1891 prices in this range did not need finagling. No less than Bernheim-Jeune, dealer-in-ordinary to boulevard culture (and as such often the butt of Pissarro's sarcasm), was giving room to four canvases of the seasons which Pissarro had done in 1872, and asking 2,500 francs per item. He had bought the lot at auction in May for 1,100 francs. Pissarro remembered selling them in the first place for 100 francs each.[9]

I think these facts are relevant to *Two Young Peasant Women* – that the painting was intended to set a crown upon a lifetime's effort, certainly, but also in a sense to contradict this effort, or alter it, or alter the notion of it that the market seemed to have settled for. Of course the picture did no such thing (nor will this chapter). But the enormity of *Two Young Peasant Women*'s ambition, and the sense of this ambition flying in the face of a structure of value that already seemed solid – I am sure these are partly what gives the picture its inimitable sad force.

They are also partly what made it hard to finish. Scale was obviously an issue here: Pissarro was moving into an area where most of his normal ways of

drawing and handling would not deliver the goods. He was improvising strange (and wonderful) solutions to problems he had never set himself before. The surface of *Two Young Peasant Women* is full – sometimes to bursting – with the effort. Part of the reason for delay was simply physical. Pissarro was in his sixty-second year. The picture had most probably been started in early summer 1891, maybe even out of doors – though it was always meant to be eventually a studio production.[10] In May the dust in the orchard at Eragny made an abscess flare up in Pissarro's right eye, putting it under bandages for weeks and sending him off to Paris for treatment. *Two Young Peasant Women* was evidently going to be an immense test of visual concentration, visual staying power. No wonder it was put off until Pissarro could be sure the eye would hold up.

But behind these facts lie other more pervasive problems – of mode, of expression. Size on its own does not explain the difficulties. Pissarro was working on at least two additional pictures of peasants in the late summer and fall of 1891, both on a much more modest scale; and his letters are eloquent, at moments agonized, about his lack of certainty over both. The pictures were eventually numbers 48 and 49 in the retrospective's catalogue: *Peasant Woman Sitting; Sunset (Paysanne Assise; soleil couchant)* (fig. 24) and *Cowherd* (*Vachère*) (fig. 25). The first measures 32 by 26 inches, the second 29 by 20. Opinions will vary as to whether in the end Pissarro pulled the pictures off. But the least glance will show what the agony had been about.

Astonishing wench [this is the critic Félix Fénéon confronting the *Cowherd* in February], a toy, a sort of toy that has suddenly come to life, and seems to take her first breath and be just discovering what life is like; she leads a cow on a serpentine string, a cow seen head-on, two-footed, neck like a camel, muzzle inching its way through the grass. And if Durand-Ruel recoils from this cow unknown to photography, old man Pissarro will say: "It isn't a cow, it's an ornament."[11]

25 Camille Pissarro:
Cowherd, oil on canvas,
73 × 51, 1892 (where-
abouts unknown)

Compare Pissarro's actual words to the novelist Octave Mirbeau, in a letter
written the previous November:

> How much I should like to show you my *Cowherd* which I have chewed on
> something fierce [*que j'ai rudement triturée*] . . . she is still not finished, but I
> think she is going well, at least till the moment of disenchantment comes,
> after the last touch of paint is put on! That fatal moment. And my peasant
> woman dreaming, sitting on a bank below a field, at sunset, she has just been
> cutting grass, and she is sad, very sad, my dear Mirbeau . . . the trouble
> is, how do you stop the thing falling into banality, ending up just
> sentimental . . . I hate sentimentality! – Just how do you avoid it, this crime?
> [*le chiendent c'est que cela ne souffre pas la médiocrité sans quoi ce sera une
> romance . . . je hais la romance! – comment ne pas tomber en ce crime?*][12]

The last telegraphic phrases (which have given more than one translator
trouble) seem to me genuinely at a loss. Of course modernist painters are always

producing the problem of when and how to finish – the problem is modernism's lifeblood, and eventually its deathknell. But this moment is special. Pissarro was on his mettle as a letter-writer when Mirbeau was the recipient. He stated principles, gave opinions (even literary ones), talked politics (to a fellow anarchist). The pattern of ambition and fear in this paragraph – the tug-of-war between necessary intensification and easy romanticizing, or between ornament and photography – speaks deeply to his purposes in *Two Young Peasant Women*.

"I've been thinking about your cowherd and her cow," Mirbeau writes back on 25 November (he had seen the picture two months before), "and about the *stained glass window* behind it [*au* vitrail *qui est derrière*]. The project gave me a religious sensation . . . of that religion the two of us love, in which God is replaced by matter Eternal and splendid, and by the infinite!"[13] "He has given up painting outdoors," says Fénéon, "and treats Nature as a repertoire of decorative motifs, frees it of the accidental, soothes the antagonism of those two characteristics, energy and sweetness – and attains to high, unconscious symbolizations [*pacifie l'antagonisme de ces deux caractères: énergie et douceur, – et atteint à de hautes symbolisations inconscientes*]."[14]

I am not saying that Pissarro would have agreed with his literary friends' precise arguments and choice of words. But the paintings he was producing in late 1891 did invite dialectic, not to say prose poetry. Mostly in 1892 journalists ignored them.[15] Fénéon was excessive – partly he was out to trump the hand of the young writers and artists who were already (crudely) calling themselves Symbolists in 1891 – but we shall see he got many things right.

Pissarro is on a knife edge, between simplicity and portentousness, or strong expression and souped-up emotion. He is pushing at the limits of modernism. For some reason his painting had now to risk the hieratic and exalted (two more words Fénéon produced) – partly to wrest those qualities from the hands of the Symbolists, partly to cast new light backwards over his own career, partly to spell out (in new circumstances) what he had been doing all along painting peasants. Of course spelling out was deeply risky. It might head painting back toward the terrain it had purposely abandoned in the 1860s and 1870s – that of the literary, the anecdotal, the big scene or small drama humming with a culture's clichés. None of these descriptions applies to *Two Young Peasant Women*, at least in my opinion. But they could have applied. The picture deliberately gives hostages to the enemy.

Think of *Peasant Women Minding Cows* (fig. 23) as one term of comparison here – the anecdotal interest safely sewn into the texture of the rectangle, held on the all-in-one surface. And then enter a pastel dated 1892, *Peasant Women Chatting, Sunset at Eragny* (fig. 26), as the second term. It measures 8 by 6 inches. "Another mistake of Pissarro's," wrote Lionello Venturi about it – the previous ones, in his view, being *Cowherd* and *Peasant Woman Sitting* – "in which is manifest a certain pretension to socialist political activity."[16] This is a voice speaking from the modernist center, of course (Venturi was one of the compilers of the Pissarro catalogue raisonné, published at the Galerie Paul Rosenberg's expense in 1939), and easy to dislike. One senses the fear and venom packed into the last five words quoted. But what other voice – what other response – did Pissarro anticipate?

Whether the technique of the pastel somehow manages to hold and solder the illuminating sun and upturned face, and rob the standing woman of the aftertaste of Millet's *Angelus* (fig. 27), is anybody's guess. I have not been able to track the picture down and judge for myself. But in any case Venturi was right,

26 Camille Pissarro: *Peasant Women Chatting, Sunset at Eragny*, pastel on paper, 20 × 15, 1892 (whereabouts unknown)

I believe, to catch a whiff of socialism in the air. I shall make that case in due course. And right that socialism put Pissarro's normal skills – his sense of decorum and self-effacing arrogance of technique – under extreme pressure. The question is whether the pressure, in *Two Young Peasant Women*, dispersed the skills or transfigured them.

"It is this Pissarro," says Fénéon, "the very recent one, that we should be celebrating. Finally master of forms, he bathes them forever in a translucent atmosphere, and immortalizes, by means of the benign and flexible hieratism he has just invented, their exalted interweave [*puis éternise, en l'hiératisme souriant et souple qu'il inaugure, leur entrelac exalté*]."[17] This too is a modernist voice – Platonist, anarchist, Mallarméan. The voice, I should say, of the best art critic after Baudelaire. What it celebrates is not so very different from what set Venturi's teeth on edge.

"I have dreamt of a more and more sober, more and more simple art. I have condensed, amalgamated, compressed . . . I have tried to say as much as possible in a few words." – Puvis de Chavannes.[18]

"As a general rule, most people . . . are much more naive and simple-hearted than we suppose. And we ourselves are too." – Dostoevsky.

The picture (fig. 20) is of two women taking a rest from work, probably chatting. Two field-women. How exactly they are resting is not clear. There are problems of relative height and placement we shall come to later. My best guess is that the woman on the left is sitting on the ground, or on a grass bank, with knees splayed wide – maybe squatting. The woman on the right is kneeling,

27 Jean-François Millet:
The Angelus, oil on
canvas, 55.5 × 66, 1857
(Musée du Louvre, Paris)

leaning on a short-handled spade. Her right hand is steadied on her far right
knee. An oil that Pissarro showed at Durand-Ruel's in 1894, called *Peasant
Woman Sitting and Peasant Woman Kneeling* (fig. 28) – the title is hard-
working about poses – makes a useful point of reference.

The women are at the edge of an orchard. Over the kneeling woman's
shoulder are the stakes of a vineyard, which is presumably what the women
have been weeding. Finicky work, not easily mechanized. A long field put to
grass stretches off to the horizon. Poplars. The distinctive shape of an apple tree
in mid-distance. All of this is local and representative: Eragny was on the fringes
of cider country, but in the 1890s still produced its own cheap wine. Like much
of France in these decades of slumping wheat prices, more and more of its fields
were turned over to stock-raising and dairy.[19] Not that I am claiming *Two
Young Peasant Women* is geared at all precisely to agriculture and topography.
It is a synthesis, partly prefabricated. Compare the small study, *Appletrees* (fig.
29), which Venturi thought was done sometime in the early 1880s. Or the
connected gouache called *Weeding the Vines, Pontoise* (fig. 30), which Pissarro
had exhibited long ago at Durand-Ruel's, in 1888.[20] It is dated '83 – that is,
before Pissarro moved away from his original 1870s base. Clearly he reverted
to things in his studio when he set about building *Two Young Peasant Women*.
The oil study in particular is stuck to doggedly for certain facts of drawing.
Nature as a repertoire of decorative motifs. *Leur entrelac exalté*, etc.

But the exaltation, as Fénéon knew, would have to come essentially from
surface and light. Drawing was important, but could not be allowed to detract
from a final totality of time of day, state of the sun. That time and state would
be carried by the whole rectangle, by touch and tone held at the same intensity
through every square inch, corner to corner, center to periphery. The figures
themselves are pinned to the frame, resting on it as if for support, leaning and

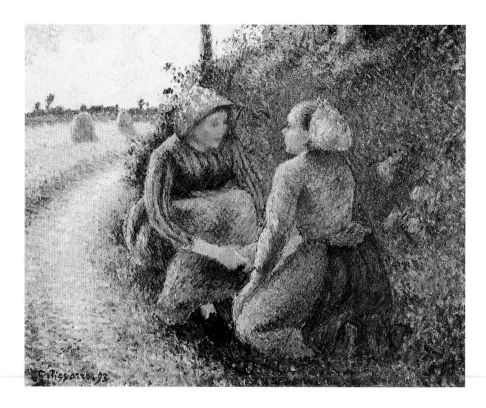

28 Camille Pissarro: *Peasant Woman Sitting and Peasant Woman Kneeling*, oil on canvas, 46 × 55, 1893 (Private collection)

spreading onto the flat – especially their dark blue skirts. (It is the hardness of surface that seems to give them substance; and the surface that they are resting on, not the earth.)

It is all a matter of surface and light. But these are the aspects of the picture that are hardest to grasp and describe – the aspects that any viewer (certainly this one) is most likely to lose hold of, or change his or her mind about, as the minutes go by. Partly this is physical. The surface of *Two Young Peasant Women* is drenched and suffused with complex color, applied dryly, varying from millimeter to millimeter. Therefore the membrane is ultra-sensitive to light coming to it from the outside world. The picture now hangs in a room where natural light, shining from above through a partly translucent ceiling, is helped out by a mixture of tungsten and neon. Only when the sun is high and unobstructed does natural light overwhelm its substitutes. And that is when *Two Young Peasant Women* comes into its own. On a summer day with broken cloud-cover – a typical New York summer's day – you sit there watching the picture flinch and recede and recover as the original studio light comes and goes.

The painting, as I have said, was done in a barn studio at Eragny. We cannot be sure how that original space was set up, except that it was simple, and that Pissarro worried in 1893 when he had enough money to build a new one (which survives, and is not elaborate). "My painting is going to put on gloves . . ."[21] *Two Young Peasant Women* is a studio picture above all in its complex stilling of a certain condition of light – the sense in it of light having stopped for a long moment and being there under controlled conditions. That does not mean the painting puts on gloves. Its object is the light of day. But it is a compromise, and offers itself as such. It is ornament not photography – a complex imagining of light, a reconstruction of it, in which the painter's distance from the facts he is remembering is admitted through and through.

Partly that distance and muting is built into the scene itself, and the two depicted figures' relation to it. For here is the picture's central, and most elusive,

effect. Only slowly, if my experience is typical, does it dawn on the viewer that the key to the picture's color organization is the fact that its two peasants are taking their rest in a translucent foreground shade, with here and there a trace of sunlight coming through the leaves onto their fists or foreheads. Of course that is what they are doing! Rest seeks shadow, work usually cannot. The contrast between the one state of light and the other is what carries the picture's semantic charge – this is its way of reinventing pastoral. But it would not be like Pissarro to polarize the contrast, or offer it with a Monet flourish. Light is the guarantee of pictorial integrity, and also, ultimately, of expressive integrity. "I know full well that my *Peasant Woman* is too pretty, that happens to me all the time . . ."[22] There can be (given the circumstances of the later nineteenth century, there inevitably will be) plenty of sweetness and sentimentality in a picture, as long as the light – the surface – countermands them. As long as it embodies the qualities of energy, equanimity, and truthfulness which elsewhere evaporate the moment they are pursued. Don't try to figure the values that matter to you, have them be instanced by what you do. This is the central modernist instruction as Pissarro understands it.

Therefore the shade that surrounds the two actors has to come out of the whole texture of colored marks – come out of it like a secretion, or emanation, which can never be tied down to this or that painterly cue. Therefore the landscape in sunlight has somehow to participate in the shade, or be viewed through it, or be shot through with its qualities. The sky is white, and the air is charged with what seems like humid overcast. Light is diffused. The atmosphere is sultry, there is a muffled quality to it. Looked at close to, the paint is as dry as a bone, happily still unvarnished; from twenty feet, the same paint is muggy noon, full of moisture. The shadow under the faraway apple tree is unequivocal about the height and strength of the sun. Is the cheap cloth of the squatting woman's workshirt shiny from wear or sweat?

It is shade, to repeat, that is the sign of pastoral in Pissarro. Leisure (*otium*) is a time of day and a partial removal from sunlight. We shall come to wondering in a moment whether Pissarro succeeded in drawing his two women convincingly, and in giving us clues (I mean intimations, not cue-cards) to their conversation. But he would have said that those things mattered less – infinitely less – than that the women be put in a particular condition of light. A light with the field-women's dreams built into it. That was intimation enough. *Elle est triste, bien triste, notre Mirbeau . . .*

29 (*above left*) Camille Pissarro: *Appletrees*, oil on canvas, 54 × 65, ca. 1883 (Private collection)

30 (*above right*) Camille Pissarro: *Weeding the Vines, Pontoise*, gouache, 24 × 30, 1883 (whereabouts unknown)

How typical a moment of modernism this is! Typical of its strength and pathos. Everything depends on an effect of saturation, and looking at light through shadow, and the effect is marvelous; but it is only on offer, in my experience, to the most sustained (fanatic) attention; and inevitably it is the quality in the picture that is mistaken for tentativeness, or too heavy a build-up of color – it is the quality that keeps the picture out of the modernist canon. And even supposing an audience that modernism, and maybe painting in general, will never have, the effect is only visible under the most special and fragile viewing conditions. It is a miracle that the room in which *Two Young Peasant Women* is now hung occasionally provides them. Only when real daylight (steady daylight, studio light coming in from above) floods the background with enough solar white-yellow to have the overcast register as sunlit – only then does the picture work. Otherwise its range of tone can seem sullen, or even subaqueous. So determined not to grimace, coloristically, that it ends up looking obstinately withdrawn. *Le chiendent c'est que cela ne souffre pas la médiocrité.*

The best critics in 1892 realized that the way Pissarro's new surfaces responded to light needed describing. One of the few times in his life Pissarro bothered to reply to an art critic was in February, when he read the following paragraphs in *L'Estafette*:

In order to translate his new intuition of nature, a new procedure was necessary. This procedure . . . is most striking in the painter's latest works, where thick, tight-fitting, close-packed brushmarks build up from the canvas surface in powerful relief. They make a kaleidoscopic mass of colors, and the painter's ability to keep them under control reveals a certainty of eyesight and an impeccable science of complementaries.

M. Pissarro hardly uses brushes any more, but works with the palette knife, not for the sake of speed, or in the fury of inspiration, but so as to give more of the impact of daylight in his composition. The uneven surfaces that he produces [*Les aspérités qu'il multiplie*] serve to catch and retain rays of light, and when the sun hits them, suddenly the colors glitter like a jeweler's display window.[23]

These lines were written by a young journalist called Clément-Janin. The piece appeared on 18 February, and Pissarro, still in Paris, replied the next day:

I have nothing to add to your way of understanding my works from a philosophical point of view, you get my thinking right, and the same goes for the division of tones, which lets me achieve more intensity of color while preserving the unity of the whole, and still staying clear and luminous. All the same, a few errors have crept in . . .

For instance, it is a mistake to believe that my uneven surfaces serve to trap rays of light, no, really, light has nothing to do with it [*c'est absolument indépendant de la lumière*]; anyway time will level out this impasto and I often do my best to get rid of it. I do not paint with the palette knife, that would make it impossible to divide color, I use long, fine sable brushes, and alas! it's these long brushes that give rise to the roughnesses, against my will.[24]

What a surface it is when the light falls on it (fig. 31)! What color! As usual with Pissarro, the predominant hues are green and blue: leaf green and grass green, light blue gingham and dark blue calico, blues of all kinds pooling

along the bank by the orchard and infiltrating the strip of shadow on the ground between the two women's knees. Blue shading to purple and indigo. But you have only to look back at *Two Young Peasant Women* after a few minutes in front of one of the other Pissarros in the same room – there is a fine peasant figure from the early 1880s hanging three paintings away – for it to be striking how much more the greens and blues are qualified by warm solar colors than in any other picture in sight. Above all there is an extraordinary rose-pink playing everywhere against the blue-purple – mixed into the strip of shadow, and across the chalky earth directly above it, and along the side of the orchard. It is there in the trunk of the nearest tree and on the squatting woman's back, and spreads laterally across the far field just before the line of poplars. The pink of sunset appearing at mid-afternoon. Pretty, humanizing, pathetic-fallacy flesh tone – the celebrated *carnation* on the peasant woman's flushed cheeks. Stifling heat. Here and there episodes of a purer straw- or lemon-yellow crop up, as a kind of counterpoint. A lot of work is done, for instance, by a patch of dry, light lemon put on to the right of the last orchard tree: it opens the distance between orchard and poplars, relieves the overcast a bit, and prepares the way for lines of pink and violet put on below the horizon.

Some of the reasons for these solar colors are technical and optical – which is to say in Pissarro's case ideological. They are the residue of a deep commitment to what Seurat and Signac had done over the previous five years, and to the whole idea of a painting that would recapitulate, in its build-up of individual touches, the raw materials of visual perception. Spectrum color, solar orange, complementary contrast. Pissarro had spent a long time trying to make the technique of pointillism work for him, with mixed success. He had been captivated by Seurat's actual painterly achievement, in the first place; by the anarchist politics of several of the young artists who followed Seurat's lead; and by the idea of escaping from the brilliant one-man improvisations of Impressionist painting to forge a collective style. The "neos," the young men called themselves. In 1891 Pissarro was in the process of learning again to do without the dot. Why he did so is a complicated story, which had better be left for now. But it matters even to our first understanding of *Two Young Peasant Women* that it was done by someone disengaging from a previous, more systematic style – one that went on haunting Pissarro's practice well into the 1890s. As late as 1896 you find him declaring (about his new use of whites), "This way I am completely freed from the neo!!!,"[25] as if up till then he had been painting under the pointillists' spell.

Two Young Peasant Women was partly an argument with pointillism, then, which is to say with his own previous work. It was intended to show that the full complexity and evenness of optical events could be managed by an improvised, flexible handling, without that handling "making nature grimace" – Fénéon's cruel and unforgettable phrase about Monet, which Pissarro had relished when it was coined.[26] The picture's handling does still have a memory of the systematic and uniform to it. In one or two places (not the picture's best) a kind of outright pointillism hangs on. On the kneeling woman's shirt, for instance, there are separate small splashes of pink, red, green, orange, and a lighter blue on top of the basic establishing hatchwork. I guess this has to do with a special effort to model the body – to make things solidify. In the arm and shoulder the effort is maybe overdone. But by and large the surface is left as hatchwork, crisscross: strokes still visibly separate, and to a degree consistent, but woven together like coarse thread. The line where the strip of shadow at the center gives way to sunlit earth is like a local demonstration, more broadly done, of the way the whole surface is made. Pure blue over pale distemper yellow.

The surface is dry. That is, animate but not organic, not borrowing the qualities of the vegetable world. Handmade. Optical. Dry as straw or tapestry. Irresistible close to.

Once you are willing or able to read the picture as surface, that is – as held together by variety, consistency, inventiveness of touch – then no doubt it holds together completely, with a richness and naivety never equalled in a big figure painting in the nineteenth century. Once you are willing or able . . . There's the rub. A viewer needs help. And is not this picture a little too diffident about giving it? Is it not a little too unwilling to direct the viewer *to* the surface – to the fact that it is there the pictorial action really takes place? I am not saying the answer to these questions is clear-cut. Pissarro was never going to beckon or cajole his spectators toward the surface in the manner of Monet – rhetorically, demonstratively. Fénéon's verdict rang in his ears. And anyway, this is a figure painting; one of the kind Michael Fried has taught us to call absorptive, held together by inwardness and dreaming.[27] It has to have literal and metaphorical depth. Therefore the picture's surfaceness and facingness has to be reconciled with the fact of our viewing everything through foreground shade.

Sometimes I think I can see, and settle for, the reconciliation. Is it not done by the strips of lit and shaded soil at the center of the picture, between the two women – stretched tight like a banner, the lit part a scroll lacking script? This is as demonstrative a piece of painting as Pissarro ever did. It billows like a late-Monet cloud in a pond. The shadow below is as sheer as a cliff-face. Light hits the picture surface in a storm of particles. It is as close as one comes in Pissarro to an image of sunshine and shade answering each other as sheer force. Jules Laforgue, who wrote passionately about Impressionism as a kind of Wagnerism in paint – a war on the surface of equal and opposite small energy-sources – would have liked this passage above all.

Surface it is, then, or surface it can be. The squatting woman at left folds out laterally across the picture plane, claiming more and more flat room. The green of the field is spread along the edges of the two women's faces, brightened slightly and smeared flat with the brush – in the case of the squatting woman quite arbitrarily, and clearly late in the day.[28] She wears it as a halo, or a puff of green thought. Then the vineyard becomes the kneeling woman's wing, the flounces of her skirt are pinned close to the picture corner, and treetrunks and branches brace the corner opposite. The handle of the spade is a stretcher bar. The picture is an Annunciation. *En l'hiératisme souriant et souple qu'il inaugure.* The Virgin ponders, the archangel waits. The soil is as fiery and infinite as gold leaf.

But this is only a moment of reading *Two Young Peasant Women*, and of course not sustainable. What matters is that the hieratic be inseparable from the commonplace, and that flatness be twisted together – weirdly, unresolvedly – with inwardness and depth. Even Fénéon knew that.

He was aware that Pissarro's painting, for all its new formality, still invited its viewers to be literal and stick to matters of fact. One cannot stand in front of *Two Young Peasant Women* very long without wondering what the protagonists are (really) talking about, and how much more work they are likely to do before turning in. Answering the latter question would be easier if the picture gave a clue – of costume, maybe, or physiognomy – to the two women's relation to the means of production. Are they day laborers, or servants living in a household, or members of the family? How hard is the work they are taking a break from? Who is the cider and cheap wine for? Is it for sale or use? How

31 Pissarro: Detail of fig. 20

strong are the women? How healthy? Are they married or single? "The body's worth more than the dowry," as the saying had it. "*Fille jolie, miroir de fou.*"[29]

Idleness is ultimately a political matter. Pastoral is a dream of time – of leisure sewn into exertion, snatched from it easily, threaded through the rhythms of labor and insinuating other tempos and imperatives into the working day. I did say a dream.

> They are going to take the fields and harvests from you, they will take your very self from you, they will tie you to some machine of iron, smoking and strident, and, surrounded by coalsmoke, you will have to put your hand to a piston ten or twelve thousand times a day. That is what they will call agriculture. And don't expect to make love then when your heart tells you to take a woman; don't turn your head towards the young girl passing by: the foreman won't have you cheating the boss of his work . . .
>
> Then, there will be no women and children coming to interrupt toil with a kiss or caress. The workers will be drawn up in squadrons, with sergeants and captains and the inevitable informer . . .

These words were written by one of Pissarro's anarchist friends, Élisée Reclus, in a little pamphlet often reprinted in the 1890s, *À Mon frère, le paysan*.[30] I think that some such scheme of values, and maybe even some such foreboding of the century to come – of course neither Reclus nor Pissarro could imagine the true horrors of agribusiness – lay at the root of *Two Young Peasant Women*, and made its dreamworld worth realizing.

"Pastoral" is a hard word. I mean this chapter to be about the nature and grounds of a certain imaginative sympathy, on the part of a modernist artist, for "We Field-Women"; and about the pressure that sympathy put on the artist's technical assumptions. Inevitably I shall talk a lot about the limitations of the sympathy, and the amount of conventionality and evasion bound up in it. The "laughing meads" and the "love too rash," etc. But I hope to steer clear of the kind of academicism that thinks that once one has pointed out the exclusions and conventions, and invoked the horror or loss the picture does not show, one has solved the problem of sympathy altogether. It is shown to be a sham.

There is no middle road here. The sympathy is utterly exterior – there is never a mention in Pissarro's letters of harvests or prices or particular peasants living across the road – but in *Two Young Peasant Women* I believe it is real. Or as real as we shall get. That is, as much of a picture of a past way of life, and of why that way of life might be valued, as we are ever likely to be presented with. I think we should look at Pissarro's painting with two kinds of testimony in mind. Firstly, the word of mouth of Leonard Thompson, farm-laborer in a landscape not unlike the Eragny valley (and not far away), recalling very much the same time – starting from a memory of going off to enlist in the First World War. (Peasants as cannon-fodder, we shall see, are on governments' minds in the 1890s.)

> We walked to Ipswich and got the train to Colchester. We were soaked to the skin but very happy . . . In my four months' training with the regiment I put on nearly a stone in weight and got a bit taller. They said it was the food but it was really because for the first time in my life there had been no strenuous work. I want to say this simply as a fact, that village people in Suffolk in my day were worked to death. It literally happened. It is not a figure of speech. I was worked mercilessly. I am not complaining about it. It is what happened to me. We were all delighted when war broke out on August 4th.[31]

Then this, from Wordsworth's Preface to the *Lyrical Ballads*.

> Low and rustic life was generally chosen [he means in the poems that follow] because in that situation the essential passions of the heart find a better soil in which they can attain their maturity, are less under restraint, and speak a plainer and more emphatic language; because in that situation our elementary feelings exist in a state of greater simplicity and consequently may be more accurately contemplated and more forcibly communicated; because the manners of rural life germinate from those elementary feelings; and from the necessary character of rural occupations are more easily comprehended; and are more durable; and lastly, because in that situation the passions of men are incorporated with the beautiful and permanent forms of nature.[32]

I know this conjunction of texts is intolerable. "The necessary character of rural occupations . . ." "It is not a figure of speech . . ." And the last thing I invite the reader to do, or think Pissarro ever did, is to square the circle of fact and value implied here. The facts are horrible, and the values based in wilful ignorance of them; but that does not mean the values are bogus. Leonard Thompson can be right, and Wordsworth (and Pissarro) can be right that "in that situation the essential passions of the heart find a better soil in which they can attain their maturity, are less under restraint, and speak a plainer and more emphatic language." Or perhaps what is ultimately at stake is that there could be (and can be) no picture of the qualities valued in Wordsworth's phrases – passion, maturity, plainness, emphasis, unrestraint – without a vision of them inhering in peasant life. It hardly needs saying that the qualities are those modernism wished for itself.

So peasant life was a screen, then, on which modernism projected its technical and expressive wishes? Well, yes. But this does not mean the screen was empty, or the projections made out of nothing. There was a form of life still actually existing in the nineteenth century (I know the word "peasant" sums it up too neatly) that stood in the way of modernity, and resisted the disenchantment of the world. Modernist values partly depended on an image of that life and its characteristic qualities. No doubt in the imaging process the qualities were idealized, or prettified, or sentimentalized. But those words are not final pejoratives. They may only describe the agony – the inevitable ruthlessness – involved in keeping a dream of humanity alive.

The year 1891, to which *Two Young Peasant Women* belongs profoundly, was a fateful time for French painting as a whole. Pissarro certainly thought so, and reacted to what took place with uncharacteristic venom. I think he sensed (as it turned out, rightly) that one era of modernism was coming to an end, and the first features of another appearing. Idealisms of various kinds were on the offensive, and materialism in retreat. Maybe Pissarro even knew in his bones (again, rightly) that the new forms were here to stay. If so, that only raised the stakes of his 1892 retrospective, and of *Two Young Peasant Women* in particular. It was not that Pissarro expected a single exhibition or painting to change the course of history. His experience of the market over the previous five years had been a crash course in artistic realism. But he was nothing if not stubborn. He intended his exhibition to show what the ambitions of previous modernism had really been (as usual the transmutation of the modernist field was accompanied by all kinds of cynical stupidities about the displaced Impressionism, "Naturalism," "positivism," and so on), and his new work was meant to take up certain features of recent art and theory, and put them to proper use. He looked at 1891 sometimes with horror, but did not intend to sulk in his tent.

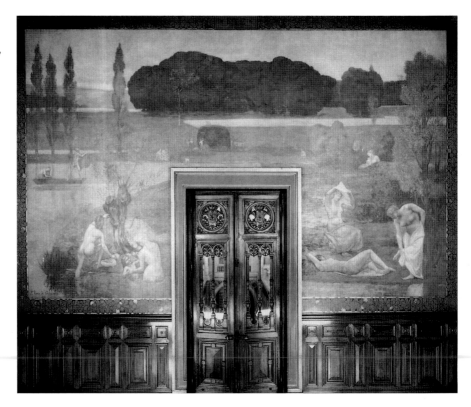

Even Symbolism, he thought, might be reclaimable. He knew that for every
young neo-Catholic claiming the name there was an anarchist just as convinced
of the necessity of a new (hieratic) sign language. Maybe Sign and Nature would
turn out not to be strict contraries. Maybe the painting that visual art might
now begin from was Puvis's *Summer* (fig. 32), not Gauguin's *Vision after the
Sermon* (fig. 33). Or Seurat's *Chahut* (fig. 35), not Maurice Denis's *Mystère
Catholique* (fig. 34). These were the pictures and arguments of the year.

1891 was thick with art events – some carefully plotted, others coming out of
the blue. On 1 April Gauguin set sail for Tahiti, after some weeks of publicity
meant to raise money for his family and make the grounds of his abandoning
the West crystal clear. (Pissarro did his bit to recruit Mirbeau to the publicity
campaign, but that did not stop him snarling at the farewell's general tawdri-
ness. Abandon the West, indeed! "He is going to Tahiti, but on a mission from
the government obtained via Renan *fils*."[33]) The paintings of Vincent van Gogh,
who had committed suicide the previous July, were shown to the public,
essentially for the first time, in small retrospectives in Brussels in February and
in Paris in March. The showing in Brussels was part of the yearly gathering of
the Belgian avant garde, the so-called Twenty. (Seurat's *Chahut* hung in a place
of honor at the same exhibit.) The poet Émile Verhaeren wrote beautifully
about van Gogh on this occasion, still struggling to make up his mind about
him.[34] Pissarro got wind of these things even in Eragny: "It seems that in
Brussels it's Gauguin and van Gogh who are winners this year. Lots of discus-
sion in the press, naturally."[35] In Paris van Gogh's paintings took up a room at
the Salon des Indépendants, the main avant-garde event of the spring. Mirbeau
celebrated them, without reserve, in a front-page article for *L'Écho de Paris*.[36]

Maurice Denis showed a version of his *Mystère Catholique* at the
Indépendants. Fénéon appeared at the same venue, holding a Symbolist, Oscar-

Wilde-type lily in a deliberately *outré* portrait by Paul Signac, complete with cod-theoretical title, *Against the enamel of a background rhythmic with intervals and angles, with tones and tints* (*Sur l'émail d'un fond rythmique de mesures et d'angles, de tons et teintes*). More or less everyone – certainly including Pissarro – thought picture and title equally tiresome. Seurat sent his latest big painting, *Circus* (fig. 36), to the show, perhaps intending to work its brilliant schematizations a little further at some later date. (Or perhaps not. One of the many distinctions Seurat's painting had put in question over the previous years was that between "painting" and "schema.") A week after the

33 Paul Gauguin: *Vision after the Sermon*, oil on canvas, 73 × 92, 1888 (National Gallery of Scotland, Edinburgh)

34 Maurice Denis: *Mystère Catholique*, oil on canvas, 51 × 77, 1890 (Private collection)

35 Georges Seurat: *Chahut*, oil on canvas, 171.5 × 140.5, 1890 (Collection Kröller-Müller Museum, Otterlo)

36 Georges Seurat: *Circus*, oil on canvas, 186.2 × 151, 1891 (Musée d'Orsay, Paris)

Indépendants opened, on 29 March, Seurat died suddenly of diphtheria at the age of 31. "I believe you are right," wrote Pissarro, just back from the dismal funeral, to his son Lucien, "pointillism is finished"; and then the characteristic proviso, "but I think other consequences will flow from it which will be of great import for art later on."[37] Lucien was not the last to wonder if Seurat's way of doing things could survive him. There were obituaries, retrospectives in Brussels and Paris, melancholy farewells from Verhaeren and Gustave Kahn. The proud word "neo" had a bitter ring.

This was also a moment in which older reputations were being remade. In May, Monet had a show at Durand-Ruel's of fifteen pictures of *Haystacks*, seen in different seasons and conditions of light (figs. 57 and 58). Rumor had it, said Pissarro, that they were all sold before the show opened, mostly to Americans. Cézanne was becoming more and more a mysterious touchstone for the new generation of painters. He had shown with the Twenty the year before. In April 1891 an issue of *Les Hommes d'aujourd'hui* was devoted to him: not that this meant he had arrived as a Third Republic celebrity (the series' heroes were a select avant-garde bunch), but nonetheless the issue put an end to ten years' press silence. Verhaeren in April, trying to get a handle on van Gogh, risked calling him a follower of Cézanne.[38] Followers did exist. By April 1892 the young writer Georges Lecomte, surveying "Contemporary Art" in *La Revue indépendante*, could be found fighting a rearguard action against the Symbolists' appropriation, and strong misreading, of Cézanne's work. He had no doubt both were widespread:

> Under the pretext of synthesis and decoration, they cover their canvases with flat colors which in no way reconstitute the luminous limpidities of the atmosphere, and give no sense of depth, or aerial perspective, or things belonging in space . . . The protagonists of this somewhat disconcerting form of art claim they derive from the synthetic, expressive interpretations of M. Paul Cézanne . . .
>
> The constant invocation of this tutelary name makes us suspect that what appeals to the new painters of ideas [*les peintres idéistes*] in Cézanne's work is not those canvases that are beautiful by reason of their logical ordering and sane harmony of tone, . . . but rather those incomplete compositions, which everyone agrees are inferior (Cézanne himself concurring) as a result of their unbalanced arrangement and a color that is truly too confused. Already, in the heroic age of naturalism, there were those who took pleasure in exalting the bizarrerie, the fortuitous construction, of certain of the painter's canvases. In other words they admired, without meaning to, one of the few deficiencies in his talent. Nowadays, from a different point of view, it is imperfections of color that are admired . . . What ought to be salvaged from Cézanne's sincere and simplifying art is the way he synthesizes line and tone for the sake of ornament, his respect for precise values, and his characteristic drawing.[39]

This has its own kind of tendentiousness, but at least it is genuinely struggling to bring a difficult object into focus. It may be prim, but it is not formulaic. As such it is considerably better criticism than Cézanne was to receive for years to come; perhaps because Lecomte could sense already in 1891 how much was at stake for modernism's future in getting Cézanne right. And how fierce would be the battle of interpretations.

The battle did not leave many traces this early in the written record: Lecomte's paragraphs are precocious. But clearly that phrase, "la constante invocation de ce nom tutélaire," is heartfelt. It registers the talk of studios and cafés. If we want an image to go with it, Paul Sérusier's *Dish with Apples* (fig. 37), certainly painted around this time, will do – except that its Cézannism

is more serious and hardworking than Lecomte lets on. But all Cézanne's worshipers were serious. They were horribly sure, as Sérusier was, of what their idol had to give.

Lecomte was a recent acquaintance of Pissarro's, recommended to him by Fénéon. He was a writer, an anarchist, a Symbolist fellow-traveller, and was in the end selected to write the catalogue essay for Pissarro's 1892 show.[40] He can stand very well for the fine line many artists and writers were trying to tread in 1891 between Symbolism and mystagogy. More than one commentator on the catalogue in 1892 thought the line in Lecomte's prose too fine to detect. "Dans un langage symbolico-décadent" was a typical jab.[41] Clearly conversations with Pissarro were at the back of Lecomte's grappling with the Cézanne phenomenon: the reference back to the heroic age of naturalism seems like a disguised (half-ironic) quote. Pissarro had fumed at the lies and misunderstandings infesting the life of Cézanne in *Les Hommes d'aujourd'hui* the previous April – all the more so because it was written by someone from Gauguin's camp. "The poor fool reckons Cézanne was at one time under *Monet*'s influence ... Beat that!"[42] He wanted the record set straight.

He wanted the full complexity of the balance of qualities in Cézanne recognized – between peculiar "synthesis" and respect for visual facts, between ornament and awkwardness. Because this was the balance he and Cézanne had worked for together in the 1870s, and that he now intended to strike again.

I do not want to give the impression that the group of artists called Symbolist in 1891 was coherent, or had a shared sense of what the word applied to them might mean. The label in any case did not long survive the year. Still less was it clear at the time which individuals, and which elements of their practice, would turn out to be crucial to modernism after 1900. Who could have predicted that Vuillard's tiny pictures on cardboard, getting their first showing at just this moment – *Lady of Fashion* (fig. 38) is a brilliant example, measuring 11 by 6 inches – would point the way to Matisse? Or that the painter of *Dusk* (fig. 39) – a bigger, more predictable production, wearing its "decorativeness" on its sleeve (of course it attracted attention at the Indépendants[43]) – would, by sheer persistence, make his whimsical version of Utamaro a cornerstone of twentieth-century art?

38 Edouard Vuillard:
Lady of Fashion, oil on
cardboard, 28.4 × 15.3,
ca. 1891–92 (Private
collection)

Clues to the future were, as usual, fragmentary. Nonetheless it is important that Vuillard and Bonnard emerged from the matrix of 1891, and that the term then used to describe them – as well as Denis, and Sérusier, and Gauguin, and van Gogh – was Symbolist. At least the word directed viewers (including Pissarro) to the essential issue now at stake in painting, which was the nature and purpose of the pictorial sign, and especially its relation to the material world.

Art critics who tried to deal with these issues explicitly at the time did not do a good job. They had not read their Hegel and Mallarmé, or not read them well. Therefore the world tended to polarize into Matter and Idea, or Object and Meaning, or some such clunking dualism from which the critic picked his pole of choice. There was a typical knockabout exchange on these matters in April between Pissarro and a young writer called Albert Aurier – Pissarro was responding to an article in *Mercure de France* with the headline title, "Le Symbolisme en Peinture: Paul Gauguin" – in which Aurier was accused, on the whole fairly, of reducing visual art to a matter of ideas "indicated by a few signs."[44] Pissarro thought that doing so evaded the issue of what then gave the visual signs their specific consistency or effectiveness – what made some indications better than others. And he cast about, blustering, for an answer, running through his preferred list of terms: "drawing," "harmony," "sensation." Look at the Japanese, he says: the point is that with them "signs have the stuff of

39 Pierre Bonnard: *Dusk*, oil on canvas, 130 × 162.5, 1892 (Musée d'Orsay, Paris)

nature in them [*les signes sont rudement nature*], but there you are, they are not Catholic, and Gauguin is."

This will not do as cultural theory, but at least the words Pissarro came up with in April point roughly in the right direction. "Sensation" in particular – which is a concept left over, I am sure, from long hours of discussion with Cézanne in the 1870s – is Pissarro's way of indicating what for him is the ultimate mystery (and motor) of signification: the way in which the raw contact of sensorium and object is always already inflected by a unique totalizing power, the one we call individuality, which is *there in the perception* and therefore potentially also in the means of registering it. That is how "signs having the stuff of nature in them" is to be understood, I think: not as crude transparency of sign to world, but as signs necessarily participating in the work of shaping the world and making it "mine." We are close to the root of Pissarro's anarchism here, and to his view of what made painting truly difficult. Signs could *admit* to their own inimitable ordering power – their belonging to a moment at which object and subject are still (always) being constituted. But such an admission had to be won on the other side of habit and knowledge and practical consciousness. It was only by utter immersion in painting, or in some comparable mere material practice, that the true structure of one's "sensation" – its uniqueness and immediacy, its folding of parts into wholes – would be made available at all. And even within the practice, most everything militated against this retrieval. Every improvisation had the potential of becoming another dead trick. Every act of submission to one's experience could turn into a system. Had that not proved true of the *point*?

Much of this is tortuous, I know. I think it represents the basic pattern of assumption underlying Pissarro's practice, and his constant stabs at aesthetic judgement in the letters; but of course he recoiled in horror from invitations to put his theory into words. His letters, especially to Lucien, take a world of shared meaning for granted.

It is enough for our purposes to point to the special nature of 1891. His letters that year are more specifically political, and more aesthetically embattled and argumentative, than at any other time in Pissarro's career. Here, for instance, is how the April explosion against Albert Aurier continues, once Pissarro has Gauguin, and Gauguin's Catholicism, in his sights. (Aurier's article had centered on Gauguin's *Vision after the Sermon*, which was a picture Pissarro knew well and particularly loathed. It was, after all, a picture of peasants.)

> I do not hold his vermilion background against Gauguin, nor his two wrestling warriors nor his Breton peasant women on the picture plane, what I hold against him is that they were lifted from the Japanese and the Byzantine painters and the rest. I hold it against him that he failed to apply his synthesis to our modern philosophy, which is absolutely social, anti-authoritarian and anti-mystical. That's how serious the question is. It is a turn to the past. Gauguin is no visionary, he is a trickster who has sensed that the bourgeoisie is in full retreat [*un malin qui a senti un retour rétrograde de la bourgeoisie en arrière*], as a result of the great ideas of solidarity springing up among the people – an idea that is still not conscious of itself, but one that will bear fruit, the only legitimate one! – The symbolists are in the same boat! What do you think? That's why we should be fighting them like the plague!

Aspects of this are local and personal. Pissarro was uneasily aware that Gauguin had once been his protégé and collaborator, and partly the anathemas of 1891 are ways of rewriting that recent past. The one-man show which Pissarro had put up only a year before at Boussod and Valadon, organized by van Gogh's brother, had ceramics by Gauguin arranged next to Pissarro's paintings – even

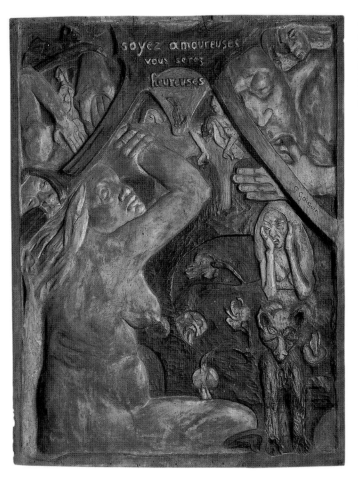

40 Paul Gauguin: *Soyez amoureuses vous serez heureuses*, colored wood, 95 × 73, 1889 (Courtesy, Museum of Fine Arts, Boston, Arthur Tracy Cabot Fund)

Gauguin's ne plus ultra relief in colored wood, *Soyez amoureuses vous serez heureuses* (fig. 40).[45] At that point, apparently, no bourgeois sleight of hand had been in evidence.

Equally telltale is the question-form of Pissarro's last sentence but one. It is addressed to Lucien, and by no means sure of his response. Lucien was in London, making his way as an artist in the world of Walter Crane (fig. 53) and *The Hobby Horse*. More than once father and son, whose correspondence in 1891 is partly a testing of oedipal limits, agree to differ over the work Lucien is doing – especially the prints he sent his father through the mail. Here, for example, is Lucien replying to one of his father's broadsides in July:

A sentimental tendency, eh! Damn it, I had a feeling that that was what must have really shocked you in my woodcut [fig. 41], which in general is as well drawn as the others. – And it is no accident if it comes out that way. I wanted to put a little more idea into the thing than I normally do . . .

As for the thinking of those who discuss the future of art [Lucien has in mind the respondents to a newspaper questionnaire which Pissarro *père* had sent him], no doubt they mean that the immediate future – that is, tomorrow – will be mystical, and perhaps they are right, since the young of all countries are tending toward this mysticism. But here, socialist artists and even Anarchists, like Crane, aren't they mystics too? For Crane is very advanced in his ideas, *in theory*. I can't make head or tail of all this, but what I do know is that we have our work cut out operating in such a milieu – and yet I find the Anarchist idea makes great strides in artists' thinking.[46]

41 Lucien Pissarro:
Figure with a Crown,
wood engraving, 1891
(Ashmolean Museum,
Oxford)

To which Camille replies:

> Yes, my dear Lucien, I saw straightaway the sentimental and *Christian*
> tendency in your *Figure with a Crown*. It is not your drawing, in fact, it is the
> character of the thing, the attitude, the expression and the general physiog-
> nomy . . . As for ideas, my dear fellow, there are plenty of those in your other
> woodcuts, only they are your own ideas, you the anarchist, you who love
> nature and leave great art till a better time comes, when man, having a
> different way of life, will have a different way of understanding the beautiful.
> In short, sentimentalism is a Gauguin-type tendency, not as regards technique
> but ideas . . . Proudhon in *Justice in the Revolution* says that Love of the land
> is bound to the *Revolution*, and therefore to the artistic ideal. – That is why
> we do not like Crane, he is not aware of what he ought to love best in art.
> Contradiction! . . .[47]

Pissarro's annoyance is local and personal, as I say, but shot through with a
sense that his own (and his son's) confusions are linked to those of bourgeois
culture at large – bourgeois culture, they thought, at a peculiar turning point. It
was because Pissarro saw new forms of idealism rampant in art all round him
that his anarchist allegiances sharpened – particularly because many of the new
idealists proclaimed the same allegiance. It was because the Third Republic
stood revealed at last (so he thought) in its true colors, and therefore an
anarchist politics seemed on the agenda, that differences over the words "sign,"
"idea," and "synthesis" had to be fought out – spelt out – in works like *Two
Young Peasant Women*.

And do not take Lucien just to be keeping up filial appearances while all the while slipping into the orbit of *The Yellow Book*. There is some of that going on; but he too was genuinely conflicted. For every *Figure with a Crown* in 1891 there was a *Capital and Charity* (fig. 42) – one of a series of lithographs Lucien did through the year, the best of them crude and unflinching, for the anarchist weekly *Le Père Peinard*. "We saw your drawing in *Père Peinard*," says father to son in March. "It is really original and full of character, the naked figure is really fine, full of terrible sensation."[48] *D'une sensation terrible*. This is Pissarro's ultimate term of praise.

Sometimes in an epoch of transition, when contrary notions of art – almost contrary notions of the category – are in contention, a single artist emerges above the fray. Everyone lays claim to him or her, for extraordinarily different reasons. He or she comes to stand for the possibility of art continuing in vital contact with its past, but also for the violence that has to be done to that past if it is to be made usable; he or she is a left-over, a simpleton, dreaming of the Golden Age in the midst of the Third Republic's vulgarities; and yet also a sophisticate, an Alexandrian, playing with his or her belatedness. The art that results from this is above all productive of interpretations, and imitations of a brilliant (forced) kind. The more forced, the more productive. Feed on this artist's naivety, seems to be the watchword, celebrate this artist's bleeding white of his or her "sources," and painting may still be able to declare its end game a new start.

In 1891 the artist was Puvis de Chavannes. He was as dear to Seurat and Signac as to the Minister of Public Instruction. The Symbolists worshiped him, the neos worshiped him, he was given the best walls of the Republic to cover. His name was a catch-all simile for everything grand and improbable that art could nudge into life. Even an anarchist booklet like Kropotkin's *The Conquest of Bread* was a "grand décor poétique, à la Puvis."[49]

Somewhere at the center of Puvis's appeal in the 1890s was his vision of the

42 Lucien Pissarro: *Capital and Charity*, lithograph, 1891 (Bibliothèque Nationale de France, Paris)

French countryside – all the more so, it seems, for its being incidental to the allegorical action presented up front, close to the picture plane. Reactionary agrarians like Count Melchior de Vogüé, for example, dreamed in front of the great mural called *Summer* (fig. 32), which Puvis showed first in 1891, and were confident that the painting could point a way forward beyond the class struggle. It was important to de Vogüé, as it would be to Pissarro, that *Summer* showed people taking their ease at harvest-time. The hard work round the hayrick can be glimpsed in mid-distance.

> This work is great, because it speaks from on high to the crowd, as did artists' creations in days gone by. Here is democratic painting, if the word means anything. All those workers, those children of the fields swallowed by the factories of Paris – if by chance they should make their way through this room, I believe they would stop in front of *Summer*, as they stop at the sound of a country song; their lungs would take in a breath of native air; they would find here what they go looking for on Sundays outside the city walls, a brief communication with the earth from which they were uprooted . . .
>
> Thanks to M. Puvis de Chavannes, the wild and the poor have forests growing in Paris, and land of their own, where they can go breathe, dream, pray, make contact with Nature again, and as a result take proper stock of transitory things. Time spent in front of *Summer* each morning is the best possible cordial to accustom life again to submission.[50]

Naturally a painter of Puvis's stature showed in the official Salon. That is where de Vogüé saw *Summer* in the first place, before it was installed at the Hôtel de Ville. But he also showed at Durand-Ruel's. A smaller replica of *Summer* was on display there in November and December 1891, and maybe earlier.[51] At one point a group of Pissarros hung in the same room. It seems unlikely Pissarro did not see and study the painting – especially as we know he admired Puvis as much as everyone else. Puvis was the exception that proved the rule. "Alma Tadema . . . wanted to do the Greeks over again. Alas! it cannot be done; remember that we only accept Puvis de Chavannes because he clothes the antique with a drawing full of sensation, *without affectation*, without that prettiness which is so terrible for art."[52]

We cannot be sure that Pissarro saw *Summer* full-size. He said to Lucien in May that he planned to.[53] But whether full-size or in miniature, I think aspects of Puvis's drawing in *Summer* – or aspects of the women in Puvis's earlier *Sacred Wood* (fig. 43), done for the stairway at Lyons, which we know Pissarro revered – found their way into what he was doing at the same time. Puvis's drawing is full of sensation. The mark of that quality, as many critics (including Mirbeau[54]) said, was its very abbreviation and awkwardness – its obviously contrived appearance. The cutout clarity of the figures, and yet their heaviness, their woodenness: this was what made Puvis so touching. "I have condensed, amalgamated, compressed." Show me a solid body coming to an edge as sharp as an Ingres and as uncharming as a Courbet! That is a body I can use, says Pissarro.

"What ought to be salvaged from Cézanne," says Lecomte, "is the way he synthesizes line and tone for the sake of ornament, his respect for precise values, and his characteristic drawing." Compare the same writer in the 1892 catalogue, praising Pissarro's work of elimination:

> For a long time now M. Pissarro has stopped working exclusively in front of nature, and putting down its momentary and accessory details. Having fixed in watercolor or pastel the physiognomy of a site, the look of a peasant or an

43 Pierre Puvis de Chavannes: *Sacred Wood*, oil on canvas affixed to wall, 460 × 1,040, 1884 (Musée des Beaux-Arts, Lyons)

animal, he applies himself to the job of composing, far from the motif, in the course of which the relative and superfluous dissipate: only essential aspects remain, those that contribute to the meaning and decorative ensemble of the work . . .

The concern for ornament, already palpable in the painter's early work, is clearer still in his recent canvases. And yet his studies stay eloquently descriptive. Style does not exclude truth. His countryfolk have the gesticulations characteristic of their functions, his cows circulate nonchalantly through rows of willows and clearings; . . . But the rumps of animals, the contours of the land, the volutes of branches, the arabesques of foliage, the attitudes of people, combine into ensembles of line which, complementing as they do the decorative harmony of color, make each picture a work of rare ornamental beauty.[55]

Function, gesticulation, ornament. Up to now in this chapter I have emphasized surface and light in describing *Two Young Peasant Women*, and I do think these qualities are preeminent. But of course what marks off the painting from most others Pissarro did is the place it gives to drawing. Only in *Cowherd* (fig. 25) are edges more wilful and ornate. *Cowherd* is interesting because it shows how fine the line was, at this point in Pissarro's career, between a drawing that condensed and amalgamated while still having about it the unpredictability of things seen – still having its signs be *rudement nature* – and one that was frankly puppeteering. Even in *Two Young Peasant Women* there are moments when Fénéon's fierce word "toy" seems right. Certainly Fénéon's syntax – its stops and starts and self-conscious doublings-back – does better at conjuring up the stresses of Pissarro's synthesis than the glib build-up of phrases in Lecomte's last sentence.

Drawing is critical because parts of bodies are the main subject. The figures are larger, as I said before, and larger in relation to the pictorial field, than any Pissarro had done. The nearest precedents in his work are *The Apple Eaters* of 1886 (fig. 44), at 50 by 50 inches his biggest figure painting ever, and *Woman Breaking Wood* of 1890, of roughly the same size. In neither do foreground figures loom quite so close. We know from letters that both these pictures were

Camille Pissarro:
The Apple Eaters, oil on
canvas, 128 × 128, 1886
(Ohara Museum of Art,
Kurashiki)

on Pissarro's mind in November, ostensibly because he had the chance of selling a big painting to the state. These two were still in Boussod and Valadon's hands, and maybe they would do. Whether he took a look at them again in Paris is not clear. He certainly planned to.[56] But in fact or memory, they fed into his work in the late fall. They were relevant points of comparison for what he was now trying to do. That was specially true of the woman at left in *The Apple Eaters*, chomping her fruit in the shade.

One immediate difference between the previous big pictures and *Two Young Peasant Women* is that in the latter the two figures are incomplete. This is a key, and uncharacteristic, decision. Peasant figures in Pissarro, except for occasional portraits, are established foursquare within the picture frame, making their separate claim on the rectangle. Even *Cowherd* is allowed to.

The decision to do the opposite in *Two Young Peasant Women* is partly the reason, I am sure, that the picture in general seems unresolved. At this level it

45 Jules Breton: *June*, oil on canvas, 77.5 × 123.2, 1892 (Arnot Art Museum, Gift of Mrs. Forsythe Wickes in memory of her mother, Fanny Arnot Haven and her aunt, Marianna Arnot Ogden, 1938)

is meant to. Incompleteness has to do above all with a fiction of closeness, of conversation overheard. Closeness but not exactly intimacy. Overhearing but not overseeing. (It is a nineteenth-century question – an Élisée-Reclus-type question – whether every kind of looking at the lower classes has to be intrusive and disciplinary.) The two women are meant to be monumental, but not overbearing or portentous. Portentousness is the enemy. "Stiffness and solemnity" (above all the latter) are the two worst qualities Pissarro thinks his son may be catching in 1891 from his English surroundings.[57] Think of the picture, then, in relation to Millet's *Angelus* (fig. 27), or better still, to an exact contemporary like Jules Breton's *June* (fig. 45), shown in the Salon of 1892. These are the pictures *Two Young Peasant Women* is painted against. The two figures' incompleteness does not flatten or derealize them. They are strongly enough modeled to occupy space; a space which belongs to them (the metaphors here are bound to be a bit small-proprietorial) and to which as viewers we have partly gained access; but only partly, that is the point – so that we end up getting a sense of figures and relations, but only a sense. We could worry endlessly about the peasants' actual poses, and the distance between them, and where the ground plane is; but of course the painting does not offer us sufficient clues to answer these kinds of questions, and does not mean to. It means us to be in limbo. We have come in close – too close to get the whole picture.

I promised to talk in more detail about relative height and placement in *Two Young Peasant Women*, and the last few sentences are not meant as a way of wriggling out of the commitment. Just a warning that the talk will not get us very far. Take the squatting woman, for example (fig. 46). *Is* she squatting? Meaning what, precisely? Sitting on her heels, or her hams, or her haunches? Sitting cross-legged or with knees splayed wide? Maybe the best-case interpretation of her knees and arms is that the arm is resting on a knee we are not shown, just below and in front of the picture plane; and the knee we can see is a farther one, bearing no weight. (You will notice a glimpse of the woman's left hand, appearing under her elbow.) But then questions multiply. How on earth can the knee be spreading this far to the right? What is it we are looking at through the crook of the woman's arm? It appears to be roughly the color of her skirt. Yet it is painted partly with longer, lighter, vertical strokes – there even

seems to be an orange – which might almost be the color and fall of the woman's hair. But surely her hair is tied in a bun?

I am not saying these local discrepancies eat away at our acceptance of the figure as a whole. At least, not mine. I think the squatting figure is a triumph of drawing, and the improbabilities easily subsumed in the overall shape. As a shape of stolid revery it has never been bettered. The face and fist are wonderful – clumsy, elliptical, aereated by light. The touches of pure blue line-drawing in between the fingers are perfectly, naively calculated. The fist is as three-dimensional a piece of painting as Pissarro ever did – a figure of uprightness, containment, firm support, like a Romanesque capital. How imperturbably it answers the hard slashing edge of the same woman's back and shoulders, squared and silhouetted against the orchard bank! How approximate the fingers of her other hand in comparison, or the hands of the woman kneeling opposite!

This is where the aesthetic (as opposed to anatomical) difficulties begin, I think – once we look at the two figures comparatively, as answering and qualifying one another. Pissarro worked ferociously hard at the comparison; especially, by the looks of it, over the last few days of retouching in January. The green halos put in around the women's profiles, for instance, were meant to establish the silhouette of each face more strongly – by color contrast of green against blue-purple – and thereby have them speak to one another more decisively across the gap. It is the staging of the conversation (the picture seems to have been called *La Causette*, or *Chatting*, by the Pissarro family) that is crucial, and that I reckon does not ultimately come off.

Where do we begin here? Maybe with the kneeling woman's face. "Je sais bien que ma *Paysanne* est trop jolie . . ." The face consists, by Pissarro's standards, of an awful lot of decorative short cuts: a wafer-flat continuous tracing of pale orange to establish the bridge of the nose and nostril, straws of pure green to make the red of the lips fizz, touches of thick cream on the upper lip and chin. These are marvelous close to, for sheer naivety. It is as if Pissarro had been looking at his beloved Corot again – at Corot's figure pieces. Or even at Renoir. But I am not sure that in the end the devices make enough of a counterpoint to the shadowed profile of the woman on the ground. The face has to be delicate to the other one's massiveness, multipartite and faceted to its partner's muffled single sphere, green and red to her pink and blue. The headscarf sets the tone. It almost works. There are parts of the face that hold up at a distance – the green shadow around the eyesocket and under the jawline, the cast shadow from the scarf. But the whole thing strikes me as just a little too brittle, too determined to be winning. Not so much pretty as prettified. "Prettiness is a worse danger than the ugly or the grotesque [*Le joli est un danger pire que le laid et le grotesque*]!!"[58]

Maybe the problem is not prettiness in itself. Prettiness has to be admitted. Not to do so is not to admit the grounds – or one of the grounds – of one's interest in the subject of peasant women. (In the letter where Pissarro says his peasant women in general are too pretty, the whole thought is that they regularly start off that way, and only become *beautiful* – that is, part of the pictures' beauty – through repeated work.) The downtrodden field-women of Millet, or the Joan-of-Arcs-in-the-making of Jules Breton, are far deadlier fictions of labor and the female body than the one *Two Young Peasant Women* works to resuscitate. Anti-pastoral was by Pissarro's time (and long, long before) as much of a cliché as pastoral, and more smug in its Realist certainties.

So ultimately the issue with the kneeling woman is not her delicate face so much as the fit between face and body – particularly between face and arm. I am sure, once again, that the contrast here between massiveness and delicacy

was what Pissarro intended. But this time, it seems to me, anatomy really is an aesthetic problem. The arm and shoulder are straightforwardly bad. The kneeling woman is too much an impossible object, a compound of incompatible modes. One can almost sense Pissarro gathering up her skirts behind – the flounces look to have been added late – in a last attempt to pin her together onto the surface and give the upper body support. The skirt is a kind of cantilever. The contrivance seems desperate to me.

"Because in that situation the essential passions of the heart find a better soil in which they can attain their maturity . . . and consequently may be more accurately contemplated and more forcibly communicated." I am not suggesting that Pissarro's drawing simply fails to do either. Locally speaking, it has accuracy and force. But the to-and-fro of feeling between the picture's protagonists (that is, the indication of the overall play of their "essential passions") strikes me finally as lopsided. The squatting woman is a triumph – of placement, of controlled awkwardness of drawing, of tension between modelling and silhouette. She occupies her corner royally, leaning on the frame with solid certainty, spreading her body out and out across the surface – flat back, knife-edge shoulders, armor-plated biceps, infinitely capacious lap. The kneeling woman has to answer this anchored dreaming. For me she just fails to. Her hold on the lower-right corner is just a little too showy (the showmanship is too much of an add-on). Her upper body is like a collapsed, impalpable version of the one opposite. The eye moves from the laconic segment of fist under the squatting woman's elbow and picks up the false rhyme in the boneless hand on the other woman's knee. One understands that both hands are meant as no more than schematic shadows of the hands above, which Pissarro has painted in full. But here again one hand is a real invention and the other a place-marker.

The crouching woman is Gauguin revivified – I have a feeling the figure may even have begun as an answer to the peasant women at bottom left in *Vision after the Sermon* (fig. 33), though no doubt the dialogue was deeply repressed. I think that the way the two women respond to one another visually in the Pissarro has more to do with Puvis de Chavannes. And here the debt, or attempt at paraphrase, would have been conscious, I guess – in 1891, orthodox. We might enter into the equation another Puvis in Durand-Ruel's possession that year, the condensed version of an earlier mural Puvis called *The Shepherd's Song* (fig. 47). Notice the foreground figures in particular. The last thing I mean to imply is that Puvis's influence on Pissarro was all for the worse. The quality of stolid separateness to the figures in *Two Young Peasant Women* is one key to its power; and the quality derives from Puvis. (Or from Seurat seen through Puvis's eyes: Seurat understood, as he often was at the time, as a "Puvis modernisant" or "Puvis matérialiste."[59]) But it does seem to me that the Puvis quality is not wholly under control. It is something Pissarro is coming to terms with from the outside, in a sense for the first and last time. Something he has ideas about, but does not necessarily know very well. Whereas Gauguin! That knave's tricks he knew like the back of his hand! And in practice (as so often with modernism) it is the negative action that is most successful. Taking Gauguin's glib simplifications apart from the inside, wresting depth back out of his clipped, playing-card edges, showing his signs stirring clumsily into life – all of this worked marvelously, partly because arguing with Gauguin was arguing with oneself. With the point in one's past at which Gauguin had still been ally and collaborator.

47 Pierre Puvis de Chavannes: *The Shepherd's Song*, oil on canvas, 105 × 110, 1891 (The Metropolitan Museum of Art, New York, Rogers Fund, 1906)

Moments like this recur constantly within modernism. There is a famous one a decade or so later when Maurice Denis, in his role as critic, rounds on Matisse's *Luxe, Calme et volupté* (fig. 48) and calls it "the schema of a theory."[60] Of course it is easy to be dismissive of the charge. We could confront *Luxe, calme et volupté* with what Denis was doing in 1891 – *Easter Mystery* (fig. 50) is a fair example – and ask which painting is the more theory-driven. Or look at the kind of picture he had turned to by the time he picked his quarrel with Matisse – *Eurydice* (fig. 49) is dated 1906 – and wonder what he thought he had gained.

But what Denis went on to say about Matisse and the Fauves later in 1905, when he was confronted with *The Woman with the Hat* (fig. 51), was genuinely troubled and deeply aware of Matisse's gifts. Even Matisse's fiercest partisans admit that it is some of the best criticism he ever received – especially if we read it in the light of what followed, with *Bonheur de Vivre* or *Harmony in Red* in mind.

What one finds above all, particularly in Matisse, is artificiality; not literary artificiality, which follows from the search for expression of ideas; nor decorative artificiality, as the makers of Turkish and Persian carpets conceived it; no, something more abstract still; painting beyond every contingency [*la peinture hors de toute contingence*], painting in itself, the pure act of painting . . .

What you are doing, Matisse, is *dialectic*: you begin from the multiple and individual, and by *definition*, as the neo-Platonists would say, that is, by

48 Henri Matisse:
Luxe, Calme et volupté,
oil on canvas, 86 × 116,
1904 (Musée d'Orsay,
Paris)

49 Maurice Denis:
Eurydice, oil on canvas,
1906 (Private collection)

abstraction and generalization, you arrive at ideas, at pure Forms of paintings
[*des noumènes de tableaux*]. You are only happy when all the elements of
your work are intelligible to you. Nothing must remain of the conditional and
accidental in your universe: you strip it of everything that does not corre-
spond to the possibilities of expression provided by reason. As if you could,
inside your own artistic domain, escape from the sum of necessities that
always sets limits to what we experience! We know millions of facts, said
Taine, but by means of a hundred or so that we do not understand. You
should resign yourself to the fact that everything cannot be intelligible. Give
up the idea of rebuilding a new art by means of reason alone. Put your trust

in sensibility, in instinct, and accept, without too many scruples, much of the experience of the past.[61]

The reference back to Taine here is touching. These are nineteenth-century arguments; and indeed, in another sentence or two Denis is pointing specifically to precedents in 1891. "In the time of van Gogh," he says, "many researches of the same kind led to identical results." And he runs on to Puvis – to Puvis's "rigid awareness . . . of his own means" – making the inevitable comparison with Poussin, for whom nature and artifice (he says) were not yet at war.

You will notice it is always the same distinction being made, between schema and sensibility, or reason and contingency, or signs with and without the stuff of nature. And always the same anxiety over how to secure the difference, and whether the difference is real. Can Art still make the difference, if the culture at large cannot? To say that Denis is struggling with his own fears and deficiencies

50 Maurice Denis: *Easter Mystery*, oil on canvas, 104 × 102, 1891 (The Art Institute of Chicago, through prior acquistion of William Wood Prince)

51 Henri Matisse: *The Woman with the Hat*, oil on canvas, 81 × 65, 1905 (San Francisco Museum of Modern Art, Bequest of Elise S. Haas)

as an artist is very far from being a put-down. It is what makes him the voice of modernism's deepest unease.

Socialist culture in 1891 was, so it thought, quietly on the ascendant. Something of its range and ambition is suggested by the contents page of the January 1892 issue of *La Société nouvelle* (fig. 52), a journal edited in Paris and Brussels. The list of contributors – the particular conjunction of voices, their styles and fields of interest, and the places they occupy on or beyond the socialist spectrum – largely speaks for itself. Kropotkin and Nietzsche, Verhaeren and William Morris, Maurice Barrès and Gustave Kahn. *News from Nowhere*, arguments with Darwinism, Ibsen's *An Enemy of the People*, Hauptmann's *The Weavers*, anarchy in Spain, class struggles in Germany, Wagner as mirror of bourgeois society. "Wagner is *the modern artist par excellence*, the Cagliostro of modernity. In his art all that the modern world requires most urgently is mixed in the most seductive manner: the three great *stimulantia* of the exhausted – the *brutal*, the *artificial*, and the *innocent* (idiotic)."[62] (Nietzsche's *The Case of Wagner* had come out in German four years before. The two words "innocent (idiotic)" were certainly penned with Dostoevsky in mind, and specifically Dostoevsky's belief in the naivety and simple-heartedness of mankind. They are, in other words, Nietzsche's version of anti-pastoral.)

These are the lineaments of socialist culture as Pissarro understood them. (I have no proof that he subscribed to *La Société nouvelle* until two years later. He certainly shared the journal's main points of reference.) And I do not bring on

8ᵐᵉ ANNÉE LXXXV-LXXXVI JANV.-FÉV. 1892

La
Société Nouvelle
Revue internationale

Sommaire

PARIS BRUXELLES
H. LE SOUDIER BUREAUX :
174, Boulevard Saint-Germain. 32, rue de l'Industrie, 32

Paris. — Albert Savine, 12, rue des Pyramides.
1892

the journal's contents page simply expecting the reader to gawp in wonder. Obviously the thing is wonderful; equally obviously, it has its peculiarities and blank spots. In it capaciousness is hard to distinguish from eclecticism; intellectual firepower is combined with a deadly Romanticism of the future; an appetite for the findings of science is accompanied by a deathly silence about political tactics, or the intersection between cultural struggles and political ones. (There is, to be fair, a brief review of the German socialists' new Erfurt program, but no real engagement with its crucial – and in the long run, fatal – blueprint for Social Democracy.) The journal is fired by an accurate sense of what any culture, socialist or otherwise, had best feed on from the art and letters of its time, but also by what looks now to be a foolhardy confidence that the new modes of individualism were to be brought straightforwardly under socialism's wing. Not that Barrès and Nietzsche could be ignored – better by far a foolhardy inclusiveness than the philistinism and sectarianism that passed for knowledge on much of the Left – but socialism should have realized from the

start that sources like these were poisoned. (There was an idea abroad in the early 1890s that Nietzsche and all the other prophets of irrationalism could simply be plundered, and used for their hatred of positivism. The movement of the future would take care of their other, more deeply embedded, hatred of the masses. Something of this can be heard even in Lucien's arguments with his father. If only it had proved true.)

The lead item in *La Société nouvelle*, you will notice, is an essay by Kropotkin, in which he reviews Darwin's theory of evolution and puts his stress (not at all an "anti-Darwinian" one) on forms of collaboration and interdependence thrown up by natural selection. The essay eventually became a book, *Mutual Aid: A Factor of Evolution*. That Kropotkin (as well as the uprising at Jerez[63]) shows so prominently in *La Société nouvelle* brings up the question of anarchism's place within socialism in 1891, and Pissarro's understanding of both.

This is a complex issue.[64] There is, to be sure, a side of anarchism that figures, and wants to figure, as the Other to socialism, its exterminating angel. Nietzsche and anarchism have things in common. Socialism, from this point of view, is only the last and dreariest attempt at a rationalization of pity, born of bourgeois society's terminal decadence. It is slave-philosophy mutated from the religious to the bureaucratic mode. And no doubt this rhetoric appealed to some artists. Pissarro was not far wrong in suspecting, in 1891, that to the catalogue of mysticisms would soon be added the mysticism of revolt.

But to leave the question there would be to miss the point (and to collude in the Leninist history of the revolutionary movement – from which we still need to escape). Pissarro, after all, is mounting his criticism from an anarchist perspective. Anarchism for him had always been one facet of socialism – a set of issues and tactics that had crystallized out of the struggles within the working-class movement in the 1870s and early 1880s, in response to the freezing and splitting that followed the Commune. Pissarro, when we first come across him looking specifically for political bearings in 1883, was a subscriber to a paper called *Le Prolétaire* – run by an ex-anarchist called Paul Brousse, one of the prime movers of anarchy within the First International in the 1870s. In the early 1880s Brousse had broken with his anarchist friends, and began to preach a dour (but still quixotic) politics of class struggle, local engagement, step-by-step pressure on capitalism from within. The full title of the paper when Pissarro first mentions reading it was *Le Prolétaire, organe officiel du Parti Ouvrier Socialiste Révolutionnaire Français*.[65]

Some time in the mid- or late 1880s (we cannot be sure when[66]) Pissarro let his subscription to Brousse's newspaper lapse and began reading the one Kropotkin had founded, *La Révolte*. His letters are largely silent about politics at this time – I have the impression that the sheer struggle for market survival left no time, or confidence, for opinions – but giving up Brousse for Kropotkin is not to be understood as much of a change of spots. It meant choosing one variety of socialism over another.

Even the notion of anarchism as something specific – a separate and coherent form of socialist politics – was brand-new, and by no means clear to everyone. The struggles within the International in the 1860s and 1870s had been rancorous, but a lot of the name-calling had been light on ideology, and certainly light on consistency. A "Marxist" was any friend of the man in question, whether he had read *Capital* or not. (And anyway Brousse and Kropotkin both took *Capital* as common ground. So it seems did Pissarro.) "Anarchist" was a useful synonym for troublemaker. It was only slowly, and with often mind-boggling changes of personnel, that certain questions elected themselves as the grounds on which "les anars" and "les autoritaires" would differ. No doubt by

1891 the questions were well rehearsed – they crop up in Pissarro's letters often with something of a ready-made air – but the idea that they constituted a discrete party identity was only ten years or so old. The identity was still being built.

At the heart of the matter was the question of the state – which straight away divided into questions of long-term philosophy and immediate tactics. It was one thing to recognize the present machinery of law and force as an instrument of class rule (this was the ABC of Marxism), and even to propose that one task of a future revolution would be to smash the machinery, as opposed to run it for the benefit of the proletariat. Marxists could agree to differ on such things. Where Marxists and anarchists fell to fighting was over how much of the present state apparatus should be attacked here and now, and with what sort of weapons. Anarchists were anti-militarists, working to subvert the loyalty of soldiers – that was why so many of them ended up in jail in 1891. They believed in confronting the police and the courts – in pushing new forms of working-class resistance and demonstration toward the breaking-point of class demand and state reply. Nightsticks and the rattle of carbines. In 1891 these matters turned on the attitude of socialists to the recent (and largely unplanned and unpredictable) movement to turn 1 May into a day of worldwide class solidarity and action in the streets. In France the May Day demonstrations, which had only begun in earnest the year before, were greeted by a fusillade in the mining town of Fourmies, near the Belgian border, killing ten people. There was a smaller, and seemingly insignificant, clash closer to home for Parisians, in the factory suburb of Clichy, between police and anarchists waving the red flag. In 1892 that clash would bear unexpected fruit. Much of the bitterness inside the socialist movement in the early 1890s derived from the question of May Day.[67] Pissarro is typical, writing to his niece on 5 May 1890:

> Well yes, things passed off peacefully in Paris. But the strikes are continuing, the socialist chiefs have done everything in their power to put a stop to the demonstrations, but the movement is under way, and you will see in due course that this eight-hour day, which is absolutely useless and will not give the working class a thing, will be the spark that will lead to one demand after another. The bourgeois will not have stolen it after all!!![68]

"It" in the last sentence means the movement in general, and "the bourgeois" are Jules Guesde, the Marxist leader, and the handful of socialists in the Chamber of Deputies.

Anarchists especially despised the efforts of Guesdists and Social Democrats to turn the events in the streets into votes. When Marx's son-in-law Paul Lafargue won the Fourmies seat in November 1891, at a by-election resulting from the massacre, anarchists accused him of building a career on corpses.[69] The Marxists in the meantime had spearheaded the exclusion of the anarchist group from the Congrès Socialiste International de Bruxelles in August. Guesde in particular was quoted as exulting in the break.[70] (He had been an anarchist himself in the 1870s, and was vigorous in apostasy.) *La Révolte* borrowed *Le Temps*'s verdict on the whole affair: "Ah! when the day comes that they will have destroyed the bourgeoisie, what fine bourgeois the socialists will make!"[71]

Behind this sad farrago, which any student of socialism will know by heart from other instances, lay real and intractable questions about what to do in the face of capitalist power. To what extent were the mass party system and the apparatus of public opinion, which had been so quickly assembled in mid-century to handle and channel the forces of universal suffrage, already firmly part of the state and therefore unregenerate? One deputy in 1891 quoted the May Day marchers in Geneva as chanting, "À bas la bourgeoisie! À bas la

presse!"[72] If electoral politics was self-defeating, what other kinds of politics were not? If the forms of working-class organization – the trade unions, the May Day committees, the local movements for the eight-hour day, and so on – were embryos of a different social organization to come, then was it not vital to struggle against centralization and bureaucracy inside each one of them, whatever the cost in terms of efficiency? The First International, so the anarchists thought, had been itself the form of freedom, the non-state growing within the state. It had been sabotaged. The point was to rebuild it piece by piece.

Anarchism was part of socialism. (In Cadiz, the anarchist newspaper was called *El Socialismo*.) That meant anarchists went on working and worrying at the problem of forging real, effective links with the working class. They knew their intransigence could easily become quietism. They knew that the question of whether the proletariat would choose, or be obliged, to accommodate with capitalism rather than try to defeat it was very much an open one. (One could say that the early 1890s are the last moment at which the working class's attitude to the emergent institutions of parliamentary democracy was still genuinely in doubt. The last moment when it still made sense to believe in an incipient rejection of the party system.[73]) In November in London Kropotkin organized a conference to discuss the outlines of anarchist tactics toward the labor movement.[74] In England especially, that question was on the agenda. The following summer the first nucleus of the future Labour Party – Keir Hardie, John Burns and Havelock Wilson – entered the House of Commons. The same Walter Crane whom Pissarro took as the image of artistic "contradiction" in July, lent his services to the cause (fig. 53).

Real, effective links . . . But of course anarchism was finally, or notoriously, distinctive for the presence in its ranks of those who believed that no such links existed, or could exist until the proletariat was shocked into life by acts of exemplary violence. *Propagande par le fait*. This is what politicians and journalists meant by anarchism in 1891. Any anarchist – certainly Pissarro – knew as much.

53 Walter Crane: *The Triumph of Labour*, wood engraving, 21.6 × 50.8, 1891 (Marx Memorial Library, London)

"Propaganda by the deed" was a proposal for socialist tactics which, like its main rivals, first came to self-consciousness in the 1870s. One could argue that both Marx's insistence on new forms of centralization and authority

within the International, and the idea of catalytic, foredoomed episodes of insurrection and revenge, were responses to the bleak years following the Commune. Either turn the International into a redoubt, ready to focus and armor the energies of the working class when they stirred again; or try to spark the energies into life, in hopes of a chain reaction that would outrun any party platform or central committee. There were plenty of arguments among anarchists about the particular occasions, forms and combinations such a tactic should take. No doubt violence would be useless unless it connected with other kinds of agitation and political work. But the tactic itself (the examples of Ireland and Russia kept recurring) was mostly accepted. "As for me," said Kropotkin, "I approve entirely of this way of acting . . . it will be propaganda by cudgel blows, or revolvers if necessary."[75] You will notice that the model is trouble at the edge of a demonstration, or a quick strike at tax records in an isolated Town Hall. Not (yet) the lone bomber.

The moment of anarchist politics in late 1891 was specific, I think, and had effects on Pissarro's *Two Young Peasant Women*. Not dramatically. Not in terms of particular imagery or even firmly identifiable tone. I do not intend to play Venturi to the painting. I see no outright socialist politics in it. There is a slight shifting of boundaries – in a modernist practice where even the slightest shift in conception endangers the economy of the whole – between expressiveness and surface integrity, or drawing and color, or pastoral and monumentality. A willingness to risk stiffness and solemnity. To bring the figures closer. To try to overhear them.

The picture was done in the fall and winter after the Fourmies massacre, but before Ravachol's first bomb. On 28 February 1892, a week or so after Pissarro's exhibition closed, the town house of the Princesse de Sagan on the Champs-Élysées was dynamited. Spanish anarchists were thought to be in town. On 11 March a bomb went off across the river at 136 boulevard Saint-Germain. In the building lived chief magistrate Benoit, who had presided over the trial of the anarchists arrested in Clichy the previous May. On 27 March, a bomb levelled a house in rue de Clichy where Bulot, the prosecutor at the same trial, had his apartment.[76] In the meantime, on 15 March, a bomb had exploded at a barracks in the rue Lobau. An anarchist called Ravachol, who was responsible for the Clichy bombings, was spotted by a waiter at the Restaurant Véry, and arrested on 29 March. His trial opened on 26 April. The day before, someone blew up the Restaurant Véry, killing Véry himself and a customer. On 27 April, Ravachol was sentenced to life with hard labor. The lawyers in court, and part of the gallery, booed the jury for not sending him to the guillotine. (He was not spared it long.) Part of the press rounded on the magistracy for having turned the trial into one of anarchism in general, and then failing to convict. Four of Ravachol's associates had been put in the dock alongside him, and three were acquitted outright. May Day was coming. This was propaganda by the deed.[77]

Pissarro's painting belongs to the moment before Ravachol. That is, to a long moment when armed struggle between the state and its enemies seemed to have become a possibility again – when the papers were full of the aftermath of Fourmies, the struggles and eventually the insurrection at Jerez, strikes and bloodshed in Pittsburgh, riots in Berlin. One anarchist group rechristened itself "Revenge for Fourmies."[78] There was already a concerted action by the state in 1891 against anarchist newspapers and personnel, centering on what they said to the troops. *Le Père Peinard* was in trouble. The editor of *La Révolte* was doing time. Marxists and Social Democrats were eager to go on record as

denouncing or ridiculing the anarchist threat.[79] *La Révolte* reprinted an article by the lawyer and poet Jean Ajalbert, "After Fourmies," in which he argued that the massacre had ushered in a new period of "passion and revolt," as evidenced by a general turn to the Left in the press and little magazines.[80] It was true that the Symbolist journals were taking on a more political tone. *Entretiens Politiques et littéraires* had already reprinted the Communist Manifesto in its April issue, as its ("anarchist") contribution to the debate over May Day. Much more in the same vein was to follow. In November, for instance, *La Révolte* reprinted an article from *Entretiens* by Bernard Lazare, "Nouvelle Monarchie" – it was the kind of survey of the new religiosity Pissarro would have especially enjoyed – and another entitled "L'An-archie" from *La Revue blanche*.[81]

It was a matter of opinion, naturally, whether Ajalbert had it right. Did the signs point to anarchism's finally becoming the specter haunting Europe or just the Symbolist press? Remember that Pissarro was a congenital optimist. In January 1892 Élisée Reclus sat down to write a preface for Kropotkin's new book, *The Conquest of Bread*. His mood (for a man usually given to stoicism, and with a long schooling in disappointment) was strangely elated. You will see that he strikes some familiar notes:

Jokers talk of "fin de siècle," and rail against the vices and oddities of elegant youth; but what is happening at present is something quite different from the end of a century; we are coming to the end of an epoch, an era of history. It is the whole of past civilization we see expiring . . . How can the defenders of the old order possibly keep it alive? They do not believe in it any longer; they fight at random, without a leader or a flag . . .

They know that the law is iniquitous and lying, that magistrates are creatures of the strong and oppressors of the weak . . . but instead of regulating their thoughts, their desires, their projects, their actions according to a sense of justice, most of them take refuge in some backwater so as to escape the implications of their own lucidity. For instance the neo-religious, who, no longer able to practice the ludicrous faith of their fathers, go in for some more original form of mystagogy, with no precise dogmas, bathed in a mist of muddled sentiment: they become spiritualists, rosicrucians, buddhists and faith-healers . . .

But since they talk incessantly about the Ideal, let me offer these "beautiful souls" reassurance. Material beings that we are, we are weak enough, it is true, to think of nourishment, because we have often been denied it; and even now it is lacking to millions of our Slav brothers, subjects of the Czar, and to millions of others besides; but beyond bread, beyond well-being, beyond the collective wealth that can come from the proper use of our countryside, we see a whole new world rising up in the distance, in which we shall be able to love one another fully and satisfy the noble passion for the Ideal – the very Ideal which the lovers of ethereal beauty, full of disdain for material life, say their souls thirst after with an unquenchable thirst![82]

"We live from day to day," Reclus writes to Nadar on 27 April, "happy and confident, listening to the great blast of the revolution which is advancing."[83]

Notice that the letter to Nadar was written on the day Ravachol was found guilty. Which is to say, anarchists did not immediately realize that with the era of bombings a new (and ultimately disastrous) turn in the history of anarchism had begun. Kropotkin in January called Ravachol a fin de siècle phenomenon. "This world is of no interest to the revolution . . ."[84] But that was before the bombings began, when all that was known of Ravachol was that he moved in anarchist circles, was probably a murderer and possibly an agent provocateur. It soon became a minority opinion in anarchist ranks.

"Now that we are quietly immersed in the contemplation of nature, did you hear the clamor coming from Paris?": Pissarro to Mirbeau, 9 April 1892. "Ravachol must have really put the wind up those good magistrates. They only got away by the skin of their teeth! Devil take it! [*Ravachol a-t-il assez fichu la frousse à ces bons magistrats, ils l'ont échappé belle! diable!*] It is not a good thing to pass judgement on others! If you get a taste for it, you're damned! They are going to have to surround them with soldiers from now on."[85]

"Someone sent me – I don't know who – the booklet of Kropotkin's. I am sending it on to you": Pissarro to Lucien, 26 April 1892 (day one of the Ravachol trial). "I am also sending *La Révolte*, which will fill you in on several new aspects of recent events. Pouget and Grave [editors of *Le Père Peinard* and *La Révolte* respectively, both friends of the family] were arrested in the round-up they have been making of the comrades, using laws that even the bourgeois papers are beginning to think unwise. – The Republic, by God, is defending its capitalists, that's understandable. It is easy to realize that a revolution is in full swing – it threatens from every side. [*Il est facile de se rendre compte que l'on est en pleine révolution – et cela menace de tout côté.*] Ideas won't stop now!"[86]

Art historians have worked so hard to prove Pissarro was a pacifist that I owe it to the record to present evidence he was no such thing. It is not that the evidence is surprising, just that it is usually passed over. Nor is it consistent. Most anarchists had doubts about propaganda by the deed, and the Ravachol phenomenon was perplexing for various reasons. Pissarro congratulated Mirbeau on the article he wrote about Ravachol for the anarchist journal *L'Endehors*, brought out on May Day.[87] Naturally the article was less exultant and optimistic than the two letters just quoted. But equally, Pissarro found time a day or so later to read and vilify an interview on anarchism Zola had given to *Le Figaro*, in which anarchists were accused of being ideologues and utopians, with not enough confidence in science. "So the people are going to be freed scientifically. That'll be right! When the men of science govern, they'll govern no less tyrannically for doing so in science's name!"[88]

Pissarro was no great political thinker. He knew his limits, and ducked the occasional invitation to put his anarchism in publishable form. (He was not above asking Lucien to do the job for him – anything to get off the hook.[89]) His version of socialism was simple. He hated bourgeois society with a passion, and was not such a fool as to think it would crumble of its own free will. He knew that violence was part of everyday life, practiced homeopathically by those in power. And then from time to time not homeopathically. He was aware that answering violence with violence was mostly a foredoomed struggle. But violence would be answered in kind – those to whom evil is done, do evil in return. And the question for socialism was how to respond to that desperation. Not presumably by hand-wringing but by help. His politics, that is to say (like those of most anarchists), were somewhere between those of "Revenge for Fourmies" and those of *The Conquest of Bread*.

We are not among those who preach acts of violence, or eat the boss and the capitalist for lunch, as once the bourgeois did the priest; nor do we incite individuals to do this or that specific thing; we are persuaded that individuals do only what they have decided to do for themselves, we believe that violence is preached by example not by writings and prescription; but we are convinced also that ideas, well understood, will necessarily, in their ascendant movement, multiply acts of revolt.

The more ideas penetrate the masses, the more their consciousness comes

to life, the more intense will be their sense of their own dignity, and in consequence the less they will be willing to endure the pestering of authoritarian power and the exploitation of capitalist thieves. Independent acts will multiply and become more frequent. We have no worries about this result. On the contrary. For each act of individual revolt is a swing of the axe at the foundations of the social edifice which weighs us down. And since it is said that progress cannot happen without victims and upheavals, we salute those who will go down in the torment, in hopes that their example will lead to many more such champions, this time armed so that the blows they strike will have more effect. May the struggle be brief. That alone will save the victims devoured each day by our Minotaur society.[90]

These are the final paragraphs of an article published in *La Révolte* in May 1891, called "Why We Are Revolutionaries," obviously written with Fourmies in view. I see no reason to believe Pissarro would have dissented from them. And the two paragraphs, especially the last lines, indicate why anarchism could not disown Ravachol when he came.

Nonetheless there are reasons (besides pure ideology) why Pissarro's opinion of Ravachol has been so strenuously repressed. For of course Pissarro was a gentle and benevolent man. It is hard to reconcile the contraries of his life and beliefs – but in that he is human and nineteenth century. And typically anarchist. For what is anarchism if not a politics of irreconcilables? Are not its strength and weakness precisely the coexistence within it, under almost intolerable pressure (and for many it was intolerable), of extraordinarily different aims, rhetorics, and modes of action? Individualism and communism. Belief in science and a taste for sacrificial gesture. Freedom and order. Quietism and terrorism. The loftiness of aristocracy and the cynicism of the *lumpenprol'*. Sentiment and *ressentiment*. Loathing of violence and embrace of it.

It is easy enough to enumerate the contradictions, but ultimately the point is to grasp the kind of political identity – political consistency – to which they gave rise. And to recognize the part that identity played within socialism. (Or the part it should have played. The price socialism paid for excluding and suppressing it.)

The answer has to do with culture, taking the word in its widest sense. It has to do with the fact that societies, in order to endure, have to go on believing in themselves – in their vision of well-being, and imagining of the future. They have to pretend to be moral. Fin de siècle society – this is the meaning of the term, and the reason it became international – existed at a moment when that pretense was wearing thin. And part of the job of socialism was to insist on this unravelling of ideology, and to present an image of possible moral (human) consistency as an alternative.

This is what anarchism managed to do, I think, in contrast to Marxism and Social Democracy. It alone, in its very bombast and naivety, had the measure of the bourgeois beast in the late nineteenth century: its rhetoric of horror and denunciation was the only one adequate to the new color of events. To Fourmies, Tonkin, Panama, Dreyfus. To the whole escalating vileness of patriotism and Empire that ended (but did not end) in 1914. The crisis of fin de siècle was moral. It was representational. You have only to walk through the rooms of a museum devoted to "popular" and mass-produced visual imagery in western Europe – I remember especially the great one at Nancy – to shiver at the special glibness and exorbitance that comes over the imagining of Nation, Youth, Freedom and Maleness as the new century approaches. You shiver

because you see modernity mutating into a truly virulent form, for which hundreds of millions would die. And the anarchists, it seems to me, were the only ones capable of turning revulsion at this turn of events into resistance, just because they were Puritans, just because they refused the (bourgeoisie's own) language of statistics, production, economy; and went on describing the problem as one of legitimacy, of representational health or disease.

I am not claiming this on its own makes a politics. Nor do I mean the above as a verdict on anarchism's overall intellectual strength in the 1890s, or on the answers it gave to the problem of organization. Tactically and politically it often deserved its opponents' scorn. (Though in retrospect the anarchists' insistence on the question of military loyalty and insubordination comes to look clearsighted. It is a good example of necessary extremism. The debacle of socialism in 1914 – the sudden discovery by proletarian internationalists every-where that the future of socialism, not to say civilization, depended on one's own country winning the war – tells the story of what the rest of the move-ment's moderacy really meant.[91]) My purpose, again, is to suggest what the anarchist version of socialism had to offer at the time Pissarro embraced it, and the ways the socialist movement suffered from refusing the offer point blank.

The tragedy of socialism around 1900 is that no rendezvous was made (or made effectively) between the two main discourses that gave socialism form: the discourse of denunciation and prophecy, and that of class consciousness. Of course the former was ancient – its roots lay in Jacobinism and the imagery of the sects – and it was always on the verge of reverting to chiliastic rant. The language of morality needed stiffening – with the eight-hour day and the laws of primitive accumulation. But there are moments in history when the very nature of class power, and the forms taken by its manufacture of the future, make questions of ethics and rhetoric – questions of representation – primary, or at least unavoidable. (We are in a fin de siècle rerun at present, with the chat room replacing the arcades.) Remember that socialism was in many ways at the height of its powers in the early years of the twentieth century. It had gained its first footholds in parliament, its influence within the trade union movement was growing, intellectuals rallied to its cause, it had reason to believe that the future belonged to it. My argument is that nonetheless it had still to devise a set of forms in which the developing nature of bourgeois society – the cultural order of capitalism as well as the economic and political ones – could be described and resisted. Anarchism possessed some of the elements needed. In closing against anarchism, socialism robbed itself of far more than fire. It deprived itself of an imagination adequate to the horror confronting it, and the worse to come.

This is as wide a field of vision, and as much of a sense of foreboding, as I need gesture toward for now. I have no doubt that Pissarro partly shared both. Being a congenital optimist does not mean living in blithe ignorance of what the cultural pessimists (like Gauguin) were responding to. When Pissarro writes to Mirbeau in April 1892 about *The Conquest of Bread*, he can be found admitting that the book is a utopia, but "there is nothing to prevent you from believing that one day these things will be possible, unless mankind founders and returns to utter barbarism."[92] The qualification here is not formulaic. Among other things, it is a further (more sober) reaction to Ravachol.

The note is genuine, but not characteristic. Above all not characteristic of 1891. Pissarro's letters that year are elated. That is to say, angry and garrulous, and deeply on the defensive, but with a sense of even the embattledness having a future glory written into it. The world may be changing for the worse (the art world especially), but the pace and confusion of the change – the sheer flagrancy

of the new avant-garde gambits, the way reaction is openly showing its face as the face of innovation – all this is somehow deeply energizing.

It's a sign of the times. The bourgeoisie is frightened, surprised by the clamor of the disinherited masses, the immense demands of the people, and feels the need to bring people back to superstitious beliefs; hence the hubbub of religious symbolists, religious socialism, art of ideas [art idéiste], occultism, Buddhism, etc., etc. Gauguin sensed the way things were going; long ago I saw him coming, that fanatical enemy of the poor and the worker; that's why the present movement must be a death-rattle, a last gasp! The Impressionists are in the right: theirs is a sane art, based on sensations, an art that is honest.[93]

And then more gloomily:

There are moments when I really wonder if I have talent, truly, I often have doubts . . . What is it that's lacking? . . . Or what is it there's too much of? . . . I am poorly understood, especially since van Gogh died [he means Theo]; what it is to have the influence of an enthusiast on your side! That's the man we have to find, but these things can't be willed into being. Perhaps I am behind the times, or perhaps my art is out of step, and does not fit with present ideas, which seem to be turning to mysticism. So it may be another generation which will have the qualities needed to appreciate the way I am taking – one which has rid itself of religious, mystical, mysterious ideas and come back to more modern ones. I firmly believe that our ideas, impregnated with anarchist philosophy, give a color to the works we do, and hence make them antipathetic to the ideas of the moment [Je crois fermement que nos idées imprégnés de philosophie anarchiste se déteignent sur nos oeuvres et dès lors antipathiques aux idées courantes].[94]

You see how wise Pissarro was to leave anarchist aesthetics to other people. But nonetheless his mood counts. It is the anarchist temper – vengeful, self-doubting, and serene – out of which Two Young Peasant Women comes.

"Temper" on its own flattens things a bit. What I am trying to bring into focus is Pissarro's politics and their effect on his art. At one level this has to do with the special circumstances of 1891, and the way they disturbed the balance on which Pissarro's working practice depended. The balance was technical and perceptual, and the terms in which Pissarro normally discussed it should be familiar by now: sensation, synthesis, freedom, unity, overtness of touch. "I began to understand my own sensations, to know what I wanted, in my forties, but only vaguely; at fifty, that is, in 1880, I formulated an idea of unity, but I could not put it into practice; now I am sixty, I begin to see how it might be possible."[95] These things are procedural, in other words: they are deeply embedded in looking and denoting and building oneself a painterly repertoire. They take time. They are only barely under the artist's conscious control. They cannot be taught (this is finally the point of the autobiography just quoted, which comes from a letter to his niece). Forcing and altering this balance of habits in response to a specific artistic situation – wanting, or feeling obliged, to reply to the situation as opposed to continue investigating the structure of one's own response – is potentially the worst kind of disaster.

Yet the balance was altered in Two Young Peasant Women, not disastrously. "Forced" may be one way of describing the result. It was certainly difficult and unstable, and Pissarro never tried anything remotely like it again – in scale, in preponderance and closeness of figures, in charged inwardness of mood. It is a limit term of his practice, the point at which his modernism (the set of proce-

dures he had built in dialogue with Cézanne and Monet and the rest) almost gives way to something else. Surface almost yields to depth. And depth almost ceases being a strictly (splendidly) technical matter and re-enters the realm of metaphor that modernism had worked hardest to destroy. "Depth" as a human possession or mystery. (How often the word mystery occurs as a term of abuse in Pissarro's letters at this time.) Depth as a sign of completed understanding. The dimension called "history" reestablished, therefore, on the other side of Manet's and Seurat's annihilation of it.

Limit terms (to go back to my introduction) are instructive. They show us what qualities and modes of apprehension have normally to be excluded from a practice, and they suggest why: in this case, they conjure back the kinds of invitation to false knowledge and easy identification that modernism thought had been the death of art. And they show us the way any practice is haunted by the questions it tries to put aside. The test of a practice, ultimately, is how it deals with those ghosts when for some reason they crowd back on stage. The ghosts of anecdote, ethos, inwardness, past and future time. I am not saying *Two Young Peasant Women* has all of these demons under control, but I do think the key to Pissarro's version of modernism is that at one moment (in extremis) it dealt with the demons directly.

This brings me back to the question of Pissarro's anarchism – to the question posed (painfully badly) by the artist himself in the sentence of his I quoted earlier. Is there a sense, to pose it differently, in which anarchism really informed and inflected Pissarro's way of painting?

Of course anarchism was a form of thinking that Pissarro came to relatively late in the day, when he had already built himself a complex style. How did the terms of anarchist understanding mesh with those he already had? Is there a way the new terms altered, or sharpened, the endless moment of "understanding one's sensations" to which his painting returned? Remember that the later 1880s are years in which Pissarro had struggled to recast his style, and discover means by which the *point* might be made part of it. The encounter with anarchism was bound up with this, though not in ways that settle easily into cause and effect. In this sense the episode of 1891 had been long in the making, so that when it came it did not throw everything out of joint.

Anarchism, among other things, is a theory of the compatibility of freedom and order. (Bellegarrique called his pioneering newspaper *L'Anarchie, journal de l'ordre.*) Its central assertion in philosophical terms is that freedom and order are dialectical moments of one another, and that the present horror of the forms assumed by each is due to that dialectic being broken.[96] Much of anarchism broods over Hegel's brooding on the Enlightenment and Year 2. Let us imagine a painter, then, who thought that pictures could be small epitomes of this repressed truth (fig. 54). In them order and freedom would be shown to be reconcilable – indeed, not entities or qualities at all without one another. Freedom would be shown to be a certain kind of orderliness, and order no more than a brittle armature – the kind academics call "composition" – unless it be formed from the energies released by individual sensations. And let the painter stake even more, in truly Hegelian fashion, on the word he chooses to describe the unique moment of contact between the organism and its surroundings – that innocent word "sensation," with its unrepentant eighteenth-century flavor. Let sensation for him be the very form of freedom and order coexisting. Let it be the moment of pure interception of sense data. But remember he is no idiot empiricist. He knows very well that the word "interception" implies some form of prior understanding, or pattern of figuration. But he thinks he can salvage the

54 Camille Pissarro: *Climbing Path at the Hermitage*, oil on canvas, 54 × 65, 1875 (Brooklyn Museum of Art, New York. Purchased with funds given by Dikran K. Kelkian.)

notion of uniqueness and particularity all the same, and that the very ideas of priority and pattern have no substance without ideas of presentness and randomness to set them off. And not just ideas, but images – instances – realizations. Here (in this painting) is *my* sensation, my singular world; but of course each singular instance answers all others, as do iron filings in a magnetic field; and they do not just mechanically obey the force field, but actually constitute it, actually contain it – they have the whole structure in each one of them, if each one of them is laid hold of properly. They are each irreducible, but utterly provisional. Somehow the marking of them will have to signify as much. They actually happen, but only in relation to the whole. Only reciprocally. Reciprocity and uniqueness are not opposites, just two imaginings of matter coming to terms with its true nature. Equilibrium, mutuality, individuality, justice. Of course the terms are ethical and political, but the painter's job – the anarchist's job – is to insist that they are ethical because in the first place they are sensate. They are facts of nature. (This is anarchism's "scientism.")

Such a painter makes problems for himself, of course. He will most likely be a fearsome mixture of hedonist and Puritan, and puritanical above all about the possibility of repeating himself, and leaning on his skills. He will have an infuriating habit of not understanding how good he has been at certain moments; he will not understand that trying to reproduce one's own classic

style is no sin, because the attempt will always fail and give rise to further variations. One need not be afraid of perfection (of the achievement of 1873 and 1874, for instance, or the paintings done in answer to Cézanne in 1877, or the idiom of the first peasant pictures in 1882). Perfection is not repeatable. It is just a good armature for lesser experiment, or a good crucible for further originalities. Monet had this right.

Clement Greenberg, who admired Pissarro greatly, was as far as I know the first to point out the kinds of risks and deficiencies that followed from his attitude to the world. He said of Pissarro that a lot of the time "the total final effect of the flat rectangle was . . . a paralyzing obsession for him. He allowed his perception of the free atmospheric diffusion of light to hush and merge all salient features, was too egalitarian in his treatment of the canvas – like another materialist, Courbet – and would mistake uniformity for unity."[97] The painter himself knew this was the danger. "Harmony," he says to his son, "is only made out of contrasts, otherwise what you have is UNISON, *it is as if you made a tune on all one note.*"[98] He is angry with his son for making him have to repeat platitudes. Nonetheless Greenberg has a point. For an anarchist, contrast and harmony, or salience and equality, are qualities deeply intertwined. They will only be discovered as faces of one another.

Anarchism, as I say, came to Pissarro late. It was a way of thinking about issues he had broached in painting for almost twenty years. I agree with Greenberg that Pissarro's first commitments seem to have been materialist, and with Greenberg's implication that this meant Courbet was his touchstone. And Corot. Corot as the absolute, cold registrar of tone. Anarchism gave Pissarro a framework in which these commitments made sense and connected with others (I am sure that part of anarchism's appeal to him was its continuing love affair with eighteenth-century materialism[99]), but did it change or exacerbate them? Did it edge his practice in any particular direction?

Answers here can be only speculative. And the best ground for speculation in this case turns out to be Pissarro's response to another artist – to the strongest artistic personality, after Cézanne, he ever felt the need to grapple with directly. That is, Seurat. (Monet, we shall see, is a special and opposite case.) Evidence suggests that the response to Seurat took place within an anarchist matrix – the formulation need be no sharper than that. The response outlived Pissarro's belief, which was by and large misguided, that Seurat might actually be imitated. *Two Young Peasant Women* was meant, among other things, as a declaration of independence from the *point*. And yet Seurat lives on in it, even technically. Pissarro is still struggling in 1891 to devise his own version of uniformity – indeed, to play a tune à la Philip Glass – literally in Seurat's shadow. And as for Seurat's drawing (fig. 55)! Seurat's abstractness, hieratism, and naive cursiveness of edge . . . Seurat's understanding of Puvis . . . Fénéon was not the only one in 1892 to warm to Pissarro's new painting because its chief influence was so openly acknowledged.[100]

Somewhere here, I think, in the continuing encounter with Seurat, is the key to the question of art and anarchism in Pissarro. I believe that if we can identify what Pissarro thought Seurat had to offer, we may understand what he thought, or hoped, anarchism in painting would be like. Partly the answer is obvious. It follows from the previous line of thought about order and freedom in pictures (and politics). What the dot seemed to promise, at least for a while, was a truly naive visualization of the singular and uniform as the same thing. The dot exploded the opposition. And this was wonderful. It planted a bomb in the middle of the bourgeois idea of freedom – and order, and individuality, and

55　Georges Seurat:
Woman with Monkey, oil
on wood, 24.7 × 15.7,
1884 (Smith College
Museum of Art,
Northampton, Mass.
Purchased, Tyron Fund,
1934.)

Art-ness, and taste, and "touch," intuition, variety, expressiveness. All the
aesthetic categories of the nineteenth century, including most of the modernist
ones, disappeared down the black hole of Seurat's technique. A technique that
pretended to be a technics – to engineer at last the "elocutory disappearance of
the poet, who cedes the initiative to words." And show us a world where "Je est
un autre" (fig. 56).[101]

　It was wonderful, and it was profoundly crazy. For of course it went counter
to the whole Hegelian temper of Pissarro's painting up till then. Painting for him
had been dialectical, a dance of the singular and orderly, of freedom and
harmony, uniqueness and interdependence. In Seurat those moments collapsed
into one another – they were equated, or duplicated, or ironized out of exist-
ence. Drawing (that is, separate identities) emerged from the wreckage as so
much whispering of ghosts. Exquisite whispering. Ghosts of an endless, igno-
minious energy (figs. 35 and 36). But not people – not objects of empathy or
sympathy. Not actors. Not things with insides. "The synthetic representation of
the pleasures of decadence" – this is Signac in 1891, mourning the master in *La
Révolte* – "dancehalls, *chahuts*, circuses, as the painter Seurat did them, he who
had such an intense feeling for the ongoing vileness of our epoch of transition
[*un sentiment si vif de l'avilissement de notre époque de transition*]."[102] Pre-
cisely. The bourgeois world, and therefore the bourgeois picture surface, had

56 Georges Seurat: *Channel at Gravelines*, oil on canvas, 65 × 81, 1890 (Berggruen Collection, National Gallery, London)

long ago given up on "life." Only the physical world was real. Light was real, and eyesight was real, and painting should make it its business to approximate both. But not to make believe this had anything to do with Nature. Not to have light (in the eye or anywhere) be lifelike. Reality was mechanism. Art should articulate that fact.

I guess I am saying that Seurat mattered so deeply to Pissarro because he saw in him the image of anarchism as exterminating angel. Seurat was the Nietzsche of painting. But in his case nihilism had nothing to do with aristocracy. He was a Leftist, a petit bourgeois, a technician. He worked quietly at perfecting his explosive device.

For Pissarro, there could be no enemies on the Left. He had known from the start that the *point* was deadly – death-dealing, inhuman, laughing at hand and "handling" – but only in retrospect did he try to deny that this had been its appeal. Or rather, the quality to it that most had to be defeated – in other words, mimicked, incorporated, reanimated somehow. Seurat had been Pissarro's opponent. His irony and pessimism – or had it been optimism? the two are indistinguishable, of course – might still be made part of a dream of freedom. What was needed, it turned out, was a version of lifelikeness that had supped with the devil and learned his best tricks. Then figures might be drawn as fictions, but alive nonetheless. The dream would show off its dream-machinery, yet still do restorative work. Surface would be positive and negative at once, factual and virtual, artificial and naive – but not the destroyer of value *tout court*. Nature would not grimace. This is what Fénéon in 1892 claimed Pissarro's new style made possible.

Anarchism, I have been arguing, was that part of socialism with the deepest feeling for "the ongoing vileness of our epoch of transition." We know nothing, and need to know nothing, of Seurat's politics beyond the fact that

57 Claude Monet:
Haystack, oil on canvas,
64.8 × 92.4, 1891 (The
Art Institute of Chicago,
Gift of Mr. and Mrs.
Daniel C. Searle)

several of his closest colleagues (including Signac) made no bones about their anarchist allegiance – and beyond the fact of what he painted. I am sure Signac has that basically right. Seurat was profoundly anarchism's painter: cruel and elusive and infinitely fond of the city's foibles and moments of freedom. He operated at the point where an all-consuming aesthetic irony happens on a truly naive delight in other people. Where negation is indistinguishable from utopia. (So that *Circus* and *Chahut* are like scenes out of Dostoevsky – Paris as Prince Myshkin would have seen it.) Perhaps I should say that rather than being anarchism's painter he was the painter anarchism made possible – the one whose rhetorical balance Kropotkin and Malatesta tried for but never quite achieved.

Of course Pissarro's version of anarchism was very different. (Where in Seurat can one find two figures facing one another, let alone conversing?) But the encounter with Seurat taught him, if he needed to know, the power of the negative in modernism. It put him in mind that any imagining of utopia – any dreaming of contact and equilibrium – had to have its own counterfactual status written into it. It had to speak to its own factitiousness. (Matisse was once asked why he, the impeccable family man, went on painting women in scanty Oriental dress. "I do Odalisques," he said, "in order to do the nude. And how to do the nude without it being factitious [*comment faire du nu sans qu'il soit factice*]."[103]) Even in dreaming, the artwork should carry, or admit it does carry, the traces of our epoch of transition. In that way it "bears witness" – this is the phrase immediately following in Signac – "to the great trial of social strength beginning between workers and Capital."

Paintings (this is another way of putting it) are so many setting suns. "Setting sun" is a metaphor for painting Pissarro cannot put down in 1891, for reasons that by now should be clear.

It comes up in connection with his own work, but most of all in connection with Monet's. Monet is his third opponent in 1891. Gauguin is the enemy – a

58 Claude Monet: *Haystack*, oil on canvas, 65.4 × 92.4, 1891 (Courtesy, Museum of Fine Arts, Boston, Gift of Misses Aimée and Rosamond Lamb in Memory of Mr. and Mrs. Horatio A. Lamb)

travesty of all one had hoped for modernism. Seurat is the moment of negation always at work within modernism, to be lived through and answered in kind. But Monet is oneself – the complete self one wishes one could be, the performing self one fears one really is. No moment is more poignant in 1891 than that at which Pissarro confronts Monet's *Haystacks* (figs. 57 and 58).

We tend to think now of the show of *Haystacks* at Durand-Ruel's in May as one of the great artistic events of the century. And so it was. But this does not mean that it caught the public's imagination, or was widely touted in the press. April and May were the months of the Salon. Fourmies and its aftermath flooded the front pages. The *Haystacks* were anyway too eccentric and unprecedented a show (and too much, it was rumored, geared to a set of buyers across the Atlantic) for writers on art to know quite what to do with them. Pissarro's exhibition the next February got far more coverage. Not for Monet the front-page column in *Le Figaro*, nor the cover illustration for *L'Art français*.[104] Of course in hard financial terms Monet did not need them.

Hard financial terms were relevant in May. "It is a bad moment for me," Pissarro writes to his son some weeks before the show opens:

> Durand won't give me a reply about my pictures. Miss Cassatt [always a reliable ally] was astonished that he won't buy me any more. Apparently his sales are up, but for the moment it is only Monets they are asking for. It seems he cannot turn out enough. The worst of it is that they all want *Haystacks at sunset*!!! Always the same routine. Everything he does goes off to America at prices of four, five, six thousand francs. "That's what comes of not scaring one's clients!" Durand said to me. True enough!! "No good arguing," I said back, "it's just the way I am."[105]

Monet's show opened on 4 May. It was not quite true that its contents were sold out beforehand, but apparently all fifteen *Haystacks* had buyers by the end of day three. Prices were high, though again the gossip Pissarro picked up may have exaggerated slightly. The account books say they fetched between 3 and 4,000 francs apiece.[106] Fourmies was on Pissarro's mind; his eyesight was

terrible; but naturally he went to Monet's opening, and the letters suggest he went back several times the following week. It is his first reaction, on 5 May to Lucien, conflicted and floating, that registers his true dialogue with himself.

> I went with my eye in bandages and could only see Monet's marvelous setting suns out of one eye. It seemed to me very luminous and very masterly, that's incontestable, but since for our own instruction we should look beyond the given, I asked myself what it could be that seemed to me missing. It is very difficult to pin down. Certainly it is not a matter of accuracy [*justesse*] or harmony, perhaps it is more the unity of execution which leaves something to be desired, or maybe a way of looking at things that is calmer, less ephemeral in certain places, the colors are more pretty than strong, the drawing is beautiful but unstable, especially in the distance [*flottant dans les fonds surtout*], but all the same he's truly a great artist![107]

This is private notation, running from comma to comma in a typically unpremeditated way. (Here more than elsewhere I have had to add punctuation to do justice to Pissarro's free flow.) But as an example of serious negative criticism – of Pissarro feeling his way toward a sense of what he thinks is missing in an art he reveres – it is a special moment in the letters. I should say unique. And I see the list of qualities Pissarro comes up with as a kind of recipe for, or premonition of, *Two Young Peasant Women*. The painting he dreams of (out of one eye) will make Monet whole. It will find a way to hang on to Monet's accuracy and fire but look at the world more calmly, have one's handling be more consistent, one's drawing more solid, one's color less gorgeous and flaring. Above all it will not be a setting sun.

What does it mean, this fantasy of Monet's light? You will notice that it is there from the beginning, established as shorthand for Monet's achievement long before the works themselves are seen. And part of the overdetermination of the phrase has to do with its being unconsciously directed at himself – at one of the things Pissarro did best, and had had to do more often in the previous years, just to find buyers. In the grim late 1880s, painted fans had been Pissarro's bread and butter. He can be seen in the letters delivering them in person to horrible patrons in the suburbs, and then venting his spleen to Lucien.[108] (One main thing the dealer system usually does is protect artists from knowledge of who their viewers really are. For a while Pissarro wore no such blinders.) The most saleable fans were those that showed the sun going down (fig. 59). And even in 1891 this rule applied. In November, still hurting financially, Pissarro made a sale to Rodin, with Mirbeau acting as intermediary. Rodin left the choice of work to the painter. Pissarro seems to have been genuinely moved at the prospect of one of his pictures belonging to the great man. He picked a *Soleil couchant rouge avec brouillard*.[109]

What do sunsets do, then? They make Nature grimace, of course, "in order to prove" – here is the rest of Fénéon's 1887 phrase – "that the moment is unique and we shall never look on its like again." Monet was a conjurer, said Fénéon, "served by an excessive bravura of execution, a fecundity of improvisation and a brilliant vulgarity." "He works up an immediate emotion in front of a spectacle [*Il s'émeut brusquement à un spectacle*], but there is nothing in him of the contemplative or the analyst."[110] Compare Pissarro the same month: "it is the art of a skillful but ephemeral decorator."[111]

Maybe it is unfair to visit on Pissarro and Fénéon the brutality of judgements made three years before, when the neos were on the warpath. But some of this, I think, is still lurking in the synecdoche of May 1891. Sunsets are too much excuses for painting. Too much metaphors for fin de siècle. Too much the unique moment (and hence the unique individual) which turns out to repeat

itself ad nauseam. Better Cézanne's weird eternity, or Seurat's asphyxiating gaslight. Yet everything in the letter of 5 May admits that the line between Monet and oneself is almost impossible to draw. One is closer to the *Haystacks* than one ever will be to Bibemus quarry or the channel at Gravelines. Impressionist paintings *are* setting suns. The painting Pissarro does next will have to admit as much, and come to terms with the merely appealing and performative in what he did, which the years in the neo hairshirt had failed to expunge. Painting is hedonism, after all. It is profoundly nostalgic. It should not pretend that what it offers as beauty is entirely different from what its receivers call prettiness. Renoir, says Pissarro in July, is "obliged . . . to make pictures to please!!"[112] But had he not always done so? And who was to say that his frankness, or cynicism, or naivety, would not eventually carry the day aesthetically? *Le chiendent c'est que cela ne souffre pas la médiocrité.*

"Obliged to make pictures to please." The phrase is loaded. Because we know that eventually in 1892 Pissarro's retrospective took place, and that paintings sold from it, some of them for as much as 6,000 francs, and that as a result Pissarro got an exclusive contract from Durand-Ruel,[113] it is easy to slip into thinking of 1891 as already the beginning of the end of the artist's failure in the marketplace. That would be wrong. In market terms, the year was still hellish.

Theo van Gogh, who had been the force behind Pissarro's one-man show the year before, followed his brother to an early grave in January 1891, and with his death Boussod and Valadon's enthusiasm (which had always been limited) largely ceased.[114] Pissarro found himself navigating between dealers again, in particular struggling with the scepticism of Durand-Ruel. Durand-Ruel did not think Pissarro's art was purged of the influence of the dot. He did not think it saleable. He thought that even if Pissarro managed eventually to move out of Seurat's baneful orbit, his chopping and changing over the previous few years – and in a sense over his whole career – might finally have alienated buyers for good. "Durand did not want my small-scale canvases, simply because they were in my recent manner. He says an artist ought to have one manner only, like Ziem. *I'm quoting.*"[115]

All through 1891 Pissarro sold little, or in dribs and drabs. He blamed Durand-Ruel. He blamed the idiocy of patrons. One among many low points was in April, when even Tadamasa Hayashi told one of Pissarro's go-betweens that he did not like the artist's latest work. "Incomprehensible! A

59 Camille Pissarro: *Flock of Sheep, Sunset,* gouache on paper, 20 × 62, 1889 (Private collection)

Japanese!!!"[116] Mary Cassatt, whose cool head in such matters Pissarro regularly depended on, tried to think of ways for them all to escape Durand-Ruel's clutches, but did not come up with much.[117] Maybe he could be played off against Boussod and Valadon – Monet was supposed to be an expert at this kind of thing. But he had Madame Hoschedé's capital behind him. And he was in demand. Maybe a living could be cobbled together with the help of smaller dealers like Heymann and Portier.[118] "If only I could find someone there to exploit me [*Si je pouvais trouver là mon exploiteur*]!!"[119]

Things got better in the fall, but still only spasmodically. Pissarro counted his sales for the year in October, and seemed almost surprised at what they added up to. "I reckon this year I may make around ten thousand francs."[120] About three or four *Haystacks*, that is. But maybe this would do. Maybe this was the market Pissarro ought to settle for. Mirbeau no doubt meant well in late October, floating the plan for a big Pissarro to be bought by the Musée du Luxembourg. "But I have to say I don't like it, having dealings with the state. I'd prefer to sell to my little art-lovers, but they need a lot of coaxing, those buggers!!!"[121]

Only in December did the tide seem to turn. Something was in the wind. Boussod and Valadon suddenly showed interest again.[122] The painter Carrière came up to Pissarro at the theatre "and shook my hand and said point-blank: 'I want to warn you that you're having a big success in New York and very soon you'll be getting offers. I thought I ought to put you on guard so they won't take you by surprise.'"[123] "The time has come for me to take off." But still Pissarro thinks he may be able to do it without Durand-Ruel. Durand-Ruel had abandoned him in his years of need. Why give the man the benefit of the dollar now? When eventually Pissarro makes up his mind to go with Durand-Ruel, the letters to Lucien are sheepish. We shall have to have put off our plans for a show of Pissarro and sons, he says. The market wants individuals. And Durand-Ruel's space is the better lit,[124] his clients the more reliable. It is clear by late December that Pissarro has swallowed his pride. But not until a letter of 10 January 1892 does he explain to Lucien that Durand-Ruel wants "a general exhibition of my works."[125] The reason for that hardly needs spelling out. Durand-Ruel still wanted to hedge his bets. He wanted to put Pissarro's recent work in the light of work he knew his buyers could tolerate. He wanted to read pointillism out of the record, and put Pissarro's present in contact with a marketable past.[126]

Retrospection, then, was far from being an innocent tactic in 1892. Pissarro knew that agreeing to it was in many ways admitting defeat. He was making his peace with the market, and saying goodbye (at least for the time being) to the idea of collaborative effort. He was giving up on the hope of avant-garde insurgency and self-support, to which he had stayed true for so long.

Is it any wonder, then, that the paintings he finished specially for the show in December and January were worked and reworked up to the last minute?[127] They were called on to do too many things. Salve a certain amount of guilt, perhaps, or at least turn compromise into triumph. Speak a language that the market would not be able to convert – or convert entirely – into its preferred (individualistic) terms.[128] Make the purpose of pastoral more explicit. Therefore risk affect. Be naive and simple-hearted, and attain to high unconscious symbolizations. From deep within the regime of privacy (and Pissarro never had illusions that his art existed anywhere else), dream of the public life.

Two Young Peasant Women, in the event, was held back by Pissarro from the market. His retrospective was a success, and attracted buyers; but he had his latest pictures returned to Eragny, worked on some of them again, and

gave *Two Young Peasant Women* to his wife, Julie – something he had done throughout his career with pictures he specially prized. Julie herself (to be crudely biographical for a moment) came from peasant stock. Her family owned two small vineyards east of Dijon. She had been a kitchen maid in the Pissarro household, twenty-one years old, fresh from the country, when Pissarro had fallen in love with her, and got her pregnant, thirty years before.

"Dream of the public life." If I am to make good on that claim, which obviously is the key one, I need to return to the question of what *Two Young Peasant Women* was of. Why (publicly speaking) are its two women peasants? Why are its peasants both women? And so on.

Pissarro knew very well that painting peasants in the 1890s meant inviting comparison with Millet and Breton (figs. 27 and 45) and a hundred other lesser imitators in the Salon. The same *L'Art français* that gave his retrospective such good coverage in March reproduced Breton's *June* the following month.[129] More than one critic in 1892 made the link with Millet explicitly, sometimes in order to put Pissarro in his place. The arch-Symbolist Kalophile l'Ermite (the kind of pseudonym Reclus and Pissarro were fond of) mounted an argument in *L'Ermitage* that Millet had been the true stylizer and seer – the true artist, in other words – whereas Pissarro had enslaved himself to the phenomenal world.[130]

What would Pissarro have made of this? How would he have responded to what Gustave Geffroy wrote of his paintings in *La Justice* (the organ, that is, of Clemenceau's Extreme Left)?

> The beings who live in these landscapes have been kept in their permanent places [*maintenus à leurs places permanentes*]. There is an accord of line and color between these people, these animals and the decor of this greenery and sky. An intimacy of earth, atmosphere, beast, man . . . These are not person-ages put in on top, posing for the painter in attitudes struck on call. Really, these peasant men and women are part of this nature, they could not be imagined anywhere else, and these landscapes would not be thinkable without them.[131]

That humans belong to the landscape they cultivate is true: it is a proposition Pissarro spent his life rephrasing. But did Geffroy's other positives follow from it, necessarily – above all, the value he apparently puts on utter peasant permanence and untranslatability (even as far as the market town down the road)?

Compare this, from Clément-Janin, the critic to whom Pissarro took the trouble to write in February – and with whose general line on his philosophy he said he had no quarrel. Again the paper that published Clément-Janin's review was firmly on the Left:

> Pissarro's temperament of a colorist has determined his philosophy: a sort of pantheism à la Jean-Jacques. Man disappears into nature. In the midst of the crushing grandeur of things, the king of creation reverts to the humble role our pride protests against, and appears no more than a motif for curious colorations, interesting silhouettes . . . We depend on the scattered forces of the world, as much as cows or trees or the stones on the highway. His peasants are bipeds who maybe have souls [*des bipèdes à l'âme incertaine*], fruits of the soil that supports them, as apples are of the appletree. Their architecture harmonizes with the rocks of the neighborhood, their large feet seem to root their toes in the earth. Evidently they feel no more than the

60 Jean-François Millet:
Man with a Hoe, oil on
canvas, 80 × 99, 1862
(The J. Paul Getty
Museum, Los Angeles)

rudimentary sensations of any organized being [*Ils n'éprouvent évidemment
que les sensations rudimentaires de tout être organisé*]...[132]

"Because in that situation our elementary feelings exist in a state of greater
simplicity..." Simplicity is one thing, mindless bipedalism another. Clément-
Janin is surely the kind of art-lover Nietzsche had in mind with his jibe at the
"innocent (idiotic)."

Oh! I know, painters just shrug their shoulders at stuff like this. It is
what art critics are paid to do. And Pissarro never had any illusions that a single
painting, or display of his life's work, would serve to open a distance between
his view of the peasantry and the figures of condescension and hero-worship in
the culture at large. He accepted pastoral as a fate. It was a given; he was inside
its realm of assumption; his peasants were reconstructed according to its dream-
dictates; most of those dictates were deeply flawed and opened almost immedi-
ately onto the worst forms of conservatism; and yet they still spoke to beauties
and possibilities he believed in profoundly and found nowhere else. Or they
might be made to speak. Of course at the start there would mostly be misunder-
standing. As I conceive him, Pissarro was a great (maybe foolhardy) believer in
the test of time.

None of this means he was simply unconcerned with present risks. Some of
them worried him a lot. The Millet comparison, for instance, was regularly
capable of setting his letters abuzz. He knew that Millet was another Monet
figure for him, an alter ego, without whom his painting would not have existed.
He hated what the Third Republic had made of the master. He never forgave his
painter neighbor at Eragny, a landscapist named Pozier, for bursting into tears
in front of the *Angelus* at the Millet memorial exhibition. "Idiot sentimen-

talism."[133] Why don't people break down in front of Delacroix? he said. Save your tears for Saint-Sulpice!

He knew Millet was a tragedian, a fatalist, whose bipeds would truly never escape their condition. And he knew that many of those bipeds had never been bettered for peasant physiognomy and movement (fig. 60). He thought – he hoped – that what he did with the schema turned it ideologically inside out. Don't talk to me about influence, he can be found saying to son Georges in 1889 (who seems to have been carping at his elder brother's borrowings from the Japanese):

> As for Okusay [sic], there's no harm in that. What [Lucien] is after is a synthesis of the effect of snow, and necessarily that connects with what the Japanese have done! Why is that surprising? It is like my peasants who people said came from Millet, but they've changed their minds, *they are too complete in terms of sensation* for people not to see it, only superficial viewers cannot tell black from white.[134]

Perhaps. As usual the dread word sensation is being called on to do a great deal of work here. And again, the special circumstances of 1891 rather disturbed this whole structure of thought. If it was necessary to push one's peasant painting a little further toward the monumental and anecdotal, then the very side of Millet one loathed might reassert its powers. *Two Young Peasant Women* seems to have started again with Millet – literally, naively. Its two figures were partly based on two Millet woodcuts, of a shepherdess and a man with a hoe (figs. 61 and 62), which Pissarro had owned since 1884. Millet's son-in-law had given them to him.[135] I interpret this as I do many other aspects of Pissarro's art in 1891. The year will not allow the implicit. Beliefs and borrowings have to be acknowledged, or at least clarified. They have to be brought up to the surface. Maybe in doing so it will be clearer what they mean.

61 (*below left*) Jean-François and Jean-Baptiste Millet: *Seated Shepherdess*, woodcut on paper, 27.1 × 21.9, ca. 1860 (The Metropolitan Museum of Art, New York, Rogers Fund, 1919)

62 (*below right*) Jean-François and Jean-Baptiste Millet: *Man with Spade*, woodcut on paper, 18.8 × 13.2, ca. 1860 (The Metropolitan Museum of Art, New York, Gift of Dr. Van Horne Norrie, 1917)

No need to exaggerate here. Pissarro's is still a modernist practice, proud of its pure technique and deeply disdainful of most of the surrounding world of ideology. It is almost sure technique can keep that world at bay. Yet the world comes to it. It sees the terms of fin de siècle appearing within the very precinct of the avant garde. Tricksters and neo-Catholics and Kalophiles l'Hermite. "All that the modern world requires most urgently . . ." A painter of peasants hears voices off-stage. People with things to say about his chosen subject.

La Révolte, for instance. Part of the reason anarchism appealed to Pissarro, I am sure, is that the great anarchists were geographers (unlike great socialists of other stripes, who tended to be lawyers and philosophers). Opening his paper in January and February 1891, Pissarro would have found a long series of unsigned articles called "Agriculture," in which the old tragic view of the peasantry was disputed – and equally, the new socialist platitude that the future lay with large-scale holdings and the end of the *petit propriétaire*. The essays were by Kropotkin, and were rewritten in the course of the year to make up *The Conquest of Bread*. Pissarro would hardly have started them before he came on this:

> Each time there is talk of agriculture, there is always the image of the peasant bent over the plough, throwing any old grain at random onto the earth and waiting in agony for what a good or bad summer will give him in return. You see his family working sixteen to eighteen hours a day and living in rags for their pains, eating dry bread and a meager ration of bad wine. In a word, you see La Bruyère's "wild beast."
>
> And for this man, bowed down by poverty, the best one hopes is to lessen his burden of taxes or rent. No one dare dream of a farmer standing up straight again at long last, having time for leisure and producing enough to live on, not only for his family but for a hundred others at least, with a few hours work per day. Even the socialists, in their wildest dreams of the future, dare go no further than the great farms of America, which in fact are no more than first steps.
>
> For us, these are dreams of the Middle Ages. For the tendency of agriculture in our own time and in the immediate future (we dare say nothing about the future beyond that) lies in a different direction altogether. The present tendency of agriculture is to increase the yield of a family's vegetable diet. On less than an acre, in the space that now is generally needed to raise a single cow, there will be twenty-five; the soil will be *made* by man, in defiance of seasons and climate; the air and soil around the seedling will be heated; in a word, a couple of acres will yield as much as used to be harvested from a hundred; and it will be done without wearing oneself out with labor, but with an immense reduction in the sum total of work – so that we shall be able to produce what is necessary on the basis of everyone farming the fields as much as they choose, for the pleasure of doing so.
>
> This is the direction of agriculture nowadays.[136]

A utopia, as Pissarro said later to Mirbeau. But followed up, in the articles appearing in spring, by Kropotkin's characteristic barrage of facts and figures on the new market gardening, fertilizers, greenhouses, strains of wheat, crop rotations. With behind it all – naturally, with the readers of *La Révolte* in mind – a final vision of the regenerative power of the new agriculture viz-à-viz the working-class movement. Anarchists had long been preaching the folly of

socialism's exclusive preoccupation with the city proletariat. The title of a pamphlet Reclus had brought out in Switzerland in 1880, *Ouvrier, Prends la machine! Prends la terre, paysan!*, spoke to their hoped-for double strategy.[137] And it was true, as their socialist opponents never tired of saying, that one vein of anarchism was deeply anti-urban. The true utopian moment of *The Conquest of Bread* is its imagining of the new countryside as a pole of attraction after the revolution, reversing at last the drift to the suburbs. Its language is typically anarchist:

> An end to frippery then! An end to dolls' clothes! We shall go back to the work of the fields and regain our strength and gaiety, seek out the joy of life again, the impressions of nature that we had forgotten in the dark mills of the *faubourgs*.
>
> That is how a free people will think. It was the Alpine pastures, not the arquebus, that gave the Swiss of the Middle Ages their freedom from kings and lords. Modern agriculture will let the revolutionary city do the same thing – free itself from the bourgeoisies of the world.[138]

The last phrase of Kropotkin's is "des bourgeoisies coalisées." It leads us from spring to summer 1891, and from *La Révolte* to the Chamber of Deputies. 1891 was a critical year for French agriculture, and French capitalism in general. The papers were filled with reports of a long series of debates, first in the Chamber and then in the Senate, over whether finally to respond to German, Russian, English, American, even Indian competition – opinions differed as to who was really the enemy – by putting an end to free trade. In particular, from our point of view, politicians argued endlessly over whether to save the peasant, who most of them thought was in worse shape than Kropotkin did, by building a customs wall – duties at the border on grain and beet sugar, livestock and processed food. The Republic had essentially made up its mind on these matters. It wanted protectionism, and in February 1892 it got it. The story of the next century of French agriculture was thereby essentially set in stone, with all that story's stubbornness and pathos. But the debates of 1891 were truly passionate and elaborate, partly because the peasant was at issue, and partly because any capitalist regime is always deeply in two minds about free trade versus protectionism. Like much else in the 1890s, this aspect of fin de siècle often has a familiar ring. I savor the moment (as did the socialist benches, apparently) when Léon Say, the eloquent defender of the free trade point of view, rounded on the Minister of the Interior with the verdict: "Protectionism – it is the socialism of the rich." To which the Minister replied: "And free trade is the anarchism of millionaires."[139]

The papers, as I say, were full of it. The days of most savage debate were in late April and early May, interrupted for a round of charges and countercharges on the subject of Fourmies. We know Pissarro was more than usually attentive to the bourgeois press at this moment – he was scouring the papers for facts about Fourmies, and told Lucien that *Le Temps* and *L'Écho de Paris*, and even *Le Figaro*, were for the moment the best sources.[140] Of course we do not know how much he read of the free trade debates. Still less how much he cared. The debates would have done no more than remind him of what the Republic was supposed to believe about the countryside, and why the peasant mattered to it. They put certain commonplaces in circulation again – maybe envenomed them a little. The debates were part of the year's harrying out of implicitness. Part of its flushing of everything up to the surface: I need claim no more for them than that.

"In Germany," says Paul Deschanel, president of the Ligue Républicaine de la Petite Propriété, toward the start of his great speech on 9 May,

> the tariffs on cereals have been fixed by M. Bismarck for the benefit of the feudal proprietors, the landed aristocracy.
>
> *Various members on the Left.* Just the same as with us! (Protests on the Right and Center.)
>
> *M. Paul Deschanel.* No! Not the same as with us! Here the soil is divided; it was put into the hands of our peasants by the French Revolution . . .
>
> Yes, it is for the sake of the people of the countryside [*la démocratie rurale*] that we have taken these measures.
>
> And the people of the countryside are not mistaken on that score . . .
>
> Remember, gentlemen, the deep crisis of agriculture in 1881 to 1884 . . . that long cry of distress, discontent and disaffection that arose from the heart of our countryside . . . Well, we took the cause of the peasant in hand; he sensed that the Republic was on his side; he had hope again, confidence, courage; and so, when, in the name of who knows what ambitions and designs, there came an attempt to disturb this work of rebuilding [he means the movement of opposition to the Republic led by General Boulanger, which in the late 1880s had come close to coup d'état], when certain great cities went over to the enemy, the peasant rose up! He with his robust good sense and fine feelings – he smelt out charlatanism when he saw it! (Applause on the Left and Center.) Let us render homage to this peasant of France, who rejected dictatorship and saved the fatherland![141]

Deschanel lays out the elements of the Third Republic's cult of the peasant almost too clearly. These were hard times for rural society: falling prices, foreign competition, and phylloxera had done their worst. A pattern of dearth and drift to the cities had taken hold in the 1880s that observers summed up in the words *la crise agricole*. The peasant stood firm. He had been more loyal to the Republic than the urban working class – a steadier voter, more sceptical of Right and Left. "Our victory is rural, not urban," (this is Jules Ferry in 1890) "the towns are rotten and remain so; it is the republican of the countryside who voted for us en masse."[142] The time had come to repay the peasant's loyalty, and protect the nation against an emptying, demoralized rural society, with production and prices spiralling slowly downward. Jules Méline himself, the prime mover of the tariff proposals – "the Torquemada of beetroot," one wag called him – put the matter in cold numerical terms. There had been 19,598,000 *agriculteurs* at the time of the 1866 census, and 17,698,000 twenty years later. This is a grave phenomenon, he said,

> because not only does it have economic consequences, but national ones. If the Minister of War were here today, he would be the first to admit that everything that diminishes our agricultural population weakens our army . . . Because the army recruits from them – I shall not call them its bravest fighters, for all our soldiers are equally brave – but the strongest, the most hardened, the most resistant.[143]

Depopulation was a touchy subject, of course. The regime could not resist spelling out its cannon-fodder implications, but they knew the topic abutted on others more frightful for national honor, like the falling French birthrate in general and rumors of peasant birth control in particular. One defender of free trade went so far as to raise the latter suspicion during the 1891 debates, and brought down the anger of the Chamber on his head. *Vives protestations sur divers bancs. Rires et bruit.*

M. Viger [Minister of Agriculture]: I protest absolutely! The people of our countryside take pride in the fact that they furnish the fatherland with so many of its workers and soldiers through their large numbers of children.[144]

Look back to Breton's *June* (fig. 45). I imagine Viger passing it in the Salon and glowing.

These are noises off. I do not expect that Pissarro had as much stomach for parliamentary debates as I do (he was never much of a masochist), and it does not need saying what he would have thought had he read them. Of course my selection of moments of maximum ideology rather misrepresents the argument as it generally went. There were columns and weeks of statistics, and lots of basic economic theory from both sides. (Curious to find the protectionists quoting Proudhon, of all people, on the folly of their opponents![145] But then, even Pissarro recognized his hero had a statist streak.)

For an anarchist reader, then and now, the debates make a good counterpoint to *The Conquest of Bread*. Here was an argument about the nature of the capitalist nation-state and state system, with classic expositions of the free trade and national security cases. Both sides inflected their arguments with May Day and Social Democracy in view. Several speakers thought Germany responsible for all of the above.[146] And never had it been so clear – this above all would have resonated with Reclus's and Kropotkin's readers – that the built form of the state was now very much more than a set of prisons, *palais de justice*, *fortif's*, *zones*, and customs posts. The state was a landscape. It was a pattern of agriculture and subsidy and monopoly and communication, whose forms had less and less to do each year with the facts of climate, geology, or regional specialization. These things were still in their infancy. Not even the gloomiest dystopian had an inkling of what was to come. The politics of water was still quite local and gentlemanly; the labyrinth of Farm Programs and Common Agricultural Policies was just a bureaucrat's bad dream; there were only the bare beginnings of monoculture, hyper-fertilization, genetic engineering and assembly-line meat production; few people had heard of scrapie and none of mad cow. But at least anarchists knew already in the 1890s that fighting the state meant thinking geographically and biologically. Mapping capitalism, that is, not just lapping up its statistics.

An end to frippery, then! An end to dolls' clothes!

The subject of *Two Young Peasant Women* is a form of sociability, and specifically of mental life, imagined as belonging to women. We know already that Pissarro was aware, acutely at just this moment, of the razor's edge on which such imagining stood – the risk it ran of romance or prettiness. The risk had to be taken, as I understand it, if a way was to be found out of Millet's great version of anti-pastoral. The deadliest aspect of that myth – and in many ways one might fairly call it *the* myth of the nineteenth century – was its vision of working-class consciousness. Mental life in Millet was wholly defined by the fact of labor; and defined here meant stultified, externalized, and all but extinguished. If, as an alternative, one wished to picture some kind of to-and-fro (and being-together in opposition) between labor and leisure, outwardness and inwardness, type and individual – and thus between the master terms Nature and sociability – then they would have to be shown as women's business. Because the world of women could be imagined as standing just a little outside, or a little apart from, the struggle with the realm of necessity.

What *Two Young Peasant Women* works hardest to figure, it seems to me, is a moment of uncertainty between people: one or both of them waiting for an answer, or thinking things over. Neither of them being quite sure – of their feelings, or of whether what one had said expressed them properly, or what the other would make of them. Again, putting the possible states of mind or forms of interaction here into words immediately hardens and trivializes them. The uncertainty is conveyed by pose, by spatial set-up, even by facial expression. Plotted more explicitly than Pissarro usually chose to, and maybe not entirely successfully. But above all the uncertainty is embodied in an atmosphere, a state of light. This is the picture's triumph, I think: that it gets its metaphor of ease and inwardness into the foreground air, into a shade that is palpable but not localized. An atmosphere that is there in the totality of surface touches, but never anywhere in particular – never marked, never epitomized. (The line of shadow that does appear between the two women, cutting across the dry earth – of course I am not trying to fantasize that demarcation out of existence – is like a parody or hypertrophy of how pictures normally conjure light and shade, and exactly does not establish the key of the picture's "lighting." Compare the key edge – the silhouetted or shadow-casting one – in a Monet *Haystack*.)

These women are working and talking. They are outdoors with no house in sight. It has got too hot to hoe. So take a break. Leisure is available in the interstices of work; not somewhere else, not allotted its own time of day or day of the week or forms and equipment. There is never enough of it, this leisure. Leonard Thompson can speak to that. But when it comes, it is charged and intimate and human, seizing on the instant and filling it with the thought of the previous mute hours. It is narrative, this leisure. Anecdotal.

The women are working and talking – the mere fact that the two words crop up in conjunction establishes the distance between Pissarro's imagining of labor and the nineteenth- (and twentieth-) century norm. They are talking, not gossiping; that is, their talk belongs to a community of two, intent on framing the particularity of an experience: it does not happen in a ring of women at the well or a group at the market, exchanging barbs and commonplaces. Not that the latter kind of exchange was incidental to the building of community. Of course not. But the folklorists had fetishized it – made it out to be what the discourse of community essentially was.[147] No one was saying the well and the market did not count. Pissarro chronicled both. It was just that such moments chimed in too easily with the notion of peasant society as all outward – all custom, proverb, and moral economy; and with the corollary idea that it did not make room for – did not depend on – quite other moments, more concentrated and individual. Taken together, these ideas confirmed the century's founding myth. Its wish to have work be the true Nature of a class.

Antwerp 7 January 91

Much revered Master,

I have the job of giving a lecture this February to the Twenty in Brussels and then to other artistic societies here, on the *Peasant in painting*. After following its evolution from the German Beham and the Fleming Brueghel, I close the study with the peasant *you have created*.

But I am afraid, master, of being too little informed about your work, having seen of it only those pictures which were shown at the Twenty two years ago, and having arrived in Paris last March just after your exhibition on the Boulevard Montmartre closed.

Recall that when I went to see it, you yourself having urged me to go all the same, I found few canvases still there.

Can you, master, make up this deficiency by letting me know, for example, *if a study has appeared* of your work; particularly *from the special point of view I wish to consider at present...*

Could I beg *a prompt word of reply?* It has taken me a long time to pluck up courage to apply to you. But that only testifies to the distance between the place you occupy in my admiration and my own humility.

Henry van de Velde
of the Twenty.[148]

Thus begins what seems to me the strangest, and in many ways the most brilliant, piece of the Pissarro jigsaw in 1891. Henry van de Velde was 27 when he wrote the letter. He was a painter and writer, and eventually became one of the prime movers in turn-of-the-century architecture and design. His paintings had been pointillist since 1888, with peasant life as their main theme. At the Twenty the previous year, for example, he had shown a picture called *Village Facts VII: Girl Mending a Stocking* (fig. 63). He had fallen under Mallarmé's spell, and counted himself a Symbolist. I suspect he already had passages of Nietzsche by heart – later he was chosen as designer of the Nietzsche archive. Certainly he knew the leaders of Belgian socialism, and was well read in anarchist and Marxist literature. He admired William Morris and Walter Crane, and in 1891 was reassessing his neo commitments. Out of that taking stock came his main entry to the 1892 Twenty, done in tempera, called *Project for Ornamental Embroidery* (fig. 64). With it the peasant in painting took a characteristic fin de siècle turn.[149]

We cannot be sure that Pissarro read *Du Paysan en peinture*. It is hard to believe that van de Velde did not send him a complimentary copy. If he did, there is no mention of it in Pissarro's letters. An extract from the lecture, centering on what van de Velde had to say about Pissarro, was published in the Brussels journal *L'Art moderne* in February 1891.[150] Again, no response. But

63 Henry van de Velde: *Village Facts VII: Girl Mending a Stocking*, oil on canvas, 78 × 101.5, 1890 (Musées royaux des Beaux-Arts de Belgique, Brussels)

remember that Pissarro was generally disinclined to give opinions on what was written about him; and be advised that if he had sat down to read van de Velde, he would soon have realized that the text was directed at everything he held dear. It is a true and magnificent homage to Pissarro's art. But as for peasant painting in general! As for the pastoral mode! As for utopian dreaming of Reclus's or Kropotkin's kind! If 1891 in general did not harry and ironize these things to extinction, it was not for want of *Du Paysan en peinture*'s pointing the way.

The text is a piece of socialist Symbolism. It is elliptical, ironic, grandiloquent, deliberately weird, deliberately wounding. Naturally it resists paraphrase. I am not at all sure I have caught its tone correctly, and certain that by the end of the text I am meant to realize that "tone" is too crude a metaphor to capture its self-consuming elation. Nietzsche, as I say, is in the wings. The lecture is a series of interconnected prose poems, in which the various appearances of the peasant in painting since Brueghel are passed in review. Partly these are meant to suggest (and they do so unanswerably, I think) that previous studies of the subject have failed to understand the stakes involved. The peasant, says van de Velde, is the very form of Reality in European culture – that culture which more and more saw itself, from the sixteenth century on, as defined by its wish, and ability, to stick to the world of things. The peasant is the Real, meaning Earth, Matter, Laughter, Skepticism, Bodily Renewal, Primitiveness, anti-Transcendence. So many pegs, essentially, for the bourgeois philosophy of life.

And because of that, the peasant in art is marvelous. Van de Velde's paragraphs on Brueghel and Rabelais, or his hymns of praise to beer, urine, and vomit in Dutch genre painting, or his passing comparison between peasant pictures and blackface, have never been bettered.[151] The prose is convulsed with anger at the conjuring trick it is describing, but nonetheless it Oohs and Aahs with the small child in the audience as the peasant rabbit comes out of the hat.

All of this is essentially preliminary to the lecture's last ten pages, which

center on Millet and Pissarro. The pages are climactic, and contradictory. I believe they are meant to play out the choices facing any painter of peasants at the end of the nineteenth century; and the further one goes in reading them, the more impossible the choices become. Of course on the face of it van de Velde is on Pissarro's side. He strikes a Kropotkin note. It is time for the tragic theatricality of Millet to be put to death. Modernity has arrived in the village, and agriculture is no longer a life-and-death struggle with the seasons. Railroads, fertilizers, and cheap insurance policies have changed all that.

What had to be done was to bring the Peasant closer to ourselves, and take him away from the factitious atmosphere of the theater. That stage on which the exaggeration of his gestures, and the visual heaviness of his poses, wore him out more than hard labor itself!

So Camille Pissarro sought him out . . .

His fieldhands no longer stand tall like heroes, and they make one suspect that the beauty of form belonging to their ancestors must have been a lie, or at any rate an exception; they make do with new, more complex shapes, more intricate and tortuous, in line with their diet of starches and scraps.

They are inclined to simpler, more servile, more external attitudes [*Ils affectionnent des attitudes plus simples, plus serviles, plus en dehors*], with real weather soaking into them at last, having them suffer its harsh cold and sunburn.

"– October, with its hoarfrosts, chaps the flesh of the young girls who mind the cows in the Eragny meadows, and the women who do the *Applepicking* [figs. 44 and 65, both of which van de Velde had seen at the Twenty in 1889] beat the trees and sweat in the real light of the sun."

This time, the Peasant evolves in the true humility of his work, bound close to a decor which is less episodic, less decorative, with the ring of truth to it, and so powerfully done that it holds the Being who moves within it in a

65 Camille Pissarro: *Applepicking at Eragny*, oil on canvas, 59 × 72.4, 1888 (Dallas Museum of Art, Munger Fund)

savage embrace, ruling him inflexibly, with all the weight of correspondences set up between Peasant and surroundings – creating a Peasant who at last is truly himself![152]

This passage is humane and suggestive, and obviously I had to quote it. But in the end what is most impressive in van de Velde's last ten pages is what happens before and after the evocation of Pissarro, and the way the before and after consume the body of painting they are meant to frame. Before is Millet. And Millet is the true hero of van de Velde's text, in spite of – or because of – his hyperbole and cant. The text knows that the nineteenth century has nowhere to go beyond the *Man with a Hoe*.

> The apparition of the Peasant in Millet is such an enormous fact, and such a work of excavation was needed to get back to the giant source of things through the rottenness that had invaded everything, that nowadays people like to say Millet "fumbled through episodes from the Bible."

This was a palpable hit. Pissarro was fond of calling Millet "too Biblical," and shaking his head at the fact that he, a Jew, found that a fault.[153]

> Why go so far to find the source of things that came, on the contrary, straight from the heart! . . .
> What Millet gave back the Peasant was space . . .
> And for the first time in Painting, the Peasant was really bound to the Earth! . . .
> Truly Hatred drives the Peasant on, making him punish the Earth interminably – that great sow the Earth, as capacious and invincible as the sea!
> It is Hatred, this endless hand-to-hand combat; an eternal flurry of foul blows, dirtying the Earth in everything She has most beautiful: flowers, which the Peasant abominates, and trees, which are his worst enemy, and which slyly he chokes to death if he is denied the ultimate pleasure of setting on them directly with an axe . . .
> If they love the Earth, these louts, it is in the way of monsters who love women for the living they get off them![154]

You will gather I am translating freely, leaving too much out; and also that translation is a lost cause. But I hope the English gives at least an idea of the temper of these pages, and the way they veer between celebration and travesty. There are six long pages on Millet – struggling with avant-garde condescension toward him, trying for a rhetoric to match the master's, berating him, glorifying him, establishing him as a horizon beyond which the century cannot pass.

Or not pass artistically. For here is the final message of *Du Paysan en peinture*, and surely the one Pissarro would have found the most truly discouraging. Of course Millet's peasant is a thing of the past, says van de Velde. The countryside is being modernized. And modernity puts an end to the possibility of representing the peasant – for modernity in the village epitomizes (brings to a head) the true banality of the late nineteenth century. Nietzsche, in the lecture's last two pages, vies with the Flaubert of *Bouvard et Pécuchet*. The present world is looked at through an architect's eyes:

> For a new decor is arriving, which will bring in turn a whole fatal, unconscious change of life; the new insurance policies will have done more than our most brilliant theories, our most ferocious attacks, to destroy that most odious of rural society's aspects – the Picturesque! They will have brought modernity to the countryside without even trying to . . . Do you not see it in the puerile new house that has just gone up, pink and cheery, fortune-teller of the village to come!

That is where modernity lives. She is straightening up the undisciplined cottages of times gone by. She has put them in pitiless straight lines, and where once upon a time they were painted all the colors of the rainbow, now they are pink – new and pink!

And in the midst of them rises the pompous new school . . . The imbecile enemy of legend and credulity, full of the vanity of the parvenu, giving itself the airs of a cathedral; fatting itself on the old blood-feuds of the countryside, so that its very sweat runs pink; huffing and puffing till it swells to the size of its rival, the Church . . .

And out beyond the village square, along the dirt roads rise up new farms, with their precious pink bricks all carefully protected by little straw hats of cropped thatch; and all their openings correct and rectangular, with blinds and shutters to match . . .

Modernity has cut everything down to size![155]

Y ou see now, I hope, why *Du Paysan en peinture* is the text that tells us most about Pissarro's situation as a painter in 1891, and why Pissarro passed over it in silence. For its version of modernism is unbearable. Everything we value in the past, it says – and that means all the dreams and duplicities the peasant was made to stand for over four centuries – is being destroyed by progress. Progress is odious and absurd; and yet we cannot argue that what we value in the past should survive, because it too was odious, even if not absurd; and because the price of it was misery, which progress ameliorates.

So what does a modernist do then? Find a way to make art eliminate the double perspective of past and future altogether, is one answer, since both are now horrible. Find a way to be truly banal, truly momentary; and have the artwork, by its very lunatic perfection, swallow up the false values which (of necessity) it will include or connote. No more Earth, no more Nature, no more Woman, no more Class. No more innocent (idiotic).

> To the Great Barn for drawing reed
> Since we could nowise chop a swede. –
> Flakes in each doorway and casement-sash:
> How it snowed!

L ong ago, talking of modernism, Clement Greenberg had things to say about the avant garde in the later nineteenth century and its double relation to politics. "It was no accident," he wrote (he was writing at a time when sentences of this form tripped easily off the pen), "that the birth of the avant-garde coincided chronologically – and geographically, too – with the first bold development of scientific revolutionary thought in Europe." (Let us include Reclus and Kropotkin under the rubric "scientific.") "Without the circulation of revolutionary ideas in the air about them, [the avant garde] would never have been able to isolate their concept of the 'bourgeois' in order to define what they were *not*."

But equally, Greenberg was of the opinion that what soon came to matter about modernism was its ability to resist the surrounding "ideological confusion and violence," revolutionary confusion included.

Once the avant-garde had succeeded in "detaching" itself from society, it proceeded to turn around and repudiate revolutionary as well as bourgeois politics. The revolution was left inside society, a part of that welter of ideological struggle which art and poetry find so unpropitious as soon as it

begins to involve those "precious" axiomatic beliefs [what I have been calling the "implicit"] upon which culture thus far has had to rest . . . Retiring from public altogether, the avant-garde poet or artist sought to maintain the high level of his art by both narrowing and raising it to the expression of an absolute in which all relativities and contradictions would be either resolved or beside the point. "Art for art's sake" and "pure poetry" appear, and subject matter or content becomes something to be avoided like the plague.[156]

These are justly famous sentences. Van de Velde would have understood them straight off. Much of what they say I agree with. At one level this chapter (and others in the book) are out to show what is meant by "ideological confusion and violence," and just why and how they are unpropitious for art-making. But of course the word "unpropitious" will not do on its own. Greenberg himself knew that modernism and the revolutionary movement were two faces of the same coin. He knew, and his language shows it, that the very idea of "precious" axiomatic beliefs being harried and winnowed in a great process of ideological struggle was very far from being unattractive to sections of the avant garde. "Upon which culture thus far has had to rest": there is a built-in proviso here, and one did not have to be a Nietzschean in the 1890s to round on it with a sneer. "Culture thus far" was coming to an end. Modernism would help in putting it to death.

This is not Pissarro's tone. Pissarro believed profoundly in Art (it is a word he often capitalizes in his letters, and regularly presents as an ultimate value, in no need of defense or explanation).[157] I think he feared a future cultural barbarism, and knew that painting was a fragile flower. One side of him, yes, "sought to maintain the high level of his art by both narrowing and raising it to the expression of an absolute." *Two Young Peasant Women* is such an expression. But I have been arguing that it only became so by opening itself to the welter of ideological struggle. Certainly in a way that threatened its maker's skills, and disturbed his normal economy of making. Yet in a way that was unavoidable, and that gave rise to something uniquely imaginative and sustained.

This last is my aesthetic judgement, of course, and I have tried all through this chapter to keep alive the fact that here, more than usual, it is likely other viewers will judge differently. But that is all right. I think it is time we threw this and many other judgements about modernism back in to the melting pot. It would be good for us to be able to retrieve even Maurice Denis's revulsion from *The Woman with the Hat*; or understand this, for instance, from the anarchist Symbolist Adolphe Retté, on the subject of Mallarmé (it is a typical piece of 1890s prose):

> In a word: morbidly in love with himself, gargling his verbal sonorities, weaving and warping them according to his fancy, just for himself alone, turning the penury of his creative faculties into a system, which he calls "refinement," lurking in a dark corner far from the social struggle, wearing as blason a frozen snake swallowing its tail on a ground of mist, Narcissus looking interminably into the unclear mirror, in which blink and gutter the feeble candles of the decomposition of art, prince of the highest impotence, behold the Decadent – thus, for those saved from his despotism, the appearance of M. Stéphane Mallarmé.[158]

I am not suggesting we retrieve the revulsion in order to share it. But so as to get back beyond canonization (which in modernism's case has been peculiarly deadly), and confront the extremity modernism was.

More than once in this chapter I have pointed to 1891 as a watershed in the history of modernism, and finally I should say what I mean by that explicitly. It has to do with the rise of Symbolism, and the Symbolists' wish to type the previous thirty years of avant-garde activity as positivist, naturalist, or materialist, and for that reason still deeply bourgeois. The arguments, as I have said, were mostly knockabout. Aurier was a poor theorist, and Pissarro not much better. But behind the catcalls and tautologies lay a real difference of opinion about ideas and materials in art, and about art's relation to bourgeois society.

The Symbolists' tarring of their opponents with the materialist brush is silly on its own. It does not remotely capture the complexity of Manet's purposes, say, or Seurat's, or even Monet's as those were developing in the 1890s. Lecomte and Fénéon made this point powerfully at the time, using Pissarro as prime example.[159] Equally, to call Bonnard and Gauguin and Denis idealists, or "Idéistes," seems not very helpful. Both sides put their stress, and pinned their hopes, on the physical substance of painting. Maurice Denis had published his "Definition of Neo-Traditionism" a few months before, which ever after would be quoted by modernists for the crudity of its opening lines. "Remember that a painting – before being a warhorse, a nude woman, or some anecdote or other – is essentially a flat surface covered with colors arranged in a certain order."[160]

The crudity was modernism's strength. Modernism was materialist where it really counted, when it came to the business of looking and making. Again Greenberg is good on this. "It did not matter that the individual artist was a professing Catholic or a mystic or an anti-Dreyfusard – in spite of himself, his art spoke positivism or materialism: its essence lay in the immediate sensation, and it operated under the most drastic possible reduction of the visual act."[161] Am I saying, then, that the differences between Aurier and Pissarro, or Denis and Fénéon, likewise did not matter, or at most were a kind of fold or eddy in a continuous (positivist) modernist flow?

Not quite. For obviously there were real arguments in 1891 – practical arguments – about the grounds on which engagement with the matter of art might now be sustainable. The disagreements had aesthetic effects – partly because they suggested different attitudes to the notions "substance," "medium," and "sign." They proposed different ontologies. And partly they were important because threaded through the portentous philosophy was another argument, just as fateful, about the relation of art to a possible public. The word "decorative," which everyone in 1891 (including Pissarro) wanted to lay claim to, is the prime indicator of that second argument's force.

Let me start on the surface. Seurat and Maurice Denis were both obsessed by the factual status of the painted mark. Denis, as I understand him, thought that this matter-of-factness could be kept vivid only if matter was pressed nakedly, paradoxically, into the service of its opposite, Idea. The stuff of painting was interesting only if it was recognized as the raw material of meaning – what we should call the signifier of some complex, intractable signified. Matter was a moment of signification. It never existed out of that artificial circuit. The belief that it did – that the material of signification might really open itself to some fact of material being, and in some sense recapitulate that fact, or improvise a wild equivalent for the shock of it, the intense totalizing uniqueness of it – was a fantasy of the bourgeois world.

By now you will recognize who, in my opinion, had that last belief as stated. But I should say that not only Pissarro, but Seurat, stood for a version of it. Seurat was an ironist. But what the dot ironized was as much the idealist's belief in an irreducible mere moment of signing as the materialist's dream of sensation recapitulated as it happens. Each utopia needs the other. "Signing" can never

exclude or stabilize the little word "of" and the metaphysics of presence that word lets in by the back door; "sensation" is only ever instanced by *this* mark, or this sequence of marks, *here* – and who is ever to say that the logic they follow is that of an experience they address, as opposed to an order of persuasion they fall into of their own (material) will? The circuit continues. The dot is a parody of each side's first mark on the tabula rasa.

Is Seurat just standing above the fray, then? No. In the terms that ultimately mattered in 1891, I should say he was on Pissarro's side. For the true paradox of this parting of the ways within modernism was as follows: that those who put their stress on the irreducibly constructed nature of art's "matter" laid the grounds for believing, as more and more artists did in the early twentieth century, that this construction could be an individual act of will. "Retiring from public altogether," to take up Greenberg's odd formulation. There is no logical necessity to this – rather the contrary. Nor was it true all the time. We shall see that in the case of Malevich and El Lissitzky, for example, their stress on the sign as profoundly arbitrary, and their belief that the world it posited was truly a fiction, led toward various forms of public and collective action. But still, the French case is typical. Exiting from positivism – casting aside the possibility of art's going back to the moment at which sensation *becomes* sign – is in practice exiting from the hope of art's inhabiting a public, fully translatable world. And that – more than positivism or materialism per se – had been the utopian motor of modernism from Courbet and Manet to Seurat and even van Gogh. (There is no "even" about it, in fact. Van Gogh believed in the material world, and art's responsibility to retrieve the shock of it, and to translate the shock into a new and fully public language, as no one had ever believed before. He was the Prince Myshkin of positivism. That after his death he became the model of alienated individuality, and the patron saint of visionaries, is I guess what simplicity gets for its pains.)

Some of this will be clearer if we focus on the word "decorative." It was, as I said, on everyone's lips in 1891. Georges Lecomte spoke to the Twenty in March the following year, and his topic summed things up: "Thesis: The concern for decorative beauty is the distinctive mark of our epoch in the history of Art." I doubt many in the audience disagreed. When Fénéon talked of Pissarro treating Nature "as a repertoire of decorative motifs," or Lecomte rang changes on the words "ornamental" and "synthesizing" in his catalogue essay, or another critic thought Pissarro's exhibition showed that his art cried out for the walls of the Hôtel de Ville,[162] they were reaching for the moment's highest praise. The issue comes up repeatedly between Lucien and his father in the course of the year. Whenever Lucien tires of his father's diatribes against Crane and the Symbolists, or feels himself genuinely hard-pressed, he reminds Camille that he too is in search of a simpler, more obviously artificial style. "And by synthesizing your figures and landscapes, are you not giving them a less episodic, more general character, and in consequence a more symbolic one?"[163] It is a question – a distinction – Pissarro *père* knows is difficult. He too reveres Puvis de Chavannes. He too admires Maeterlinck, the new favorite of the young, and for much the same reasons as Denis and Sérusier (figs. 66 and 67). "It [meaning Maeterlinck's *Les Aveugles*] is . . . simple and cold and terrible and very modern."[164] He takes the idea of the decorative seriously. By 1895 he is collaborating with van de Velde on the decor of a room at Bing's Salon de l'Art nouveau.

The key terms here – "decoration," "ornament," "synthesis," even "style" – shift wildly in meaning from text to text all through fin de siècle. And that is because they are called on to do the (magic) work, which modernism still believed possible, of soldering together the aesthetic and the social. On the one

hand, the word decorative had and has a pejorative undertone to it, even (I should say especially) when it is presented as a demystifying alternative to higher aesthetic values. Decorative means *merely* decorative – meaning overt in its simplifications, ostentatious in its repeated patternings, and unashamed of its offer of visual delight. It mocks the idea of a beauty distinct from prettiness, or glitter, or blinding coloristic shock. And it can rest easy in its mockery (here is the other, opposite work the word does) because it asserts that these are the qualities that allow Art to speak to the public realm. They are the qualities that prepare it – even if in reality the picture is no more than 35 by 46 inches – for the work of persuasion and chastening to come.

It would not be fair to judge this strategy by van de Velde's *Project for Ornamental Embroidery* (fig. 64) or Bonnard's *Dusk* (fig. 39). They are early works. Bonnard, we know, was later to make of the decorative – meaning the flimsy, the gaudy, the repetitive, the cheaply consoling – something uniquely passionate and regretful. His *Countryside* (fig. 68) is a cruel version of pastoral – a First World War version. And van de Velde was to move into three dimensions proper in the years around 1900 (fig. 69), and find his own show-stopping voice.

Nonetheless, I believe that in the form it mostly took in the early 1890s the decorative was a pretend solution to modernism's problems. It gave an alibi to weightless simplification, and coquetted with the idea of the architectural – hence presumably the social – while all the while pressing the visual arts toward whimsy and nostalgia. (It would take a Matisse to retrieve the tactic. Part of the reason Maurice Denis was so angry with him in 1905 was that he saw the indictment Matisse's art represented of most things done in the name of the decorative during the previous ten years.)

66 (*above left*) Maurice Denis: Sketch of Maeterlinck's *The Intruder*, pencil on paper, 1891 (reproduced in *La Plume*, 1 September 1891) (Bibliothèque Nationale de France, Paris)

67 (*above right*) Paul Sérusier: Sketch of Maeterlinck's *The Intruder*, pen on paper, 8 × 6.8, 1891 (reproduced in *Théâtre d'Art* program, 1891–92 season) (Collection Josefowitz)

68 Pierre Bonnard: *Countryside*, oil on canvas, 130 × 160, 1916–20 (Private collection)

This brings us back to *Two Young Peasant Women*. Certainly that painting was meant to be seen in relation to the jobs Pissarro had done in the 1880s as a decorator of fans. The fans were a not unimportant part of Pissarro's production. Their modesty was in their favor. Pissarro knew that the scale and format had loosened his drawing, particularly of the body, and given him license to compose with the kind of cleverness he otherwise was afraid of (fig. 59). He enjoyed the license, and part of his effort in 1891 was to find a way to import it into his full-scale paintings. There were five fans shown in the retrospective, including a particularly fine-tuned one called *Harvest*, done in 1890 (fig. 70). I think Pissarro hoped his viewers would look at *Two Young Peasant Women* with the little gouache in mind, and notice how the hard edges and fluent poses of the one bore a family resemblance to the other. We on our part can look back with hindsight to *Peasant Women Picking Grass*, done in 1885 (fig. 71), and wonder how much of a memory of its figures fed into the later, larger ones.

Two Young Peasant Women is decorative, then. But it is also profoundly an easel painting, with an easel painting's qualities: density of handling, solidity and nuance of form, intensity of atmosphere, complexity of affect. It is this careful negotiation between the qualities of a modernist past and those of a possible modernist future that in the end I admire most deeply in the work. I have said that Pissarro went along with contemporaries in adopting the word decorative as a value. So he did. But it was not the term he used most often, and

those he preferred in 1892 give us a clue to his hopes. He gave two interviews to the press in early February (again, a sign of the artistic times). The first was to Joleaud-Barral in *La Justice*:

> These are my favorites, the artist said to us yesterday morning, showing us his latest canvases. These are the ones that best represent my thought as an artist, the ones where I have realized my theories most completely.

He points to the *Peasant Woman Sitting; Sunset* (fig. 24), interestingly enough, and to another picture done earlier, in 1891, *Peasant Women Planting Peasticks* (fig. 72).

> These are my favorite paintings. In them I have tried to join the division of tones to a great exactitude of modelling, and to realize a synthesizing harmony of colors [*réaliser l'harmonie synthétique des couleurs*].[165]

The interview with Paul Gsell in *La Revue bleue* is a little longer and more informative. Pissarro talks movingly of his intimacy with Corot as a young man, and is proud of Corot's influence on him. Then he explains why his recent work has been done in the studio:

> I do not paint my pictures directly in front of nature; I only do studies there; but the unity that the human mind gives to vision can only be found in the studio. It is there that our impressions, scattered as they are at first, become coordinated, and bring out each other's qualities so as to form the true poem of the countryside [*nos impressions, disséminées d'abord, se coordonnent, se font valoir réciproquement pour former le vrai poème de la campagne*]. Out of doors, one can seize the fine harmonies that immediately strike the eye: but one cannot sufficiently interrogate oneself, so as to make the work affirm what one is feeling within. That is what my work is directed to – in search of this intellectual unity.[166]

The words are those he used constantly. Unity, harmony, synthesis, coordination, a reciprocal sorting out and clarification of impressions. But also feeling,

70 (top) Camille Pissarro: *Harvest*, gouache on paper, 28 × 55, 1890 (Private collection)

71 (above) Camille Pissarro: *Peasant Women Picking Grass*, gouache on paper, 19 × 60, 1885 (Private collection)

self-interrogation, theory, intellectual unity. *L'unité que l'esprit humain donne à la vision.* Paintings should be cognitive – that is, investigative and totalizing, rooted in the paradox of sensation – before they are decorative. "Decorative" means owning up too early to the realities of painting's actual social function. If one does that, harmony and synthesis will likely turn out to be no more than neat solutions to problems that were never very difficult in the first place.

These passages bring to mind a cryptic sentence or two in a letter Cézanne wrote to Émile Bernard. They form part of Cézanne's perpetual struggle to persuade Bernard (remember he had been Gauguin's most brilliant disciple) to put his art back in relation to eyesight. "Time and reflection," says Cézanne,

little by little modify the way we see, and finally comprehension comes to us . . .

It is only old residues [*vieux culots*, a metaphor from metallurgy] that obstruct our intelligence, which needs to be whipped into shape . . .

You'll understand me better when we see each other again; study modifies

our vision to such an extent that the humble and colossal Pissarro finds his anarchist theories substantiated [*que l'humble et colossal Pissarro se trouve justifié de ses théories anarchistes*].[167]

The word "theory" recurs. And the notion of study – long and hard looking, and reflection on that looking – actually changing the sensorium, or at any rate burning off our inert apprehension of what the sensory amounts to. Partly this is directed to a smug passage in an essay Bernard had published on Cézanne the previous year, 1904. Artists are never iconoclasts, he had said. "Far from them the infantile notion of surpassing the art of the past! The best painters, whether they are called Courbet, Manet, or Monet, are not out to make us forget Michelangelo . . . They are not anarchists who want to start the world over again and have it date from themselves."[168] I wonder, Cézanne replies. I wonder if modernism is really possible, at the highest pitch, without a utopian hope or belief that the process of representation might remake the world and our knowledge of it. And how else is such an idea to be fired except by a wild disdain for the past. Dross in the crucible! Waste that remains and kills. The whip! The whip!

72 Camille Pissarro: *Peasant Women Planting Peasticks*, oil on canvas, 55 × 46, 1891 (Private collection; on loan to Sheffield City Art Gallery)

73 Camille Pissarro: *Portrait of Cézanne*, oil on canvas, 73 × 59.7, 1874 (Property of Graff Limited on loan to National Gallery, London)

74 Camille Pissarro: *La Mère Presle*, oil on canvas, 73 × 60, 1874 (Private collection)

75 Unknown
photographer: Pissarro's
studio at Eragny, ca.
1903

Hanging opposite Pissarro's easel in a photograph of his studio taken
soon after his death is a mixture of old and new paintings (fig. 75). He would
have seen them each day as he worked. Given pride of place are two from the
1870s, the years of action in common with Cézanne. A canvas from 1874 called
La Mère Presle, of a peasant woman bringing buckets from a well (fig. 74). It
is one of the first of Pissarro's pictures in which the peasant figure predomi-
nated. A small painting, but evidently treasured. And the portrait Pissarro
had done of Cézanne the same year, showing his friend in aggressively rustic
uniform, posed against a strange (uncharacteristically up-to-the-minute) back-
ground of other images – mainly caricatures from the press (fig. 73).[169] Courbet
the beer-swilling Communard rampant top right. One of Pissarro's own studies
of a village street – trust him to choose the most modest and throwaway! – just
visible past Cézanne's sleeve. The odious Thiers top left, midwife to the Third
Republic – exulting in the bourgeoisie's ability to pay off the war debt to
Germany.

The room in the photograph is quiet. Contingency has ebbed away. *La Mère
Presle* is a dim shape – Courbet and Thiers barely visible. I forget what the anger
was about . . . But the wall was a daily reminder, nonetheless, of what theory,
study, and intellectual unity meant under modernist conditions. Out of what
ideological confusion and violence they came, and on whose shoulders they
might rest. So that "our elementary feelings might be more accurately contem-
plated and more forcibly communicated." "So as to make the work affirm what
one is feeling within."

Obviously these latter wishes and identifications are naive. It is open to
anyone to call them innocent (idiotic). I see why. I just feel the paintings on the
studio wall are testimony to what the wish made possible.

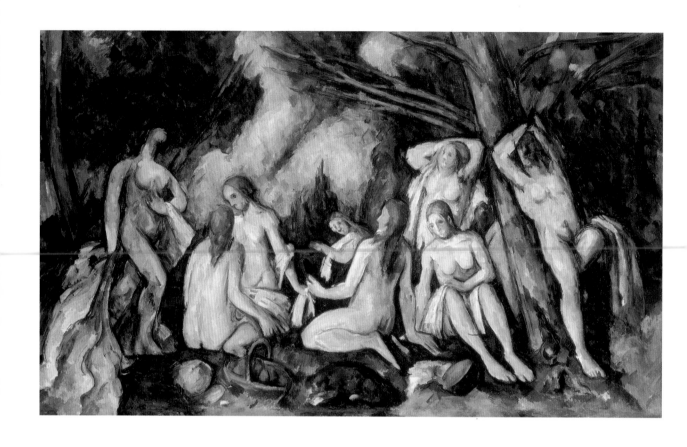

3 Freud's Cézanne

> The intention of this project is to furnish us with a psychology which shall be a natural science: its aim, that is, is to represent psychical processes as quantitatively determined states of specifiable material particles and so to make them plain and void of contradictions.
>
> Freud, "Project for a Scientific Psychology," 1895[1]

Modernism and materialism go together. This does not mean, any more than with modernism and socialism, that the fellowship was always recognized or welcomed at the time; or that, even when it was, artists agreed on which version of materialism to follow and exactly how. Cézanne, for instance, seems to have missed the point of Seurat's atomism (possibly because he had too few opportunities to see Seurat's paintings firsthand). Malevich thought the Constructivists were clanking along with weight-and-beam Physics as if Poincaré and Einstein had never happened. How many modernist Puritans had a place in their hearts for Bonnard – for his terrible restriction to the world of things? And so on. Strong materialists most often misunderstand each other. Mondrian's being able to recognize Pollock's matter-of-factness when he saw it in New York is the (heroic) exception that proves the rule.

There is no such thing as a tradition of materialism, then, in the art of the last hundred and fifty years. But I do not think we shall begin to understand modernism unless we look at the way it was seemingly compelled, over and over, at moments it knew were both testing-ground and breaking-point, to set itself Freud's task. Which is also Diderot's task, or the task of Enlightenment, or the task of bourgeois philosophy in its ruthless, world-breaking and world-making mode. Pursue it with Diderot's impudence and Freud's grim care.

Of the three large *Bathers* pictures Cézanne labored over for the last ten years of his life, the one that now hangs in the Barnes Foundation (fig. 76) seems to have been started first. Cézanne said to Émile Bernard in 1904 that he had been working on it for a decade.[2] That would put its beginnings in and around Cézanne's show at Vollard's in 1895 – the show that was the start of Cézanne's wider public reputation. It would suggest connections to at least two paintings we are sure had pride of place in that exhibition: the *Bather with Outstretched Arms* (fig. 77), whose deadlock of psychic forces it seems intent on resolving, and the even more enigmatic – and therefore seminal – *Bathers at Rest* (fig. 78). We know this latter picture was on Cézanne's mind. In 1895 it was already

76 Paul Cézanne: *The Large Bathers*, oil on canvas, 133 × 207, ca. 1895–1906 (Barnes Foundation, Merion Station, Penn.)

77 Paul Cézanne:
*Bather with Outstretched
Arms*, oil on canvas, 73
× 60, ca. 1880–85
(Private collection)

twenty years old. It had been the centerpiece of Cézanne's submission to the
third Impressionist exhibition in 1877, alongside the equally preposterous *Scene
by the Seaside* (fig. 79); had been duly savaged by the critics; and had therefore
lived on in avant-garde mythmaking as the ne plus ultra of Cézanne's early
work.[3] Here it was again. Cézanne showed it with other more recent versions of
the same subject in the Vollard retrospective, and some time in the years
immediately following – when the Barnes *Bathers* was certainly under way – he
chose to make a lithograph of it, in black and white and then in color.[4] He was
right, I think, to want to revive the old monstrosity, and even to insist on it as
the starting point for the work he then had in hand. Like so much else in
Cézanne's last years, the three large *Bathers* reach back to images and directions
that had been abandoned long ago, in the 1870s and even the 1860s, as if only
now the means were available to complete the dream-work then begun.

Bringing on dream-work, I realize, tips my hand. If you put the *Bathers at
Rest* alongside a typical scene of swimmers from the early 1890s (fig. 80) – the
kind it would have hung next to in 1895 – and then look for a word to
distinguish its tone and tactics of representation from what came later, the word
"dream" seems to me to come to mind irresistibly. Or maybe "nightmare." By
this I mean several things. Never, for a start, has a picture declared itself so
openly – so awkwardly – as made out of separate, overdetermined parts
coexisting only on sufferance.[5] The paint is piled up and up around the contours

of the bather in the center, or the one lying on the ground, or the smaller one at rear staring off into the landscape, and the build-up in each case seems intended to effect some final disengagement of figure from ground – some absolute, and no doubt absurd, isolation of the body not just from the others next to it but from *anything* else. Even from light (which snaps at the heels of the figure in the background like an ineffectual shark). The picture is paratactic. One can almost hear the dream-narration beginning. "We were in a meadow by a stream . . . There was a mountain in the background . . . An individual of some sort was lying on the grass with no clothes on . . . I couldn't see if it was a man or a woman . . . One arm was thrown up over its head, making a kind of pillow . . . One knee was bent double, so the genitals were hidden . . ."

And, of course, to say that what results from this is a compound of separate images is exactly not to say that the scene lacks unity. Just as much as a dream it is irrevocably (ludicrously) all one thing. It is shot through with visionary intensity. There will never be a moment like it again. Even the clouds seem to participate in the general dementia. They peer down on the poor bathers' doings with shocked solicitude, inquisitive despite themselves, like the gods in Homer. It is just what this charged momentariness might be about that is obscure.

78 Paul Cézanne: *Bathers at Rest*, oil on canvas, 79.4 × 100, ca. 1875–77 (Barnes Foundation, Merion Station, Penn.)

" 'In any case,' he added, giving his forehead a tap, 'painting . . . it's inside here!' ['*D'ailleurs,*' *ajouta-t-il en se frappant le front, 'la peinture . . . c'est là-dedans!*']"[6]

Choosing the title and epigraph I do for this chapter, and talking straight away about dream-work and psychical forces and so on, is not meant as preliminary to a Freudian reading of the three late *Bathers*. I doubt I could do one if I tried. In any case the Freud I quote is the Freud before Freud, still struggling to think the unconscious in a language borrowed from Helmholtz and Fechner. This is the Freud, ultimately, whom I take to be closest to the *Bathers'* mental world.

All the same, I have never understood why writers about Cézanne shy away from the strict coincidence of the ten years spent on the three large *Bathers* with those of the founding of psychoanalysis – the years of Freud's self-analysis and the publication of *The Interpretation of Dreams* (1900), the letters to Fliess, the treatment of Dora, the writing of *Three Essays on the Theory of Sexuality*. I like to think of the Barnes picture as roughly the equivalent of *The Interpretation of Dreams*, and the cooler atmosphere of the painting in the Philadelphia Museum (fig. 88) as corresponding to that of the *Three Essays*. Though I admit that still leaves me with the problem – it is the one I am furthest from solving – of the picture now in London (fig. 92). Would it help if we saw it as Cézanne's *Jokes and their Relation to the Unconscious*, which Freud published along with *Three Essays* in 1905? Ernest Jones tells us that the manuscripts of the two books were laid out on adjoining tables and dealt with according to Freud's mood.[7] The London picture seems to have been begun around 1900 and worked on right to the end. The Barnes picture, we shall see, was massively altered even after 1904. The Philadelphia picture makes sense as a product of maybe the last year or eighteen months of Cézanne's life.[8] For various reasons, I shall concentrate in what follows on the first and last of the series: the Barnes picture and the one in the Philadelphia Museum. Apart from anything else, the fact that they are hung within ten miles of one another means they are easier to look at comparatively.

Here, to begin, is a fragment of Cézanne's self-description. It occurs in Bernard's 1905 memoir. Cézanne is trying to explain to Bernard his horror of human contact, after a pathetic scene in the street the day before. He reaches back to an ancient memory. "I was going quietly down a staircase, when a *gamin* who was sliding down the bannister, going full speed, gave me such a kick up the arse as he went by that I almost fell down [*en passant m'allongea un si grand coup de pied dans le cul que je faillis tomber*]; the shock being so unexpected and unlooked for, it hit me so hard that for years I have been obsessed by its happening again, to the point that I cannot abide being touched or even brushed by anyone [*l'imprévu et l'inattendu du choc me frappèrent si fort que depuis des années je suis obsédé que cela se renouvelle, au point que je ne puis souffrir l'attouchement ou le frôlement de personne*]."[9] One can almost hear the analyst breathing a discreet sigh of relief. This patient's phantasies are close to the surface.

The Barnes picture is hard to see. It shows nine naked or near-naked figures in a clearing by a stream, some apparently toweling themselves and others just basking in the sun. There is a dog on the grass in the foreground and the makings or leavings of a picnic close by – a basket of fruit, a tipped-up bowl (or is it half a watermelon?). I think it helps to conceive of the scene as made up essentially of a central group of six women, their bodies and faces all interconnected, with two somewhat separate figures flanking them on either side. (There is in fact a seventh figure in the central group, disappearing behind the great right-hand tree. But he or she is vestigial to the plot. All the *Bathers* have figures which seem to have loomed larger in earlier states, but end up miniaturized or shadowy.) The two flanking figures are different from the central group, anatomically and physiognomically. Rather in the same way as in *Bathers at Rest*, a great deal of effort has gone in to marking them off, spatially, from the figures next to them. There is a tremendous notch of bubbling paint lodged between the towel held by the striding figure at left and the back and shoulders of her nearest neighbor, and, likewise, the gap between the elbow of the figure propped against the tree at right and that of the woman leaning in the opposite direction is filled up (to a depth of inches) with trials and errors at keeping them distinct.

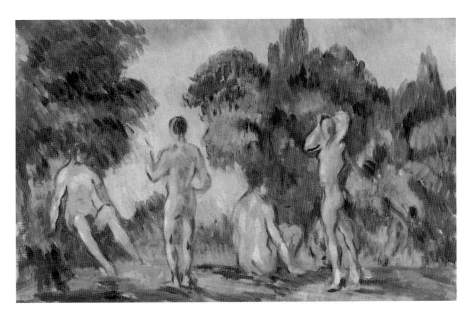

80 Paul Cézanne: *Bathers*, oil on canvas, 22.2 × 34.9, ca. 1890–94 (The Art Institute of Chicago, Gift of Mrs. T. Clifford Rodman, 1973)

Even to call the left-hand figure "striding" is to beg the question of her strange pose, which seems to be as much a matter of standing and displaying – look at her hand splayed out across her blue-green chest – as of walking in from somewhere outside. There is a quality of revelation to the figure, and of inruption and movement. Her great train of towelling seems dragged a bit reluctantly into the scene from an elsewhere below and in front of the picture plane. I shall call her the striding woman for short.

As for her partner on the right-hand side, I suppose I should say from the outset that he or she seems to me insecurely sexed. This is a matter of musculature and physiognomy, as compared to standard expectations for this kind of scene, and as compared with the specific (familiar) signs of femaleness in the bodies center-stage. And it is bound up with the curious energy of the marks that hollow out – gouge out, I am inclined to say – the empty space between the figure's thigh and upraised leg. They insist too much on absence, as if fearing or hoping that there was something there to be made absent – something which, as so often, the cancelling process partly reinstates. All this, I admit, is gross reading-in on my part. But the picture invites – I should say, coerces – such reading-in. Would there be agreement at least to the proposition that gender here is not fixed or self-evident? And could we further agree to take the pose and expression of the figure – its separation from the main group, the propping of the heavy body against the tree, the deep shadow across its face – to signify some kind of revery or inward-turning? I shall call it the dreaming figure. Of course I know the label is tendentious.

The dreaming figure is deeply linked, in pose and expression, to the figure stretched out on the grass in *Bathers at Rest*.[10] The two share the same shadowed, disconsolate face. They exist in the same interim between the sexes. It is as if Cézanne had waited thirty years to go back to his root figure of sexual differentiation, and put it (unstably) upright – turn it toward us and show what it lacked. Or as if the more distant figure in the 1877 picture – the one facing the landscape and seemingly daring it to do its worst – had swung round on its heel and revealed that it too belongs between genders.

When Jasper Johns turned to the Barnes *Bathers* in 1994 as the source of six ink-on-plastic *Tracings after Cézanne* (fig. 82), he took advantage of another obvious aspect of the dreaming figure's anatomy, which for some reason (as they say in the trade) I had overlooked. He noticed the line of shadowy blue going up vertically from the crotch, and made it unmistakably a penis.

Well, yes, I am embarrassed by my prudery – but having recovered for a moment, there is a side of me that wants to hang onto it. My wish not to see, or not to see separately, is also true to Cézanne's strange perceptual balancing act. Johns knows this. Some of his tracings are rudely explicit, others float the penis back into the complex of shadows (fig. 83). Tracings are necessarily reductive. The question (here and elsewhere) is whether the Freudian kind of reduction – phallus for shadow, and so forth – points seeing in the right direction.

Color in the Barnes picture is saturated. The tone is set by supercharged greens. The clouds building up in the background, the general suffusion of deep blues, the glistening yellow on the bodies in the center, a slight (and, on the whole for Cézanne, uncharacteristic) oiliness to the color, even in areas where the loading of pigment has turned the surface into a crust: these features all

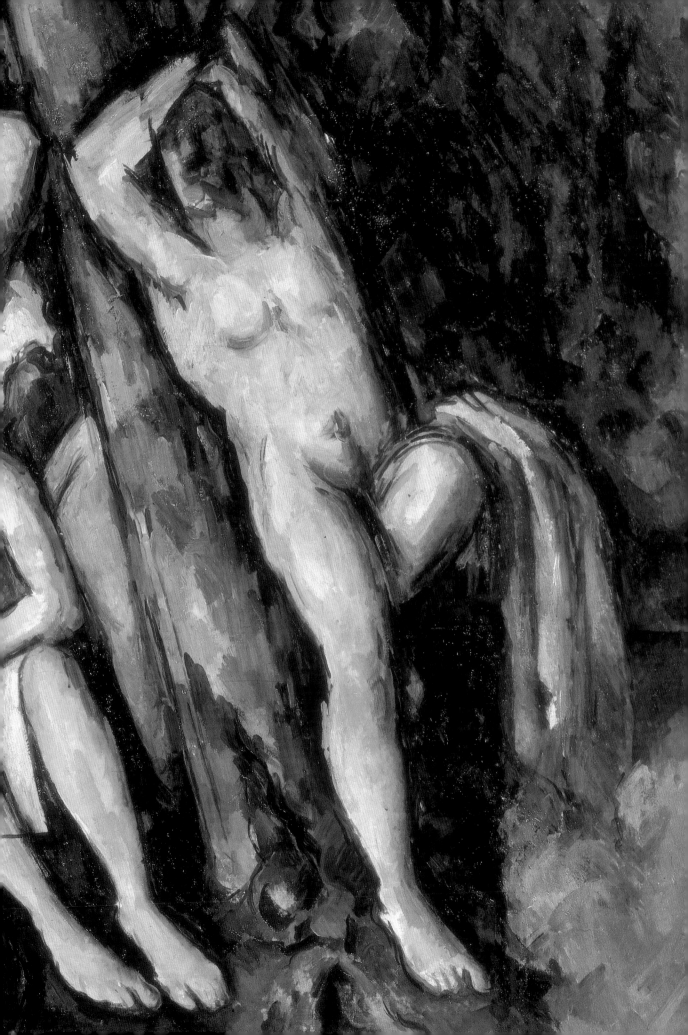

seem to license a reading of the scene's color as the product of actual humidity, at a moment shot through with sunlight but about to come to a violent end. Any second now the picnickers will hear the first clap of thunder. The dog is already hunkered down.

Of course this is fanciful. I am not saying that looking at the Barnes *Bathers* need necessarily turn on such a before-and-after narrative. But some sense of the momentary, a feeling of time here having stopped, some sense of the particular as opposed to the generalized – these do seem to me warranted, and in a sense necessary. Because the particularity of the light in this case goes along with – is support for – the particularity of the bodies. It is what seals the profound isolation and inwardness of each figure, above all of the two superintendents left and right.

Lowering Weather is a title Clement Greenberg is supposed to have suggested for the painting Pollock eventually called *One*. It would do even better for the painting we are looking at.

Hard to imagine trees more melodramatically phallic – their branches rigid and repetitive with the same useless assertion. Or a towel more like a honeymooners' Niagara than the one on the right, falling endlessly from the dreaming figure's knee and dispersing in spray at the corner. Or a rent in the clouds more ominous and all-devouring.

But I am going round the subject. I am trying not to look at the striding woman's head.

The head is not much of a metaphor. It tries to be literal about sex, and show us the phallus once and for all – show us what the phallus is, physically, anatomically, materially. "To make it plain and void of contradictions." Wonderful, hopeless, nineteenth-century project!

This is what I meant, essentially, by invoking the Freud of the "Project for a Scientific Psychology" at the beginning. I wanted to suggest that Cézanne's late *Bathers* would look less strange, or more properly strange, if they were connected to other such doomed, magnificent limit-cases in the history of materialism – moments at which materialism tried to confront the paradox its opponents cast most confidently in its face. Let me present you, say Freud and Cézanne, with a fully and simply physical account of the imagination. Let me show you bodies thoroughly subject, as we agree they must be, to the play of phantasy; that is, deformed and reconstituted at every point by the powers of mind. But let them appear as they would in a world where all the key terms of our endless debate – imagination, mind, body, phantasy, and so on – would be grasped, by the bodies and imaginations themselves, as descriptions of matter in various states. Then the world would truly be remade in representation. All of the mind's previous attempts to imagine its own deforming power would look pallid by comparison. Pallid because they did not understand what that power was *of*.

No wonder Cézanne's idealist supporters (the Symbolists and Neoclassicists who had kept his reputation alive in the 1890s and early 1900s) recoiled in horror when they saw the *Bathers* finally in the flesh. "Cézanne has no knowledge of the human body and has not worked out its laws; he goes naively ahead, inserting into the tissue of his patient and logical touches forms that are illogical, because ignorant and without foundation."[11] What kind of dreary academician would you expect this to be from? It is Émile Bernard, of all people, reviewing the Cézanne retrospective in 1907. Likewise Remy de Gourmont the same year: "Cézanne is everywhere at the Salon d'Automne. Everywhere his raw earth grays and terra-cotta reds, his washed-out greens, his dirty whites; everywhere his rotting carcasses of women [*ses femmes en viande pourrie*]!"[12] Both writers have the *Bathers* specifically in mind.

Maybe Remy de Gourmont's phrase is not completely off the mark, at least as regards affect. I take the Barnes painting to be a staging of some ultimate sexual material – ultimate for Cézanne, that is – which could only gradually be dragged into the light of day, and even more gradually (if at all) brought into order. It took ten years. We know that some of the key decisions in the staging were made more or less at the last minute. In the photographs Bernard took in 1904 of Cézanne sitting in front of his canvas (figs. 84 and 85) the striding woman has a very different body – longer-legged, more flaccid, less pneumatic and substantial – and her penis-head is as yet no such thing. She is bigger, but seemingly lacks sexual charge. (We know that figures in the *Bathers* regularly got whittled down over the years, as if to concentrate their energies.

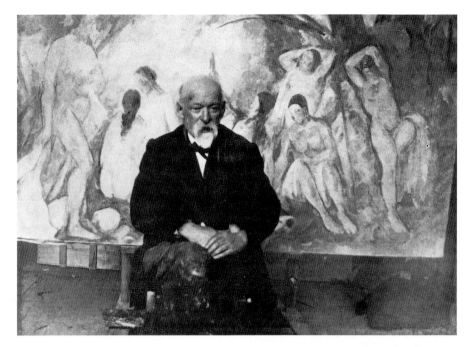

84 Émile Bernard:
Cézanne in front of *The
Large Bathers*,
photograph, 1904
(reproduced from Erle
Loran, *Cézanne's
Composition*)

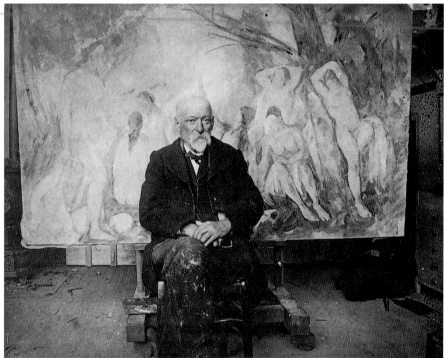

85 Émile Bernard:
Cézanne in front of *The
Large Bathers*,
photograph, 1904
(Musée d'Orsay, Paris)

Sometimes, as I said before, the process took on a life of its own and could not
be stopped. Look, for instance, at the wraith furthest to the right in the London
picture: she seems to have been smothered by the hatchwork foliage all around
her, and cut in two by the back of the bather next door. The striding woman,
then, is almost a special case, of shrinkage resulting in real jack-in-the-box
compactness.) The main lines of the dreaming figure were well established by
the time of Bernard's photographs, but it looks as though considerable work
went on after 1904 to fix, or unfix, the figure's upthrown arms, to flatten its

breasts (especially the one originally shown in profile to the right), and to carve out and darken the space between its thighs. Even to add the penis-shadow. That is, to turn the figure more and more into a hybrid.

Phantasy: "Imaginary scene in which the subject is a protagonist, representing the fulfillment of a wish (in the last analysis, an unconscious wish) in a manner that is distorted to a greater or lesser extent by defensive processes."[13]

"If we consider the themes which can be recognized in primal phantasies, the striking thing is that they have one trait in common: they are all related to origins. Like collective myths, they claim to provide a representation of and a 'solution' to whatever constitutes a major enigma for the child. Whatever appears to the subject as a reality of such a type as to require an explanation or a 'theory,' these phantasies dramatize into the primal moment or original point of departure of a history. In the 'primal scene,' it is the origin of the subject that is represented; in seduction phantasies, it is the origin or emergence of sexuality; in castration phantasies, the origin of the distinction between the sexes."[14]

Phallic woman, phallic mother: "Woman endowed, in phantasy, with a phallus. This image has two main forms: the woman is represented either as having an external phallus or phallic attribute, or else as having preserved the man's phallus inside herself."[15]

The Barnes picture, then, is a staging of that moment in the dissolution of the oedipus complex at which the threat of castration is so intense and overwhelming that the male child is unable to take the exit into repression; and instead remains frozen in a world where, in spite of everything, the Father is absent and the phallic mother's return is awaited. She will possess the phallus and restore it to her son. And everyone will have the same sexuality.

It shows us the moment of inconsolable clinging to infantile sexuality, the stage of psychic development which "knows only one kind of genital: the male one."[16] Freud called it the phallic stage. No doubt the moment is a dark one, and the subject – the dreaming figure – is locked in the cold snows of passivity and fear. Father has all the weapons. But the child will not give up. He refuses to renounce the mother as love-object. He will not accept the Symbolic – not accept sexuality as a structure of exchange. The body is here and now and integral. It can still exist, naked under the trees. Women are fearful, but only *these* women – the six women in the center – and in a moment the mother will have come again and made them whole. The storm will break. The fruit will get eaten.

You will gather that if I saw it as necessary or possible to psychoanalyze Cézanne, I would hazard the guess that in his case the moment never did dissolve, and that the late *Bathers* were his attempt to reconstitute a world of sexuality which, at some level, he had never left. Maybe the Barnes picture does reconstitute it – there has never been such an effort to materialize a phantasy world, to have it be palpable – but of course it also summons up its doom-laden atmosphere. There has never been a subject so constituted under the sign of loss and despondency as the figure leaning on the tree. Maybe he does not even see the phallic mother arriving. Maybe in a sense he does not want to. He is content to spend his life grieving for the body he once had. "The shock being so unexpected and unlooked-for, it hit me so hard that for years I have been obsessed by its happening again, to the point that I cannot abide being touched or even brushed by anyone."

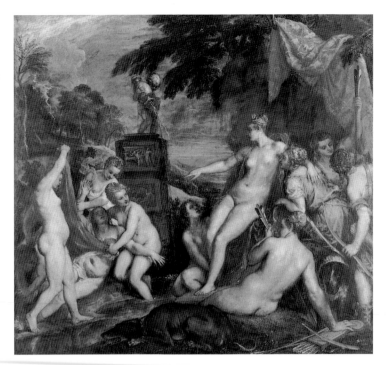

86 Titian: *Diana and Callisto*, oil on canvas, 188 × 206, ca. 1556–59 (Duke of Sutherland Collection, on loan to the National Gallery of Scotland, Edinburgh)

Dreaming and grieving are words too passive, I realize, to capture the agony of Cézanne's self-identification here. For part of the dreaming figure's femininity – I have slipped into calling it "he" in my text, but only for convenience – has to do with the way its basic outline of arms and shoulders against the tree carries with it the shadow of so many nineteenth-century images of women held sexual captive.[17] Andromeda and Angelica, the harem and the bandits' cave. This is bondage as much as reverie.

Maybe somewhere back of the Barnes picture lie memories of Titian's two great primal scenes, *Diana and Actaeon* and *Diana and Callisto* (fig. 86), which similarly turn on seeing the unspeakable and paying the price. The striding woman is Actaeon, roughly, but also the pitiless nymph in Titian's other picture lifting the drapes from Callisto's giveaway stomach.

If we are looking for the ultimate source of the dreaming figure in Cézanne's art, I think we have to go back even further than *Bathers at Rest*, to the gloomy hermaphrodite on the right of the *Temptation of Saint Anthony*, done in 1870 or thereabouts (fig. 87). Theodore Reff long ago identified this as a crystallization of Cézanne's guilt and remorse.[18] Only what at that stage had seemingly been guilt at having (in phantasy) too many genders becomes, in the Barnes painting, sadness at never quite attaining to any – or never quite being able to do so in a way that wards off the *gamin* on the stairs.

The script, as I say, is easy to write. This patient's phantasies are close to the surface. Or rather, they are on the surface – that is the point. A tremendous, interminable effort has been made to have the existence of the body in phantasy be literalized, made present as so many "quantitatively determined states of specifiable material particles." We should not be surprised if the effort finally opens onto a scene and dramatis personae which seem almost to illustrate "On the Sexual Theories of Children" or the "Analysis of a Phobia in a Five-Year-Old Boy." What is surprising is that the return of the repressed does not shatter

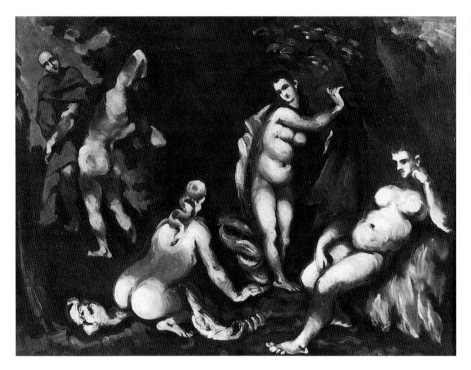

87 Paul Cézanne:
*Temptation of Saint
Anthony*, oil on canvas,
54 × 73, ca. 1870
(Collection E. G. Bührle
Foundation, Zurich)

Cézanne's empiricism so much as drive it on to a last ferocious effort at "realization." Bodies summon forth the phallus as their symbol, says Freud, because what most of all has to be symbolized is the absoluteness of each body's identity, its self-enclosure and inwardness. We are all like the dreaming figure at heart. We all need a tree to lean on.

The real difficulty (and real power) of the Barnes *Bathers* is thus not that it follows some specifiable phallic scenario, but that it never gives up trying to imagine that imagining in material terms. The more the material of phantasy bubbles to the surface – and the tortured surface of the actual oil paint is itself a kind of literalization of this *Acheronta movebo* – the more the representation insists on phantasy's inhering in a world of bodies, sensations, sights, shocks, touches, *coups de pied dans le cul*, "quantitatively determined states." And who is to say that this ambition distinguishes Cézanne from the Freud who was his contemporary, as opposed to making him Freud's most literal interpreter? I talked of the Freud who wrote the "Project for a Scientific Psychology" in 1895 being the Freud before Freud, but of course there is a sense in which the Freud who wrote *Three Essays* and *The Interpretation of Dreams* was just as belated or premature – a sense in which Freud never stopped struggling to convert his insights back into systems of neurons and quantities of excitation.

> Let us picture a living organism in its most simplified possible form as an undifferentiated vesicle of a substance that is susceptible to stimulation. Then the surface turned towards the external world will from its very situation be differentiated and will serve as an organ for receiving stimuli. Indeed embryology . . . actually shows us . . .[19]

Present-day readers of Freud tend to skim such passages, which crop up all through the later work – the one quoted here is from *Beyond the Pleasure Principle* – or denounce their "scientism." I imagine Cézanne's reading them all agog.

We might think of the final alterations made to the striding woman as the point where the patient finally takes over the analysis and tells the analyst what he or she has been waiting to hear. At last it is revealed what the previous bodily symptoms – in this case, from the look of the figure in the 1904 photographs, gigantism and flaccidity – were always most deeply of. Not that the patient's taking over the analysis is necessarily the sign of, or even preliminary to, the patient's being cured. Some truths, as Nietzsche never tired of telling us, are best not blurted out. Prognosis in this case seems bleak.

Let me turn to the picture in the Philadelphia Museum (fig. 88). And of course in this case the lecture hall phrase "Let me turn to" is, even more than usual, ludicrously bland. "Let me wrench myself away" might be better. "Let me look deliberately in the opposite direction." For in all sorts of ways the Philadelphia painting seems meant as Barnes's contrary, not to say corrective. It is colder and more consistent. Blue rules over green. The whole thing stands, maybe a trifle stiffly, on its aesthetic dignity.

A lot here depends on change of format. The Philadelphia painting is as high as the Barnes painting is wide, and a foot and a half longer. It measures 82 inches by 99: decisively larger than its two predecessors, and visually registering as a vast – a truly scaleless and all-encompassing – square. It is utterly unlike the previous packed rectangles.

How this alters the way the scene presents itself is hard to say. Clearly it means that the picture surface comes off looking less cluttered and impacted, and the nature of Cézanne's handling, we shall see, reinforces this. There is room to show the river the bathers have emerged from. One of them is still swimming, half way across. There are other, smaller figures on the far shore. A wood, a steeple, a cloud bank which keeps its distance (unlike its airbag predecessors in Barnes and London) and even manages to look decently vaporous. But I do not think that the painting registers – from any reasonable viewing distance or position – as any the less insistently of bodies. I do not think the new format puts those bodies convincingly into a landscape, or even establishes a balance (this is a word that comes up often in connection with the painting) between bodies and setting or figures and Nature. I am not sure Nature gets much of a look-in. Nor do I feel that the figures seem fitted or constrained by the framework of trees above them.[20] It is more as if the great surface and structure in the picture's upper half, which for some reason had to be this gigantic and schematic, had been extrapolated out of the figures – especially out of their interleaving postures and gestures. I would say that the setting confirms the unreality of the figural scene below: that is, its quality of intense generalization, the insistent rhyming and redundancy of its key shapes, the look the figures all have of obeying a strict but obscure choreography. It is not that constraint is the wrong word for the way these individuals carry themselves, and even for some of their facial expressions; but the tension and repetition seem to me generated out of the bodies – out of the effort at fixing and placing their typical states – not out of some abstract imperative to have them bend with the tree trunks or line up parallel to the picture plane.

Ever since the Philadelphia picture entered the public realm – it and the London painting were shown in the Cézanne retrospective of 1907, while (perhaps understandably) the Barnes picture was kept under wraps – people have talked of its being unfinished. The talk seems misleading to me. Of course paint is applied more thinly and evenly than in the other two *Bathers*, and there

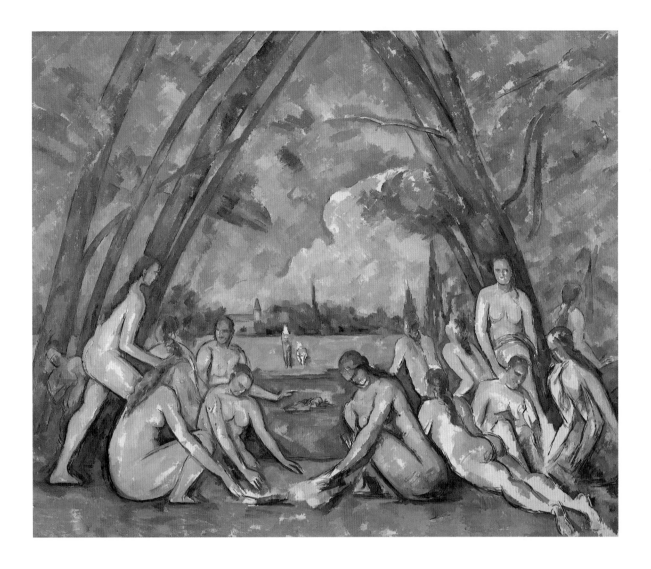

is an amount of bare canvas showing. But in all senses that matter this picture is the most definitive of the three. Its unfinishedness *is* its definitiveness; and it is an unfinish that comes out of forty years spent meditating on what a conclusion in painting could be. This is a conclusion. It states what the conditions of depicting the body in the world now amount to, and it does so with utter completeness.

I have to justify that verdict, and in order to do so I shall focus on a pair of figures to the right of the picture that seem to me to epitomize the work of representation as Cézanne now conceived it. I shall treat the figures as emblematic of modernism – above all, of its cognitive ambitions. There is a danger in this, I know. Extracting one or two figures from such a tightly woven mix is bound at one level to traduce the picture's (and modernism's) main point. Language, as usual, will pile up descriptions and qualifications, and treat what it talks about as self-sufficient. It will totalize with a vengeance. But the two figures are, I am convinced, an epitome of everything around them: they bring to the surface the ways this picture's language – this picture's approach to phantasy – differs from that of the *Bathers* in the Barnes. I shall describe and reflect on them, and then draw back to the picture in general.

At the far right of the painting (fig. 89), overlapping much the same treetrunk as had supported the dreaming figure, is a woman squatting or kneeling. We

88 Paul Cézanne: *The Large Bathers*, oil on canvas, 208.5 × 251.5, ca. 1904–06 (Philadelphia, Museum of Art, Purchased with the W. P. Wilstach Fund)

read her pose, which peters out toward the bottom into shadow or some other obscurity, by analogy with the figure squatting at the center – or, if we know the London picture, with the similar figure there, placed more or less in the same position as hers. The kneeling woman is seen in profile, but with her body swivelled slightly in our direction. Her shoulders are curiously hunched and contracted. As usual in Cézanne, you can find echoes of the set of the shoulders elsewhere – in one of the pair of standing women at the back of the same group, staring off across the river; and in the London picture, in the terrifying woman whose face is revealed to us center left, shadowed and scarified with the wrong end of the brush. But however much we try to help along our reading of the Philadelphia figure's shoulders by seeing them as variants on others less odd – well, somewhat less odd – the shoulders will never quite settle down to be shoulders. And that is mainly because they are buttocks and legs as well. They seem to belong to a second figure, standing upright, whose head and shoulders and right arm can be seen just above. It is a moot point, of course, which figure of the two is seen first. But pretty soon both are. And once they are, it is impossible to settle for either of the two possible readings of the play of marks that make up buttocks or shoulders. Enough has been given by the paint to make both readings necessary. The configuration just is more plausibly, more easily, a standing woman seen from behind than a squatting woman seen from the side. And yet it cannot be, or cannot be once and for all. The squatting woman's face and hair are there where they should be.

M aybe this episode has been discussed as little as it has in the Cézanne literature because there is something ludicrous or worse about having to talk about buttocks and shoulders melting into one another. If only Cézanne had chosen to play duck-rabbit with some slightly more mentionable part of the human anatomy! But he did not. And bodies in general in the *Bathers* are ludicrous or worse. That is part of Cézanne's materialist point. (I remember years ago seeing a comic routine about the London *Bathers* in which two idiot visitors to the National Gallery were impressed by Cézanne's ability to make the figures' bottoms "follow you round the room." Not bad criticism, I thought at the time.) I want the faint air of embarrassment here not to be dispelled by anything I go on to say.

Freud, of course, would have had a word for it. Two in fact: condensation and displacement. And no doubt condensation is the word we want – one figure, that is, standing for more than one possible dream-content – but the notion of displacement will never, in my experience, entirely go away. First, because there is a sense – a visual sense – in which you go on seeing the one reading as suppressing or getting in the way of the other. They never do quite coalesce. And second, because the sense built into "displacement" of actual shifting in space – as opposed to dreamlike (non-actual) belonging together – seems appropriate, again, for Cézanne's brand of empiricism. Even when he wants to show us the body's interminable shifting and reconstruction in the space of desire, he wants the space to be literalized and the body's states to be individually solid as a rock.

Dr R. in my dream about my uncle with the yellow beard [this is Freud in *The Interpretation of Dreams*] was a . . . composite figure. . . . What I did was to adopt the procedure by means of which Galton produced family portraits: namely by projecting two images on to a single plate, so that certain features common to them both are emphasized, while those which fail to fit in with one another cancel one another out and are indistinct. In my dream about my

89 Cézanne: Detail of fig. 88

uncle the fair beard emerged prominently from a face which belonged to two people and which was consequently blurred; incidentally, the beard further involved an allusion to my father and myself through the intermediate idea of growing grey.[21]

"Composite figure" is almost right, but I want a form of words that respects the fact that in the Cézanne the projected images have not quite cancelled each other out, and never will. "Indistinctness" and "blurring" will clearly not do. Sometimes I want to opt for "transparent figure," but that would misrepresent the measure of materiality in the case. There may be bare canvas showing, but that does not rob the buttocks/shoulders of their massiveness. On the contrary it confirms it. The bare canvas is light, which catches and fixes the points of maximum salience. Would "figure of displacement" do? Or even "the figure in two places"? They are a bit cumbersome. I shall opt for the simpler formula: "double figure."

F reud's musings on Galton in *The Interpretation of Dreams* link back to a whole world of late nineteenth-century psychology and physiology, which Cézanne too could hardly have lived in ignorance of. People in the 1890s were interested in the power of suggestion in human affairs – in hypnosis, notoriously, but also in the way ordinary acts of perception were open to interference and misdirection, almost as a matter of course. A lot was at stake here for the culture of positivism. And certain kinds of optical illusion or visual ambiguity were common ground to participants in the debate: they were taken as convenient test cases. "Drawings that can be seen two ways [*les dessins à double jeu*]," says Paul Souriau, for example, in *La Suggestion dans l'art*, "which have been for a dozen years now *the question of the day*, bear witness to this selective power of the imagination. As such they have real psychological interest."

Thus, you are shown an engraving from a distance which represents a death's head. Look at it closer; now what you see is two children at an arched window: the window opening is the edge of the skull, the two children's heads are its eyes, etc. . . . The effect produced at the moment you pass from one interpretation to another is very like that of a pun. You can make one or the other image appear by fixing your attention on one of the details of the figure, or looking at it as a whole. Sometimes, when you are considering these drawings, a sort of conflict or alternation is established between the two interpretations which recalls the antagonism of colors in the stereoscope. You perceive the image as a whole [*l'image composée*], then an instant later, and without knowing why, the images that make it up [*les images composantes*]. No doubt it is because the field of vision, as Wundt remarks, has a tendency to expand and contract by turns.[22]

It is a special intellectual world. (Souriau's book was published in 1893. Wundt had brought out his *Hypnotismus und Suggestion* the year before. Galton's offering for 1893 was *Decipherment of Blurred Finger Prints*. His method of composite portraiture, promoted in the 1880s, had arisen from an interest in inherited characteristics, and concomitant hopes to "improve . . . the racial qualities of future generations."[23]) I am not suggesting that Cézanne belonged at all closely to this world, or necessarily shared its assumptions. I hope he did not. But some of its imagery he seems to have been able to draw on.

I take the double figure in the Philadelphia picture to sum up two basic conditions of knowledge and representation as Cézanne came to understand them. First, that our representation of bodies – our own and other people's – just is some such process of interchange and duplication, of unstoppable weird empathy, of our somehow putting an internal sense of what being in the body feels like into our picture of how another body looks. (Of course that empathy informs our looking at everything: it is just that looking specifically at the body makes the odd and uncontrollable nature of the process declare itself. The weirdness of the *Bathers*, to repeat my previous point, is what they most deeply have to say about what seeing the body is like. The double figure is the emblem of that.)

The rest of the picture is full of the same thing. At point after point, parts of bodies seemingly run into each other at high velocity, or a line of intersection between two or three of them becomes an expanding zone that both or all bodies lay claim to. The most poignant and overdetermined of these areas – the one that for some reason I find I cannot tear my eyes away from – is the one in the middle of the group of five women toward the left. There the striding woman's hand explodes into the hair of the woman crouching in front of her; the crouching woman's face flushes and flattens; one possible contour of the back of the woman turning away from us has been allowed to stray across the arm of the figure next to it; and the whole area between the five figures – the area that ought by rights to be simply the turning woman's lower back – comes to seem more and more a metaphor for what the five women share, almost the five figures' true physiognomy. But this is only one incident among many (and I know my description of it glamorizes a strangeness that creeps up on the viewer more slowly, and less in the mode of paradox, than language is good at registering). If one wants a simpler example – in its way just as poignant – I would choose the hand of the woman standing against the tree at right: the way her hand opens into the gray on the neck of the figure in front of her. As if reaching out to that figure's dejection.

I said two conditions. The other is maybe even more basic. Bodies, says the double figure, can never be made to exist at a determinate distance in representation; they never finally and unequivocally settle down *here*. Or rather – and at this point we could narrow our looking to the figure standing with her back to us, and try to stabilize the relation of her head and shoulders to her buttocks and legs – no body, however singular and strongly bounded, occupies just one space. Not even the *Bather with Outstretched Arms*. The parts of a body, and the movements and positions of those parts, generate different and incompatible imaginings of their surroundings – different scales, different degrees of empathy and identification, different intuitions of distance or proximity – which simply cannot (ever) be brought to the point of totalization. Because in the case of bodies (to make the point about empathy again, slightly differently) *we are* what fills, or reaches out to, the space another body occupies; and the space gets multiplied by our imagined acts, by the plurality of our own experience of our body getting beyond us.

This, as I say, is everywhere in the picture. It is the picture's main subject. Maybe we should understand the double figure as opposed or counterbalanced, conceptually, by the strange pair of much smaller bathers right at the picture's center, looking at the scene from the other shore (fig. 93). Nothing could be more rigid and separate and self-sufficient than these two: both of them with blank squares for faces, one standing at attention like a figure on a tomb from Thebes, the other looking equally stiff, but seemingly toppled over on its back in extreme foreshortening. (They hark back – for want of a better point of reference – to the two impossible children romping on the riverbank in *Scene by*

the Seaside, the one silhouetted and symmetrical against the light, the other sprawled headlong across the grass. Is the child who falls headlong the *gamin* sliding down the bannisters? Or perhaps Cézanne's immediate vengeance on him?) No one has ever been sure of the smaller bathers' gender, but the stiffness and pathos of distance seem phallic. We do not need the church steeple to know what kind of a landscape we are in. These are figures of pure outsideness, of viewing at (from) the vanishing point, of the body of another at last put away from us, in a space we do not (and could never) occupy; and therefore these can only be diagrams of bodies, so many fallen or frozen geometries as opposed to the real thing. The real thing is here where we are – in "the scene where the subject is a protagonist" not an onlooker. Remember Pissarro's self-instruction: "So as to make the work affirm what one is feeling within." Or Cézanne's explosive "La peinture . . . c'est là-dedans!"

Maybe the best way of understanding the shift between buttocks and shoulders, then, is as a figure of one body necessarily being in another, entering every body it encounters, always and interminably reading the configurations someone else's body takes by trying them on for size; and occasionally managing the conjuring trick as whimsically (meaning, as completely and preposterously) as this.

Which would be to say that this is the final figure of Cézanne's materialism. That is, his plainest attempt to rewrite phantasy in material terms – as an actual (brutal, funny) displacement of one totalization of matter by another.

What would it mean, in other words, to materialize the play of phantasy? It seems the answer is a kind of literalization of the notion of the body's being always subject to movements of substitution, replacement, shuttling between possible places or identities. A literalization of metaphor, we might say. And even this form of words is too highfalutin'. On one level the main thing about the buttocks/shoulders configuration is the sheer crudity, the straightforward desublimatory force, of its picture of bodies imagining each other. Imagination be damned! It is physical entry or incorporation that bodies want. Empathy is intercourse lightly disguised. This too – this moment of sudden, interpolated *vulgar* Freudianism – reminds me of Freud himself.

But ultimately I stand by my slightly grander form of words, because to talk of the Philadelphia painting as trying for a literalization of metaphor does speak, I think, to its overall abstractness of drawing and color. And it points to the way the picture's ambitions differ from those of its neighbor in the Barnes. (Remember that in 1905 and 1906 the two paintings would have been worked on physically side by side, or back to back. Though I suspect that one had to be covered up or turned to the wall in the studio for the other to continue.) In some sense the Barnes picture was still committed to the idea of going beyond or beneath metaphor to some bedrock of experience that had originally given it birth. It was going to show the body coming on – or coming back – as it really was. Not nude but naked. The Philadelphia picture is not exploratory in the same way: it is not archaeological. Two of Freud's recent interpreters say at one point that what marks off his notion of phantasy from others is the degree to which he attributes to the phantasy itself – not to some "experience" from which it is made – specific power. "Coherence, organization, and efficacity" are the words they use.[24] I think those are the qualities of the unconscious that the Philadelphia picture is feeling for. "If I bring this fellow off, he said, it'll mean

the theory is true [*Si je réussis ce bonhomme, disait-il, c'est que la théorie sera vraie*]."[25]

Everyone agrees that the great metaphor of coherence, organization, and efficacity in the Philadelphia *Bathers* is the flatness of its surface. Writers (after the first shock subsided) have been impressed by the quality of open and even patchwork to the way paint is put on here, especially as compared with the surface in the Barnes. Getting the body right, finally – finding a consistent idiom for its materiality – was in some sense bringing it onto the flat (which had been too small a space to contain the Barnes picture's agonizing narrative).

Flatness in general in Cézanne had always been at root a metaphor for materiality – for the painter's conviction that in a world made up of matters the being-in-the-eye of an object is also its being-out-there-at-a-distance, known to us only by acquaintance. This is the truth to which the Philadelphia picture naively returns. The being-in-the-eye of a body – that is, the full and adequate representation of its purely optical existence – will be, if we manage it, the representation of the body as it is, in its plenitude, in all its irrevocable separateness from us. If we manage to represent the fact of our mere acquaintance with the world, our lack of appropriation of it, then we shall represent the world – as it is for us. I know my words go round in circles, as I think Cézanne's visualizations do.

And is not this the ultimate paradox of the double figure: that it succeeds in offering us a phantasy of complete revelation (which is why the word "transparent" will never entirely go away as a description of it) but combined now with a deep turning away of body from viewer, toward and into the surface of foliage? How much of the color of that foliage invades the standing figure's back and arm! So that the figure has a quality of absolute distance to it as well as looming proximity. Completeness of seeing is detached from the usual accompanying phantasy of physical possession. (I think of Rubens as the great master of that kind of identification. And Rubens – Cézanne's hero of heroes – is finally kept at bay in the Philadelphia picture. This *is* more like Poussin redone after nature [fig. 90], whereas in the Barnes we are still essentially in the *Garden of Love*, or exploring another allegory of *Peace and War* [fig. 91].)

Seeing the body completely – seeing it in material terms – is more like losing it than gaining it. It is setting the body a little apart. Not as far as the lookers on the other side of the river. But far enough.

90 (*below left*) Nicolas Poussin: *Bacchanalian Revel before a Term of Pan*, oil on canvas, 104 × 142.5, ca. 1631–35 (National Gallery, London)

91 (*below right*) Peter Paul Rubens: *Horrors of War*, oil on canvas, 206 × 342, ca. 1637–38 (Galleria Pitti, Florence)

159

One way of understanding the difference between the Barnes and Philadelphia pictures would be to see them too as enacting the late nineteenth-century shift from easel painting to the decorative. Certainly the Philadelphia *Bathers*' scale and format, and the openness and frontality of its handling, move it toward the space of the mural – or the peculiar space between easel and mural staked out by Puvis de Chavannes. But, as with Pissarro, what seems to me decisive about Cézanne's version of mural painting is the way the new scale and procedure seem to intensify, as opposed to disperse, painting's cognitive ambitions. The Philadelphia picture is Poussin revivified: meaning it stays true to Poussin's easel-painting gravity and point-by-point calculation. The space between easel and mural in modernism exists essentially to keep easel painting alive – that is, the notion of painting as investigation and epitome. Easel painting, especially as it came down to the French from Poussin, is best understood as a defensive maneuver against the culture at large, predicated on the belief that the possibility of a public language has to be preserved in the face of everything (in the actual social world, and the world of ideology) that militates against it. Compare El Lissitzky's view of his *Prouns*, or Pollock's of his drip paintings. "I believe the time is not ripe for a full transition from easel to mural. The pictures I contemplate painting would constitute a halfway state."[26]

Here is one definition of modernism, then: it is the art of "the time that is not yet ripe" – always pulled to and fro between private (defensive) and public (expository). Always *dreaming* of the public life.

I have been trying to pin down what is unique to the Philadelphia *Bathers*, and I realize there is a danger I shall overlook, or not give proper attention to, the obvious: that its figures are a grand recapitulation and synthesis of those at the Barnes and in London.

It is always the same body being pictured. I do not think, for instance, that we shall get on terms with the affect invested in the double figure unless we see it as part of a group – joined to the woman standing against the tree, and the desolate figure seated in front of her – which reworks the same trio at the right-hand side of the Barnes. The desolate individual takes over the affect of the Barnes dreaming figure – takes it on her shoulders, so to speak – while the double figure takes on the burden of (sexual) differentiation. Again, the striding woman at left in the Philadelphia *Bathers* is in some respects closer to the original idea at the Barnes than to the revised version of the figure tried out in the painting in London. She is partially detached again from the bathers next to her. She is given a strange shadow *imago* crouching to her left, neither male nor female by the looks of it, holed up uncomfortably among the trees. It is as if the dreaming figure from the Barnes had swapped sides finally and come home to mother – and therefore gone into permanent eclipse. There are many other such transfers and reworkings. The London picture in particular is quoted from literally.

I said at the start that the *Bathers* in London (fig. 92) was the one of the three I understood least. Obviously that fact makes me uneasy. I am enough of a Freudian to think that the part of the dream one skips over mumbling may be the key to the whole thing.

The London *Bathers* is more or less the same format as that of its Barnes prototype: 52 inches by 77 as compared with 52 by 81. The two must have been painted for several years in tandem. Again, studio conditions presumably meant that for some of the time they eyeballed one another across the room. Clearly

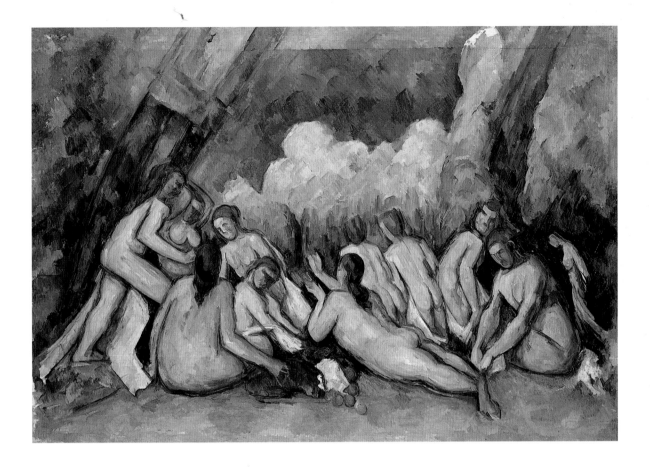

one thing being tried for in the reworking was to open the group of figures to the landscape and have the atmosphere be less supercharged and oppressive – though even here the clouds and greenery end up boiling as if with the figures' body heat. The figures are less disparate than those in the Barnes. The striding woman is now one of the crowd (which is not to say she is less ominous). The dreaming figure no longer exists – unless the wraith on the right began as a version of it, which I doubt. Bodies in general are fatter and fleshier. Poses and gestures are locked together on the picture surface and repeated and repeated until the dullest viewer gets the point. Buttocks certainly follow you round the room. Yet there is an airlessness and compression to everything, as if the figures were paper puppets on a three-inch-deep stage. The world is flat, hard edged, and impacted. If surface is the dominant matrix, its dominance has for some reason to be expressed as outright pressure, slicing and spreading the particulars it encounters – like a steamroller or a giant flatiron. Limbs and torsos look pumped up, but also hemmed in, by blue lines that suddenly cancel the body's internal modeling – the striding woman's upper arm and shoulder is a good example. A lot of the picture's *Jokes and their Relation to the Unconscious* flavor derives from this.

Sometimes in front of the picture I am moved by its hardness and restlessness. At others I pine for the Barnes *Bathers*' empty space – minimal, maybe; crammed, certainly; but enough for striding and dreaming.

Of course I see that Cézanne wanted to put these aspects of the Barnes picture behind him. He was a modernist. He wanted to escape from narration,

92 Paul Cézanne: *The Large Bathers*, oil on canvas, 172.2 × 196.1, ca. 1900–06 (National Gallery, London)

and from the dream-space – the invitation to come inside, to circulate easily and identify at will – which narration in pictures was supposed to bring with it. And he thought at first that he could do so by filling in the gaps between his protagonists, repeating and multiplying them, and making the trees and clouds follow the same story line. But what resulted in the London *Bathers* was not so much the dissolution of narrative, it seems to me, as a picture become all one great narrative machine – the gears grating and whirring in the same old way, even if disengaged from a readable plot. The surface was still too full (ludicrously full) of bodies telling their story. Their being essentially the same body, or different bodies adjusted slavishly to the ones next door, did not really change anything. It turned out that format was the key. Format was what carried the force of narrative within it. The London painting was still shaped like a story. It was not until the Philadelphia picture that a narrative of sexual difference (sexual difference actually happening, as if it had never happened before) gave way to a kind of tragic positing of sexuality as fate.

One kind of commentator (maybe a Freudian, though not necessarily) might say of the bodies in all three *Bathers* that here, as usual, the question of what and what not to show comes back to the figures' genitals. The issue of decorum is ultimately a mask for the deeper issue of absence and disavowal. Partly I agree with this. I do not think anyone looking long enough at the Barnes picture could fail to. And no doubt it would be possible to stage a reading of the Philadelphia painting which would have that image's final truth-of-the-body be absence and substitution. Hair in the *Bathers* certainly partakes of the quality of fetish. Time and again it peels away from the head it supposedly belongs to ("covers") and becomes horribly solid, separate, and animate. (This is truer still of the picture in London.) And the bodies in Philadelphia, especially on the right-hand side, are built up around a lot of empty canvas. I guess I would argue that neither of these structures – the hair taking on a life of its own, the flesh giving way to nothing – seems in the end determinant: they are part of a to-and-fro, open-ended play of phantasy, not the final terms (the repeated maneuver) to which the play returns. The empty canvas, to take the most plausible candidate of the two, seems to me vivid because it is so completely intermeshed with assertions of solids and salience. On the prone woman's ridiculous orthogonal back and sides, for example; on the desolate individual's bright-orange knees; indeed, on her dreadful face; in among the electric greens and tans of the woman sitting on the ground nearest the center, her limbs like the blades of a jackknife about to snap shut. But I know that my seeing the empty canvas as part of phantasy, not its truth, is likely helped on by my own repressions.

I think of the three figures in the Philadelphia painting's center (fig. 93), with arms reaching down to an unformed patchwork of marks on the ground – from which the bare canvas shines triumphantly – as embodying *care*. For what precisely we are not shown, and should not guess. They reach out so tentatively, attentively, almost recoiling from contact before it is made: touching, comforting, paying homage. A tremendous nexus of wishes is in play here. To have what they are attending to be absence, or lack, or some such formula, seems to me to ditch the best side of Freud – the side summed up in the word "overdetermination." They seem so confident of the absent center's infinite generative powers. As if they were drawing the whole figurative world of the picture, themselves included, out of the primed canvas's positivity. What word will do here – positive or negative, high or low, abstract or lumpishly concrete – to register Cézanne's sense of matter at ground zero?

93 Cézanne: Detail of fig. 88

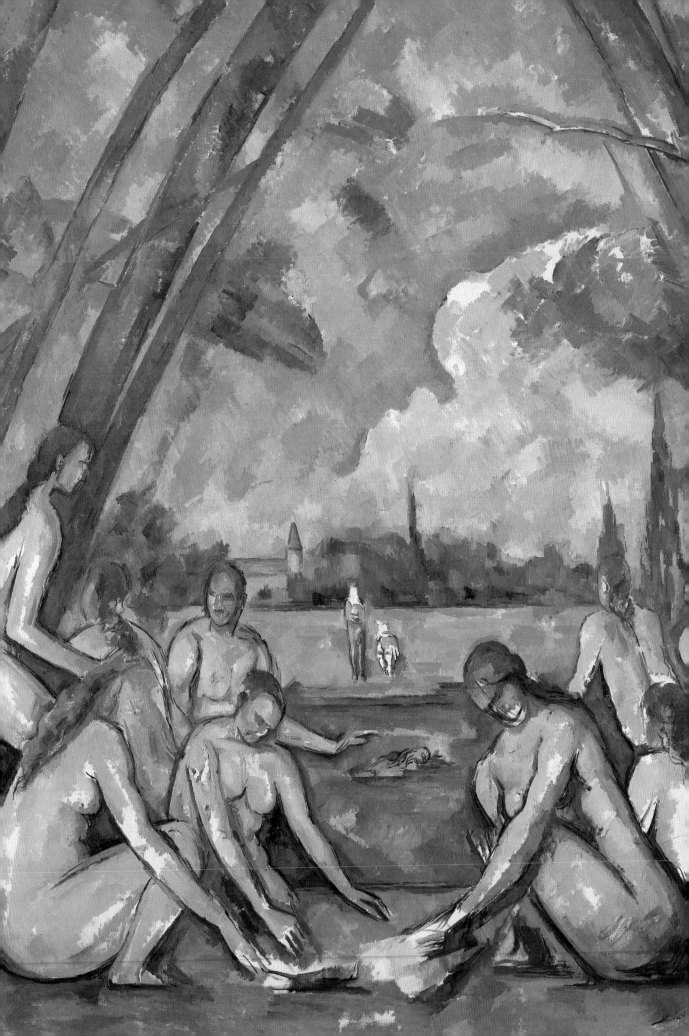

The body in Cézanne *is* awful – is absence – but at the same time madness and plenitude. On the back of a sketch for his treasured project for an Apotheosis of Delacroix (he is still talking of doing the picture as late as 1904,[27] and one way of understanding the Philadelphia *Bathers* is as his last try at it) Cézanne at some point scribbled a few bad lines à la Baudelaire:

> Voici la jeune femme aux fesses rebondies.
> Comme elle étale bien au milieu des prairies
> Son corps souple, splendide épanouissement;
> La couleuvre n'a pas de souplesse plus grande
> Et le soleil qui luit darde complaisamment
> Quelques rayons dorés sur cette belle viande.[28]

(Behold the young woman with plump buttocks./How in the midst of the fields she shows off/Her supple body, that splendid blooming;/The snake has no more suppleness than she/And the sun as it shines obligingly darts/A few golden rays on this beautiful piece of meat.)

Bernard in his memoir has Cézanne coming back from the Château Noir one day singing Baudelaire's praises, and reciting *Une Charogne* by heart "without a mistake."[29] His other favorites, according to Léon Larguier, were *Les Phares*, *Don Juan aux Enfers*, *L'Idéal*, *Sed non satiata*, *Les Chats*, *Le Mort joyeux*, *Le Goût du néant*.[30] A good unflinching selection.

I have said what I have to say about the *Bathers*, essentially. *Une Charogne* would be a good place to stop. But I am aware as I write this chapter that we no longer live in a world (thank God) where readers take it for granted that the *Bathers*, or *Une Charogne*, for that matter, are worth studying at all in the way pursued here. The pictures in the Barnes and Philadelphia are canonical. I have focused on them relentlessly, and made big claims for them. Why? How do I think what I have done differs from the normal eulogies in the art-history books? This is a question that could be asked of most of my chapters, and my approach to modernism in general.

One limited kind of answer is just to point out that in fact there are no eulogies of Cézanne's last *Bathers* – or no descriptions (no extended, nonobvious interpretations) to go with the eulogistic noises.[31] Other questions then follow. Why, even if these works did eventually enter some kind of modernist canon in the twentieth century, could they not be described by those who did the canonizing? What was it that stood (and stands) in the way of description? Is it the case that canon and modernism are for some reason antithetical terms, in spite of the best efforts of modernists – particularly modernist institutions – to prove otherwise? (The issue haunted my previous chapter. If I chose there to focus on one of Pissarro's many "failures," that was because I believe that precisely in failing his modernism attained its highest aesthetic dignity. "Some defeats," as Karl Liebknecht put it, "are really victories, while some victories are more shameful than any defeat." This is modernism's consolation.) These questions are intractable, but I see no way of avoiding them if what we are aiming to do is understand the visual culture of the last two hundred years. The courting of failure and indescribability is one main key to what that culture was. Taking indescribability as an invitation not to look, or not to look closely, is truly to get modernism wrong.

But this answer is not adequate on its own. It does not address the ultimate (in its way, attractive) shrug of the shoulders from one's opponent – the implicit "Who cares?" So I want to meet the "canon question" challenge directly and, for better or worse, propose a theoretical answer to it.

Visual art offers many different kinds of interest. Any attempt to argue that one kind is superior to all the rest regularly ends up as not much more than apology for one's own narrowmindedness. But what is possible, I think, and maybe necessary to criticism, is to identify a kind of interest that certain works of art have which marks them off from the forms of image-making all around them. (It is not the only kind of interest that even these works of art have to offer. It is just the kind that is peculiar to them.) Certain works of art, I should say, show us what it is to "represent" at a particular historical moment – they show us the powers and limits of a practice of knowledge. That is hard to do. It involves the artist in feeling for structures of assumption and patterns of syntax that are usually (mercifully) deeply hidden, implicit, and embedded in our very use of signs; it is a matter of coming to understand, or at least to articulate, what our ways of world-making most obviously (but also most unrecognizably) amount to. I think that such work is done with real effectiveness – and maybe can only be done – at the level of form. It is the form of our statements, and the structure of our visualizations, that truly are our ways of world-making – at any rate the ways that hold us deepest in thrall. That means there is a necessary (though of course not sufficient) relation between the intensity and complexity of a work of art's formal ordering and its success in pursuing the questions: What is it we do, now, when we try to make an equivalent of a world? And what does the form that such equivalence now takes tell us about the constraints and possibilities built into our dealings with Nature and one another?

I am not asking anyone to assent to the fiction of "us" and "we" that haunts the previous paragraph. I am saying that certain works of art show what was involved, at a certain moment, in producing this kind of false (but effective) commonality. They put a specific set of representational powers through their paces, so to speak – riding them hell for leather, daring viewers to find them wanting. For *isn't* this the world laid out whole, manifold, and fully articulate? Well no, not quite. So what further measure of inclusiveness and particularity could you possibly want, in the face of a Rubens or Bosch? Stop a moment and I'll try to explain.

My argument has been that Cézanne's art pursues questions of form and equivalence relentlessly, and does so in a deeply nineteenth-century way. I want the reader to see Cézanne as belonging to the world of Helmholtz, Charcot, and *La Revue encyclopédique*. As positivist and materialist in the strong senses of those words. Freudian in the way of Freud in 1895.

Nonetheless, if I am also proposing that the ultimate interest of Cézanne's art lies in its happening on the powers and limits of a particular system of representation, then presumably I do not believe that his art lies simply within that system – imprisoned by it, exemplifying it. I should expect the sheer doggedness with which Cézanne tries to exercise the powers in question to lead him continually to their boundaries and insufficiencies. My argument is that glimpses of alternative systems of representation are only thrown up by the most intense and recalcitrant effort to make the ones we have finally deliver the goods. It is only in the process of discovering the system's antinomies and blank spots – discovering them in practice, I mean – that the first improvised forms of contrary imagining come to light. Though in the end these forms are less interesting in their own right – they are too approximate, too preliminary for that – than as *repoussoir* for the system they still belong to. They are what makes that system visible as such.

This seems true of Cézanne. I agree with all those who have written about him that somewhere at the heart of his (and Pissarro's) epistemology is an idea of knowledge built out of singular, equivalent units – events that happen in the eye, and which the dab of paint will analogize precisely. We are back to the wording of Freud's "Project for a Scientific Psychology": "The intention of this project is to furnish us with a psychology which shall be a natural science: its aim, that is, is to represent psychical processes as quantitatively determined states of specifiable material particles and so to make them plain and void of contradictions." I am sure these words apply to the *Bathers*. But here is the rub. They apply and they do not apply. We should not be able to see Cézanne's epistemology of the singular and equivalent as the strange thing it is if it were not so palpably at odds in the *Bathers* with altogether different metaphors of our being in the world and having knowledge of it. This is what I have been trying to say all along. Not just that the *Bathers* are haunted by figures of inconsistency and displacement, or by kinds of coexistence (of marks and objects) that are more painful than natural, more like interruption than juxta-position, more like the grating and locking of the parts of a great psychic machine than the patient disclosure of a world – not just this, but the fact that these figures and ways of doing things do not muffle or overtake the dream of piece-by-piece realization but drive it on to new heights, new naiveties. Out of the whirl of distractions and ambiguities will come the singular *quand même*. The body may never take place anywhere once and for all; but what it is made of – what our imagining of it is made of – will take place, and take on its own consistency. Its place is the picture surface. And the kind of consistency it has is hard for us to deal with – that is why we retreat into the world of the imaginary – just because it is ultimately inhuman, or nonhuman, or has humanity as one of its effects. That is what the relation of bodies to the picture rectangle in the Philadelphia *Bathers* has most powerfully to say, I think. We do not like the proposition, so we call it forced or artificial. Even the best commentators on Cézanne – Roger Fry and Meyer Schapiro, for instance – can be found recoiling from the *Bathers* on these grounds. Or inventing a *Bathers* with no inorganic chill in the air – having its surface be vibrant, tense, or sensitive. Having it "breathe." But no surface has ever been less animate than this one. No handling has ever been less a means of laying hold of (getting one's hands on) a human world.

I realize these last few sentences have essentially crossed from Freud's territory to that of another, more savage kind of materialism, which I associate with the mechanists of the high Enlightenment, and with the writer who seems to me their best spokesman in our own day, Paul de Man. But I do think the two territories – the Freudian and the mechanistic-materialist – overlap. The "Project for a Scientific Psychology" is linked in my mind with the great essay by de Man on "Aesthetic Formalization in Kleist."[32] To show why in detail would take me too far astray. But I cannot resist ending this chapter with a quote or two from Kleist's "On the Marionette Theater."

Mr. C in Kleist's text is the principal dancer in the opera at M, and an enthusiast for the puppet theater in the park. He prefers it by far to the human ballet. The narrator expresses his astonishment "at the attention C is paying this species of art form intended for the masses":

> I said that the job of the puppeteer had been presented to me as something done without sensitivity, somewhat like turning the handle of a barrel organ [*das Drehen einer Kurbel sei die eine Leier spielt*].

"Not at all," he answered. "In fact, there is a rather ingenious relationship between the movement of his fingers and the movement of the attached puppets, somewhat like that of numbers to their logarithms or the asymptotes to the hyperbola."

And yet he believed that even the last trace of human volition to which he had referred could be removed from the marionettes, that their dance could be transferred completely to the realm of mechanical forces and that it could be produced, as I had thought, by turning a handle . . .

[If that were done,] he said, it would be impossible for man to come anywhere near the puppet. Only a god could equal inanimate matter in this respect . . .[33]

This is not offered as a description of Cézanne's last *Bathers* – not even of the London version – but rather of a logic that threatens to overtake them, and which strikes me as the key to their mixture of Grand Guignol and utopia, or absurdity and perfection. I only say "threatens to overtake them," and of course what is ultimately most touching in the *Bathers* is their will to resist the vision of bodies that the pictures' own ruthlessness makes possible. What Kleist gives voice to, in de Man's reading, is the necessary other dream of materialism – the one to which the various (but limited) mechanisms we call aesthetic give access, and from which we regularly draw back. It is the reason we all hate the beautiful so much.

Modernism, I am convinced, would not anger its opponents in the way it seems to if it did not so flagrantly assert the beautiful as its ultimate commitment. And if it did not repeatedly discover the beautiful as nothing but mechanism, nothing but matter dictating (dead) form. This is a horrible proposal, and I understand and sympathize with the wish to retrieve the human, the social, and the discursive on the other side of it. I too would like there to have been a sane (that is, surviving) van Gogh to cancel Seurat's nihilism, or a truly clever Marcel Duchamp to save us from Malevich's divine idiocy. But it turns out there was neither. This is modernism's worst discovery.

We might say that the aesthetic, as Kleist depicts it, is materialism's uncanny. Which is to say, its repressed truth, its ridiculous conclusion – its familiar. And who could look at the striding woman in the Barnes *Bathers*, or the double figure in Philadelphia, or the terrible, cramped repetitions of bodies in London, without realizing that ultimately the horror in these pictures reaches beyond any recoverable or irrecoverable human content to the sheer turning of the handle of the representational machine? I stand in front of the Barnes *Bathers* and hear a hurdy-gurdy playing.

4 Cubism and Collectivity

Mais les ténèbres sont eux-mêmes des toiles
Où vivent, jaillissant de mon oeil par milliers,
Des êtres disparus aux regards familiers.

(But shadows themselves are pictures/In which there live,
darting from my eyes by the thousand,/Vanished entities with
familiar faces.)

 Baudelaire, "Obsession."

Some time in late summer 1912 Picasso took a photograph (fig. 94) at
the front door of the villa he had rented for the season at Sorgues. We know that
Braque had brought down the "machine à photographie" specially from Paris
a week or so before.[1] The picture records the main paintings Picasso had done
over the previous two months. On the doorstep, from left to right, are perched
the imposing *Portrait of a Man*, which in time got called the *Aficionado* (fig.
95), the equally grand *Man with a Guitar* (fig. 97) in the center, and an only
slightly smaller canvas next to it, differentiated from its neighbors by the
amount of dry, pink fleshtone added to the browns and grays that had made up
Picasso's palette since the winter of 1909–10. (Someone, maybe Kahnweiler,
responded to the sardonic gendering later and titled the picture *The Model*.)
Two oval paintings, both best called *Guitar*, are hung on the doorframe above.
Floating between them, apparently propped on top of *Man with a Guitar* – it
looks as if both paintings were affixed to some kind of easel post – is a dense,
squarish canvas, again with the look of a portrait, which Picasso showed in
Munich the following February under the title *The Poet* (fig. 96).[2]

The snapshot is faded and crude: one should beware of trying to make too
much of it. But the set-up is far from casual; all of the pictures on view survive;
and enough can be made out, particularly of those on the doorstep, for various
concrete questions to arise. Did Picasso consider these paintings finished when
he had them photographed? Presumably he did. And if later he changed his
mind in one or two instances, and altered the paintings in slight but detectable
ways, then why? What could have occurred to him as still needing work? What
kind of changes did he make? It is rare, in the case of Cubism, for questions of
intention to come up in such seemingly limited, circumstantial ways, as matters
of specifiable difference between states A and B. Of course anyone who has got
so far in the interpretation of Picasso's painting as to notice that there *are*
alterations will probably also have learnt not to expect too much from any one
test case – especially one like this, glowing with the false aura of the factual. But
you have to start somewhere, even with Picasso. There is no harm in clutching
provisionally at straws.

94 Pablo Picasso:
Paintings at Sorgues,
photograph, 1912
(Musée Picasso, Paris)

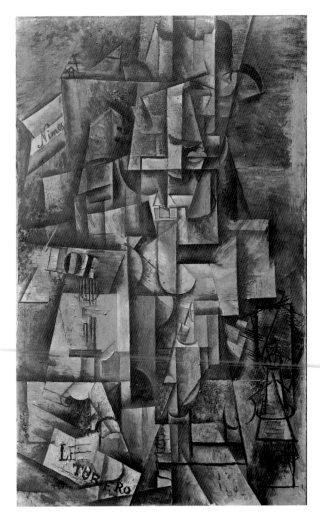

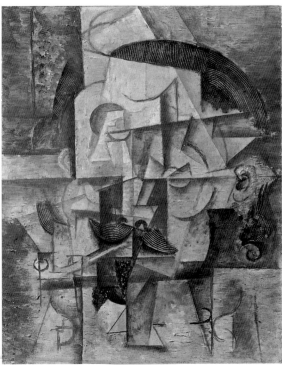

96 Pablo Picasso: *The Poet*, oil on canvas, 60 × 48, 1912 (Kunstmuseum, Oeffentliche Kunstsammlung Basel)

95 (*left*) Pablo Picasso: *The Aficionado*, oil on canvas, 135 × 82, 1912 (Kunstmuseum, Oeffentliche Kunstsammlung Basel)

97 Pablo Picasso: *Man with a Guitar*, oil on canvas, 131.8 × 89, 1912–13 (Philadelphia Museum of Art, The Louise and Walter Arensberg Collection)

What we are after are clues to Cubist decision making. *Man with a Guitar* is the picture we should concentrate on; partly because the changes made to it later are easiest to read, and partly because it relates so strongly, even in its altered state, to the whole line of work Picasso had done over the preceding year – the period, that is, of Cubism pure and extreme. ("Classic" Cubism, the commentators call it: as usual pining for something modernism will not give.) The episodes of stencilled and freehand lettering in the *Aficionado*, by contrast – and even that picture's overall flavor of caricature,[3] or at least pungent definitiveness – are something essentially new in Picasso's art, pointing forward to pictures to come; so does the simpler, brighter geometry of the two *Guitars* on the doorframe, and even *The Model*'s parody pink. "I think my painting is gaining in robustness and clarity," Picasso had written in June.[4] But *Man with a Guitar*, where muted, fragile browns predominate, seems to me more retrospective in tone than its companions, maybe even a trifle nostalgic already for the style it tries to sum up: it is simpler and gentler than the pictures whose idiom it borrows – "*Ma Jolie*"'s (fig. 99), from the fall before in Paris, for example, or *Young Girl with an Accordion*'s (fig. 98), from the summer at Céret in 1911 – but even its simplifications are best understood as a meditation on the previous method rather than as a turning against it. No doubt it remained to be seen whether a painting could do now by nuance and slight modification what its predecessors had done by mad internal multiplying: it was, I think,

170

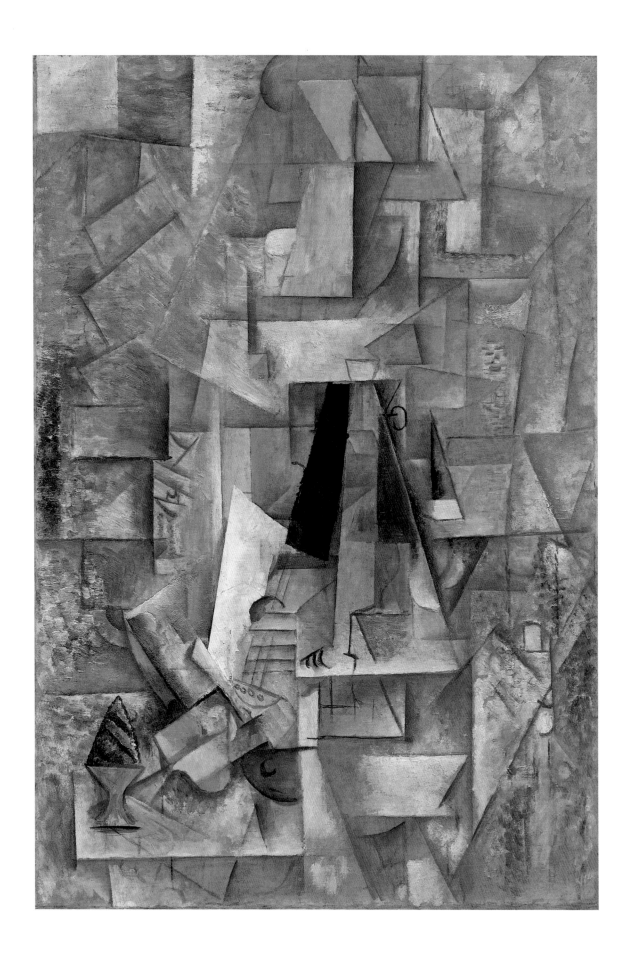

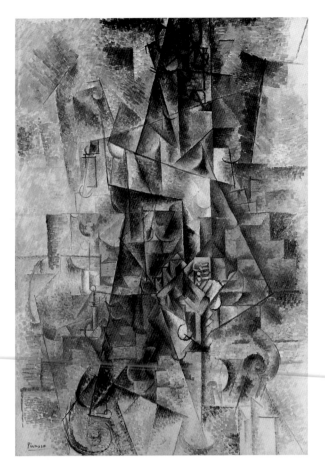

98 Pablo Picasso:
*Young Girl with an
Accordion*, oil on canvas,
130 × 89.5, 1911
(Solomon R. Guggenheim
Museum, New York,
Gift, Solomon R.
Guggenheim, 1937)

essentially the same thing that was being tried for. What same thing? And what, in the picture's state at Sorgues, would have struck Picasso as not measuring up to "*Ma Jolie*" or *Young Girl with an Accordion*?

 It had something to do with the guitar. Certainly it is thereabouts, in the picture's middle and just below it, that the changes are most dramatic, and most obviously (even if you look at the picture without the Sorgues photo in mind) added in on top. What they seem mainly meant to do, at first sight, is introduce more unequivocal indicators *of* the guitar and its spatial direction. That is the point, or effect, of the incident that seems most extrinsic to the original play of browns: the black diagonal, plumb center, put on almost like a piece of collage, standing unmistakably for the guitar's neck. There are seven or eight of the instrument's frets hatched across it in black and white, and three strings stretching down across a shaded soundhole to a neatly delineated bridge. None of these tokens, at any rate to my eyes, was there on the doorstep at Sorgues. (There is a segment of a circle that might already signify "soundhole" visible in the photo, but it looks as if the cusp of black paint that eventually opened the half-circle back into space – making it give onto darkness in the guitar's interior – was a later improvisation, perhaps using the paint mixed to put in the ebony neck.) And all of this signing and spacing of the guitar seems bound up with an effort – maybe this was the fundamental problem – to alter the visual weight of the large, light, right-angled triangle (the one with its top cut off and seemingly stoppered by a contrary quadrilateral) that had, at Sorgues, lorded it over the picture's right of center.

It seems, does it not, as if that shape (so powerfully there in the black-and-white photo) struck its maker finally as too detached from the surrounding play of forms. The triangle registered visually as too much, or too unequivocally, "on top" of the darker browns and grays abutting it, with space disappearing behind its vertical left edge and going on somewhere in the imagination, to emerge intact on the other side of the hypotenuse. Is the stoppered triangle perhaps a bottle or carafe, meant to go with the green-and-pink sorbet on the table bottom left? Whatever it is, the shape was originally secure in space, safe in its very transparency. It was a salience that made everything around it an ambience. Its edges were endings over which the eye passed unobstructed, as opposed to hinges on which space and solid pivoted two ways. In all of these regards, we shall see, the stoppered triangle in its Sorgues manifestation sinned against Cubism's basic rules.

It was not, by the way, that any of this – this peeling apart of space and solid, this settling down of signs into a perceptual order – had gone uncontested in the picture as we know it from Sorgues. Of course it had not. The contest was what Cubism was about. The mind's wish to have the stoppered triangle be in front or on top of the forms that touch it was already ironized in the Sorgues state of the painting, sometimes with almost a pedagogical niceness. Look at the sharp black line near the base of the triangle, for instance, setting off so boldly toward the carafe's bottom edge and then stopping dead, only to reappear, offset just slightly, in the shadow world below. Is this one line refracted through different transparencies? Or a line moving back from the surface it seems to start on, through that surface, into a space behind? Or two lines on two surfaces, just happening (almost) to align? Or two lines on one surface, set up to elicit an infinity of readings? And therefore to ironize them all. These are, we shall see, the ordinary means of Cubism – the ironies it lived by. What is special about *Man with a Guitar* is that this constant groundswell of local impossibilities (I have picked out the most programmatic for description, but there are scores of others) did not, in the end, strike the painter as sufficient. The central triangle still floated free and clear. The black guitar was brought on above all to press back and destabilize that triangle – to make its left-hand side flicker satisfactorily between figure and ground, and prevent the forms next to it from sidling and sliding into the void. The triangle was likewise invaded, by a dark repeat of itself top right, again brushed on with the slightly oilier mix of paint (grayed down a little) prepared for the ebony neck. A strong linear rhyming which had been there at Sorgues, between a guitar-curve on the face of the stoppered triangle and an echoing one outside it, across the hypotenuse to the right, was occluded and qualified, almost painted out, as if its mechanical play of similars – repeating the game of the lines below, more floridly – was judged in the end to do the work it was meant to parody. And so on. All of these alterations must have seemed the more reckless because the picture as it stood in the photograph depended so much – and still depends – on its fragile unison of color. The black on the neck was brutal. A last resort.

This is the sort of attention, I feel – moving over the picture surface piece by piece, paradox by paradox – that Cubism was designed to elicit. The Sorgues photograph states the case. It shows us a summer's effort at sustained visual articulacy. It means to insist on the paintings' consistency and density, on the look they have of sharing a language and pressing that language on to new and more difficult discriminations; and it imagines a viewer able and willing to tune into the least particulars of the articulation, trying on readings and discarding them with real Nietzschean gaiety.

But those last three words are also the clue to what has gone wrong in the previous page or so, and always goes wrong in descriptions of Picasso's painting at this moment. The describer's tone is never Nietzschean enough. The particular readings are always too local and commonsensical, and their rhetoric instates the little world of spatial transitions to which Cubist sign-language never adds up, as if at some point it might have meant to, or might mean its ideal viewer really, seriously, to have that world in mind – to imagine Cubism as starting off toward that world and happening on another. This is not wholly wrong. Cubism, we shall see, does stand constantly in some kind of relation to a world we might recognize and traverse. But the point is the "some kind." The point is Cubism's annihilation of the world, its gaming with it, its proposal of other, outlandish orders of experience to put in the world's place. The problem for description is to build into the point-by-point detail – which I do not intend to leave off – a sense of Cubism's deep, wild, irredeemable obscurity, and of that being Cubism's first move, not final conclusion. "You say Uhde doesn't like the last pictures I did, the ones with the Ripolin and flags. Perhaps we shall end up disgusting everybody, and we haven't had our full say yet."[5] The problem is to lay and keep hold of Cubism's *ambition* for its obscurity, its seeming certainty about the mad language it used – its great totalizing will.

Here is where the photograph from Sorgues is precious. For this surely is what matters most about it: that never has a document so reeked of world-historical suspense. Painting at Sorgues, says the photograph, stands on the threshold of a new order and chaos; and not just painting, by the looks of it, but picturing in general; and not just picturing but maybe perceiving; and not just perceiving but maybe being-in-the-world, or at least having-a-world-be-visible; maybe the world itself.

> The state of the world is not yet fully known, and the aim is to give it reality. This is the object of world-historical individuals . . . They can discern the weakness of what still appears to exist in the present, although it possesses only a semblance of reality. The spirit's inward development has outgrown the world it inhabits, and is about to progress beyond it . . . It is not easy for us to know what we want; indeed, we may well want something, yet still remain in a state of negativity, a state of dissatisfaction, for we may as yet be unconscious of the new positivity. But the world-historical individuals know . . . There is a power within them that is stronger than they are . . . They have discerned what is true in their world and their age, and have recognized . . . the next universal.[6]

Just so. The paintings in the doorway at Sorgues are gathered into an unholy polyptych, with *The Poet* raised high in place of the pantocrator. They are a kind of altarpiece, its wings unfolded for Easter or Pentecost. They set out the positivity to come. Of course the claim is partly comic; and that too – the coexistence of farce and metaphysics in what Picasso did at this time – will somehow have to be hung on to in the descriptions that follow. But comedy is a thin disguise: *The Poet* itself is a good figure of exactly that ambivalence in Cubism, with its seeming wish to semaphore its own jauntiness – all that smarmed-down hair and brilliantined ringlets, those waxed mustachios, chubby pink cheeks and bags under the eyes – and none of them saving the likeness as a whole from an impacted, melancholic severity. And in my opinion not meant to.

So far this chapter has tried to make vivid the two main kinds of description that the Sorgues photograph seems to me to call up. Let us call them

the local and formal, and the world-historical. I should warn you that if I manage to keep both kinds alive in what follows, it will be at the expense of connectedness. The best I can offer on Cubism, it turns out, is a medley of *pensées détachées sur la peinture* – a series of stabs at description, full of crossings-out and redundancies, a bit like the Cubist grids I am trying to find words for. This disconnected quality seems necessary to me, precisely because it is the opposite quality that I most distrust in the accounts of Picasso's painting we already have: that is, the way they are driven by a basic commitment to narrative continuity, by a wish to see Picasso's work from 1907 to 1912 as possessing a logic or forming a sequence, as not being broken or interrupted in any important way – not, above all, encountering failure. I would say that these wishes and structures are what Cubism *is*, discursively speaking; and they seem to me tied in with (maybe to produce) the final telltale blankness of writing on Cubism in the face of the moment it most wants to celebrate. Everyone agrees that the painting Picasso did in 1911 and 1912 represents some ultimate test-case and triumph of modernism: I could fill pages with characterizations of it hardly less manic than Hegel on Napoleon. But if what we want is analysis as opposed to intakes of breath, we are hard put to it to come up with anything. The manic at this point gives way to the mute.

 I hate books that spend their time pointing out other people's errors and blind spots. This chapter more than any other will lay itself open to that charge. But I think it has to. Cubism, to repeat, is the moment when modernism focused on its means and purposes with a special vengeance. The idiom that resulted became *the* idiom of visual art in the twentieth century: Picasso's and Braque's way of organizing a picture was borrowed, adapted, or fought against by almost all subsequent art, and very often taken as the still point of modernism – the set of works in which modernity found itself a style. (The passage I quoted from Kubler in chapter one is typical.) Therefore all those who wish to secure an account of modernism as a line of art, or tradition, or canon, have had to confront Cubism preeminently – to spell out its purposes, and show why and how they gave rise to such rich variations. Cubism is the theme of modernism. Giving an account of it cannot avoid having a programmatic, thematizing edge.

 So far in the book I have referred to the most powerful program or theme on offer in somewhat guarded terms. "Modernism's false friends," "those who did the canonizing," and so on. Now I am bound to name names. The historians and critics I have in mind are those whose picture of modernism I first learnt in the 1950s and 1960s. They were and are the movement's most passionate advocates. I remember pinning illustrations from Herbert Read's *The Meaning of Art* on my bedroom wall. I remember the shock and excitement of reading Clement Greenberg for the first time, and the hours spent coming to terms with the latest essay by Michael Fried in *Artforum*. I still learn more from an afternoon in MoMA – from the links and analogies its installations argue – than from fifty essays denouncing its biases and exclusions. Nonetheless, I basically agree with many of the essayists' points. The history of modernism constructed by its apologists in the 1950s and 1960s – I shall call them "the modernist critics" from now on, but always with the proviso that their modernism was local and in a sense terminal – does not seem to me to have worn well. Even at the time it was chilling to see Greenberg's views become an orthodoxy. What was deadly, above all, was the picture of artistic continuity and self-sufficiency built into so much modernist writing: the idea that modern art could be studied as a passing-on of the same old artistic flame (now under threat from "ideological confusion and violence") from Manet to Monet to Seurat to Matisse to Miró . . .

These are old battles and vanished supremacies. (The best modernist writers in any case resisted Greenberg as much as followed him, and in particular reworked his myth of medium and continuum to the point of unrecognizability. That was true of Michael Fried in the 1960s, and *a fortiori* of Fried's work since, which, to repeat, is by far the most serious account we have of modernism's extremity and changes of face.[7]) But there is something about Cubism that makes the old issues come up again. Cubism is the last best hope for those who believe that modern art found its subject-matter in itself – in its own means and procedures. And that in doing so it found an idiom adequate to modern experience. And therefore founded a tradition.

A fair test of these hopes, it follows, is what those who entertain them can find to say about Picasso's and Braque's paintings at the key moment of 1911 to 1912. I think the answer is "precious little," or anyway, "not enough."

Here, for example, is the strongest, most detailed description I can find of *"Ma Jolie"*; that is, of the painting which is taken to epitomize the moment of Cubism more often than any other, ensconced as it is in the MoMA collection. (A possible alternative title for the painting is *Woman with a Zither*. There is no way to translate *"Ma Jolie"*, I feel, without losing hold of its Tin Pan Alley triviality. *"My Pretty One"* sounds too much like a folksong.) The description comes from a catalogue of MoMA's Picassos by the museum's then Chief Curator, William Rubin. I shall quote nearly all of the entry's opening paragraphs, before it devolves into a straight – and increasingly formulaic – listing of the picture's formal features. What I quote, in other words, is the part of the text that offers itself as an account not just of what *"Ma Jolie"* looks like but of what this look has to say about seeing, painting, and modernity. It is, to repeat, the most powerful description of *"Ma Jolie"* we have.

> Such paintings [it is typical that the entry begins by pluralizing its commentary, and talking of *"Ma Jolie"* as one of a group, alongside the slightly earlier *Still Life "Le Torero"* and the slightly later *The Architect's Table*, both also in MOMA's collection] are difficult to read, for while they are articulated with planes, lines, shading, space and other vestiges of the language of illusionistic representation, these constituents have been largely abstracted from their former descriptive functions. Thus disengaged, they are reordered to the expressive purposes of the pictorial configurations as autonomous entities.

It is tempting to stop right here and put a little pressure on the last ten words, which do tend to recur as explanations, or something pretending to be such, when this painting – and modernism in general, with this painting as its high representative – is in question. "The expressive purposes of the pictorial configurations as autonomous entities." Tell me about "autonomy" here; or better still, tell me about "pictorial configurations" having (in and of themselves, it seems to be claimed) "expressive purposes." Is Rubin saying that what actually or mainly produces the ordering of parts in *"Ma Jolie"* – I mean an ordering as dense and obdurate and off-putting as the one we are looking at; resistant to reading, and yet apparently inviting reading of the closest kind – just *is* "the expressive purposes of the pictorial configurations"? Strange purposes; strange configurations – but let the writer proceed.

This impalpable, virtually abstract illusionism is a function of Cubism's metamorphosis from a sculptural into a painterly art. Sculptural relief of measurable intervals has here given way to flat, shaded planes – often more transparent than opaque – which hover in an indeterminate, atmospheric

99 Pablo Picasso: *Woman with a Zither ("Ma Jolie")*, oil on canvas, 100 × 65, 1911–12 (The Museum of Modern Art, New York. Acquired through the Lillie P. Bliss Bequest)

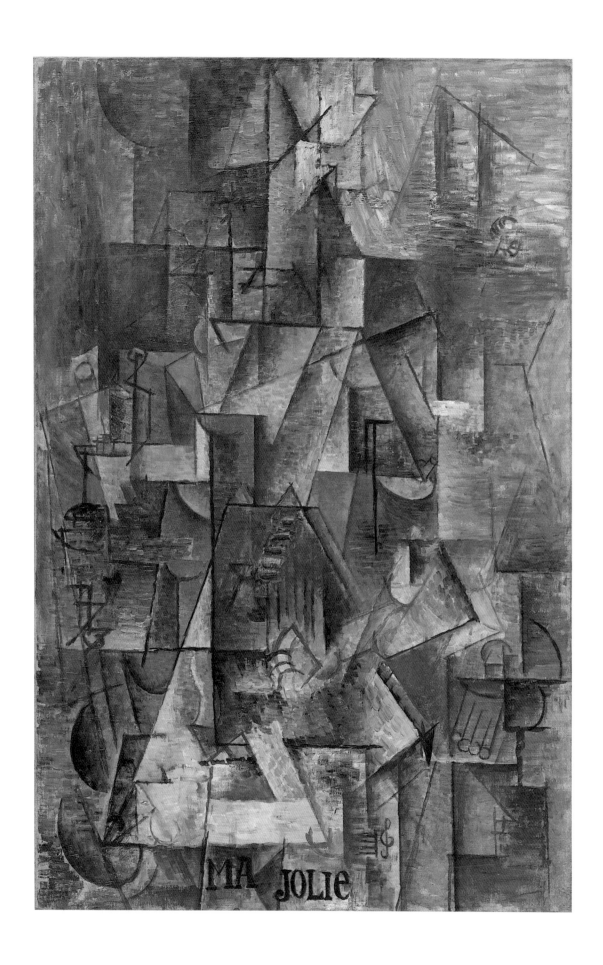

space shimmering with squarish, almost neo-impressionist brushstrokes. That this seems finally a shallow rather than a deep space may be because we know it to be the painterly detritus of earlier Cubism's [that is, the paintings Braque and Picasso did in 1908 and 1909] solid relief.

The light in these early Cubist paintings did not function in accordance with physical laws; yet it continued to allude to the external world. By contrast, the light in these high Analytic Cubist pictures is an internal one, seeming almost to emanate from objects that have been pried apart. Accordingly, the term "analytic" must here be understood more than ever in a poetic rather than scientific sense, for this mysterious inner light is ultimately a metaphor for human consciousness. The Rembrandtesque way in which the spectral forms emerge and submerge within the brownish monochromy and the searching, meditative spirit of the compositions contribute to making these paintings among the most profoundly metaphysical in the Western tradition.[8]

I have not brought on this piece of writing to scoff at it, or even declare it useless and wrong. Many of the things it points to in Picasso's painting – above all, the picture's profound engagement with the techniques that Western painting had thrown up through the centuries in pursuit of strong likenesses of an object-world – seem to me to hit the nail on the head. Modernist critics (and Rubin is one of the best of them) got a lot about modernism right; only a half-wit would be hoping for an account of Cubism somehow magically purged of their terms. The terms will do fine: it is the relation between them that seems troublesome to me.

What does it mean, in other words, for a painting to "abstract" the various constituents of a "language of illusionistic representation" "from their former descriptive functions"? Is this what seems to be happening here, from the spectator's point of view? The fragments of planes, lines, lighting, and spacing that make up the texture of *"Ma Jolie"* may or may not have forfeited "their former descriptive functions" – I shall get to this later on – but they clearly still carry their former descriptive appearance. They are full of the kinds of particularity, density, and repleteness that usually go with visual matching. They still look to be describing. How great is the tension between that look and the overall, equally pervasive uncertainty about what the describing is of? William Rubin seems to think that what the illusionism now describes is the "pictorial configurations": it intends, so to speak, to dramatize the configurations' autonomy. This is what he means by "abstract illusionism," and he does not seem to want the reader to give that phrase any particular oxymoronic force. But does not the *picture* give it one? Rubin knows full well that *"Ma Jolie"*'s dramatization of its means has a dark side to it: that its abstractness may be atmospheric and shimmering but is also clotted, sedimented, schematic, and grim. He is aware that his account has to shift gears somewhere to take account of this; and shift he does, into the metaphoric register – the Rembrandt register, that is – the internal and metaphysical one, from which leaks a "mysterious inner light," a metaphor "ultimately" for (what else but) "human consciousness."

It is not just that the comfortable humanism of this conclusion seems to me at odds with *"Ma Jolie"*'s relentless shallowness – the way the edges of everything in the picture are drawn too sharply, and shaded so as to erase inwardness (mystery, emanation) even as the signs of such things are trotted out; the way paint is dragged and spackled back to a surface as hard as it is flimsy; the way limbs and instruments creak on pulleys, digits are pressed together like matchsticks, and geometry repeats itself across the body with a deliberation, not to say a pernicketiness, that gets to seem positively tinny. The problem goes deeper

than this. It is that Rubin's shift into metaphor anyway strikes me as coming too late. The picture's metaphorizing of its subject, as I see it – and I want to call that subject simply the process of representation (as Rubin himself does, at least until he gets to Rembrandt) – happens in its microstructure: the metaphor, the shifting, is in the relation of procedures to purposes, of describing to totalizing, of "abstract" to "illusionism." The metaphor, if I can put it this way, is in the obscurity not of consciousness or inwardness, but of what is most outward and on the surface in *"Ma Jolie"* – what are most matters of fact or practice about it. Modernism's metaphors are always directed essentially (tragically) to technique; because only technique seems to offer a ground, or a refuge, in a merely material world. I did say "seems to."

Here I am already at the heart of the argument I find myself having with the modernists (and I think with their semiotic inheritors) about high Cubism.[9] So the point I am making had better be labored a little. What Rubin and I are disagreeing about (as in many such arguments) is the nature, or rather, the place, of the "figural" in Picasso's painting – the place, so to speak, where the metaphorical moves get started. Everyone agrees that once they do get started they career on to the edge of utter obscurity. So what provokes them in the first place is crucial. It may also be what drives them to the abyss.

The metaphor, I want to say, is in the materialism of the works we are looking at – in that "base kind of materialism" which Picasso proposed, in retrospect, as the essence of Cubism in the years before collage.[10] (As usual with Picasso, he was partly playing with his interlocutor. The phrase occurs in a conversation with his dealer Daniel-Henry Kahnweiler. And Picasso was well enough aware of Kahnweiler's high-toned Kantianism to know that the formula, applied to the paintings Kahnweiler most revered, would seem little short of sacrilege. He pretended to regret Cubism's first baseness, and be glad that he and Braque had later grown out of it. I reckon this is 90 per cent gamesmanship on his part; which is not to say that the phrase itself, the "base kind of materialism," does not point to something real in paintings like *"Ma Jolie"*. The title itself, taken from a pop song of the day, is sufficient token of the Cubists' wish at all costs to be low.[11]) The question to ask of Cubism, it follows, is what kind of metaphorical structure it gives *to its procedures*, to the local acts of illusionism which lead us as viewers across the surface, now that those acts are conceived – and, if lucky, actually carried out – as nothing but manual, nothing but matters of fact? Into what key, if I can work *"Ma Jolie"*'s pop-musical subtext one or two notes further, is the "base kind of materialism" transposed? I take it we would agree that it was bass as opposed to treble. The treble clef at the picture's bottom center is as much out of tune with *"Ma Jolie"*'s grid and monochrome – and surely meant to be – as the mock-title just below it. Nothing here is high-pitched.

My description of Cubism therefore starts from the question: What metaphors of matter strike us as giving the surface of *"Ma Jolie"* or *Man with a Guitar* their characteristic tone or consistency; and in particular, what metaphors of painting's matter? The answer will not necessarily be the same for both pictures. Let me concentrate for the moment on *"Ma Jolie"*.

What the viewer of *"Ma Jolie"* is offered, in a beguiling, not to say button-holing kind of way, is illusionism, but illusionism in disguise; as if the various procedures thought they should not add up to a mere object any more, and pretended that they added up to something else instead, or to the same object conceived under a completely different rubric; one for which, or to which, all the little local acts of illusionistic description are meant to be seen as incidental in the end, mere ladders or props – since "I gotta use words when I talk to you."

What we are asked to attend to – say, by the outlandish bravura of the "pulled" veil of light just to the right of top center, with its feel of some membrane through which light pours almost unobstructed, or some banner from which light is shaken like tinfoil (the point is that we cannot be sure which) – are precisely the best, most pungent resources of illusionism; but put through their paces just a trifle too coldly, too showily. They reveal themselves thereby *as* resources; or devices, in Viktor Shklovsky's sense of the word; that is, as ways of making a painting. But always, I think, with the further pretense: that these resources, for all their factitiousness – or is it in their very factitiousness? in a sense because of it? – are addressing some other object-world, or some other way of world-making, or some altogether different section through the three dimensions of visual experience. This is a pretense, in my view. But the pretending in Cubism is done with such imaginative vehemence and completeness that it constantly almost convinces – both the viewer and no doubt the painter in the first place. Pretending is Cubism's power.

Let me be clear. When I talk about "local acts of illusionism" in the case of *"Ma Jolie"*, I do not have in mind the notorious introjected tokens of reality that often crop up in Picasso's grids from 1911 and 1912: the waxed mustachios, clay pipes, shaded soundholes, translucent sorbets, and so on. In any case in *"Ma Jolie"* they are in short supply. No, I mean the overall play of light and shade in the picture, the intersection and overlap of planes, spaces, and directions – the kind that Picasso seems not to have been satisfied with in the center of *Man with a Guitar*, and which we saw him working to the point of undecidability. I mean a certain kind or degree of complexity, a seeming openness of each mark to correction, a nuance and precision in the whole fabric of touches; or a quality to the touches that does not seem to make sense except as nuance and precision, even if we cannot see what provokes them; the effort after effort apparently to "fix" some definite but elusive phenomenon – "here," "now," "like this" – and plot its relation to others around it/behind it/belonging to it, and so on. Let the reader's eye move down from the pulled veil in *"Ma Jolie"*, for example, and examine the gradient of shadow across the two rectangles just below and to the left of it; or better still, look at the play of brown, gray, and black marks in the fat parallelogram underneath the left-hand rectangle, and the way they aid and abet the intersection of two lines upon it and make them edges, of surfaces that flicker in and out of possible positions, textures, consistencies, degrees of reflectiveness. These efforts can only be understood, it seems to me, as efforts at illusionism, using illusionism's bag of tricks – pushing them hard, straining them a bit, exemplifying them. And I take it that they are readable only in the terms provided by the tradition they come out of: looking at them locally, we apply the usual tests of vividness; but somehow, finally ("really," profoundly) the performance of matters is supposed not to be read in these terms – or not merely in these terms. Look again, the picture says, look beyond the details to the totality! But how, exactly? With what criteria? If the totality does not come out of the details, then where *does* it come from? How is a complex sequence of illusions – imitations of some sort – supposed to generate a non-imitative whole? Does it, in this case? Did it at Sorgues?

And yet of course the invitation – the sense in these pictures of something else being there, if only we knew how to look (and maybe the pictures will prove to be lessons) – is strong enough to resist any amount of demystification. There seems, at one level, plenty to go on. The pictures are stuffed with particulars, or at least with what looks like particularization. They have a logic, or at any rate

a geometry; and is not the one supposed to be evidence of the other? Surely it must have been logic of some sort (whether perceptual or conceptual remains to be seen) that gave rise to this degree of precision and regularity. The latter two qualities are irresistible, rhetorically speaking. Things may be difficult, they say, but a lot of the work has been done for you. Pay close attention, but do not get lost in minutiae; look at what the drawing does to the modelling; admire the strength of the syntax; trust that the qualities of precision and regularity are transitive, so to speak – problem-solving, addressed to the next universal. Only a plodder would not go along.

What I am going to say next about Cubism, though it applies to the pictures we have been dealing with so far, had better be said of a still life. For instance, the one that includes Gertrude Stein's calling card (fig. 100), which Picasso identified in a letter to her as "votre nature morte (ma jolie)": the phrase from the pop song appears again, with what look to be lines of music (or maybe guitar strings) in the vicinity. The sexual humor hoped for in the counterpoint between *"Ma Jolie"* and *Mis [sic] Gertrude Stein* is about up to Picasso's usual standard. Kahnweiler preferred to take his cue from the carpenter's T-square visible upper left, and christened the painting *The Architect's Table*.[12]

Let us agree, first of all, that the world in this painting is still thing-like, made up apparently of objects, or aspects of objects, accumulated, intersecting, fighting for room in the oval. As a matter of fact, if we do agree on that much we have already come far in the interpretation of Cubism, for this opening onto an object-world has always been disputed or downplayed in the case of the paintings from 1911 and 1912, often by those with most to say about them.

The most brilliant early example is Ivan Aksionov, in his book on Picasso published by Centrifuge in Moscow in 1917. But even here the case is complicated. Coming as it did out of a milieu where Futurism and Formalism had already struck up a tactical alliance, Aksionov's treatment of his hero was strong, not to say dazzling, in its handling of "devices" – it had more to say about Picasso's peculiar sense of the paint surface, and the ways in which his brushwork managed to avoid virtuosity, than anyone before or since. All the same, Aksionov saw the pictures from Sorgues and thereabouts – his main example, in fact, is the Poet-pantocrator he may have seen in Munich or Paris – as still in the grip of the object-world they are trying to describe.

> [T]he elements of the picture continue to be volumes, stubbornly refusing to give up their third dimension to the will of the painter who created them. Picasso went on increasing the number of layers and divisions, evidently supposing that if the curve of the object's surface were sufficiently broken up, then this would secretly show up in the elements of analysis. The multiplication of planes results in a multiplication of paint layers: in the most complicated composition, *The Poet*, in even the most simply painted area we can count up to eight layers and each layer appears as a volume.[13]

And Aksionov knew full well, of course, that *The Poet* was a picture already deliberately simplified by comparison with many of those from the months before.

Nobody is going to say that reference to the things of the world has simply ceased in high Cubism. But it may not be the point any longer. It may not be what drives the depiction toward the kind of orders it finally offers us. Might we do better to understand the world of high Cubism as one in which objecthood, however qualified, or thing-likeness, however generalized into a set of reconstructed, semi-detached qualities, has been overtaken by the act of signification

100 Pablo Picasso: *The Architect's Table*, oil on canvas, 72.6 × 59.7, 1912
(The Museum of Modern Art, New York. The William S. Paley Collection)

itself – "absolute generalization" (Aksionov's phrase), a freer and freer play of the signifier, a set of devices discovering that simply the difference between them is enough to make a world?

These last are serious proposals about Cubism, and indeed its relation – its exemplary relation – to modernism in general. A certain picture of modernism's overall trajectory can turn on them, and in a sense depend on them. I believe the proposals are mistaken, but I am aware that arguing against them cannot possibly be a matter of faulting them on particular points or pieces of evidence. It is a question, as usual, of how two different attitudes to Cubist work – two reconstructions of Picasso's intentions (that is, his intentions in practice) – do or do not hang together as a whole: it is a question of how they fare at generating thick descriptions. The test of my disagreement with the semioticians is therefore the economy and relevance of my whole account: the kinds of purchase it has on particulars: what features of Cubist painting it is able to discriminate and, above all, to connect: whether those features seem to the viewer and reader the ones in need of attention; and so on.

That being said, let me offer, first, one inconclusive piece of evidence for these paintings' being best construed as descriptions of an object-world. It is the kind of verbal description offered of them at the time, casually, in passing, by Picasso himself. Now and then in his correspondence from 1911 and 1912 one comes across him telling Braque or Kahnweiler about a painting he is working on, or those he has just finished. The situation, as I understand it, was not one that compelled or encouraged any particular sort of description, let alone any particular degree of detail. "Nature morte" or "une jeune fille avec un accordéon" would have done perfectly well; and in fact the latter phrase is produced in a letter of 25 July 1911 without further fleshing out. But not "nature morte." That specification, when it did come up, gave rise straight away to a positive inventory – which had better be left as it issued from Picasso's pen – "une nature morte d'un verre un presse-citron un demi-citron et un petit pot avec les chalumeaux et la lumière [a still life of a glass a lemon-squeezer half a lemon and a little pot with drinking straws and the light]."[14] This is addressed to Braque in the same July letter: it is intriguing that the watercolor to which the description seems to apply (fig. 101) is one of the sparsest of the summer: one wonders how many nouns Picasso would have used if he had written home about *The Architect's Table*. Or this to Kahnweiler in June the next year:

> Décidément je vous envoi les tableaux desquelles je vous parlai ier dans ma lettre . . . il i a troi le plus gran un violon couché et après une nature morte de chez Druetrx le hotelier avec des letres Mazagran armagnac café sur une table ronde un compotier avec des poires un couteau un verre. L'autre nature morte le Pernod sur une table ronde en bois un verre avec la grille et le sucre et bouteille écrit Pernod Fils sur le fond des afiches mazagran café armagnac 50. [For certain I am sending you the pictures I told you about yesterday in my letter . . . there are three of them the biggest a violin on its side and then a still life done at Druetrx the hotel-keeper's place with the letters Mazagran armagnac café on a round table a fruit bowl with pears a knife a glass. The other still life Pernod on a round wooden table a glass with strainer and sugar and bottle written Pernod Fils with in the background posters mazagran café armagnac 50.][15]

In this case the pictures turn out to be almost as cluttered as the sentences (fig. 102).[16]

It is not, to repeat, that I take this evidence as decisive (someone could easily counter that all Picasso's terrible French was up to at this time was a pile of metonymies): it just seems to me to tally with the attention so many of the

101 Pablo Picasso: *Glass with Straws*, ink and watercolor on paper, 29 × 22.6, 1911 (Stedelijk Museum, Amsterdam)

102 (*right*) Pablo Picasso: *Fruitbowl and Fruit*, oil on canvas, 55 × 38, 1912 (Private collection)

pictures mean to provoke. Run your hand over the architect's table, they say, pick up the unlovely Miss Stein's calling card, hang on to the knife by its handle. Of course we shall not be able to hang on (that is also the point), but we are expected to be stubborn. Look for the lemon squeezer and the sugar strainer: be prepared never to find them, or not in any form they have taken before: learn by all means to make the best of that obscurity, and finally to revel in it – but take it to be a texture of difficulties inhering in objects or objecthood.

So here is my description. Something is happening to the things of the world in *The Architect's Table*, something is being done to them: different, unstable relations between things (or aspects of the same thing) are being imagined or denoted. But it is all being done *by painting* (here I think I cross the path of the semioticians): in other words, by the power of a particular representational repertoire to contradict experience, set up impossible orders, and imagine otherwise. This is not, I shall argue, an "otherwise" discovered in perception; that is, in the various overlapping modes of visual experience that exist, and are subject to change, in the culture as a whole; but *it has to pretend to be* (here I part ways with the semioticians again). It has to pretend to be discovering its contrary orders in some process or pattern of seeing which we as viewers ought to be able to reconstitute from the evidence before us; all the more so because the orders are ultimately rooted in a general revision of perception which (it is claimed) the artist has sensed or anticipated, given a

provisional clarity, made the best case for. If the orders were not so rooted, or if the painting failed to make the claim that they were, then its procedures and devices would implode. They would lose their (essential) dimension of other-directedness, they would no longer be addressed to some difficult, resistant fact "out there" – they would not intend a world held in common. The pretense in a painting like *The Architect's Table* – and it seems to me one that Cubism cannot dispense with in 1911 and 1912 – is that what is being done to the world in the oval is done not by "painting" alone but by painting-in-the-service-of-epistemology; and that pretense is necessary precisely in order to keep "painting" alive, since painting in Picasso's view is a set of means generated out of imitation, and unthinkable – empty, inconsistent, unconstrained – without it.

This is the key, as I see it, to *The Architect's Table*'s tone. Gertrude Stein, when she wrote about Picasso in *Camera Work* the same year, had some warnings to offer anyone trying too hard to tie down Cubism's meaning, or even its burden of affect.

> Something had been coming out of him, certainly it had been coming out of him, certainly it was something, certainly it had been coming out of him and it had meaning, a charming meaning, a solid meaning, a struggling meaning, a clear meaning . . . He did have some following. They were always following him. Some were certainly following him. He was one who was working. He was one having something coming out of him something having meaning. He was not ever completely working . . . This one was always having something that was coming out of this one that was a solid thing, a charming thing, a lovely thing, a perplexing thing, a disconcerting thing, a simple thing, a clear thing, a complicated thing, an interesting thing, a disturbing thing, a repellent thing, a very pretty thing.[17]

I agree with Gertrude Stein that interpretation of Cubism had better be a stream of metonymies than a neat metaphorical fix.

But supposing meaning was our object in *The Architect's Table* – the meaning of the monochrome, that is, and the meaning of the grid. The tone of the picture's repleteness (yet cursoriness) of handling. And even the tone of its offer to us – is it true or false reassurance? – of bits and pieces of a bourgeois world. Miss Stein's dog-eared calling card, a pipe and liqueur glass, Victorian furniture-fringes with little tassels, curtains with heavy silk cords. What could we find to say about them?

Provisionally this. The claim or pretense in *The Architect's Table* to articulate an order made out of perception – the claim I described just previously – is a mighty one, but a pretense. And no doubt at a certain level all art is a matter of pretending – a matter of "as if" – but works of art do differ dramatically in their recognition of that fact. They differ in their willingness to admit, or to "fore-ground," the arbitrariness of the sign. The work of art we are looking at strikes me as fiercely unwilling. Not that it fails or refuses to admit it: on the contrary, the admission is everywhere; but it does so always in a dark mode. The freer and freer play of the signifier is represented, at the same time as it is embraced, as a mereness, a mechanizing or automatism of markmaking, an overall-ness which registers as the opposite of liberty or even "autonomy." Or to put it another way: no doubt the great pretense of re-seeing the world in *The Architect's Table* is one that in practice leads back or up to obscurity – back to the surface, back to the play of procedures. But that play is also exactly what the picture has to resist; and it is best resisted by always again being represented as the threat that for some reason (every reason) it is felt to be – as the mereness and coolness of monochrome, the brittle impalpability of surface, always con-

gested but also volatilizing, the anxious (not to say anal) redundancy of the grid. "I will get the world in order – just watch me! I will have the picture be more than the sum of its parts!" The grid is a strange image of totality. We have missed its tone altogether, it seems to me, if we read out of it the flavor of pedantry and overkill – the mereness, again, of the blueprint or diagram.[18] What does it mean for art to need a ruler, or to make-believe it needs one?

No doubt Kahnweiler was too highminded with his *Architect's Table*. Gertrude Stein's "A repellent thing, a very pretty thing" was closer to the mark. But jokey or po-faced (or some peculiar mixture of both), the picture does turn on the T-square, and the implied claim that painting as a whole should now be a matter of measurement.

I cannot agree with Carl Einstein, then, when he says in his marvelous "Notes sur le Cubisme" of 1929 that

> Now [he too has in mind Picasso's pictures from around 1911, which he takes as pivotal for modern art] the totalization of the picture comes about by the very fact of its being unverifiable, and because the spectator never exits from the reality of the picture and the artist's vision is not interrupted by observation. One cuts oneself off and forgets. [*Maintenant la totalisation du tableau s'opère par son invérifiabilité, et le fait que le spectateur ne sort pas de la réalité du tableau et que la vision de l'artiste n'est pas interrompue par l'observation. On s'isole et on oublie.*][19]

Or rather, I believe that Einstein is responding here to only one aspect of Cubism's rhetoric (no doubt under the spell of Picasso's freezing and framing of Cubist language in his great paintings of 1928, about which Einstein had written eloquently in the same magazine two months before), whereas the point is, in 1911–12, that the rhetoric be two-faced. On the one face – and only Einstein knew how to speak of this side of Cubism with the right apocalyptic snarl – there is darkness and obscurity, a deep shattering of the world of things; but on the other, there are the signs of that darkness and obscurity being produced by sheer tenacity of attention *to* the world and its merest flicker of appearance; and a deep fear, not to say loathing, of the picture's totalization looking "unverifiable."

Up to now I have been saying of Picasso's pictures from 1911 and 1912 that they are given their characteristic texture by what passes for a pursuit of likeness. It is to be likeness of a kind that none of us has seen before, and that most of us will recoil from with a shudder or a snigger (*"Ma Jolie"* indeed!), but the word still applies – the paint is out to prove that it does. The paint is obstinate and painstaking (as well as exquisite and masterly): it will not let go of whatever it is it sees. But then I also want to say (and maybe here I am coming at Einstein's basic intuition about modernism from the opposite direction) that these pictures are full of a recognition – indeed, a flaunting – of the counterfeit nature of that not letting go. My word would be counterfeit as opposed to unverifiable.

There is, for example, a lot of talk in the literature about Cubist painting's being done in a version of "monochrome divisionism." The talk is not wrong, and the evidence suggests that the painters rather hoped, or assumed, that their build-up of regular touches would be recognized as borrowed from an earlier style. Writing to Braque in 1911 (again I am milking the letter of 25 July),

Picasso describes one of his new paintings of the summer, most probably *Young Girl with an Accordion*, as "very liquid in the beginning and done systematically Signac-style – with scumbling only at the end [*très liquide pour commencer et facture méthodique genre Signac – des (frottis?) qu'à la fin*]." It is a good phrase, that "facture méthodique genre Signac," and one sees the parts of the painting it applies to: not only the lighter, airy background but much of the denser center. All I want to do is insist on the oxymoronic quality of the phrase "monochrome divisionism" and the practice it describes. The phrase is a contradiction in terms. And so, I think, is the way of painting.

Note that the name invoked is Signac's, not Seurat's. That is, the name of the man who remained convinced – and in 1911 was still fighting to convince others – that Seurat was imitable because his method was true and complete. We might say that what Picasso does with that conviction is in a sense faithful to one side of Seurat's actual achievement – the exterminating angel side – but that makes it no less cruel. The highest, most rigorous and slavish achievement of late nineteenth-century scientism – the very technique of obedience to the phenomenal, of immediacy to the world of light – that, of all things, is converted into brown, or black and white. Its artifice is insisted on. Painting really does put on gloves.

No doubt the reduction of things and persons to monochrome served many purposes in the paintings we are looking at, and took on many valencies (am I alone in seeing it exude in *Young Girl with an Accordion* a fragile, ghostly, almost ghastly sensuality, in tune with its vanishing subject?); but one of the ways it was meant in 1911, especially conjoined with "facture méthodique genre Signac," was as a metaphor of painting itself. It was the sign of painting's impoverishment, of its flimsiness in the face of the world – of the necessity, seemingly, of putting that world always at a greater distance. And also the sign of its triumph – of painting's resourcefulness in the face of anything the world could do to it. No one is going to deny Cubist pictures their edge of elation. They are resourceful: it is just that in them the very term "resource" is put in such a peculiar light.

The reader will have noticed that the last three or four sentences do no more than repeat, apropos of monochrome, what it turns out I have mainly to say about Cubism in general. I too am not sure all the time whether the "on the one hand" and "on the other" here is a response to a dialectic genuinely within Cubism, or just me wanting to have my cake and eat it. The task I set myself initially was to conjure back into descriptions of Picasso's pictures a memory of the hubris of Sorgues. I wanted my descriptions to be suitably world-historical. But it turns out that if they are historical at all it is only insofar as they constantly seem to be moving toward some declaration of epoch-making failure – painting at the end of its tether, so to say, or in an ether where its means are hopelessly clotted or more and more impalpable. (The early writers on Cubism could exult all they liked in the style's sloughing off of the bright outsides of things. The young painter and poet Jean Metzinger, for instance, was already claiming in 1910 that "Picasso disdains the mostly brutal game of the so-called colorists [I guess it is Matisse who is meant] and returns the seven colors to their primordial white unity."[20] But even Metzinger knew that nothing he could do would ever make Picasso a new Mallarmé. The world of the mind, in Picasso's hands, turns out to have a brutal inconsistency that makes the worst colorist look well behaved.) Painting at the end of its tether, then. I do not intend to flinch from the cliché. We can best lay hold of these pictures' overweening ambition, it seems to me, if we see them under the sign of failure. They should be looked at in the light of – better still, by the measure of – their inability to conclude the remaking of representation that was their goal.

103 Pablo Picasso:
Marie Laurencin in
Picasso's studio,
photograph, 1912
(Musée Picasso, Paris)

Let me introduce another photograph as corroborative evidence (fig. 103). The picture was taken, presumably by Picasso, in the fall of 1911 in his studio on boulevard de Clichy. It shows the painter Marie Laurencin striking a quite difficult and conventional pose – knee raised, dress pulled tight over calf and thigh, torso half-swivelled, mandolin in hand – at the foot of a tall, clearly unfinished canvas. We cannot be sure that the canvas ever was finished to Picasso's and Kahnweiler's satisfaction, but certainly the bottom third was worked on subsequently, in rather the fragile manner of *Young Girl with an Accordion*. It stayed in the painter's possession for the rest of his life, and at some point acquired the title *Man with a Mandolin* (fig. 104). No one, to my knowledge, has proposed that the photograph, which surfaced only after Picasso's death, be read as putting the gender of *Man* in doubt. Is there a feeling abroad that that would be taking the photograph too literally? And yet the

104 Pablo Picasso:
*(Wo)man with a
Mandolin*, oil on canvas,
158 × 71, 1912 (Musée
Picasso, Paris)

photograph asks to be taken literally. And its asking us to see Marie Laurencin – not to mention the tasseled table with its *bibelot*, and even the table's tripod legs and creaking castors – in the painting on the easel is all the more pointed and poignant an invitation because the painting is still under way, and clearly in need of radical surgery. It seems that originally it had missed its mark. A whole extra bottom third has been sewn onto it.[21] The first outlines of something else have been drawn in. But what had been missing in the original state? Marie Laurencin? And what is to say, in Cubist painting, when she will have appeared?

The upper two-thirds of the picture in question – let us try to think of them as self-sufficient for a moment, and ask why they needed adding to – are one of the most fanatically labored passages of painting by Picasso to survive from this moment. They are done in an altogether different color register from the added third below; a register that any reproduction is going to rob of its gravity, since so much depends on a heaviness of color corresponding to a dryness of touch. (This is as dry and granular as Picasso ever got, at least until he perfected a similar, equally unforgiving surface texture as one of his main weapons in the 1920s.) There are dark grays, outright blacks, grim whites, relatively little brown (especially compared with the addition); an area toward the middle right has oddly inorganic greens worked into it; the whole thing is compacted, grave, dour, steely. And even "steely" here strikes me as trying to reclaim for the world of things a set of textures that in the end are barely reclaimable – the paint conjures up a substance or substances that look to be metallic but at the same time deeply unstable, here and there thinning or accelerating to the point of transparency.

Looked at on its own, the original picture is a good example of one kind of difficulty Picasso's painting regularly fell into at this time – I would say, deliberately courted. There is no very simple way to describe it. It is not enough to maintain, for instance, that the picture was over-complicated in the first place, since that is a quality paintings of 1911 often cultivate and seem quite happy with. In terms of sheer piece-by-piece arithmetic, and even coloristic and tonal congestion, who is to say where to draw the line between the first state of *(Wo)man with a Mandolin* and, say, the *Man with a Pipe* (fig. 131) done at Céret? The difficulty has to do, I think, with the way the piece-by-piece complexity was originally hung onto the picture plane, or related back to it; that is, to take up the language of my previous discussion of Cubism and metaphor, the way the figures of body or embodiment in *(Wo)man with a Mandolin* were tied to – were also – figures of material process, of mere manufacture. It is important that the language of the upper two-thirds, in contrast to the tailpiece, is not frontal, not even straightforwardly planar; and where planes are established, they are most often imperfectly aligned to the picture surface. So that one of the things the addition is meant to do, and does a bit glibly, is effect a transition *to* the surface – letting the picture find its footing, so to speak. More and more of unpainted surface is literally left to appear; and in terms of illusion, the planes get more and more transparent, as if they were hung across and in front of an unbroken ground. Most of the grid's hard edges are vertical, repeating the picture's upright format.

These are all rules the original packed rectangle disobeyed. I see the grid there as largely diagonal, hung from left to right, its main lines descending at various speeds from the vertical but approximating forty-five degrees – often a bit steeper. And into the scaffold or suspended from it – behind it, in front of it, that depends – is put a series of hard-edged curves, sometimes reading as the edges of wafer-thin solids and sometimes entirely cursive, like treble or bass clefs. Once or twice the fretwork circles are lined up in rows repetitively, as if ready

at last to face front, but for the most part they go on bucking, bowing, turning, overlapping.

Why in the end did that fact seem threatening? The answer, again, cannot be simple. Nobody who has looked hard at Cubist paintings, especially without modernist blinkers, will be inclined to say that this canting and tilting of forms away from the surface, in disobedience to the surface's gravitational pull, automatically produces problems. On the contrary. The canting and tilting are Cubism's lifeblood. They are the action – the effort at likeness, the opening into depth – which the "grid" is invented to contain, and which prevents the grid from being a dead a priori. (Insofar as the metaphor "grid" is the right one at all for what happens in Cubism in 1911 and 1912, I should say that Picasso's grids are very often, perhaps most often, stretched or filled to breaking point. "*Ma Jolie*" is exceptional in this. Its trueing and fairing are meant to be ostentatiously – in Gertrude Stein's sense, "repellently" – neat.) The problem in the first state of *(Wo)man with a Mandolin* is one of degree, not kind. There is such a thing as *too much* depth, too much obliquity, too much multiplication and excavation of spaces; with the chiaroscuro getting thicker and thicker, and ending up not exactly muddied or impenetrable, but rather, too vibrant, for all the paint's dryness – maybe we could say, too tactile. The forms stand back from the surface too neatly, too sharply: they are stacked too literally either as straight repetitions of the surface further back, or as pathways in toward some cluttered center. The acts of illusionism work too efficiently, they do not happen enough on the surface. They have lost hold of the metaphor of their own insufficiency.

Hence the photograph. I need claim no more for it than that its in-group joke is overdetermined. It is a joke about likeness – about Cubism being obscure by excess of illusion, and sometimes taking steps to give the viewer ground to stand on and room to breathe. Let me be world-historical again. The photograph is a staging of the great scene in Balzac's *Le Chef-d'oeuvre inconnu*, where Frenhofer's dream of complete resemblance – resemblance to the female model – gives rise to a canvas no one can read. Cubism proceeds, in other words (like modernism in general), under the sign of Frenhofer's failure. It stages the failure of representation; though not often, of course, as literally as this. This is a special case. It may even be that the reason the original *(Wo)man with a Mandolin* stood in need of a supplement was precisely because, inside itself, it failed to stage its own failure effectively enough. It lost hold of the fact that its illusionism, to re-use a phrase from Clement Greenberg, was essentially "homeless." It grew too much at ease with surface, and therefore with depth as well. It let the grid be generative, not cramping – extrapolation, not imposition. The grid in Cubism had to be both at the same time.

Here is the moment, which I have purposely been delaying, where my account of Cubism ought to be given a bit of chronology. I delayed, as I said before, because this seems to me the point at which most other accounts of Cubism go wrong. One can see why. Clearly there is something eye-catchingly sequential to the work Picasso and Braque did between 1908 and 1912. It looks to have a kind of logic and consistency, to be looping back and back to the same or much the same set of problems, edging forward to new ways of doing things, plotting a syntax and testing it out across the usual range of subjects – still life, landscape, nudes, figure paintings, portraits of dealers and friends. This look is not misleading. There is a quality of insistence and repetitiveness to Cubism that sets it apart from all other modernisms, even the most dogged – even Mondrian,

even VKHUTEMAS. Monochrome, again, is one sign of that "back to the drawing board" frame of mind.

The danger, then, is not in trying to follow the sequence and say what the problems might have been, but in the assumption that the sequence from 1908 to 1912 is all one thing: that, for example, the run of work from 1908 to 1910 (from the summer spent at La Rue-des-Bois to that spent at Cadaqués) in some way gives rise to the work that follows. I want to argue that it does not. I believe we can best understand the painting Picasso did in 1911 and 1912 if we see it as *not* issuing from the process of inquiry of the previous three years. Of course in a sense all I am doing in suggesting this is putting a little more pressure on a moment in Picasso's work that everyone agrees was odd – the moment of summer 1910, and the pictures done on vacation in Cadaqués. We should not have needed the famous reminiscent sentence of Kahnweiler – the "Dissatisfied, he returned to Paris in the fall, after weeks of painful struggle, bringing back works that were unfinished"[22] – to have sensed that the summer had been a bad one. There is evidence, again from photographs Picasso took at the time, of major works unaccountably lost, altered out of all recognition, cut up, maybe just burnt. The pictures that do survive speak a uniquely spare, impalpable, diagrammatic language: they are, and have always been recognized to be, Cubism near freezing point.

I ought to make clear straight away that none of the terms in the previous sentence is meant necessarily as judgement of the Cadaqués pictures' formal coherence or succinctness. On the contrary, it may have been part of Picasso's dissatisfaction in 1910 that his paintings looked good as well as evacuated. The work done during the summer, or at least the best of it – take, for example, the Cadaqués version of *(Wo)man with a Mandolin* (fig. 105) – had an evenness and openness of touch, of arrangement of elements, of color and light, which must have made a lot of Picasso's previous painting look decidedly cluttered. Evenness and openness did seem to mean better painting – had not that been Braque's essential proposal to Picasso for the preceding three years? – but they also meant emptying, reducing, diagrammatizing, blanking out.[23] This, as I see it, must have been what Picasso's twisting and turning in the fall following Cadaqués (again the evidence of the pictures that survive tends to back up Kahnweiler's memories) was most deeply about. Not that the summer's work had been a failure, but that it had been the wrong kind of success: that a kind of painting had emerged from the trials and errors of July and August which went on looking lean and authoritative however much one fretted at its simplifications: that one had to admit that the preceding years of experiment had yielded, at last, a "solution," but of a profoundly inimical sort. Picasso was the last person to want, or perhaps to see how, to pursue the Cadaqués solution to its logical conclusion (Mondrian being the first). Therefore he changed course. He made his way back to the world of phenomena. He put together a great counterfeit of everything that had, at Cadaqués, evaporated under his brush.

This is to anticipate. Before I can have my proper say about Cadaqués, I have to establish, however sketchily, what I think the previous three years of experiment had been after. What were the main questions and strategies of 1908 to 1910, once the aftershock of the *Demoiselles d'Avignon* (which is another story) had subsided?[24] It comes down once again to the issue of illusionism.

The main line of work that Picasso did from La Rue-des-Bois onward can best be described, I think, as critical and skeptical in temper, concerned above all to see if some other model of representation might be salvaged from

105 Pablo Picasso: *(Wo)man with a Mandolin*, oil on canvas, 91.5 × 59, 1910 (Museum Ludwig, Cologne)

the wreck of the nineteenth century – I mean from the masters whose versions of mimesis still mattered, in Picasso's view: the early Manet, for example, the later Puvis, the *Odalisques* of Ingres, Courbet at his most truculently materialist, all stages of Cézanne. (This is an odd pantheon, I know. The machinery of avant-garde retrospection in the early 1900s, which whirred on smoothly, had given Picasso a chance, it turns out, to look at shows of all the above at the Salon d'Automne in the previous five years.[25]) The project involved, alongside toying with "primitive" alternatives to Western painting, an unprecedented seriousness about the very aspect of Western art that the avant garde had learnt most to despise – its effort at better and better imitation of an object-world.

106 (*right*) Pablo Picasso: *Man's Head*, oil on panel, 27 × 21, 1908 (Kunstmuseum, Berne)

107 (*far right*) Pablo Picasso: *Man's Head*, gouache on panel, 27 × 21, 1908 (Musée Picasso, Paris)

This meant that for two or three years Picasso's painting repeatedly set out on the way back to some ground of Western painting – painting, that is, since Giotto and Cimabue – in pursuit of that project's most basic and inescapable presuppositions. It may even be that African sculpture, which Picasso certainly fed on at this time, was recruited essentially to help that pursuit – as an aid to understanding illusionism, not disposing of it. Masks, in Picasso's work from the spring of 1908 and later, very often offer a simplified ground on which the A B C of resemblance could be run through over and over again, sometimes to the point of lunatic redundancy.[26] If there is truck with magic in these pictures, as has often been supposed, it is above all with the magic of resemblance. What is fetishized – say, in the small *Man's Head* which Kahnweiler was successful in selling in 1908 (fig. 106), or the gouache of the same size and subject which Picasso kept for himself (fig. 107) – is not so much some set of representational powers that are deeply foreign to the world Picasso knew, but the powers that are least of all "other" to a painter brought up in the Western tradition: the crude effectiveness of light and shade in conjuring up volume. Masks were places where the mechanics of illusionism could be reduced to bare essentials – made to play over simplified edges and volumes – the better to see and show what the mechanisms were.

To see and to show, yes, but also to render strangely laughable. I think it was this combination of qualities in the pictures he produced that most interested Picasso in 1908, and led on later the same year to his infatuation with Douanier Rousseau. The Douanier's version of painting's powers – and the Douanier is as much the presiding genius of a painting like *The Dryad* (fig. 108), labored over mightily for much of 1908, as anything brought back from Picasso's "chasses aux nègres"[27] – was vital just because in it the boundary-line between effectiveness and absurdity was impossible to draw. The one quality inhered in the other. Maybe always did. Illusionism, that is, was to be rediscovered in all its true (enviable) simple-mindedness – as the conjuring-trick it once had been. Illusionism was a toy. Ludicrousness and monstrosity were not affects or accidents which this kind of art sometimes fell into: they were its deepest purposes – certainly the purposes that Picasso found most indispensable. In its heart of hearts painting never gives up dreaming, of wild beasts and jungles and women coming out of the woods (fig. 109).[28]

108 Pablo Picasso: *The Dryad*, oil on canvas, 185 × 108, 1908 (Hermitage Museum, St. Petersburg)

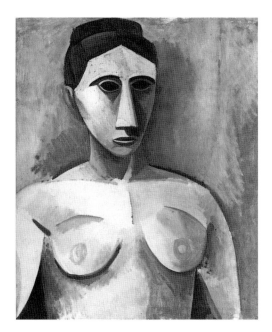

110 Pablo Picasso: *Bust of a Woman*, oil on canvas, 73 × 60, 1908 (National Gallery, Prague)

So what was illusionism exactly? What were its deep structures, so to speak – the set of procedures that lay at the root of it? How much or how little did it take for painting to materialize a world? These were the matters that had to be recaptured in particular paintings from 1908 to 1910, and restated in the simplest, baldest terms on offer; the better to see what eventually canceling or exceeding the terms might be like. That the language was simple, sometimes to the point of burlesque (Picasso remembered Leo Stein and Matisse bursting out laughing in front of *Bust of a Woman* [fig. 110] in 1908, and Stein saying "This must be the fourth dimension they're all talking about!"[29]), does not mean that the answers given to the questions were at all neat and tidy. Yet there is a main drift to them; and in 1909 in particular, moments crop up of positively fierce exposition and recapitulation of the problems, as if to insist that progress was being made. One of these moments, everyone agrees, occurs in the summer at Horta de Ebro (fig. 111). I shall do no more than indicate the general form – maybe the controlling figure – of a reading of the work produced there.

Let me begin by disagreeing with what the books on Cubism traditionally point to as the key to Picasso's proceedings at Horta.[30] I have never been happy with the way they single out a repeated episode in the figure paintings done there (they are almost all portraits of Picasso's lover and model Fernande Olivier), in which a long wedge of fleshtone that looks as though it belongs to the far side of the subject's neck or shoulder – the side that ought by rights to be mostly invisible – is put down in apposition to the parts of neck and shoulder that do commonsensically face us. Least of all am I happy with the way that apposition is usually described, and has been since the very beginning of writing on Cubism: as a multiplication or unfixing of point of view, a kind of moving of the eye round or behind the side of a solid, so as to take in what the observer knows is there, even if it is out of sight.[31] But I shall come to that. For the moment I simply want to propose that we look elsewhere for the governing figure of Picasso's work: not to Fernande Olivier's neck and shoulder at all, but to her forehead, and in particular to that hard-edged, spotlit, reversible cube that migrates through so many of these pictures and finally, in *Woman with Pears (Fernande)* (fig. 112) gets affixed at the point of maximum salience – *becomes* that salience, so to speak.

109 Henri Rousseau: *The Unpleasant Surprise*, oil on canvas, 193.2 × 129.5, ca. 1901 (Barnes Foundation, Merion Station, Penn.)

111 Pablo Picasso:
Seated Woman, oil on
canvas, 81 × 65, 1909
(Private collection)

I prefer the reversible cube as the figure of our reading for several reasons.
First, because it conjures back so vividly one of the high moments of Western
illusionism – the Piero moment, I would like to call it – and reminds us of the
reflexive quality of that previous tradition, its admission of paradox even at the
height of its powers. (Not that the ghost of Piero exorcizes that of Douanier
Rousseau. For every passage in *Woman with Pears* where space and solid turn
in upon themselves and will not stop shifting, there is another where paint does
enough to make them stand still: look at the black that says shadow under the
chin, for instance, or the play of highlights across the triumphant hairdo.
Paradox is admitted so that illusionism can go on doing its ludicrous best.) And
second, because the cube can stand, in its absolute, interminable swapping of
places between figure and ground, concavity and convexity, for just the kind of
work on illusionism that Picasso was doing in general through this whole
period. It is not, as I see it, that the illusion of a forehead is meant to be
magicked away by the contradictory shading, or spread out across a mere

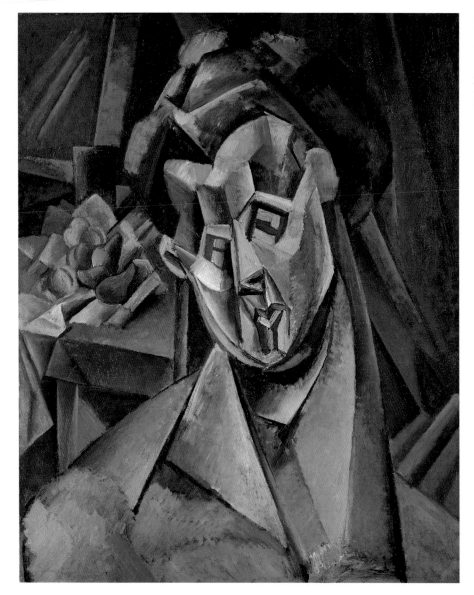

112 Pablo Picasso:
*Woman with Pears
(Fernande)*, oil on canvas,
92 × 73, 1909 (The
Museum of Modern Art,
New York. Florene M.
Schoenborn Bequest)

surface. On the contrary, the illusion of salience is still strong, indeed vehement. In this sense I see the pictures of Fernande Olivier as largely going against the grain of certain works Picasso had done the previous spring, in more immediate dialogue with Braque. In several pictures done at that time there crop up curious thumbnail sketches of houses in the background, or of things that look more like houses than anything else. There is one to be seen in the background of *Harlequin* (fig. 113), for example, or over the shoulder of one of the figures in *Two Nude Women* (fig. 114); or again, less a house than a pure schema of surfaces, behind the formidable *Seated Nude Woman* (fig. 115), toward bottom right. The tension here between leakage and irresolution in the schema and terrifying salience in the body itself is characteristically extreme.

The motif is most obviously a keynote in those pictures from the spring that reach back beyond the Cézanne of the late *Bathers* and portraits (of course he is the superintending deity of Picasso's art) to the first Cézanne, the young painter of outright fantasy pictures. Again the Douanier is never far away. That

113 (*above left*) Pablo Picasso: *Harlequin*, oil on canvas, 93.5 × 72.7, 1909 (Private collection)

114 (*above right*) Pablo Picasso: *Two Nude Women*, oil on canvas, 100 × 81, 1909 (Private collection)

115 Pablo Picasso: *Seated Nude Woman*, oil on canvas, 73 × 60, 1909 (Private collection)

is true of the gouache *Temptation of Saint Anthony* (fig. 116), for example, where the house gives rise to the shading on Harlequin's hat, and thence to the side of his nose and so on; or maybe it was the other way round.

I take these fading "reversible" houses to be quotations from Braque, in particular from the compelling version of Cézanne that Braque had worked up the summer before in Estaque. There is a picture of trees and buildings which Braque seems to have been working on through the winter of 1908 (fig. 117), where the devices are laid out almost programmatically. They stood for a kind of skepticism toward representation, which Braque was sure would be productive – a fading-out, an inconclusiveness. Perception was to be shown always getting in the way of definition, producing a flickering and interruption of edges. The motif is more openly contrived and schematic in Picasso's retelling of it in the canvases I just brought on, but essentially the tone is the same.

The cube that was finally lodged in Fernande's forehead at Horta strikes me as a counter-proposal to all this. (It is, if you like, Picasso's response to the side of Cézanne's art summed up in the Philadelphia "double figure.") Illusionism is not just going to fade out of the picture, making sophisticated excuses. It will go on doing its damnedest: a palpable likeness will be insisted on, however much the particular means used to generate likenesses are shown to be untrustworthy: the figure – the forehead – will be present with a vengeance. And yet there is a basic, primordial equation of illusionistic art that the cube allows one to put in question: not by letting the thing-likeness of things leak out round the edges, but by not having it *be* anywhere.

I take the basic equation of illusionism in this case to be PRESENCE = SALIENCE – with salience in turn played off against some lesser, emptier thing it is not. (Salience, we could say, has many different opposites in Western painting,

and in a sense creates its various negative terms: ambience, background, atmosphere, void, no-thing, concavity to its convexity, vanishing point.) It is the kind of equation that survives a whole history of innovation or iconoclasm. PRESENCE = SALIENCE is as much the rule of Monet's universe, say, or Gauguin's or Maurice Denis's, as it had been of David's and Bouguereau's. Presence equals salience: we could almost say, presence equals convexity. These structures are stubborn. Some might say they are constitutive: that there would not be painting at all without them.

Might it be possible, nonetheless, for a painter to make a strong equivalent of a body in space without this being the generative grammar? Might the reversible cube be made, or lead onto, a set of procedures in which the machinery of illusionism would be worked, with real ferocity, in such a way that the equation PRESENCE = SALIENCE was seen to cancel out – not to open onto paradox, but positively to produce its own determinate negation? These, I believe, are the questions at Horta.

Look, for example, at the whole pattern of reversible cubes on top of the hill in *The Reservoir, Horta* (fig. 118), one of the landscapes Picasso did that

118 Pablo Picasso:
*Reservoir, Horta da
Eloro*, oil on canvas, 60
× 50, 1909 (Private
collection)

summer; and compare it with the previous kind of fading and inconclusiveness of shape – the drifting of everything up to the surface – that is still to be found in this picture, but more and more as decorative grace note, hardly interfering with the action of the cubes at center, certainly not undoing them. (I am thinking in particular of the to and fro of colored segments going up *The Reservoir*'s left edge, where the higher they go, the more the segments lose their feeling of thing-likeness, ending by fading into thin air.) Here is *The Reservoir*'s wager, it seems to me: that it would be precisely by fastening on the aporia and undecidables of illusionism that a new system of spacing and singling out the parts of a world would be generated. It would be done by working the undecidables to breaking point: sharpening the edges and exacerbating the play of light until the very outlandishness of the structure – its letting in of more and more alternative readings – took on a great positing power. Let us run the machinery of illusionism for all it is worth: let us engineer the ultimate figure of clarity, of difference and distinctness of parts, and have the machinery open exactly *there* onto its opposite or its ground. The words I think we want to describe what is being tried for here are deadlock, face-off, warlike coexistence of readings, intermittence, outright (uncanny) duality. The reversible cube is the figure of all these; and of course I am claiming that it points to the general, overriding idiom of *The Reservoir* and pictures like it, not just to the three or four houses on top of the hill. It is a better figure, I am arguing, than the homeless chequerwork at left.[32]

I even believe that this may be the proper framework to make sense of the strange things done to Fernande's neck and shoulder. Return for a moment to the basic equation. If PRESENCE = CONVEXITY, then everything in painting ultimately turns on the artist's success in establishing a strong, cored, convex form in and against an opposite flatness or void. And in practice this basic illusion depends on the engineering of a *not*-seen, a *not-seeable*. (Shades of Marat in his bath.) The moment of maximum visual information in a picture is that at which the object goes out of sight. Is not that still as true of Manet's *Fifer*, say (fig. 119), or Cézanne's *Still Life with Plaster Cupid* (fig. 120), as of the most grinding hackwork from Gérôme?

119 (*far left*) Edouard Manet: *Fifer*, oil on canvas, 160 × 98, 1866 (Musée d'Orsay, Paris)

120 (*left*) Paul Cézanne: *Still Life with Plaster Cupid*, oil on canvas, 71 × 57, ca. 1895 (Courtauld Institute Galleries, University of London)

Hereabouts, if anywhere, are the minimum conditions of illusionism in painting: the kind or degree of illusion it must offer the viewer if it is to offer the presence of a world at all. Presence in painting depends on part of presence being necessarily absent to the eye. And this, it seems to me, is the notion of representation that the "hidden shoulder" motif is meant to put in doubt – as opposed to the villain of the piece ordinarily brought on in this connection, poor old one-point perspective. (As if one-point perspective had not been declared dispensable by avant-garde painting for two or three generations by the time Picasso gave it his attention – as if the least Nabi did not think he could make illusions without it! And indeed he could. That was the problem. The system of illusionism had not ultimately been perturbed by the flattening and unsettling of the previous forty years: there was more to its power than one-point perspective. Its hold on us lay deeper. Painting had to find out again, in practice, what that hold was and whether it could be loosed.)

The claim that is made, or the possibility floated, by picturing the "hidden shoulder" is therefore a radical one. It is that presence might now no longer depend on the securing of a not-seen somewhere within the rectangle – an absence of viewing or an absence of anything (much) to view. That one might have the objects of the world be fiercely secured in a picture, laid out in all their separateness and interrelatedness, without the whole thing hinging on an equation of presence with resistance to viewing – resistance to the very idea of visual knowledge laying hold of its objects completely, or completely enough.

The "hidden shoulder" does not stand, in other words, for more knowledge of the same convex solid – this was what writers on Cubism got wrong – but is meant as a challenge to the whole notion that convexity is the aspect of the body on which its being-to-the-eye is grounded. The body becomes a map. Its aspects and gradients are hardened and simplified, the better to open them out – almost to unfold them, like a piece of intractable origami – onto the surface, into the surfaces that do not "surround" them. Least of all is the eye set free to wander and take a peep at the other side of things. There is no space to wander in, only interlocking positions. Things do not have other sides. And if all goes well (this is the wager), if the hinging and flattening and dovetailing are carried through with the requisite vehemence, filling the rectangle almost until its sides and surface buckle, then the body will end not by being robbed of its objecthood, but by being given back another – a new kind of coherence and centeredness, of demarcation from other things, and of otherness to the viewer. (This is the kind of spatiality that Picasso was struggling to retrieve in the center of the Sorgues *Man with a Guitar*.)

Somewhere woven into this practical reasoning – in a way that the best early commentators on Cubism did glimpse, I think – is a peculiar new version of the old modernist saw about truth to the world in painting depending on truth to what painting consists of. What is peculiar (what marks off Picasso's version of modernism from that of the Fauves and the Nabis, say) is once again the degree of insistence on both sides of the equation. No doubt the spaces and intervals of the world were betrayed, or conjured only mechanically, by a painting that did not own up to its actual flatness; but "owning up" to flatness in painting turned out to be a much more difficult and paradoxical process than any previous avant garde had imagined. It would only be done by discovering what it was in flatness that could be put utterly at the service of the depiction of depth; it would only be by having the surface be chock-full, almost overwhelmed, by spatiality – having the surface in some sense *be* depth, be its complete and sufficient realization – that the true force of painting's confine-

ment to two dimensions would be made clear. Writers at the time did not necessarily approve of the form Picasso gave this proposition in his canvases, but they did seem to see what the argument was. Thus Jacques Rivière in 1912:

> Nothing is more hypocritical than perspective. For on the one hand it pretends not to know that the picture is a plane surface, and on the other it imitates depth solely by means of a system of profiles, all of them established on the same plane – precisely that of the picture. To represent depth sincerely, the painter will first have to acknowledge that he works on a flat surface: that is what he will do if he establishes all his objects next to one another, side by side. From then on he will have to try to imitate depth with something that has more of the nature of depth than a play of flat profiles [*imiter la profondeur avec quelque chose qui soit davantage de sa nature qu'un jeu de profils plans*].[33]

Though he never quite says so, what Rivière seems to hope for from Cubism is an end to both sorts of hypocrisy. From now on, everything in the picture will admit to the picture being flat. The object-world will offer itself in the form of juxtaposition, not silhouette. But painting, insofar as it is representation at all, will always have depth as its object. The way forward for painting lies not in a set of flimsy tautologies about its own physical characteristics, but in having those characteristics actually participate in – actually materialize – the depth that painting does not have. Here is the key passage:

> Depth is not the same as pure emptiness . . . So the painter will be able to express it by some other means than perspective – by giving it a body, not any more by evoking it, but by painting it as if it were a material thing [*en lui communiquant un corps, non plus en l'évoquant, mais en la peignant, comme si elle était chose matérielle*]. To that end, he will have transparent planes of shadow issue from all sides of the object, moving off toward other objects further back . . . Depth will appear as a subtle but visible slippage keeping the objects company; it will hardly matter that literally they remain on the same plane: between them will creep this positive distance [*cet éloignement positif*], this spacing produced by the little sloping shadows. They will be distinguished from one another, without needing to change their real visage – it will be done solely by the sensible presence, in between their images, of the intervals that separate them in nature. By becoming incarnate in shadows, space will preserve the discrete existence of objects in the picture itself. [*En s'incarnant en des ombres, l'espace maintiendra jusque dans le tableau leur discrétion.*]
> . . .
> This to and fro, this coming and going, by making hollows and saliences, will end up giving the picture as a whole a certain volume, more or less independent of perspective. The whole scene, like the individual object, will be endowed with a geometrical firmness; it will show itself in its true solidity, which is altogether different from the dry and fictive depth of a stage setting. We shall have before our eyes no longer the fragile and artificial vision of an instant, but an image as dense, full and fixed as reality.[34]

Compare Metzinger two years earlier, in October 1910 – writing, I think, with the Horta canvases specifically in mind:

> Picasso does not deny the object, he illuminates it with his intelligence and feeling. To visual perceptions he joins tactile ones. He experiences, understands, organizes: the picture will be neither transposition nor schema [this is what makes me think Metzinger had yet to see, or take into account, the

summer's work from Cadaqués], in it we shall behold the living and sensible equivalent of an idea, the total image. Thesis, antithesis, synthesis, the old formula undergoes a brisk transposition in the substance of its first two terms [*la vieille formule subit une énergique interversion dans la substance des deux premiers termes*]: Picasso calls himself a realist. Cézanne showed us forms living in the reality of light, Picasso brings us a material accounting of their real life in the mind [*un compte-rendu matériel de leur vie réelle dans l'esprit*], he lays the foundations of a free, mobile perspective, like the one from which the sagacious mathematician Maurice Princet deduces a whole geometry.[35]

Both these writers have axes to grind. I doubt Picasso was ever much drawn to the (pseudo-)Kantianism lurking in the wings here – the idea that reality is fixed and that painting should be likewise, or the notion of painting's real subject-matter being the way things are in the mind. The word "mobile" seems wrong to me, for reasons given previously. Rivière's "légers plans d'ombre" and "petites pentes sombres" strike me as far too literal ways of describing what Picasso does to paint space as if it were matter. But I realize these criticisms are easy to make. What is impressive in the two texts is the battle going on – somewhat against the writers' will, it seems – to find words for the sheer dialectical violence of Picasso's materialism. "Total image," "sensible presence," things no longer having to "change their real visage" in painting, the painter giving depth a "body" or attempting "a material accounting" of the real life of forms as we produce them mentally: all of these metaphors, excessive or clumsy though they may be, at least strike me as struggling with the right issues in some of the right terms. Which is more than can be said for most of the claptrap about Cubism that followed.

Even the notion of Picasso's being some kind of daft inverted Hegelianism, in which the Idea of an object-world is to be made over completely into matter, so that it is no longer clear which of Matter or Mind is thesis or antithesis – even this faking of philosophy (which for some reason Cubism brings on in spades) for once is appropriately Gertrude-Steinish. A clear thing, a complicated thing, a perplexing thing, etc. Look at the carafe bottom left in *Bottle of Anis del Mono* (fig. 121), done at the end of the Horta summer! Look at the way its whole form has become a ziggurat of reversible cubes – and the way space solidifies and ties itself in knots all round, gripping the individual objects and overtaking them – generalizing them, reducing them, making them functions or possibilities of a teeming, stuffed, truly Princet-and-Poincaré geometry!

It is not easy for us to know what we want; indeed, we may well want something, yet still remain in a state of negativity, a state of dissatisfaction, for we may as yet remain unconscious of the new positivity. But the world-historical individuals know . . . There is a power within them that is stronger than they are.

Of course it is also part of the *Bottle of Anis del Mono*'s effect – part of its weird yoking of the empirical and world-historical – that even the treatment of the carafe cries out, on one level, to be taken as visual fact. For are not cut-glass carafes quite like this? Is not their ready-made faceting and transparency what the picture is trying to replicate? Not Aksionov's "absolute generalization," then, but always a wild transformation of normal appearances, which nonetheless lays claim to this form, this entity, this particular truth.

Horta is a special moment. There is no need to tell the story of how and why its totalizing confidence gave way to the opposite mood the year following.[36]

121 Pablo Picasso:
Bottle of Anis del Mono,
oil on canvas, 81 × 65,
1909 (The Museum of
Modern Art, New York.
Mrs. Simon Guggenheim
Fund)

What matters is simply that the reader be struck by the distance traveled between, say, *Nude Woman* (fig. 122) from the end of the summer at Horta – I deliberately choose one of the most elusive and approximate of the pictures done there – and *The Guitarist* (fig. 123) from the same point at Cadaqués.

Again, the last thing this comparison is meant to suggest (or would have suggested to Picasso, I think) is that the distance traveled was all in the wrong direction. The problem, to repeat, was that *The Guitarist* looked so good. In many ways it must have seemed a logical conclusion to the line of inquiry begun, or given its first full performance, in the Horta studies. If one were feeling for a means, that is, to cancel the equation of presence with salience, then maybe there would prove no other way of doing it than reducing the body to a set of contingent positions and directions in space – possible not actual, mapped not materialized. In which case drawing would attenuate and float up to the surface, getting to look more and more like diagramming: a plotting of functions and appositions, so to speak, as opposed to entities and demarcation lines. The organizing structure of representation would no longer be edges and

122 Pablo Picasso: *Nude Woman*, oil on canvas, 92 × 73, 1909 (Private collection)

surfaces – solids folding out into spaces abutting them – but a tissue of virtual locations, relations, kinds of orientation or topology. That all locations are now virtual is expressed, in *The Guitarist*, by the fact that more and more surfaces seem to be transparent or nearly so, opening onto other possible positions, declaring themselves not to be solids, or even forms of transparent material, but rather configurations of space. Transparency displaces reversibility as the main metaphor. And therefore the picture really does, at last, get itself an overall "geometry." Edges can be regularized at Cadaqués because nothing much hinges on them any more: they are not where the work of depiction gets done: there is no particular ambiguity left to constrain them. Everything is ambiguous. The reversible cube gives way to the grid.

I hope that the rhetoric of this description strikes the reader as positive and negative by turns. Because that is how I understand Picasso's own reactions to what he had done at Cadaqués wavering in the months that followed. He knew that the idiom left behind from the summer had a new degree of economy and nuance. Maybe 1910 really was the moment, which writers on Cubism are always on the lookout for, when rumors of the new physics kept up his epistemological spirits. But of course the main doubts and elations were about what the new idiom had to offer painting, not whether it might meet with Maurice Princet's approval. Picasso's questions are usually practical. Would the new pattern of positions and directions, if that was what the subject of painting had now become, turn out to provide the kind of resistance to depiction – the kinds of difficulty, unexpectedness, and particularity – which had previously

123 Pablo Picasso: *The Guitarist*, oil on canvas, 100 × 73, 1910 (Musée National d'Art Moderne, Paris)

kept painting alert? How would the grid *look*? Like some sort of genuine, flexible geometry, or just a set of convenient arrangements on the surface – a "making to look geometrical" which left the viewer, once the basic language was learnt, mainly impressed by its elegance and suavity (and not much caring what either applied to)? What was to stop transparency declining into emptiness, or the mere display of painterly effects? Was "decline" even the right word here? Picasso's questions, that is to say, are not ultimately about painting's (moral) duty to some "Real," but whether the modes and degrees of reduction arrived at in Cadaqués would result in the notion of picturing being given a new sense – first of all its procedures, then its whole ontology. Or would they result in thinning and repetitiveness, "loss of problems," a *facture – genre Signac* or, worse, *genre Picasso* – that really was merely *méthodique*? That last is always Picasso's great fear.

My argument is that in the end, over the winter months of 1910–1911 and into the spring, the logic of Cadaqués was abandoned. But I do mean "in the end." Picasso was stubborn. Only particular paintings would show what the new idiom was capable of. The paintings that seem to me to have shown it most vividly at this time are the *Head of a Young Girl* (fig. 124) – for once the title is firmly attested – the female *Violinist*, which was probably shown in Cologne and Munich the two years following, the *Woman Playing a Guitar* (fig. 125), bought by Kramár soon after, the vanished but originally imposing *Monk with a Mandolin*, the even bigger *Soldier and Girl* (fig. 126), and the ultimate *Head* (fig. 127), *Table*, and *Apple* (fig. 128).[37] Some of these pictures are small studies,

124 Pablo Picasso: *Head of a Young Girl*, oil on canvas, 41 × 33, 1910 or 1911 (Private collection)

125 (*below left*) Pablo Picasso: *Woman Playing a Guitar*, oil on canvas, 65 × 54, 1911 (National Gallery, Prague)

126 (*below right*) Pablo Picasso: *Soldier and Girl*, oil on canvas, 116 × 81, 1910 or 1911 (Private collection)

looking to press the new language deliberately to extremes, and others were clearly meant as masterpieces. To my eye they all point in much the same direction. They are a kind of end game, with fewer and fewer pieces left on the board. Next to some of them even Cadaqués looks long-winded.

Here is what I take *Head* and *Apple* to be saying. It seems, after all, that the project begun at Horta had come to nothing. There had proved to be no sustainable other model of representation to put in place of PRESENCE = SALIENCE; or none that could be grafted onto or incorporated into the practices of illusionism in such a way as to give those practices a new lease of life – give them the density they seemed to have lost. The alternative models that had seemed so promising for a while – the mapping and unfolding, the diagramming and geometricization – had ended up swallowing the techniques of illusionism, or standing in ironic relation to them, holding them in a cold, simplistic grip/grid. Reduction looked more and more an act of abstract will. Picasso seemed almost to revel in the process, especially as applied to Cézanne's apple. There are moments – in the *Nude Woman* (fig. 129), for example, which Picasso seems to have finished soon after returning from Cadaqués – when the very arbitrariness of the process gave the body back a sinister glamor.

Fernande Olivier, writing about her life with Picasso long after the fact, echoed Kahnweiler's opinion that the period after Cadaqués was specially grim.[38] The evidence is anecdotal: only a fool (or a Picasso biographer) would lean on it very hard. It just seems to me in this case to chime in with the evidence of the pictures.

So I return to Céret and Sorgues. I do not want to paint a picture of the winter of 1910–1911 as relentlessly bleak; nor do I think we can seal off the work done then from the periods surrounding it. There are individual pictures from the fall and winter – the *Portrait of Kahnweiler*, notably – that are florid

127 (*above left*) Pablo Picasso: *Head*, oil on canvas, 46 × 38, 1910 or 1911 (Private collection, courtesy Galerie Beyeler, Basel)

128 (*above right*) Pablo Picasso: *Apple*, oil on canvas, 19 × 26.5, 1910 or 1911 (Whereabouts unknown)

129 Pablo Picasso:
Nude Woman, oil on
canvas, 98.5 × 77, 1910
(Philadephia Museum of
Art, The Louise and
Walter Arensberg
Collection)

and high-spirited (not to say a bit glib) in ways unlike the handful I have chosen
as typical. Dating is generally a nightmare at this time: any attempt to draw a
firm line between Cadaqués and what followed is bound to be arbitrary, and
who is to say how many spare or schematic works from later in 1911 have been
moved back to this interim period because they do not fit with the Céret *Glass
of Absinthe* (fig. 130) or *Man with a Pipe* (fig. 131)?[39] All the same, I stick to
my general characterization. However one reconfigures the body of work from
the first six months of 1911, I still do not see that anything in it prepares the
way for Céret.

This is what I meant by saying that we would understand the classic moment
of Cubism better if we saw it as not issuing from the previous three years. Of
course the paintings from Céret have a recapitulatory look. They are full of the
ways of doing things that the previous years had thrown up: the airless,
impacted quality of Horta is somehow combined with Cadaqués's leaner geom-
etry: reversible cubes – say, in the center of *Young Girl with an Accordion* – can
be seen dimpling and evaporating in front of our eyes; and so on. But what
matters to me in the last sentence is the "somehow." Just *how* are the idioms of
Horta and Cadaqués made to work together? *Do* they work together? In ways
that really pursue and reconcile the experiments – the processes of inquiry, the
tries at epistemology – that had given rise to them in the first place? I do not
think so. Painting at Céret, I want to argue, is reassembled on a wholly different
basis from that supposed or tried for from 1908 to 1910. I shall call the new
basis *painting "as if."*

What the pictures from Céret posit is a hypothetically complete and alternative system of representation, which they have found and instantiate. Nothing could be more different from the manner and matter of the paintings done in the years before. That work had the quality of always incomplete exploration, with individual pictures seeming to test out possible (possibly sustainable) strategies of representation, putting them through their paces. (Of course Horta did not have this exploratory quality written on its face in the same way as Cadaqués, but it was there nonetheless. The appearance of excess and overload in so many of the works done at Horta was as much the sign of their prototype status as Cadaqués's fading and canceling.) Pictures were offered as experiments, not models, as strategic moves dependent for their force on the presence in the picture of just what it was the experiments aimed to dismantle – the established mechanics of Western illusionism. It is not that those mechanics are any less present in the work done from Céret to Sorgues – everyone agrees that they are all over the place – but they are meant to look as if they are not, or as if they had finally been put to a transfigured purpose. "What would it be like," these paintings ask, "to have a new means of representing the world, and have those means be complete and efficient, with the power to discriminate a whole other set of aspects to visual – maybe mental – appearance?" "It would be like this." Not that the pictures actually do discriminate such another set of aspects, but they succeed in imagining, and indeed representing, what such a discrimination would involve, what the signs of it would be – as regards pictorial density, for instance, or flexibility and exquisiteness of handling, or thickness of clues to spatial location.

Nothing I have just said is meant as demotion. The sad word "classic" still may apply. It is just that I think we should recast our notion of what the classic moment of modernist painting was. It was not a devising of a new description of the world – one in which, to take the most widely touted example, the terms of space and time were recast in a way that responded to changes out there in

130 Pablo Picasso: *Glass of Absinthe*, oil on canvas, 38.4 × 46.4, 1911 (Allen Memorial Art Museum, Oberlin College, Ohio, Mrs. F. F. Prentiss Fund, 1947)

131 Pablo Picasso: *Man with a Pipe*, oil on canvas, 92 × 72, 1911 (Kimbell Art Museum, Fort Worth, Texas)

physics or philosophy. It was a counterfeit of such a description – an imagining of what kinds of things might happen to the means of Western painting if such a new description arose. And a thriving on that imagining: thriving here simply meaning an immense, unstoppable relish at putting the means of illusionism through their paces, making them generate impossible objects, pressing them on to further and further feats of intimation and nuance – all for the purpose of showing the ways they might form a different constellation, the ways they could possibly be recast, in some overall recasting of social practice (the kind that happened in Giotto's and Piero's centuries). There was no such recasting in Picasso's time. Painting rarely dines well on the leavings of science. Here what it feeds on is mainly itself.

I dare say nothing I can add to this, my basic thesis, will prevent some admirers of Cubism from taking it as an insult. They will understand the descriptions I offer as robbing the founding monuments of modern art of one kind of authority (perhaps they do, but only to suggest they have others), and will seize on the phrase "in some overall recasting of social practice" as a last residue in my text of Marxist determinism or worse (in which they will be entirely right). Let me try, nonetheless, to put the argument less baldly. I want to make plain what it is I am not saying – or not intending to say – by calling Picasso's painting counterfeit. The last thing I want (though of course it will happen) is for the "as if" hypothesis to take on a life of its own in discourse about Cubism, as a vaguely ominous, vaguely pejorative catch phrase.

What do I mean, first of all, by asserting that Cubist pictures, though they claim to denote and discriminate a new set of aspects to the world, do no such thing? I am obviously not saying something as daft as "There's really nothing there in Cubist paintings the more you look at them. They simply don't offer an account of an object-world, for all their pretending to do so." Of course they offer an account; and after a while the habits of reading required by it become more or less second nature. It is not difficult to do an approximate totalization in face of *Man with a Pipe*, for example – to make out the body in its main lines and dispositions, savor the play of weight and transparency, see the elbow on the table at right or the page of the book being turned bottom center. My point is not about the possibility of accepting the picture as descriptive, and no doubt coherent, but about whether the description has any genuine cognitive dimension of the kind it seems to profess.

Perhaps even the word "cognitive" will seem hectoring. I do not think it should in this context – if Cubist paintings do not look as if they are delivering some kind of epistemological goods, then no painting ever has – but I am happy to retreat to the connected word that has cropped up several times already, "metaphorical." Let us persist with *Man with a Pipe*. What sort of metaphorical work do we think is done here by the ways of describing that occupy most of the picture's surface: done, that is, to the ordinary identities of things as they occur in the picture (in profusion) – the clay pipe and moustache, beady eye and nostrils, cleft chin, cylinder of sleeve, stopper in the bottle, buttons and pencil and so on? Let us agree by way of preliminary that all painting, however determined to be literal, effects some kind of metaphorical shifting of the world: that the world itself – the brute familiar – is a compound of metaphors. The pattern of figures and turns of phrase, we could call it, with which we find we can operate most effectively most of the time. But for argument's sake, let us compare the Picasso with a kind of painting where the metaphorical action is already strong and strange; where a notable distance is opened up between the painting's idiom and any we are familiar with. It could be El Greco, for instance,

132 Vincent van Gogh: *Olive Trees: Yellow Sky with Sun*, oil on canvas, 74 × 93, 1889 (The Minneapolis Institute of Arts)

whose art was evidently on Picasso's mind all through this period; or, just as good, van Gogh (fig. 132).

Looking at either case at all closely would confirm, I think, that metaphorical qualification in a picture is powerful only insofar as it can be understood to apply to particulars: taking them up, giving them a new kind of detail, fixing or framing them differently, giving them another arrangement – one that strikes the viewer as true of, or true to, those particulars now that they are shown in this light. A certain kind of handling, for example, may strike the viewer of a van Gogh as applying to a set of qualities belonging to olive trees – their surface texture, say, and their internal energies, even their overall pattern of growth and adaptation to a harsh environment. The handling puts those various qualities in a relation to one another that may strike the viewer as strange; but the new relation eventually (or maybe rapidly) makes sense, by appeal to our ordinary means of judging this kind of contrary proposal about things. Van Gogh's recasting of the notions of hardness, dryness, energy, and "survival of the fittest" may look hyperbolic. New metaphors often initially seem trumped up. That eventually some of them come to seem less so, and make previous descriptions look thin, has to do with our recognizing that the parts of a scene they connect really do connect, and need insisting on in this way for the connection to be vivid. And this is the kind of assessment we go in for all the time. Is not understanding a language constantly a matter of sifting the metaphorical wheat from the chaff?

Is this what happens with *Man with a Pipe*? Does the picture effect a connection between its overall visual language and its stated particulars, or even the generalized ghost of a man to be found in it? And if not – if the metaphorical proposal here stays as general as "Objects and spaces are really continuous and interpenetrating, you understand" or "It makes better (more modern?) sense to think of a body not as a solid but a transparency, or as something that merely, contingently happens in a field of force" – then have the metaphors been given

any content? Have they been shown to apply? Here is where my answer is No. It seems to me that the pattern of metaphor in this case – the shiftings and displacements, the build-ups of texture and translucency, the infinite, brittle qualification of edge and spatial position – has not altered our understanding of anything in particular. It has the status of a general vatic aside, something along the lines of "Isn't (modern) life like that?" or "It's all relative, you know." Compare the status of Freudian asides in most twentieth-century discourse.

Maybe the point will become clearer if I focus for the time being on the actual formal disposition of those bits and pieces of the world that we are offered in *Man with a Pipe* – the moustaches, buttons, sleeve ends, etc. From very early on, writers about Cubism knew that the play between obscurity and obviousness of denotation was one feature of the style that was meant to appeal immediately to viewers; and was not just beguiling but necessary. "The indispensable mixture of certain conventional signs with the new ones [*Le mélange indispensable de certains signes conventionnels aux signes nouveaux*]": the phrase is Metzinger's in 1911, talking of Le Fauconnier, but with Cubism generally in mind.[40] Or Apollinaire in *The Cubist Painters*, taking an early stab at collage: "sometimes the object itself, occasionally an indication, occasionally an enumeration which marks it out individually, less nuance than grossness [*quelquefois l'objet même, parfois une indication, parfois une énumération qui s'individualise, moins de douceur que de grossièreté*]."[41] Two of the three elements or aspects of denotation that Apollinaire mentions here – the play between indication and enumeration, and the deliberate crudity of the latter – are already Cubism's stock in trade at Céret. So what kind of balance or imbalance is finally struck (this seems to be Metzinger's and Apollinaire's question) between the new signs and the old?

Here is my answer. The old signs just *are* what does the main job of describing in *Man with a Pipe*; but it is exactly the picture's task to insist or insinuate that nothing could be further from the truth. Where the picture denotes the parts of a world with any vividness, it seems to me it does so by means of indicators that could hardly be more common or garden; and when you (or at least I) come down to it, the picture does not have any other way to tie its exquisite idiom to a pattern of experience – a possible world – that a viewer might recognize. But this is what has not to be admitted. The picture has to proclaim, in its very form, that the tokens and icons it contains are exactly not doing the "real" work of referring. That is going on elsewhere, in the parts where moustaches and cleft chins are not in evidence.

So a formal task presents itself, which Picasso carries out to perfection. The painting has to offer the normal indicators of a distinctly normal world (viewers of Cubism have always relished the sheer banality of the things it does denote), but in such a way that those indicators never seem the actual stuff – the effective vehicle – of the painting's proposal about how the world is now seen. There turn out to be many different ways of doing this. One of them, which is much in evidence in *Man with a Pipe*, is to have the indicators look so extrinsic – so quick, so facile, so generic, done with such diagrammatic line, shaded or spotted so mechanically – that the viewer understands them straight away as bluffing signatures put in on top (so the handling and structuring say) of something else, which, by the contrary look of it, must be the genuine description. Or the effect is accomplished by tying the tokens somehow deeply into the grid, as if the geometry had secreted them; and as if the grid, if we looked, was where the deeper identities and coherencies were being made. (Look at the way the buttons in *Man with a Pipe* are rolled along various lines to apexes or points of

133 Georges Braque: *Woman Reading*, oil on canvas, 130 × 81, 1911 (Fondation Beyeler, Riehen/Basel)

intersection in the grid, like zeros in a three-dimensional sum; or the way the litter of papers on the table to the right takes on more and more geometric correctness – a pair of orthogonals going off to infinity, the bare bones of the inevitable reversible cube, and so on – till the bottle and stopper portrayed there seem to come out of the emerging order quite naturally; and the pencil too, for that matter.) Or sometimes it is done – I think particularly of the dense, reticulated center of *Young Girl with an Accordion* – by making the tokens almost (but not quite) as elliptical as everything else. "*Ma Jolie*" generalizes that principle. So does Braque's *Woman Reading* (fig. 133).

These are moments when Cubist painting pushes its language furthest. They are nuanced as well as gross. The task of constructing a subordinate status for these episodes of brute or schematic likeness – indeed, for the whole stubborn, persisting structure of resemblance on which the picture rides – is one that produced some of Picasso's and Braque's best improvisations. Counterfeiting is difficult work.

But was not one of the main things I said at the start of this chapter – about *"Ma Jolie"* and *The Architect's Table*, in particular – that high Cubism had built into it all kinds of metaphorical admission of its counterfeit status? I am not going to retract that. Even in *Man with a Pipe* there is a sheer dazzling efficiency to the episodes of likeness – look at the page of the book or newspaper I have already pointed to, rustling and billowing as it is turned, or the pipe stem wedged so firmly between the lips, or the light catching the points of the pipe smoker's shirt collar – which threatens to overtake the process of "making strange." They are absurd, these episodes, but also monstrously good. The picture admits it depends on them. All the same, I believe that we will not get the measure of these metaphors as they occur at Céret – will not catch their tone – unless we give full weight to everything in Cubism in 1911 that claims or feints a new kind of literalness. Everything that says the tokens are not any more where it is at. Painting has taken hold of the world again. It has opened toward a new totality, one actually grasped and articulated in every square inch of the oval. The grasp is there in the paint.

We shall not understand the grid at Céret, in other words, unless we see it as "lit" – or, maybe better, *re*-lit – and therefore meant to exorcize the nerveless, truly academic shading of the summer and winter of 1910. The grid had been, and still was, essentially a compositional device – a means or convenience, as Albert Gleizes put it in 1911, "to reestablish an equilibrium which these audacious inscriptions had momentarily broken"[42] – but at Céret it becomes also a guarantor of totality. It is filled with the luminous, the dappled and glistening, the chequered shade, the translucent and half-penetrable – indicators that geometry had somehow now been divulged by seeing. Lines are invaded by light. The grid shivers again with Cézanne's perceptual uncertainties, not the Douanier's confidence in the sign. What at Cadaqués and after had been reduced to a sequence of pure, disembodied differences and repetitions – gradients of position, marks of minimum differentiation in the process of conjuring up virtual worlds – is now replete, and not just replete but "one." The picture becomes a totality, infinitely nuanced and divided, but in ways that ultimately confirm its consistency – its all being made of the same experiential stuff.

There is an aside in Paul de Man's "Anthropomorphism and Trope in the Lyric" that seems to me to help clarify the issue here. Trying to make sense of the metaphor of light "speaking" in Baudelaire's poem "Obsession" – light speaking a known language – de Man writes as follows:

> Light implies space which, in turn, implies the possibility of spatial differentiation, the play of distance and proximity that organizes perception as the foreground-background juxtaposition that links it to the aesthetics of painting. Whether the light emanates from outside us before it is interiorized by the eye, as is the case here . . . or whether the light emanates from inside and projects the entity, as in hallucination or in certain dreams, makes little difference in this context. The metaphoric crossing between perception and hallucination [here de Man quotes the three lines from "Obsession" I chose as this chapter's epigraph] occurs by means of the paraphernalia of painting, which is also that of recollection and re-cognition, as the recovery, to the senses, of what seemed to be forever beyond experience.[43]

As usual with de Man, the argument moves (fast) from the commonplace to the deeply counter-intuitive. No one is going to object too strenuously to the idea that painting organizes its world in ways that are predicated on a play of distance and proximity, a dividing of things into foreground and background. It may be a little harder to accept the supplementary point, which certainly haunts this passage in de Man, and others like it, that such a division is as much

a matter of artifice as all the other divisions that make signification possible. In any case de Man seems to me right when he links this basic construction of painting to a further metaphorics of light – of light falling, emanating, crossing always from some outside to some interior, being "beyond experience" but also most palpably what experience is made out of. Light is painting's great paradox, no doubt, but it is always already a paradox of experience, of the senses established in a world – of what de Man calls "phenomenality."

These are the structures, I want to argue, that had been put under pressure at Cadaqués: not just the organization of perception into foreground and background, the two juxtaposed, but the two being tied together again, even as they are divided, by the metaphor of light. What was truly terrifying at Cadaqués was not so much that the body (the foreground) became cryptic and insubstantial, but that light too evaporated: it came apart into bits and segments, it did not do its work of crossing and falling, it did not totalize. And how is painting to operate, says Picasso, without either of the structures that make a painting a picture? (Even collage, by contrast, is lit and foregrounded. Perhaps especially collage.)

Painting at Céret operates again with both structures. It turns back to the world of phenomena, and fills – stuffs – its spaces with the signs of crossing and emanation, the boundaries of inside-out. (In that sense even our modernist critic's purple passage on Rembrandt was summoned up by something in its object, though I think it would have done better for *Woman Reading* than for "*Ma Jolie*.")

And yet the play of light in high Cubism is meant, I think, to be schematic and arbitrary as well as rich.[44] The divisionism is monochrome. The grid is never entirely part of the perceptions it totalizes: it never takes place in an inside or outside (which does not mean to say it just sits there, stably, in an "outside" imagined to be the picture plane). Even the handling, fine-tuned as it is, is also strangely impatient with its own performative power: it is like a membrane always on the point of being punctured, always about to give onto a world but never quite doing so. (The famous stencilled letters, which again are a Céret invention, only serve to make the fretful, vulnerable, interminable quality of the rest of the brushwork look more pronounced.) These pictures are on a razor's edge. The same passage that leads the viewer at first sight into a world of possible positions, shadings, consistencies, kinds of coexistence, can seem at the next like pure (ironic) production. Think back to the now-you-see-it/now-you-don't diagonal in the Sorgues *Man with a Guitar*. Are these paintings fired by the wish to deny their "as if" status, or do they admit it in their least touch? The answer is that they do both. Either activity is impossible without the other; or anyway, impossible at this level of intensity.

At Cadaqués Picasso had come face to face with the disenchantment of the world. Which meant, in Picasso's case, the disenchantment of painting – the revealing of more and more, and deeper and deeper, structures of depiction as purely contingent, nothing but devices. I guess disillusion would be a better word for this than disenchantment.

The work done at Céret and Sorgues, by contrast, is painting that posits a re-enchantment of experience, or a new form of necessity, but always in a dark mode. Or a sardonic one – it is never clear which. Cubism is comic and tragic or nihilistic and painstaking simultaneously. You never know if you are back in Seurat's laboratory, working on the new formula for everything, or being jerked from paragraph to paragraph in *The Gay Science*. The way painting continues, it turns out, is by counterfeiting necessity (on the surface) but having one's

metaphors of matter reinstate (on the surface) pure contingency at every point. Laughing at contingency, but not from anywhere outside it. This is Cubism's (modernism's) "base kind of materialism."

One last qualification. When I said a few pages ago that the language of high Cubism performs no effective metaphoric work on the particulars of a possible object-world, I did not mean to suggest it does no effective metaphoric work at all. On the contrary, once we correctly identify the limited particulars to which Cubism's metaphors do apply, then the force of Picasso's metaphorical shifting finally becomes clear. The limited particulars are the means of illusionism; and these the Cubist language does represent with genuine vividness, and manage to make strange: it effects a point-by-point reframing and rearticulation of painting's pursuit of likeness, which reveals this pursuit and its procedures as the unlikely things they always were. (This is a parallel claim to the one I made for Cézanne with regard to the epistemology of positivism.)

In a sense this is what modernist writers have said about Cubism all along. But for some reason they have shied away from the knowledge they happened upon, or at least from its implications: they have oscillated between asserting that the illusionistic means in Cubism really were, if only we knew, still generating precise descriptions (though of a world made totally new), and retreating to the metaphysical notion that the means had at last become themselves, without residue of metaphor – merely being or performing the material processes they "are." Either interpretation strikes me as missing the metaphorical point: that high Cubist pictures give a metaphorical account – a florid, outlandish and ineradicably figural account – of what the pursuit of likeness now looks like, in a situation where all versions of such a pursuit have proved impossible to sustain. The semiotician seems to think the problem here is solved if one substitutes "semiotic" or "signifying" for "material" in the last sentence but one. But this is just swapping one form of foundationalism for another – if anything I prefer the former. In practice, just as much as the modernist, the semiotician pines for a moment of modernism in which the figural – in de Man's sense – gives way to the grammatical. "Now we've discovered what signing amounts to!" This never quite happens, it seems to me, for reasons bound up with modernity (and maybe signing and consciousness in general). Certainly it did not happen at Céret and Sorgues.

I have kept to the end one notorious fact about Picasso's paintings in 1911 and 1912: that Braque's paintings from the same period look strikingly similar. We can talk till we are blue in the face about how different the paintings turn out to be on further investigation, how much the particular interests and temperament of the two individuals are still readable, and so on: given the complexity of the Cubist idiom in 1911, and its strangeness, what matters first is that it has the look of a language, and one that is shared.

It mattered, we know, at the time. Part of the hold this painting immediately took on a whole group of artists, in Paris and elsewhere, was that in it, and maybe by it, the monad of avant-garde practice had been multiplied by two. Two people may seem a small collectivity. In bourgeois society you settle for the collectivity you can get. "We are arriving, I am convinced, at a conception of art as vast as the greatest epochs of the past: there is the same tendency toward large scale, the same effort shared among a collectivity. If one can doubt the whole idea of creation taking place in isolation, then the clinching proof is when

collective activity leads to very distinct means of personal expression": thus Léger in *Montjoie!* in 1913.[45]

In the epoch the painters were living in, it had better be said, the collectivists (in art) were mostly on the Right. Or rather, Left vied with Right for the ultimate image of national rebirth.[46] There was much talk of a new art of the cathedrals. "Jamais, depuis les temps dits gothiques . . ." and so on.[47] The journal in which Léger's piece of wishful thinking was published had the subtitle *Organe de l'impérialisme artistique français*. Its editor, who singled out Léger's article for praise, had had his main say on the new artistic revolution in an essay a few weeks before entitled "Le Juif au Théâtre".[48] Renewal was bound up with ethnic cleansing.

Later on these matters became a theme of Picasso's and Braque's reminiscence. "Things got said with Picasso in those years that no one will ever say again, things that no one would be able to say, that no one could understand any more . . . things that would be incomprehensible and which gave us such joy . . . and those things will die with us."[49] "Almost every evening, either I went to Braque's studio or Braque came to mine. Each of us *had* to see what the other had done that day . . . A canvas wasn't finished unless both of us felt it was."[50] "Picasso and I were engaged in what we felt was a search for the anonymous personality [one would give a lot to know what words in French the phrase 'anonymous personality' translates, but Braque's manuscript seems not to have survived]. We were prepared to efface our personalities in order to find originality."[51] "You know, when Picasso and I were close, there was a moment when we had trouble recognizing our own canvases . . . I reckoned the personality of the painter ought not to intervene and therefore the pictures ought to be anonymous. It was I who decided we should not sign our canvases and Picasso followed suit for a while. The moment someone could do the same thing as I did, I thought there was no difference between pictures and they should not be signed. Afterwards I understood that all that was untrue . . ."[52] "People didn't understand very well at the time why very often we didn't sign our canvases. [This is Picasso in Françoise Gilot's recollection.] It was because we felt the temptation, the hope, of an anonymous art, not in its expression but in its point of departure. We were trying to set up a new order and it had to express itself through different individuals. Nobody needed to know that it was so-and-so who had done this or that painting. But individualism was already too strong and that resulted in a failure . . . As soon as we saw that the collective adventure was a lost cause, each one of us had to find an individual adventure. And the individual adventure always goes back to the one which is the archetype of our times: that is, van Gogh's – an essentially solitary and tragic adventure."[53] "At that time our work was a kind of laboratory research from which every pretension or individual vanity was excluded."[54]

I guess we should beware of being dazzled by old men musing on the days of their youth; but these do seem like fragments left over from a common language. What Picasso has to say about van Gogh as modernism's ultimate model, for example, is worth pages of stuff on modernist autonomy, or art as self-criticism. "One cuts oneself off and forgets." Two people, as I say, may look like a small collectivity (or would anonymity be better?); nonetheless this one seemed powerful, and made converts, precisely because its first viewers sensed that Picasso's and Braque's picture-making had reached a stage where the idiom they were using might not be there, first and foremost, to qualify or express some irreducible individuality. It might be designed to reduce that irreducible. Redescribing the world, which is certainly what these painters and critics thought Picasso and Braque were up to, seemed to be predicated on just such a reduction. The highest effort and achievement of painting might exactly be the

production of pictures that "looked alike." (Likeness, in bourgeois representation, is a quality that is ultimately guaranteed by the accompanying unlikeness of individual ways-of-seeing. This is something Carl Einstein's book on Braque bears down on relentlessly. It follows that a root-and-branch challenge to bourgeois representation will involve questioning its criteria not just of likeness but of unlikeness as well. The critique of resemblance is harmless without the critique of individuation. But I see I am slipping into Picasso's valedictory tone.)

Many of these issues will recur apropos of Jackson Pollock, in whose art "irreducible individuality" and endless, anonymous sameness confront one another nakedly. Though of course by then the tone is agonized, not investigative. It is as if van Gogh himself had happened upon Céret-type Cubism and made a last, desperate effort to turn it to his purposes.

I have been arguing that from 1911 to 1912 Picasso, and to a lesser extent Braque, devised a way of painting as if they had happened on a whole new representational idiom – a new understanding of the world. And what, after all, is the ultimate test of a representational idiom offering such an understanding? It is the test of collectivity. That is to say, it is whether the idiom comes to be shared – used and abused, adapted, expanded, misread, in some determinate series of representational acts, with a spreading circle of participants. Therefore another way of putting my "as if" hypothesis would be this: from 1911 to 1912 Picasso and Braque devised a way of painting as if they were a collectivity; as if the two of them were enough of a community of users, so to speak, and the tests of practice had already pared away the flourishes and incidentals of description, giving rise to a language.

Not that I think they had. Cubist painting is not a language: it just has the look of one. And if it is not a language, then naturally there will not be two native speakers. I am afraid the critics are ultimately right to insist on the differences between Picasso and Braque in 1911 and 1912; and even right when they say that what we are confronted with at this point in Cubism (in contrast to others) is a hierarchy as opposed to a collectivity. A dyad with Picasso on top. (His way of putting this later was characteristic. "He was my wife," he said of Braque.)

What else would you expect? Classic Cubism, to repeat, is not a grammar of objects or perceptions: it is a set of painterly procedures, habits, styles, performances, which do not add up to a language-game. These are exactly the circumstances in which there will most likely be one performer who invents the main ways of doing things (or sees the point of the other's inventions) while the other just imitates or reproduces them, not very well. Not very well, because at the deepest level these are not ways of doing things that can be learned. They are not thrown up by any particular descriptive task. They do not reach out beyond themselves to a world where facility is no longer the issue, and pure endless inventiveness (the kind Picasso had up to here) is subject to the tests of practice. They are not sharable. Anyone can acquire the habits – the history of twentieth-century painting is largely made up of people acquiring them – nobody will ever discover what the habits are for.

5 God Is Not Cast Down

The powers that be are attempting to create a revolutionary art from above. The state has always had its David, who paints on demand today an *Oath of the Horatii* and tomorrow a *Coronation of Napoleon*. But at the moment a David is what we don't have.

El Lissitzky, Moscow, 1925[1]

Malevich who, like all other Bolshevik artists, has been working to express the greatness of Lenin in a model for his monument, proudly exhibited a huge pedestal composed of a mass of agricultural and industrial tools and machinery. On top of the pile was the "figure" of Lenin – a simple cube without insignia.
 "But where's Lenin?" the artist was asked. With an injured air he pointed to the cube. Anybody could see that if they had a soul, he added. But the judges without hesitation turned down the work of art. There must be a real figure of Lenin, they reason, if the single-minded peasant is to be inspired.

Art News, 5 April 1924[2]

I begin again with an old photograph (fig. 134), which I invite the reader first of all to compare with that taken at Sorgues. The two photographs sum up modernism for me. This book's argument turns on the contrast between them, and also their deep interconnectedness. These are the opposite moments of modernism as I understand it. Sorgues stands for modernism's privacy, obscurity, and autonomy, and the dream of history inhabiting that condition. The other photograph is the dream made real. Whether the dream made real by modernist artists regularly (necessarily) turns out to be nightmarish, and whether the dream or nightmare has anything left to tell us, is what this chapter (in a sense, this book) is about.

134 El Lissitzky: Propaganda board in street, photograph, 1920 (Private collection)

It is spring or summer eight years after Sorgues. We are standing in the street in Vitebsk, a small town in Belorussia – a Jewish town, inside the old Pale of Settlement, too close to the Front in the war with Poland for its citizens not to feel the enormity of the moment. The Bolsheviks are trying to export their revolution. World history waits off-stage. This time the artist has set up a single huge picture on a block of concrete at the curbside, and presumably tied it to the two fluted iron pillars which appear photo center, going up out of shot. If the curb is eight or nine inches deep, the picture must be roughly twelve feet high and fourteen feet wide – monstrously bigger than anything the artist had done

up to that time, or would do for several years to come. In 1920 he was twenty-nine. He was Jewish. Most of his childhood had been spent in Vitebsk. His father had been the agent for a factory making glass and porcelain. The son had been sent to Darmstadt before the war to study architecture (Jews in Czarist Russia having no chance of getting places in such schools at home), had come back to Moscow when the war began, worked for a while in an architect's office there, been swept up in the renaissance of Jewish life and art after 1917, and returned to Vitebsk at Marc Chagall's invitation. Under the influence of Kasimir Malevich, who arrived in the town soon after, in 1919, he had changed his name from Lazar' Mordukhovich Lisitskii to El Lissitzky. The "El" was taken, so it seems, from the epigraph to a small book by Malevich, *On New Systems in Art*, published the previous fall by the Vitebsk Free Art Workshops:

> Static and speed
> > I follow
> > u-el-el'-ul-el-te-ka
> > my new path
> Let the overthrow of the old world of art
> be traced on the palms of your hands.

Resolution A:
Taking my position on the economic surface of the suprematist square, that perfect expression of the present epoch, I let the square have a life of its own, I let it be the basis for the economic development of its own activity.

I declare Economy to be the new fifth dimension, the test and measure of all artistic and creative work in the present epoch.[3]

The group to which Malevich and El Lissitzky belonged in Vitebsk called itself UNOVIS, an acronym for Affirmers of New Forms in Art.[4] "U-el-el'-ul-el-te-ka" was one of their (many) battle-cries. They believed in working together on all forms of visual imagery, putting their individual interests and styles on hold for the moment; and even this degree of collectivity, which at times seems to have been real and productive, was conceived as a kind of way-station on the road to a more comprehensive dissolution of the self. Hence Malevich in June 1920, writing in *UNOVIS Almanac 1*:

> "Collectivism" is one of the paths marked out on the road map which leads to the "world-man," but perhaps it is still no more than one of the necessary crossings on the main highway, restraining the millions of egos; it offers no more than an instantaneous convergence of forces, on their way to perfecting the image of "being"; in it each ego preserves its individual force, but if we want to attain perfection, the self must be annihilated – just as religious fanatics annihilate themselves in the face of the divine, so the modern saint must annihilate himself in the face of the "collective," in the face of that "image" which perfects itself in the name of unity, in the name of coming-together.[5]

To call El Lissitzky an "artist" in 1920, and the object he put on the curbside a "picture," is to beg many of the questions lurking in Malevich's mad rant. "Economy" and "collective," the key terms in UNOVIS's self-reflection, are words that resist being put to casual metaphorical use. El Lissitzky once or twice referred to the work he was doing in 1920 – even the work done in his tiny studio, in oil or gouache or strips of tinfoil on canvas (fig. 135) – as "ex-pictures" (*ekskartina*).[6] In that too he was following Malevich. "I am painting pictures (or rather, non-pictures – the time for pictures is past)": this from a

135 El Lissitzky: *Proun 2C*, oil, paper, and metal or metallic paint on wood, 60 × 40, ca. 1920 (Philadelphia Museum of Art, A. E. Gallatin Collection)

letter of 1915.[7] And "Economy," in the most obvious sense of the word, is indeed the measure of the object shown in the photograph we started with. It is a piece of "production propaganda." Thus Lenin, later the same year:

1. In connection with the R.S.F.S.R.'s military victories and its international position in general, production propaganda must now be given special prominence, and be accentuated and organized.

2. The leading newspapers, Izvestia and Pravda in the first place, should:
 a) reduce the space devoted to politics, and increase space for production propaganda;

b) influence all the work of the Party and of Soviet institutions, in the sense of mobilizing greater forces for production propaganda;

c) endeavor to work systematically to place production propaganda on a nation-wide footing, and take extensive measures to encourage and improve it, with a special view to verifying what successes have actually been achieved in practice.

. . .

9. It is indispensable that engineers, agronomists, school-teachers, and also Soviet functionaries possessing definite professional qualifications, be drawn into systematic participation in production propaganda (this in connection with the liquidation of illiteracy).

The organisation of lectures, talks, reports, etc.

Compulsory labor service on the part of all those who are able to acquaint the population with the problems of electrification, with the Taylor system, etc.

10. The more extensive and systematic use of films for production propaganda. Joint work with the cinema section.

Soviet gramophone records. Displays of diagrams and cartograms at clubs, village reading-rooms, in streets, etc. Bills and placards to be displayed near factories, workshops, technical schools, and so on.

Less politics, more Taylorism. We shall see that Lenin had reasons in 1920 to hanker after both. What I have just presented are some of his notes for a series of theses published in *Pravda* on 27 November, under the heading "Production Propaganda (Draft Theses of the Chief Committee for Political Education)."[8] I imagine the members of UNOVIS keeping an eye on the Party newspaper at this time with just such instructions in mind. And responding to them 100 per cent. Here, for example, is fifteen-year-old Lazar Khidekel, another Vitebsk native, newest and fiercest of UNOVIS's recruits, in the second UNOVIS almanac brought out the following January (bear in mind that the almanacs were modest wartime productions, handmade and scruffily printed):

In the equipping of the technico-electrical society there is no place for the artist with his aesthetic rubbish [*esteticheskim khlamom*], and every kind of creator will in future be required to participate in the strong and powerful culture which is on the point of coming into being in our Communist state.

In this work we must take part on an equal footing with the engineer, the agronomist and workers in every specialist field.[9]

Or someone we know only as M. Kunin, writing the lead article, "*Partiinost* in Art," in the same publication:

All of these new tasks can be carried out only under the leadership of an organised, cohesive UNOVIS Party – one which will overthrow the old worlds of art and create a new world, a new building, new structures of a new culture, a culture for all, in accordance with the new forms of the commune.[10]

Or a UNOVIS street flyer from the previous May:

On our way to a single pictorial audience!
We are the Plan
 the System
 the Organization!
Direct your creative work in line with Economy![11]

The placard in El Lissitzky's photograph reads: *Stanki depo fabrik zavodov zhdut vas*. Then below to the right: *Dvinem proizvodst[vo?]*.

Which means (my translation is a first stab at a typically malleable piece of Agit-prose): *The Workbenches of the Depots and Factories are Waiting for You. Let Us Move Production Forward.*

I had meant to start slowly, moving out from the photograph toward the various histories and audiences it might have wanted to address. But the language of 1920 – that "hyperlaconic and hypertelegraphic" style which Gastev recommended at the time to Soviet citizens[12] – is catching, and already the photograph is beset by a buzz of voices, all rattled and contradictory, each sure El Lissitzky's picture is dancing approximately to his or her tune. Malevich and Lenin, Taylor and Khidekel, the "world-man" and the "Soviet functionary possessing definite professional qualifications" – transrational yodelling drowning out, or being drowned out by, the bark of the Commissar. There are many other voices, we shall see, waiting their turn. Trotsky's at the Ninth Party Congress in March. Mikhail Bakhtin's. General Budennyi's. Comrade Chagall's ("Gubernatorial Plenipotentiary for Art Affairs," as he liked to style himself in 1919).[13] Nina Kogan's and Vera Ermolaeva's (colleagues of El Lissitzky at the Vitebsk art school, both early members of UNOVIS).[14] And voices which at this distance we are never likely to overhear as much more than statistical whispers. Like that of the nameless Menshevik worker shot by the Cheka in the summer of 1918 in Vitebsk, for posting bills protesting the Bolsheviks' suppression of a conference of workers' *upolnomochennye*.[15] (Less politics, more Taylorism. Putting up propaganda in the streets in Vitebsk was not a risk-free enterprise.) Or the voice of one Lazar Ratner, likewise from Vitebsk, found "guilty of malicious criticism of Soviet power and its activities," again by the Cheka, in November 1920, and sent to the concentration camps.[16] Or that of the local Yevsektia – the Jewish section of the Communist Party – which organized a notorious (and widely unpopular) public trial of the town's religious schools in January 1921, and then superintended the closures that followed.[17] Or the I. L. Peretz Society – Peretz remaining the central personality of Yiddish literature in the years following the revolution – writing to *Vitebskii Listok* on 4 April 1919 to denounce the "Futuristic" dictatorship of Chagall's Art Commissariat, with its system of permits for any and every item of outdoor decoration done within city limits.[18] "Only under the leadership of an organized, cohesive UNOVIS Party . . ."

All of these, minus the dead Menshevik, seem to me possible viewers of El Lissitzky's propaganda board in 1920 – possible passers-by. El Lissitzky himself seems to have anticipated close reading by just such interested parties. Vitebsk was a city of texts:

> The traditional book was torn into separate pages, enlarged a hundredfold, colored for greater intensity, and brought into the street . . . By contrast with the American poster, created for people who will catch a momentary glimpse while speeding by in their automobiles, ours [this is El Lissitzky looking back from 1926] was meant for people who would stand quite close and read it over and make sense of it.[19]

Slow down, in other words. Imagine the pace of reading in Vitebsk as well as its dogmatic flavor. Keep the Babel of competing viewpoints as groundbass, but at the same time be stubborn and literal, like a good pupil in the *cheder*. Stand quite close, read the photograph over, have it make sense.

The street is empty. The photographer has taken pains to put the board in suitable situ, and a fair amount of urban furniture is visible on three sides. The sidewalk and building shown to the left seem to slope off downhill at an angle. Maybe the placard was on a bit of a prominence, at a bend in the road. The building is brick, with fussy Victorian attached pilasters and stringcourse, probably in job-lot terra-cotta. Massive iron shutters. Something to protect. Battered canopies over the coal-holes to keep the snow from accumulating. Is this a *depo*, a *fabrika* or a *zavod*? One of the three, presumably. If a *depo*, what does that mean in Russia or Russian in 1920? Not just a railway station, by the looks of it, nor a goods yard, nor a warehouse – none of these would have *stanki* in sufficient numbers. No, it must mean something more like a round-house or an engine repair shed. Perhaps even a place where replacement locomotives got built. That would fit with the problems of 1920. But I doubt Vitebsk had anything so grand.

The building itself *is* quite grand, however, in a slightly broken-down way.[20] The concrete (or cut stone) block on which El Lissitzky's board is perched seems to be one of a pair – the edge of the other is just visible to the left – each supporting two narrow cast-iron columns, which in turn support a great wrought-iron canopy, all honeycomb brackets and palmettes and hanging fringe. Along both sides of the canopy, in flowing nineteenth-century Cyrillic, is what must be the ex-proprietor's name: LANYN. The canopy and pilasters frame an enormous round-headed doorway, lurking back there in the shadows. This is definitely the Way In. The workbenches are waiting. Best go do Lanyn's or Lenin's bidding.

It is a place in the provinces, the kind of town where the countryside never seems far off. The cobblestones are irregular, and long ago worn down into their matrix of mud. Only the sidewalk in front of the works' entrance is dignified with a proper curbstone. Most everything looks cracked or stained. One thinks of the effortless anti-Semitism of the *Encyclopaedia Britannica*, informing its readers in 1910 that Vitebsk was "an old town, with decaying mansions of the nobility, and dirty Jewish quarters, half of its inhabitants being Jews. There are two cathedrals, founded in 1664 and 1777 respectively [as well as sixty synagogues and *cheders*; but the reader of *Britannica* did not need to know about these] . . . The manufactures are insignificant, and the poorer classes support themselves by gardening, boat-building and the flax trade, while the merchants carry on an active business with Riga in corn, flax, hemp, tobacco, sugar and timber."[21] Out of the mud and cobbles next to the official curbside struggles a valiant, massacred tree, pruned by a repairer of locomotives. Its agonised branches can be seen along the propaganda board's top edge. A few leaves refuse to say die. (The pruner may even have given them a kind of trellis to hang onto in their last moments.) The tree seems to act as a second batten for El Lissitzky's propaganda board, and maybe there is even a third, to the right. (The right-hand edge of the photograph is a puzzle in general, as if cropping or emulsion went haywire at some point – hence the missing letters from *proizvodstvo*? – but there does look to be the beginnings of a post, or another concrete block, in among the cobbles just before the image ceases.) Three uprights for the board would not be excessive. It is a cumbersome, flimsy thing. Plywood, almost for certain.

The board itself is apparently lost. The photograph is all that remains of it. But we can get an idea of its color-scheme, and maybe of its materials, from a similar picture in oil on plywood – the oil paint occasionally roughened and thickened with sand – clearly done at the same moment, which recently came out of the storerooms of the State Museum at Baku (fig. 136). (UNOVIS painters did well, for a time, with government purchases. By one tally the state acquired

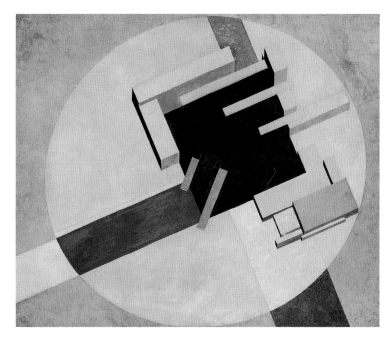

136 El Lissitzky: *Town*, oil and sand on plywood, 47 × 63.5, 1919–20 (State Mustafaev Azerbaijan Museum of Art, Baku)

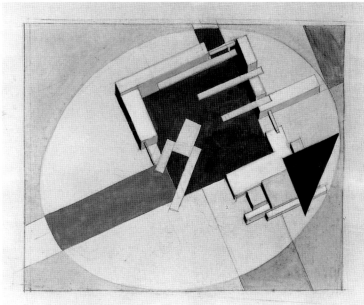

137 El Lissitzky: Sketch for *Proun 1E: Town*, graphite and gouache on paper, 18.1 × 22.8, 1919–20 (Private collection)

thirty-one paintings by Malevich alone between 1918 and 1920.[22] One can see why *Art News* took it for granted in 1924 that he was a "Bolshevik artist.") The Baku picture is called *Town*.[23]

I think we may start to get the measure of El Lissitzky's modernism in the propaganda board if we compare it with the Baku panel, and with a connected sketch by El Lissitzky for *Proun 1E*, also subtitled *Town*, done in pencil and gouache on paper (fig. 137). (*Proun* was the word for his artworks El Lissitzky eventually settled on after *ekskartina*. Naturally he never said what it meant. Most probably just Pro-UNOVIS, or Project for the Affirmation of New Forms in Art.) Other works that need to be added into the equation – I imagine them all being done in a matter of months in 1920 – are a Polish campaign poster actually printed and distributed, so it seems, by the Literary Publications

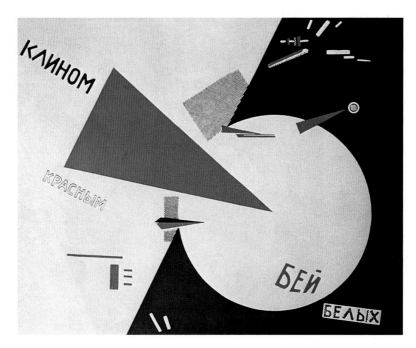

138 El Lissitzky: *Beat the Whites with the Red Wedge*, lithograph on paper, 49 × 69, 1920 (Lenin Library, Moscow)

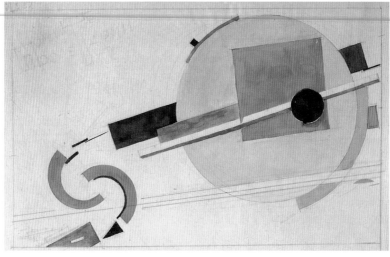

139 El Lissitzky: *Communication Workers, Remember the Year 1905*, gouache, ink, and graphite on paper, 14.5 × 22.8, 1920 (State Tret'iakov Gallery, Moscow)

Section of the Political Directorate of the Revolutionary Military Council of the Western Front (fig. 138)[24]; a sketch for a billboard for the post and telegraph workers, commemorating the 1905 revolution, apparently never done full size (fig. 139); and a small study in ink and gouache – the size is in inverse proportion to the ambition – for a work in homage to the martyred revolutionary Rosa Luxemburg (fig. 147). Should we think of this last as El Lissitzky's *Death of Marat*? In which case his *Beat the Whites with the Red Wedge* could be the equivalent of David's cartoon for the Committee of Public Safety, which likewise pours shit on the (English) army of intervention (fig. 140).

This is, I am aware, already a bewilderingly rich field of imagery, and I do not want to give the impression that it provides us with anything like a syntax or vocabulary, which we could then see the propaganda board deploying to a specific end. The point is that El Lissitzky did not *have* a syntax or vocabulary in 1920: he was still in the process of patching together something a bit like one or the other, from materials provided by Malevich and his own architectural

140 Jacques-Louis David: *The Army of Jugs*, etching with hand coloring on paper, 30 × 50, 1793–94 (Bibliothèque Nationale de France, Paris)

training. No doubt he wanted abstraction to be grammatical (he was a systematizer, and his art eventually became too well behaved for its own good), but in 1920 he still wanted it also to say Nothing – to say *u-el-el'-ul-el-te-ka*. War Communism, I shall argue, kept Malevich's nihilism alive in El Lissitzky. That was to his advantage as an artist. Whether it made for good or bad propaganda is a different question (which I do not intend to shirk).

Compare the board with the Baku *Town*. Obviously there is a great, maybe embarrassingly great, amount of common ground between the two, though which is prototype and which variant is not easy to say. Both make use of black-and-white and gray-and-white building blocks which are meant to be seen, with part of the mind, as architecture in bird's-eye view. The Baku title could hardly be more straightforward. No doubt the text in the propaganda board invites the viewer to be a bit less literal, and try out analogies with *stanki* as much as *depo* or *zavod*, or with what might actually be seen on the workbenches – pieces of precision-milled material, maybe, glued together or held in a vise. But the general mapping of picture onto world is the same in both cases; and in both cases the straightforwardness is essential to the picture's overall effect. There are local repeats from board to painting: the "building" at the right-hand corner of the tilted central square cradles the edge of its piazza in a similar way (compressed in one case, spread out more shallowly in the other); the pair of curious small "floating" bars overlapping the central square's edges plays a key role in both images; and so on. The basic armature of circle, tilted square, and four diagonal axes radiating from them, or supporting or invading them, does not alter much.

But everything, really, is different. In *Town*, for a start, the central organizing circle is intact. The bits and pieces of architecture all rest on it. It looks to have substance. Where the three main radiating bands of gray or white cross the circle's circumference they change color and, even more decisively, change tone. The circle is confirmed as something hard and concrete. "We inspected the first stages of the two-dimensional space of our structure, and found it to be as firm

and resistant as the earth itself."[25] Or again: "Our lives are now being built on a new Communist foundation, solid as reinforced concrete, and this for all nations on earth. On such a foundation – thanks to the PROUNS – monolithic Communist towns will be built, in which the inhabitants of the whole world will live."[26] I do not think the space and architecture of the propaganda board are monolithic in this sense. The circle has been pushed to the top and right of the board's surface, shrunk by half in relation to the pictorial field, and of course it has changed color. I hazard a guess it is black, with the tilted square in red (as in the 1905 billboard). It could possibly be the other way round. I would like to know the color of the tiny, decisive square floating at the center "on top" of the larger one. Could it be another shade of red, like the black-on-black of the same elements in *Town*? And could the radiating bands – at least, some of them – also be reds? It is probably unwise to read in too much color. "In its perfect state, suprematism freed itself from the individualism of orange, green, blue, etc. and won through to black and white. In them we saw the purity of energy."[27] "I envisaged the revolution as having no color. Color belongs to the past. Revolution is not decked out in colors, not ablaze with them. Color is the fire of the *ancien regime*." "Anarchy [even writing in 1923 or 1924 Malevich still gave this word a positive valency] is colored black; that is, . . . a single dark ray has swallowed up all the colors and placed everything beyond mere difference and advantage. Everything is now the same . . ."[28]

Colored or not, El Lissitzky's propaganda board is a lot less like architecture in its overall structuring than the painting from Baku. The same goes for its relation to the sketch for *Proun 1E*: turning the circle into an ellipse, as Lissitzky does there, hardly alters the basic architectonics: if anything it makes the architectural analogy easier to sustain: it puts the circle and square in perspective, and has the buildings nestle around their central ground plane all the more convincingly. The circle and square in the propaganda board strike me, by contrast, as much more non-spaces, undecidably solid or void, in shifting relation to one another and the space (or surfaces) around them. (Of course this is a guess at how the board worked. Color was no doubt the decisive factor, and color is what we no longer have.) The four main bands radiating from the center of the picture now travel over the edge of the circle with an altogether different velocity. They are tilted up or down from the board's edges at a steeper angle than in Baku or the *Proun*. The band coming in from bottom left, hurried on its way by two needle-sharp arrows, one internal to it and one traveling alongside, stops dead when it hits the circumference: the three stripes or spokes at top right seem like its lines of force reappearing. The band going up from *Dvinem proizvodstvo* rides roughshod over the black circle and meets the red square head on, uninterrupted, flat against flat – something the bands in the other two pictures could not be allowed to do (their abstract force was there to be handled and channeled, overlaid or partly hidden, till it was safely part of the Communist town plan). The band at the top seems likewise to go across the edge of the circle without paying it much mind, though here the effect is different again from the banner flatness of the band below: whatever the color of the topmost diagonal, it has the look of being tentative, maybe transparent – a layer of some substance we can look through to the circle underneath. "My research has shown that color in its basic state is autonomous; that is, each ray has its own energy and characteristics . . . I think that freedom can be attained only after our ideas about the organization of solids have been completely smashed . . . Nature's perfection lies in the absolute blind freedom of units within it – units which are at the same time absolutely interdependent."[29] "I have ripped through the blue lampshade of the constraints of color. I have come out into the white. Follow me, comrade aviators. Swim into the abyss."[30]

Even energized by these fragments of Malevich's practical criticism – the kind, I am sure, that would have been echoing in El Lissitzky's skull as he worked – my descriptions are too elaborate and pernickety for the object they aim to capture. El Lissitzky's effects are simple. The unaccustomed scale of the propaganda board is presumably one reason for that. So is the nature of the job in hand – the sense of possible viewers' skills and interests. And simplification in El Lissitzky's case made for better work, not worse.

One cliché of modernist art history I see no need to dislodge. Time and again within modernism, making convincing pictures seemed to depend on an ability to lay hold again of the fact of flatness – the object's empirical limits and resistance – and have it be interesting, even in some sense true. We are looking at just such a case. El Lissitzky's board is organized around a series of head-on collisions between three-dimensional plotting and two-dimensional constraint: on the one hand, the dovetailing and accumulation of the bits of architectural solid-in-space, and on the other, the overriding matrices or fields of force – the invading bars, the dark circle, the patterns of text. It seems as though in El Lissitzky there needed to be this kind of outright, dramatic confrontation of formal instances – this staging of flatness and depth at loggerheads – for him to be able to retrieve "flatness" as anything more than Maurice Denis-type tautology. Certainly for him to find a way of totalizing it as "energy" in Malevich's sense: that is, as emptiness and objectlessness, "absolute blind freedom" – the black square, the white abyss, the space "beyond mere difference and advantage."

This leads me back to the *Prouns* in general. My feeling is that by and large in El Lissitzky's art there is too much mere difference and advantage, and too little blind freedom. Of course El Lissitzky is as hypersensitive to the flatness of the picture support as any other ambitious painter around 1920; and he sets up, in his *Prouns*, a series of paradoxical pathways, which lead the viewer back to the black, white, and gray – the "technical materials" – stuck like a crust to the ex-picture surface (fig. 141). The problem, it seems to me, is the piece-by-piece nature of the demonstration too much of the time. "Flatness" in the *Prouns* is always virtual. It is one more paradox or possibility among others. It is never a field of force, or a brute totality, never a kind of palpable gravity which sucks the bits and pieces of pictorial architecture into its orbit – buckling them, steamrollering them, "follow me, comrade aviators."

The last thing I mean to imply here is that one or the other conception of flatness just offered is correct. We are dealing with aesthetics, not ontology. In aesthetics the proof of the pudding is in the eating. And the *Prouns*, elegant and inventive as they are, strike me too often as a rarefied meal. "I think that freedom can be obtained," says Malevich, "only after our ideas about the organization of solids have been completely smashed." Smashed, not subjected to polite skepticism. In this, I am afraid, Malevich is the voice of modernist wisdom. El Lissitzky's normal inability (or unwillingness) to signify flatness as force, or resistance, seems to me the key to his limitations as an artist. The propaganda board is as good as he gets, just because the circumstances seem to have enabled him to make flatness a metaphor, for once – give it a hectoring, War-Communist kind of intensity.[31]

The metaphor (like the formal language) was essentially simple – some might say, simple-minded. Flatness just *was* the totality, meaning the Plan, the System, the Organization. FLATNESS = ENERGY + INTERNAL LOGIC:

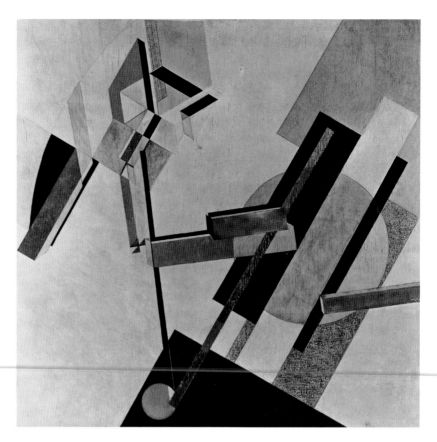

141 El Lissitzky: *Proun 19D*, gesso, oil, collage, and mixed media on plywood, 97.5 × 97.5, ca. 1920 (The Museum of Modern Art, New York, Katherine S. Dreier Bequest)

The basic condition of the economic recovery of the country is the undeviating carrying-out of a *unified economic plan*, reckoning with the next historical period . . .

1. The working out of a plan of electrification of the national economy and the realization of a minimum program of electrification . . .

2. The construction of the basic regional electrical stations of the first series and of the basic lines of electrical transmission, with a corresponding extension of the activity of factories for the manufacture of electrical equipment.

3. Equipment of district stations of the second series, further development of the network of electrical lines and successive electrification of the most important production processes.

4. Electrification of industry, transportation and agriculture . . .

The realization of the above mentioned plan is possible not by means of separate and single heroic efforts of the leading elements in the working class, but by means of stubborn, systematic, planned labor, which attracts into its sphere larger and larger masses of workers. The success of such an expanding mobilization and education of labor can be assured only if there is a wide and insistent campaign of explanation among the masses of city and village, pointing out the inner meaning of the economic plan, its internal logicality, which assures fruits that will be perceptible to all only after the expiration of a long period, and which demands the greatest exertion and the greatest sacrifices.[32]

Thus the Resolutions of the Ninth Party Congress, published just after its closing on 4 April.

Our problem is to imagine a situation where language like this, and images of the future like these (none of which, I take it, adds up to a version of utopia that strikes us nowadays as having much poetry), got into the artistic bloodstream and gave abstraction a sense of purchase on the world. "Inner meaning." "Internal logicality." Fruits "perceptible to all only after the expiration of a long period." Phrases like these have a familiar ring. We are looking at the lingua franca of modernist art practice becoming a form – for a while, *the* form – of the social imaginary. Artists rarely live through moments when their kind of esotericism seems really to duplicate that of the people in power. Best seize the moment while it lasts. "Not by means of separate and single heroic efforts," but "under the leadership of an organized, cohesive UNOVIS Party."

Two quotes are put at the head of a piece of writing by El Lissitzky from this time: one from Spengler's *Decline of the West*:

> All the arts are mortal, and not just the individual artwork, but Art as a whole. One day Rembrandt's last portrait will cease to exist, even though the painted canvas will still be intact; because the eye that can apprehend this language of forms will have disappeared.

and the other from Malevich himself:

> The Civil War between the new Art and the old still continues.[33]

There are many things still to be said about the propaganda board. In a sense, we have not even begun to tackle the aspect of it that seems to me the true root of El Lissitzky's utopianism: that is, his sense of the possible relations, in spring and summer 1920, between the two great forms of established sign language in the culture at large – visual and verbal, picture and text. It is above all because the circumstances following 1917 were felt for a while to be bringing about a breakdown and remaking of these distinctions that abstract artists could believe their project was political, with a part to play in the world's death.

> The Factory refutes the two previous speakers [that is, Art and the Church] and says: "I shall remake the world and its body, I shall modify man's consciousness, I shall make man omnipresent by the knowledge of those perfections that are in me, and the world shall become incarnate in me . . . I shall be He who knows everything, I shall be God, for God alone knows all the doings of the universe. All the elements of Nature shall be gathered together in me, and I shall be eternity. I shall give man the gift of sight, of hearing, of speaking in a multiplicity of spaces, I shall reconstruct the mechanics of his body along perfect lines. I shall have man's will be part of my own smooth functioning, I shall absorb the power of the wind, of water, of fire and of the atmosphere, I shall make them all man's exclusive property. And when all is said and done, the whole of this world, which is simply an unsuccessful technical experiment on the part of God, shall be rebuilt by me, and I shall make it good." So who is it that speaks thus so audaciously through the Factory's lips? It is God Himself, shouting brusquely through the Factory's mouth.[34]

Be advised that for Malevich in 1920 – this is a passage from his *God Is Not Cast Down*, written that year in Vitebsk – the terms God and Factory are almost infinitely elastic. God is a Nothing that men have built, which exactly means He is indestructible. And Factory equals much more than technology, or even technocracy. It equals the Party. It equals Materialism. It equals the Marxist dream of totality.

I do not think we can make any sense of the question of UNOVIS's textuality in 1920 – and Malevich was a writer, not a painter, in the years we are chiefly looking at – without attempting to answer the question of what Party and politics were, during the period called War Communism. It is a daunting task. I shall try not to get lost in the details, or utterly sidetracked by the catalogue of horrors.

Some such catalogue is obligatory. In the spring and summer of 1920, for instance – and you will gather that this is my best guess at the moment when El Lissitsky's *Stanki depo* was done[35] – the Bolsheviks were fighting for existence on at least five fronts. Vitebsk was only a few miles from one of them. It was the center for the Red Army's reserves: that meant it was occupied and surrounded by hundreds of thousands of soldiers.[36] (The Red Army in 1920 claimed to be five million strong.[37] An inflated estimate, obviously, but at least it gives a sense of what "militarization" – a favorite Trotsky trope at this time – amounted to.) With armies go deserters. Between March and July, according to one Party Committee report, 30,000 deserters (and 313 bandits) had been captured in the countryside between Vitebsk and its larger neighbor, Smolensk.[38] A lot of them were peasants going back to their villages for supplies. The Party's paper for the village masses, *Bednota* (Poverty), reported a successful exercize of the Vitebsk District Committee for the Struggle against Desertion in its 18 August issue, in which ninety-five deserters, seven horses, and one pig had been reclaimed by the state.[39]

Anyone trying to piece out the state of the Union in 1920 – I am thinking of UNOVIS in particular, worrying about its art-worker rations, counting the divisions of the Fifteenth Red Army, watching Budennyi's cavalry (with its twelve real aeroplanes!) pass through the city, going west – would have dined on hearsay, half-truth, and rumor. Victor Serge, who lived through the period, is eloquent on the subject:

> In the countryside the harvest had been brought in. It was being hidden. Peasants who had fought with their scythes under the red flag now buried their wheat and sounded the tocsin at the approach of the Anti-Christ. Others, their sons, with red stars sewn into their old Imperial Army caps, arrived to search their barns. Workers, fearful of being stoned, harangued the village elders . . . Around the edges of this bizarre continent, like feverish ant heaps, moved armies which melted into armed bands and armed bands which swelled until they became armies. In the land of blues and yellows – peaks and sand dunes – a non-com transformed into an ataman had railroad workers thrown alive into the boilers of their own locomotives. But, a son of the people, he gave the daughters of his old generals to his exasperated soldiers. From armored trains the blind eyes of cannon peered out over steppes once overrun by the archers of Gengis Khan. Gentlemen with immaculate bodies daubed with cologne, wearing perfectly laundered underwear beneath the uniforms of the Great Powers, . . . watched the Russian earth pass by the windows of their Pullman cars. Their orders were dated Washington, London, Paris, Rome, Tokyo. They had . . . ideas as polished and well rounded as their fingernails: ideas about barbarism and civilization, about the Jewish plague, about Slavic anarchy, German gold, Lenin's treason, Trotsky-Bronstein's madness, about the inevitable triumph of order . . .[40]

(All ideas which are back in fashion, of course. But then, Serge was the last person to assume his irony would end on the winning side.)

In January and February 1920, the papers were full of the death-throes of the regime of Admiral Kolchak in Siberia. The Czecho-Slovak legions had handed the Admiral over to the Reds. General Janin and his Allied forces – French, American, Japanese – headed for the Pacific. The Cossack armies turned south across the desert toward Persia and Turkestan. In the Ukraine, the Poles under Pilsudski struck south and east in late April. They took Kiev on 6 May. Behind Bolshevik lines the army of the anarchist Nestor Makhno carried on its fight against "institutions of terror, such as your Commissariats and Chekas, which commit arbitrary violence against the working masses."[41] Dzerzhinsky himself, head of the Cheka, was sent to supervise the war in the rear in the Ukraine.[42] In June and July, the tide turned against Pilsudski. By mid-July the Polish armies, in the Ukraine and on the plains to the west of Vitebsk, were in full retreat. The Bolsheviks hesitated for a moment over the wisdom of trying to export revolution, but eventually pressed on toward Warsaw. They were defeated outside the city in mid-August. Stalemate ensued. The Whites took their last stand in the Crimea. Baron Wrangel proclaimed himself head of state there in early April. Worried telegrams from the British High Commissioner in Constantinople soon made it clear that the Allies were washing their hands of their clients. Once the armistice was signed with Poland in October, the writing was on the wall. Budennyi himself came south to the Dnieper. By mid-November, French warships and troop transports were ferrying Wrangel's armies – all 145,693 of them, by the Baron's estimate[43] – across the Black Sea and down the Bosphorus. Makhno had given the Reds a helping hand for a month or so in the campaign against Baron Wrangel. The regime had even agreed in return, in October, to release its imprisoned anarchists and give them the right to make propaganda. Once Makhno's armies had served their purpose, the agreement was torn up. The Red Army wheeled west toward Gulai Polye and its anarchist Republic (for some reason these last two words are invariably hemmed in by quotation marks in the standard histories, as if to dissociate the writer from the very idea). Makhno took to the steppes. He was still at large, his army of peasants dwindling, when the Kronstadt sailors rose against Petrograd in March 1921.

This is a heavily edited version of a year of chaos; or should we call it a year of state-formation (painful but not in the end unproductive, and as these things go – that is, state-formations – perhaps not even specially bloody)? Makhno's Republic was only the tip of the iceberg of peasant struggle. All through 1920, in Tambov province pre-eminently, and along the Volga, between Samara and Orenburg, in the Caucasus and on the western fringes of Siberia, a score or more peasant armies came into being, some of them hordes of bandits coalescing for a month or so, others publishing manifestoes and trying out the first forms of alternative government.[44] (One of the slogans of the *chapany* in the Volga in 1919 had been "Down with the domination of the Communists and the Anarchists! Long live the power of the Soviets on the platform of the October Revolution!"[45] The ideology of peasant revolt is full of strange twists.) Lenin, musing later on the phenomenon, exaggerated only a little when he called the uprisings "more dangerous than all the Denikins, Yudeniches and Kolchaks put together, since we are living in a country where the proletariat represents a minority, and where peasant property has gone to ruin."[46]

My guess is that it would have been the to and fro of events in the Ukraine that the group in Vitebsk tried hardest to follow. Malevich was a native of Kiev. Makhno's politics may have interested him. El Lissitzky had worked in the same city in 1919, immediately before moving to Vitebsk. He had been employed by the art section of the local Commissariat of Enlightenment. His energies had gone into designs for Yiddish books. Denikin's capture of Kiev in the summer of 1919 probably put paid to a series of children's fables El Lissitzky had

contracted to do for Yidisher Folks Farlag.[47] The Whites were not likely to have taken such projects under their wing. It was a time of pogroms. Some say that over 200,000 Jews were done to death in the Ukraine between 1918 and 1921, over 300,000 children orphaned (a grisly context for El Lissitzky's nursery stories) and over 700,000 Jews made homeless. These figures may be underestimates. It was the worst killing of Jews since the seventeenth century.[48]

What eventually got christened War Communism will not make sense unless it is seen against this black background. It was a set of expedients in a time of cold and death. It was a way of keeping the skeleton of a state in being. It was what Marxists do in a country careering back toward feudalism and worse. (We have photographs of peasant cannibals taken during the famine in Samara in 1921, standing in line behind the piled-up limbs of their victims.[49]) It was the dictatorship of the proletariat in a nation where the proletariat had disappeared. All that, yes – but utopia just the same.

Victor Serge has a great scene in *Conquered City* – it is meant to take place some time in early 1920 – which puts the regime's (and the historian's) dilemma in a nutshell. The Bolshevik leaders have gathered to hear their civil servants report on the state of the nation. "What makes you think" – the questioner's voice is as usual with Serge done in *style indirect libre* – "that the city can hold out when the whole Republic is about to crumble?"

> Experts have studied the problem of transport, the problem of food supply, the problem of the war, the problem of epidemics. They conclude that it would take a miracle. That's their way of telling the Supreme Council for Defence: "You're all washed up!" They withdraw, very dignified, veiling their prophets' arrogance. One knows that the wear on the railroad line will become fatal in less than three months. The other that the big cities will be condemned to die of hunger within the same lapse of time. It's mathematical. The third that the minimum program for munitions production is perfectly unrealizable. The fourth announces the spread of epidemics . . . History can't be forced. Production cannot be organized by Terror, don't you see, with one of the most backward populations on earth! They barely refrain from passing sentence, out of deference for the men of energy who have embarked on this formidable adventure, and who are lost, but whose least errors will be studied for a long age to come. How to explain these men? That's really the problem of problems. There is fear in that deference; irony, too; perhaps even regret.[50]

Later historians, as I say, have largely repeated the experts' verdict. Many of them have leaned heavily on the numbers provided in 1925 by the Bolshevik Lev Kritsman, in a book called *The Heroic Period of the Great Russian Revolution* – plenty of deference in the title, obviously, but more than a trace of the Marxist's professional doubt. Kritsman could have been one of the players in Victor Serge's melodrama.

The numbers are stupefying. What other industrial (or part-industrial) society has lived through the shrinkage of its two main cities by half in three years? That is what happened to Moscow and Petrograd from 1917 to 1920. Petrograd had two-and-a-half million people in 1917. In 1920 it had 700,000.[51] If we take 1913 as our base year for measurement of industrial output in Russia (100, in other words), the index in 1917 had already fallen to 77, in 1918 to 35, in 1919 to 26, in 1920 to 18. Industrialization had the look of a reversible phenomenon. The number of workers employed in big factories and depots – the kind listed as *tsenzovaia* in the surveys – went from 2.6 million in 1913 to less than 1.6 million in the first months of 1920.[52] And even this figure masks the true extent of de-industrialization. Scores of sources at the time talk of the factory areas of cities as half-dark wastelands, starved of coal and electricity,

waiting in vain for the ruined railroads to bring in pig iron or wool, with the proletariat engaged in piecing together cigarette lighters and can openers from industrial debris, for sale in Sukharevskaya Square. The machines were broken. The engineers who knew how to mend them were long gone. One day in three the worker was off somewhere on his or her own initiative, looking for food, nursing a low-grade infection, scavenging for fuel and raw materials, trying to find a way to keep life (and industry) going in the face of the imminent end of both.[53] Kritsman put food consumption in the cities at 40 per cent of pre-war levels. Seven million people died from malnutrition and epidemics between January 1918 and July 1920. The death rate more than doubled.[54] Transportation, in particular the railroads, seemed to be juddering toward a total halt. Four thousand bridges were blown up during the civil war. Eighty-six thousand *versts* of telegraph line were pulled down. By January 1920 only 6,700 locomotives were still operational – as compared with more than 20,000 in 1913. There were more locomotives in the repair sheds than out on the tracks. Idle freight cars (tens of thousands of them stood around in sidings) were rented out by the local Soviets or railroad unions as cheap housing. The figures sent back to the Commissariat of Transport naturally listed them "in use." Sometimes unloading the trains that did still arrive meant risking a gun battle between groups of bandits fighting for whatever was on board. So the trains stood fully loaded in the freight yard, under armed guard, awaiting further developments.[55] Early 1920 – the period that directly concerns us – was by general agreement the absolute zero of all available indices.[56] *Stanki depo* would have had a cruel, desperate ring, or maybe a faintly ludicrous one, to those who knew what depots and workbenches were actually like.

None of this was a secret at the time. Lenin's and Trotsky's speeches are full of it (in suitably edited versions). This is what the "Theses on Production Propaganda" were about. And naturally Marxists were early on aware of the paradox. Here they were, making the proletarian revolution in face of "the disintegration of the proletariat" – Bukharin's phrase at the Seventh Party Congress.[57] The Mensheviks, as good Marxists also, had always predicted some such plunge back into chaos if the revolution were forced before its time. They did not flinch from pointing to the emptiness of a "dictatorship of the proletariat" exercised in the name of a class that the dictatorship was putting to death. Lenin even fell to arguing with the dissenters (when they were all safely in exile or behind bars) in May 1921: "Even when the proletariat has to live through a period of being de-classed ... it can still carry out its task of conquering and retaining political power."[58] It was possible to put a good apocalyptic face on even the worst statistics. In a book brought out early in 1920, titled hopefully *Economics of the Transition Period*, Bukharin seems to have mirrored the general mood among the cadres that year – what one historian calls a "mood of euphoria and desperation" – which is striking, for instance, in the proceedings of the Second Congress of the Comintern in July.[59]

Anarchy in production [Bukharin writes], or in Professor Grinevetsky's words, "the revolutionary disintegration of industry," is an historically inevitable stage which no amount of lamentation will prevent. The Communist revolution of the proletariat, like every other revolution, is accompanied by an impairment of the forces of production (civil war) ... But ... we should examine the role of this particular phenomenon by starting from the subsequent cycles of reproduction on their broad historical scale. Then the cost of revolution and civil war will be seen as a temporary reduction of the forces

of production, which nevertheless laid the foundation for their massive growth, once the relations of production were reconstructed on a new basis.[60]

We shall not understand Malevich's mad optimism/pessimism without Bukharin's pseudo-dialectics ringing in our ears. The God shouting brusquely through the Factory's mouth was partly a God like this.

This chapter's main concern is art, and specifically modernism. I am trying to reconstruct the patterns of experience that may have informed, say, the project for a Malevich-type ration card done in the UNOVIS workshops at just this moment – probably by a student named Aleksandr Tseitlin (fig. 142). I am trying to imagine whom and what El Lissitzky thought he was addressing in *Stanki depo*. And whose voice he was adopting.

This last is a question about the Party. About what the Party did in response to the circumstances just outlined, or how much of the circumstance was the Party's doing. To what extent was the Party itself the "Economy" in 1920? To what extent did it imagine itself to be? And had to imagine itself, in order to be a Party at all?

Answering these questions involves describing what the Bolsheviks did, in 1919 and 1920, in an attempt to put economic life on a new footing. But there is no such thing as factual description here. Every statement of fact is haunted by questions of motive, origin, and ideology. What for one set of experts is a chain of improvised expedients, patched together from day to disastrous day, is for another a process driven from start to finish by certain political imperatives – above all by a vision of capitalism coming to an end, in a matter of years, maybe months. From my point of view, it is exactly this undecidability that counts. It is because War Communism was both chaos and rationality, both apocalypse and utopia – because it presented itself as such, in a flurry of apologetics and prophecy – that it gave rise to the modernism we are looking at. Proletarian rule, says Kritsman, "exudes a monistic wholeness unknown to capitalism, giving a foretaste of the future amid the chaos of the present."[61] It is not hard to see how this fantasy of dictatorship colluded with the avant garde's theory of its own historical mission.

I hope the reader will not think I am overlooking or trivializing the real horror of the time – I have done my best to make some of it vivid – if I also say that in this undecidability War Communism seems to me to epitomize the horror of modernity in general. It is because so much in El Lissitzky's photograph speaks to the life we live now – the flat imperative of utopia up there on the billboard, ironized by the empty desolation all around it – that the photograph refuses to die. Of course the utopia on our billboards is different. Production has given way to consumption. Consumption has proved the only vision of utopia capable, in the circumstances of capitalism, of reminding us with requisite frequency that the workbenches are waiting. Have Mr. Lanyn's descendants reclaimed his property from the state, I wonder? No doubt the streetcorner in Vitebsk, if it survives, has been comprehensively redecorated.

A Party member looking around in 1920, or a reader of *Pravda* or *Bednota*, would have seen the following landscape. In the countryside, because the peasants refused to give up their grain (because there were no industrial goods to exchange for it, because money was more and more worthless), there had been for two years a regime of forced requisition, sometimes with a fixed

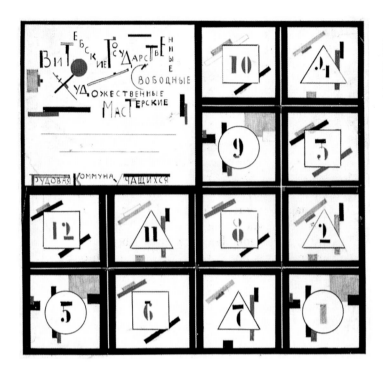

142 Aleksandr Tseitlin: *Ration Card*, gouache, ink, and graphite on paper, 17.5 × 18.8, 1920 (State Tret'iakov Gallery, Moscow)

quota of commodities traded in return, most often without. This is the situation Victor Serge has in mind with his "sons with red stars sewn into their caps." The Bolsheviks called it *prodrazverstka*.[62] The Red Army was the main enforcer and beneficiary of the system; and that verdict applies to most other aspects of economic (and social and political) life at this time. In 1920 the Red Army *was* the bureaucracy. It and the Party were most of the state. Not forgetting the Cheka. The peasants, we know already, had not done well out of revolution and civil war. The state soaked them for everything it could get. Forced requisitions made up four-fifths of its revenue.[63]

There was supposedly no more private trade. The Cheka and the army roamed the railway stations in search of speculators and bagmen bringing in salt beef and cheese from the hinterland. Food rationing was in force in the towns – it was an expedient the Bolsheviks had inherited from the Provisional Government – officially administered on strict class-preferential lines. In practice the army and labor aristocracy did best, followed by *apparatchiks* and approved intelligentsia.[64] Young Tseitlin's ration card was partly a vote of thanks. (The main reason UNOVIS dispersed from Vitebsk in 1922 seems to have been that it came off the local Soviet's list of deserving parties.[65]) Banks and insurance companies were nationalized. So were the larger factories. The Party was hatching further episodes of expropriation of the expropriators. Total nationalization might do the trick.

Mood swings among those responsible for running the economy in these circumstances were, understandably, extreme. The Committee for Labor Conscription, for instance, made this diagnosis in *Pravda* on 26 February: "The workers of the towns and some of the villages choke in the throes of hunger. The railroads barely crawl. The houses are crumbling. The towns are full of garbage. Epidemics spread and death strikes out right and left. Industry is mined from within."[66] Early in April, on the other hand, the *Pravda* reader would have been bucked up no end by the Resolutions of the Ninth Party Congress, noting "with

satisfaction the indisputable signs of a rise in productivity among the foremost sections of the workers."[67] Forward toward Communism! The new law of 29 November 1920 declared nationalized all plants that employed more than ten workers, or more than five if motor power (modern luxury) was in use.[68] (I say "declared" because the actual means to carry out and monitor the nationalization were almost wholly lacking. The same goes for most of the plans and decrees issuing from SOVNARKOM and GOSPLAN as the months went on. Lenin's speeches are haunted by this realization.) Leakage of goods into the private market was to be stopped once and for all. The Food Commissariat was to extend its monopoly to objects as humble as honey and mushrooms.[69] There was talk of a crash program for collective farms. Committees for Obligatory Sowing of Seed were planned for the spring of 1921 – they were overtaken only by the last paroxysms of War Communism and the retreat to NEP.[70] Trotsky was seized with enthusiasm for the military life, and thought that labor in general – society in general, if necessary – could do with a taste of the bayonet. He poured scorn on those Marxists who thought a return to servitude might put productivity at risk:

> We are now heading toward the type of labor [this is Trotsky speaking at the Trade Union Congress in April] that is socially regulated on the basis of an economic plan, obligatory for the whole country, compulsory for every worker. This is the basis of socialism . . . The militarization of labor, in this fundamental sense of which I have spoken, is the indispensable basic method for the organization of our labor forces . . . Is it true that compulsory labor is always unproductive? . . . This is the most wretched and miserable liberal prejudice: chattel slavery too was productive . . . Compulsory serf labor was not a product of the feudal lords' ill will. It was a progressive phenomenon.[71]

Well might the Menshevik Raphael Abramovich rise up, as he dared to do on this occasion, and say: "You cannot build a planned economy in the way the Pharaohs built their pyramids."[72]

I realize that more and more of Abramovich's sarcasm seeps into my catalog of state institutions the longer it gets. But I am not sure I can or would want to prevent that. A history of Bolshevism not written in the light of what was done to the Mensheviks, the anarchists, and the Social Revolutionaries at this time is a history, in my view, that utterly fails to grasp the first features of its object. Fantasies of centralization and control in the economic realm are the counterparts – maybe the ideological products – of anything-but-fantasy in the sphere of politics. A Cheka is set up more quickly than a national grid. Or, more to the point, a Commissar is easier to dismiss when he or she disagrees with you than is a delegate from the local Soviet.

> It stands to reason [says Bukharin in *Economics of the Transition Period*] that the element of compulsion, which is the self-coercion of the working class, increases from its crystallized center towards the . . . amorphous and scattered periphery. It is the *conscious cohesive force* of a fraction of the working class which, for certain categories, subjectively represents an external pressure, but which, for the whole of the working class, objectively represents its *accelerated self-organization* . . .
>
> From a broader point of view – that is, from the point of view of an historical scale of greater scope – proletarian compulsion in all its forms, from executions to compulsory labor, constitutes, paradoxical as it may sound, a method of formation of a new Communist humanity from the human material of the capitalist epoch.[73]

"Paradoxical as it may sound." Even good Bolsheviks recoiled at times from Bukharin's and Trotsky's logic. Trotsky's proposals for the militarization of labor got only two votes out of sixty when he presented them to a conference of trade union leaders in January.[74] Not surprising, given the audience. They knew how far they could stretch things with their membership. Mikhail Olminskii, one of the older generation on the Moscow Party executive, thought *Economics of the Transition Period* had abandoned anything resembling Marxism in favor of the "Bukharinist method – of penal servitude and shooting."[75] It was a method with the future in its bones.

O̲ne way of putting all this would be to say that War Communism, rather than being an *Economics of the Transition Period*, was an attempt to destroy or short-circuit the transition between capitalism and those forms of socialized production and exchange that could possibly replace it. It was, or imagined itself to be, the negation of capitalism there and then. Or to put it another way, it tried to do without mediations. There were no intermediate, hybrid forms of economy and social organization existing in the interstices of the market (mainly because there was no market to speak of, or a market of a more and more rudimentary kind): so let the state create them out of whole cloth.

This is too neat, of course. It smoothes over the question of political options and motivations even in the worst of circumstances. It makes out the economics of War Communism to be more of a totality, or an effort at totalization, than perhaps they were. But there is no need for us to bite the snake's tail of Leninism yet again. From our point of view, what matters is simply the extraordinary being-together in 1920 of the grossest struggle with the realm of necessity and the grandest (or at least, most overweening) attempt to imagine necessity otherwise. Imagining otherwise was for a while actually instituted as part of the state apparatus. Some might say it was what the state did best – the one realm in which production propaganda really had results. And this seems to me generally true. In conditions of modern state-formation, what matters is not the content or effectiveness of any particular exhortation (hence the futility of sneering at the Russian modernists' ineffectiveness after 1917, say as entertainers of the working class) but the self-sufficiency of exhortation itself: that is, the exhorting classes' belief in exhortation, the state's belief in the exhorting classes, and their being-together in the dance of ideology. One thing we learn from the Fall of the Wall is how abruptly this kind of ideological system can cease to believe in itself, and how soon that local malfunction comes to threaten the state as a whole, in its ordinary violence and materiality.

Again, these problems are too large. All I want to do is point to the exemplary character of War Communism – point to its modernity (chaos and all). And insist that this is why a phenomenon like UNOVIS could be part of it, not as an aberration but as a main symptom of the disease. Art is one of the several forms – I should say effectively permanent forms, unless maybe we take Bukharin's "broader view" – of imagining otherwise. That is a chief thing it does. Any attempt on the part of the state to create new forms of such imagining, or monopolize old ones, puts art at risk. It can respond to the situation in a defensive or offensive manner. UNOVIS chose to go on the attack. Maybe that was not what the state wanted, but it meant that for a while UNOVIS interpreted the state's dream back to it in a way the state found irresistible. It "exud[ed] a monistic wholeness unknown to capitalism, giving a foretaste of the future amid the chaos of the present." The state paid the piper. Left artists got their special rations. All Kritsman was wrong about was the idea that "monistic wholeness"

is necessarily foreign to capitalism. Tell that to someone who lives in the world of the multinationals, the (one) superpower, the global market. It is because UNOVIS shows us what the state essentially still is – what it is more and more effectively – that reading Malevich, or looking at El Lissitzky, continues to strike a chord.

I am trying to imagine, as I said previously, whom El Lissitzky thought he was addressing in the propaganda board, and whose voice he was using. This is a question that turns partly on conditions of reading and looking – in the case of the placard, especially of reading. "The traditional book was torn into separate pages . . . and brought into the street." "Ours was meant for people who would stand quite close and read it over." "The Bible of our time cannot be presented in letters alone."[76]

When, earlier in the chapter, I gave a first translation of the board's instruction to passers-by, I talked of its prose being malleable. There is no need to overstress this. The main slogans are strikingly clear. *Stanki depo fabrik zavodov zhdut vas. Dvinem proizvodst[vo?]*. *Stanki* means "workbenches," and appended to it are three possible genitives: *fabrik* and *zavodov*, a traditional doublet, both words meaning "factory," the distinction between the two – is it size? type of labor? modernity or otherwise? – as much a matter of uncertainty to the native speaker, so I am told, as that between "hue and cry" or "kith and kin" in English; and preceding *fabrik* and *zavodov*, the notable, foreign, uninflected, late-nineteenth-century word, *depo*, whose meaning I have already debated.[77]

Depo is the word that counts. You will notice that it is decisively larger than the other two, put neatly on top of them in a separate tabulation; and its lack of a genitive ending (its foreignness) produces a momentary hesitation in the reading – a moment of wondering what the relation between *stanki* and *depo* will turn out to be – before the subordinate words bring the import properly to heel. Again, no need to exaggerate. The suspension of meaning is over in a flash. All the same, it is part of the poster's signing of its modernity that the "American" (or maybe English) word be given pride of place, not yet entirely part of the syntax that surrounds it.

Zhdut vas is straightforward: "await you" is only a little too stiff a translation. *Dvinem proizvodstvo* would be similarly transparent – "Let us move production forward" or "Let us get production moving" – if it were not for the final two letters of *proizvodst[vo]* being cut off by the photo's right edge. And in a sense this is a happy accident. A lot of effort has already gone into making the poster's last words *dynamic*: they are tilted from horizontal to diagonal, their letters lined up with the arrows flying in from bottom left; and *proizvodstvo* is written along a kind of crossbar (could it be colored red?), seemingly part of, or minimally differentiated from, the broad band which goes up to the edge of the square. So that writing at this point – in contradistinction to the writing top left – seems part of the push and pull of forces turning the central wheel. If that means the abstract machine has worked up enough energy to hurl *proizvodstvo* literally off frame, then so be it.

The board is a piece of agitprop. Its basic message is never in doubt. Even at the level of typography, El Lissitzky has been, by his standards, noticeably well-behaved. Certain of the letters in the top left slogan – in particular some of the initial capitals – have been opened up so that their formal elements can be analogized with the play of shapes to the right and below. Semicircles are much in evidence. The D and P in *Dvinem proizvodstvo* have become hieroglyphs of a basic (workbench) architecture. But there is no point at which the viewer is

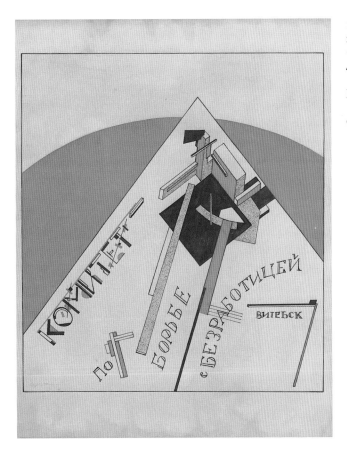

143 El Lissitzky: Cover for *Booklet of Vitebsk Committee for the Struggle against Unemployment*, lithograph on paper, 21.8 × 16.9, 1919 (Weinberg Collection, Switzerland)

invited to see the individual words and letters as invaded by (maybe remade out of) the non-objective geometry next to them. And this represented, I think, a deliberate turning-down of typographic volume from, say, the work El Lissitzky had done a few months earlier for the Vitebsk Committee for the Struggle against Unemployment (fig. 143) – look in particular at the first word *Komitet* on the booklet's cover, which is a small universe of Malevich's making. Or think of the kind of work by Malevich himself that must still have been El Lissitzky's main point of reference at the time of the propaganda board: for instance, the cover for the ill-fated Congress of Committees on Peasant Poverty which Malevich had done in Petrograd in November 1918 (fig. 144).[78] Here *S'ezd* and *Bednoty* positively explode into separate gray-black-and-red elements, bucking and kicking against the upward flow of the Suprematist force field to the right. Words are split in two or four or seven. Letters become individual planetary systems, sometimes with the look of armored or mechanized bodies, sometimes like architecture floating whimsically in space (the language, especially the gray shading, harks back to the costumes and sets Malevich had produced five years earlier for Kruchenykh's opera *Victory over the Sun*). Writing is no great respecter of lines here. On the left-hand side each word has its own distinct orientation. *Bednoty* has two, if not more. Legibility – obviously I am depending on the verdict of those at home in the language when I say this – does seem to be an issue. It takes time to piece out the portfolio's message.

No doubt the contrast I am pointing to derives partly from the circumstances of the commission. A cover for a delegate's portfolio is a different kind of object from a poster in the street. It assumes a more interested, maybe a more sophisticated, audience. It does not have to issue instructions, only find an appropriate icon for words that the users are supposed to know already. (But is

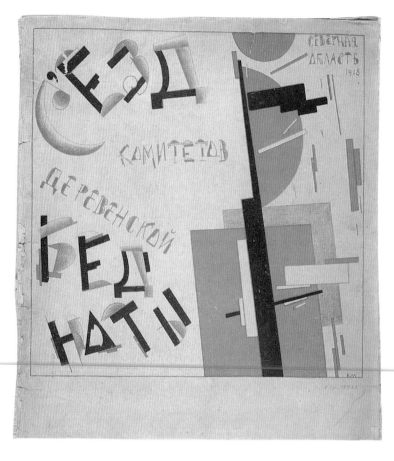

144 Kasimir Malevich: Cover for *Portfolio of Congress of Committees on Peasant Poverty*, lithograph on paper, 28.9 × 29, 1918 (State Russian Museum, St. Petersburg)

the propaganda board really any different? Is not its idiom of first-time effectiveness – of immediate relay from addresser to addressee – ultimately a kind of fiction? Call it the fiction of propaganda. Not that the fact of the circumstances being largely imaginary need prevent them from being generative – in this case of the artist's best work.) Scale is all-important. I have the feeling that Malevich's forms are already screaming for more room than the conference folder allowed. In that sense the backcloth he and El Lissitzky did in November and December 1919, again for the Vitebsk Committee for the Struggle against Unemployment (fig. 145), is only the logical conclusion of the work done one year earlier – particularly of the Suprematist architecture on the portfolio's right-hand side. The backcloth is as measured and stately as Malevich ever got. My hunch is that El Lissitzky at this point was still mostly doing what the master told him. And learning fast. As an exercise in relentless, repeated frontality – the great overlapping rectangles squeezing and subordinating the aeroliths in the center – the backcloth too lay behind the language of contraries in the propaganda board. Was there a way to hang onto the frenzy of the Peasant Poverty cover, and yet somehow have its energies be compatible with the Unemployment backdrop's idiom – its stressing of surface, its weighting of simplified parts? It seemed there might be.

Once again, as so often with modernism, the great question is how to strike a balance between making demands of one's viewers and leaving them completely behind. Between difficulty and obscurity, that is, or newness and obscurantism. It is the same question as with Cubism, only now exacerbated by

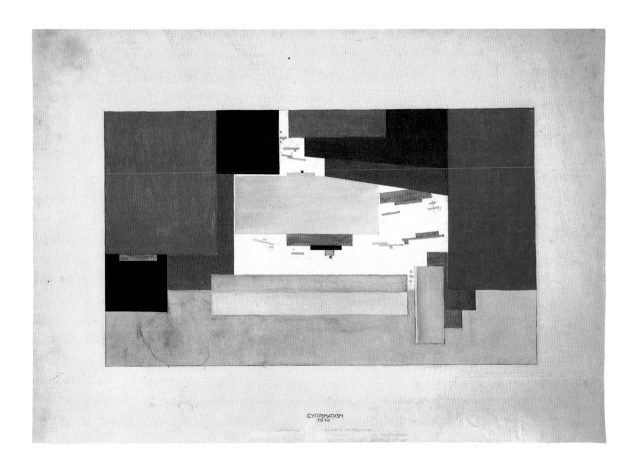

145 Kasimir Malevich and El Lissitzky: Study for *Backcloth for Vitebsk Committee for the Struggle against Unemployment*, gouache, watercolor, graphite, and ink on paper, 49 × 62.5, 1919 (State Tret'iakov Gallery, Moscow)

the thought that the "new" might be taking on concrete form – that modernism might really play a part in its manufacture.

I said just now that the text in the propaganda board was, by El Lissitzky's standards, typographically well-behaved. That was not meant as criticism. (El Lissitzky is often weakest as an artist when most taken up with typographical fun and games.) The achievement here – which I see as central to the board's overall effect – is to devise a kind of textuality which is fully part of the picture's emphatic, stripped-down idiom, yet distinct enough, within the board's formal economy, to raise the question of what text *is*, in relation to the other sign systems on show. Modernism at this moment turned on a fine-tuned balance between text as transparency and text as a particular (mysterious) form of the visual. It had to be balance, not outright warfare. So finally there had not to be a manic push and pull of different signifying elements, of the kind seen in the Peasant Poverty cover. Each way of signifying – the textual, the architectural, the diagrammatic (those arrows and lines of force), the fully symbolic (the black circle and the red square) – had to be given its own determinate weight and consistency, and its own space to move in; so that in the end the viewer's attempt to think the connections and differences between the systems would be a matter of trying out possible analogies, and of course contradictions, as opposed to a plunge into the signifying abyss. The tone is exactly not "Follow me, comrade aviators . . ." But neither is it "Our lives are being built on a new Communist foundation, solid as reinforced concrete . . ."

El Lissitzky seems really to have believed for a while that Malevich's language had in it the makings of a new kind of signification, which would be at the same time strange and understandable, eerie and familiar, to a mass audience.

Lecturing in 1922 about Malevich's Peasant Poverty cover, he claims that after the conference, when the disappointed *kombedy* went back to their villages, the cover "hung in many huts in the northern provinces, alongside their icons and colored prints." He says that the delegates themselves had selected Malevich's design in preference to others. "The Russian village . . . recognized itself in Suprematism."[79] I doubt we shall ever be able to confirm or refute these claims from other evidence. But I do not doubt El Lissitzky believed them. They were his myth of modernism in 1920. The propaganda board is what the myth gave rise to.

That is to say, a means of signification had to be devised which would be comprehensively weird, for sure – the photograph exults in the sheer unlikeliness of the board's showing up in its dismal surroundings, like a message beamed down from a passing satellite – but also effective and graspable in an instant. The paradox of the board's textuality is that it is the carrier of both vectors at the same time. Text is what secures the board's message. But also what most profoundly unsettles the whole economy of picturing within the board's four sides. Having a text be part of a field of signs where some – most – of the signs are still not fixed as regards reference, or even as regards means of referring, produces, I think, a series of unsettling effects. I believe they were the effects El Lissitzky worked hardest for.

What does text do to abstraction, then? This was El Lissitzky's great problem as an artist. (Not always, as I said before, to his advantage. Though without its hold on him we would never have had the greatest of all modernist *Gesamtkunstwerk*s, his *Pressa* exhibit of 1928 [fig. 146]. *Pressa* is the propaganda board generalized and incarnate.) Perhaps we shall best get a hold on what El Lissitzky was looking for in 1920 if we start with an example which is

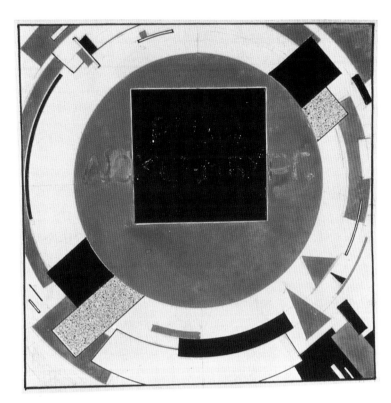

147 El Lissitzky: *Untitled (Rosa Luxemburg)*, gouache, graphite, and ink on paper, 9.7 × 9.7, 1920–21 (Private collection)

deliberately, grandly simple – done in the elegaic mode – his project for a monument to Rosa Luxemburg (fig. 147).

I shall treat the elements in the gouache as fourfold. There is a red circle and a black square "on top" of it. There is a universe of smaller, more random Suprematist elements at the picture's edges, most of the elements being segments of circles, as if answering the shape of the central red planet. And then, written into the square and the circle – seemingly half-inscribed into them, but with their color seeping back into the lines of lettering – the words ROSA LUXEMBURG, in formal script, complete with period (fig. 1).

The effect, as I say, is simple. The symbolism is more or less transparent. Red = world = revolution. Black = death = matter = nothing. (The last two terms in the series would have had, for someone under Malevich's influence in 1920, a strong positive valency.) The arrows and aeroliths are the various forces, some of them maybe still hostile, about to be brought into the orbit of world revolution. None of this is exactly disturbed by the final inscription of Rosa Luxemburg's name, but I do think that the presence of writing energizes and complicates the picture's whole economy. (We have a convenient control case here: a larger gouache of almost the same composition, probably done a year or so later, minus the lettering [fig. 148].)

It is hard to say exactly how the unsettling takes place. Partly it is a matter of lettering being ineluctably flat, and being placed by the mind and eye on some further, absolutely proximate surface, which is *here* – in front of even the flattest and simplest slice of geometry. Malevich and co. were steeped in Cubism – it was the first and main thing UNOVIS students were taught. This was one of Cubism's basic lessons. But something more is going on in the original Luxemburg gouache, I think, than a mere rehearsal of writing = flatness. An immense deal of care has been taken to get the letters to be visually "in" the black and red. And to have the black and red be fields – materialities – only partly interrupted by the presence of writing across them. Where is "flatness" in

148 El Lissitzky: *Proun*, gouache and graphite on paper, 52 × 50, ca. 1922–23 (Van Abbemuseum, Eindhoven)

this case? As usual jesting Pilate will not stay for an answer. The letters float, and take on airy substance. They sink back into the black square. They are no more than temporary – barely legible – eddies in the black's real, that is, material, indifference. "I paint energy, not the soul."[80] "Anarchy is colored black . . . a single dark ray has swallowed up all the colors and placed everything beyond mere difference and advantage. Everything is now the same . . ."

I am not saying that this last remark of Malevich's is the key to El Lissitzky's intention in the Luxemburg project. Not at all. No doubt he drew back from the depths of Malevich's nihilism – from the depths of his master's scorn for mere difference, mere signification. But I do think that he was partly infected by Malevich's madness. Textuality is a force that ironizes the efforts of all the other elements in the picture to "take their places" and do the decent work of signifying. It is a reminder of the weirdness – the black hole or black square – that signifying ultimately is.

More than once in the years around 1920 El Lissitzky struggled with the notion of Suprematism as a kind of sign language in which the names – the meanings – of the signs had still to be ascribed. "A symbol can have two derivations. Its meaning can be stipulated beforehand, by agreement – that is the first derivation . . . The second . . . is when a symbol is born, when it acquires its name later and when its meaning is revealed later still. That is why the symbols created by the artist are incomprehensible to us – the number of convolutions (of a great deal more than the brain) has not multiplied enough in man."[81]

What El Lissitzky seems to believe will eventually do the ascribing, if it happens, is some future history of use and misuse (some number of convolutions) in social practice. All I would add from our present point of view is that in 1920, under the spell of Malevich, part of the point still was the non-naming, the *un*meaning – the use of text to foreground what text was not. "I overheard a socialist saying he was sure that the red flag meant the worker's blood. I thought otherwise. If the worker's blood were blue or green the revolution would still have taken place under the red flag."[82] So what (to carry Malevich's argument with the socialist a few steps further) do the two words ROSA

LUXEMBURG mean in the gouache? And how do the black and red inflect them? What is a proper name, exactly? Does it *refer*? If so, how? This particular proper name belongs to a corpse. It is a prosopopeia. Does it speak, as presumably socialists want it to speak, from beyond the grave? Is that what revolutionaries do? (Is that their blood staining the circle?) Or is what makes certain proper names "revolutionary" precisely the fact that they do not belong to anyone – that they get attached (rightly attached) to any matter or practice which sees a way of putting them to use? Is that why the name here is barely legible? Is it meant to be understood as on the point of being effaced by the matters it is written on – as if wiped off the square's blackboard or burnt by the planet's fire? "Football in space," says Malevich, "the ball being the tangled mass of past centuries . . ."[83]

Maybe this is to carry the argument with the socialist too far. There is a difference, after all, between a memorial and a game of football in space. But still I would say that some kind of doubt about naming and meaning is induced by El Lissitzky's gouache. The more we attend to its textuality – to where its textuality is, and what it is supposed to be doing – the more the picture's non-textual elements are thrown into free fall. What, for example, is the relation between the black square and the red circle – between the congeries of qualities they are meant to stand for? Does one ground or support or subordinate the other? Which has the most visual (maybe conceptual) weight? Are these the right kinds of questions to be posing at all? What would other questions – about death, revolution, memorializing, naming, and martyrdom – be like? Perhaps the gouache is a glimpse of the form they might take.

I do not want to imply that text and picture in the propaganda board cannibalize one another's identities in at all the way I have just described. The Luxemburg project is special. There is a work of mourning going on in it, opening to past and future, which is quite unlike the eternal present tense of *Stanki zhdut vas*. But I do want to say that the Luxemburg project epitomizes the *kind* of work that El Lissitzky thought writing should be called on to do within modernism. The work was formative. Without it abstraction would certainly decline into just another set of certainties.

Let me put it this way (and here what I am saying certainly applies to the propaganda board). Abstract art, right from the moment of its inception in and around 1914, was haunted by a dream of painting at last leaving the realm of convention behind, and attaining immediacy. The words for that latter state were, and remained, legion. Some of them were apparently technical, others lunged toward distant reaches of metaphysics: "unison," "presentness," pure sensation or pure plasticity, "truth to materials," final simplicity, "zero," "infinity," an absolute inwardness or an equally absolute exteriority; being "in" the painting, or escaping from painting altogether, or having painting be the realm of some deep unknown – "paintings the contents of which are not known to the artist" (as Malevich put it in 1915).[84] All of these, I think, are ways of rephrasing the old dream of a purely visual totalization in painting – of escaping from words into seeing and being. Abstract art was late-Romantic. It thought that painting, of all the artforms, was best equipped to move signification from the realm of the discursive into that of the symbol – where symbols would simply make or be meaning, with meaning inhering in them, as substance or essence.

This is such an extreme version of signifying utopia that of course it immediately spawned an opposition, even from within its own ranks. It was possible for artists to believe and not believe in it at the same time. Malevich's art is

149 Kasimir Malevich: *Black Square*, oil on canvas, 79.2 × 79.5, 1915 (State Tret'iakov Gallery, Moscow)

about believing and not believing. The *Black Square* (fig. 149) is at once the strongest instance of the new belief-system and its *reductio ad absurdum*. Among its many other undecidables – is it figure? is it ground? is it matter? is it spirit? is it fullness? is it emptiness? is it end? is it beginning? is it nothing? is it everything? is it manic assertion? or absolute letting-go? – is the question of whether it laughs itself to scorn. (And even if it does, laughter and scorn could as well be Nietzschean positives as Duchampian nay-saying. They might lead the way to the Nothing that is.)

Somewhere here is where El Lissitzky stands. Close to Malevich. Maybe not understanding or sympathizing with the full depth of Malevich's nihilism, but infected by it.[85] And certainly wanting abstraction to be an eternal war between the discursive and the immediate, the total image and the fragile assemblage – between signs with names attached to them (some of them actually being names pure and simple) and others still floating in the ether of nonsense. *U-el-el'-ul-el-te-ka.*

Writing in the propaganda board, as I said before, is part of the picture's formal economy. But a distinct part, with its own spatial and conceptual effect on all other elements. Letters are flat. They participate in the metaphorics of flatness I have already pointed to, and of course they tie down the politics of the metaphor. At the same time they raise the question of whether flatness is ever an

adequate description of what we see a system of surfaces *as*. The stacking of words in the script top left, the different sizes of the words, or of letters within words (notably of *Stanki* and *Zhdut*, but even the final "c" of *vas* is deliberately miniaturized and thickened) – all of these are invitations to imagine the words and letters as existing spatially, floating in and out from distance to proximity, obeying the pull of the central circle, and so on. And maybe both choices here – writing as resting literally on the surface, or writing as entering the circuit of illusion – are the wrong ones. Maybe writing is not seeable at all, at least in the way we see an arrow or a parallelepiped. Maybe writing exists in a non-space, where flatness and depth are simply not the terms of the encounter. One of the most extraordinary achievements of the propaganda board, it seems to me, is the way it manages to establish an absolute visual otherness for the block of text top left. It exists in a separate universe from the forms next door. In Paul de Man's terms (which again seem appropriate here), it does not partake of "phenomenality."

That sets off, or encourages, a series of questions about where the other elements – the ones that on the face of it *are* fully part of some possible world of experience – are properly to be "seen." The pointing arrows (almost like the Black Square) are on the edge of being parodies of three-dimensionality. And the force of that three-dimensionality is meant to be understood as purely rhetorical. "You want to be pointed out the way. I'll show you pointing! Pointing *objectified*." That is what makes the third "arrow" – to the right of the others, at the edge of the circle, arrow reduced to pure tetrahedon, so full of depth it cannot do its directional work any more – such an effective joke.

Or take the two short bars of some lighter color poised over the edge of the central square. And the final, decisive tiny square – again it is not clear if it is black or red – put in on top of the same shape, its axes at forty-five degrees to its parent. (Maybe the three elements here were differentiated from their ground by some slight change in the consistency of pigment. That is the case in the Baku *Town*, for instance. At all events the elements are crucial to the picture: they are a kind of seal on its visual center.)

I would say that the two bars and the tiny square continue the non-space of textuality – the possibility of visual elements not existing anywhere, not being seeable, being best understood as permanent blind spots or interruptions in the visible – inside the Communist circle. They are as close as the propaganda board gets to the letters of ROSA LUXEMBURG. Certainly they ironize the neat pile-up of architectural bits and pieces just off to the right. Their absolute lack of orientation (the last thing they will ever be is flat) is another reason the arrows and the parallelepiped look self-important. They reach out to the stripes top right, or the weird T-square that puts an end to the band of color coming in with its arrows from bottom left. It is not that they ever quite connect with these elements, but they are enough like them (in shape, primarily) for the question to arise whether it might be there – in the undecidable space-and-surface these stripes and crossbars occupy – that they really belong. Not hovering over the Communist city at all.

These things no doubt seem contrived, maybe a bit clunky, in the retelling. I do not believe that in the first place – visually – they were. Again, the effects are basically simple. The two bars and the small square, for example, are handled in a much more four-square, declarative way than in the Baku *Town*. There is blessedly little fine-tuning. Just enough to have the non-space of textuality disperse, like a stolen bacillus, over the board as a whole. Enough for the metaphor of revolutionary totality to be qualified (infected) by the metaphor

of endless revolutionary discursiveness – a deferring of meanings, even of perceptions; a shuttling between spaces, and between kinds of materiality, kinds of narrative construction, kinds of agreement about reading. This is what it would be like, the propaganda board says, to live in a world where the sign was arbitrary, because subject to endless social convolutions. It is not a world we shall live in without the revolution taking place.

The action of text on various other modes of picturing, then, is at the heart of El Lissitzky's modernism. (Maybe one of the reasons the project for the 1905 billboard [fig. 139] came to nothing is that in it text stayed too extrinsic to the formal action, and did not unsettle the play – the balancing-act – of the preponderant circles and squares. Certainly I think that the Rosa Luxemburg project minus its lettering [fig. 148] is in every way a lesser work than the one we have been mainly looking at: every element tidied and disembodied, every surface too transparent, every intersection too pat.) But this does not mean that I see the action as all one way. Not at all. Of course text too can be a dead given. Maybe it mostly is. And one of the tasks of the poster in a time of revolution is precisely to transform the conditions and possibilities of reading – to give the reader back reading as an activity of construction (and deformation) rather than reception of the ready-made. This is where El Lissitzky's dream of visual totalization, however brutal and hectoring, begins really to do work. For the visual totality – the being-together of all the elements relentlessly on the flat – presses against the linearity of writing. And, come to that, against the linearity of even the visual staging (or narrating) of the message: arrows showing the way from A to B, revolutionary forces turning the wheel of production, Communist towns clustering round their Red Square. I say "presses against." There is no final breakthrough by either side. The Whites are not beaten by the Red Wedge, or vice versa. But enough is enough here. Imagery is ironized *enough* by text for the question of imaging – of what imaging ultimately is – to arise in viewing. Text becomes sufficiently part of a field of signs-without-names-properly-at-tached-to-them for reading to be allegorized. The difference between reading and seeing – that shibboleth of all dead modernisms – is just for a moment suspended.

"Nature's perfection lies in the absolute blind freedom of units within it – units that are at the same time absolutely interdependent." "Wear the Black Square as a mark of world economy."[86] "Thought is nothing but a process, an activity of an unknowable excitation. That is why Nothing has an influence on me, and why Nothing, as an entity, determines my consciousness; for everything is excitation, understood as a single state, stripped of all the attributes given it in the language of the tribe."[87] "When the community wants to fix infinity, or trace its frontiers, it has recourse to conventions. That is why life takes on the aspect of . . . a huge nursery in which children play every possible sort of game, full of imagined rules; and in these games they live reality, build towers, castles, forts and towns, then demolish them, then rebuild them all over again . . ."[88] "The world is like a hole and the hole itself is not hollow. I can cut a section across the emptiness, a grid or a sieve . . . and maybe here – out of the grid – I can extract a point or a line . . . but once again Man will fall into the error of taking the point or line for reality, for *things* that *exist* . . ."[89] What must man do to become God (a Vitebsk question)? "Not much: govern the firmament of suns and the systems of the universe. And meantime, in its senseless fall, our Earth will carry him on toward infinity, toward Nothingness, in the crackling

of the movement of non-objectivity – the rhythm of the whirlwind of the universe."[90]

"Meantime, in its senseless fall." I realize it is one thing to reconstruct the content, even the tone, of Malevich's and El Lissitzky's utopianism (as I have just tried to do), and another to understand the circumstances in which such a re-imagining of difference could be productive. There is no shortage within modernism of similarly apocalyptic half-poetry. Usually it is accompaniment to (excuse for) bad work. Not so here. Something about the world of War Communism seems to have meant that these attitudes had purchase – or could envisage that they would have purchase – on actual practice, on the shaping of specific sign languages. I am not claiming that in the end they did. But I think it remains a problem for us that the dream that they might was not debilitating.

The problem has no one solution. The particular depth of Malevich's nihilism is crucial, and the kind of personal hold he evidently had on a talented group of people. Provincial isolation is important, compounded by civil war. It was a time when individual communities could easily breathe nothing much besides their own hothouse atmosphere, provide themselves with scraps from the newspapers, and imagine themselves at the center of things. My picture of UNOVIS is of a group feeding on the whole enormity of War Communism. All of the facts and dreams I adduced in describing it previously are relevant. But I shall single out one or two in particular, which had immediate resonance for makers of visual signs. My question, again, is why modernism could believe, not absurdly, that it was on the side of history.

Most people capable of reading the papers in 1920 thought they were living through the end of capitalism. They were in the *Economics of the Transition Period*. And maybe the clearest symptom of that passing from one system to another was the crisis in capitalism's most precious means of representation, money. Makhno as usual saw the point. The money he issued in his anarchist republic had printed on it the message that no one would be prosecuted for forging it.[91] But Makhno was only carrying to its logical conclusion the general collapse of "confidence in the sign," which not only anarchists thought might be terminal.

Since 1918 there had been raging inflation. By the middle of 1919, says E. H. Carr, "the value in terms of goods of a rapidly increasing volume of rubles was already approaching extinction."[92] Printing presses had to run full time, just trying to keep enough notes in circulation (and never quite managing to). The more money was printed, the less the value of the individual ruble. By July 1921, according to later Soviet figures, the real value of the paper produced by the treasury was three million rubles. This did not even cover the costs of physically producing the money in the first place.[93] "The demand for currency became so great" – this source is also a Soviet one – "that factory tokens were on bits of ordinary paper, with the stamp of some responsible person, or local institution, or president of some committee or other, and they passed as money."[94]

Needless to say, in such a situation more and more of the real economic life of society took place outside the sphere of money altogether. There was talk in Bolshevik and SR circles of the final "naturalization of wages." In other words, workers were paid with the goods they produced, or with goods from other factories with which they had exchange relations. Forced requisition of food in the countryside was accompanied by a regression to barter in the towns. As the

gap widened between prices on the free (black) market and those fixed by the state, rationing came to have the look of an alternative to money altogether. It seemed a short step to abolish money outright as the medium for basic goods and services. In 1920 the step appeared to be being taken. In January "free common dining rooms" were set up for the factory and office workers of Moscow and Petrograd. They were imagined as prototypes for the country as a whole. In October plans were laid for the abolition of charges for postal service, telegraph and telephone, water and electricity (when you could get them). In December rationing was finally converted into free distribution of goods to designated classes. Rents and rates on municipal and nationalized housing stock were to be abandoned. Travel on the railroads was to be free. The last independent bank in the country was liquidated. Taxation was now a more or less meaningless exercise (except for the forced levies from the peasantry). There was a decree on the table in February 1921 to end taxes for good and all. NEP put a stop to the project in the nick of time.[95]

Behind all these glamorous figures and plans – and this time hardly disguised by them – lies a world of civil-war misery. And of improvised, mostly desperate responses to it by government and the people. Carr pays homage to the period as illustrating "the persistence and ingenuity of human beings in devising ways and means to exchange goods when this becomes necessary to their survival."[96] Most ways had little to do with socialism.

But again, our subject is perception, not reality. UNOVIS kept getting its rations. And what marks off this period of financial free fall from most others – from the same process as it happened in Germany, for instance – was the belief, seriously entertained and propagated by at least some Bolsheviks, that the end of money was a necessary part of the end of capitalism, to be welcomed as such. Makhno's exaltation was widely shared.

> The constant decline of money [this is the Bolshevik economist Larin, writing in *Ekonomicheskaya Zhizn* in November 1920] will increase in accordance with the growth of the organized character of Soviet economy... Money, as a sole measure of value, does not exist. Money as a means of circulation can already be got rid of to a considerable extent. Money as a means of payment will come to an end when the Soviet state frees the worker from the necessity of running to the Sukharevka [the black market]. Both these developments may be foreseen and will be realized in practice within the next years. And then money will lose its significance as treasure and remain what it really is: colored paper.[97]

Already in 1919, in the *ABC of Communism*, Bukharin and Preobrazhensky had welcomed inflation as a form of forced expropriation of the wealth of the bourgeoisie. The next year Preobrazhensky dedicated his *Paper Money during the Proletarian Dictatorship* to "the printing press of the People's Commissariat of Finance . . . that machine gun which attacked the bourgeois regime in its rear – its monetary system – by converting the bourgeois economic law of money circulation into a means of destruction of that same regime, and into a source of financing the revolution."[98] At the Tenth Party Congress Preobrazhensky congratulated the delegates on the fact that, whereas the Jacobins' *assignat* had depreciated a mere five hundredfold in a year, the ruble had shrunk by a factor of twenty thousand. "This means we have beaten the French Revolution by forty to one."[99]

Of course Preobrazhensky was partly intending to play the role of court jester. The Tenth Party Congress took place in March 1921. NEP was already under way. But there was no such double edge to the plans, seriously pursued through much of 1920, to discover a suitable Marxist substitute for exchange

value altogether. Economists went back to Bogdanov's old *Short Course in Economic Science* and pored over the pages where he had tried to quantify the labor theory of value in terms of physiological expenditure of energy in the act of manufacture. They did not care much that Lenin had long ago consigned Bogdanov to outer darkness. Maybe one could have a system of social value based on the calorie, or the *tred* (a basic unit of labor expended), or the *ened* (a unit of total energy outlay: labor plus thermo-mechanics), or even a specified amount of salt. Commissions were set up to investigate the possibility.[100] SOVNARKOM took an interest. Whatever the unit might turn out to be – experts disagreed mightily – there was a sense in 1920 that society was on the verge of turning back from the realm of exchange to that of use. This was the future Communism had always promised. Maybe it would be ushered in precisely in the realm of representation. An Anti-Money – an Anti-Exchange – would hasten on the general transvaluation of values. "The traditional book would be torn into separate pages . . ." Colored paper would be everywhere.

It is anybody's guess how much of this technical discussion filtered through to UNOVIS, or how much it would have meant to them if it had. But I am sure the general sense of "confidence in the sign" collapsing was one that Malevich exulted in. And he and his followers would have seen the point of the fact that signifying chaos was setting in, most flagrantly and bewilderingly, right at the capitalist heart of things. "Economy" was a UNOVIS war cry in 1920. "I declare Economy to be the new fifth dimension, the test and measure of all creative and artistic work . . ." "Suprematism has a new criterion for evaluating everything created in plastic design. Instead of beauty it is economy."[101] "Wear the black square as a mark of world economy!" And so on.

I do not think we get close to understanding the tone and force of these pronouncements – why after all is the sign of economy the undecidable Black Square? – if we do not build into them a sense of what Economy *was* in the year they were made. Economy was on the point of disappearing into absolute immiseration. But Marxists were capable of finding a grim futurity in that fact. Economy was the new zero Malevich was always on the lookout for – like the zero of his old "0,10."[102]

More than once already I have implied that Malevich's view of the crisis in signification was very unlike that, say, of his contemporary Ferdinand de Saussure. The new signs would be discovered, Malevich thought, in a social space beyond "difference and advantage," where "everything is now the same." This is very far from being a Marxist view of a possible future, but it was aided and abetted, I feel, by a certain kind of Bolshevik utopianism which was rampant in 1920. Part of the utopianism I sympathize with. Particularly the implication that there is a deep connection between the representational order called capitalism and the belief (which we could call, for short, Saussurean) that all representational orders are at heart systems of difference, of pure exchange values generated out of the relations between the elements of a signifying system. Marxists would say that the insight here – and certainly there is an insight – occludes the further problem of the sign-systems' materiality, and thus their belonging to patterns of material production and reproduction which we call social practice. (The stress here is on the historical, material place and determination of the whole language-game, not just the phenomenal "stuff" of any one token within it. Obviously the least modernist or semiotician is capable of recognizing – I would say, fetishizing – the latter.) Nobody is pretending that

this further field of problems comes with convincing answers provided. Saussurean skepticism has a lot on its side. But the point is that the further field of problems is what, within the signifying regime we belong to, has not to be thought. Everything about the forces and relations of symbolic production under capitalism encourages the fantasy that meanings are the product of a self-enclosed circuit or system, opening nowhere onto the realm of necessity. Pure presence wars eternally with pure absence, the latter winning hands down. Signification is imagined always under the sign of money, or nowadays of similar action (conversion) at a distance, happening in the ether of "information." Symbol managers rule. "We are the Plan, the System, the Organization," and so on. It takes a very special (and no doubt terrible) moment for these structures to be thinkable at all as socially determined. 1920 was one such.

El Lissitzky's great image of the other (social) dimension to human sign-systems was "architecture." The term is not to be understood literally. Within UNOVIS in general, architecture is a state toward which all forms of signifying practice tend, the closer they come to breaking with the old order. Architecture is another name for collectivity, or for a historicity which recognizes itself. Both are connected with a present or future re-materialization of the world.

> Those ages of mankind which were possessed of cohesion always possessed a cohesive means of architectural expression, this materialized assemblage of all the arts – of literature, music, the plastic arts, painting. [Notice that textuality is included in the mix called architecture.] But then fragmentation and dematerialization set in. Ensuing ages found their highest expression in one of the arts alone. Sculpture had its day, painting its day, music and literature their moment, and then eventually they were drawn together again. We have just lived through a time when painting stood at the forefront of the attack. Now we are reaching the point of transition from sculpture/painting to the unity of architecture.

From fragmentation and dematerialization, that is, to relations of symbolic reproduction ruled by an opposite logic.

> Our struggle against representational art is also a struggle against number [meaning the whole previous system of identity and difference, the culture's whole imagining of absence and presence] and against death.
>
> It is not for us to see how the new world will be built. It will not be built with our knowledge and technology. It will be built with a direct and accurate force – a lunatic force, from which all will recoil in shame.[103]

No ringing pronouncements, then, on Art and Revolution. No verdict on modernism at its moment of truth. *Above all, no verdict on Bolshevism –* apart from the obvious, absolute, preliminary one. No dancing on the grave, no mourning among the ruins. Because the dancers and mourners are scum of the earth. History is a puppet they jerk on an argument's string.

Long ago the sociologist Karl Mannheim imagined an art history that would ask the following questions:

> Whose mentality is recorded by art objects? What action, situation and tacit choices furnish the perspectives in which artists perceive and represent some aspect of reality? If works of art reflect points of view, who are the protagonists and who the antagonists? Whose reorientation is reflected in changes of style?[104]

Try asking these questions of El Lissitzky's propaganda board.

Protagonist 1 could be Trotsky. Speech on 18 April 1920 to the Committee for the Fight against Desertion on the Railroads:

Let me sum up. First, with regard to agitprop. I believe we are not doing all we could in this area, and I think I should set out the tasks we need to assign to *Glavpolitput* and *Tsekprofsozh* [the Party arm of the Commissariat of Transport and the railroad workers' union]. We shall not be able to manage without cooperation from the trade unions. *Glavpolitput* and *Tsekprofsozh* ought to start straightaway organizing agitation about work on the railroads and the fight against labor deserters. We need to organize this fight with the help of posters – popular ones – which will show the deserters as the criminals they are. These posters should be hanging in every workshop, every department, every office. Right now transportation is the lynchpin. And therefore there should not be a single theater, a single public spectacle, a single movie-show, where people are not reminded of the harmful role of the labor deserter. Wherever the railroad worker goes, he should find a poster which mocks the deserter and puts the shirker [*progul'shchik*] to shame . . . We need to use gramophones for agitation purposes. Posters are all very well for the city, in the village they are not much use. Let us make ten or so records against shirking and desertion. Lists of deserters should be printed and circulated. Even if we do not get the deserters back by these means, at least we shall shame and frighten anyone who is leaning in that direction . . . Besides, we have to instill the awareness that labor conscription [part of Trotsky's general dream at this time of the militarization of the economy] means staying at one's post as long as the circumstances demand it . . . The courts should likewise be a mighty engine of agitation and propaganda. Their role is not just to mete out punishment to the guilty, but to agitate by means of repression. We should organize a show trial [literally, a loud trial] of one or two doctors who give out phoney certificates . . . If we put the trial on in a theater in one of the cities, and invite representatives from all the workshops, and have the trial reported in all the papers, and broadcast on the radio – that will really do some educational work.

. . .

As regards workers on the railroads who are systematic absentees, we should organize a number of trials. The railroad workers could track down several such individuals and, after a show trial, could steer them back toward a responsible attitude. One or two examples would make a colossal impression nationwide.[105]

Protagonist 2 could be Mikhail Bakhtin. Twenty-five in 1920. Schoolteacher, accountant, philosopher of language. Moved to Vitebsk in 1920, from a small town called Nevel seventy miles north. Friendly with Pavel Medvedev, prime mover of the local Commissariat of Enlightenment. No friend of Marxism (his brother was known to be fighting with the Whites in Crimea). Lecturer to the Regional Communist Party School, the Party Club, the Political Department of the Fifth Vitebsk Infantry Division, the Propaganda Center, the Union of Post and Telegraph Workers, the Union of Soviet Workers. Lecturer and organizer for the Provincial Women's Department. Participant in "public trials" of literary characters. Defended (usually successfully) Khlestakov from Gogol's *The Inspector General*, Katerina Maslova from Tolstoy's *Resurrection*, and so on. Not in receipt of "academic rations." An intellectual making ends meet.[106]

Complete published works in 1920, as follows (the brief essay, from which I have trimmed only an opening sentence or two, had been published in Nevel the previous September):

The three domains of human culture – science, art and life – gain unity only in the individual person who integrates them into his own unity. This union, however, may become mechanical, external. And unfortunately that is exactly what most often happens. The artist and the human being are naively, most often mechanically, united in one person; the human being leaves "the fretful cares of everyday life" and enters for a time the realm of creative activity as another world, a world of "inspiration, sweet sounds and prayers." [The quoted phrases are from Pushkin.] And what is the result? Art is too self-confident, recklessly self-confident, and too high-flown, for it is in no way obliged to answer for life. And, of course, life despairs of ever catching up with art of this kind. "That's too exalted for us" – says life. "That's art, after all! All we've got is the humble prose of living."

When a human being is in art, he is not in life, and conversely. There is no unity between them and no inner interpenetration within the unity of an individual person.

But what guarantees the inner connection of the constituent parts of a person? Only the element of answerability. I have to answer with my own life for what I have experienced and understood in art, so that everything I have experienced and understood will not remain ineffectual in my life. But answerability entails guilt, or liability to blame. It is not only mutual answerability that art and life must assume, but also mutual liability to blame. The poet must remember that it is his poetry which bears the guilt for the vulgar prose of life, whereas the man of everyday life ought to know that the fruitlessness of art is due to his willingness to be unexacting and to the unseriousness of the concerns of his life. The individual must become answerable through and through: all of his constituent moments must not only fit next to each other in the temporal sequence of his life, but must also interpenetrate each other in the unity of guilt and answerability.

Nor will it do to invoke "inspiration" in order to justify want of answerability. Inspiration that ignores life and is itself ignored by life is not inspiration but a state of possession. The true sense, as opposed to the self-proclaimed sense, of all the old arguments about the interrelationship of art and life, about the purity of art, etc. – that is, the real aspiration behind all such arguments – is nothing more than the mutual striving of both art and life to make their own tasks easier, to relieve themselves of their own answerability. For it is certainly easier to create without answering for life, and easier to live without taking art into consideration.

Art and life are not one, but they must become united in myself – in the unity of my answerability.[107]

If works of art reflect points of view, asks Mannheim, who are the protagonists and who the antagonists? Of course he did not mean the question literally. It is not our job to plump for Trotsky on the one side, or Bakhtin on the other. (The reader will anyway have discovered, maybe with a touch of horror, that on the subject of art and life there is a great deal of common ground between the two. Guilt and blame are the subjects of both. If art is to get an answer from everyday life at all, it seems it will be some kind of mea culpa.) Still less am I interested in the fantastic (though maybe factual) question: What would Bakhtin or Trotsky have thought of the propaganda board if they had actually seen it – Bakhtin on his way from the Women's Department to the Propaganda Center, and Trotsky, of course, on his way to the Front? It does not matter to me if they would have approved or not. This is not art that is seeking approval. The question is, where did this work wish to situate itself in the

debate about "Art and Answerability" – that is the title of Bakhtin's article, but it could as well have been of Trotsky's – which was pressing in on its everyday life? Obviously at some extreme. The propaganda board anticipates the Commissar's skepticism. But what kind of arguments did it deploy – within itself, primarily, but also by way of verbal justification to the world outside – to insinuate that time would prove the Commissar wrong?

Bakhtin's arguments, partly. No one was more aware than El Lissitzky that very much of the previous history of art and life, particularly during the nineteenth century, had been a struggle by both parties to dissociate themselves from one another – "to relieve themselves of their own answerability." "For it is certainly easier to create without answering for life, and easier to live without taking art into consideration." Putting an end to that (modernist) state of affairs would involve a strange kind of double activity. On the one hand, men and women would have to take the question of answerability literally. Pose it crudely. Put art on the streets. Not be afraid to adopt the hectoring, accusatory tone of Trotsky's speech; nor even to "exude a monistic wholeness unknown to capitalism, giving a foretaste of the future amid the chaos of the present." But, at the same time, they could have no illusions about the enormity of the task. They knew the question of art and answerability was a bath of fire. Any art that believed it could pose the question in less than apocalyptic terms was fooling itself utterly, and dooming itself to the worst kind of failure – the failure of *pretended* practicality, in a situation where practice (and value, and representation, and production, and all the vulgar prose of life) was precisely the category in doubt. "Many people, especially socialists, seem to think that art exists for the purpose of painting comprehensible donuts . . ."[108]

Of course it is always and rightly possible to dismiss this utopia with a shrug. Like the judges confronting Malevich's Lenin. Or like Lenin himself in 1919, hearing from a Comintern delegate from Budapest that one of the first acts of the new Soviet government there had been to have Comrade Lukács nationalize the theaters, and asking the delegate if the regime had not had more important things to do.[109] There never will be a dialectical reconciliation of the two verdicts ascribed to Anatoly Lunacharsky, the Bolsheviks' Commissar of Education, in 1920. On the one hand: "Futurism [Lunacharsky was talking about Meyerhold in particular, but with the whole family of modernism in mind, certainly including the likes of El Lissitzky] has fallen behind the times. It already stinks. I agree it has only been in the tomb three days, but already it stinks. There is no need to look for a Picasso for the proletariat."[110] And on the other: "In their revolutionary struggle the lowest classes have always attracted noble renegades from above. In the realm of art too the proletariat will find its Marx."[111] These are the two halves of a torn unity, as Theodor Adorno would say – to which, however, they do not add up. What should we call the unity if we had it? Not culture, says Malevich. Not even (not especially) PROLET-KULTure.

"Go and stop culture" – this is Malevich on the flyleaf of his book *God Is Not Cast Down*, dedicating it to a favorite student in 1922:

> For it is no easier for culture to go through the eye of a needle than it is for a camel; because culture tries with its wit, its consciousness and its sense to go through something that has no consciousness, no wit and no sense. However witty and brilliant it may be, it will never get inside that which is senseless.[112]

An athlete's slipper for that Cinderella. The crackling of the movement of non-objectivity.

Malevich has moved in and out of this chapter so far as a kind of vanishing point. And that is how it should be. That was his role in Vitebsk. (In a sense, his role in modernism generally.) But I want him as Black Square, not *éminence grise*, so there are some things that need to be said directly about him and his work at this moment.

In the years that concern us – 1919, 1920 primarily, 1921 – he does not seem to have done any painting. He was a writer, teacher, and lecturer. The latter activity seems to have been particularly important in the Vitebsk years. We have records of him speaking in public on at least three occasions in early 1920 on the matter of individualism and collectivity in artistic work: on 14 February, 6 April, and 23 May. The last of the three lectures was called "Concerning the 'ego' and the collective." Some of this material found its way into the UNOVIS almanacs published in June and the following January, but probably not all. The issue of collective work was on the minds of most of the contributors to UNOVIS's leaflets and flyers at this time. Malevich was clearly the prime mover. *God Is Not Cast Down* was published by UNOVIS in 1922. But we know that it was largely written in 1920. (There are many possible reasons for the delay in bringing it out. Paper shortage is one of them.) Some at least of the book's arguments were certainly given in lectures in 1920 and 1921. There was a Malevich seminar and lecture in Smolensk on 20 and 21 October, under the auspices of a UNOVIS group there which had gained a foothold in the town's ROSTA. Later in the year he talked on "Art and Production" to the Vitebsk All-Russian Union of Art Workers. He and his students went to and fro to Moscow throughout this period, making sure their efforts and arguments were not neglected at the center. The most evocative of all UNOVIS documents (fig. 150) shows them setting off by train in June 1920 to a Conference of Teachers and Art Students in the capital. Malevich holds center stage. He grasps a Suprematist plate under his left arm and makes a clenched-fist salute with the other. One of his followers (or is it his wife?) puts a restraining hand on his sleeve. Black Squares are much in evidence: pinned up on the carriage door, worn in his lapel by a man in the foreground, stuck in the impish Iudin's hair (?) top left, and, by the looks of it, sewn onto El Lissitzky's sleeve – El Lissitzky is the character in the soft felt hat and light-colored jacket, directly under Malevich's fist. They are a wild-looking bunch.

We do not know if Malevich lectured in Moscow at the time of the Teachers' Conference, but there is a record of him toughing it out with the Constructivists at INKhUK the following January. (El Lissitzky was by this time back in Moscow on the INKhUK payroll, so UNOVIS must have thought it had a bridgehead there.) On 22 December 1921, Malevich lectured at INKhUK on "Our Tasks." Then the next June at INKhUK in Petrograd. And so on. *On New Systems in Art* was brought out in Vitebsk in the Fall of 1919. NARKOMPROS published Malevich's *From Cézanne to Suprematism* some time in 1920. The Smolensk group brought out *The Question of Imitative Art* the same year, maybe to coincide with the master's visit in October. Vitebsk UNOVIS did his *Suprematism: 34 Drawings* in December. A book called *We – As Utilitarian Perfection* was announced but never appeared. When UNOVIS put up its last collective entry, in May 1923 in Petrograd, as part of an exhibition of "Work by Petrograd Artists Belonging to All Tendencies" (fig. 151), the show was accompanied by a new Malevich pamphlet, *The Suprematist Mirror*.

Some of these are exceedingly slim volumes, and one or two – the NARKOMPROS booklet, notably – are old material. All the same, the record of productivity in and around the Vitebsk period is daunting, and we know that for every item published, there were usually several more in manuscript, often circulated among the chosen few. The "philosophy, pom pom!" (the phrase is El

150 Unknown photographer: The UNOVIS delegation to the First All-Russian Conference of Teachers and Students of Art, 1920 (Galerie Gmurzynska, Cologne)

Lissitzky's in a letter of 1924[113]) just would not stop. From time to time the disciples must have chafed at the bit, or managed a wry chuckle. Mostly they read, marked, and inwardly digested. I imagine them on a good day, stumbling from Bakhtin's study group on Russian literature – "when lecturing to this small circle, Bakhtin always behaved as if he were addressing an entire auditorium"[114] – in time to hear Malevich in full flight "Concerning the 'ego' and the collective." Maybe there would be an hour to spare, helping Suetin with his mural for the State Committee for Foodstuffs.[115] Or rehearsing for the Front Week production of *Victory over the Sun* (fig. 152).[116] Or reading El Lissitzky's report on his week at the All-Russian Propaganda Congress in Orenburg. And discussing the latest from PROLETKULT. Not to mention the obligatory round of the studios

to terrorize students still faithful to Chagall. ("The atomization of blinkered personalities within separate workshops is not in accordance with the times. It is counter-revolutionary in its general direction. These people are landlords and owners of their personal programs . . ."[117] "The private property aspect of creativity must be destroyed . . ."[118]) On our way to a single pictorial audience! No time to lose.

The text that Malevich's followers seem to have read most closely in 1920 was the set of theses then going round in manuscript, with the cryptic title *God Is Not Cast Down*.[119] Bits and pieces from it have appeared, and will appear, throughout this chapter: I do not intend even to try to gather them together in any one place.

But here at least are a few skeleton keys to the whole. The pamphlet is a kind of debate between three vectors or possibilities, called Art, Church, and Factory. The reader can rarely be sure which of the three is speaking, or whether they have been overtaken by the author's voice; and it is almost never clear what Art, Church, and Factory "stand for."[120] "Factory" is sometimes naive modernism, by the look of it, sometimes the dream of technology, and sometimes, as I have already said, Marxism and the Party. But the last-named is also the "Church," or one of the Church's forms (one of the signs of God Not Being Cast Down).

Some things become clearer if Art, Church, and Factory are understood to be three necessary and ineradicable aspects of the project that is UNOVIS. Then the text can be read as a frantic dialectical meditation on three modes or moments of social practice – the human urge to a perfection of making, the ritual self-enclosure and self-defence of the cult or sect, and the fierce commitment to a material, technological world – which will inevitably persist in any effort to make the world otherwise once Art is dead. I am not saying this framework solves all local problems of interpretation – far from it – but at least it helps to explain why *God Is Not Cast Down* seemed to Kogan and Chashnik of such

152 Vera Ermolaeva:
Set design for the opera,
Victory over the Sun,
woodcut with added
watercolor, 16.7 × 20,
1920 (Private collection)

practical importance. The book is a guide to the various errors and traps that stand in the way of collective work and the crushing of individuality.

Of course such a guide, in the circumstances, necessarily had Marxism in its sights. What is chiefly wrong with Marxism (and also religion), in Malevich's view, is its lingering belief in the possibility of seeing the world whole – the possibility of totalization.[121] Malevich is sure that no such completion of knowledge can ever take place, or should be attempted: not even a "dialectical" one, which would have written into it a sense of its own provisional, necessarily contradictory status. This is just coquetting with the unknowable. It is materialism averting its eyes from the Black Square.

You will gather that Malevich was not much of a philosopher, and his swipes at "totality" have a knockabout (to late twentieth-century readers, familiar) flavor. But one thing he was good at. He was good at providing intimations of what an untotalizable knowledge would be like. His prose is a fair and serious example of it. And he was no fool – no academic jester. He knew what the world would make of his textual play. Therefore threaded in and out of his text was the suggestion that there might (have to) be a different kind of knowledge, which *could* totalize because it had finally admitted, and made explicit, its own lack of connection to the "world." "It seems to me that it will only be possible to analyze, study and know when I have extracted a unity [from the world of things and appearances], one which has no relation to the surrounding ensemble of things, and is free from all influence and subjection."[122] Here is the first shadow, I sometimes think, of a truly hard (truly rhetorical) form of textual materialism. Of course it was also (meant as) description of Suprematist painting.

Members of UNOVIS presumably had access to examples of all the different kinds of work Malevich had done when he was still a painter; at any rate to work from 1915 and after. For instance, in one of the Alice-in-

Wonderland photographs we have of UNOVIS in session (fig. 153), there is an appropriately whimsical abstraction by the master hung high on the back wall. The master himself lines up his Duke of Urbino profile flat against the blackboard, next to a Suprematist satellite he is still drawing – and explaining to Chashnik and Khidekel. UNOVIS students were evidently free to plunder all stages of Suprematism. The installation shots that survive of their work are proof of this (figs. 151 and 154). But inevitably those stages would have been seen in the light of the final one: the paintings in white on white that Malevich had done in and around the October Revolution, which appeared to have led to his current abandonment of art (fig. 155). These were the pictures that haunted UNOVIS practice in 1920 – these and the ubiquitous Black Square. (Malevich has put the latter in negative at the top of his blackboard, as the always repeated Lesson One. Iudin, sitting in the foreground here, seems to have given up on the idea of the square as halo or headdress, and sewn it, as one was supposed to, onto his sleeve.)

How UNOVIS members would have been expected to understand the *White on White* series is a difficult question. Many of the texts by Malevich I have already quoted – "Forward comrade aviators . . ." etc. – were written with *White on White* specifically in mind. The texts are apocalyptic. They are all about endings. But this did not mean that viewers and users of *White on White* were supposed to look through the pictures' actual manufacture to some absolute blankness or emptiness they might signify. They are not empty. "God! I was wrong about these pictures," I remember Michael Fried saying in front of them a few years ago, "I thought they were extremist gestures, and they really are *paintings*!" Quite so. I imagine El Lissitzky experiencing a similar change of mind. And then being thrown back, as were all the other UNOVIS participants, on the question that seemed to follow: if these are paintings – if these are the only paintings the revolution has so far given birth to – then what other, further

153 (*below left*)
Unknown photographer: UNOVIS classroom, 1921 (Galerie Gmurzynska, Cologne)

154 (*below right*)
Unknown photographer: The UNOVIS exhibit at Moscow VKHUTEMAS, 1921 (including work by Kudriashev, Klutsis, and El Lissitzky) (whereabouts of original unknown)

paintings are now possible? One listened to Malevich – one pored over the thirty-three theses of *God Is Not Cast Down* – above all because he appeared to be trying to work that problem out.

The task of a follower, that is, was to come to terms in practice with Malevich's extraordinary physicality and concreteness as a painter, and with the deployment of those qualities in pursuit of an ending, maybe a self-canceling. That was and is the Malevich paradox. No painter has ever been less schematic than he was: every square inch of his canvases, even or especially those with little or nothing in them, is hideously detailed and particular, as if proving a point irrefutably, or exorcizing a kind of horror at particularity by apotropaic magic. And this is the magic that makes him a painter. This is Malevich's project. It is one thing to *say* that the truth of the world is the Nothingness

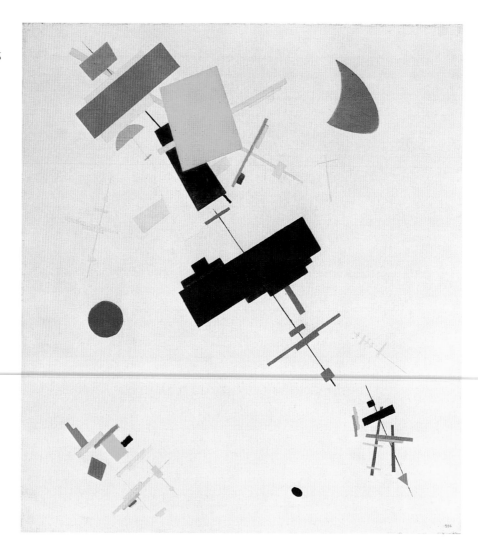

lurking behind it: that "Reason cannot reason, and judgement cannot judge, for nothing exists in Nature that can be judged, reasoned, or examined; she is lacking that unity which could be taken for the whole."[123] But supposing you were convinced that the only way to *show* the aforesaid was by painting. Supposing you believed that the proper vehicle for your eternal ironizing of the dream of totality – the theme is by no means confined to *God Is Not Cast Down* – was painting; just because painting, of all the arts, was the one with totalization seemingly in its bones.

You would have the makings of a life's work. Your painting would be fired by the task of always again constructing a new myth, or new figure, of painting's ending. Because here was how you could actually materialize the dream of totality coming to nothing. Look at the picture ironizing its own existence as all one thing. Look at its physical stuff opening, in spite of everything we believe to be its God- or Factory-given character, onto "the motiveless excitation of the universe."[124] (In his metaphysics of unstoppable, unknowable energy-states, Malevich can often sound uncannily like Diderot in *Pensées sur l'Interprétation de la nature*. Modernism, as we have seen already, is haunted by an eighteenth-century dream of science.)

There turned out to be many ways of making pictures behave as Malevich wanted. Sometimes it was done by sprinkling independent entities seemingly at

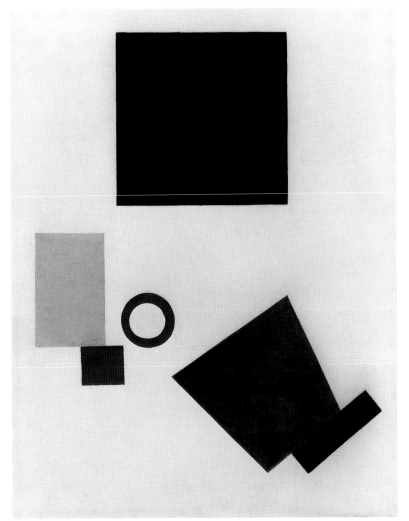

157 Kasimir Malevich:
*Suprematism: Self-
Portrait in Two
Dimensions*, oil on
canvas, 80 × 62, 1915
(orientation as for "0,10"
and Moscow, 1919;
reversed in Berlin, 1927)
(Stedelijk Museum,
Amsterdam)

random (fig. 156), each repeating the message – but was it a message or a threat? – that "Nature's perfection lies in the absolute blind freedom of its parts." Sometimes (repeatedly) the painting's brute presentness as an entity – as a square or a rectangle – would spawn an image of itself inside itself (fig. 157), and the two totalities would confirm and refute one another till the viewer turned away with a snort. Sometimes there would be an ebb and flow of pictorial elements within the frame which had more of the look of a picturing – a dreaming – of literal otherness to the world, of escape from it. "Follow me, comrade aviators . . ." On the one hand a peremptory upward rush and rigidity, as of forces or particles trapped in a deadlock of planetary influences (fig. 158). Or a dangerous seesaw of spikes and girders (fig. 159). Or a throwing of balls and batons in the air (fig. 160). "A hard, cold, unsmiling system," Malevich put it in 1919, "set in motion by philosophical thought."[125]

Several times in his writings after the revolution Malevich described himself as a colorist. For instance, in the 1919 manifesto just quoted: "It became clear to me that what had to be built were new frameworks for a painting of pure color. And they would have to be constructed so as to obey color's own demands. As a defender of individual independence within the

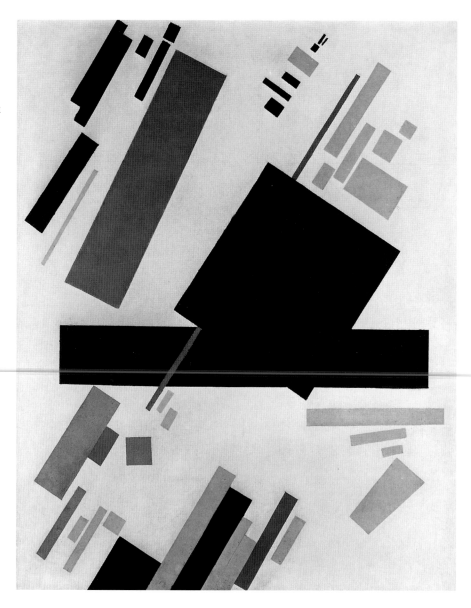

158 Kasimir Malevich: *Suprematist Painting*, oil on canvas, 88 × 70.5, 1916 (orientation as for Moscow, 1919 and Warsaw, 1927; reversed in Berlin, 1927) (Stedelijk Museum, Amsterdam)

collective system [note that the language of the following year's Vitebsk lectures is already in evidence here, and Malevich clearly takes it for granted that the problem of individual versus collectivity has direct pictorial consequences] I understood that painting should also dispense with painterliness – with a mixing of colors – and make color an independent unity, playing its part freely in the overall construction."[126]

It may strike the late twentieth-century art lover as strange for the same painter to claim that his paintings obey "color's own demands" and that they are systems "set in motion by philosophical thought." The two statements are not supposed to go together in modernism. Maybe they do not in Malevich's case. Clearly Malevich is not a colorist of the sort Matisse is, say, painting *Harmony in Red*, or Kandinsky *In Gray*. That is, he does not wish the viewer to believe, in front of *Supremus no. 50* or *56* (figs. 159 and 156), that the shape-construction of the picture has been generated out of an intuition of what a color needed in order to become itself – to consume and irradiate its own particular (totalized) world. Color does not do totalizing magic in Malevich,

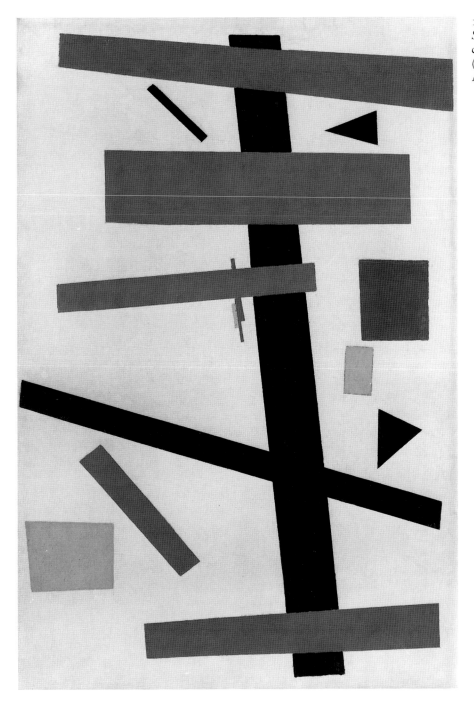

159 Kasimir Malevich:
Supremus no. 50, oil on
canvas, 97 × 66, 1915
(Stedelijk Museum,
Amsterdam)

even when there is only one color on show. It does not consume form, or even render it provisional. Even in *White on White* that is true. Where occasionally in Malevich one does come across colored forms petering out into the ground they float on (fig. 161), that fact does not register as a sign for instability or indefiniteness – certainly not for the yellow quadrilateral in this case being fragile. It is as hard as nails. The title Malevich gave an associated drawing a few years later is indicative: "Suprematist element the moment of dissolution of sensation (non-objectivity)."[127] That is, the moment when the sensation of color

160 Kasimir Malevich: *Suprematist Painting*, oil on canvas, 96.5 × 65.4, 1917 (The Museum of Modern Art, New York)

reveals its true phenomenological character. Which is not to be fluid and formless (that was the Impressionists' mistake) but to be Nothing. "The empty place where Nothing is perceived but sensation."[128]

Malevich, I would say, is a hard, cold colorist – a calculating colorist. And color is supposed (within modernism) to be the place where calculation gives way to feeling. Feeling is not a notion Malevich has any use for. It is beneath his nihilist dignity. When he uses the word – from time to time he talks of an art of "pure feeling," or of Suprematism building "a new world, the world of feeling," and so on – he never means affect. Affect is the enemy of art. It is part of "the

161 Kasimir Malevich: *Suprematist Painting*, oil on canvas, 106 × 70.5, 1917–18 (Stedelijk Museum, Amsterdam)

scum of 'interiority,'" which he especially loathes.[129] Expression, in Malevich's universe, is a superfluous concept, which turns us back to the world we think we inhabit. It is one of the children's toys.

I think that the stress on color in Malevich's self-explanations is less paradoxical than it may seem. Malevich always knew that nihilism had to start somewhere. And color in his view was the aspect of our everyday experience that already (commonsensically) eluded our best efforts to reify it. Ordinary language admitted as much. It knew that no color is ever quite "local." The blue of the sky is our general (permitted) metaphor for all color's belonging and not-belonging to the world. Malevich, of course, had broken through the blue of the sky. "I have ripped through the blue lampshade of the constraints of color... I have set up the semaphores of Suprematism. I have overcome the colored lining of the heavens."[130] He wanted color to be a hard cold absence: he wanted its nowhere to be *here*. And what better visualization could there be of that paradox than (yet again) the fact of the picture's being two-dimensional? Hardness and coldness are qualities that color will take on only if it is relentlessly flattened – pressed out of its radiance and immateriality and put down pat upon the surface. One way Malevich did that was geometry. Color is always held, in his paintings – I guess the word would be "unsmilingly" – by hard straight edges. Another way was handling. Nothing is more material than a Malevich off-white. No doubt there are usually other aspects of the picture – its composition, notably – that encourage the viewer to see this material as not subject to the laws of gravity. Malevich's great metaphor from 1915 to 1918 is

of elevation and escape. But even then it is never a matter of color volatilizing back into ether or spreading like wildfire to all four corners of the room. Color is a weight that something else has elevated. Colors are planets in a planetary system. Composition is an energy that keeps the colored shapes in the air, but only for the time being. We are meant to share the juggler's anxiety as well as his or her rapt concentration.

I am trying to reconstruct the view of Malevich's painting that he himself might have encouraged in his students. Or in Nina Kogan and El Lissitzky. They would have known him primarily as a writer and lecturer, and been puzzled (probably exhilarated) by his present abstention from painting. They would have had on hand examples – some of them projects, some of them present in the flesh (figs. 145 and 162) – of his current thinking about art for public occasions. Maybe there were already drawings by him toward architecture – the kind that finally issued, several years later, in the architecture/sculpture he called *Architectons* (fig. 172). Certainly architecture was on UNOVIS's collective mind. El Lissitzky was in charge of the architecture department in Vitebsk. When he left, Chashnik and Khidekel took over.

None of this meant, in my view, that students and colleagues looked any the less hard at what Malevich had once done as a painter. "Architecture," as I said before, was as much a tendency within painting (or within all the arts) as the name for a separate practice. "We need a workshop where we shall create the new architecture. And there we, the painters, must do what the architects cannot do. We need plans, sketches, projects, experiments."[131] Least of all were UNOVIS students meant to put the master's lessons to utilitarian use. That is not what the piece of Suprematist pottery under Malevich's arm was ever meant to suggest. "Purpose is what is behind us . . . PROUN's power is to create aims."[132] "Those of us who have escaped can see vast distances opened up by the Revolution, we can see a great turning point. And the reason for this is always the same – the confines of expertise have been blown to bits."[133]

the first forges of the creator of the omniscient omnipotent omnific construc-tor of the new world must be the workshops of our art schools. when the artist leaves them he will set to work as a master-builder as a teacher of the new alphabet and as a promoter of a world which indeed already exists in man but which man has not yet been able to perceive.

and if communism which set human labor on the throne and suprematism which raised aloft the square banner [the Black Square] of creativity now march forward together then in the next stages of development it is commu-nism which will have to remain in the rear because suprematism – which embraces the totality of life's phenomena – will lure everyone away from the domination of work and the domination of the intoxicated senses. It will free all those engaged in creative activity and make the world into a true model of perfection. this is the model we await from kasimir malevich.[134]

This is the model we think we can see in his art.

What model, then? Perhaps the best way to answer the question is by comparing Malevich directly with El Lissitzky, whose voice is the one I just brought on to stand for UNOVIS in general. Writers on modern art have always been struck by the contrast between the master and his chief disciple, and have had good things to say about it.[135] All I want to do differently is use the comparison as an aid to understanding Malevich's art mainly, not El Lissitzky's. Because with Malevich we need all the help we can get. (El Lissitzky's is a strong misreading of Suprematism. That is what makes it useful for my purposes. Only Chashnik was capable of a similarly idiosyncratic response; but that came later, for the most part, and too near the end of Chashnik's short life to be properly developed.)

Malevich often made an analogy between his painting and atomic energy. "Atomization – the freedom of units regardless of their makeup . . ."[136] I have quoted connected fragments of the argument already. Chashnik was on to this aspect of the master's thought from the start. Suprematism for him equaled dynamism, high velocity of various sorts. The basic mistake of too many of Malevich's followers, Chashnik argued in his 1922 diploma paper, is to fail to see that the key to a Malevich painting is not geometry in general, but a geometry that "expresses the dynamic condition of forms."[137] "We can only be aware of space," says Malevich at one point, "if we break away from the earth, if the fulcrum disappears."[138]

Now it seems to me that El Lissitzky was thoroughly in two minds about just this side of Suprematism. Not that he failed to see it was central, or that he cannot be found promoting much the same ideas on occasion – I have quoted enough of him in 1920 and 1921 for anyone to see he had a good line of his own in chutzpah – but that it conflicted with his deepest instincts as an artist. I have said that his conception of architecture was a metaphorical one. It was utopian. It meant a reunification of the arts, but it also meant their re-materialization. It meant the expression of specific weights and stresses, a bridging and balancing of parts. *Bridge, Town, Arch, Moscow*: these are the typical, and I think necessary, titles or subtitles of much of the work done at just this moment. The last thing that happens in an El Lissitzky painting (figs. 135 and 141) is that the fulcrum disappears. No doubt the perceptual sums we are invited to do in order to discover where the fulcrum *is* are often mindboggling. Spaces are undecidable, solids and voids convert into one another at the drop of a hat. But the whole construction is tensed and stable. Architecture equals forces finally contained. And architecture in this sense is the ruling metaphor of El Lissitzky's art.

"We inspected the first stages of the two-dimensional space of our structure, and found it to be as firm and resistant as the earth itself. We are building here in the same way as in three-dimensional space, and therefore the first need here too is to effect a balance between the tensions of the forces of the individual parts." "Material form moves in space along specific axes – across the diagonals and spirals of stairs, in the verticals of elevators, along the horizontals of railroad tracks, along the straight lines and parabolas of the aeroplane..."[139] I do not think that any of the above sentences could have been written by Malevich. Certainly he would have agreed that the surface of the picture ought to be "firm and resistant," but not "as the earth itself"! That is just the metaphor he wants to dispose of. Once upon a time he called an abstract painting he had done *House under Construction* (fig. 163), but even in this case it was the unfinishedness that seemed to be the point. This house will never have a center of gravity. And anyway, the title is exceptional. The ones he preferred are *Aeroplane Flying*, *Painterly Realism of a Football Player*, *Dynamic Suprematism*, *Sensation of Dissolution (Non-existence)*, *Self-Portrait in Two Dimensions*. Earth and house have negative valencies in Malevich's manifestoes. "The earth has been abandoned like a worm-eaten house," and so on.[140]

Of course these titles, and the rhetoric accompanying them, are in one sense misleading. The earth has not been and never will be abandoned in a Malevich, because painting, whether it likes it or not, *is* earth. Malevich is a materialist where it matters – in procedure, on the surface, in his sense of how painting has to declare itself. Master and pupil agree on this. (El Lissitzky's limitations as an artist are bound up, in fact, with the difficulty he always has making matter stay on the flat. Too much of the time matter is something he melodramatizes – all those shadows of stairs and elevators, all that gesso and tinfoil – as opposed to makes the picture with.) The difficult thing, once again, is to find a way of describing how Malevich's materialism and nihilism go together, and in particular what attitude to composition they dictate. For Malevich's sense of composition is what makes his art unique. It is what UNOVIS most thrived on.

Abstract art in its first flowering – in Kandinsky and Mondrian, notably – was (rightly) anxious about the composedness or composure of a non-figurative field. It was felt that without the tests and obligations that came with the making of likenesses, the orders taken on by the elements in a picture would tend to be too neat, or too obviously fine-tuned. The composition would end up looking merely ingenious – too perfectly balanced, reveling too much in the push and pull of aesthetic forces. Abstract artists coped with the danger in different ways: Kandinsky by a reckless proliferation of pictorial detail, Mondrian by outright repetition of elements, or beguiling austerity and reduction. What is special about Malevich – in *Supremus no. 50*, for example (fig. 159), or the picture from 1916 in the Stedelijk Museum (fig. 158), or the tremendous *Supremus no. 58* (fig. 164) – is the willingness to pursue a stacking and balancing of elements which could at any point have settled into an order that looked precious, or obvious, or arch, or over-calculated; and yet in practice to have exactly this kind of ordering hum with the metaphor of infinity. It is the conjuring of escape, abyss, elevation, excitation, non-existence out of these too-well-behaved materials that is the Malevich effect.

"Man is only the master of the world insofar as his production of things leads on always to the unknown; and all his workshops and factories exist only because there is an unknown perfection hidden in Nature, which all the workshops and factories strive to bring together in the one totality of technique."[141] And of course they never will. Nature cannot be totalized. Its truth is emptiness and excitation. "If materialism were content to build scaffolding on which to ascend to the nebulae and transform itself into so much mist in the turning of

163 Kasimir Malevich:
*House under
Construction*, oil on
canvas, 96 × 44, 1915–
16 (National Gallery of
Australia, Canberra)

the great cosmic vortex – well, that would be a point in its favor, in my view; but as long as it presents itself as simply a 'fight for survival' or a struggle with Nature, all its victories strike me as meaningless." This is Malevich in 1920.[142] His view of Marxism and civil war.

 Another way of putting it would be this. There is a side to Malevich's writing, and indeed to his practice, that might lead one to expect all of his art would look like the Black Square. Or like the pictures containing a single tilted quadrilateral, or a rectangle and a circle, or a rectangle invaded by a triangle, or the sparest of the *White on Whites*. What is uncanny about Malevich – what makes the installation shots of 1915, 1919, and 1927 (figs. 165, 166, and 167)

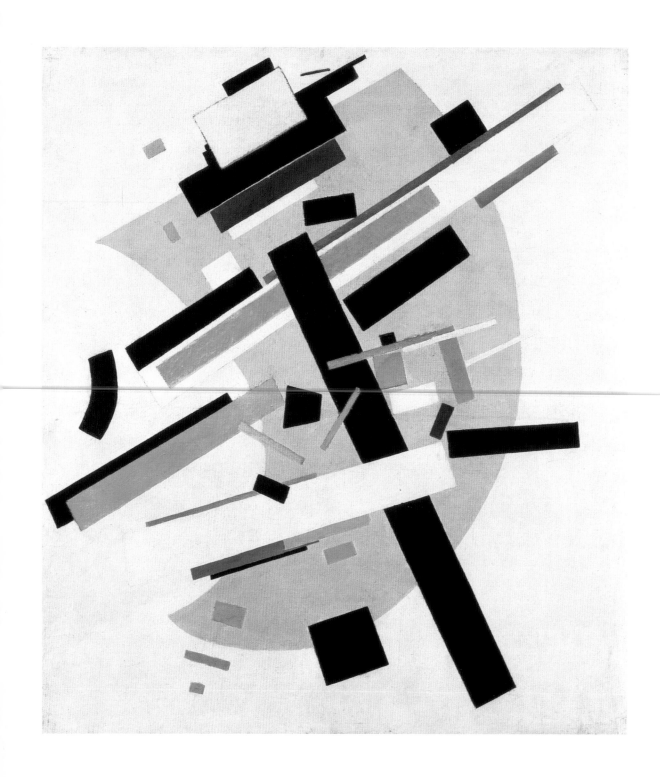

164 Kasimir Malevich: *Supremus no. 58*, oil on canvas, 80 × 70.5, 1916 (State Russian Museum, St. Petersburg)

so moving – is the coexistence of the more complex "composed" or "dynamic" Suprematist works with the icons of the new non-being; and the fact that the orderliness of the multi-element paintings does register as part of – necessary to – the new picture of the world.

The paradox goes deeper. For the more one looks, the more it appears that the niceness and obviousness of Malevich's composition is essential to his pictures' final effect – especially in situ, surrounded by their neighbors. It is what gives the best of his pictures their air of profound inevitability, of finality

and truth-telling. Marvelous as I think it is, a picture like *Supremus no. 56* (fig. 156) seems to me ultimately not quite as good as the Stedelijk's stacked diagonals (fig. 158) or MoMA's neat survey of the solar system (fig. 160). It depends just a little too much for its vitality on Kandinsky's tactic – multiplication of local detail, pictorial cells dividing and redividing in a whirl of cosmic dust. Motley life, as Kandinsky once called it. The effect is dazzling, but I miss the final dogmatic declaration of "This is how it is." And Malevich without the dogmatism is not quite Malevich at all. His visual imagination is only fully mobilized – only fully becomes itself, happening on orders and qualifications of order that nobody else would have risked – when he speaks pictorially at the top of his voice. Exuding the monism of *God Is Not Cast Down*.

165 Unknown photographer: The Malevich exhibit at "0,10" exhibition, 1915 (Stedelijk Museum, Amsterdam)

166 Unknown photographer: The Malevich retrospective in Moscow, 1919 (whereabouts of original unknown)

167 Unknown photographer: The banquet at the Malevich exhibition in Warsaw, 1927 (Stedelijk Museum, Amsterdam)

It turns out, then, that Malevich and El Lissitzky have more in common than one might have suspected. The neatness and orderliness of El Lissitzky, which I have borne down on a bit relentlessly, are certainly features that the disciple would have found in the master. But art is as usual unfair. Qualities that in Malevich's hands were positives, because in tension with qualities and commitments which by rights ought to have overwhelmed them, in El Lissitzky's were by and large a limitation.

Of course I have been arguing that there are exceptions to this rule. Vitebsk is an exceptional period in general, just because the Malevich force field is so close. The propaganda board is one proof of that. The Rosa Luxemburg memorial another. The fact that in both cases we have an example of El Lissitzky's habits reasserting themselves with much the same material – the *Town* and the Rosa Luxemburg minus the writing – only makes the moment of freedom the more remarkable. And I am not saying the moment of freedom never reappeared. There is *Pressa*. There is El Lissitzky's *Proun* room. There are the best (the crudest) of his Stalinist photomontages.

Two rules of thumb for El Lissitzky:

First (which is implicit in much of what I have said already): the closer El Lissitzky's abstractions get to architecture, the worse they are as paintings. This is because the to and fro of possible positions of solids in space becomes locally absorbing, for maker and viewer, and gets in the way of our grasping – and him articulating – the whole pictorial field. An accumulation of paradoxes ends by blocking totalization – not any one or final totalization, needless to say, but a gathering of particular paradoxes for a moment into one paradox, which then again, immediately, fractures into centripetal bits. If there simply are no strong vectors or figures of totalization – no pull of everything back onto the flat – then the viewer will not see the centripetal activity *as* centripetal. That is, as a kind of energy undermining the (modernist) authority of the picture plane. The paradoxes will look nerveless and contrived. They very often do.

Second (which again has been lurking in my previous discussion): the better a Bolshevik El Lissitzky was, the better his art. Not a verdict likely to endear him or me to anyone much at present: but *Pressa* – which I take as the best of his propaganda work – will live on as the finest of all modernist "installations," in my view, long after the *Merzbau* and *Étant Donné* are forgotten.

This is partly because *Pressa* is haunted by Malevich's ghost. Above all, by Malevich's willingness to break his own rules, and make fun of his own purism. *Pressa* is marvelous because it is a kind of satire on "architecture" – certainly on the dream (which we know El Lissitzky believed in deeply) of architecture as reunification of the arts. Of course the surviving photographs of the exhibit inevitably split it up into separate tableaux (figs. 146 and 168). But surely the space must always have seemed madly overstuffed and heterogeneous. The rule seems to have been semantic and sensory overload. The tone was shrill. The exhibits fought tooth and nail with one another and their overall spatial container. It was far more of a Mad Hatter's Tea Party than anything Schwitters ever did. Given the subject matter – this was unabashedly propaganda about propaganda, meant to confirm the West's worst fears – the edge of absurdity seems appropriate.[143]

Some of the time with Malevich's paintings there is a question about which way up they should hang. El Lissitzky himself in 1920 or 1921, seeming to want to make a distinction between his painting and the master's (one that later critics have often gone along with) had this to say on the subject:

> For all its revolutionary character, the Suprematist canvas remained in the form of a picture. Like any canvas in a museum, it possessed one specific perpendicular axis (vis-à-vis the horizon), and when it was hung any other way it looked as if it were sideways or upside down. It is true that sometimes only the artist noticed what had happened.[144]

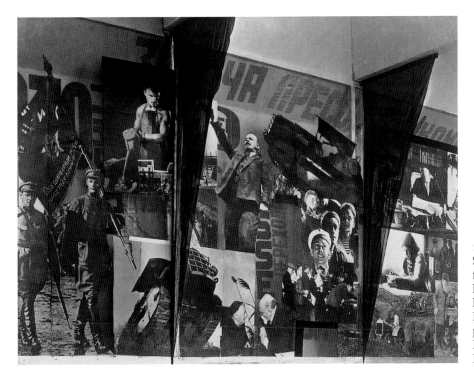

168 El Lissitzky and Sergei Senkin: Photo-frieze for the Soviet Pavilion of the International Press Exhibition, Cologne, photograph, 1928 (Getty Research Institute, Research Library)

I am not so sure. We know from the early installation shots – of "0,10" at the end of 1915, of the one-man exhibition in Moscow in December 1919, and of the retrospectives in Warsaw and Berlin in 1927 – that strange things happened to Malevich's pictures when they went on their travels. The Stedelijk's diagonals, for example (fig. 158), were hung as I show them for the exhibitions in Moscow and Warsaw; in Berlin they were flipped the other way round. *Supremus no. 50* was hung vertically in Moscow and Berlin; in Warsaw it was put on its left side, and hung over a doorway, as almost a traditional *dessus de porte* (fig. 167). There is even a painting – the untitled abstraction now in the Guggenheim in Venice (fig. 169) – which was tried three different ways in three different places. Some lovers of Malevich do not seem to like this. They blame the critic Alexeï Gan, who supervised the hanging of the Moscow exhibition because Malevich had more urgent business to attend to in Vitebsk. Or they imply that Malevich, who certainly was there in Berlin and Warsaw, just thought he ought to be courteous to his foreign hosts and not fuss too much about their bright ideas. *Dessus de porte* indeed! Or they say that Malevich played fast and loose with orientation only *post hoc*, under the influence of his own (later) bright ideas, in ways that do not ultimately tell us much about his intentions in 1915 and 1916.[145]

Again I have my doubts. It comes down, does it not, to a judgement of whether Malevich was right to perceive his pictures as partly escaping the laws of orientation. (I say "partly" because even the Guggenheim picture has one orientation that simply will not go. And *Supremus no. 50* could function

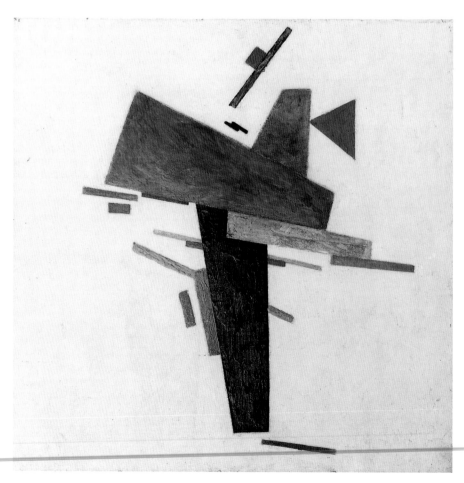

169 Kasimir Malevich: *Untitled*, oil on canvas, 53 × 53, ca. 1916 (Peggy Guggenheim Collection, Venice)

horizontally only on its left, not its right, side. The reasons are similar in both cases. In the disqualified orientation, the forms in the painting have too much weight, too much stability – they are propped against a central pillar like quantities in a complicated balancing-act, or they line up too tidily along the picture's bottom edge, depending on it for support. "Support" and "balance" are tabooed qualities in Malevich's art. "We can only be aware of space" – to repeat his key self-instruction – "if we break away from the earth, if the fulcrum disappears.") My judgement, you will gather, is that the best Maleviches really do *not* turn on the relation of their parts to a built-in horizon, drawn or implied, or even to the picture's overall shape conceived as a finite, generative entity, having a top and bottom, and ultimately dictating the behavior and gravity of the forms within it. That would be true – maybe true preeminently – of the Black Square. Just because the Black Square completely repeats the shape of its container, there ends up being not so much a relation or hierarchy between the one and the other as a stand-off, or an infinite ironizing of the very idea of relation. And it is important that what is repeated is a top- and bottomless square, not a rectangle. (Critics are fond of telling us that it is not a square, really, but a shape with its own subtle inequality of sides. But that is only a kind of pictorial entasis. It is a square. Its squareness is the root cause of its undecidability. It is a black square. Its blackness is the sign that it is Nothing. "Anarchy is colored black . . .")

The variables in a Malevich painting are flatness, hardness, separateness, and weightlessness. Picturemaking is a matter of making these barely compatible qualities coexist in the same set of non-things. Flatness, as I said before, is essential to Malevich because it stands for the fundamental non-being of all the elements on show. Malevich never doubts that if he robs the world of dimension, he is on the way to robbing it of other false appearances. "The world is like a hole and the hole itself is not hollow. I cut a section through the emptiness . . ." "There is no empty space. Nor is it possible to draw a line or any other figure, because everything is already filled, occupied; and the point itself, or the line, is already a multitude; the point and the line are infinite in width, in depth, in height, and also in space and time. In infinity, everything will be nothing . . ."[146] Therefore the last thing a Malevich wants to be, or be read as, is as an image of some possible loss of gravity, some "breakaway from earth." We do not have the means as yet to make such an image. The means will only be found on the picture surface, in the actual, material place where forms can be made to negate their usual connotations – of uprightness, density, scale, self-support, interdependence, equilibrium, imminent collapse.[147]

"Communism . . . is already non-objective. Its problem is to make *consciousness* non-objective, to free the world from the attempts of men to grasp it as their own possession. In this lies the attainment of the highest end. Here the new religion has found its own international limit, the signs of which lie in Leninism, not Lenin."[148]

Malevich's politics, needless to say, are almost totally submerged by anti-Soviet factoids. The episode of the Lenin monument is politely ignored. Likewise, usually, the extraordinary struggle that went on in Malevich's writing in 1924 to wrest "Lenin" from the hands of the Party and make him UNOVIS's property.[149] The sentences just quoted are part of that episode. The Party has the body, but UNOVIS has what the body stands for. "Lenin" is the Black Square incarnate.

Andrei Nakov would have us believe that Malevich gave back his party card some time late in 1918 (no evidence adduced).[150] Vasilii Rakitin says that

toward the end of his stay in Vitebsk he was threatened with arrest, and spared only thanks to the efforts of the painter Robert Fal'k (likewise no evidence given).[151] It is clear from the series of articles Malevich wrote for the journal *Anarkhiya* in spring 1918 – at the time of *White on White* – that his first post-revolutionary politics put him squarely in the nihilist/libertarian camp. The journal ceased publication in April for reasons that hardly need spelling out.[152] Later on in the 1920s Malevich certainly fell foul of Stalinism. He was arrested and interrogated. Friends burned his papers. He spent his last years in poverty. But none of this helps much in trying to reconstruct what he may have hoped from the Party in 1920 – many an anarchist made his peace with the Bolsheviks then, under the shadow of civil war – and how he conceived of UNOVIS's relation to the local Soviet.

The leaflets and almanacs Malevich masterminded during the UNOVIS period flirt constantly with the Party analogy.[153] *God Is Not Cast Down* is partly a polemic against Leninism, I believe, but it (deliberately?) leaves open the question whether the Bolshevik Factory/Church is to be displaced by a UNOVIS one, or whether what the Bolsheviks need is simply to recognize their own nihilism and take UNOVIS for their God. Of course Malevich fancied himself as Lenin to Chagall's Kerensky. No prizes for guessing who El Lissitzky fancied he was. We know that UNOVIS was interested in the movement called PROLETKULT in 1920. At the Smolensk meeting in October one of the items on the agenda was the PROLETKULT line on art and class.[154] I suspect that UNOVIS imagined it could carve out a similarly independent sphere of action, as "laboratory" for the culture to come. Malevich later claimed (maybe he thought he was demonstrating his political reliability) that he had sought out PROLETKULT in Petrograd in 1922, and discussed the possibility of joint action.[155] By that time it was already too late.

I do not mean to adopt a high moral tone about all this – how would I or any of us have done in the circumstances? – but there is no point in not recognizing these maneuvers for what they were. One aspect of UNOVIS was jobs for the boys. Another was play-acting. Anyone who has spent time teaching in art schools will recognize early on that UNOVIS pamphlets and bad behavior have the flavor of any art school putsch. A lot of the anti-individualist sloganizing seems to have been done in the deepest of bad faith. Reading it, there are times when one is tempted finally to rally to poor Chagall's defense, even (especially) on revolutionary grounds. He ran a good pro-Soviet show for two years in Vitebsk. His banners (fig. 170) no doubt did a better job of raising class consciousness than anything UNOVIS managed. Nor was he just a wishy-washy Liberal waiting for revolutionary flowers to bloom. He intended his Commissariat to set standards in Vitebsk, and crowd out the opposition. He knew Suprematism would be good at that. Ivan Puni (the first of Malevich's circle to be summoned to Vitebsk, a matter of months after Chagall moved in) was a shrewd hiring in this respect, and quickly got the local opposition's back up.[156] It is just that Chagall never calculated on the hatchetmen he brought in from Moscow eventually turning their weapons on him. He had not read enough histories of the French Revolution.

But I digress. And anyway, what I am concerned with in the case of UNOVIS is not its effectiveness, even as pedagogy. I think that the cluster of people around Malevich produced tremendous work in 1919 and 1920. The group installation shots (figs. 151 and 154) make that case pretty well, and of course they leave out much of the larger and impermanent work UNOVIS did best. But I do not believe that any of this happened because Malevich was a good teacher. I soon nod off over his endless wall charts and additional elements, and I bet Chashnik and Khidekel did too. What mattered was the madness lurking

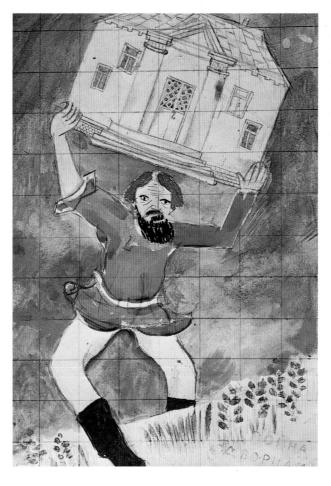

170 Marc Chagall: *Peace to the Huts, War on the Stately Homes*, design for street decoration, watercolor and pencil on paper, 34 × 22.9, 1918–19 (State Tret'iakov Gallery, Moscow)

behind the platitudes about Cubism. What mattered were the circumstances – the soldiers in the streets, the news from Ukraine, *Victory over the Sun*, the "mood of euphoria and desperation." In a word, what mattered was modernism.

Compare El Lissitzky's *Lenin Tribune* (fig. 171) – the project seems to have begun in the UNOVIS workshops, and maybe was not in the first place El Lissitzky's idea – with one of Malevich's experiments in architecture from the mid-1920s, the example called *Zeta* (fig. 172).

The *Lenin Tribune* assumes that the principles of Suprematist painting can be materialized – made over fairly directly into architectural form. This belief underlay a lot of UNOVIS's practice and theory. It was one reason for the group's exalted mood. When Malevich finally turned his mind to architecture (and maybe his first sketches for models were done as early as Vitebsk), he seemed intent on suggesting that no such transfer was possible. Architecture, says the *Zeta* model, is an object-activity, tied utterly to a metaphorics of solidity, symmetry, support, columniation, buttressing, addition and build-up of elements, definitiveness of form – in a word, monumentality. Maybe this object-activity can be deconstructed, but only by pushing and stressing objecthood to the point where its logic doubles back on itself. By a true and painstaking deconstruction, that is, not a totalizing reinvention – a fantasy – of architecture lifted clear of the earth.

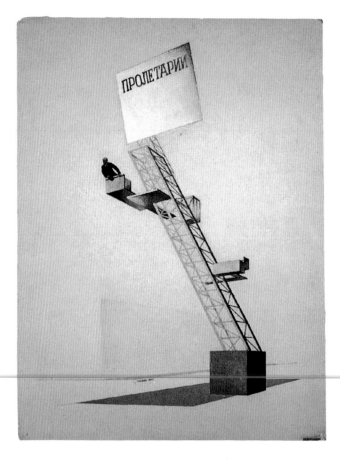

171 El Lissitzky: *Lenin Tribune*, gouache, ink, and photomontage on cardboard, 63.9 × 48, 1924 [original project by El Lissitzky, Chashnik, and others, 1920] (State Tret'iakov Gallery, Moscow)

Modernism in architecture, says Malevich, ought to be monumentality gone mad. A hypertrophy of solids and buttresses and markers and centerings and symmetries, in which Nothingness puts in an appearance (if it ever does) round the edges of the monolith – as a ghost in the architectural machine.

Of course one can never be sure of catching Malevich's gist. Least of all here. *Zeta* is truly impenetrable. And no doubt there is a side of me that wants it and the other *Architectons* to be ironizing architecture, not doing architecture pure and simple. I want them to puncture the *Lenin Tribune* dream. Need it be said that if they do – if they truly are ironical – the result is just as deadly to the Bauhaus, or the Vesnin brothers, or Le Corbusier, as to anything hatched by art students in 1920.

"Our lives are being built on a new Communist foundation, solid as reinforced concrete . . . On such a foundation – thanks to the *Prouns* – monolithic Communist towns will be built, in which the inhabitants of the world will live." Typical of Malevich to take his best pupil's version of utopia (the words come from a lecture by El Lissitzky given in 1921) and explode it by literalizing it.

It will have dawned on the reader by now that the tug of war between Malevich and El Lissitzky is meant as an allegory of modernism in general. But a tug of war of what, precisely? That is what the allegory can never quite put its finger on. Which of the two men is the materialist, and which the idealist or idealizer? Whose art is the more revolutionary, or even the more extreme? (Obviously I have painted El Lissitzky as in some sense the normalizer of the two, but these things are comparative, putting it mildly. The normality he

172 Kasimir Malevich:
Zeta, plaster, 79.4 high,
ca. 1923–27 (Musée
National d'Art Moderne,
Paris [partial
reconstruction])

thought he could adjust to was a blood-soaked abyss.) Whose art is the more
inward-turning? Who comes across as focused the hardest on sheer procedure,
or the calculation of effects? Which set of images is most open to contingency
– to the unknown and unpredictable, the ebb and flow of circumstance, the
vagaries of politics? Which art most confidently "refers"? You will gather that
modernism strikes me as most fully itself at moments (like 1920) when ques-
tions of this sort are unanswerable, because the distinctions they rest on are
what art practice puts in doubt.

My hunch is that one of the reasons the Left in art thought its time had
come in 1920 was that it sensed not just a general crisis of confidence in the
sign, but also a specific crisis in the Bolsheviks' relation to their own sign
language. It was a bad year for any party that believed it was, or represented,
the dictatorship of the proletariat. Isaac Deutscher, who was not necessarily on
the lookout for signs of strain, singled out 1920 as a time when support for the
Bolsheviks among what was left of the working class was at rock bottom.

Mensheviks and Social Revolutionaries, who in the course of three years had been completely eclipsed and had hardly dared to raise their heads ["eclipsed" is a good Deutscher verb, and "hardly" disguises a great deal of daring and raising in 1918 and 1919, usually against fierce odds], were now regaining some popular favor. People listened even more sympathetically to anarchist agitators violently denouncing the Bolshevik regime. If the Bolsheviks had now permitted free elections to the Soviets, they would almost certainly have been swept from power.[157]

Trotsky's fantasies of the militarization of labor, and a culture of total cajolement and accusation directed at those falling out of step, were certainly partly fired by a sense that the relation of Party to proletariat had been all but destroyed. Writing to Lunacharsky in 1926, he looked back on the "menacing discontent" of the working class – and the Bolsheviks' awareness of it – as groundbass to all the debates about policy in 1920 and 1921.[158] We should understand Lenin's turning aside from his day-to-day duties to draft his *"Left-Wing Communism" – An Infantile Disorder* in April and May 1920 as part of the same syndrome.

Vitebsk produced its share of danger signs. Summer 1918, as I have said already, had seen a head-on clash between Mensheviks and Bolsheviks in the city over the summoning of a conference of workers' *upolnomochennye*. The conference had managed to assemble and was immediately broken up. A few Mensheviks were arrested for "counter-revolutionary conspiracy." Socialist party organizations in the province were declared illegal, and all socialists ordered to leave the province forthwith. One Menshevik billposter was shot. Part of the reason for all this was the fact that the Mensheviks had won an overwhelming majority on the Vitebsk provincial Soviet earlier in the year.[159] Early 1920 seems to have seen a recrudescence of Menshevik activity in the city. Raphael Abramovich in May cites Vitebsk as a place where the party had done particularly well in recent elections.[160] Reviewing the year, the Menshevik Central Committee listed Vitebsk (alongside Samara, Rostov-on-Don and Mogilev) as one of the areas where "the most severe arrests took place" in the fall. "During the campaign of elections to the Vitebsk Soviet many party members were arrested, among them Karavkin, Seredinskii, and a well-known party leader, formerly a Central Committee member, B. S. Tseitlin. [Any relation to the designer of the UNOVIS ration card?] Because of the terrible conditions in prison, Tseitlin caught typhus and died. Comrade Karavkin began coughing up blood. The Cheka offered to release them if they would stop campaigning. Naturally they refused."[161] This is the point at which a Cheka document actually turns up – Verdict No. 2821, 14 November 1920 – listing Lazar Ratner of Vitebsk, a Menshevik, as "guilty of malicious criticism of Soviet power and its activities" and sentencing him to the camps. Martov, writing his usual survey of such things in *Volia Rossii* (an SR paper published in Prague) in December, puts Vitebsk as one of the cities from which reliable reports of the execution of Mensheviks have arrived.[162]

I am not claiming that these are more than scraps of information. In the circumstances scraps are all one would expect. At least they give an inkling of what being on the Bolsheviks' side in art might have involved, by way of day-to-day turning a blind eye. And they put a bit of flesh on Trotsky's "menacing discontent." I do not think we shall catch the tone of *Stanki depo* completely if we do not build into our reading of it a sense not just of absence and abstention, but of actual violent disagreement about who could speak to, or for, the people no longer at the factory benches – speak in whose language? speak in whose name?

Georg Lukács tells the story of coming down into the streets from his office

the morning after Béla Kun took power, and happening upon two billposters slapping up Kun's declaration of principles. (The story is not particularly telling, and maybe a bit too good to be true; but at least for once it has poster makers and poster readers face to face.)

> "Good morning, comrades," he greeted them eagerly. "Let's see what you've got there" ... Without looking up from their bucket of glue and rolls of posters, the workers muttered something about a "new government." Lukács corrected them. "Listen, comrades, the proletarian dictatorship is more than a new government." Putting down his brush, one worker glanced at Lukács and snapped, "What I would like to know is why this fucking poster couldn't have waited till later this morning. Obviously you gentlemen think the poor working man doesn't need a good night's sleep." Lukács pointed at the poster headed "To Everybody." It portrayed a face, flushed with excitement, shouting that the proletariat had seized power. "But didn't you read it?" Lukács asked. One of the workers burst out laughing. "My dear sir [that sounds like Lukács' transcription of the form of address], since 1914 we've glued up more posters all over Budapest than the number of hairs on our heads. Do you think we actually have time to read what's on them?"[163]

Of course these are tensions and absurdities attendant on any effort to move politics out of its usual charmed circle. I am not saying they were just a Bolshevik problem. But I do say that in 1920 the bad faith involved in claiming to speak and act on behalf of those who actually resisted the speaking and acting – resisted their own "accelerated self-organization," as Bukharin would have put it – was dangerously close to the surface. And this was Left Art's opportunity. If the attempt to map Bolshevik categories and prescriptions onto the world was more and more transparently impossible, then put the blame on the mapping. Do not map the world, transfigure it. That is what El Lissitzky's propaganda board promises to do. Take the mood of euphoria and desperation, and finally synthesize the two terms. "At long last create a situation from which all turning back is impossible." Create at the level of language. Make a revolution of the sign.

Readers will please themselves whether they find this last utopia grisly or attractive. Certainly the utopia did not happen, and you will gather that I do not think it could. But again, my subject is limited. As a set of fantastic instructions to artists – instructions for Art's "accelerated self-organization," that is – they proved hellishly fruitful. Modernism thrives on situations of signifying collapse, or situations where it can persuade itself (where features of the environment collude in persuading it) that such a transvaluation of values is about to take place. Lenin once said that a revolutionary situation is one not just where the soldiers refuse to obey orders, but where the officers do not believe in the orders in the first place. Modernism is always looking round for a suitably demoralized officer class. Usually it thinks it can hasten on the demoralization. In 1920 it reckoned that if it could finish the process of disorienting and demoralizing the Party, it might save the Party from itself. Looking at the twentieth century as a whole, this might in general be a better picture of modernism's relation – its functional relation, I mean – to the powers-that-be.

El Lissitzky's board was meant as propaganda. We know the subject of mass persuasion was on people's minds in 1920. Lenin more than once exulted

in the Western powers' admission that the Reds had been victorious in the propaganda campaign, and poured scorn on the convoluted explanations for that success offered by experts on the other side. The Reds had won because Truth was with them – or anyway, more of Truth than was with the Whites. It is true that White propaganda was spectacularly inept. El Lissitzky was UNOVIS delegate to the All-Russian Propaganda Conference in Orenburg in summer 1920 (perhaps on the same swing that took him to the congress of the Comintern in Moscow).[164] I would give a lot to know more about the conference's proceedings. Suprematism was evidently thought (by some) to be particularly strong when it came to propaganda work. When Chagall summoned Ivan Puni to Vitebsk in 1919, he put him in charge of the propaganda faculty.[165] The UNOVIS group set up in Smolensk survives in the art-historical record thanks only to a couple of posters, again with crushingly orthodox production-propaganda motifs (fig. 173). In the one I illustrate, Malevich's cheerleading about Suprematist space colonies to come ("The earth and the moon. Between them a new Suprematist satellite can be constructed, equipped with every component, which will move along an orbit shaping its new track . . ."[166]) is literalized in just the way the master would have hated, I think – as if the Smolensk artists could not resist the analogy between getting production off the ground and a general (high-tech) defiance of gravity.

173 Smolensk ROSTA [Wladislaw Strzeminski?]: *Raising Your Output, That is the Best Guarantee of Success at the Front!*, lithograph on paper, 1920 (whereabouts of original unknown)

All of this ought to put me in a position to say something about propaganda as a concept, and UNOVIS's particular take on it. But the subject is elusive. There is so little agreement about what the word "propaganda" means.

Suppose we agree on the following rough definition:

Propaganda is a representation of events and problems, simplified in such a way that the meaning of the events, and the solution to the problems, seems immediately present in the representation itself; and perceivable in a flash, in a manner that brooks no argument. The representation serves the interests of those who ordered it. It invites its viewers and readers to take sides, or better, it assumes that there is only one side for viewers and readers (as opposed to enemies and cretins) to take. It tries to tune out or drown out contrary understandings. It says the facts – the ethical facts, the facts of allegiance and human sympathy – speak for themselves.

Obviously the line between propaganda and other forms of representation is hard to draw. All representations are partial and interested: propaganda is a word for a particular form taken by that partiality and interestedness. Noam

Chomsky, for instance, has argued over the past several years that the representation of American interests and actions in the media – both those directly financed and managed by the government and those independently owned – has a degree of coherence and partiality to it that deserves the description "propaganda system."[167] I think the evidence of flattening and exclusion he presents is overwhelming. But I know this will remain a minority view.

Why? Surely because of something in the nature of propaganda itself. One of the main jobs of a propaganda machine is to define the enemy's system of representations *as* propaganda. That is, it poses the question of propaganda in terms of style. The style of the Other is uniform and monistic. (The Other totalizes all the time.) Our system is different. A good propaganda machine is able to promote and sustain a degree of difference within itself (within limits, of course), a plurality of voices, styles, and "viewpoints."

For present purposes, the feature of Chomsky's model I want to emphasize is simply the idea that the effective unit of propaganda is what he calls the propaganda *system*. (Here is why posing the question of propaganda effectiveness in terms of the individual item and its power to persuade seems to me so misguided.) If we hold on to the notion that the word propaganda describes a certain, more or less complex representational system, and that such systems do not come out of thin air, but actually get built, by trial and error, in circumstances of disagreement about what might be needed here and now, or as part of the next Five-Year Plan (All-Russian Propaganda Conferences and so forth), the building going on most often in the worst of circumstances (Whites, Poles, and peasant guerillas just over the horizon), then the phenomenon of UNOVIS might come to make more sense. I do not think for a minute that Malevich and co. were idiot totalitarians who fantasized a "leading role" for themselves in the Bolshevik state. Or maybe sometimes they did. "I strive toward centralization so that I can direct the world and all its details."[168] But by and large they knew they were a tiny minority of extremists. It is a question of what they thought the role of an extreme minority might now be. That was a question about the place of its products in a propaganda system.

UNOVIS language – say, the pattern of text and picture in El Lissitzky's propaganda board – was obviously "difficult." Maybe that meant it lost out in terms of effect on the passer-by. (Maybe not. Difficulty has its own power of attraction. Everything the avant garde said about the sheer dullness, and therefore inefficiency, of the available propaganda alternatives seems in the long run to have been borne out by events.) In any case, as I have said, on-the-spot effectiveness is not a necessary or sufficient condition for efficacy in a propaganda system. The UNOVIS wager was that the Bolshevik propaganda system had reached a stage where it needed modernist extremism as a kind of mirror image of its own.

To put it another way. Western critics of UNOVIS's utopianism in the realm of propaganda really only repeat the mistake of the judges in the Lenin competition of 1924. They posit a "single-minded peasant" (or proletarian) who simply cannot be interpellated by this kind of language. But what about this kind of language *as a limit-case within a system* – one to which in terms of verbal message (and even some aspects of its visual idiom) it unequivocally belongs? Systems need limit-cases. They need implication of background values as well as explication of foreground taboos. Suprematism was remarkably bad at whipping up class hatred, which is what the West thought Soviet propaganda was all about. ("First of all there was the overwhelming hatred of the . . . Russian people, who formerly lived in poverty, ignorance and filth, for anyone who possessed property, education or breeding. It was by exploiting and fanning this sentiment that the Communists could hold a certain part of the poorer classes

even when material conditions under their rule were most desperate."[169]) On the other hand, it did quite well at dramatizing "the inner meaning of the economic plan, its internal logicality." The propaganda system certainly needed an imagery of the latter. It needed – I should say, above all it needed – imagery for the exhorting classes. UNOVIS was not wholly misguided (though it may have been cynical) in thinking it might just be able to provide the necessary.

Between the lines of this chapter has been the question of UNOVIS's relation to Marxism – maybe the question of Marxism's relation to modernism in general. I do not think there is an "in general" answer to this question on offer, but we shall not make much sense even of particular cases unless we come to terms with what Marxism was, or became, after 1917.

Some years ago a pamphlet I had a hand in writing risked the following on the subject of Marxism's relation, as a body of thought, to the long struggle between Leninism and the West:

> We do not mean to deny that "Marxism" was a player, or a counter, in that game of ideological checkers; but only insofar as it became, in the wake of Bolshevism, the ideology of "development" for those national bourgeoisies that went on dreaming of an end-run round capitalism, to a miraculously stabilized commodity economy. The versions of Marxism these dreams gave rise to in the last seventy years were, to put it mildly, a bit exotic. There may be differences of opinion among us as to whether, in the light of this history, the old dog of Marxism has any life left in it. How could there not be, after half a century of hearing Marxism out of Ulbricht's mouth, or Kadar's, or Mugabe's? But one thing we agree upon. If Marxism is to be retrieved at all as a critical weapon against capitalism, it has everything to gain from being thus "discredited" – that is, with most of the people who previously gave it credit. It may still prove to be an idiom of use to those for whom it was first meant. Certainly they have not gone away.[170]

I want essentially to stand by that verdict, but with one or two provisos. The verdict is brief, and therefore may seem dismissive. Our choice of Mugabe may stick in some readers' craws. Particular histories are always agonizing. War Communism too had its tragic and heroic side. I would have wanted even in 1920 to be with Bakhtin in Vitebsk, not with his brother in Crimea. (And the brother in exile thought much the same thing. He ended as a member of the Communist Party of Great Britain.) To say that Marxism became the ideology of development in a capitalist world is not to say that the ideology (or the development) was unnecessary. It just bore a more and more vestigial relationship to anything Marx said.

Marxism in the twentieth century became the ideology of state-formation in conditions of primitive accumulation. This is not said, again, to denigrate the Marxisms of the Second and Third Worlds, but to bring into focus the kind of work Marx's ideas were called on to do in those worlds, in the face of what constraints. And War Communism in 1920 – this is what I have been arguing – is the moment of Marxism's meeting with its ideological destiny. The year is thick with the cunning of reason. In this sense, and this sense only, nothing could be more modern than El Lissitzky's propaganda board. Nothing foretold the future with such dismal accuracy.

This book was written, as I said at the start, after the Fall of the Wall. And whatever one's views of the relation between the Soviet Union and the

project called socialism (mine by now should be fairly clear), it is a moment when anyone concerned for the project looks about – maybe a bit furtively – for consolation. I take mine from a handful of lines Wordsworth wrote in *The Prelude*, in the aftermath of Year 2:

> ... When a taunt
> Was taken up by scoffers in their pride,
> Saying, 'Behold the harvest which we reap
> From popular government and equality,'
> I saw that it was neither these nor aught
> Of wild belief engrafted on their names
> By false philosophy that caused the woe,
> But that it was a reservoir of guilt
> And ignorance filled up from age to age,
> That could no longer hold its loathsome charge,
> But burst and spread in deluge through the land.[171]

Wordsworth, as usual, offers a harder wisdom than he seems to at first sight. The reservoir that makes for revolution, he says, and for its degeneration into tyranny, is the inheritance not just of ignorance from the past – of unpreparedness for the tasks of history – but also of guilt. Guilt belongs mainly to the exhorting classes – to those who lead the revolution as much as those who fight it tooth and nail (and exult in its downfall). But guilt is loathsome. It distorts and perverts the best vision of the future. It cannot dam off its affect from other fantasies – of power, revenge, freedom, unanimity, and the end of time. Lenin would be the crucial case study here. But guilt is what the exhorting classes *have*. Once upon a time their best representatives tried to face that inheritance and think of a way of dealing with it. William Morris once said that making and enjoying art in the circumstances of capitalism was "like feasting within earshot of a patient on the rack."[172] "The poet must remember that it is his poetry which bears the guilt for the vulgar prose of life."

Such statements are unfashionable these days. (It is reckoned they lead to "totalitarianism.") But something is being pointed to in them – some loathsome charge, some Bhopal or Gaza or El Mozote. What to do with that guilt is another matter. And I am not intending some last-minute psychological explanation, or excuse, for Bolshevism by raising the question at all in these paragraphs. Questions about Bolshevism are political. But one thing you do learn from looking at UNOVIS: there is no end to the madness we come into from the past, and which revolutions release. The Black Square means that among many other things. And the darkness it tries to contain, or ironize, remains the fuel – and the chief threat – for any revolution to come.

It may seem strange to end an essay on El Lissitzky's propaganda board with reflections on guilt (answerability) and state-formation. But I cannot see what other, lesser terms would do justice to the board's ambition. There is a third term, of course – the old mole, or chestnut, "revolution."

In the 1960s I remember being struck by an article by Theodor Schieder, in which he argued that our name for the nineteenth and much of the twentieth centuries ought to be "the age of revolutions"; since revolution was the governing metaphor of political and cultural life in the period, and certainly what marked off its self-consciousness from those of societies before it.[173] That may be so. Lately there is something like general agreement in the First and Second Worlds (maybe even the Third) that the period and metaphor have come to an end. Every last hack expects us to be cured of "revolutionary romanticism" by

the events of 1989. (It serves their turn to present us with a scoffing caricature of both terms, and to insinuate that they always belong together. It serves their turn to make out Lenin – of all people – a "utopian"!) Even those with something genuinely to say on the subject most often strike a valedictory note. "Marxism," one of them has it, "only takes root in a society that is *imagining* having industry."[174] This is a grim diagnosis (in my opinion), but my chapter on UNOVIS has ended up largely agreeing with it.

What we need to understand, then – and this chapter is intended as a contribution to the understanding – are the circumstances in which a society's imagining itself having industry takes place in Malevich's or Lenin's terms. (The two examples are in my book typical, of what seems to be a necessary veering in the industrializing imaginary between fantasies of totality and fantasies of endless shifting – shall we say, between Party and utopia, or Leninism and nihilism? Or between the "Life and Art" of Bakhtin's article.) I think we might look at the terms "guilt," "state-formation," and "revolution" under the rubric of a fourth and more capacious one, proposed by Norbert Elias, "the civilizing process."[175] Let us agree with Elias that the great change in social behavior and self-consciousness which went along with the process of modern state-formation from the end of the Middle Ages (and with a vengeance once industrialization took off) was a turning-away from the brute enforcement of power relations between people, and between state and citizen, toward "the internalization of social instructions." And not only instructions, but idealizations – more and more imaginary paradigms of what self and others really are, or ought to be, or might become. More and more *belief* in the state (cynicism about politics only being part of the belief). More and more self-policing. "The individual must become answerable through and through." "But answerability entails guilt . . . It is not only mutual answerability that art and life must assume, but also mutual liability to blame." "Wherever the railroad worker goes, he should find a poster which mocks the deserter and puts the shirker to shame . . . Even if we do not get the deserters back by these means, at least we shall shame and frighten anyone leaning in that direction." "It will be built [meaning the world to come] with a direct and accurate force – a lunatic force, from which all will recoil in shame." It is the "all" in this last sentence that is truly accurate and chilling.

Elias and others have shown convincingly, I think, that this internalizing of social idealizations is necessary – strictly functional – for the securing of a modern nation-state. You could not have such states without them constantly creating and reinforcing their own exhorting classes. Self-exhortation is very much part of it. (Michel Foucault, whom I shall deal with directly in the next chapter, was Elias's great interpreter in this regard.) But here is the rub, I believe. The more ferociously internalized are the myths of the state's beneficence, or of the possibility of the good life under its aegis, or even of a deep privacy which the state guarantees – which it exists to guarantee – the more appalling is the realization, if and when it comes (and it always does come to a few), that the myths are founded on hypocrisy, duplicity, and repression. The guilt that is generated by such a realization strikes me as unique. It is not like any previous skepticism, or disappointment with the way of the world; because no previous world had made its larger idealizations so much part and parcel of its subjects' sense of themselves as moral actors. Again, William Morris would be a good example; or Lenin in relation to his brother's execution; or, come to that, El Lissitzky's sudden and total falling out of love with his Jewish inheritance.

We are talking now about revolution as an occurrence *in the life of the exhorting classes* – a moment of terrible apostasy, which then certainly can fuel a lifetime's effort. I am very far from saying that these are the only energies

operative in 1917 or on 25 Vendémiaire; but they are some of the energies, and have real effects: I think we discount them at our peril. (It is part of the exhorting classes' self-laceration to think of themselves as extrinsic or epiphenomenal to a revolution always imagined as coming from elsewhere, from outside or below – from sources untainted by the guilt they are trying to shake off.) Revolution in the sense I am pointing to is a specific malady of the civilizing process and the business of state-formation that goes with it. It is a product of Elias's "internalization of social instructions."

And likewise nihilism – meaning an absolute rejection, root and branch, once and for ever, of the world and its values (not just of the values the world happens to have at present, but of "world" and "value" as such, conceived in any possible relation to one another) – in the hope that such a negation will be curative of the notions of guilt and answerability which are the problem. A lunatic rejection, by the looks of it. But sometimes one lunacy deserves another.

Nihilism and answerability, then. These are the two organizing ideas, it turns out, of a study of UNOVIS in Vitebsk. It is because El Lissitzky's propaganda board puts the ideas at odds with one another so fiercely – Red Square versus Black Circle, *Stanki depo* versus the crackling of the movement of non-objectivity – that the board goes on (and will go on, I think) having aesthetic life.

Nihilism and answerability. And above all – third term – the state. The state, not revolution. In this too resides the photograph's dreadful staying power. For perhaps the scoffers will be proved right. Perhaps "the age of revolutions" really has come to an end; and it may even be that the death of the metaphor is no bad thing. A space may emerge for resistance on the other side of the endless dance of idealizations and apostasies – repetitions of Year 2. Perhaps the phrase of Marx's that will turn out to be most truly prophetic (it is certainly Marx at his most utopian) is his opinion, or hope, that "the working class has no ideals to realize."

I hope so. But the job of this chapter, in any case, has not been to lay the ground for predictions about the future, only to point out the horrors of the past – the horrors of modernization, and of so many of the efforts (even the best and most ruthless) to imagine modernity otherwise. We need to know these horrors, I think, and what the horrors tried to address, if we are to have the least chance of transforming anything. We need to know the true face of our opponent. That is why El Lissitzky's propaganda board will not go away. It shows us the state shouting (as it usually does) through the revolution's mouth. This double image ought to be stamped on our brows, I feel, or sewn on our sleeves. For whether or not the age of revolutions is over, the age of state-formation has only just begun.

6 The Unhappy Consciousness

Farai un vers de dreit nien:
non er de mi ni d'autra gen,
non er d'amor ni de joven,
ni de ren au,
qu'enans fo trobatz en durmen
sus un chivau.

(I shall make a poem out of [about] nothing at all:/it will not
speak of me or others,/of love or youth, or of anything else,/for
it was composed while I was asleep/riding on horseback.)

William IX of Aquitaine[1]

Once Upon a Time. When I first came across the lines by the duke of
Aquitaine some years ago, naturally I imagined them in Jackson Pollock's
mouth. They put me in mind of modernism; or of one moment of modernism,
which I realized I had been trying (and failing) to get in focus ever since I had
read *Harmonium* or looked at *Le Bonheur de vivre.* Two things were clarified.
Not just that modern artists often turned away from the detail of the world in
order to revel in the work of art's "essential gaudiness," but that the turning
away was very often associated with a class attitude or style not unlike Duke
William's, or, at least, an attempt to mimic that style – its coldness, brightness,
lordliness, and nonchalance. Its "balance, largeness, precision, enlightenment,
contempt for nature in all its particularity."[2] Its pessimism of strength.

You might expect such an effort at aristocratic world-weariness on the part
of bourgeois and even petty-bourgeois artists, operating in the nineteenth and
twentieth centuries not the eleventh and twelfth, to bear some strange fruit.
Largeness and lordliness, after all, were not likely to be these artists' forte. Take
the novelist Gustave Flaubert, for (central) example, at the beginning of work
on *Madame Bovary* in 1852: already chafing at the bit of reference that seemed
to come with the form he had chosen, and dreaming of "a book about nothing,
a book dependent on nothing external, which would be held together by the
internal strength of its style . . . a book which would have almost no subject, or
at least where the subject would be almost invisible, if such a thing is possible."[3]
What strikes me as truly strange in Flaubert's case is not so much the project he
outlined for himself – though as an ambition for a novel rather than a sestina
or a set of haiku it has its own pathos – as the distance between the book he
imagined and the one he actually wrote. No book has ever been fuller than
Madame Bovary of the everything external which *is* the bourgeois world. Fuller
in its heart of hearts, I mean; fuller in its substance; in the weight it gives to

174 Jackson Pollock:
Sea Change, oil and
pebbles on canvas, 141.9
× 112.1, 1947 (The
Seattle Art Museum, Gift
of Signora Peggy
Guggenheim)

words themselves. It is as if the more intense a bourgeois artist's wish to dispense with externals and visibilities, the stronger will be their hold on the work's pace, structure, and sense of its own objectivity. Or maybe we could say that what brings on the word "bourgeois" at all as a proper description of *Madame Bovary* is exactly the deadlock within it between a language so fine and cold that it hopes to annihilate the emotions it describes as it describes them, and an absolute subjugation to those emotions and the world of longing they conjure up. A deep sentimentality, not relieved but exacerbated by a further (ultimate) sentimentality about language – call it a belief in the arbitrariness of the sign.

Which leads me to Pollock. To the moment in late 1947 when he produced the first group of abstract canvases done in a newly devised technique involving poured and thrown paint, and named two of them, with Lee Krasner's and his friends Mary and Ralph Manheim's help, *Sea Change* and *Full Fathom Five* (figs. 174 and 175).[4] I do not want to claim there was anything particularly Flaubertian to this choice of words, but – especially compared to the over-wrought, confessional mode of Pollock's titles in the immediately preceding years (*Circumcision, Totem Lesson, Troubled Queen, Blue Unconscious, Something of the Past*, and so on) – they were deliberately cool and gaudy.

Sea Change and *Full Fathom Five* are phrases taken from Ariel's song in *The Tempest*, one of the play's most glittering, masque-like moments; and the titles being so much larger than life – they chime in with others from the same group like *Magic Lantern, Enchanted Forest, Galaxy, Reflection of the Big Dipper, Phosphorescence, Lucifer* – seems to me to have been meant to establish the basic tenor of the new body of work, and encourage viewers to look at it through Ariel's eyes. Which is to say, look through the paintings' superficial roughness and materialism, and see them as magic – spells or disguises of some sort, fanciful, filigree, made out of nothing:

> Full fadom five thy father lies;
> Of his bones are coral made;
> > Those are pearls that were his eyes:
> Nothing of him that doth fade,
> But doth suffer a sea-change
> Into something rich and strange.

Sea Change has a scattering of small pebbles across its surface, mostly covered in aluminum paint. *Full Fathom Five* has nails of various sizes, a disintegrating cigarette, tops off paint tubes, a button, thumbtacks, matches, a key, pushpins, pennies. The debris of everyday life. You expect if you go on looking long enough to come across one or two of Pollock's tranquilizers. But the bits and pieces are only detectable from eighteen inches away. Go back a couple of paces, to normal viewing distance, and they disappear into the slow swirl of water and weed.

*D*on *Quixote*. It remains to be seen if this atmosphere of courtly artifice was something Pollock could sustain. He was, need I say it, a petty-bourgeois artist of a tragically undiluted type – one of those pure products of America (of Riverside County, California) we like to believe will go crazy strictly on their own class terms. It is hard to think of him playing the aristocrat for long. And whatever the ultimate figure that the poured paintings were meant to conceal – father? mother? *Troubled Queen? Mad Moon-Woman? She-Wolf?* (I guess the titles point mostly one way) – Pollock, of all people, was unlikely to content himself with an image of the concealment (the pouring) as enchant-

175 Jackson Pollock: *Full Fathom Five*, oil and assorted materials on canvas, 129.2 × 76.5, 1947 (The Museum of Modern Art, New York. Gift of Peggy Guggenheim)

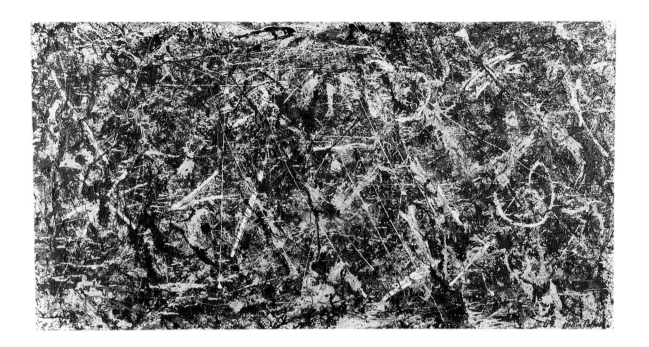

176 Jackson Pollock:
Alchemy, oil, aluminum,
and string on canvas, 114
× 195.5, 1947 (Peggy
Guggenheim Collection,
Venice)

ment. Paint for him was not pearls and coral. The most fiercely worked of the
pictures from the end of 1947 got called *Alchemy* (fig. 176). Its surface is as
belabored as its color. It is made up of minerals utterly untransmuted and
untransmutable, most of them mud brown and tar black. Alchemy, so the books
say, may originally have meant just "pouring". Zosimus put the blame for the
whole business on the fallen angels, teaching secret arts to the women they
married.[5] Now here is a metaphor Pollock could ride to the bitter end.

But I anticipate. For the time being, all that needs to be established is that
Pollock's drip paintings, when they started, and maybe even as they continued,
were alternately *Alchemy* and *Sea Change* – *Alchemy* always failing, *Sea
Change* never. The pictures were dazzling ("almost too dazzling to be looked at
indoors,"[6] wrote Clement Greenberg of one of them at the time). They were
lordly and playful, like something a master had thrown off. *Magic Mirrors*.
Shooting Stars. Enchantment was part of them. And this seems to me true of
modernism in general. Of *Sweeney Agonistes* as much as of *Harmonium*, of
Picasso as much as of Matisse. An art of high negativity – books about nothing,
paintings done with consciousness deliberately on hold – is not necessarily
anarchical, scabrous, or otherwise low. On the contrary, it has often come out
of courtly surroundings. Dukes have gone in for it, on horseback, as part of
their general "contempt for nature in all its particularity." Negation is stylish.
For stylish, at certain moments, read fashionable.

Scent. So it proved in Pollock's case. On 1 March 1951, *Vogue* maga-
zine published four pages of photographs, black and white and color, by Cecil
Beaton (figs. 177 and 178). In them Irene and Sophie showed off a range of the
season's evening dresses in front of pictures by Pollock from a show just closed
at Betty Parsons. Beaton had ideas about how the pictures and dresses matched.
He reveled in the analogy between *Lavender Mist*'s powdery transparency – or
the transparency his lighting gave it – and that of the chiffon and fan. The fan
struck a Whistlerian note. He tweaked Irene's black cocktail dress into a to and
fro of diagonals which made it quite plausibly part of Pollock's *Autumn*

302

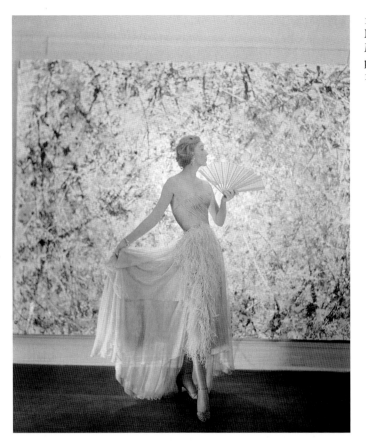

177 Cecil Beaton:
Model in front of
Number 1, 1950,
photograph in *Vogue*,
1 March 1951

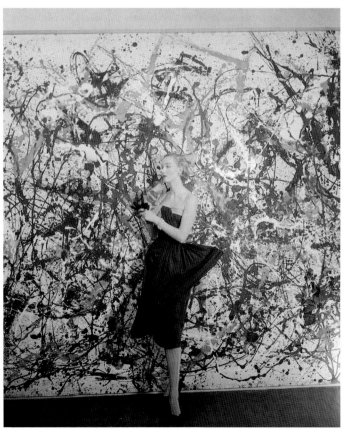

178 Cecil Beaton:
Model in front of
Autumn Rhythm,
photograph in *Vogue*,
1 March 1951

Rhythm behind. And so on. The effects are not subtle, and did not need to be. Hedging his bets just a little, the *Vogue* subeditor informed readers that "the dazzling and curious paintings of Jackson Pollock, which are in the photographs on these four pages, almost always cause an intensity of feelings."

Vogue in the 1940s and 1950s was not to be sniffed at.[7] It sold copies and was on Pollock's side. The magazine had printed a full-color photo of *Reflection of the Big Dipper* as early as April 1948, the first time a drip painting was reproduced in color (beating *Life* with *Cathedral* by a full six months). Financially speaking, early 1951 was not a very good moment for Pollock: he was waiting for his contract with Betty Parsons to expire, and broke with her once it did; nobody seems to have made much money out of the show the previous December – the one Beaton used – and in any case Pollock had a reputation for working the media when he had a chance (Mark Rothko to Barnett Newman in 1946: "Pollock is a self contained and sustained advertising concern"[8]). His tone when he mentioned the *Vogue* event to Alfonso Ossorio in February was matter of fact: "This issue of Vogue has three pages of my painting (with models of course) will send a copy." These things happen. They help a bit. "There is an enormous amount of interest and excitement for modern painting there [he means in the wider America] – it's too damn bad Betty doesn't know how to get at it."[9]

Taken on their own, the *Vogue* photographs are slippery evidence. They are falsely conclusive, like the formal analogies Beaton went in for. I did not quote Rothko to Newman thinking the photographs just proved Rothko's point. Certainly they suggest some of the terms of Pollock's reception in his own time. But the fact that *Vogue* was a fashion magazine does not mean that paintings appearing in its pages were, or became, fashionable. Fashion is a fragile construction, which regularly feeds on its opposites. The opposites often stay much as they were. Beaton in 1951 occupied a particular (lordly) place in the culture industry. His photos were meant to produce a slight intake of breath. And in any case, there is always the option open to us of dismissing the Beaton episode altogether, at least as evidence about Pollock. I remember seeing the model in front of *Autumn Rhythm* for the first time in a lecture, and thinking it made a powerful point, but then afterwards having the comment reported back to me: "So the Pollocks got used as background in a fashion magazine. We all know that by now. So what?"

There is a phrase that sticks in my mind from a similar conversation about the work of Serge Guilbaut – about his book *How New York Stole the Idea of Modern Art* – to the effect that his account of Pollock and Abstract Expressionism amounted in the end to an exercise in "guilt by vague association." For is not any art of real complexity (this is the implication) fated to be used, recruited, and misread? What are we supposed to say, for example, about a photo of Mussolini's shocktroops running in formation through the Arch of Constantine? (This too I saw in a lecture, at much the same moment as the Beaton images, and the comparison struck home.) Are we to put the blame on the Arch, somehow? Pretend that the Fascists got Roman architecture right? (To which the reply might reasonably be, in fact: Are you saying they got it wrong? What, after all, was the Arch of Constantine for?)

None of these questions is open and shut. This chapter, and to an extent the next, are meant as answers to a few of them in Pollock's case – in particular to the baldest, most pugnacious question put to the *Vogue* photos: the "So what? Do they matter?"

Convergence. A first stab at an answer would be this. The photographs matter for much the same reason as the facts of *Marat*'s first showing given in chapter one, or the bits and pieces of evidence assembled about how UNOVIS fared in the streets. That is, they raise the question of Pollock's paintings' public life; and one main hypothesis of this book has been that painting's public life is very far from being extrinsic to it, *ex post facto*. (Of course modernism believes the opposite a lot of the time. But that is because it sees with such clarity what the public life of visual imagery now is, and understandably would like not to be part of it. Better a collectivity of two.)

The *Vogue* photos raise the question, then, of what possible uses Pollock's work could anticipate, what viewers and readers it expected, what spaces it was meant to inhabit; and, above all, the question of how such a structure of expectation can be seen, by us in retrospect, to enter and inform the work itself, determining its idiom. It turns out that once again Mikhail Bakhtin is the best guide we have to such matters – especially the great essay he wrote in the 1930s, called "Discourse in the Novel." That essay can help us think further, I hope, about the problems raised in the Vitebsk chapter about sign-systems and their opening onto the social world.

Any particular utterance, Bakhtin tells us (and I do not think it is forcing things to treat a Pollock painting as an utterance in Bakhtin's sense) "finds the object at which it was directed already as it were overlain with qualifications, open to dispute, charged with value, already enveloped in an obscuring mist – or, on the contrary, by the 'light' of alien words that have already been spoken about it. It is entangled, shot through with shared thoughts, points of view, alien value judgements and accents."[10] ("Entangled" is a good Pollock word. The whole passage could do as description of *Full Fathom Five*.) Not only the object of the utterance – and it goes without saying that Bakhtin constantly plays on the ambiguity of *object* in phrases like this – but the utterance's very material is always "already bespoken."[11] "The word in language is half someone else's," Bakhtin says.[12] "*Word is a two-sided act*."[13] Therefore the so-called "context" of a work of art is not to be conceived as a mere surrounding, separable from form: it is what the speaker or maker has most concretely to work with. Context *is* text: the context is the medium, and therefore the very idea of having and sustaining "one's own word" – an idea basic to Pollock's view of art – is fragile and paradoxical. "*The organizing center of any utterance, of any experience, is not within but outside*."[14] "Discourse lives, as it were, on the boundary between its own context and another, alien context,"[15] which means that any speaker "strives to get a reading on his own word, and on his own conceptual system that determines this word, within the alien conceptual system of the understanding receiver."[16] All utterances anticipate answers – provoking them, eluding them, orienting themselves towards an imagined future in which something is said or done in reply. Works of art for Bakhtin, because they are specially elaborate and pondered cases of utterance, are most of all shot through with such directedness.

The future that works of art envisage, at least in modern circumstances, is very often one of misuse and misunderstanding. We know by now that they may either try to contain and figure this future, in an effort to control it, or attempt instead – as certain of Pollock's do, I think – to annihilate the very ground of misreading, shrug off past and future alike, and have the work turn on some impossible present, thickened to the point where it can dictate its own (unique) terms. "Narrowing and raising it to the expression of an absolute," to take up Greenberg's formulation again, "in which all relativities and contradictions would be either resolved or beside the point." "Retiring from public altogether." Not that Pollock was incapable of pragmatism on this issue, or even

optimism of a kind – at least when writing grant proposals. "The pictures I contemplate painting would constitute a halfway state, and an attempt to point out the direction of the future, without arriving there completely."[17] "Well, yes, they're an impractical size." "I think the possibilities of using painting on glass in modern architecture – in modern construction – terrific."[18]

*V*ortex. A further reason the *Vogue* photographs matter, from my point of view, is because they bring to mind – or stir up in us against our will – the most depressing of all suspicions we might have about modernism as a whole. The bad dream of modernism, I shall call it. I think it is a nightmare modernism has often had about itself, and which may even be the root of its extremism; but when I look about for those able or willing to put the bad dream into words, not surprisingly I land on two members of modernism's official (late) opposition: Manfredo Tafuri and Michel Foucault.[19] For better or worse, I cannot quite bring the suspicions into focus without imagining them spoken by the two of them, the sardonic glumness of one alternating with the other's grim exaltation. But the nightmare itself is commonplace: it goes as follows.

Just as the early twentieth-century vision of utopia comes to seem in retrospect – this is Tafuri speaking – not much more than an idealization of capitalism and its representations – art putting the best face on rationalization, and imagining a world where capital would finally have disposed of the inconvenient "subject" (imagining it mostly with sanctimonious glee) – so too does the modernist exploration of an Other to bourgeois experience – its dream of discovering an "outside," a "before," an opposite or underneath of consciousness – more and more seem part of a general policing of spaces in the culture which previously had been useless, and therefore uncharted, but which capital eventually saw it could profit from, and wanted brought into the realm of representation. By the end of that monstrous sentence, you will have realized, the voice has changed from Tafuri's to something like Foucault's; but in any case the two voices overlap. The bad dream of utopia is only the other face of the bad dream of nameless wildness.

As regards Pollock, it is Foucault's charge that strikes closest to home. Pollock, for sure, had truck with nameless wildness: his art was very often, as Greenberg put it in 1947, one of "Gothic-ness, paranoia and resentment," or "violence, exasperation and stridency." It was "an attempt" – this is Greenberg again – "to cope with urban life; it dwells entirely in the lonely jungle of immediate sensations, impulses and notions, therefore is positivist, concrete."[20] "The work . . . makes one think of Poe and is full of a sadistic and scatological sensibility."[21] No doubt there is a sense in which Foucault would have felt more at home in such a realm of feeling than Greenberg ever did (I shall come to this later), but all the same, he would have had some unforgiving things to say about it. Here is how his argument might have gone.

These impulses in modern art were genuine, and perhaps unavoidable, and it may even be that they added up to "contesting bourgeois hegemony in the realm of consciousness." (This last phrase would not have tripped lightly off Foucault's tongue, but he can nonetheless be imagined using it, especially toward the end of his life.[22]) The point, however, is this. Contesting bourgeois hegemony in the realm of consciousness meant appropriating sets of representations which were already there in the culture, but which until then (until 1907, say) had been thought of as primitive, childish, or deviant – lunatic, chaotic, otherwise beneath contempt. And in a sense they *were*, they are. "Bourgeois hegemony" may be a tired catchphrase by now, but it is not an empty one: it describes a complex mapping and extension of experience over the

centuries, from at least 1500 onward; and all that the hegemony left outside itself (by 1907) was the dislocated, the inarticulate, the outdated, the lacking in history, the solipsistic, the *informe*. These areas have provided art with good raw material; but they are no kind of basis for conflict with, or criticism of, the bourgeoisie, which possesses descriptions and practices far and away more powerful, because more differentiated, than anything modernism can come up with. Not much of the world is reflected in a gob of spit, or upset by the sight of a toenail in close-up (fig. 179).

179 Jacques-André Boiffard: *Gros Orteil*, photograph, 1929 (Musée National d'Art Moderne, Paris)

True, this search for the outside of bourgeois consciousness has sometimes gone hand in hand with an immanent critique of particular forms of representation, and been effective in a limited way. As a depiction *of* illusionism, or of illusionism without a "world" to represent, Cubism is poignant and devastating. (Even the photos of toenails, taken by the Surrealist Jacques-André Boiffard in 1929, are wonderful as comments on, or instances of, "close-up" and "close-upness," considered as phenomena which a new machinery of representation could now propose – truly or falsely – as possible dimensions of experience.) But insofar as this "outside" has been posited and organized as a new territory on which representation could take place, in ways never seen before – a territory with its own rich sources of supply – what resulted was to the bourgeoisie's advantage rather than otherwise.

On the one hand, for example, there was primitivism: which is to say, a largely parasitic and second-rate imitation of objects from the colonies, by artists who lacked the skills to do the job of imitation properly, not having so much as the beginnings of an understanding of what was being imitated – not

thinking such an understanding necessary. On the other (and here we steer back to Pollock and *Vogue*), there was what looks in retrospect to have been a kind of cultural softening-up process going on: art preparing the ground for the real, ruthless incorporation of marginal and underdeveloped states, which was to be effected, in the end, by the central organs of bourgeois culture itself. For what became of *Völkischness*, finally? Who made best use of the forms art provided for celebrating the irrational? In whose interests was atavism? (Boiffard, who started as a medical student in the 1920s, and then joined the Surrealists and the Communist Party, went back to full-time radiology in 1936. My guess is he stayed a Party member through thick and thin. Like many another avant-gardist, he came to believe the times needed cures, not monstrosities. Of course I am not saying the cure he chose was the right one.)

Birds of Paradise. This is the bad dream of modernism, as I say: that however urgent the impulse had been to recast aesthetic practice and move out into uncolonized areas of experience, all that resulted from a century's activity was a thickening – a stiffening – of the same old aesthetic mix. I take this to be Pollock's own suspicion of his work – a bad dream he had, built into his practice. I shall give my reasons for thinking so in what follows. But for the moment, let me look again at the Beaton photographs, and try to approximate Foucault's verdict on them.

What else, he might say, did modernism expect from the public realm? What else did it think art was for? What Pollock invented from 1947 to 1950 was a repertoire of forms in which previously marginalized aspects of self-representation – the wordless, the somatic, the wild, the self-risking, the spontaneous, the uncontrolled, the "existential," the beyond or before our conscious activities of mind – could achieve a bit of clarity, and get themselves a relatively stable set of signifiers. A poured line with splatters now equaled spontaneity, etc. A certain kind of painted interlace now could be taken to stand – taken quite casually – for "sustained paroxysms of passion" (1956), or "ravaging aggressive virility" (1949)[23]; another "suggests the fluids of life, intermingling, expanding and undergoing gradual chemical change" (1952)[24]; it "has an ecstatic, irritable, demanding force" (1959)[25]; it "is done in great, open black rhythms that dance in disturbing degrees of intensity, ecstatically energizing the powerful image in an almost hypnotic way" (1950)[26]; and so on. "Jackson Pollock is a painter who has freed himself from those hindering restrictions which keep one from coming to grips with the world which is called unknowable" (1951).[27] "For Pollock the acceptance of freedom, the striving for fluidity, is and has been the supreme discipline" (1955).[28] He "could paint ecstasy as it could not be written."[29]

What do these readings of Pollock add up to? It seems as if there are aspects of experience – and you will notice that the family resemblances between them are strong – that the culture quite urgently (and to a degree, quite suddenly) wants represented, perhaps because it sees it can make use of them; because its organizing powers have come to need a more convincing account of the bodily, the sensual, the liberated, in order to extend – maybe to perfect – their colonization of everyday life. Of course the *Vogue* photographs give that process of recuperation a somewhat glib, superficial form: we think we can condescend to the models' outdatedness: fashions change, art endures. But the process these photos glamorize is not glamorous, and not incidental: it is one that the practice of modernism knows lies in wait for it, and may prove its truth. That fact or fear is internalized by modernism and built into its operations: it is part, perhaps

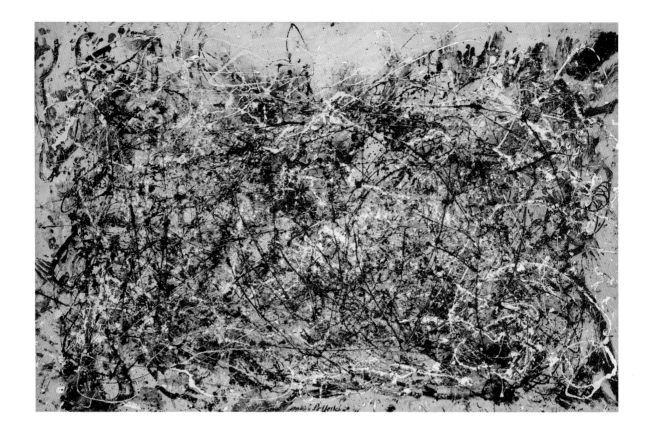

even cause, of modern painting's way with its medium. It is certainly part of Pollock's way with his.

180 Jackson Pollock: *Number 1, 1948*, oil on canvas, 172.7 × 264.2, 1948 (The Museum of Modern Art, New York. Purchase)

Moby-Dick. I realize that the last flurry of assertions does not necessarily follow from the account of modern art I have outlined, and that for present purposes it is the last assertion of all – the one about Pollock – that most needs arguing. This is what the rest of the chapter tries to do. It lays out the reasons for my thinking the previous pages the right frame of reference in Pollock's case.

The tests are the same as with Cubism. What I am looking for are ways to describe Pollock's achievement convincingly, particularly in the three years after 1947. How would a picture like *Number 1, 1948* (fig. 180), for example, have been scanned and adjudged by its maker? What sense would Pollock have had of its purposes? "All cultures," he said to an interviewer at the time, "have had means and techniques of expressing their immediate aims . . . The result is the thing . . . It doesn't make much difference how the paint is put on as long as something has been said."[30] Obviously the "something" in this case will be hard to put into words. Getting at it even approximately will involve a fair amount of overlay and overstatement, repetition, monotony, big pronouncements followed by long-winded qualifications, backtracking, mess: all of it unavoidable, I think, given the subject – "that wild whaling life," to quote one of Pollock's sacred texts, "where individual notabilities make up all totalities."[31]

But this immediately has too much the flavor of an excuse, and not even strictly the right one. For the roundabout character of my descriptions does not derive so much from Pollock's paintings' wild uniqueness as from their ordinary

(strictly representative) distance from the world they were part of. Abstract painting intended to set the world aside. And therefore it truly is difficult to think at all of *Number 1, 1948* as belonging to a social body; beyond, that is, the brute fact of its being produced at such and such a time by such and such a member of the petty bourgeoisie. I think this difficulty ought to be admitted, and made the motor of the argument.

Number 1, 1948 wants to efface the "social" in itself: which is not to say that it succeeds in doing so, or even (in my view) that such a project makes sense: but that the social will be found here, if it is found, very thoroughly "absorb[ed] into the work by implication or articulation."[32] Nobody wants to write a history of Pollock's painting which works by vague association, whether the links end up proving the artist guilty or innocent of his class. Nobody wants the social history of art to be, in Hegel's words in the *Phenomenology of Spirit*, "an external activity – the wiping-off of some drops of rain or specks of dust from the [artistic] fruit, so to speak – one which erects an intricate scaffolding of the dead elements of their outward existence – the language, the historical circumstances, and so on."[33] But to do more than this is difficult, especially with fruit like Pollock's. "Collective actions, ritual gestures, paradigms of relationship, and shared images of authority" – this is a critic writing about *King Lear* – "penetrate the work of art and shape it from within."[34] Perhaps they do. Some such assumption informs what follows. But the fact that immediately in Pollock's case we would have to negate all the great social positives that give *King Lear* its form: put "modes of privacy and privation" in place of collectivity, and histrionics in place of ritual; put "non-" in front of "relationship"; delete "shared images of authority" altogether: and all this in face of the culture's continuing, insatiable appetite for value of *some* kind, for imagery of some sort, for the faint trace of authority somewhere – these things should suggest what the social will look like in modernism, if and when it is unearthed.

Number 1, 1948. The painting is 5 feet 8 inches high and 8 feet 8 inches wide. Rounding the corner of the gallery and catching sight of it, I am struck again by the counter-intuitive use it makes of these dimensions. To me it always looks small. Partly this is because it hangs in the same room as *One: Number 31, 1950* (fig. 181), which measures 8 feet 10 by 17 feet 6. But this comparison is anyway the right one. The canvases Pollock did in 1950 – the 15 and 17 footers – define what bigness is, in this kind of painting. And it is not a matter of sheer size. *Lavender Mist* (fig. 182) is only a foot or so longer than *Number 1, 1948*. *Number 1, 1949* (fig. 183) is the same length and not quite as high. But I should call both of them big pictures, because what happens within them reaches out toward a scale and velocity that truly leaves the world of bodies behind.

Not so *Number 1, 1948*. It looks as wide as one person's far-flung (maybe flailing) reach. The handprints at top left and right of the picture – a dozen in black, a fainter four or five in blood-brown – are marks which seem made all from one implied center, reaching out as far as a body can go. (I am describing the way they look in the finished picture, not their actual means of production.) The picture is fragile. Tinsel-thin. A hedge of thorns. A gray and mauve jewel case, spotted with orange-red and yellow stones. The clouds of aluminum and the touches of pink toward bottom left only confirm the essential brittleness of the whole thing – the feeling of its black and white lines being thin, hard, friable, dry, each of them stretched to breaking point. They are at the opposite end of the spectrum of markmaking from *One*'s easy, spreading trails. *Number 1, 1948* is a *thrown* painting. One can imagine many of its lines hurled at speed as far

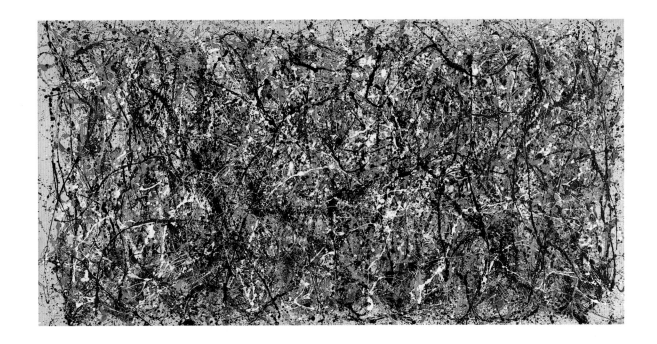

as possible from their points of origin. *One*, by contrast, is more poured than thrown, and more splashed (rained) than poured. Spotted. Sprayed. Which does not mean that its surface looks straightforwardly liquid. Finding words for the contradictory qualities of Pollock's surfaces is, you see already, a tortuous business.

Number 1, 1948 is thrown. Therefore it is flat, with lines hurtling across the picture surface as if across a paper-thin firmament. *Shooting Stars. Comets.* Once again, as with Malevich, the high moment of modernism comes when the physical limits of painting are subsumed in a wild metaphysical dance. The Manheims' titles are wonderful on this. And I think the verdict applies even to those aspects of the picture that aim to rub our noses in physicality. For instance, the handprints (fig. 184).

Commentators have argued that one thing the handprints do is make the resistant two dimensions of the canvas come to life again. They show flatness actually occurring – here, here, and here in the picture, at this and this moment. I am sure that is right. But anyone who does not go on to say that there is a histrionic quality to the here and now in this case is not looking at the same picture as I am. Pollock was quite capable of putting on handprints matter-of-factly when he wanted. The ones at the left-hand side of *Lavender Mist*, for example, are as gentle and positive – as truly repetitive – as handprints can be. They climb the edge of the picture like a ladder. Everything about the prints in *Number 1, 1948*, by contrast – their placement in relation to the web of lines and the picture's top, their shifting emphasis and color, their overlapping, the way they tilt to either side of uprightness, the rise and fall of the row they make – is pure pathos, and presumably meant to be. The tawdriest Harold-Rosenberg-type account will do here. Because part of Pollock *is* tawdry. (It is just that Rosenberg could not see any other part.)

The same goes for flatness conceived as a characteristic of the whole criss-cross of lines. There is no *ipso facto* reason why a web of lines should be, or look, flat. Often in Pollock it does not. But in *Number 1, 1948* flatness is the main thing. Even more than the handprints, this overall quality is what gives the picture its tragic cast. And in a sense, there is no mystery to how the quality is

181 Jackson Pollock: *One: Number 31, 1950*, oil and enamel on canvas, 268.8 × 530.5, 1950 (The Museum of Modern Art, New York. Sidney and Harriet Janis Collection Fund [by exchange])

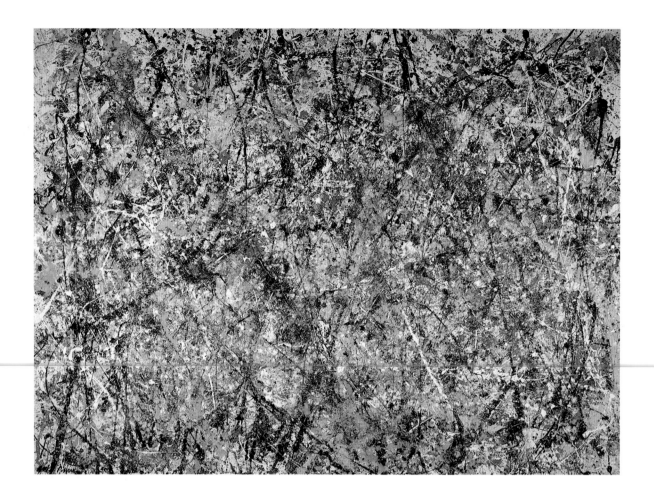

182 Jackson Pollock: *Lavender Mist*, oil, aluminum, and enamel on canvas, 221 × 299.7, 1950 (National Gallery of Art, Washington, D.C., Ailsa Mellon Bruce Fund)

achieved. It is a matter of manufacture. This particular web is built on a pattern of rope-like (literally string-thick) horizontal throws of white, seemingly the first things to be put down; most of them overlain by subsequent throws of black, aluminum and so on; but thick enough that they emblematize the physical resting of the paint on a surface just below – a surface wrinkling and flexing into shallow knots, like tendons or muscles under a thin skin. All of Pollock's more elaborate drip paintings are built in layers, of course. But this quality of the final surface's being stretched over a harder, spikier skeleton is specific to *Number 1, 1948*. The layers of *One*, by comparison, are deeply interfused, and do not look to be on top of the canvas surface so much as soaked into its warp and woof. Even *Number 1, 1949*, which may look superficially similar to its 1948 partner, is built essentially out of a top layer of flourishes which push the darker under-layers back into space. The aluminum in *Number 1, 1948* has no such illusory power.

All this, as I say, is unmysterious. It can be described in technical terms. But compare what happens along the painting's top edge. No viewer has ever been able to resist the suggestion that here is where the picture divulges its secrets, literal and metaphorical. Here is where the thicket of line adheres to the canvas surface – becomes consubstantial with it. And though the handprints tend to be what commentators talk about, they are only part of the effect: they are not what does the adhering: they are one kind of mark among others, less important than the transverse jets of white, and the final loops of white and black, which somehow – improbably, in spite of their wild spiraling back into space – make

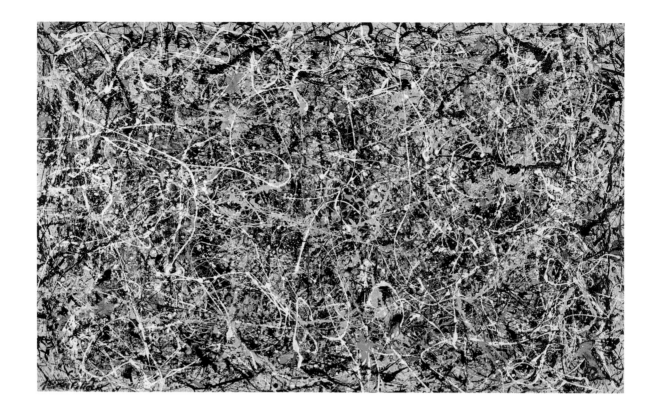

the thicket flatten and thin out, become papery-insubstantial, and therefore (by some logic I cannot get straight) part of the rectangle.

I cannot get the logic straight because obviously the marks at the top do not pay any literal, formal obeisance to the canvas edge. They meet it, as critics have always said, in a devil-may-care kind of way. (Compare the delicate, essentially circumspect dance along the top of *One*.) And yet everything they do is done in relation to the final limit.[35] The central black whiplash with its gorgeous bleep of red, and the final black spot to the right of it, seal the belonging of everything to the easel-size and easel-shape. I do not understand why these – of all shapes and velocities – do this kind of work. Still less why the incident should strike me, as it does each time I see it, as condensing the whole possibility of painting at a certain moment into three or four thrown marks.

The Magic Mirror. So here I come clean. You will gather I think *Number 1, 1948* is a great painting, which pushes our understanding to the limit. If I had to choose a moment of modernism in which the forms and limits of depiction were laid out most completely – most poignantly – in ways that spoke to an age, or created one, this would be it. If I am asked what I ultimately mean by modernism and contingency, for example, I shall point in *Number 1, 1948*'s direction.

These are banal opinions, I know. I only offer them here because in my view an account of Pollock would hardly matter, or be worth doing, if the opinions were not mine. And also because, even if they are banal, they came to me slowly. They do not tally in any obvious way with other (equally banal) opinions I have about politics, realism, modernity, capitalism, and so forth. Therefore, though I was interested in Pollock almost as soon as I was interested in painting, for a long time I did not know what to make of the interest. I did not know how

183 Jackson Pollock: *Number 1, 1949*, enamel and aluminum on canvas, 160 × 259, 1949 (The Museum of Contemporary Art, Los Angeles. The Rita and Taft Schreiber Collection)

coming to see these paintings as epitomizing our and their time would end up affecting how I saw the *time*. So I did not, for many years, come to see them, period. Of course all this is my verdict in hindsight. And I hate its confessional tone. But unless I make plain what I think is involved in having modernism turn on this painting in particular, then the book as a whole will stay out of focus.

Let me put it this way. *Number 1, 1948* is the painting of Pollock's I would choose over any other – even over the majesty of *One* – *because* of its smallness and brittleness; or because "small" and "brittle" occur as possible descriptions of it, alongside, say, Greenberg's "huge baroque scrawl in aluminum, black, white, madder, and blue."[36] That is, I think *Number 1, 1948* contains contraries within itself, in a way that *One* does not. Especially the contraries "Nature" and "anti-Nature" – skeleton and script, thicket and palimpsest, depiction and inscription, infinity and confinement, entanglement and paper-thinness. I am not saying that these contraries are simply no longer part of *One*'s conceptual universe. (I shall come back to the difference between Pollock's painting in 1948 and 1950 later on.) Nor do I want a criticism that posits contained contrariness *as* aesthetic quality. Though I agree with Longinus that some such push-and-pull is what most effectively generates passion in art. ("Homer forces and compels into unnatural union prepositions which are not easily joined together when he says '*from under* death.' He has tortured his line into conformity with the impending disaster . . . and almost stamps upon the words the very shape of the peril: 'they are carried from under death'."[37]) And passion, for modernism, is what art is ultimately made of. Of course modernism has many modes. I admire its coldness and craftsmanship as well as its pathos. But pathos is its deepest note, I think. That applies to Malevich and Picasso every bit as much as to Pollock.

O*ut of the Web.* "He has tortured his line into conformity with the impending disaster." There may be a deep connection, that is, between modern art's cult of pathos – meaning "the quality in speech, writing, music, or artistic representation which excites a feeling of pity or sadness" – and its continual emptying and forcing of medium. Writers on modernism have often thought so. But there is another side to the matter, which sets limits to the forcing. Pathos is a mood or condition that cannot tolerate outright negativity. It does not go in for pessimism of strength. In its heart of hearts, modernism is touchingly honest about its own petty-bourgeois will to power. It knows it can never attain to William of Aquitaine's atony. It fools itself if it tries (viz. Marcel Duchamp, who fooled others).

If there is to be a positive moment to an account of Pollock's abstraction, then – and you see that I think there must be – again it is suggested by Bakhtin's "Discourse in the Novel." I have in mind those moments in the essay (they are sometimes seen as weaknesses) when Bakhtin reflects not just on the otherness of language – its being always "already bespoken," its being "populated . . . with the intentions of others"[38] – but on the possibility, nonetheless, of some form of dialectical retrieval of the word by the speaker. For the word, in Bakhtin's view, is very much more than an entity possessed at random by individual monads, each wishing to make a way of speaking their own private property. "Discourse lives, as it were, beyond itself, in a living impulse [*napravlennost*] toward the object";[39] and it is in relation to this overall movement of construction – this continual opening of discourse toward its objects, this effort to tie word to world, this wish for agreement and grounding – that the possibility of truth arises. "The speaker breaks through the alien conceptual horizon of the listener, constructs his own utterance on alien territory, against

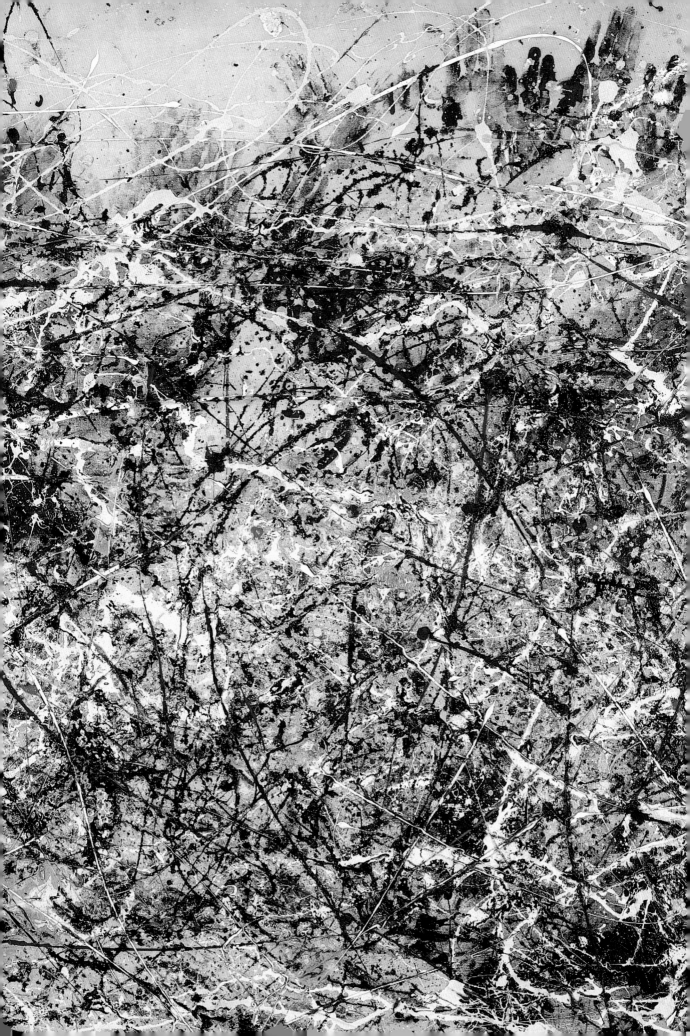

his, the listener's, apperceptive background."[40] Which possibility – of a dialogue other than of the deaf – seems connected in Bakhtin's way of thinking to yet another, more uncompromising, image of movement beyond and toward: "The word, breaking through to its own meaning and its own expression across an environment full of alien words and variously evaluating accents, harmonizing with some of the elements in this environment and striking a dissonance with others, is able, in this dialogized process, to shape its own stylistic profile and tone."[41] Put "sign" or "mark" or "metaphor" in place of "word" in this sentence, and I think you have a good image – good because convoluted – of Pollock's utopia.

Echo. Matters of vocabulary first. If what we want is to reconstruct Pollock's intentions in a painting like *Number 1, 1948*, are there words and phrases we could put in Pollock's mouth, without thinking we were forcing things – beyond the unavoidable forcing that follows from making the man talk at all, when mostly he preferred not to?

How far, for example, do the terms of Pollock's best and closest critic at the time, Clement Greenberg, still prove of help? The question comes up not simply because of the cogency and force of Greenberg's writing, but also because of evidence we have of some real closeness between the two men – difficult closeness, it looks like, no doubt a bit wary and ironic, but all the same operative, in ways other people recognized and even resented. "You must understand," writes William Baziotes to his brother in March 1947, "Clem Greenberg boosts Pollock and considers me in a slump."[42] "Dear Clem," writes Peggy Guggenheim in December, "I am so happy you are carrying on the battle of Pollock."[43] It is a figure of Pollock journalism all through the later 1940s that certain unnamed arbiters of taste (people with strong critical opinions are always "arbiters of taste") have already decreed that Pollock's is the great American painting the world has been waiting for: so that Douglas MacAgy in the *Magazine of Art* for March 1949, for example, writing in general terms of the divorce between painters and writers, can first of all describe what he sees as the typical state of affairs – that "only a few [American painters] have found the company of American writers congenial" – and then run on quite confidently, as if his audience will know what he means, to two significant exceptions, Thomas Hart Benton and the critic Thomas Craven, and Greenberg and Pollock: "Clement Greenberg's espousal of Jackson Pollock's work must have been useful to that artist."[44] A lot of MacAgy's readers would have put it with more of a snarl.

The relation between Greenberg and Pollock is all the more interesting because it was so clearly not, at the level of basic aesthetic preferences and commitments, an easy one. Pollock was doing the best painting in America, Greenberg thought, but a lot of the time he wondered how. All of the qualities he rightly found in Pollock's painting in 1946 and 1947 – the "Gothic-ness, paranoia and resentment," the "morbid" atmosphere, the wish to be "wild and extravagant," the "pretentious" American "exasperation and stridency," the constant whiff of Poe and Sade[45] – all these are the opposite of what Greenberg considered the real strengths of the modern tradition, and what he hoped might happen next "in this country, the development of a bland, large, balanced, Apollonian art in which passion does not fill in the gaps left by the faulty or omitted application of theory but takes off from where the most advanced theory stops, and in which an intense detachment informs all."[46] The proof of the pudding, though, was in the eating. Pollock was a great painter: the inessential, boring qualities worked for him – even those Greenberg despised

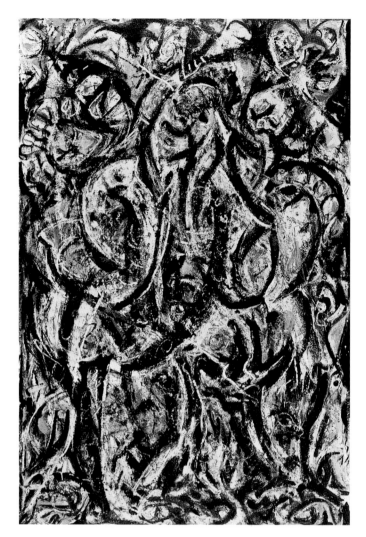

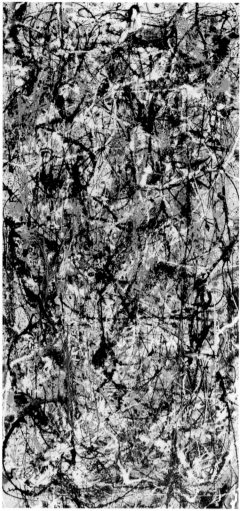

most. "Gothic-ness," for example, in Greenberg's lexicon, was a code word for Surrealism, than which art could sink no lower. "Surrealism has revived all the Gothic revivals," he wrote in 1944, "and acquires more and more of a period flavor, going in for Faustian lore, old-fashioned and flamboyant interiors, alchemistic mythology, and whatever else are held to be the excesses in taste of the past."[47] What price Pollock's *High Priestess* and *Mad Moon-Woman*, or, come to that, his *Alchemy* and *Lucifer*?

I cannot help wondering if, when Pollock titled a 1944 picture *Gothic* (fig. 185), he did not mean partly to provoke his new ally, or at least to make clear he was not going to be browbeaten by him. (He knew Greenberg liked the picture very much.) So that when he chose to include *Gothic* in his first show of the drip paintings four years later, the decision likewise seems loaded to me. *Gothic* was still there under *Cathedral*'s aluminum deadpan (fig. 186). Almost literally there – its forms still detectable – under the Faustian fireworks of *Galaxy* (fig. 187), the picture in which the drip technique was launched.[48] And did not an intense detachment paradoxically inform all three?

Does it come down, then, to no more than the fact of recognition and support on Greenberg's part, at a time when Pollock needed them? And to hell with shared points of reference? In which case we could give up looking at Greenberg's writing altogether, at least for our present purposes.

185 (*above left*) Jackson Pollock: *Gothic*, oil and enamel on canvas, 214.8 × 142.2, 1944 (The Museum of Modern Art, New York. Bequest of Lee Krasner)

186 (*above right*) Jackson Pollock: *Cathedral*, enamel and aluminum on canvas, 181.6 × 89, 1947 (Dallas Museum of Art, Gift of Mr. and Mrs. Bernard J. Reis)

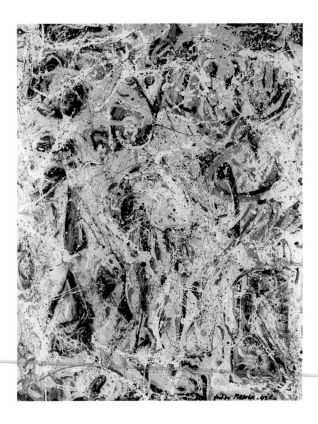

187 Jackson Pollock: *Galaxy*, oil and aluminum on canvas, 110.4 × 86.3, 1947 (Joslyn Art Museum, Omaha. Gift of Miss Peggy Guggenheim)

I do not think so. It is clear, for example, from various things Pollock said, that he subscribed to a fairly straightforward notion of the cause of a work of art's quality. He would have agreed with Greenberg in 1946 – this is the critic working up to declaring Pollock's grisly puppet-show *Two* (fig. 188) the only major picture in the Whitney Annual that December – that "Everybody knows what has *already* made painting great. But very few know, feel, or suspect what makes painting great anywhere and at any time – that it is necessary to register what the artist makes of himself and his experience in the world, not merely to record his intentions, foibles and predilections."[49] In its very simplicity, this seems to tally with Pollock's view of what was at stake. (Again, it is interesting that Greenberg recognizes *Two* meets the test. Its sadism could hardly be writ larger.) Equally, it seems to me that Pollock would have understood – and in large measure responded to – the accompanying stress in Greenberg's criticism, on painting as a form of positivism, and modernism as materialist deep down. Greenberg is at his most eloquent in the 1940s when he tries to explain to America that what had made French painting miraculous for a century was its willingness to dwell in the world of immediate sensations. Why could not Americans do the same? And why, when they did, was their view of that world always as a lonely jungle? Why did they populate it with *Two*? Had they not looked at *Luncheon of the Boating Party* or *A Burial at Ornans*?

Direction. It may even be that this was a stress that came to mean more to Pollock as the 1940s wore on, and was part of the reason his painting changed. For *Luncheon of the Boating Party*, read *Eyes in the Heat* (fig. 189). Certainly I think Pollock would have sympathized, reading the long comparison between himself and Jean Dubuffet which Greenberg mounted in February 1947 – in the end the comparison is to Pollock's advantage, but a lot of time is

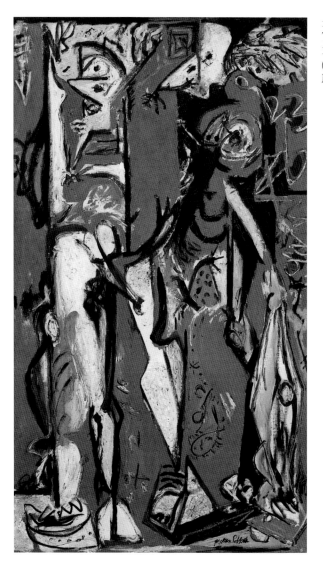

188 Jackson Pollock: *Two*, oil on canvas, 193 × 110, ca. 1945 (Solomon R. Guggenheim Museum, New York)

spent insisting on what the two painters shared – with this sort of cutting and slashing: "Where the Americans mean mysticism, Dubuffet means matter, material, sensation, the all too empirical and material world – and the refusal to be taken in by anything coming from outside it. Dubuffet's monochrome means a state of mind, not a secret insight into the absolute; his positivism accounts for the superior largeness of his art."[50] (By "the Americans" here Greenberg meant Rothko, Newman, and Adolph Gottlieb, specifically, but for him they were only the latest in a line of tent preachers anathematizing the flesh. How he must have loved Pollock's gorgeous *Earth Worms*, done just at this moment, or his fragile *Tea Cup* from a few months before! They were more like Bonnard than Max Ernst.)

In other words, I believe that Pollock in some sense responded to the pressure of Greenberg's argument: not, of course, because it was a good one (though it was), but because it framed a real set of tensions inherent in Pollock's practice – it saw where Pollock was going. "Unless American art reconciles itself," here is the argument in a nutshell, put to *Les Temps modernes* in summer 1946, "with that minimum of positivism on which rests, in my view, the continuity and force of modern art in France, unless we integrate our poetry into our art's

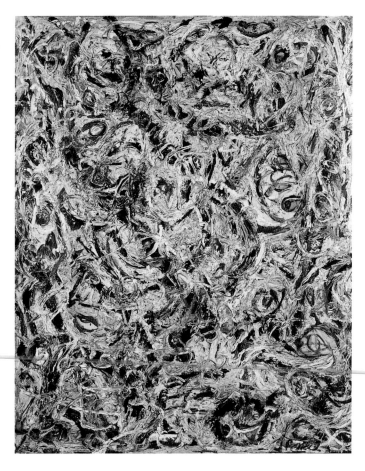

189 Jackson Pollock: *Eyes in the Heat*, oil on canvas, 137 × 109, 1946 (Peggy Guggenheim Collection, Venice)

immediate physical dimensions," Americans will go on producing limited, fitful, discontinuous work. All this in spite of the fact, which Greenberg acknowledges once again, even to his Paris readers, that Gothic-ness has been and is "at the root of most of the best works of American literature and painting."[51] That last was a real proviso. Quality was what ultimately counted, in Greenberg's view, not sanity. He was notably unable or unwilling, a year later, to celebrate the mode of *Earth Worms* and *Eyes in the Heat* by talking directly to any one picture. And when he wrote about the first show of drip paintings in January 1948, he admitted he had doubts. The poetry of *Two* may have been silly or horrible or both, but it had been poetry. The sexual tearing and touching was what "integrated the poetry into the art's immediate physical dimensions." The more powerfully, the more preposterous the nightmare.

"Jackson Pollock shows a rather unsatisfactory painting," this is Greenberg responding to his first sight of *Galaxy* in January, "in which white lines are so evenly laid out on an aluminum-paint ground that all intensity is dissipated and the picture becomes merely a fragment."[52] "Pollock's mood has become more cheerful these past two years, if the general higher key of his color can be taken as a criterion."[53] Of course Greenberg approves. But approval and aesthetic judgement are two different things. Intensity may have dissipated. Only time would tell.

Sea Change. I think that Pollock in 1947 was in much the same two minds. Maybe for a moment he thought his new way of painting had solved the

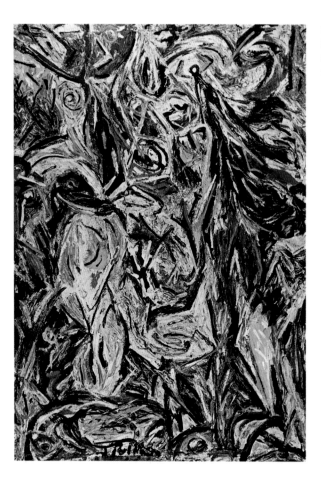

problem of the previous four years: there is an elation to the 1947 titles, and a richness to his first dripped surfaces, that suggest as much. Not that the titles are cheery. There is a *Lucifer* for every *Cathedral*, a *Vortex* for every *Prism*. In Pollock's art there always would be. But surely the nature of Pollock's problem as an artist was going to be clarified – in a sense exacerbated – by having it hinge on technique. That seems to me the mood (the wager) of the fall.

What was Pollock's art to be – here is the question that had haunted Greenberg's criticism since the great pictures of 1943 – if *not* "Gothic, morbid and extreme"?[54] Perhaps it was true that an imagery of rage had proved itself unworkable in the end, the picture space stuffed to the point of ludicrousness with shrieking, plangent bits and pieces of emotion, each buttonholing the viewer and talking at once. What painter would not retreat from *Something of the Past* (fig. 190)? (This painting, by the way, was in the show Greenberg preferred to Dubuffet's in 1947.) Some kind of balance had now to be struck – struck in the act of painting as opposed to the imagery, struck by the picture's positivity, its tempo and handling – between nameless wildness and the "high impassiveness of true modern style."[55] Some kind of balance. One struck by the painter of *Something of the Past*. I do not believe, in other words, that Pollock envisaged his new way of doing things – getting paint on canvas, I mean – as simply putting an end to the previous exasperation and stridency. For these qualities were, as Greenberg knew, what "the artist made of himself and his experience in the world." Without them Pollock's art would most likely decline to a record of "his intentions, foibles and predilections."

Guardians of the Secret. I shall take it for granted that most of us approximately know (or think we do) how the drip paintings were done. And the things we do not understand about the process – how many sessions went into a painting like *Number 1, 1948*? were there many paintings Pollock did at one fell swoop and never returned to? how long were pictures left hanging round the studio, in some kind of unfinished state, or while Pollock decided if they *were* unfinished? what proportion of pictures got discarded? – these questions never will get answered now, though there are things in Hans Namuth's or Lee Krasner's testimony that give hints of answers.[56]

Nor do I think the reticence of privileged witnesses means they were holding out on us. The process was partly a secret at the time, for all Pollock's release of fragments of information about it as part of his "self contained and sustained advertising concern." Some of the key questions do not seem to have occurred to Pollock's first onlookers, and cannot be decided in retrospect. Occasionally witnesses agree about the non-obvious. Greenberg at the time described Pollock's movements while painting as "often very careful and deliberate."[57] Herbert Matter used the words "harmonious and quiet." "He would do things, and then looked, and then he went to the other side and looked again and did a few more things. It was never fanatical."[58] Certainly less fanatical than the looking and doing one imagines going into *Something of the Past*. "He wanted to get a different edge," Greenberg was fond of saying. "A brush stroke can have a cutting edge that goes deep into space when you don't want it to."[59] Sure. A brush in Pollock's hands was always potentially a knife.

Hard evidence, then, is less plentiful than it might seem. In any case, the questions that most need asking of the drip technique are interpretative. What was it that Pollock's new way of painting allowed, aesthetically, and what did it disallow? "Technique is just a means of arriving at a statement."[60] There are at least two aspects to the problem here, which I should like to keep partly (only partly) separate: issues to do with Pollock's physical procedure, on the one hand, and issues of perception and judgement, on the other.

In the first place, as has often been pointed out, the new technique disqualified certain kinds of painterly habit and know-how, or made them difficult to mobilize: it put the painter literally out of reach of his skills, his "touch." Though even here one should not exaggerate. Photographs taken in the studio, like those of Pollock in 1947 with *Alchemy* on the floor (fig. 191), seem to posit a degree of intimacy between painter and canvas which is still redolent of the handmade. Pollock is kneeling. One photo has him leaning across *Alchemy* to put on what is supposed to be a finishing touch or two with his fingers. All of this was staged, no doubt – *Alchemy*, as far as I can tell, was already finished when the photographer arrived – but it is the kind of staging that Pollock thought appropriate which is interesting. (There is a later photo by Arnold Newman which has Pollock again kneeling over a three-foot-square canvas – I cannot identify which picture, if it survived at all – and putting on paint with his hand from a small pot. Many so-called drip paintings look to have been done in similar fashion. I do not think, for example, that much of *Full Fathom Five* was poured. Squeezed, maybe, and pushed and smudged. It is basically a hands-on impasto painting, done in deep greens and so forth, with filigree pouring introduced on top, at the last minute, to pull some space out of the murk.)

Nonetheless, distance counted. Part of the time, throwing and pouring, Pollock was no longer at arm's length. This was important because in previous years Pollock had developed into a monstrously skillful arm's-length painter. Maybe too skillful for his own good. One critic in 1946 had quoted Arthur B. Carles against Pollock – a remark Carles was supposed to have made when asked why he did not do more watercolors – "They terrify me ... they get

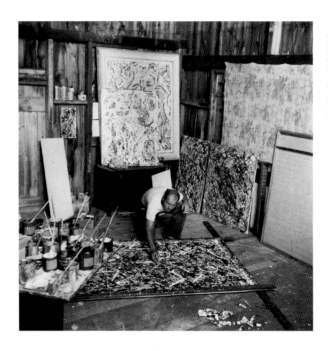

191 Wilfred Zogbaum:
Pollock in his studio,
photograph, ca. 1947
(Jackson Pollock Papers,
Archives of American
Art, Smithsonian
Institution)

beautiful so quick." Pollock suffered, so the critic thought, from the same
"ability to achieve surface virtuosity."[61] This was not altogether a cheap shot, at
least by comparison with most of the criticism Pollock received at the time; or
rather, cheap or not, it may well have chimed in with some of Pollock's own
doubts – and Clement Greenberg's. "Emotion that demands singular, original
expression tends to be censored out by a really great facility, for facility has a
stubbornness of its own and is loath to abandon easy satisfactions": this is
Greenberg on de Kooning in 1948.[62] It is as much a leitmotif of his criticism in
the 1940s as the songs of praise to French positivism. And as usual, his thinking
on the matter is complicated. It is no good simply suppressing facility, he says
– that is de Kooning's mistake. Trying for a rhetoric of awkwardness and
naivety regularly ends by producing "indeterminateness or ambiguity" in a
picture, of the sort bad modernism specializes in. For skill, says Greenberg, is
connected to qualities painting desperately needs, like will and clarity. A painter
has to get into an area where skills are reinvented because the purposes of
picture-making are seen in a new light. "This demands a considerable exertion
of the will in a different context and a heightening of consciousness so that the
artist will know when he is being truly spontaneous and when he is working
only mechanically." Obviously Pollock is meant here as much as de Kooning.
He is mentioned by name in the review's next paragraph.

So Pollock's method was partly prophylactic. It did not let him lean on his
previous ways of multiplying hard edges and working up the "thick, fuliginous
flatness"[63] that Greenberg and others had fallen for. More than this, it interfered
with Pollock's whole way of looking at the pictures he was making while they
were being made, and upset most of the habits of scanning and understanding
he had acquired from twenty years at the easel. Standing or crouching over the
canvas, coming at it from all four sides, dribbling paint through his fingers or
shooting it from a turkey baster, moving from oil to aluminum to enamel to
encaustic – the battery of new techniques set Pollock at a distance from his own
sense of the aesthetic, and made it hard again to decide when the work had
reached a proper "state of order" and "organic intensity." (The two phrases
crop up in a handwritten poem-manifesto of 1950.[64] They are Pollock's key
terms of aesthetic judgement, I think.)

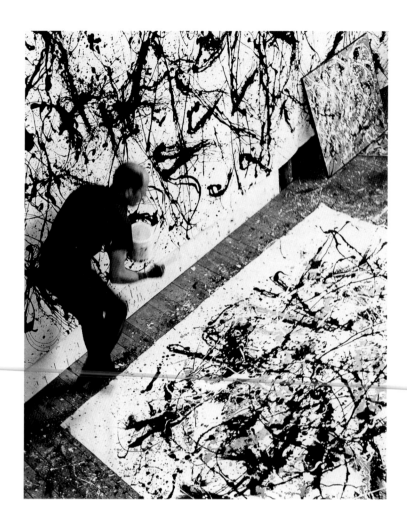

Mural. Pollock protested in his lifetime against a tendency to exaggerate the novelty of his method. "I paint on the floor and this isn't unusual – the Orientals did that."[65] But nobody who has looked at a Hans Namuth photograph (fig. 192) can escape the feeling that something strange and unprecedented is taking place. Technique is at war with control and assessment. Maybe the hostilities will give rise to that "heightening of consciousness [in which] the artist will know when he is being truly spontaneous and when he is working only mechanically." But why did it take this degree of de-skilling for the distinction to be clear?

Making an abstract painting at all, in Pollock's case, for some reason involved making it this way. The stakes are high, then. If we could understand Pollock's actual, technical way of doing things from 1947 to 1950, then surely we should get into focus what he thought the non-figurative was for. Or so the commentators hope. "I try to stay away from any recognizable image; if it creeps in, I try to do away with it . . . to let the painting come through. I don't let the image carry the painting . . . It's extra cargo – and unnecessary . . . Recognizable images are always there in the end."[66] Remarks like these are modernist boilerplate. What makes them vivid in Pollock's case is our knowledge of what it took, technically and emotionally, for him "to let the painting come through."

Hence the temptation to have the bits and pieces of evidence in this area add up, when in fact they are mostly ambiguous. We know, for example, from Lee Krasner, that an amount of time and effort went into dragging the drip paintings

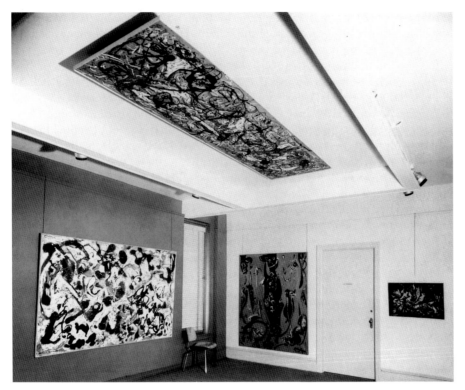

193 Oliver Baker:
Installation of Janis
Gallery Show,
photograph, 1955
(Jackson Pollock Papers,
Archives of American
Art, Smithsonian
Institution)

up from the floor and hanging them, provisionally – leaving them around on the wall, and deciding whether they worked there or not.[67] Pollock seems to have tried to explain this to *Life* in 1949. "While he is painting, he knows when a picture is 'working,' but afterwards, when the inspiration is somewhat remote, he has to get acquainted with his pictures."[68] "When I am painting I am not much aware of what is taking place – it is only after that I see what I have done."[69] It would be easy to make too much of this. When Rosalind Krauss, for example, decides on the basis of Krasner's memories that "there was a caesura, a very great one, between the state in which [Pollock] worked the painting itself, and the one in which he 'read' it; the painting itself, in order to be read, had to be transferred to the wall,"[70] I note the difference between her metaphor, "read," and the one Pollock regularly preferred, "get acquainted." I do not believe that reading and working were ever separate in Pollock's practice. The picture was put on the floor to be worked on, but I think it was always being read on the floor as if it were upright, or in the knowledge that it would be. To pretend otherwise would have been naive, and Pollock was never naive about painting. Not for him the delusive idea that one might solve the problem of uprightness and orientation in art by literally upending the depiction and having it be "flat." Leave that kind of simple-mindedness to Giacometti.

If Pollock had a dream of exceeding the normal terms of painting's reference – and I am sure he had – the fantasy was more of endlessness and transparency than of physical grounding. "There is no accident, just as there is no beginning and no end."[71] Or maybe the dream was of extra-terrestriality. *Constellation. Reflection of the Big Dipper.* In the exhibition Pollock had in 1955 at Sidney Janis's gallery, he hung his 1948 painting *White Cockatoo* on the ceiling, giving it its airborne name for the occasion (fig. 193).[72] No doubt this too was simple-minded. It just seems to me the kind of simple-mindedness one would expect in Pollock's case. Infinite elevation as opposed to ruthless *bassesse*. Positivism and Gothic-ness, not low materiality.

No one is denying that working on the floor was important, and in a sense destructive. "You've got to deny, ignore, destroy a hell of a lot to get at truth."[73] The picture's facing-ness and verticality, that is to say, had to emerge unexpectedly, against the grain of process. Facing-ness and verticality were, or had become, clichés. Or, not so much the modalities themselves (which I believe Pollock thought, rightly, were part of what "being a picture" consisted of), but the means by which they were usually rediscovered in the act of painting. These had become clichés. Easy readings. Easy satisfactions. No doubt some kinds of too-soon totalization were made difficult, or next to impossible, by the fact that the field Pollock was working on – this is Krauss again – "was so large that the painting, as a whole image or configuration, could not be seen by him from the position in which he was working on it."[74] But the same had been true for Tintoretto or Tiepolo at work on a ceiling; and only a few of Pollock's pictures, in fact, were monsters swallowing the whole studio floor.

Even of these I think we can say the following. Pollock did "read" the totality of his painting as he worked on it: he synthesized an image of the whole picture from the various partial views he had. He was reading his pictures and acting all the time upon what he read; but what he seemed increasingly to want in practice was a situation where the synthesis of aspects – the reading – came about as part of a sequence of movements: it took place but was never arrested. Not that arrest and deliberation simply vanished from the process of picturemaking. Of course not. Photographs of the studio are full of evidence of paintings being stopped, put up for inspection, left to mature for hours or days, returned to the floor for further work. At least two of the photos taken in 1950 by Rudy Burckhardt (figs. 194 and 195), for instance, show what I take to be the picture *Silver Plaques* – its strict title is *Number 9, 1950* (fig. 196) – still in transit, without its final, erasing smudges of aluminum. At first it is hung on the barn wall, next to a long picture on the floor that is hard to identify – it turns out to be an early stage of *Number 3, 1950* – and then it is propped by the side of the same painting, which by now is complete but for a few final throws of aluminum and olive green. How much time elapsed between the first photo and the second? Minutes? Weeks? Time enough for *Number 3, 1950* to take on a new level of complexity, and for *Silver Plaques* to be set in a different relation to it. Each time the relation looks quite formal and deliberate, as if the two pictures were in some sense being done with a view to one another.

194 (*below left*) Rudy Burckhardt: Pollock's studio, photograph, 1950

195 (*below right*) Rudy Burckhardt: Pollock's studio, photograph, 1950

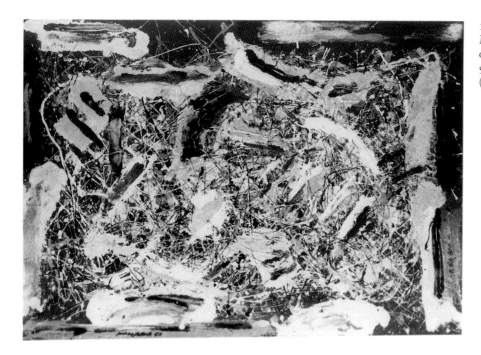

In the photo of *Alchemy* on the studio floor, there are two paintings of similar
dimensions propped up against the wall for further study. The squarer of the
two is *Reflection of the Big Dipper*. It stayed the way it was. The other I take
to be a penultimate stage of *Phosphorescence* (fig. 197), the most dazzling and
encrusted of all the first group of drip paintings.[75] It is already loaded with
thrown paint. But at some subsequent moment Pollock went back to it, and
covered almost the whole surface with swathes of aluminum and straight jets of
white.

Examples like these could be multiplied. The studio photographs are a
treasure trove. The process of reflection and judgement seems to have been
interminable in some cases, and, according to Krasner, not something Pollock
relished: pictures were sat up straight, tried out in more than one orientation,
made to dance with others, finessed with brush or fingers, conjured away by
new layers, sometimes abandoned. There has never been a studio so superin-
tended by work already done. No painting was safe from Pollock's second
thoughts. All the way through the 1940s he worked time and again (I would say,
centrally) by erasure – by literally painting out previous configurations. *Galaxy*,
on top of the chest of drawers in the *Alchemy* photo, is the great icon of that
fact. The first drip painting is meant to be understood as hiding and revealing
an imagery underneath. Again it is done mainly with white and aluminum. And,
half-hidden by *Galaxy* in the photograph, is another tremendous picture,
framed from some previous exhibition – it has much of the feel of *Something of
the Past*, and roughly the same dimensions – which has utterly disappeared.
Was it too put back on the floor, and swallowed by further pouring?[76]

Ritual. I am insisting that the play of process and judgement in
Pollock was more elaborate than it looks. But that still leaves us with the
Pollock Hans Namuth shows us, moving at various speeds alongside the canvas,
bending and straightening, stopping and stepping back, throwing in wide arcs
or repeated small stitches of paint from the can. (In the out-takes of Namuth's
movie, part of the time Pollock is using what looks like two old brushes dried

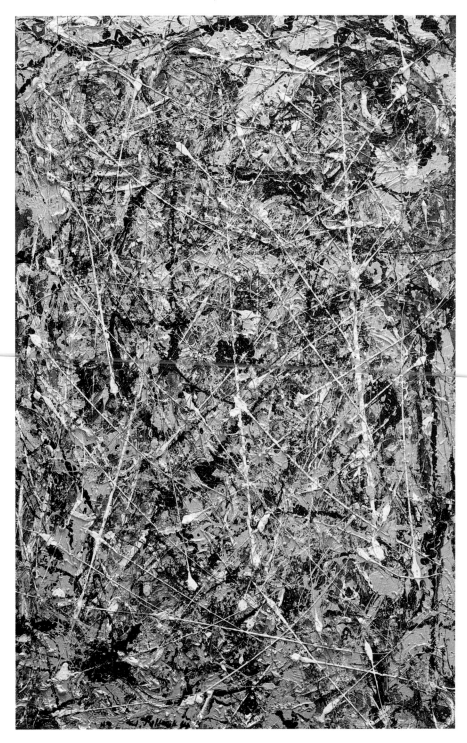

197 Jackson Pollock:
Phosphorescence, oil and
aluminum on canvas,
111.7 × 66, 1947
(Addison Gallery of
American Art, Phillips
Academy, Andover, Mass,
Gift of Mrs. Peggy
Guggenheim)

and stuck together, their shafts thereby forming a channel down which the
liquid paint could run at a slightly slower, more easily controllable, speed.[77]
Modernism is craftsmanship, even in its wildest moments.) Nothing I have said
is meant to normalize what we see going on here. The process is as strange and
extreme as any painting process ever was. Paintings may have been kept around
and brooded over, but it seems that in the act of manufacture there had to be
built in a whole series of obstacles to aesthetic freezing and framing. Aesthetic

decision-making had somehow to be ingested into the act of manufacture, the de-skilled address to the surface from above – "the positive moment of prac-tising what it does not understand," to borrow a line from Hegel on the Unhappy Consciousness.[78]

I do not want to offer Hegel's words as a catchphrase summing up Pollock's method, or modernism in general. But I did not choose my Hegelian chapter-heading for nothing. The more I know of Pollock (the higher my estimate of him), the more the pages on the Unhappy Consciousness from the *Phenomenology of Spirit* enforce themselves as a point of reference. Remember that the pages are partly literary criticism, written with Diderot's *Rameau's Nephew* in mind. They still seem to me the discussion from which any future psychology of modernism – and we are worlds away from possessing one – will have to start.

Modernity for Hegel is that moment at which contingency and selfsame-ness confront one another as tragic opposites. The "simple Unchangeable" on one side, the "protean Changeable" on the other. Absolute individuality (meaning undividedness) stands cheek by jowl with the endless whirl of difference. For Hegel, of course, the essence of Spirit or Consciousness is the being-together of both in One. But the essence of modernity, for him, is the failure to grasp that. The Unhappy Consciousness knows it is twofold and divided, but does not know, or cannot accept, that this division is its unity. "The two [kinds of self-consciousness] are, for the Unhappy Consciousness, alien to one another; and because it is itself the consciousness of this contradiction, it identifies itself with the Changeable consciousness, and takes itself to be the unessential Being."[79] Things would be more bearable if at least the Unhappy Consciousness could pursue its self-laceration to the point of extinction. But it never can. It can never lay hold of mere difference and embrace it as its Truth, because difference turns on indifference, and contingency on essential nature. The Unhappy Conscious-ness can never get to the Unhappiness it seeks. It can never "attain the depres-sive position," as the Kleinians would say. Here is my catchphrase in context:

> Through these movements of surrender, first of its right to decide for itself, then of its property and enjoyment, and finally through the positive moment of practising what it does not understand, it truly and completely deprives itself of the consciousness of inner and outer freedom, of the actuality in which consciousness exists *for itself*. It has the certainty [an illusory certainty, in Hegel's terms, but even this moment of false objectification is part of the work of Reason] of having truly divested itself of its "*I*", and of having turned its immediate self-consciousness into a *Thing*, into an *objective* existence.

The movements of surrender Hegel had mainly in mind here are those of the modern forms of religion. And of course there is a way in which the religious surrenderings have been extended and amplified by those of art. This would be the level on which even the self-satisfied Leftist claptrap about "art as substitute religion" might be reworked so as to have some critical purchase. Partly this book is an attempt to do that. To investigate why *God Is Not Cast Down*.

*U*nformed Figure. Questions about method, then, cannot be disentan-gled from ones about aesthetic and intention. "Technic is the result of a need."[80] So what need, precisely? In particular, what formal need? What kinds of configuration were made possible by Pollock's way of doing things? What kinds of work on the language?

Answers to these questions have never been in short supply, and the best have come from the painters and writers who looked at Pollock's work in the 1960s, under Clement Greenberg's spell. Their account has got a bit inert and tedious since, from repetition, but attempts to leap out of it viz-à-viz Pollock have been singularly unsuccessful, and I do not intend to try making another one. Because a description is over-familiar does not mean it has come to the end of its usefulness. Maybe, if we are lucky, we can mine it a bit from within.

The main thing the modernist critics got right, I think, about Pollock's paintings from 1947 to 1950 is their fierce, almost doctrinaire quality, their quality of renunciation. Not that this meant the pictures renounced sensuality or did not often have beauty, even charm, in view. Cecil Beaton saw part of the truth. *Lavender Mist* (given the proper lighting) is as evanescent as Watteau. (But could not the same be said of a Malevich *White on White*? And are not Pollock's paintings ultimately driven by something analogous to Malevich's mad rigor?)

If a painting is to be abstract at all – this seems to me the drip paintings' logic – then it ought to be so through and through, down to the last detail or first gestalt: it ought to be made into the opposite of figuration, the outright, strict negative of it. One main driving force of Pollock's work from 1947 to 1950 is an effort to free the most rudimentary elements of depiction – line, color, handling – from their normal associations with the world we know, or, at least, with the world of objects, bodies, and spaces between them. Line, to quote from the *locus classicus* of this discussion in Michael Fried's *Three American Painters*, "has been freed at last from the job of describing contours and bounding shapes." The passage continues:

> It has been purged of its figurative character. Line, in these paintings, is entirely transparent both to the non-illusionistic space it inhabits but does not structure, and to the pulses of something like pure, disembodied energy that seems to move without resistance through them. Pollock's line bounds and delimits nothing – except, in a sense, eyesight. We tend not to look beyond it, and the raw canvas is wholly surrogate to the paint itself. We tend to read the raw canvas as if it were not there. In these works Pollock has managed to free line not only from its function of representing objects in the world, but also from its task of describing or bounding shapes or figures, whether abstract or representational, on the surface of the canvas. In a painting such as *Number 1, 1948* there is only a pictorial field so homogeneous, overall and devoid both of recognizable objects and of abstract shapes that I want to call it *optical*, to distinguish it from the structured, essentially tactile pictorial field of previous modernist painting from Cubism to de Kooning and even Hans Hofmann. Pollock's field is optical because it addresses itself to eyesight alone. The materiality of his pigment is rendered sheerly visual, and the result is a new kind of space – if it still makes sense to call it space – in which conditions of seeing prevail rather than one in which objects exist, flat shapes are juxtaposed or physical events transpire.[81]

There are things here that strike me as debatable, especially in the last sentences. I have already given my view of the role of raw canvas in *Number 1, 1948*, and you will see that Fried's is different. I do not agree – this will emerge more clearly later – with what gets said in passing about the materiality of Pollock's pigment and the viewer's perception of it; and for all that the remark seems incidental to Fried's argument, a great deal turns out to depend on it in the essay as a whole. "Optical," a few lines earlier, is a word called on to do an immense amount of rhetorical work, as the text freely admits. (Fried's "wanting to call it" optical, and putting the concept in slightly anxious italics, makes one feel

churlish at not wanting to do the same.) The phrases that follow – "addresses itself to eyesight alone," "rendered sheerly visual," "conditions of seeing prevail" – are fine as long as they are not meant to conjure up some bogus ontological threshold which Pollock's line magically crosses. (A lot of terrible 1960s criticism thrived on this sort of thing.)

But the main point of Fried's description – the attempt to describe the strange things that happen when something as basic to painting as line is turned aside from its normal behaviors – still stands, and to my mind says something vital about Pollock's art. It could be extended, in fact, to other formal elements about which Fried has less to say. Color in the drip paintings, for instance, often seems to me pushed in the same disobedient direction. When the process of pouring is successful, color radically misbehaves. It fails to take on any of its normal states or relations. It is no longer seemingly the attribute of a surface, or the effect of a set of textures; and yet it is equally far from having the look of a transparent film or atmosphere. It is never a disembodied property. Color in Pollock is too much matter of fact for that to happen, too much aluminum as opposed to silver and gray. I tried to find words for this characteristic in my previous description of *Number 1, 1948*. "Clouds," "swathes," "thin skin," and so forth. But none of the metaphors was satisfactory: not because the color in Pollock refrains from participating at all in the metaphorical dance – how could it? – but because, when they are verbalized, the metaphors dispose of the matter metaphorized just a little too efficiently. In depiction it is different. However confidently we hold what we are looking at in the frame of one or another kind of "seeing as," there is still (in Pollock) the thickness and obtrusiveness of the paint as sheer substance – the matter it is and the matters that are crushed or folded into it. And not just "matter," either. Because the whole thing – the whole appearance of color – has an evenness and openness that give the lie to congestion. The final throws of white and aluminum are decisive here. There is the mud and the sheen: *Ocean Greyness* and *Phosphorescence*. Color ought to be one or the other, and in a good Pollock never is.

Sleeping Effort. Likewise "handling." Handling in a work of art – traces of making, demonstrations of the artist's touch – has normally functioned as a kind of descant to the main line of figuration. The point came up with reference to the empty upper half of David's *Marat*. Traces and touches are features of a painting that seem to operate, I argued there, below the level of signifying will. They are repetitive and exquisite (exquisite because repetitive) – produced by the intersection of body, conceived as a set of purely physical habits, and medium, conceived as a set of purely chemical possibilities. They are not to be dismissed because of that: on the contrary, painters have always been fond of shoving their fingers in viewers' faces, as Courbet used to, and saying: "La peinture, c'est ça!" But the *ça* was ultimately an overtone or undertow to the image (Courbet himself would not have disagreed with that): something in which the spectator was meant to "see" the artist, but see him behind or in front of the figurative order – in the adjustments and nuances that lent the picture its consistency, and made it a unity of sorts.

Handling in *Number 1, 1948*, and *a fortiori* in the gargantuan *Number 32, 1950* (fig. 198), is not like this any more. It is not simply that the pictures have in a sense become *all* handling, nor even that handling is no longer the embodiment of control, or finesse, or maybe even of skill; rather, that handling here seems not to be the sign of unity, whether the picture's or the picturemaker's. The marks in these paintings, as I understand them, are not meant to be read as consistent trace of a making subject, but rather as a texture of interruptions,

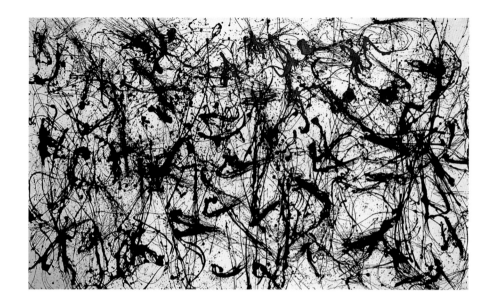

gaps, zigzags, a-rhythms and incorrectnesses: all of which signify a making, no doubt, but at the same time the absence of a singular maker – if by that we mean a central, continuous psyche persisting from start to finish. "There is no accident, just as there is no beginning and no end." Of course this enactment of absence may be as much of a fiction as the assertion of presence it is aimed against. Even this is sometimes admitted. Part of what is special about *Number 1, 1948*, for example, is the degree to which it never makes up its mind about its own non- or super-humanness. The picture is labyrinthine but centered on a possible human scale. Flat but upright. Its handprints are all but swallowed by the field, but still magically charged.

Endless difference may be a fiction, that is to say (for reasons Hegel is eloquent on), though no doubt it is the fiction Pollock wanted. He wished to be "in" his painting and out of himself. To be where "thinking as such is no more than the chaotic jingling of bells, or a mist of warm incense, a musical thinking that does not get as far as the Notion."[82] Painting was a way to be certain of having truly divested oneself of the "I." Abstraction was worth pursuing because it, more than any other form of painting, might lead to just such divestiture.

This is what I meant before by pointing to the fierceness of Pollock's abstraction – its quality of renunciation. If a painting was to be abstract at all – if it no longer could depend on likeness to specify its relation to other matters in the world – then everything in the painting should take that fact as the great one. The picture had to be rid of resemblance, rid of it utterly, emptied of all the mere forms that resemblance left behind (and which most abstract painting took as its birthright).

The First Dream. Why? Oh, for many reasons.

Because modernism had better find its way back to the ground of representation, and confront the moment when marks first stood for things besides themselves – the moment when the handprint on the wall (fig. 199) was no longer merely an index of presence but "seen as" a hand, a hand out there, someone else's. A hand in the negative. (Not that I believe for an instant that Pech Merle came out of any such moment, or even that such a moment took

199 Hand stencil, from the upper section of the Spotted Horse Panel, blown-on mineral colors, late upper Paleolithic (Pech-Merle, Cabrerets, Lot)

place, at least punctually. It may have been that Pollock thought so: it may not. The handprints in *Number 1, 1948* come with a lot of Art-History-Survey loading.)

Because abstraction seemed to mean priority in Pollock's case: the possibility of making the first painting again. Giving his paintings numerical titles, as Jonathan Weinberg suggested, was most of all attractive because it allowed Pollock to call certain key pictures *One* – an opportunity he availed himself of four times in three years.[83]

Because if abstract painting could finally dispose of its parasitic relation to likeness, then it might discover – here we steer closer to things Pollock said – some other means of signifying experience. It might be able to put itself in a different relation to the world. To be "in" it, or "of" it, in ways which twist the familiar prepositions back on themselves.

Prism. "The modern artist, it seems to me, is working and expressing an inner world – in other words – expressing the energy, the motion, and other inner forces."[84]

$$
\begin{array}{c}
\text{States of order} \rule{1.5cm}{0.4pt} \\
\text{Organic intensity} \rule{2.5cm}{0.4pt} \\
\text{Energy and motion} \\
\text{made visible} \rule{4cm}{0.4pt} \\
\text{memories arrested in space,} \\
\text{human needs and motives} \rule{1.5cm}{0.4pt} \ \rule{1cm}{0.4pt} \\
\text{acceptance} \rule{1.5cm}{0.4pt} \ \rule{1cm}{0.4pt} \ ^{85}
\end{array}
$$

I like the fact that Pollock listed *Pasiphae* in his 1947 résumé as *Pacify*. And *Constellation* as *Consolation*.[86] *Finnegans Wake* was not one of Pollock's favorite books for nothing. Words like "world," "need," "motive," "motion," and "experience" are similarly slippery. I do not intend to make them stick. "But we want to walk; so we need *friction*. Back to the rough ground!"

"Experience," as I said already, seems to have been a key word in Pollock's lexicon. "The self-discipline you speak of – will come, I think, as a natural growth of a deeper, more integrated, experience."[87] There are ghosts of the psychoanalytic institution here, as Pollock repeatedly encountered it. "The

source of my painting is the unconscious." "Any attempt on my part to say something about it, to attempt explanation of the inexplicable, could only destroy it." "When he talked about the work, he always talked about it in psychoanalytic terms . . . He would say, 'This is the apex,' and 'here is the relationship of the id to the superego,' and 'this is what the censor plays [?says],' and 'this is the line of the orbit of the division'."[88]

In Pollock's conversation, the concepts "experience" and "unconscious" often seem to overlap. Neither is clear. Both are probably mediated – I am convinced by Michael Leja – by all manner of popular and semi-popular philosophies of mind. Books like Harvey Fergusson's *Modern Man: His Belief and Behavior*, in Pollock's library at his death, whose very phrasing seems to crop up in the statements of 1947 and 1950; or James Harvey Robinson's *The Mind in the Making*, whose account of induction – it is not a very brilliant one – is there in note form, in Pollock's handwriting, on the back of a drawing from the 1930s.[89] These sources are not impressive, and not surprising. Reach-me-down versions of Freud, as Leja dryly puts it, are often more useful to artists than the real thing: their "very shortcomings – ambiguity, eccentricity, meta-phorical extension, or oversimplification"[90] – are what make them stick to a practice, or suggest a new one.

This line of thought cannot be pressed too far. "When you're painting out of your unconscious . . ." "I think the unconscious drives do mean a lot in looking at paintings." "I just can't stand reality." "We're all of us influenced by Freud, I guess." "I saw a landscape the likes of which no human being could have seen."[91] A proper account of Pollock has to respect these statements' banality, as well as their deadly earnest.

*T*he Deep. "When you're painting out of your unconscious." One thing Pollock was aiming for between 1947 and 1950, and surely thought he had obtained, was a kind of orderliness in painting after the previous shrieking clutter. Alexander Calder is supposed to have said with a sigh to Pollock, on a visit to his studio in 1942: "They're all so *dense*." At which Pollock deliberately looked round for a painting even more congested, with: "Oh, you want to see one less dense, one with open space?"[92] Pollock was right, of course. In the early- and mid-1940s his paintings depended on being overcrowded. And that humor or need never entirely vanished. *Alchemy* or *Number 1, 1949* are still under its sway. But by this time density did not necessarily mean building a brick wall. The drip paintings (or some of them) let a little open space in round the edges, or had space press against the web from behind as a kind of leaven. They were "One." There was a grand evenness and seamlessness to the best of them.

What was to be signified by the interlace now was the logic of a certain way of dealing with the world – the logic, the order, the integration. And yet this was clearly a kind of dealing that, given its existence at the edge of our normal categories, could only be pictured as "something like pure, disembodied energy." What shall we call it, this mode of experience? Vestigial? Immediate? Unfigured? Unfounded? The last word crops up in Betty Parsons's records as the title of two of Pollock's first drip paintings, which later got called *Vortex* and *The Nest*.[93] One of them was used as the signature image on the announcement for the 1948 show (fig. 200). *Unfounded* is a good, overdetermined title, and I have a feeling the word was salvaged from Pollock's reading – from *Moby-Dick* or *Finnegans Wake*, though I still cannot find the source. It goes well with Pollock's other, later title in the negative, the *Unformed Figure* of 1953.

Unfounded, maybe, but for this very reason rich. There is a kind of experi-

ence, these pictures say, that is vestigial, by the looks of it – unusable, marginal, uncanny in the limiting sense of the word – but that at least the parent culture leaves alone. It is the kind of experience modern painting has often been forced back on: the only kind, so it believes, not colonized and banalized by the ruling symbolic regimes. The proposal here is double-edged, and registers as such in the painting. This experience is not occupied by the usual discursive forces because it is a wilderness. There are spaces in any symbolic order where the mechanics of "making ordinary" do not get under way because there is nothing much for them to work on. But are such spaces interesting? Is not openness also emptiness here? Is not finding one's own voice the same as pretending to be inarticulate? And freedom too much like confinement? These are the questions I think the drip paintings were made to decide.

Enchanted Forest. Let me try to draw the threads of this description together.

The drip paintings of 1947 to 1950 were intended to signify a certain order to experience. They were, in Parker Tyler's words at the time – it is a piece of criticism Pollock seems to have valued – to be "made to represent." But there was a necessary preliminary to doing that. Tyler's sentence reads in full: "Something which cannot be recognized as part of the universe is made to represent the universe in totality of being."[94] The last phrase is too vague and lofty; but the first phrase is right on the mark. Aiming for depth and order in signification meant pulverizing the belonging of things in the picture to any one conceptual space – to any one part of the world or imagining of Nature. Not that Pollock saw what he was doing in the drip paintings in this light from the start. In the beginning, in the first flush of discovery – over the last months of 1947 – the world was overtaken and transformed, but that very transformation was fitted to a single (or at least, dominant) metaphoric frame. The metaphor was of magic and release: richness, incrustation, sea change, an endless plunging (like Lucifer) through the heavens. *Shimmering Substance. Watery Paths.* The titles are familiar by now. The world was one of delight, of fullness and strangeness – suspension of gravity, the slow turn of things in a green sea, the impossible gray fire of phosphorescence off Accabonac Harbor. "My concern is with the rhythms of nature . . . the way the ocean moves . . . the Ocean's what the expanse of the West was for me."[95]

Sitting on a bank,
Weeping again the King my father's wrack,
This music crept by me upon the waters,
Allaying both their fury and my passion,
With its sweet air.

The mood was powerful but it did not last. *Number 1, 1948* is the picture, I think, that signaled its coming to an end. Names gave way to numbers, and the paintings began to stand in a difficult, more contradictory relation to any world we might recognize or imagine. They no longer conjured the world away, or put it in an alchemist's crucible. They were not lordly and glittering. (Nor abject and muddy either. Not low.)

I realize there are too many negatives in play here, and I do not intend to take Parker Tyler's way out of them, exactly – inventing a Pollock as superman, inhabiting "the viscera of an endless non-being."[96] This is too much like William of Aquitaine. We need Greenberg's positivism as counterweight. Or Bakhtin's "entangled, shot through with shared thoughts." We need a modest theory of the sign, and in particular of the mark.

Four Opposites. In order to represent at all, as I see it, marks in pictures have to be understood as standing for something besides themselves: they have to be construed metaphorically. (This is true even of indices, if that is what we think Pollock's marks are: the moment a character or quality is attributed to an index, we are making it into a metaphor of sorts – of its maker, or of that which gave rise to it. A circumstance or a state of mind; a tempo; an ease or unease with the flesh. Heady things to imagine leaving traces!) Metaphor is inescapable in the case of markmaking, and what at any rate would an exit from it be like? Not like Pollock's work from 1948 to 1950, it seems to me, which moves quite legibly between two broad metaphoric poles.

On the one hand, there are those figures of totality which Parker Tyler and I have already put a stress on: the "One"-ness, the evenness and endlessness, the "pure harmony, easy give and take." "There was a reviewer a while back who wrote that my pictures didn't have any beginning or any end. He didn't mean it as a compliment, but it was."[97] And on the other, there is a family of metaphors I shall call, a bit warily, "figures of dissonance." I mean by this simply those aspects of the drip paintings that do not partake of the One-ness Pollock clearly was trying for, and that usher back the temporality he and the reviewer thought had disappeared: the quality of "handwriting" to the pictures, and of handwriting often become wild crossing-out: the figures of obstruction, undergrowth, uncertainty, randomness, of a kind of peremptory violence done (still) with the sticks and dried brushes: the persistence in the markmaking of Pollock's original "Gothic-ness, paranoia and resentment." Stops and starts, births and deaths, beginnings and ends. *Something of the Past.*

It is hard not to melodramatize this side of Pollock's painting, but running that risk seems on the whole preferable to what the modernist critics did, which was mainly to look through it as if it were a bit embarrassing. (Pollock's "concern in his art was not with any fashionable metaphysics of despair but with making the best paintings of which he was capable": thus Fried.[98] A false distinction propped up nicely by the scareword "fashionable.")

What are we supposed to do, is the question, with the marks in the picture of discontinuity and aimlessness, of cantankerousness and risk, of abrupt reversals of direction, inconsistencies, scrawling, episodes of rhetorical excess – crushed glass, chicken wire, whorls of paint squeezed convulsively from tubes, twine,

sand, pebbles, cloth, spatter and clotting, glaring industrial metal-grays and enamel-blacks, transfixing (melodramatic) handprints – all those elements in the work that leave behind the signs of discomposure in its making, and insist that these pictures obey no rules, or none we shall know, and have no horizon lines – no top and bottom, no sense of the whole preceding its insubordinate parts? Are we meant to pretend these aspects are just instrumental – that they do not really signify, that they disappear (at proper viewing distance) into the visual totality?[99]

I do not think so. All the same, "dissonance" is a difficult word, and one that could easily lead in the wrong direction. It sounds too dark. We need a critic like Theodor Adorno – a truly melancholy critic, but with an unshakeable belief in art's redeeming power – to give the word back its positive valency. "Dissonance," Adorno says, "the trademark, as it were, of modernism – lets in the beguiling moment of sensuousness by transfiguring it into its antithesis, pain."[100] "Dissonance is the truth about harmony. Harmony is unattainable."[101] It follows that dissonance stands on the side of mimesis, in Adorno's view, as opposed to what he calls "aesthetic illusion." By which he means the moment in a work of art that reaches out to endlessness and atemporality.

> Dissonance is effectively the same as expression; whereas consonance and harmony seek to soften and do away with it. Hence expression and illusion are fundamentally antithetical to one another. Expression is hardly conceivable except as expression of suffering. Delight has shown itself to be inimical to expression (perhaps because there never was such a thing as delight), to say nothing of bliss, which is completely inexpressible.[102]

Compare the world of *One* with that of *Lucifer* (fig. 201), or *Lavender Mist* with *Number 32, 1950*.

Lucifer. Are the drip paintings expressive, in Adorno's terms, or do they attain to the "high impassiveness of true modern style"?

I think expressiveness in Pollock often hinges on the kind or degree of three-dimensionality that is given the throws of paint. Three dimensions mean mimesis. So the question becomes: Are the throws in a particular Pollock meant to look as if they are making an instantaneous impact on the surface, hitting it hard and sealing it down, like the final whiplash lines of white in *Number 1, 1949*? Or is there a heavy, incrusted build-up of marks, making the surface palpable, as in *Alchemy*? Or have the throws been allowed to drift partly free, to loosen and aereate a bit?

Lucifer, which is a painting we know Pollock was particularly fond of, is one of the earliest (and most successful) tries at getting beyond incrustation and airlessness. A lot depends on its fragile format, 3 feet 5 inches high and 8 feet 9 inches long. (It is still a rectangle as opposed to a scroll or wall panel. Still an easel painting, but only just. Later experiments with the format tended to tip the scale toward stretched horizontality. *Number 2, 1950*, whose dimensions are closest to *Lucifer*, was exhibited upright and signed at the bottom. *Number 3, 1950* – the picture on the floor in Burckhardt's photos – is just a little bit taller and less long. It is essentially a history-painting shape. *Lucifer* is almost a panorama.) Compare *Lucifer* to *Phosphorescence*. Or to *Full Fathom Five*. Its throws reach out toward weightlessness: they are lacy, nebulous, blown by a horizontal current of air: that applies even to the staccato, straight-line ejaculations of purple, blue, and orange which were evidently put on last. These have the look of a peculiar material thrown to the limit of thinness, and therefore caught up in the general lateral flow. The background of grays and red-browns

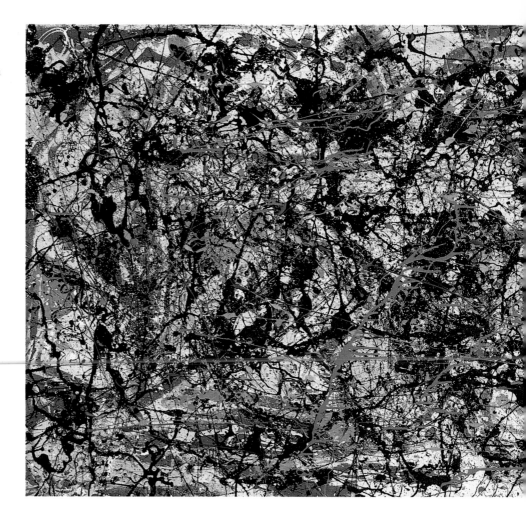

201 Jackson Pollock, *Lucifer*, oil and enamel on canvas, 104.1 × 267.9, 1947 (Collection of Harry W. and Mary Margaret Anderson)

has an unapologetic emptiness, like a glimpse into deep space, with the black foreground silhouetted against it. The canvas has been primed, meticulously, with a wash of pale limestone cream. The green and aluminum are cold as ice.

> And Satan there
> Coasting the wall of Heav'n on this side Night
> In the dun Air sublime, and ready now
> To stoop with wearied wings, and willing feet
> On the bare outside of this World.

A terrible, strictly *performative* beauty takes place on this side Night. And the shape of the Air, the pull of the empty horizontal, bends everything (gently) to its will. There is something of Malevich's elation in this, something of Milton's foreknowledge of the Fall.

Burning Landscape. Dissonance – do not misunderstand me – is not the truth of Pollock's art. It is one moment of it, one aspect of its sensuousness. *Lucifer* is extraordinary because that sensuousness is allowed almost to shake itself free. Pollock's project, as I see it, is exactly not to let the figures of dissonance hold sway in a painting, any more than the figures of totality. This is what links him to Cézanne. His work is a constant action against metaphor: that is to say, against any one of his pictures settling down inside a single

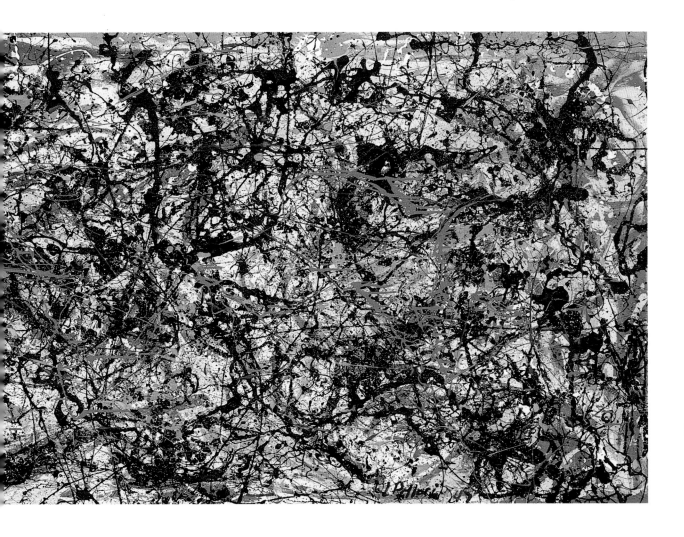

metaphorical frame. He wants to cross metaphors, to block connotation by multiplying it. He aims so to accelerate the business of signifying that any one frame of reference will not fit. Figures of dissonance cancel out figures of totality: no metaphor will get hold of these pictures' standing for a world, though we think each picture does somehow stand for one – it has the requisite density. As Don Judd put it in the 1960s: "The elements and aspects of Pollock's paintings are polarized rather than amalgamated."[103] Not that "polarized" means straightforwardly at odds. The web is consistent as well as brittle. Throws register as staccato but also will-o'-the-wisp. Space gets swallowed up but infiltrates everything. *Vortex* never cedes to *Lavender Mist*.

One thing that needs to be spoken to here is how these points about metaphor connect with the kind of reading via Fried and Greenberg I did earlier on. They do and they do not. A painting could very well be purged of all traces and afterimages of likeness, in the way Fried celebrates, and still not do the work against metaphor I have just been describing. We could have – I think we do have – a strictly "optical," anti-figurative abstract painting which all the same stood in a reiterative relation to the imaginary orders of a world we think we know. An inert relation, Pollock would reckon. A relation to Nature, for instance, in which nothing of that dismal category was put under pressure.

And does not this last possibility loom, for Pollock, the better he gets with his new techniques? Part of the reason for them, from *Number 1, 1948* onward, was to elicit a kind of touch, color, and spatial organization that could keep

analogies to the world of landscape (or even sea- or skyscape) at bay. Pollock in 1948 and 1949 turned back to the kind of hot, brash technical effects he had learnt in Alfonso Siqueiros's workshop ten years before. Which does not mean he could ever have emulated Siqueiros's wilfulness and bombast, or ever really wanted to. *Number 1, 1949* (fig. 183) still has something of *Lucifer*'s delicacy. But Nature, I want to say – "Nature" meaning openness, evenness, and organic growth – is in the new *Number 1* collided hard with qualities more or less its opposite. The picture is packed. Its colors are dirtier than they ever look in reproduction, rawer and more naive, its throws more lassoed and linear. It is not a thicket but an arabesque. There is a lot of cartoon color in evidence: piglet pink, blue suede blues, common-or-garden green, yellows with just a touch of lime to them: the aluminum (again there are floods of it) adds up to a definite, matt, no-nonsense gray. Not glistering, not phosphorescence (not even the deathly frosting of *Number 1, 1948*). I think it is part of this painting's accomplishment – for me *Number 1, 1949* is the classic of the 1947 to 1950 pictures, the one where the language attains the maximum of economy and fine-tuning – that it so resists a viewer's effort to have it be like even the modes and qualities of a mineral or vegetable world. "Something which cannot be recognized as part of the universe is made to represent." An intense detachment informs all.

Number 1, 1949 stood sentinel over Pollock's efforts the following year. It is propped vertically against the studio partition wall in one of Namuth's photographs, with what looks like *Autumn Rhythm* under way next to it; and in another taken earlier (fig. 202) it is hung on a sidewall, with Pollock bending over *One* on the floor. It is already signed bottom left. The paintings done under its aegis in 1950 seem to me not quite to follow in the direction it pointed. This is not meant as a judgement against them, necessarily, but more as an attempt to come to terms with their lateness in Pollock's work – the fact that they usher in, so abruptly, the end of abstraction as this painter's main way of doing things. This is the moment of Pollock's modernism that most needs explaining. Making it a function of his sad biography – his hitting the bottle again, his being somehow exposed and drained by Namuth's relentless attention – is putting the cart before the horse.

Let me try adopting Adorno's point of view. In the 1950 paintings, Adorno might say, the poles of metaphor tend to split apart and simplify. On the one hand, the figures of dissonance become schematic, black and white: dissonance recognizes itself as mimesis, as handwriting, as theater of some sort: it is extracted from the mix of sensuousness. *Number 32, 1950* (fig. 198) is the prime example. And on the other, Nature returns – *Lavender Mist, Autumn Rhythm, One* – metaphors whose very breathing completeness carries within it the sign of a practice coming to an end.

As usual with Pollock, the order in which paintings were done during 1950, and the amount and duration of work on each, are largely matters of guess-work, despite the wealth of what ought to be hard evidence – photographs, title numbers, film sequences, Namuth's and Krasner's say so.[104] *Lavender Mist* (fig. 182) seems to have been the year's first big picture. Pollock originally called it *Number 1, 1950*, before Greenberg came up with the title that stuck.[105] The title is ingenious but a bit misleading. No doubt the great loops and splashes of pale pink which were thrown on toward the end do just about hold the picture together. (*Lavender Mist* is the squarest of the big paintings, 7 feet 3 by 9 feet 10. It is a shape that takes a lot of structuring, because there is so little built-in orientation to it.) The pink is abetted as usual by aluminum gray, very similar in tone. One color gives body to the other. But *Mist* does not seem quite right to me. What kind of mist would it be that contained or extruded such a

crisscross of blacks, all fibrillated and staccato, as if made from some razor-thin and razor-sharp material? If this is water vapor, it is folded up in barbed wire: if this is Nature, it is a generality (a continuity) evoked only to be interrupted – almost choked – by the to and fro of events.

These things are epitomized by the quality of *Lavender Mist*'s insistence on its own two dimensions. As so often in modernism, everything turns on this. I said previously that the handprints at the picture's left side were matter-of-fact in comparison with those of *Number 1, 1948*; but that does not mean they are unimportant. They establish the picture's key. The great square field is going to be pressed into evenness and equality – pressed as much as painted. Or maybe painting *is* pressing – impacting everything into the surface, and not letting the surface, however full of incident, take on a thickness of its own. We are worlds away from *Alchemy*, or even the knots and fibers of *Number 1, 1948*. Flatness is to be achieved by what looks like physical, manual flattening, a stamping down and ironing out as if by a vast flat-bed press. (Sometimes I worry that the picture may have suffered in its later travels. Ossorio, its first owner, thought it had grayed over time. But the pressed quality ultimately seems bound up with the picture's whole sense of color and tone.) The surface is like a close-stitched tapestry, but also a bruised and flaking wall.

Greenberg's title does point to something. *Lavender Mist* may be sulfurous and tense, but it is also charming: one could easily imagine the blacks receding a little further into the pink haze, and totality holding the field altogether –

almost sweetly. Greenberg might have welcomed that. Cecil Beaton had ways to make it happen. And I am not saying that either of their readings was simply wrong. The picture is on a razor's edge: it looks back to *Number 1, 1949*, but also forward to *One* (fig. 181).

One. We know from Namuth that *Number 31, 1950* (Pollock seems first to have been satisfied with Greenberg's suggested title, *Lowering Weather*, and only later gave it the more metaphysical one we know it by) was worked on in two or more sessions and changed radically along the way.[106] It measures 8 feet 10 by 17 feet 6 – apart from the earlier *Mural* for Peggy Guggenheim, the biggest picture Pollock had done. Namuth remembered it having a first stage which was "white, black and maroon," when presumably the oppositeness of the picture's elements was starker, or anyway more pronounced than it became. "There was more work to be done." What the work seems to have amounted to, if one looks at the picture and tries to see what was put on top of the three base colors, was softening, pulverizing, and sewing together: the kind of work that had been done in *Lavender Mist*, though this time pushed further. (And done much more elaborately. The surface is sealed not by a few last-minute declarative sweeps of color, but by an overall weaving and speckling – blue-greens and grays, browns, more whites and blacks, olives. The maroon Namuth talked about is thoroughly embedded in the mix, to the point where one wonders if it is there at all. Perhaps, once again, time has altered the color balance.) The painting is calm. The undergrowth glows with a lowering-weather light. Lines congeal into atmosphere: the tone is even, cool, rich, unassertive, suggesting nothing so much as landscape (humid as opposed to burning), or vegetable matter through which landscape can be glimpsed: a kind of ethereal, rain-sodden foliage, "the likes of which no human being could have seen."

Then came *Autumn Rhythm* (fig. 203). It is more or less the same size as its predecessor. The title is Pollock's own. (Again, it seems to have been decided on rather slowly. In the show Pollock had at Bennington in 1952, the picture is still called *Number 30, 1950*.[107]) The white, black, and maroon which Namuth remembered in *One* have become white, black, and brown here, and they can be left as an open structure of opposites, just because the opposition between them has become strictly (confidently) formal. The painting is a dance, a choreography – measured and repetitive and (with its cantilevered loops and rectangles) even a trifle florid – compare the jerking, histrionic stops and starts of *Number 32, 1950*. *Autumn Rhythm* is air-filled and three dimensional, the thicket bursting with the amount of space held in its clutches. Space seems to come through to the viewer from behind: from an openness implied and celebrated at every point, like a force invading and moving the parts of the organic machine. The black and brown pistons are working furiously.

All of these movements, it seems to me, are superintended by analogies to the natural world – evoked quite matter-of-factly by color and drawing. Dry leaves. Bare branches. Air reappearing where before, in high summer, it had been all but smothered in green. Kinds of natural rigidity and shaking against the cold. (Are we meant to be embarrassed by such equations or to revel in them? The latter, surely.) The picture is an instance of autumn: it makes the natural category vivid again, generalizing and aggrandizing it, giving it room to breathe. Trees in painting should be this size, it says. Landscapes should stop miniaturizing what they are of.

None of this, I should add, is meant to demote or decry the paintings of 1950 – as if demotion or promotion were the issue. I am trying to look at these

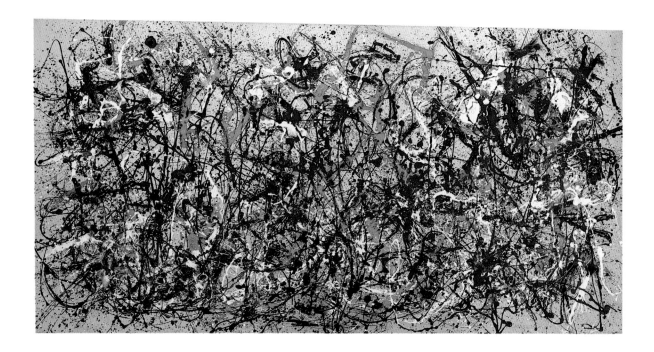

203 Jackson Pollock:
*Autumn Rhythm:
Number 30, 1950*, oil on
canvas, 270.5 × 538.4,
1950 (The Metropolitan
Museum of Art, New
York, George A. Hearn
Fund, 1957)

pictures as an end game, and understand the game and the ending. I am trying
to see why abstraction stops at its moment of triumph.

Cathedral. What had Pollock expected of painting during the years
1947 to 1950? Nothing very realistic. That it be abstract: that every last trace
of likeness be harried out of it: that it put itself utterly at odds with the world
we inhabit, and discover kinds of pleasure and agony that would put the very
notion "world" in doubt. Instead of "world's" great gathering of sensations
into a singularity, there would be "pleasure" and "agony's" infinite dispersal
and transfiguring.

One further dimension to the project, which will also have a familiar ring,
was Pollock's interest at this time in abstract painting's literal, physical relation
to "the world we inhabit." In his statements and interviews he keeps coming
back to the question of whether painting might be on its way to occupying a
different space altogether in the wider culture, and as a result might have to be
conceived with different conditions of viewing in mind – seen as part of a Mies-
van-der-Rohe-type architecture, for instance, as wall or window or some new
built element partaking of the qualities of both. Not quite painting any longer,
that is.

It may even be that Pollock never thought the project of abstract painting had
a chance of succeeding without its becoming part of some such general reorder-
ing of space. "I believe the time is not ripe for a full transition from easel to
mural. The pictures I contemplate painting would constitute a halfway state,
and an attempt to point out the direction of the future . . ."[108] In the studio in
1950, next to the skulls and paint cans on the table (fig. 204), can be seen a
model of a Miesian museum by Pollock's friend Peter Blake, in which paintings
by Pollock were used as wall-dividers.[109] It was a first sketch of how abstraction
might go beyond the halfway.

204 Rudy Burckhardt:
Pollock's studio,
photograph, 1950

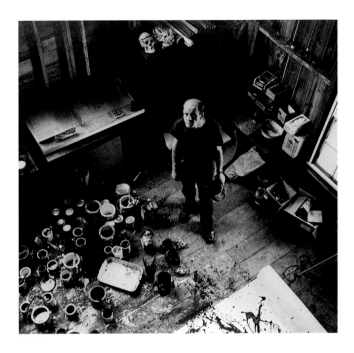

Cut Out. There is one element of Pollock's practice that so far I have given short shrift; and if I pull it out of the hat after the others it is not because I want it to upstage them, or seem like the truth of the matter, finally. All the same, it has its determinate weight.

Painting in Pollock's case had ended up abstract for a reason: because figuration had proven, in practice, impossible to sustain – that is, at the level of intensity which *was* painting, as far as Pollock was concerned. The old forms were flyblown, the new too much the possession of their particular makers – Orozco, Picasso, Miró, Siqueiros, and so on.[110] The attempt to remake them "out of the unconscious" had led, as it often did, to amateur theatricals, portentous, overstuffed, and overwrought. (This is not meant as a verdict on the best of Pollock's paintings in the earlier 1940s – the best are among the best of the century, and certainly as near as one gets in painting to a fulfilment of Surrealist hopes – but, rather, as the kind of doubt I imagine Pollock himself having about them, especially in 1946 and 1947.) Abstract painting was a way out of the mess; but it was also a means of signifying what had stood in the way of the figure in the first place, and left it "unformed" and "unfounded." Pollock never seems to have made up his mind for certain, in the drip painting years, whether such signifying could get done without the figure – I mean the word literally now – reappearing in the abstract. The problem, of course, was to find a way of reconciling that second coming of the figure with the work to annihilate likeness being done at the same time. The figure, if it was to appear at all, would have to do so *out of* or *against* that work, as the strict contrary of it – the negation of the negation.

This problem haunts modernism all through. Even Malevich eventually confronted it, under the shadow of Stalinism. All I want to do with reference to Pollock is point to the problem being repeatedly tackled from 1947 to 1950, and recapture a little of the sense of uncertainty that some of Pollock's best critics then had about where his abstraction might be headed. Here, for instance, is Clement Greenberg's reaction to Pollock's one-man show at Betty Parsons in November and December 1951. The pictures in the show – *Number 14, 1951* is a fair example (fig. 205), and Greenberg singled it out for praise –

were not abstract any longer. Masks, fingers, and faces, the shapes of animals and demons, bits and pieces of a half-human world, had been thrown up by the flow of black enamel, or only partly erased by it. But Greenberg did not seem to see this as a fault-line in Pollock's practice, and certainly not a fall from grace:

> Jackson Pollock's problem is never authenticity, but that of finding his means and bending it as far as possible toward the literalness of his emotion. Sometimes he overpowers the means but he rarely succumbs to it. His most recent show, at Parsons', reveals a turn but not a sharp change of direction; there is a kind of relaxation, but the outcome is a newer and loftier triumph . . . Some recognizable images appear – figures, heads, and animal forms – and the composition is modulated in a more traditional way, no longer stating itself in one forthright piece. But everything Pollock acquired in the course of his "all-over" period remains there to give the picture a kind of density orthodox easel painting has not known before. This is not an affair of packing or crowding, but of embodiment; every square inch of the canvas receives a maximum of charge at the cost of a minimum of physical means . . .
>
> Contrary to the impression of some of his friends, this writer does not take Pollock's art uncritically. I have at times pointed out what I believe are some of its shortcomings – notably, in respect to color. But the weight of the evidence still convinces me – after this show more than ever – that Pollock is in a class by himself . . . He does not give us samples of miraculous handwriting, he gives us achieved and monumental works of art, beyond accomplishment, facility, or taste. Pictures *Fourteen* and *Twenty-five* in the recent show represent high classic art: not only the identification of form and feeling, but the acceptance and exploitation of the very circumstances of the medium of painting that limit such identification.[111]

The masks and figures, that is to say, were part of this painter's meditation on medium. They were "the literalness of his emotion"; and in this case, at least, the literalness did not interfere with the harder task (for Pollock) of making his native violence and exasperation part of the painting – part of the pictorial order, not an addition to or interruption of it.

Coming from Greenberg, this judgement on the 1951 pictures may seem strange. But it is not an aberration. Greenberg had known all along that the figure – human or animal or some amalgam of both – was a question that Pollock's abstraction kept open. "Pollock," he says in 1947, "again like

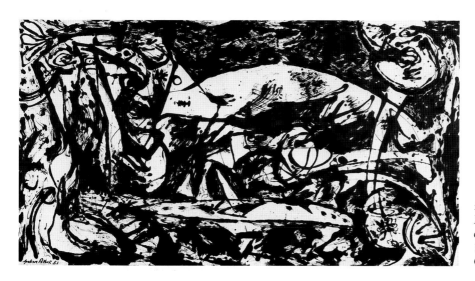

205 Jackson Pollock: *Number 14, 1951*, enamel on canvas, 146.4 × 269.2, 1951 (Tate Gallery, London)

206 Jackson Pollock: *Shadows: Number 2, 1948*, (?) oil and paper on canvas, 136.5 × 111.8, 1948 (Private collection)

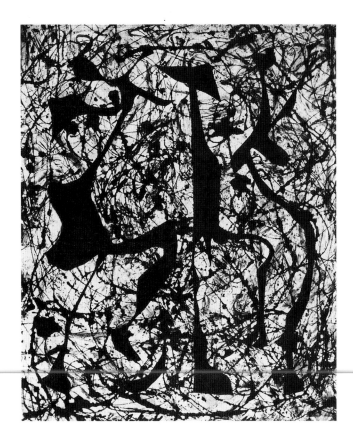

Dubuffet, tends to handle his canvas with an overall evenness; but at this moment he seems capable of more variety than the French artist, and able to work with riskier elements – silhouettes and invented ornamental motifs – which he integrates in the plane surface with astounding force."[112] He has in mind pictures like *Grey Center*, which he later owned, or even *Something of the Past*. These riskier elements did not disappear subsequently, nor did Greenberg pretend they had. Among the paintings he put second in quality to *Number 1, 1948* in Pollock's show the following year was *Number 2*, "the one," as he put it, "with the black cut-out shapes."[113] In the sales records it is already called *Shadows* (fig. 206).

Exactly how the cut-out figures in *Shadows* are integrated in the plane surface is at present impossible to say – the painting has not been shown for thirty years. But "exactly" does seem to be the right word. A lot of finessing has gone into the process. There is what looks to be an initial layer of pastel and light earth-tones, then the cut-outs, and then a tangle of poured black enamel, tying the figures at least partly into their surroundings. The painting connects with several others from the same moment and slightly later, where drip and figure are set up – sometimes just as elaborately, and sometimes with a kind of jubilant naivety – as positive and negative poles, presence and absence, both states likely to reverse their charge at a moment's notice.

There is a pair of pictures from 1948, for instance, the first of them in oil paint built up thickly on paper, with two spindly dancers cut out of the crust (fig. 207); and the second with the two figures stuck onto black canvas and teetering about unstably underneath a final flurry of thrown paint (fig. 208). Again, the adjustments are subtle. The final whiplash of white-on-black is partly responsive to lights and darks already there in the pasted figures, and partly

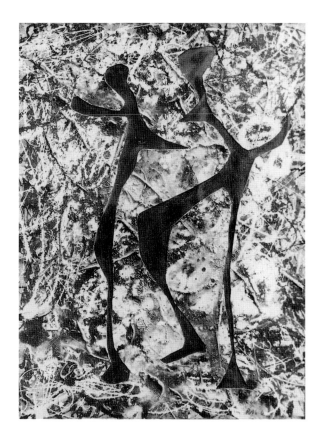

amplifies the figures' movement and tonality. Time has meant that the same white has become two separate colors according to whether it rests on canvas or oil-soaked paper. There must always have been *some* difference, which Pollock depended on to keep his figures spinning in the void. Facility may have a stubbornness of its own – I have to say I find this facility irresistible.

Then there is *Cut Out* (fig. 209), which takes the previous train of thought to its logical conclusion. In it the figure appears quite strictly and visibly in the negative, as that which is absent from the incrusted field.[114] The picture is 30 inches by 23 – all of these paintings are quite small – done in poured oil on paper, with a rough humanoid cut out of the middle, and the paper glued onto canvas, which looks to have been stained beforehand with a few traces of black, gray, and yellow. If there is to be a figure at all in a drip painting, that is to say, it will be one that the activity of markmaking has excluded. The abstract will displace the figurative – cut it out, put it nowhere – and then give the weightless, placeless homunculus just enough character for it to be someone, after all. A few splatters, enough of a physiognomy.

Greenberg was right to say that the elements in this kind of game were risky. The last thing Pollock wanted, in my view, was to end up redoing Paul Klee. The basic idea of *Cut Out* was indistinguishable from a type of modernist kitsch that was rampant in mid-century – always the *Little One Going for a Walk* (innocently, idiotically) through the confusions of the grown-up world. Always the "child" holding up a magic mirror to modernity and keeping its terrors at bay. Was there a way to prevent this tired scenario showing through the splatters, so to speak, and stopping the play of negation? Pollock was not sure. *Cut Out* can be seen in one or two of Namuth's photographs from 1950 (fig. 210), still hanging round the studio – it was begun, by the look of things, a good two years

207 (*above left*) Jackson Pollock: *Untitled (Rhythmical Dance)*, oil on canvas and paper mounted on board, 81.2 × 60.9, 1948 (Private collection)

208 (*above right*) Jackson Pollock: *Untitled*, oil on canvas and paper mounted on board, 78.7 × 58.4, 1948 (Private collection)

347

209 Jackson Pollock: *Cut Out*, oil on paper mounted on canvas, 77.3 × 57, (?) 1948–56 (Ohara Museum of Art, Kurashiki)

210 Hans Namuth, Pollock painting, photograph, 1950

211 Jackson Pollock: *Cut-Out Figure*, oil on paper mounted on masonite, 76.2 × 55.8, 1948 (Private collection, Canada)

earlier – left as cut-out in the strict sense of the word, the figure existing as literal *nothing* in the middle of the paint. It took time to decide what to do with that nothing – to give it just enough of positivity to make it coexist with the crust of paint (the evidence of artwork) eating into its sides. And to take what had been extruded, and make a second painting out of it (fig. 211), endowing the cut out shape with a parody of presence – of cocksure, jaunty, material being-there. Pollock eventually lent the figure a black void again as environment, and filled the void with flashes of random energy, as if fresh specters were taking shape in the dark. This time there is no to and fro between the white pours and the stuck-on homunculus. The pours keep their distance. The yellows and reds in the painting's center float the little one out of the emptiness, and give the body substance of sorts – you might almost say, modeling.

Some of these pictures seem successful to me, others less so. But they all have a one-off, hit-or-miss quality, like prototypes that never made it into production. There is a picture called *Triad* (fig. 212), done for a real estate ad in *Partisan Review*,[115] which is the negative again to the negative of *Cut Out*, and a good example of the bathos that picture was trying to avoid. In *Triad* it is as if the pourings of white had emerged from their black surroundings and congealed into half-human shapes. Presumably some kind of rough stencil was used. So the void is left pitch black, and the flashes of random energy have ended up with almost a well-behaved appearance, going to and fro across the figures like hatching produced by a fairground machine.

Finally there is *Number 7, 1949*, which Pollock afterwards titled *Out of the Web* (fig. 213). It was done later than the other pictures – perhaps as much as a year later – and is three or four times as big. Eight feet long to *Shadows*' 44 inches, four feet high to *Cut Out*'s 2 feet 8. The mannequins have again been extracted quite literally from the field: this time the initial dripping was done on masonite, and the figures then cut out of the crust of paint, down to the masonite backing, when the paint was dry. In comparison with *Cut Out*, I would say the figures are less distinct, or, at least, less obtrusive. A great deal of care (almost of fuss) has gone into folding and sliding them into the general blur of white and aluminum. They are dancing much the same quadrille as *Shadows*, but more deliberately, as if the figures were now obliged to own up to the demon facility and positively use it. Their outlines – in contrast to *Shadows*, say, or even *Cut Out* – are cursive, rhymed, "ornamental" in Greenberg's sense (which is not in any simple way pejorative). Pollock was as capable of whimsy as the next man. There were plenty of good modernist precedents for it. Why not go in for glib biomorphic comedy, Miró-esque and Chaplin-esque, with the dancers all giving a last wave of their club feet and fishtails before disappearing into the shallows? Why should not figurative painting be lighthearted? (By and large Pollock knew that lightness was not his strong suit.)

213 Jackson Pollock: *Out of the Web: Number 7, 1949*, oil and enamel on masonite, 121.5 × 244, 1949 (Staatsgalerie, Stuttgart)

An Ace in the Hole. These are experiments, in method, drawing, and overall tone. They did not come easily. When I talked previously about *Cut Out*'s unfinished status in the studio photos of 1950, I said "It took time to decide." In fact, I am not sure that Pollock ever did decide. One of the photos Hans Namuth took in the same studio in 1956, a week or so after Pollock's death (fig. 214), shows *Cut Out* pinned to the wall over another painting. It still has its center empty, though Pollock was obviously looking for a sequence of marks to fill it up – that was the point of the exercise. The marks he selected are easily recognizable. They come from a picture that was first shown separately two years later, as *Black and White Painting*, 1951–52 (fig. 215). The picture was shown the other way up – compare not just the 1956 photo, but others taken in 1951 (fig. 216), where it is still part of a larger unit – and it was signed. The signature, as far as I can see, was not there at Pollock's death.

What this amounts to, I think, is that Lee Krasner made *Cut Out* in the form we have it. Whether she should have is not a question that interests me much. She made a good painting, and the 1956 photo suggests she made it on reasonably good grounds – on the basis of experiments (pinning-up and looking) which she saw were still under way. There will be differences of opinion as to whether the solution Pollock had on the wall at his death would have been a better one. In it, the balance between figure and field would have been crucially different. The black and white markings within the cut-out would have been much stronger. Certainly the black and white painting Krasner salvaged as a result of all this is notably weak.

The point of the story is not art-world-ethical but aesthetic. *Cut Out* is one of Pollock's triumphs, I think. Critics have rightly been eloquent about it – notably Michael Fried. But it is a triumph of a hair's-breadth kind: there are no rules for putting the figurative and abstract back together again once the abstract has arrived. No available criteria, no leaning on facility. These are the circumstances in which pictures most need interpreters, even ruthless ones. And not just interpreters, collaborators. Modernism is full of novels and poems rescued from the wastepaper basket by their authors' best friends.

214 Hans Namuth,
Pollock's studio,
photograph, 1956

215 Jackson Pollock:
*Black and White
Painting*, oil on canvas,
87.6 × 77.8, 1951–52
(Private collection)

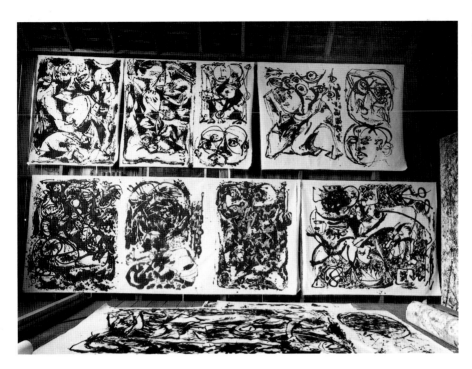

The Wooden Horse. Putting the pictures with figures from 1947 to 1950 into a sequence, as I have just done, is not meant to seal them off from the general run of work going on all round them. They are pictures *made out of* drip paintings – experiments the new technique gave rise to. Other tactics intersected. Under the spell of the larger drip paintings, we tend to overlook those many pictures from this period (most of them modest in scale) where the interlace of line is exactly not even and all-over, but centered, sometimes vertical, and prone to give rise to the figurative again. Sometimes the suggestion is wild and approximate, as if the painter's wish had been to conjure up the shadow of figurative expectations in order to do violence to them more effectively. I have in mind a picture like *Number 10, 1950* (fig. 217), which is the brashest and largest of its type, but there are others. Sometimes the mood seems parodic or fanciful, as in the *Cut Out* series. Triads put in an appearance, or ghostly fish faces.[116] Often the comedy gets overtaken, more or less, by an access of the old Gothic-ness and stridency.

This is certainly true of *Number 10A, 1948* (fig. 218), another picture that stayed in Pollock's studio until his death. According to Lee Krasner he called it *The Wooden Horse.* It was shown in his lifetime with the title *Horse's Head.* The picture is a collage: brown canvas mounted on board, painted in oil and duco enamel, with a stuck-on head from a hobbyhorse, two or three inches deep. The collage inevitably turns on the issue of likeness – the horse's head is inescapable – and in a sense its tactics are the same as *Cut Out*'s. There is the field and the figure, the found object and the object-not-being-found, and the two only make sense – conceptually and visually – as negations of one another. The picture's tone, however, seems to me different.

"Likeness is easy," says the hobbyhorse head. "It happens without us even meaning it." (One of the reasons Pollock chose to use the hobbyhorse fragment, as I understand it, was the classic duck-rabbit reversal thrown up by the ragged end of the horse's neck, with its notches standing for another creature's nose, mouth, and chin.) "To avoid likeness as you do is just bravura, the last kind modern painting allows itself, and as meretricious as all the rest."

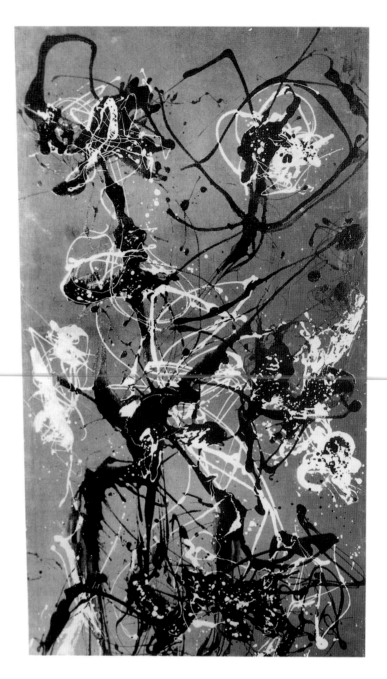

217 Jackson Pollock:
Number 10, 1950, oil on
canvas, 165.1 × 92.7,
1950 (Private collection)

To which the oil and duco reply, just as vehemently: "At least the test you propose is the right one. If the painted marks in this picture do not strike you as really aimless, then they have failed. If they come across as skillful – even in the art of avoiding skill, or dismantling it – then the game is up. For aimlessness is the heart of the matter. Painting now stands or falls exactly by its ability to show what gets in the way of likeness, and to what extremity art must resort if it wants to make likenesses in spite of everything. For modern art [remember this is the oil and duco's opinion] has never been driven by a dogmatic wish to avoid the pursuit of resemblance per se, but by the belief that in present circumstances it could only reinvent the possibility of making and matching by having it be exactly that – a possibility, not a foregone conclusion. These thrown lines, this wretched meandering – the scratches of blue, red, and yellow

354

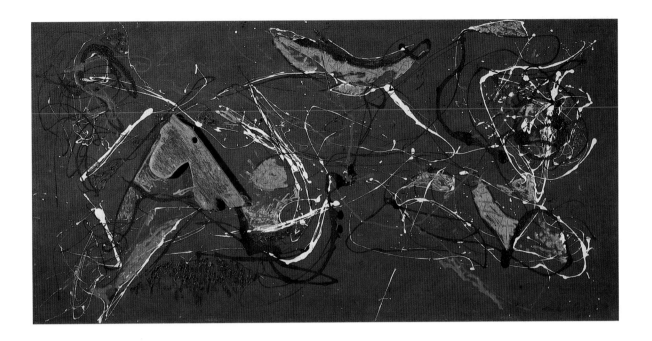

that (almost) fill them out and give them body – they are ways of circling *around* likeness, looking for likeness in those movements of matter and body where you would least expect it. With always the chance that it will not be found.

"And here is the cause (or, at least, the technical and conceptual precondition) of modern painting's obscurity. This is what strips it of its skills, and pushes it back time and again to the infantile and disorganized. Not that it occupies such territory with enthusiasm – how could anyone looking at *The Wooden Horse* not see the depth of the painting's disdain for its own language? – but there is no other ground, it reckons, on which painting might rediscover itself as exploration, rather than dead entertainment. Of course modernism in general leans on the artless and childlike as a crutch. But the clichés may still be revivable. At any rate, they are all we have. There may still turn out to be a kind of artlessness that has power to wound. Or an encounter with childhood touched by Little Hans's fears. Out of this scrawling, a world may emerge."

Two. I realize there is an element of bizarrerie involved in staging *The Wooden Horse* as an *agon*, and giving its different idioms voices. But the picture is an argument, it seems to me. What marks it off from most previous uses of collage is the sheer extremity – the shrillness – with which collage and painting are opposed: the absolute of blandness on the one side, and the hectoring and exasperation on the other. We may think the opposites end up all but pulling the picture apart, aesthetically: certainly the hobbyhorse head is no sufficient fulcrum (nor meant to be). There is likeness and its opposite, the "found" and the "unfounded": what we know too well already, and what we know only "out of the unconscious." Whether the one kind of representation contradicts the other (as I think Pollock believed it could) depends on the velocity at which they collide.

Male and Female. One thing the figures in the 1947 to 1950 pictures share is that none of them has much of a gender. I believe this is new in Pollock's work, and marks the drip painting period off from the four or five years

218 Jackson Pollock: *The Wooden Horse: Number 10A,* 1948, oil, enamel, and wood on brown cotton canvas mounted on board, 90.1 × 190.5, 1948 (Moderna Museet, Stockholm)

preceding it. Gender, and more specifically sex, had been at the root of Pollock's figuration from 1942 to 1947. Among the ways in which he seems to me to have made good the main claims of Surrealism (in contrast to most others operating under the movement's banner) was in his ability, or willingness, to conjure up the terror of sexual phantasy – terror to the phantasizer as well as to the phantasized. Whatever else *Cut Out*, *Shadows*, and *Out of the Web* may be, they certainly lack *terribilitá*. Put them alongside *Male and Female* (fig. 219), or *Two*, and they look almost wilfully bland.

Not that I am saying gender distinctions were previously clear in Pollock's paintings, even or especially when they bore down heavily on matters of sex. Sex for Pollock most often was splitting and merging and rending and tearing. Most of the efforts of later commentators to get a fix on the dramatis personae involved in the case, even down to their secondary sexual characteristics – here an ejaculating penis, there the endowment of Diana of Ephesus, here a chicken making off with the tip of a finger – seem to me ludicrous, and to miss the point of the *pictures*' ludicrousness. Pollock is always aware that sexual theatrics (in painting) are, on one level, deeply silly. Generative but puerile: I should say generative because puerile. In a word, "masculine." But even with these provisos, it is plain as day that sex is the driving force in the earlier paintings. It is what we are expected to look for and not find. In *Cut Out* and *Shadows*, that is not the case. "Abstract" in them means generalized to the point of disappearing, or not being relevant.

Huge questions occur here, which I shall deal with only glancingly. Would it be fair to say, for instance, that the figures in the 1947 to 1950 pictures could afford to be sexually anodyne because the real gender dynamics underlying them – which had powered the paintings of the earlier 1940s, and still did – had been absorbed into the very texture and structure of the larger, fully abstract work? "Paradigms of relationship," to quote our critic of *Lear* again, "and shared images of authority penetrate the work of art and shape it from within." Well, maybe. No one in her right mind would want to deny that Pollock's drip paintings are implicated in a whole metaphorics of masculinity. The very concepts that seem most immediately to apply to them – space, scale, action, trace, energy, "organic intensity," being *in* the painting, being (or hoping to be) *One* – are, among other things, operators of sexual difference. The operators served Pollock well. He became a master: that is to say, part of the pact he made with his viewers involved them coming to see the (self-) risks he had taken and to appreciate the physical powers he had at his command: he expected the public to empathize with his "Gothic-ness, paranoia and resentment," and see them as part of his being a man. He got his wish.

All this is true and limiting (it takes us to the heart of what goes on preventing "Pollock's art" from ever getting out from under "Pollock the man's" shadow); but in my opinion it is not the be-all and end-all of the issue. My argument so far has been that the drip paintings are involved in an effort to dismantle or jam metaphor, or, at least, not to have metaphor congeal into totalization; and one aspect of that dismantling, it seems to me, is a gradual questioning or bracketing of the "masculine" theatrics of, say, the handprints in *Number 1, 1948*. Of course the questioning is partial and incomplete. All the same, I would argue that *Lavender Mist* or *One* or *Number 1, 1949* are no longer propelled by the myth of entry, action, and immediacy on which the drip paintings were founded. Maybe that was partly the reason Cecil Beaton and Parker Tyler could make use of the later paintings in the way they did. Not that I want to claim that those paintings stand in any sense outside the myth, nor that their touch and scale do not continue to reek of maleness. There are, after all, still handprints visible in *Lavender Mist*, soldering the picture's edges and corners, and pro-

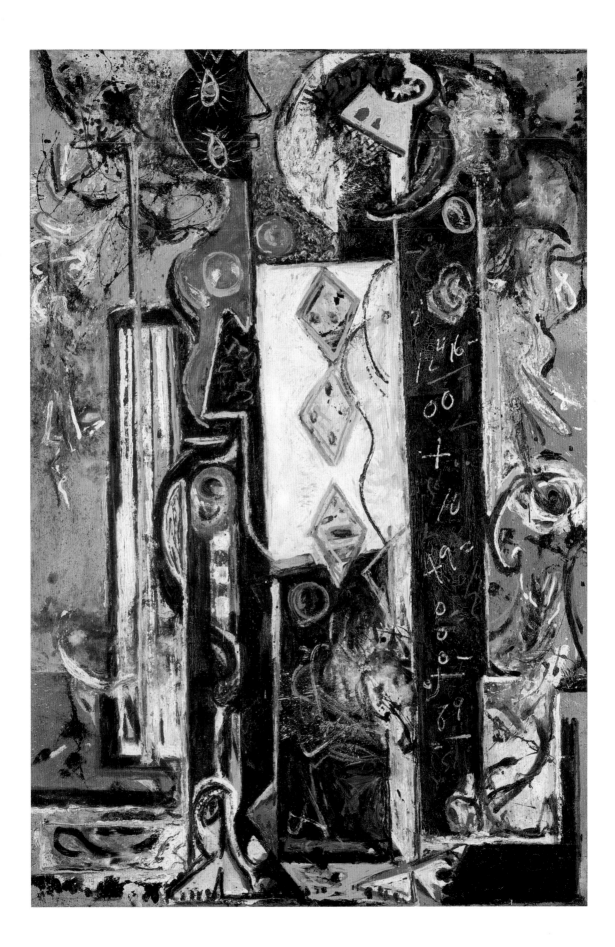

claiming the artist's physical, once-for-all being-there. But there are ways and ways of declaring oneself a master: the new prints, as I said before, seem in many ways meant as the opposite of the earlier ones: they are robbed of their self-assertive, heroizing tone. (And even *Number 1, 1948* cannot be described as self-assertive and heroizing just because it contains self-assertive and heroizing episodes. That way utter crassness lies. I for one, for reasons given earlier, would say that the whole account of mark, self, and masculinity offered by *Number 1, 1948* is deeply unsettled. It has tortured its line into conformity with the impending disaster.)

Again, I do not want for a moment to suggest that Pollock's art ever stopped being Gothic; and the heart of its Gothic-ness, clearly, was its veering between sexual rage and euphoria. *One* is to *Number 32, 1950* as *The Little King* is to *Circumcision*. It may even be that part of the coming-to-an-end of Pollock's abstraction in 1950 had to do with this previous gendering of technique beginning to evaporate, perhaps under the pressure of sheer scale – to the point where practice no longer seemed rooted, or rooted firmly enough, in some fictive project of self-risk and self-realization. The dread word "decorative" loomed. And Pollock was profoundly in two minds about the complex of problems the word brought in its wake. One side of him seems always to have been looking for a way for art to be "background" (for some reason still the ultimate pejorative!) and not forfeit aesthetic coherence. Peggy Guggenheim's *Mural*, in that sense, set the parameters for the rest of the decade. It remained a touchstone.

Or rather, it remained a touchstone as long as Pollock was capable of painting abstractly. What Pollock turned back to in the black paintings of 1951 was assuredly a language "modulated in a more traditional way." Greenberg as usual intuited what was most deeply at stake. "The more explicit structure of the new work reveals much that was implicit in the preceding phase and should convince any one that this artist is much, much more than a grandiose decorator."[117] The point is that no one ever was convinced, least of all Pollock. And the time was past when he felt able to glory in his not being sure. "What each work said," this is Clyfford Still writing to Pollock in 1953, "what its position, what each achieved you must know. But above all these details and attentions the great thing to see came through. It was that here a *man* had been at work, at the profoundest work a man can do, facing up to what he is and aspires to."[118] There would be plenty more where that came from.

Male and Female in Search of a Symbol. "Pollock's titles are pretentious," said Greenberg in 1943. He was not far wrong. And so were the paintings – hopelessly, incorrigibly pretentious, as if painting from now on had no choice but to fuel itself on dime-store totemism and *New Yorker* psycho-analysis. Maybe it did have no choice. Anyway, I do not think that because Pollock's sexual mythology was embarrassing the part it played in his art was small, or simple. We are still nowhere near understanding it, in my view (having been utterly sidetracked by a debate over whether or not these pictures – just look at them! – follow scripts from Jung). What I offer here is no more than a series of notes toward a first understanding, always with the main question, of Pollock's markmaking and mythology between 1947 and 1950, driving my choice of topics.

Certainly the earlier paintings turn on some kind of horror at sexual difference. The first germ of *Male and Female*, for instance, seems to have been a drawing in ink and crayon on a sheet from the very early 1940s (fig. 220). The drawing hardly needs commentary. Copulation in it is portrayed as an upright

220 Jackson Pollock:
Untitled, ink and crayon
on paper, 52.1 × 66.3,
ca. 1939–42
(whereabouts unknown)

and basically ludicrous sacrifice, of dignity and identity. Penetration is a laying
of horizontal tracks, which seem to belong to neither party. The man looks up
from the mêlée toward the sky, and sees (in his mind's eye, by the look of it) a
Miró-type aeroplane in flight. A kind of a "lie back/stand up and think of
England/transcendence" scenario. The whole thing reminds me of nothing so
much as Leonardo's famous (inaccurate) notation of the same subject in his
notebooks. The rest of the doodlings on Pollock's sheet, especially the cryptic
male(?)-head-next-to-haunches(?) adjacent to the unhappy couple, only confirm
the general atmosphere. I should say that the atmosphere is less one of misogyny
than of an attempt – of course it is unsuccessful – to rise above the horror and
ludicrousness, and manage to be comic on the subject. Comic or scientific. The
amoebas having intercourse left and center are straight out of Freud in *Beyond
the Pleasure Principle*, brooding on undifferentiated vesicles and stimuli.

I do not want to claim that *Male and Female* in its painted version moves very
far from this point of origin. Scale makes a difference, of course. It means that
the basic idea of uprightness and rigidity can be insisted on with a vengeance –
materialized, not to say fetishized – and that space exists for the amoebal
couplings actually to enter the Male and Female preserve, though only as
marginalia. (Contact between vesicles becomes an explosive spraying and
scrawling, which hereafter recurs as Pollock's preferred sign of organic energy
in the big pictures from 1943 to 1945 – *Pasiphae, Mural, Gothic, Guardians of
the Secret*. It is the *ur*-form of his later non-figurative pouring.) All I would say
in *Male and Female*'s favor – and, like it or not, one does end up defending or
prosecuting pictures of this sort – is that it manages its attempt at comedy
somewhat more convincingly than the first sketch. It is comic above all about its
own expository (long-suffering) tone. The painting is a blackboard. This is sex
education, with sperm counts and percentages of failure. It aims to get the
unmentionable up front, and do a working diagram of it.

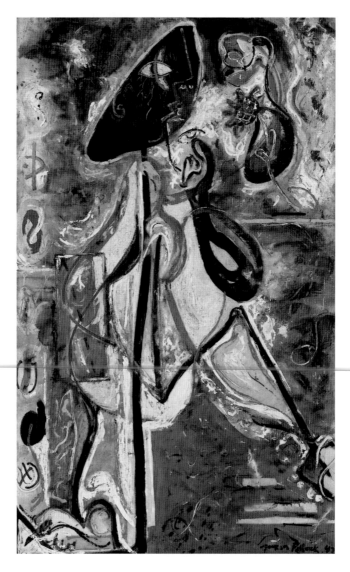

221 Jackson Pollock: *The Moon-Woman*, oil on canvas, 177 × 107, 1942 (Solomon R. Guggenheim Museum, New York)

This mode is repeated in several of the key pictures from the same moment – in *Stenographic Figure*, for example, and *The Moon-Woman* (fig. 221), *Two*, and *Totem Lesson 1*, and certainly in the pathetically titled *Male and Female in Search of a Symbol* (fig. 222). When Sidney Janis tried to be lugubriously playful about the latter – "your new 'personage over and about the conference table'," he called it – he was at least getting closer to its tone than the squads of po-faced exegetes who came later. The tone is truly bizarre. The point is that the pictures are trying, too hard, to be playful and pretentious in the same breath. To get what they want while pretending not to want it *really*. The last thing I mean to do by bringing on the word "comedy" with reference to them is to suggest we should bracket the other words that obviously come up – like violence, portentousness, horror, scatology, Totem and Taboo. All I want to insist on is that the peculiar quality of Pollock's art when it was figurative – I mean its peculiarity *and* its quality – was bound up with an ambition to invent a truly capacious, truly omnivorous form of the grotesque, in which Picasso would collide with Miró. Sometimes that happened, I think. *Male and Female*, *Pasiphae*, and *Guardians of the Secret* are as black as comedy can get without turning into something else. Even *Moby-Dick*, remember, has episodes of tragic tomfoolery.

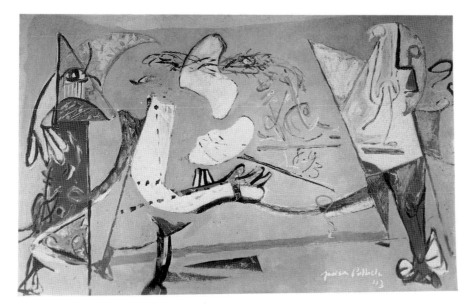

222 Jackson Pollock: *Male and Female in Search of a Symbol*, oil on canvas, 109.2 × 170.1, 1943 (Private collection)

Wounded Animal. No one is suggesting, in other words, that comedy in Pollock ever reconciles the Unhappy Consciousness to its fate. It is Pollock's way of raging against it. *Something of the Past* is an Hegelian title most deeply, I think (see the following chapter), but also a Freudian one. "Everything past is preserved," as Freud put it in *Civilization and its Discontents*. Hence Pollock's paintings' congestion. Hence their rancor and repetitiveness. A whole history of modernism could be written, I think, in terms of the cross-fertilization between Hegel's pessimism and historicism, and that of the Freudians. Pollock would be as much a central instance as Cézanne. Both of them compounds of Frenhofer and the Wolf Man.

Could we even read *Two* and *Male and Female*, then, as Pollock's (predictably slapstick) restaging of the striding figure/dreaming figure drama in the Barnes *Bathers*? Only now, of course, phallic mother and disconsolate son stand next to one another and exchange blows. Or is it bodily fluids? With Pollock one can never be sure.

Watery Paths. One main term of the earlier paintings, that is, was sexual difference run riot. The other was writing. *Guardians of the Secret* (fig. 223), *Male and Female*, and *Stenographic Figure* are only the most obvious examples of a procedure – I should say, a subject-matter – that haunts the figurative painting all through. Bodies, rather in the way of the dead Marat, are constantly holding up scripts. And of course the boundary line between body and script is not clear, for all that boundary lines so often seem what bodies *are* – lines drawn with a ludicrous geometric overkill, frantic lines, dividing lines, rigid designators, lines drawn in the sand.

Oh! but the nature of line-making (say the paintings) is to outrun the human work of division and become inhuman arabesque. That is to say, writing. Writing that never stops making distinctions (not for Pollock the utopia of the endless self-same), but so many, and so over-emphatically, that they end up as snakes devouring their own tales. The snakes being always would-be phallic. This is the hopeless, self-consuming linear energy that drives *The Moon-Woman* and *Totem Lesson 1*. I guess I am saying, to put it in a nutshell, that the war against line which Michael Fried rightly seized on as basic to Pollock's

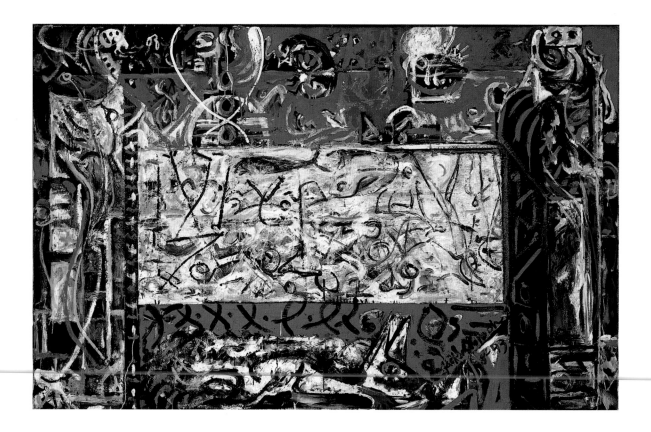

223 Jackson Pollock: *Guardians of the Secret*, oil on canvas, 123.8 × 190.4, 1943 (San Francisco Museum of Modern Art, Albert M. Bender Collection, Albert M. Bender Bequest Fund Purchase)

abstraction was rooted in a previous (maybe continuing) dream of gender writing itself to death. This again is phantasy, in my view – and profoundly a masculine one. Men always think they can write their way to the woman inside the snorting bull or sleeping dog. And so have their sadistic cake and eat it. The dream is futile and nasty. As so often, the more difficult question is whether the energy (the forms) released by the dreaming simply enforces the dream-content, or puts viewers in mind of its limits.

The Little King. Somewhere hereabouts are the means to press home the comparison between Pollock and William of Aquitaine with which this chapter began. The contrast is one of class, obviously. Pollock's art is little as well as kingly, and owes its pathos precisely to its not flinching from either side of the equation. That is what I tried to argue in the case of *Number 1, 1948.* Years ago, writing about Clement Greenberg, I quoted him saying in a footnote, by way of apology for his own artistic preferences: "It's Athene whom we want: formal culture with its infinity of aspects, its luxuriance, its large comprehension."[119] And I added to the list other qualities we tend to associate with high art (that European episode) at its best and worst: "intransigeance, intensity, and risk in the life of the emotions, fierce regard for honor and desire for accurate self-consciousness, disdain for the commonplace, rage for order, insistence that the world cohere."[120] These are specifically feudal ruling-class superlatives, I said then, and ones the bourgeoisie believed (for a time) it had inherited.

Roughly speaking I stand by this. Pollock will pass the test of time, I think, because his work both *is* our image of these qualities, and of the tortuousness and hopelessness involved in trying to preserve them. I see this ultimately as a drama of class (again, see the following chapter). But of course I do not claim

that the drama of class is spelt out directly in Pollock. Littleness and kingliness occur in his art only insofar as they are part of a dream of sex – a staging of sexual powers and humiliations. Maybe I believe (we are back to an aspect of Foucault's argument) that this too – the fact that selfhood can only, or most poignantly, be staged in terms of "sexuality" – is part of a bourgeois economy of bodies. But that does not alter the first work of interpretation (which in Pollock's case has hardly begun). All of the qualities Greenberg and I list are, for Pollock, first and foremost qualities of bodies on their way (or not on their way) to orgasm. Class may or may not be "what Pollock has to say" – what he says it with is always gender. "Non er d'amor ni de joven" could never have been his motto.

War. The drip painting that seems to me closest in temper to the nightmares of 1943 and 1944 is *The Wooden Horse*. To that extent it is an exception, almost a holdover, in the drip painting period: it does not represent what Pollock normally hoped and worked for from his new technique. The pouring here has stopped short too soon. The point was for it to go further, to take over more fully from the Unhappy Consciousness and give rise, at least tentatively, to "states of order." Out of these might eventually come a new kind of figuration, and even of sexual difference – one not "cut out," not negative, not introduced by fiat, not unformed nor unfounded but *One*. Which brings me to my starting point, the photographs in *Vogue*.

Mentioning them in the same breath as *The Wooden Horse* may seem like loading the dice. I do not do it to glorify one moment of Pollock's painting at the expense of another, or even to stigmatize the whole of abstract painting by associating it with haute couture. The word "fashionable," as Michael Fried's use of it demonstrates, is likely to recoil on all of us in time. What the juxtaposition is meant to suggest is simply that abstract art has lived for much of its life in productive anxiety about the uses the culture might make of it. In particular it has claimed (not only in 1920) that the orders art would discover by doing away with resemblance would be the opposite of easy or enticing: they would not simply be "decorative." The claim was serious, and had real effects. But insofar as the claim is testable by looking at what society actually did with abstract works of art, then we could say that indeed they have been thought to be decorative, and put through their paces in that spirit. They have seemed the appropriate backdrop to ball gown and bolero, to the black-tie "do" at the local museum, and the serious business of making money.

Of course, someone might reasonably reply at this point that any culture will use art as it sees fit, and that the very idea of art resisting such incorporation is pie in the sky. At a certain level of low or high cynicism, there is no answer to that. At other levels, a few unsatisfactory answers occur. Yes, this idea about art's relation to its host culture is pie in the sky; but so are most, perhaps all, other ideas about art's purposes and responsibilities – art as the vehicle of Truth or transcendence, for one; art as distilling the hard possibilities of *Geist*; art as opening onto a territory of free play and pleasure; art as putting an end to reference and being able to live off its own resources; art as Universal and Particular (seeing the world in a grain of sand); or art as the real form – the pure expression – of Individuality. The pie in these cases is so far in the sky as to be considerably less visible, to my way of thinking, than the pie we are looking at – the pie of resistance and refusal. And the test in all cases is not, it seems to me, the cogency or adequacy of the discursive claims, but whether the claims have led to production – whether the claims, for all their muddle and double-think, have been associated with real complexity in the work of representation.

I think they have. There is a line of art stretching back to David and Shelley that makes no sense – that would not have existed – without its practitioners believing what they did was resist or exceed the normal understandings of the culture, and that those understandings were their enemy. This is the line of art we call modernist. Pollock is part of it: perhaps at the end of it, perhaps not: it is hard to tell at present whether ideas of resistance and refusal have any sustaining force still left them, or have been hopelessly incorporated into a general spectacle. The ideas have an old-fashioned ring to them, it is true; but then, so does the parent culture. This is (still) the age of Reagan and Deng Xiaoping, not of Baudrillard and Bill Gates.

In any case, the question is about the past, not the present – about the force these beliefs once had, in Pollock's art and before him. I shall put it dogmatically. In the visual arts since 1850, it seems as if no work of real concentration was possible without it being fired – superintended – by claims of this kind. The test of art was held to be some form of intransigence or difficulty in the object produced, some action against the codes and procedures by which the world was lent its usual likenesses.

This leads me back to *The Wooden Horse* (fig. 218). For if the test of art is intransigence, then surely it is clear – or at least understandable – why "abstract" and "figurative" go together in Pollock's practice, and so much other modernism. A work of art will only strike the receiver as difficult, I have been arguing, if it succeeds in showing (or intimating) what its work against likeness is for or about: on what other basis in shared experience it might be seen to rest, how it could alter our attitudes to objects and processes we recognize as held in common: in a word, what the meaning of abstraction is, as applied to these materials (this "world"), at this particular moment. Again, do not misunderstand me. The objects and processes we may agree we share – and none of this commonality is ever fixed – include the objects and processes of art. So part of our reaction to *The Wooden Horse* is bound up with the fact that it has its way so violently with notions of unity in a picture, and with what normally counts as drawing, shading, and "touch." Part of our difficulty has to do with having the category Art disrupted. ("Is this a painting?," as Pollock once asked about one of his own.[121] Whatever work against likeness Pollock was doing, that is, had to be done not just against likeness but against *painting* – on the edge of the category Art, in places where criteria for Art-ness were lacking. I think this is why, even after forty years in the museum catacombs, Pollock's paintings tend to make their neighbors seem too much like paintings for the neighbors' own good. It is no use disposing of all other forms of likeness, it turns out, and yet depending on the likeness to Art.)

"Part of our difficulty," I said. Not all. What is hardest to take about *The Wooden Horse*, I think, is that in it the work against resemblance is still going on, and looks like it will go on forever. Nothing will finally put paid to making and matching. The banal simulacrum of horse will always win. A painter can seize on our infantile certainty about reference and parrot it to the point of disintegration (like a word repeated until it becomes pure nonsense). But "horse" is still there. Reference is imperturbable. Abstraction is parasitic on likeness, however much achievement in abstraction may depend on fighting that conclusion to the death. The "non-figurative" happens because the world no longer falls into an agreed order of images, or one not overlaid with lies (*The Wooden Horse*, as a title, is full of undertones of deception). There may be ways in which abstract art can incorporate these conditions of its existence into itself, and have them be signified. Perhaps no such ways exist. I believe Pollock thought they did, or they might.

Grey Center. But even this much of affirmation, hedged in as it is by "mays" and "perhaps" and "mights," strikes me on second thoughts as too much. It says the wrong thing about Pollock's abstraction. It is still too conclusive. What I want to say, finally, is that Pollock's painting in its best period, from 1947 to 1950, is contradictory: it lives on its contradictions, thrives on them, and comes to nothing because of them. Its contradictions are the ones that any abstract painting will encounter as long as it is done within bourgeois society, in a culture that cannot grasp – for all its wish to do so – the social reality of the sign. That is to say: on the one hand, abstract painting must set itself the task of canceling Nature, and ending painting's relation to the world of things. It will make a new order to experience: it will put its faith in the sign, in the medium: it will have painting be a kind of writing at last, and therefore write a script none of us has read before. But on the other hand, painting discovers that none of this is achievable with the means it has. Nature simply will not go away. It reasserts its rights over the new handwriting, and writes a familiar script with it – the script of *One*-ness, *Autumn Rhythm*, *Lavender Mist*. So that painting always reneges on its dream of anti-*phusis*, and comes back to the body – that thing of things, that figure of figures. It cuts the body out of the sign, out of the field of writing.

There is a story about Mondrian in New York, dancing to his beloved boogie-woogie, and all at once the band switches to another kind of jazz. "Let's sit down," says Mondrian to his partner, "I hear melody."[122] This is the dream and disappointment of abstraction in a nutshell. The idea of an art made in outright opposition to the Natural – an art without melody, that is – is a great notion, and a hopeless one. The band will always pick up the tune. "Let's sit down. I see a figure." So let the figure be in the picture on purpose – in the negative, taking the lordly, footling, rudimentary form that is the best (or worst) that painting can do with it. Let it be there as negation – as the sign of antinomy, not dialectic. For the grounds are lacking on which the great contraries of bourgeois art – its claim to Nature and its wish for the free play of the signifier – could be dialectically reconciled.

The Mask. I see two or three ways this chapter could end. One would be concrete and limited. I could steer back to the *Vogue* photographs one last time (figs. 177 and 178), and make sure some basic (uncomfortable) points have not got lost in the flurry of argument. Nothing I have said in praise of Pollock's painting was meant to suggest that the bad dream of modern art – the one voiced by Foucault and Tafuri – can be shrugged off. The photographs are nightmarish. They speak to the hold of capitalist culture: that is, to the ease with which it can outflank work done against the figurative, and make it part of a new order of pleasures – a sign of that order's richness, of the room it has made for more of the edges and underneath of everyday life. There is a danger in any discussion of modern art that the Other to modernism – the normal understandings it is supposed to be resisting and refusing – will come to seem a dead formula. But that Other does exist. The *Vogue* photographs show it. They show the sort of place reserved within capitalism for painting like Pollock's. These are the kinds of functions it is called on to perform, and the public life it can reasonably anticipate. Nothing it can do, I think, will save it from being used in some such way as this.

But that is a general verdict, and too lofty and final to be of much use. The fact is that some painting makes this public life its matter, and fights for room within and in advance of it. "Harmonizing with some of the elements in this environment and striking a dissonance with others." Pollock's painting

attempts this, I have been arguing: that is to say, it turns back to the root conditions of its own abstractness, and tries to give them form. The form it chooses is refusal of aesthetic closure: cutting out, interruption, efforts at infantile metonymy: dissonance meaning mimesis, meaning sensuousness *as well as* "Gothic-ness, paranoia, and resentment" – the one set of qualities in the form of the other.

Going West. Another way to end would be this.

Here is a voice talking about abstract painting. It could be any Western speaker from toward the end of the Cold War: any Westerner having his say about Soviet Russia, Socialist Realism, and what we do in America. It comes from a book called *Where the Nights are Longest: Travels by Car through Western Russia* – but where it comes from is unimportant. This is a piece of bourgeois wisdom. It is *Vogue* speaking:

> The fear of abstract painting, which may unlace the understanding to a world less simple than was apparent, is the fear that primacy may pass to the private, rather than the collective, vision. And there can be no return, once the journey has started, to tribal innocence.[123]

I like the idea of some refurbished ex-Party hack in Vitebsk or Kharkov now mouthing the same script.

And here is another voice – one much closer to Pollock's time and world view, speaking to the First Closed Session of the American Artists' Congress in 1936. Abstract art is on the speaker's mind, and he does not much like it:

> As in the fantasy of a passive spectator, colors and shapes are disengaged from objects, and can no longer serve as a means in knowing them. The space within pictures becomes intraversable; its planes are shuffled and disarrayed, and the whole is re-ordered in a fantastically intricate manner. Where the human figure is preserved, it is a piece of picturesque still-life, a richly pigmented, lumpy mass, individual, irritable and sensitive; or an accidental plastic thing among others, subject to sunlight and the drastic distortions of a design. If the modern artist values the body, it is no longer in the Renaissance sense of a firm, clearly articulated, energetic structure, but as temperamental and vehement flesh . . .
>
> The individual is identified with the private (that is, the privation of other beings and the world), with the passive rather than active, the fantastic rather than the intelligent. Such an art cannot really be called free, because it is so exclusive and private; there are too many things we value that it cannot embrace or even confront. An individual art in a society where human beings do not feel themselves to be most individual when they are inert, dreaming, passive, tormented or uncontrolled, would be very different from modern art. And in a society where all men can be free individuals, individuality must lose its exclusiveness and its ruthless and perverse character.[124]

What I have quoted is the end of a speech to the Congress by Meyer Schapiro, but again, whose voice this is does not matter. It could be anyone, almost: any old Stalinist in full cry, exhorting us to wake from our separate (temperamental) dreams.

These are the voices, alas, that call the tune of abstract art. It is as if for some reason the matter of abstraction can only be talked about in terms like these: as if our culture needs abstraction to be a little battlefield of basic cultural pieties: individuals versus collectivities, freedom versus tribalism, anti-Soviet drivelling versus Stalinist high moral tone. This seems to me a reason for studying abstract

224 Gerrit Rietveld,
Schroeder House,
Utrecht, 1924–25

art, not for avoiding the subject: something is at stake here, producing these
false alternatives: but the fact that this is the general currency of debate does not
make the job exactly easy.

Something of the Past. Abstract painting (this is my third attempt at
an ending) could perhaps be compared to one of the forms of art it was
supposed to replace: the series of strict classical and medieval revivalisms that
formed such an important part of the nineteenth century in architecture and the
other visual arts. We have given up feeling superior to that revivalism, and
nothing we can say now is likely to derogate from Labrouste's achievement, say,
or Furness's, or Puvis de Chavannes's. Does that mean we should learn to act as
Labrouste's or Puvis's spokesmen, and simply dismiss what the earlier twentieth
century saw in them of desperation, dogmatism, pedantry, pomposity, dim
fantasy, brittle didacticism, overbearing and empty utopia? I do not think so.
These things are written into revivalism, just as they are into the project of
abstraction. Suppose that our object of study were the Bibliothèque Sainte-
Geneviève, or Puvis's *Summer*, or UNOVIS, or Rietveld's Schroeder house in
Utrecht (fig. 224). What we should need to see first, in each of these cases, is the

225 Unknown photographer: Mondrian's Paris studio, 1929 (Gemeentenmuseum, The Hague)

226 Unknown photographer: Malevich in his coffin, 1935 (Stedelijk Museum, Amsterdam)

work's embattled resistance to the century it lived in – the fierceness of the acts by which it hoped to direct and compel attention, the effort to make meaning irrefutable, to "condense and compress" it, to reduce it to its bare elements. We should need to understand what it was these works seemed to think they had to exclude from their world-making – what made for the distinctive brittleness and thinness of their formal language.

None of this would be done to belittle Labrouste and Puvis, any more than Malevich and De Stijl. It would be done from a sense that this was what the phenomena were like, and that pointing to their deficiencies is pointing to their

strengths. Coming to understand a work of art, or a line of art – coming to see the way a certain idiom makes sense in retrospect – is not the same thing as apologizing for it. A history of abstract painting is different from a public relations exercise on its behalf.

I know very well that nothing I can say will stop the exercise from continuing. There is something about the object in question that elicits it: abstract art is perniciously lively, but always seemingly on its last legs. And it has to be protected: something is at stake in it: something the culture as a whole is still trying to sort out, of which this art is an emblem.

Emblematic of what, precisely? Of the true form of individuality, or the false one? Of the free play of the signifier, or the impossibility of any such play – until the moment, that is, when the sign is discovered again as common property or collective work? Of *Victory over the Sun*, or *Victory Boogie-Woogie*? Of a concrete, practical, hands-on world; or of some final giving-over of the self to an endless shifting – and even a kind of glorying in that condition – "the positive moment of practising what it does not understand"?

Considered at all coolly, these claims and metaphors of abstraction are senseless. They put too much weight on the business of making a picture. And no doubt I have been infected by the general atmosphere of rhetorical overkill: this chapter has spent too much time snooping round Pollock's studio, looking for culture heroes and signs of art in crisis. Not that I intend to draw back at the last moment. My ending by bringing UNOVIS on stage, and Rietveld, and Mondrian, and the whole previous history of modernism's intransigence, is meant to raise the stakes, not lower them.

Put the photograph of Pollock at work on *One* (fig. 202) alongside Mondrian's Paris studio (fig. 225), or next to El Lissitzky's propaganda board, or to Malevich lying in state underneath the Black Square (fig. 226). These photographs are carefully staged, and they conjure up the purposes of abstract art in ways that the artworks themselves, sealed in museums (where they survive at all), never quite can. Of course the purposes are various, and at odds; but in each case what seems to me essential – the photographs speak to it almost too vividly – is the work's overweening, utopian, slightly lunatic character. History is going to be *overcome* by painting. Human nature is going to be remade. Artists have invented a new alphabet. Pictures will tell the truth.

Whether the artworks illustrated did so, or could have done so, is another matter. You will gather I am skeptical. I do not want to be made to choose between a dream of hygiene and a vision of endlessness. But of course modernism is out to make me choose, or at least to articulate what the choice was about – what facts of the age may have made it seem necessary, and plausible. This (to paraphrase Greenberg) is what makes modernism great: not the solutions it offers, needless to say, but its picture of a culture where solutions were still the order of the day. There would have been no such picture, has been my argument, without the attendant claims to truth – that is, to annihilation and totality. These claims are the substance of abstract art: they are what give it its fierceness and sensuousness, and make it turn on its own disappointment.

7 In Defense of Abstract Expressionism

I assume you speak of the age in which great forms
appear, only to be taken apart ten years later . . .

The angriness of the captive is felt,
is very plain, it is a large feeling
like a light in a toe, a voice of the sky;
now it has yielded all its bars, its robes,
and become the gentle sentiment of a class.

Frank O'Hara, "About Courbet," *Art News*, 1958

We are forty years away from Abstract Expressionism, and the question of how we should understand our relationship to the movement starts to be interesting again. Awe at its triumphs is long gone; but so is laughter at its cheap philosophy, or distaste for its heavy breathing, or boredom with its sublimity, or even resentment at the part it played in the Cold War. Not that any of those feelings has dissipated, or ever should, but that it begins to be clear that none of them – not even the sum of them – amounts to an attitude to the painting in question (figs. 228 and 229). They are what artists and critics went in for because they did not have an attitude – because something stood in the way of their making Abstract Expressionism a thing of the past.

227 Douglas M. Parker Studio: Marcia Simon Weisman residence, photograph, ca. 1991

Not being able to make a previous moment of high achievement part of the past – not to lose it and mourn it and, if necessary, revile it – is, for art in modernist circumstances, more or less synonymous with not being able to make art at all. Because ever since Hegel put the basic proposition of modernism into words in the 1820s – that "art, considered in its highest vocation, is and remains for us a thing of the past"[1] – art's being able to continue has depended on its success in making that dictum specific and punctual. That is to say, on fixing the moment of art's last flowering at some point in the comparatively recent past, and discovering that enough remains from this finale for a work of ironic or melancholy or decadent continuation to seem possible nonetheless. The "can't go on, will go on" syndrome. I think of the relation of nineteenth-century orchestral and chamber music to the moment of Mozart and Beethoven; or of how nineteenth- and twentieth-century literature managed to continue living on the idea of "the Romantics," or on the terminal images it fashioned of Baudelaire and Rimbaud; or of the past that "Impressionism" went on

228 Jackson Pollock: *Vortex*, oil and enamel on canvas, 52.3 × 46.3, ca. 1947 (Private collection)

providing for French painting deep into the twentieth century (till the deaths of Bonnard and Matisse); or of the feeding of later modernisms on the myth of the Readymade and the Black Square.

Hegel's dictum had to be localized, in other words. And pointing to the fact that it can be localized, and therefore in a sense evaded, is of course to confirm the Hegelian thesis, not to refute it. For Hegel did not anticipate any literal ceasing, or even withering-away, of activities calling themselves art. He just did not see that they could possibly be the form any longer in which men and women articulated the relations of mind and body to possible worlds. Or rather, articulated them to good effect. What he did not see, I think, was that the full depth and implication of this inability – the inability to go on giving Idea and World sensuous immediacy, of a kind that opened both to the play of practice – would itself prove a persistent, maybe sufficient, subject. That was because he had a naive hubris about philosophy, and because he could not detach himself from the sense of world-historical beginnings and endings that came with an adulthood passed in the shadow of the French Revolution. And other reasons besides. He could never have guessed that the disenchantment of the world would take so long.

229 Hans Hofmann:
Lent, oil on canvas, 188
× 121, 1960 (The
Detroit Institute of Arts)

Modernism, as I conceive it, is the art of the situation Hegel pointed to, but its job turns out to be to make the endlessness of the ending bearable, by time and again imagining that it has taken place – back there with Beethoven scratching out Napoleon's name on the Eroica symphony, or with Rimbaud getting on the boat at Marseille. Every modernism has to have its own proximate Black Square.

Therefore our failure to see Pollock and Hans Hofmann as ending something, or our lack of a story of what it was they were ending, is considerably more than a crisis in art criticism or art history. It means that for us art is no longer a thing of the past; that is, we have no usable image of its ending, at a time and place we could imagine ourselves inhabiting, even if we would prefer not to. Therefore art will eternally hold us with its glittering eye. Not only will it forego its role in the disenchantment of the world, but it will accept the role that has constantly been foisted upon it by its false friends: it will become one of the forms, maybe *the* form, in which the world is re-enchanted. With a magic no more and no less powerful (here is my real fear) than that of the general conjuror of depth and desirability back into the world we presently inhabit – that is, the commodity form. For one thing the myth of the end of art made possible was the maintenance of some kind of difference between art's sensuous immediacy and that of other (stronger) claimants to the same power.

The situation I have just been describing may not be remediable. It may be that we have lost Abstract Expressionism because we have lost modernism *tout court*, and therefore the need to imagine art altogether – whether continuing or ending. I have my doubts. But my question here is more limited. I want to mount a defense of Hofmann and Pollock and others, couched in historical terms. Whether the defense makes any of them usable, in the sense I have been proposing – whether it makes them a thing of the past – depends on whether it tallies in the long-term with art practice. At the moment I see no reason why it should; but equally, I find it hard to believe that the present myth of post-ness will sustain itself much past the year 2000. All this remains to be seen – it is not art historians' business: I only bring it up because it would be futile to pretend that I do not think a great deal hinges on somebody, eventually, giving this painting its due.

A word about interpretations, then. There has been a feeling in the air for some time now that writing on Abstract Expressionism has reached an impasse. The various research programs that only yesterday seemed on the verge of delivering new and strong accounts of it, and speaking to its place (maybe even its function) in the world fiction called America, have run into the sand. Those who believed that the answer to the latter kind of question would emerge from a history of Abstract Expressionism's belonging to a Cold War polity, with patrons and art-world institutions to match, have proved their point and offended all the right people. But the story, though good and necessary, turned out not to have the sort of upshot for interpretation that the storytellers had been hoping for. It was one thing to answer the question, "What are the circumstances in which a certain national bourgeoisie, in the pride of its victory after 1945, comes to want something as odd and exotic as an avant garde of its own?" It is another to speak to the implications of that encounter for the avant garde itself, and answer the question, "To what extent was the meeting of class and art-practice in the later 1940s more than just contingent? To what extent does Abstract Expressionism really belong, at the deepest level – the level of language, of procedure, of presuppositions about world-making – to the bourgeoisie who paid for it and took it on their travels?"

Not that answers to the latter questions will never be available, in my view, nor that writers have given up looking for ways to ask them more convincingly. Work is getting done. And certainly they seem to me the kind of questions still most worth asking of the paintings we are looking at – far more so than going

through the motions of discovering, for the umpteenth time, that in *Vortex* or *Lent* "paintings . . . are made . . . to block the viewer's impulse to constitute an imaginary object out of the painting's sensory reality, the eye being led back incessantly to painting's constitutive elements – line, color, flat surface [*les tableaux . . . sont faits . . . pour entraver le mouvement de constitution d'un objet irréel à partir de la réalité sensible du tableau, l'oeil étant incessamment reconduit aux éléments constitutifs de la peinture, la ligne, la couleur, le plan*]."[2] Once upon a time even this semiotic fairy tale evoked a faint sensation of wonder. But that was in another country . . .

At least the tellers of the historical story (the New-York-in-the-age-of-Joe-McCarthy-and-Nelson-Rockefeller story) recognize that their researches have landed them in a quandary; at least they are aware their objects resist them. The semioticians, it seems to me, are frozen in the triumph of their prearranged moments of vision.

Sometimes the way out of this kind of impasse in historical work comes from proposing another set of possible descriptions that the paintings in question might "come under" – making the proposal, especially in the beginning, with no very clear sense of where it may lead. How would it alter things, one asks, what sort of new orders in the objects would be set up, if we chose to look at them this way? How different would they look? Would they look better? Or properly worse? (Sometimes the way out of an impasse of understanding involves putting an end to a false, or even true, cathexis of the object. F. R. Leavis said more about Milton, and Fénéon more about Monet, than all Milton's and Monet's admirers put together.) The theses that follow are offered in a similar speculative spirit.

I think we might come to describe Abstract Expressionist paintings better if we took them, above all, to be *vulgar* (figs. 230 and 231). The word for us is pejorative, and to be understood as such in the arguments that follow. But this should not present an insuperable problem, especially for anyone used to thinking about modernism in general. After all, modernism has very often been understood as deriving its power from a range of characteristics that had previously come under the worst kind of pejorative descriptions – from ugliness, for example, or from the merely fragmentary and accidental; from the material as opposed to the Ideal; from the plain and limiting fact of flatness, from superficiality, from the low and the formless.

Nonetheless there still may be a slight *frisson* to the idea that the form of Abstract Expressionism's lowness is vulgarity. It is not clear how characterizing Willem de Kooning's *Woman, Wind, and Window II*, for instance, or Bradley Walter Tomlin's *All Souls' Night, No. 2*, as "vulgar" is to do anything besides denigrate them. That is fine by me. Not to be certain, for once, that the negative term brought on to describe a modernist artifact can ever be made to earn its positive keep – to emerge transfigured by the fact of its having been attached to a difficult painting or sculpture – may mean we are on to something. To call an artwork vulgar is obviously (at least for now) to do something a bit more transgressive than to call it low or *informe*. To have made it vulgar in the first place – to have had vulgarity be the quality in it (maybe the only quality) that raised the work from inertness and had it speak a world – this surely must have felt weird to those doing the job, and for much of the time was barely recognized or tolerated by them, at least when it came to finding words for what they were up to. Pollock's drip paintings, for instance, as I argued previously, seem

230 Willem de Kooning: *Woman, Wind, and Window II*, oil on canvas, 41.9 × 50.8, 1950 (Private collection)

to me to have been begun at the end of 1947 in a mood of triumphant access to the gaudy and overwrought. *Vortex* is typical; and yet the title Pollock settled for, beautiful as it is, somewhat naturalizes the painting's mad centrifugal force. The same is true, ultimately, of most of the titles he and his friends dreamed up at this moment – of *Phosphorescence* and *Reflection of the Big Dipper*, or *Galaxy* and *Watery Paths*, or even *Sea Change* and *Full Fathom Five*. They all try to conjure back depth and tactility (I mean natural tactility, the look and feel of the elements) into paintings that hinge, in my view, on not having much of either. They offer the sea and stars, not an indoor (*Unfounded*) fireworks display.

It is an advantage to the term "vulgar," as far as I am concerned, that discursively it points two ways: to the object itself, to some abjectness or absurdity in its very make-up (some tell-tale blemish, some atrociously visual quality which the object will never stop betraying however hard it tries); and to the object's existence in a particular social world, for a set of tastes and styles of individuality which have still to be defined, but are somehow there, in the word even before it is deployed. Herein, I hope, lies the possibility of class ascription in the case of paintings like *The Oracle* and *Woman* (figs. 232 and 233) – the possibility of seeing at last, and even being able to describe, the ways they take part in a particular triumph and disaster of the petty bourgeoisie. But I am coming to that.

In Abstract Expressionism – and here is the painting's continuing (maybe intensifying) difficulty for us – a certain construction of the world we call "individuality" is revealed in its true, that is to say, contingent, vulgarity. And so is painting; or rather, so are paintings like Hofmann's *The Garden* and Adolph Gottlieb's *Black, Blue, Red* (figs. 234 and 235) – done as they were

under the sign or spell of such a construction, by "individuals" believing utterly (innocently, idiotically) in its power.

I should try to define my terms. It will not be easy. The entries under the word "vulgar" and its cognates in the Oxford English Dictionary revel, really a bit vulgarly, in the slipping and sliding of meaning over the centuries, and in the elusiveness (but for that very reason, the intensity) of the panics and snobberies built into them. The three quotations that seem to me to help most with what we are looking at are, first, Jane Austen in 1797, in *Sense and Sensibility*, having Elinor reflect on "the vulgar freedom and folly" of the eldest Miss Steele and decide it "left her no recommendation" – I think it was the lady's freedom even more than her folly that Elinor objected to, and needed the word "vulgar" to dispatch. Then Matthew Arnold in 1865, making the link between vulgarity and expressiveness that particularly concerns us here: "*Saugrenu* [it means 'preposterous'] is a rather vulgar French word, but like many other vulgar words, very expressive." And lastly, George Eliot, quoted in Cross's *Life* as saying of Byron, in a letter of 1869, that he seemed to her "the most *vulgar-minded* genius that ever produced a great effect in literature." Everyone will have their own favorite candidate – Clyfford Still, Willem de Kooning, Franz

377

Kline, Hofmann, Pollock when things went best for him – for the proper substitution in the case of visual art.

Scanning the columns, the eye stops at OED usage 13: "having a common and offensively mean character; coarsely commonplace; lacking in refinement or good taste; uncultured, ill-bred." Of actions, manners, features, recorded from 1643; of persons, from 1678; of language, from 1716; of mind or spirit, from 1764. The key idea, from the present point of view, is of vulgarity as betrayal, on the part of those who by rights ought to be in the vanguard of good taste. The dictionary does not seem quite cognizant of this shift, though it provides the evidence for its taking place. It is there already in Coleridge's complaining, in 1833, of the "sordid vulgarity of the leaders of the day!" and it becomes a nineteenth-century commonplace. Ruskin in volume 5 of *Modern Painters*, we shall see, has a great climactic chapter, "Of Vulgarity," struggling with the shades of Quilp, Chadband, and Mrs. Gamp – and of Dickens himself behind them – and speaking to his deepest fears and hopes for art. The noun "vulgarian" – "a vulgar person; freq., a well-to-do or rich person of vulgar man-

233 Willem de
Kooning: *Woman*, oil,
enamel, and charcoal on
canvas, 152.4 × 121.6,
1949 (Private collection)

ners" – is coined around 1800. I guess it is what Ruskin and George Eliot most
have in mind.

I am proposing that one main kind of intensity in Abstract Expres-
sionism is its engagement with the dangers and falsehoods just catalogued. And
what is special about Abstract Expressionism – what marks it off from all other
modernisms – is that the engagement is with the vulgar as opposed to the
"popular" or "low." I think we should understand the "popular" in nineteenth-
and twentieth-century art as a series of figures of avoidance of the vulgar: that
is, figures of avoidance of art's actual belonging to the pathos of bourgeois taste:
a perpetual shifting and conjuring of kinds of simplicity, directness, naivety,
sentiment and sentimentality, emotional and material force, in spite of every-
thing about art's actual place and function that put such qualities beyond its
grasp. Abstract Expressionism does little or no such conjuring. That is what
makes it hard to bear. We are used to an art that always sets off again in search

234 Hans Hofmann: *The Garden*, oil on plywood, 152.4 × 117.9, 1956 (University of California, Berkeley Art Museum and Pacific Film Archive, Berkeley, gift of the artist)

235 (*facing page*) Adolph Gottlieb: *Black, Blue, Red*, oil and enamel on canvas, 182.9 × 127, 1956 (Adolph and Esther Gottlieb Foundation, New York)

of the true underlying the tawdry, and where the tawdry may divulge the true (to the artist) just because the tawdriness is someone else's, out there in the mass or the margin. But Abstract Expressionism does not go elsewhere for its language, and at its best (its most appalling) it seems in search of the false underlying the vehement; where the point is that cheap vehemence, or easy delectation, are what painting now is – the only values, the only forms of individuality, that it can stage without faking. Only those Abstract Expressionist canvases will do that are truly consumed with their own empty intensity, with painting as posturing, with a ludicrous bigness and lushness and generality. (Pollock's big paintings of 1950 are no longer ludicrous and self-consuming enough: they have become almost comfortable with their scale and degree of generalization of touch: the "true" is leaking back into the paintings, giving them depth and coherence, displacing the great empty performatives of 1948 and 1949. This again is one way of saying why the big paintings could not be continued.)

Nobody would expect the terms and issues I am claiming as most deeply Abstract Expressionism's own to be readily available in the discourse of the time, any more than issues of flatness and modernity were, for example, to even the best of Manet's critics. But one would at least expect to find the traces in discourse of the issues being avoided. Here is a New York critic in 1951, writing of an artist he greatly admires:

> In this case the background is without question the most outrageously overwhelming the artist has ever contrived. Inspired by the most flagrant and bombastic French Baroque wallpaper, [he has] intensified to a maximum its brown and orange arabesque which surrounds areas of the harshest blue in the centers of which cluster pink and red roses . . . All these gratuitous incidents superimposed on the wall and floor serve to break up and confuse the patterns on these surfaces so that the eye can find no security even in the repetition of ornamental motif – a comfort afforded in . . . earlier compositions . . .
>
> Visually the *Decorative Figure* is a garish, violent, and upsetting picture. The rather mild problems which [the painter] had been posing for himself during the previous five years are here suddenly exacerbated almost to the point of burlesque. *Luxe, calme et volupté* have disappeared and in their places discomfort, excitement, and tension reign. The . . . *Seated Nude* of the year before had expressed [the painter's] rebellion against ease and softness; this big odalisque adds a revolt against charm and good taste. It represents a triumph of art over factitious vulgarity. Yet because the picture is so clearly an act of will in a field of artifice, the victory seems Pyrrhic.[3]

The last two sentences in particular – "It represents a triumph of art over factitious vulgarity. Yet because the picture is so clearly an act of will in a field of artifice, the victory seems Pyrrhic" – seem to me to provide the terms for a description of Abstract Expressionism. The key question, of course (which this critic understandably skirts) is whether the victory over vulgarity is *meant* to seem Pyrrhic – whether the hollowness of the victory is what the picture wants to figure most urgently. But of course it is right and proper that even though these words were written at the height of Abstract Expressionism, and from what was to become the seat of the movement's institutional power – by Alfred H. Barr in a MoMA catalogue – they precisely could not be written of Gottlieb or Hofmann or de Kooning, but only of Matisse, of his *Decorative Figure on Ornamental Ground* (fig. 236) done a quarter of a century earlier.

236 Henri Matisse:
*Decorative Figure on
Ornamental Ground*, oil
on canvas, 130 × 98,
1925–26 (Musée
National d'Art
Moderne, Paris)

I realize that it is still not clear what Barr or I mean by the word "vulgarity" as applied to paintings. And I do not think it ever will be. The word is opaque: it points, as Ruskin knew, to a deep dilemma of bourgeois culture: it is as close to an ultimate term of ethics or metaphysics as that culture maybe will ever throw up. "Two years ago," ends Ruskin's chapter "On Vulgarity" in *Modern Painters*,

> when I was first beginning to work out the subject, and chatting with one of my keenest-minded friends [Mr. Brett, the painter of the Val d'Aosta in the Exhibition of 1859], I casually asked him, "What is vulgarity?" merely to see what he would say, not supposing it possible to get a sudden answer. He thought for about a minute, then answered quietly, "It is merely one of the forms of Death." I did not see the meaning of the reply at the time; but on testing it, found that it met every phase of the difficulties connected with the inquiry, and summed the true conclusion. Yet, in order to be complete, it ought to be made a distinctive as well as conclusive definition; showing *what* form of death vulgarity is; for death itself is not vulgar, but only death mingled with life. I cannot, however, construct a short-worded definition which will include all the minor conditions of bodily degeneracy; but the term "deathful selfishness" will embrace all the most fatal and essential forms of mental vulgarity.[4]

I do not bring on this passage of Ruskin in hopes of solving our problem of definition, but more because it shows (more clearly than anyone nowadays would dare to) what the problem is – what terrible cocktail of class ascriptions and bodily disgust the word "vulgar" is empty container for, and how fatal and essential is the sliding within it between a handy form of class racism and a

237 Franz Kline, *Requiem*, oil on canvas, 257.8 × 190.5, 1958 (Collection Albright-Knox Art Gallery, Buffalo, New York, Gift of Seymour H. Knox, 1959)

general sense of class doom. Vulgarity is foulness and degeneracy, it is a "dulness of bodily sense," "all which comes of insensibility." "The black battle-stain on a soldier's face is not vulgar, but the dirty face of a housemaid is."[5] But Brett's dictum is ultimately impatient of such distinctions. We are all house-maids now.

"Vulgarity is merely one of the forms of death (figs. 237 and 238)." Beware of taking Brett's dictum too literally in the case of Abstract Expres-sionism, and, above all, beware of converting it back into some ridiculous (vulgar) retelling of Abstract Expressionists' life stories. I think there may be some kind of fatal connection between this painting's vulgarity and its incessant courting of Death; but that is not to be understood as a biographical proposi-tion but a formal one. It is a way of thinking again about Pollock's or Kline's

238 Jackson Pollock:
Number 9, 1949, oil on
canvas, 112.3 × 86.3,
1949 (Wadsworth
Atheneum, Hartford,
Conn. Gift of Tony
Smith)

repetition compulsion, their constant (fruitful) drive toward emptiness, endless-
ness, the non-human, and the inorganic.

Perhaps the last paradox these works contain is that of death [this is the
novelist Parker Tyler once again, writing of Pollock's drip paintings some
time early in 1950, before the last show of them at Betty Parsons]. For in
being a conception of ultimate time and space, the labyrinth of infinity,
Jackson Pollock's latest work goes beyond the ordinary processes of life –
however these might be visualized and recognized – into an absolute being
which must contain death as well as life. Hence the spatial distinctions
achieved by lines and spots of color within Pollock's rectangles go as much
beyond mere optical vision as seems possible to painting . . .

Jackson Pollock has put the concept of the labyrinth at an infinite and
unreachable distance, a distance beyond the stars – a non-human
distance . . . If one felt vertigo before Pollock's differentiations of space, then
truly one would be lost in the abyss of an endless definition of being. One
would be enclosed, trapped by the labyrinth of the picture-space. But we are
safely looking at it, seeing it steadily and seeing it whole, from a point
outside. Only *man*, in his paradoxical role of the *superman*, can achieve such
a feat of absolute contemplation: the sight of an image of space *in which he
does not exist.*[6]

239 Mark Rothko: *White Center*, oil on canvas, 205.7 × 141, 1950 (Private collection)

It would be easy to make fun of this. Its metaphysics are vulgar. But the terms and tone seem to me as close as Pollock got to appropriate criticism in his lifetime. It is fitting, again, that these were paragraphs deleted from Tyler's article in 1950 by Robert Goldwater, editor of the *Magazine of Art*. They only survive at all as part of Pollock criticism because the artist seems to have been given a typescript by the writer, and kept it in his files.

Maybe the Death in Brett's dictum is simply or mainly that of painting. Maybe it always was, for Brett and Ruskin as much as Pollock and Parker Tyler.

240 Mark Rothko: *Number 12*, oil on canvas, 145.4 × 134.3, 1951 (Private collection)

Death makes a bad metaphor. Pictures that summon it up too readily – Newman's passim, Rothko's from 1957 on – get to look Gothick before their time. That we are meant to take the portentousness as ultimately having to do with "painting," or "signification," or some such, only makes matters worse. Death is enlisted to make vulgarity look deep.

The trouble with Barnett Newman is that he was never vulgar enough, or vulgar only on paper. "The First Man Was an Artist," "The Sublime Is Now," "The True Revolution Is Anarchist!" etc.

The great Rothkos are those everybody likes, from the early 1950s mainly (figs. 239 and 240): the ones that revel in the new formula's cheap effects, the ones where a hectoring absolute of self-presence is maintained in face of the void; with vulgarity – a vulgar fulsomeness of reds, pinks, purples, oranges, lemons, lime greens, powder-puff whites – acting as transform between the two possibilities of reading. *The Birth of Tragedy* redone by Renoir.

When they are hung in tight phalanx, as he would have them hung, and flooded with the light he demands that they receive, the tyranny of his

ambition to suffocate or crush all who stand in his way becomes fully manifest . . . It is not without significance, therefore, that the surfaces of these paintings reveal the gestures of negation, and that their means are the devices of seduction and assault. Not I, but himself, has made it clear that his work is of frustration, resentment and aggression. And that it is the brightness of death that veils their bloodless febrility and clinical evacuations.

Thus Clyfford Still on Rothko, in a letter to Sidney Janis, written in 1955.[7] It puts me in mind of Fénéon on Monet: which is to say, it is mean-spirited, partial, and tendentious, but somehow for that very reason (because it steps out of the circle of deference for once) the best criticism Rothko ever received.

And so to the question of class. "While formal analysis," says Adorno in his *Introduction to the Sociology of Music*, "was learning to trace the most delicate ramifications of [a work's] manufacture, . . . the method of deciphering the specific social characteristics of music has lagged behind pitifully and must be largely content with improvisations."[8] Quite so – and maybe improvisation will turn out to *be* its method. But equally (this is Adorno in the same paragraph): "If we listen to Beethoven and do not hear anything of the revolutionary bourgeoisie – not the echo of its slogans, the need to realize them, the cry for that totality in which reason and freedom are to have their warrant – we understand Beethoven no better than does the listener who cannot follow his pieces' purely musical content, the inner history that happens to their themes."

What remains to be thought about Abstract Expressionism (though the thought haunts everything written on the subject, especially those texts most anxious to repress it) is the painting's place in a determinate class formation; one which, though long prepared, took on the specific trappings of cultural power in the years after 1945. I said "its place in a determinate class formation," not in a state apparatus, or a newly improvised system of avant-garde patronage, or a museum/art-world superstructure. Not that the latter are irrelevant. But they cannot be what we mean, fundamentally, when we talk about a certain representational practice inhering in the culture of a class. We mean that the practice somehow participates in that class's whole construction of a "world." We are talking of overlap and mutual feeding at the level of representational practice – at the level of symbolic production (ideology). When we say that the novel is bourgeois, the key facts in the case are not eighteenth-century subscription lists, or even the uses early readers made of *The Sufferings of Young Werther*.

Clement Greenberg begins a review of an exhibition of Courbet at Wildenstein's in January 1949 by saying that "Bosch, Brueghel, and Courbet are unique in that they are great artists who express what may be called a petty bourgeois attitude."[9] Like Barr, he seems to me to be averting his eyes from Pollock and Clyfford Still. What is new in their case, of course, is that now a particular (hybrid) form of petty-bourgeois culture – I am including in the term "culture" a set of political and economic compromise-formations, with myths and duplicities to match, as well as a set of established styles of personhood – has become the form, the only viable medium, of bourgeois class power. It is not that the petty bourgeoisie in America *has* power, but that its voice has become, in the years after 1945, the only one in which power can be spoken: in it, and only in it, can be heard the last echoes of what the bourgeoisie had once aspired

to be – "the echo of its slogans, the need to realize them, the cry for that totality in which freedom [no longer reason] is to have its warrant."[10]

Abstract Expressionism, I want to say, is the style of a certain petty bourgeoisie's aspiration to aristocracy, to a totalizing cultural power. It is the art of that moment when the petty bourgeoisie thinks it can speak (and its masters allow it to speak) the aristocrat's claim to individuality. Vulgarity is the form of that aspiration.

Or could we say: Abstract Expressionism is the form of the petty bourgeoisie's aspiration to aristocracy, at that fateful moment when the bourgeoisie itself no longer so aspires; when the petty bourgeois has to stand in for a hidden – nay, vanished – bourgeois elite. (Of course we are dealing here with two class formations, two fictions or constructions, not two brute sociological entities. We are dealing with forms of representation; which is not to say that the kind of representational doubling described here does not have specific, often brutal, sociological effects. McCarthyism was one of them, in which the bourgeois Frankenstein was for a while really paralysed by its petty-bourgeois Monster.)

Vulgarity, then (to return to our subject), is the necessary form of that individuality allowed the petty bourgeoisie. Only that painting will engage and sustain our attention which can be seen to recognize, and in some sense to articulate, that limit condition of its own rhetoric. Maybe it will always be a painting that struggles to valorize that condition even as it lays bare its deficiencies – for here we touch, as Adorno never tired of telling us, on some constitutive (maybe regrettable) link between art and an ethics of reconciliation or transcendence – but what we shall value most in the painting is the ruthlessness of (self-)exposure, the courting of bathos, the unapologetic banality. The victory, if there is one, must always also be Pyrrhic.
You see now why the concept "vulgarity" has more and more the notion of betrayal written into it as the nineteenth century goes on. For the bourgeoisie's great tragedy is that it can only retain power by allowing its inferiors to speak for it: giving them the leftovers of the cry for totality, and steeling itself to hear the ludicrous mishmash they make of it – to hear and pretend to approve, and maybe, in the end, to approve without pretending.

If this frame of reference for Abstract Expressionism turns out to work at all, one of the things it ought to be good for is rethinking the stale comparison between America and Europe. European painting after the war, alas, comes out of a very different set of class formations. Vulgarity is not its problem. In Asger Jorn, for example – to turn for a moment to the greatest painter of the 1950s – what painting confronts as its limit condition is always *refinement* (figs. 241 and 242). Painting for Jorn is a process of coming to terms with the fact that however that set of qualities may be tortured, exacerbated, or erased, they still end up being what (European) painting is; and the torture, exacerbation, and erasure are discovered in practice to *be* refinement – that is, the forms refinement presently takes if a painter is good enough. They are what refines painting to a new preciousness or dross (it turns out that preciousness and dross are the same thing).

241 Asger Jorn: *Paris by Night*, oil on canvas, 53 × 37, 1959 (Collection Pierre Alechinsky)

In calling Jorn the greatest painter of the 1950s I mean to imply nothing about the general health of painting in Europe at the time (nor to deny that Jorn's practice was hit and miss, and the number of his works that might qualify as good, let alone great, is very small).[11] On the contrary. The clichés in the books are true. Jorn's really was an end game. Vulgarity, on the other hand, back on the other side of the Atlantic, turned out to be a way of keeping the corpse of painting hideously alive – while all the time coquetting with Death.

An Asger Jorn can be garish, florid, tasteless, forced, cute, flatulent, overemphatic: it can never be vulgar. It just cannot prevent itself from a tampering and framing of its desperate effects which pulls them back into the realm of painting, ironizes them, declares them done in full knowledge of their emptiness. American painting by contrast – and precisely that American paint-

242 Asger Jorn: *To Become, That is the Question. To Have Been, That is the Answer*, oil on canvas, 129.8 × 97.2, 1961 (Private collection)

ing which is closest to the European, done by Germans and Dutchmen steeped in the tradition they are exiting from – does not ironize, and will never make the (false) declaration that the game is up. Hofmann and de Kooning, precisely because they are so similar to Jorn in their sense of "touch" and composition, register as Jorn's direct opposites.

It is my hope that conceiving of Abstract Expressionism as vulgar will lead to a new set of discriminations between particular painters within the group, and between moments in the work of a single artist. I have already referred to one or two such possibilities – for instance, the difference between Pollock's drip paintings in 1947 and 1948 and their final appearance in 1950.

243 Adolph Gottlieb: *Under and Over*, oil on canvas, 243.8 × 121.9, 1959 (Wadsworth Atheneum, Hartford, Conn., Gift of Susan Marse Hilles)

I have tried also to give a preliminary sense of the new priorities, and the new kinds of belonging together under the general (too capacious) banner, by means of the pictures accompanying this chapter's text. Let me say a word or two more about this.

Gottlieb, you will have noticed, emerges as the great and implacable maestro of Abstract Expressionism (figs. 243 and 244). He is Byron to Greenberg's George Eliot – the most vulgar-minded genius that ever produced a great effect in oils. A Mantovani or a Lawrence Welk. Charlie Parker playing insolent variations on the theme of "I'd Like to Get You on a Slow Boat to China" – feeling for a way to retrieve, and make properly unbearable, the pop song's contempt for the masses it aims to please. Gottlieb is at his best when he goes straight for the cosmological jugular, straight for the pages of *Time* or *Life* – his worlds on fire so many atomic-age parodies of El Lissitzky's *Story of Two Squares*, ghastly in their beautification of destruction.

244 Adolph Gottlieb:
Jagged, oil on canvas,
182.9 × 121.9, 1960
(Adolph and Esther
Gottlieb Foundation,
New York)

Certain moments and sequences of work in Abstract Expressionism that everyone, then and since, agrees to have been a turning-point for the new painting begin, in this light, to take on a different valency. For example, De Kooning's *Woman* series, and the vehemence of Clement Greenberg's reaction to it. (Actually the "vehemence" is mainly a matter of Greenberg's conversation as recalled by witnesses. He said little in print about the *Women*. But that, of course – coming from the person chosen to write the catalogue essay for de Kooning's 1953 retrospective – was felt to be the point. Greenberg's silence, or his occasional offhandedness, was telling above all by contrast with the general run of journalism at the time, which took it for granted that, love 'em or hate 'em, the *Women* were Abstract Expressionism's truth.) What Greenberg was recoiling from, I think, is the way in which choosing *Woman* as his subject allowed de Kooning to extrude a quality of perception and handling that stood at the very heart of his aesthetic, and fix it onto an Other, a scapegoat. "The black battle-stain on a soldier's face is not vulgar, but the dirty face of a housemaid is." For "dirty face of a housemaid" read "perfect smile of the model in a Camels cigarette ad." Greenberg drew back from this not, need I say it, out of concern over de Kooning's misogyny, but from an intuition that such splitting and projection would make it impossible for de Kooning's painting to go on sustaining the right pitch of tawdriness, idiot facility, overweening self-regard. I think he was right. Only when de Kooning found a way to have the vulgarity be his own again – or rather, to half-project it onto cliché landscape or townscape formats, which were transparently mere props – did he regain the measure of meretriciousness his art needed (figs. 245 and 246). The male braggadocio, that is to say, had to be unfocused if he was to paint up a storm.

It had to be a manner in search of an object, and somehow aggrieved at not finding one. What was wanted was generalized paranoia, not particular war of the sexes.

Vulgarity is gendered, of course. At the moment we are looking at, the attribute belonged (as a disposable property) mainly to men, or, more precisely, to heterosexual men. Not that this meant the art done under vulgarity's auspices was closed to reading from other points of view. What Beaton and Alfonso Ossorio and Parker Tyler and Frank O'Hara did to Pollock, with or without Pollock's permission, is clearly part – sometimes, as I have said, a central part – of any defensible history of the New York School. It seems important that, apart from Greenberg, the strongest early readings of Pollock's work (the strongest, not necessarily the best) all came from gay men. Namuth's films and photographs partake of the same homosocial atmosphere. Perhaps the deep reason why Greenberg was never able to realize his cherished project of a book on Pollock was that he found no way to contain, or put to use, the erotic hero-worship that sings in the prose of his shorter pieces about his friend.[12]

246 Willem de Kooning: *Suburb in Havana*, oil on canvas, 203.2 × 177.8, 1958 (Private collection)

By talking as I have about Pollock's 1947 titles, or Alfred Barr's 1951 treatment of Matisse, I do not mean to give the impression that the set of issues I see as central to Abstract Expressionism simply never appeared in critical discourse at the time, or did so only in utterly displaced form. Now and again they surfaced directly; but what is striking when that happens is how the writer seems not to know what to do with the issues and terms once they show up. The terms are embarrassing. Greenberg, for instance, has the following to say about Clyfford Still's color and paint handling in his great essay, "'American-Type' Painting," published in *Partisan Review* in 1955:

I don't know how much conscious attention Still has paid to Monet and Impressionism [Greenberg has just been musing on the power within Abstract Expressionism of "an art like the late Monet's, which in its time pleased banal taste and still makes most of the avant-garde shudder"], but his . . . art likewise has an affiliation with popular taste, though not by any means enough to make it acceptable to it. Still's is the first really Whitmanesque kind of painting we have had, not only because it makes large, loose gestures . . . but just as much because, as Whitman's poetry assimilated, with varying success, large quantities of stale journalistic and oratorical prose, so

Still's painting is infused with that stale, prosaic kind of painting to which Barnett Newman has given the name of "buckeye." Though little attention has been paid to it in print, "buckeye" is probably the most widely practiced and homogeneous kind of painting seen in the Western world today . . . "Buckeye" painters, as far as I am aware, do landscapes exclusively and work more or less directly from nature. By piling dry paint – though not exactly in impasto – they try to capture the brilliance of daylight, and the process of painting becomes a race between hot shadows and hot lights whose invariable outcome is a livid, dry, sour picture with a warm, brittle surface that intensifies the acid fire of the generally predominating reds, browns, greens, and yellows. "Buckeye" landscapes can be seen in Greenwich Village restaurants (Eddie's Aurora on West Fourth Street used to collect them), Sixth Avenue picture stores (there is one near Eighth Street) and in the Washington Square outdoor shows . . . I cannot understand fully why [these effects] should be so universal and so uniform, or the kind of painting culture behind them.

Still, at any rate, is the first to have put "buckeye" effects into serious art. These are visible in the frayed dead-leaf edges that wander down the margins or across the middle of so many of his canvases, in the uniformly dark heat of his color, and in a dry, crusty paint surface (like any "buckeye" painter, Still seems to have no faith in diluted or thin pigments). Such things can spoil his pictures, or make them weird in an unrefreshing way, but when he is able to succeed with, or in spite of them, it represents but the conquest by high art of one more area of experience, and its liberation from *Kitsch*.[13]

There is a lot going on here, and no one interpretation will do it justice (the tangents and redundancies in Greenberg's text, which I have left out for the sake of brevity, are actually vital to its detective-story tone). But what I see Greenberg doing essentially is struggling to describe, and come to terms with, a specific area of petty bourgeois taste. He rolls out the place names and pieces of New York City geography with a cultural explorer's relish, all the better to be able to plead class ignorance in the end – "I cannot understand fully . . . the kind of painting culture behind them." Readers of Greenberg will know that the final enlistment of the word *kitsch* is heavily loaded. *Kitsch* equals vulgarity, roughly. In Greenberg's original Trotskyite scheme of things the word had strong class connotations. But 1955 is too late, by several years, for Greenberg to be willing to pursue this any further. It is interesting that he pursues it at all – that Still's painting seemingly forces him to think again, at some length, about high art's courting of banality. And he is in no two minds, at this point, about the importance of such a tactic, for all its risk. The next sentence after the one on Still and *kitsch* reads as follows: "Still's art has a special importance at this time because it shows abstract painting a way out of its own academicism."

This sentence is altered out of all recognition in the version of " 'American-Type' Painting" Greenberg put in his book *Art and Culture* six years later.[14] All of the section on Still is given heavy surgery. The word *kitsch* gives way to "one more depressed area of art" – where surely "depressed" is exactly the wrong word. (*Kitsch* is manic. Above all, it is rigid with the exaltation of *art*. It believes in art the way artists are supposed to – to the point of absurdity, to the point where the cult of art becomes a new philistinism. This is the aspect of *kitsch* that Still gets horribly right.) The "buckeye" of the *Partisan Review* text is abandoned in favor of "demotic-Impressionist" or "open-air painting in autumnal colors." (Or almost abandoned – Greenberg cannot resist a single, unexplained appearance of the word toward the end.) There are no more names and addresses on Eighth Street. No more baffled talk of a separate, impenetrable

"painting culture." This is a critic in flight from previous insights, I feel. And I think I see why.

Then, finally, there is the problem of Hans Hofmann. You will not be surprised to hear that it was in coming to terms with Hofmann in particular that the vocabulary of the present argument first surfaced. For everyone who has ever cared at all about Hofmann (including Greenberg, who cared very much) has always known that in Hofmann the problems of taste in Abstract Expressionism come squawking home to roost. A good Hofmann is tasteless to the core – tasteless in its invocations of Europe, tasteless in its mock religiosity, tasteless in its Color-by-Technicolor, its winks and nudges toward landscape format, its Irving Stone title, and the cloying demonstrativeness of its handling. Tasteless, and in complete control of its decomposing means (figs. 247 and 248[15]).

Seen in its normal surroundings, past the unobtrusive sofas and calla lilies, as part of the unique blend of opulence and spareness that is the taste of the picture-buying classes in America, a good Hofmann seems always to be blurting out a dirty secret which the rest of the decor is conspiring to keep (fig. 227). It makes a false compact with its destination. It takes up the language of its users and exemplifies it, running monotonous, self-satisfied riffs on the main tune, playing it to the hilt – to the point of parody, like Mahler with his sentimental Viennese palm-court melodies. A good Hofmann has to have a surface somewhere between ice cream, chocolate, stucco and flock wallpaper. Its colors have to *reek* of Nature – of the worst kind of Woolworth forest-glade-with-waterfall-and-thunderstorm-brewing. Its title should turn the knife in the wound. For what it shows is the world its users inhabit in their heart of hearts. It is a picture of their "interiors," of the visceral-cum-spiritual upholstery of the rich. And above all it can have no illusions about its own status as part of that upholstery. It is made out of the materials it deploys. Take them or leave them, these ciphers of plenitude – they are all painting at present has to offer. "Feeling" has to be fetishized, made dreadfully (obscenely) exterior, if painting is to continue.

I do not believe that what I have just offered is an account of Hofmann's intentions; any more than if my subject had been, say, the coldness and hardness of Matisse's hedonism in the 1920s, or the pathos of Picasso's eroticism in 1932. (Of course it would be possible to give an account of all three phenomena which argued that up to now our understanding of the artists' intentions had been deficient, and ought to include the pathos or the coldness or the capacity for self-parody. I just do not think the inclusions are necessary or plausible in Hofmann's case.) No doubt Hofmann believed in his own overblown rhetoric. (What would it be like to go in for it at this pitch of intensity without believing in it? Like Asger Jorn, maybe – not like *And Thunderclouds Pass*.) I dare say Hofmann thought his titles were wonderful. (Who is going to quarrel with Nikolaus Lenau and the *Sonnets to Orpheus*? Only a modernist cynic like me.) And as for the place of his paintings in Marcia Weisman's sitting room? He surely assumed that at the level that really mattered – the level of taste, as opposed to day-to-day preference – there was a profound community of interest between himself and the best of his clients. And so there was. He could not have painted their interiors if they were not his interior too.

These are not the matters at issue, ultimately. The task for the critic is to

247 (*following page*) Hans Hofmann: "*. . . And Thunderclouds Pass*", oil on canvas, 212.7 × 153, 1961 (University of California, Berkeley Art Museum and Pacific Film Archive, Berkeley, gift of the artist)

find an adequate language for the continuing *effect* of, say, Hofmann's overblownness (I am not even saying that this is the sole or primary quality of Hofmann's version of Abstract Expressionism, but it is the one that gets more interesting over time). The overblownness matters only because it seems to be what lends the pictures their coherence, maybe their depth. Nor am I meaning to congratulate Hofmann on getting a quality to petty-bourgeois experience somehow "right." The quality is not hard to perceive and mimic. What is hard (what is paradoxical) is to make paintings out of it. That is what Hofmann did. Of course I am saying that doing so involved him in an encounter with the conditions of production and consumption of his own art. That is my basic hypothesis. But the encounter could take place only at the level of work, of painterly practice – the encounter was getting the overblownness to be pictorial, or discovering that it was the quality out of which paintings now had to be made. Even to call this an "encounter" is to give it too much of an exterior or discursive flavor. It was what Hofmann did, not what he discovered.

Still less is this chapter as a whole an argument about Abstract Expressionists' social or political opinions. Of course I relish the fact that Clyfford Still supported Joe McCarthy, and that Pollock, in Greenberg's opinion, was "a Goddamn Stalinist from start to finish"[16]; in much the same way that I like to know Manet was a frightful Gambettist, and Renoir believed that "siding with the Israelite Pissarro, that's revolution [*rester avec l'israélite Pissarro, c'est la révolution*]."[17] But I know my interest does not count for much in understanding what any of the four did as painters. At best the facts may strike us as dimly consonant with one or other aspect (usually a surface aspect) of their subject-matter or handling – with Manet's epigrammatic brittleness, say, or Renoir's over-anxiousness to please. But they get us nowhere with what really matters, which is the artists' ability to have these surface qualities coexist with others seemingly at odds: Manet's pessimism and compassion, for instance, or Renoir's uncomplicated monumentality.

I am not saying that Abstract Expressionists' social attitudes are just irrelevant. No doubt it helps to know that Rothko, for instance, had his own vision of the petty-bourgeois future; and again, the fact that he saw it in the shape of the university – the University of Colorado at Boulder – is for me irresistible:

> The University . . . is on the hill. At its base are the faculty apartments which are shells around appliances facing a court into which the children are emptied. Two hundred yards away is Vetsville, in which the present faculty itself had lived only four or five years ago when they were preparing to be faculty. Vetsville itself is occupied by graduates from army headquarters, already married and breeding who will be faculty in faculty quarters three or four years hence. They breed furiously guaranteeing the expansion which will perpetuate the process into the future.
>
> The faculty itself is allowed to stay here only 2 years whereupon they must assume mortgages in similar housing slum developments where thereafter they must repair their own cracks and sprinkle their grass . . .
>
> Here is a self-perpetuating peonage, schooled in mass communal living, which will become a formidable sixth estate within a decade. It will have a cast of features, a shape of head, and a dialect as yet unknown, and will

248 (*previous page*) Hans Hofmann: "*And, Out of the Caves, The Night Threw a Handful of Pale Tumbling Pigeons into the Light*", oil on canvas, 213.7 × 153, 1964 (University of California, Berkeley Art Museum and Pacific Film Archive, Berkeley, gift of the artist)

propagate a culture so distorted and removed from its origins, that its image is unpredictable.[18]

Anyone familiar with nineteenth-century styles of irony at the expense of the *nouvelles couches sociales* will recognize this as generic (solecisms and all). Condescension just *is* the form of the petty bourgeoisie's self-recognition. Compare the 1980s' literature on yuppies. All the same, even this passage does not help me with what is really interesting, and ultimately baffling, about Rothko as an artist: why the same banal loftiness could lead to the brightness of death at one moment (1950), and to clinical evacuation at another (1965).

My chapter title, "In Defense of Abstract Expressionism," is not meant ironically. I have offered what I think is the best defense possible of this body of work, and of course I am aware that in doing so the noun "vulgarity" has turned into a term of value, whether I wanted it to or not. If the formula were not so mechanical, I would say that Abstract Expressionist painting is best when it is most vulgar, because it is then that it grasps most fully the conditions of representation – the technical and social conditions – of its historical moment (figs. 249 and 250).

The moment was brief. By the time of the two paintings I choose to end with – 1961 and 1962 – it was almost over. The mode, and indeed the titles, of the two pictures – *Memoria in Aeternum* and *Coalescence* – are nothing if not valedictory. Death puts in its usual appearance. The coffin is straight out of Evelyn Waugh. And this overstuffed, unctuous, end-and-beginning-of-the-world quality seems to me, to repeat, the key to these paintings' strength. They have a true petty-bourgeois pathos. One can see why art in New York felt obliged to retreat from such dangerous ground in the years that immediately followed, and why a last effort was made to restabilize avant-garde practice in its previous (exhausted) trajectory. The "popular" was easier to handle than the vulgar – it had more of the smell of art about it. Reduction was a better way to generate recognizable modernist artworks than this kind of idiot "Ripeness is all." The site-specific was preferable to the class-specific. Art had to go on, and that meant returning art mainly to normal avant-garde channels.[19] But for some of us – certainly for me – the price paid for this accommodation in the 1960s and after seems prohibitively high. The ridiculous moment of coalescence, or of mourning, or of history, is what we still want from painting, and what Abstract Expressionism managed to provide.

So now I think I understand what I have been defending all along. It seems that I cannot quite abandon the equation of Art with lyric. Or rather – to shift from an expression of personal preference to a proposal about history – I do not believe that *modernism* can ever quite escape from such an equation. By "lyric" I mean the illusion in an artwork of a singular voice or viewpoint, uninterrupted, absolute, laying claim to a world of its own. I mean those metaphors of agency, mastery, and self-centeredness that enforce our acceptance of the work as the expression of a single subject. This impulse is ineradicable, alas, however hard one strand of modernism may have worked, time after time, to undo or make fun of it. Lyric cannot be expunged by modernism, only repressed.

Which is not to say that I have no sympathy with the wish to do the expunging. For lyric in our time is deeply ludicrous. The deep ludicrousness of lyric is Abstract Expressionism's subject, to which it returns like a tongue to a loosening tooth.

249 Adolph Gottlieb: *Coalescence*, oil on canvas, 228.6 × 182.9, 1961 (Private collection)

250 Hans Hofmann:
Memoria in Aeternum,
oil on canvas, 213.4 ×
183.2, 1962 (The
Museum of Modern Art,
New York. Gift of the
artist)

This subject, of course, is far from being the petty bourgeoisie's exclusive property. That is not what I have been arguing. Anyone who cares for the painting of Delacroix or the poetry of Victor Hugo will be in no doubt that the ludicrousness of lyric has had its *haut bourgeois* avatars. But sometimes it falls to a class to offer or suffer the absurdities of individualism in pure form – unbreathably pure, almost, a last gasp of oxygen as the plane goes down. That was the case, I think, with American painting after 1945.

Conclusion

But to have done instead of not doing
 this is not vanity
To have, with decency, knocked
That a Blunt should open
 To have gathered from the air a live tradition
or from a fine old eye the unconquered flame
This is not vanity.
 Here error is all in the not done,
all in the diffidence that faltered.

Ezra Pound, Canto LXXXI

There are always many modernisms, and I do not want the last two chapters to give the impression that the important ones in the late twentieth century all took place in New York. The modernism that mattered most to me in the beginning – for years I had a blow-up from Roberto Rossellini's *Paisà* on my wall – was that of film and literature in Italy after 1945. Modernism from Italo Calvino's *The Path to the Nest of Spiders* (1947), roughly, to Antonioni's *The Cry* (1957) and *L'Avventura* (1960). Modernism beginning with the wonderful first sentences of Cesare Pavese's *The House on the Hill*:

> For a long time we had talked of the hill as we might have talked of the sea or the woods. I used to go back there in the evening when it grew dusk, and for me it was not just another place but a point of view, a way of life . . . The roads were swarming with people, poor people who scattered to sleep even in the fields, carrying their mattresses on their bicycles or on their backs, shouting and arguing, obstinate, gullible, and amused.
>
> We began to climb, everyone discussing the doomed city, the night, and the terrors to come . . . [1]

and ending with the last (interminable) longshot of Visconti's *Rocco and his Brothers* (fig. 251). There Ciro the "well-adjusted" brother, the Party member and property-owning democrat in the making, turns away finally from the movie's world of tragedy (the past, the South, Mother, the sea and the woods) and heads for the city's outskirts – a wilderness of building sites, skeletons of factories and tenements, dirt roads waiting for asphalt, billboards for candidates and hair cream.[2] Bland promises, great collective dreams. The shot reaches back to a world of nineteenth- and early twentieth-century longing (fig. 252).

All this got called "neo-realist" when it was happening; though, as Calvino said in retrospect, the label largely flattened the filmmakers' and novelists' engagement with the modernist past. "Italian literary and figurative culture had

251 Luchino Visconti: Still from *Rocco and his Brothers*, 1960

252 Umberto Boccioni: *Dusk (Outskirts of the City)*, oil on canvas, 90 × 120, 1909 (Private collection)

missed the appointment with expressionism in the post-World War I period," wrote Calvino, "but it had its great moment after World War II."[3] Modernism has repeatedly thrived – and will go on thriving, I think – on such picked-up threads and uneven development through history. Or again:

> The literature we were interested in carried this sense of teeming humanity and mercilessness and nature. The Russians too, at the time of the civil war – before Soviet literature became so Victorian and oleographic – we felt as our contemporaries, especially Babel, whose *Red Cavalry* we knew in an Italian translation even before the war, one of the exemplary books of our century's realism, born from the relationship between the intellectual and revolutionary violence.[4]

I guess this sense of teeming humanity and mercilessness and nature is the aspect of modernism my book has been most interested in, and also puzzled by. For why "merciless," exactly? Why "teeming humanity" represented this way – as corpse, or ghost, or cut-out, or last first handprint? Why not "We Field-Women" instead? Why not people "carrying their mattresses on their bicycles or on their backs, shouting and arguing, obstinate, gullible, and amused"? I believe there have been reasons why, which resist being hectored or wished out of existence. Modernism's subject has been the reasons. Which does not mean that it has merely buckled down under them, mutely and fatalistically. Anyone who cannot hear the shouting and arguing still going on in a Pollock or Picasso has, to my way of thinking, a tin ear for agony.

For me it is right that the moment of modernism I begin and end with belongs to Rossellini as much as to Pollock. And that the terms "neo-realist" and "neo-expressionist" apply to it equally. For partly this book has been about modernism's continual two-facedness – its inward-turning and outward-reaching, its purism and opportunism, its centripetal and centrifugal force. I think this doubleness has to do with the fact that art, in our culture, finds itself more and more at the limits, on the verge of emptiness and silence. So that practitioners have continually been forced to recognize how little space, or representational substance, they are given to work with in the all-consuming world of goods.

They crowd my memory with their faceless presences, and if I could enclose all the evil of our time in one image, I would choose this one which is familiar to me: an emaciated man, with head dropped and shoulders curved, on whose face and in whose eyes not a trace of a thought is to be seen.[5]

> . . . Quanto più è vano
>
> – in questo vuoto della storia, in questa
> ronzante pausa in cui la vita tace –
> ogni ideale, meglio è manifesta
>
> la stupenda, adusta sensualità
> quasi alessandrina, che tutto minia
> e impuramente accende, quando qua
>
> nel mondo, qualcosa crolla, e si trascina
> il mondo, nella penombra, rientrando
> in vuote piazze, in scorate officine . . .[6]

(The emptier is each ideal – in this vacuum of history, in this buzzing pause when life is silent – the more obvious the stupendous, ancient, almost Alexandrian sensuality, which impurely decks out everything in golden light, when there in the world something collapses, and the world drags itself along, in the twilight, reentering the empty piazzas, the disheartened workshops . . .)

Think, pig! (Pozzo jerks the rope. Lucky looks at Pozzo.) Think, pig!

I bring on these "neo-realist" sentences here – stanzas from Pasolini's *The Ashes of Gramsci* (1954), a fragment from Primo Levi's *If This Is A Man* (which began its life with most readers on republication in 1958), a line from Beckett's *Waiting for Godot* (1955) – because they seem to me to speak so clearly to the ultimate reason for modernism's changes of face. The clue is the value given by all three writers to the notions of "thought" and "ideal"; and the accompanying hope in their works that the present, however vicious and driveling – and modernism has made it its endless business to show what those two adjectives mean – is only incompletely ripped from its historical frame. Only temporarily. In a buzzing pause, not a brainwashed peace. The writers were communists, humanists, Resistance fighters, survivors of the camps. They were pessimists and extremists (not necessarily both), whose modernism was tempered by the worst kinds of experience. And though no doubt they would have recoiled from having their achievement summed up, as my conclusion's

epigraph dares to do, by a rueful Fascist – writing in Pisa in 1945, and partly apologizing for the regime at whose hands they had suffered – I think Pound's verdict does apply to them. It is typical of modernism that it has me end by imagining Pound and Pasolini barking slogans at one another, and then Pound falling to listening, in spite of himself, to his enemy's closing lines.[7] The subject, as so often, is passion and history; and fueling the latter, the myth of socialism:

> eccoli, miseri, la sera: e potente
> in essi, inermi, per essi, il mito
> rinasce . . . Ma io, con il cuore cosciente
>
> di chi soltanto nella storia ha vita,
> potrò mai più con pura passione operare,
> se so che la nostra storia è finita?[8]

Which goes into English, approximately (though having no way to render the defiant echo of Dante in Pasolini's *terza rima* is having no way to convey his poem's true scope):

> here they are, the wretched, at evening. And potent
> in them, the defenseless, through them, the myth
> is reborn . . . But I, with the heart and consciousness
>
> of one who can live only in history,
> shall I ever again be able to act from pure passion,
> when I know that our history is finished?

"He has tortured his line into conformity with the impending disaster," to quote Longinus for the last time. Well, yes. Yet the poem's mood is relentless, and ultimately impersonal, as if hope and despair were equally irrelevant to the horror of the moment. The myth will survive its historic defeat. The present is purgatory, not a permanent travesty of heaven.

Notes

INTRODUCTION

1 See Armand Hammer Museum catalogue, *Kasimir Malevich 1878–1935* (Los Angeles, 1990), 213.

2 Walter Benjamin, *Gesammelte Schriften*, vol. 5, *Das Passagen-Werk*, ed. Rolf Tiedemann (Frankfurt, 1982), 1: 292.

3 Percy Bysshe Shelley, "Preface to Prometheus Unbound," in Thomas Hutchinson, ed., *Shelley, Poetical Works* (Oxford, 1970), 205.

4 In the original photomontage for the Heartfield, it is clear that the small scene at extreme right is also of workers being read to from a newspaper.

5 UNOVIS slogans, discussed below, 226–29, 247.

6 "Platform of the Church Socialist League," 1906, quoted in Peter d'A. Jones, *The Christian Socialist Revival 1877–1914* (Princeton, N. J., 1968), 241.

7 Benjamin, *Das Passagen-Werk*, 2: 1010.

8 See Donald Sassoon, *One Hundred Years of Socialism* (London and New York, 1996), 5–82 for a succinct discussion of rhetoric versus practice.

9 Marc Bouloiseau, *La République jacobine* (Paris, 1972), 123.

10 I realize that I shall be taken here and elsewhere to be idealizing pre-modern society, and inventing a previous watertight world of myth and ritual, agreed-on hierarchies, implicit understandings, embodied places, and so on. There is no easy way out of this dilemma. Of course all pre-modern societies (and certainly the ones existing in Europe immediately before the spread of mercantile capitalism and the seventeenth-century crisis) were conflicted and ideologically incomplete. I am on the side of historians who have fought against the old picture of a pre-modern Europe characterized by absolute cultural uniformity, immovable religious consensus, the unthinkability of alternative views of the world, etc. Nonetheless, if we do not make a distinction between societies built, however inefficiently, upon instanced and incorporated belief, with distinctions and places said to be inherited from time immemorial, and societies driven by a new kind of economic imperative, in which place and belief are subject to constant revision by the very forces that give society form, then I reckon we forfeit the chance of thinking critically about the past two hundred years. To call such comparative thinking "nostalgia" (or in the present techno-ecstatic conjuncture, "Luddism") is just the latest form of philistinism about history in general.

11 See especially Michael Fried, *Courbet's Realism* (Chicago and London, 1990), and his *Manet's Modernism, or, The Face of Painting in the 1860s* (Chicago and London, 1996).

12 Claude Monet to Alice Hoschedé, 30 April 1889, in Daniel Wildenstein, *Claude Monet, biographie et catalogue raisonné*, 5 vols. (Lausanne and Paris, 1974–91), 3: 247.

1 PAINTING IN THE YEAR 2

1 Speech on 27 June 1789, quoted in Jean Jaurès, *Histoire Socialiste de la révolution française*, 3 vols. (1900; Paris, 1983), 1: 362: "L'histoire n'a trop souvent raconté les actions que des bêtes féroces, parmi lesquelles on distingue de loin en loin des héros; il nous est permis d'espérer que nous commençons l'histoire des hommes." I shall give the French only where the source is obscure or the original language particularly important.

2 George Kubler, *The Shape of Time: Remarks on the History of Things* (New Haven, 1962), 70. Kubler is aware of the problem here: he knows that modern art "is an expression corresponding to new interpretations of the psyche, to a new attitude of society, and to new conceptions of nature," and that "all these separate renovations of thought came slowly." This only makes it the more interesting, in his view, that the transformation in art was as if instantaneous. However gradual and cumulative the change might have been in the realm of ideology, "its recognition in perception by a corresponding mode of expression in the arts was discontinuous, abrupt, and shocking."

3 See Daniel Wildenstein and Guy Wildenstein, *Documents Complémentaires au catalogue de l'oeuvre de Louis David* (Paris, 1973), document 601.

4 See Jules Michelet, *Histoire de la Révolution française*, 2 vols. (1847–53; Paris, 1952), 2: 602, and compare the chronology on p. 1664. This chapter is full of French Revolutionary names and terms, and would get hopelessly clotted if I tried to identify all of them along the way. What the reader needs to know is that in 1793 the Revolution was dominated by the Left in the National Assembly (otherwise known as the Convention). The Left's shape on the benches gave it the further nickname, "the Mountain." In terms of state power – control over the key executive committees that did the work of policing, running the economy, and preparing for war – the prime movers within the Left for most of the year were the Jacobins, who had come together as a kind of party in and around the Jacobin Club. Robespierre and Saint-Just were the group's chief leader and thinker, respectively. Their main opponents in the Assembly were the so-called Girondins.

Besides the Assembly, the Committees of Public Safety and General Security (on which David served), and the main political clubs, the other great centers of power in Paris were the district associations known as *sections*. They were variously organized, and we shall see that questions of their composition and affiliation were deeply disputed; their relations with the Jacobins were moot; but they had a degree of independence, were obliged to answer to a working-class constituency, and at key moments clashed with the more moderate, propertied Conventionnels. A motley assortment of individuals claimed at moments to lead or speak for the *sections*. Jean-Paul Marat was one of them, alongside (or in opposition to) Jacques Hébert, François Vincent, Jacques Roux, Claire Lacombe, and others. Roux and Lacombe, whose faction was known as the *enragés*, seem to have spoken most circumstantially to the interests of the Paris *petit peuple* – though as usual with such figures what we know of them is mostly from their enemies.

5 See Pierrette Jean-Richard and Gilbert Mondin, *Un Collectionneur pendant la révolution: Jean Louis Soulavie, 1752–1813* (Paris, 1989), 90–91.

6 Albert Soboul, *Les Sans-Culottes parisiens en l'an II, mouvement populaire et gouvernement révolutionnaire, 2 juin 1793–9 thermidor An II* (1958; Paris, 1962), 304. Compare Section du Muséum, *Ordre de la Marche. Pompe funèbre qui aura lieu le 26e jour du 1er mois de l'an deuxième de la république française, une et indivisible (vieux style, mercredi 16 octobre), pour l'inauguration des bustes de Marat et Le Pelletier* (Paris: n.d.). Soboul points out that 16 October equals 25, not 26, Vendémiaire.

7 See Wildenstein, *Documents*, no. 601: "avant de vous l'offrir, de me permettre de le prêter à mes concitoyens de la section du Muséum, ainsi que celui de Lepelletier, afin qu'ils puissent être l'un et l'autre présents en quelque sorte aux honneurs civiques qu'ils reçoivent de leurs concitoyens ... je vous y invite les premiers à les venir voir chez moi au Louvre, à commencer de Samedi prochain." The procession was on Wednesday; David is inviting the Conventionnels to a showing of the pictures in his studio a few days later.

8 See Ian Germani, *Jean-Paul Marat, Hero and Anti-Hero of the French Revolution* (Lewiston, N. Y., 1992), 274, and discussion on p. 86.

9 D. A. F. Sade, *Oeuvres Complètes*, 12 vols. (Paris, 1966–67), 12: 121: "Sexe timide et doux, comment se peut-il que vos mains délicates ayent saisi le poignard que la séduction aiguisoit? ... Ah! votre empressement à venir jetter des fleurs sur le tombeau de ce véritable ami du peuple, nous fait oublier que le crime pût trouver un bras parmi vous. Le barbare assassin de Marat, semblable à ces êtres mixtes auxquels on ne peut assigner aucun sexe, vomi par les enfers pour le désespoir de tous deux, n'appartient directement à aucun. Il faut qu'un voile funèbre enveloppe à jamais sa mémoire; qu'on cesse surtout de nous présenter, comme on ose le faire, son effigie sous l'emblème enchanteur de la beauté. Artistes trop crédules, brisez, renversez, défigurez les traits de ce monstre, ou ne l'offrez à nos yeux indignés qu'au milieu des furies du Tartare." Sade's instructions to artists put me in mind of David's decision not to represent Corday in his picture, or rather, to do so by her writing. A reading of the *Marat* in terms of Jacobin gender politics would certainly be possible, though the versions of such a reading I have come across strike me as smug and schematic. To imagine that the last word has been said on Jacobin attitudes to women by pointing to the suppression of the *Citoyennes républicaines révolutionnaires* on 9 Brumaire (nowadays an obligatory trope in histories of the Revolution) is like imagining that all that needs chronicling of the Jacobins' relation to the sans-culottes is the pattern of action against the *sociétés sectionnaires* happening at the same moment. Whereas the historical questions in both cases are: What fears led to the final suppression? Fears of what kinds of symbolic and political energy? To what extent had features of Jacobin politics led to those energies being released in the first place? And so on.

Gender politics as applied to Marat are double-edged. Marat's impeccable home life was a standard feature of Jacobin oratory, and sometimes more attention seems to have been paid to the virtues of Simone Evrard than to Marat himself: see Martyn Lyons, *Revolution in Toulouse, An Essay on Provincial Terrorism* (Bern, 1978), 161. The *Citoyennes républicaines révolutionnaires* were prime movers in the setting up of a wooden obelisk in Marat's honor in the place de la Réunion, and on 18 August carried his bathtub, chair, table, pen, and paper in

procession to the obelisk's inauguration: see Germani, *Marat*, 73. It hardly needs saying that the basic facts of Marat's assassination stir up all kinds of oedipal fears and wishes in those trying to represent them. Sade's first sentences get that right. One can imagine him as an interested spectator on both 18 August and 25 Vendémiaire.

10 See Germani, *Marat*, ch. 3, "The Sans-Culottes and the Cult of Marat," and his list of "Pamphlets and Festival Programs," 265–75, for the fullest documentation. Compare Jean-Claude Bonnet, "Les formes de célébration," in Bonnet, ed., *La Mort de Marat* (Paris, 1986), 101–27; and Albert Soboul, "Sentiments religieux et cultes populaires pendant la Révolution. Saintes patriotes et martyrs de la liberté," *Annales Historiques de la révolution française*, no. 148 (July–September 1957): 193–213.

11 See the Museum section *Ordre de la Marche*: "Les défenseurs de la liberté de la première réquisition de la section du Muséum, porteront et environneront les bustes de Marat & de le Pelletier, avec le respect qu'inspire la vertu à ceux qui ont juré de vaincre ou de mourir pour la patrie. Ils auront chacun une branche de chêne à la main."

12 See Albert Lenoir, "David, souvenirs historiques," *Journal de l'Institut historique* (August 1835); quoted by Robert L. Herbert, *David, Voltaire, Brutus and the French Revolution: an Essay in Art and Politics* (London, 1972), 145, n. 107: "une chapelle ardente." Contemporary commentators settled for the vaguer words "monument" or "sanctuaire." See the manuscript copy of a 1793 account in the Deloynes collection, vol. 54, no. 1584, and an anonymous item in "Variétés," *Feuille de Salut public*, no. 120 (8 brumaire, an II): 3 (both items discussed below, n. 74). It is Herbert who suggests the chapel would have been made of branches (p. 101), and as far as I know he was the first to point out that the Marat procession happened on the day of Marie Antoinette's execution.

13 See Wildenstein, *Documents*, no. 602.

14 See Eugène Defrance, *La Conversion d'un sans-culotte. Gabriel Bouquier peintre, poete et conventionnel* (Paris, 1912), 181. Defrance does not claim to be sure that these verses, originally published anonymously in the *Gazette de Paris* just after Marat's death, are the ones used again in

Vendémiaire, but he makes a good case for their being so. Bouquier described his role in Vendémiaire in his manuscript *mea culpa*, "De quelques faits révolutionnaires composés sans ordre," Archives de l'Assistance Publique, MS B1, fol. 110, quoted in ibid., 237–38: "David et moi avons sans doute le cerveau troublé par les vapeurs irritantes qu'exhalaient les écrits révolutionnaires et les motions exaltées qui frappaient chaque jour nos oreilles, lorsque, dans la cour du Louvre, il fit élever un catafalque sur lequel il exposa à la vénération du peuple le tableau de Marat mort assassiné, et moi lorsque j'attachai à son cercueil *quatre vers* que j'avais la sottise de faire à sa louange, et qui formaient sa menteuse épitaphe . . . J'en demande pardon à Dieu!" (Again, the wording here does not make it certain that *catafalque* and *cercueil* are part of the same set-up. But that seems the most reasonable interpretation.) Bouquier, deputy from the Dordogne, author of a 1793 plan for national public education, had got to know David in Rome in the 1770s. There is a good brief biography of him in Auguste Kuscinski, *Dictionnaire des Conventionnels* (Paris, 1916), 76–77.

15 Soboul, *Les Sans-Culottes*, 304, n. 259.

16 Ibid., 276, n.144, quoting a report in *Journal de la Montagne*, no. 140 (29 vendémiaire, an II): 1017–18. Issue 136 of *Journal de la Montagne* carries a report of a delegate from the Museum section inviting the Jacobin Club to the procession, and stressing that the event will include a burning of the act of accusation against Marat drawn up "par l'infâme comité *des douze*." All the right party notes are being sounded. Soboul himself does not seem to have made a connection between the events of 25 and 26 Vendémiaire, which crop up in different parts of his book.

17 Soboul, *Les Sans-Culottes*, 275, quoting an intervention by Brochet (see below): "que celles dont le comité révolutionnaire aurait formé le noyau après s'être épuré lui-même, que celles dont tous les membres auraient passé par le scrutin épuratoire de ce même comité." Soboul's discussion of the push and pull between the Jacobin Club and the sections is on pp. 274–82.

18 François Furet, "Revolutionary Government," in Furet and Mona Ozouf, eds., *A Critical Dictionary of the French Revolution*, trans. Arthur

Goldhammer (Cambridge, Mass., 1989), 552. Unless otherwise indicated, the quotes and facts in this section are all from pp. 551–52.

19 See R. Gotlib, "Jacques Roux," in Albert Soboul, ed., *Dictionnaire Historique de la révolution française* (Paris, 1989), 939; and compare Daniel Guérin, *La Lutte de classes sous la première république: bourgeois et "bras nus," 1793–1797*, 2 vols. (Paris, 1946), 1: 231–49, "Liquidation des «enragés»."

20 See Soboul, *Les Sans-Culottes*, 183–91.

21 Paragraph 1 as reported by an ex-priest from Luzarches named Oudaille; see Richard Cobb, "Marat comparé à Jésus," *Annales historiques de la révolution française*, no. 161 (July–September 1960), 312: "Ô toi Jésus, ô toi Marat, ô Cœur Sacré de Jésus, ô cœur sacré de Marat, vous avez les mêmes droits à nos hommages . . . Compare ensuite les travaux du Fils de Marie avec ceux de l'Ami du Peuple; les apôtres sont à [m]es yeux les Jacobins et les Cordeliers, les Publicains sont les boutiquiers, les pharisiens sont les aristocrates. Jésus, enfin, était un prophète, mais Marat est un dieu." Paragraph two from a similar *Éloge Funèbre de Jean Paul Marat, député à la convention nationale, prononcé à Schiltigheim le 26 brumaire et à Strasbourg dans le temple de la raison, par le citoyen Morel, capitaine au premier bataillon du Jura*, quoted in Frank P. Bowman, "Le «Sacré-Cœur» de Marat," in Jean Ehrard and Paul Viallaneix, eds., *Les Fêtes de la révolution, colloque de Clermont-Ferrand* (Paris, 1977), 161: "Comme Jésus, Marat aime ardemment le peuple et n'aime que lui; comme Jésus, Marat déteste les nobles, les prêtres, les riches, les fripons; comme Jésus, il ne cesse de combattre ces pestes de la société; comme Jésus, il mena une vie pauvre et frugale; comme Jésus, Marat fut extrêmement sensible et humain . . ." Bowman also quotes alternative, almost identical reports of the Cordeliers orator's speech.

22 Oudaille's report, quoted in Cobb, "Marat comparé à Jésus," 313. (Oudaille also tells the story of Brochet's search for the vial.) Interpolated sentences from *Les Révolutions de Paris*, no. 10; quoted in Bowman, "Le «Sacré-Cœur» de Marat," 164: "Brochet, après avoir rendu un hommage aux grands talents de l'orateur, blâme le parallèle:

Marat, dit-il, n'est pas fait pour être comparé à Jésus de Nazareth; cet homme, fait Dieu par les prêtres, jeta sur terre les semences de la superstition, il défendit les Rois. Marat au contraire combattit le fanatisme et déclara la guerre au trône. Qu'on ne nous parle jamais, s'est écrié Brochet, de ce Jésus! [Il ne faut jamais parler de ce Jésus, ce sont des sottises. Des germes de fanatisme et toutes ces fadaises ont mutilé la Liberté dès son berceau.] La philosophie, oui, la seule philosophie doit être le guide du Républicain, leur seul Dieu doit être la Liberté." The exchange in the Cordeliers is quoted and discussed in connection with David's Marat in Klaus Herding, "Davids «Marat» als *dernier appel à l'unité révolutionnaire*," *Idea: Jahrbuch der Hamburger Kunsthalle*, no. 2 (1983): 100–04, though Herding draws different conclusions.

23 Compare Cobb, "Marat comparé à Jésus," 313, n. 2, with Soboul, *Les Sans-Culottes*, 770.

24 See Soboul, *Les Sans-Culottes*, 852–53.

25 See ibid., 897.

26 *L'Ami du Peuple*, no. 132 (13 June 1790); quoted in Michel Vovelle, ed., *Marat: Textes choisis* (Paris, 1963), 217–18: "Dans l'état de guerre où nous sommes, il n'y a que le peuple, le petit peuple, ce peuple si méprisé et si peu méprisable, qui puisse imposer [la liberté] aux ennemis de la révolution, les contenir dans le devoir, les forcer au silence, les réduire à cet état de terreur salutaire et si indispensable pour consommer le grand œuvre de la constitution [et] organiser sagement l'État . . ."

27 *L'Ami du Peuple*, no. 670 (10 July 1792); quoted in Vovelle, *Marat*, 220.

28 *L'Ami du Peuple*, no. 539 (27 August 1791); quoted in Vovelle, *Marat*, 36: "Il en est de notre Révolution comme d'une cristallisation troublée par des secousses violentes, d'abord tous les cristaux disséminés dans le liquide s'agitent, se fuient et se mêlent sans ordre, puis ils se meuvent avec moins de vivacité, se rapprochent par degrés et . . . finissent par reprendre leur première combinaison . . ."

29 Session of 6 April, in *Réimpression de l'Ancien Moniteur*, 32 vols. (Paris, 1863–70), 16: 76, quoted in Guérin, *La Lutte de classes*, 1: 39.

30 See Wildenstein, *Documents*, no. 428.

31 See *L'Ami du Peuple*, no. 493 (18 June 1791); in Vovelle, *Marat*, 225–26, and Vovelle's comments.

32 See Guérin, *La Lutte de classes*, 1: 235–38.

33 *Le Publiciste de la république française*, no 245 (21 July 1793); quoted by Germani, *Marat*, 52, who gives a good account of the initial battle for Marat's legacy in July and August, pp. 50–60.

34 See Maximilien Robespierre, *Oeuvres*, 10 vols. (Paris, 1950–67), vol. 10, *Discours: cinquième partie, 27 juillet 1793–27 juillet 1794*, 59–60; quoted by Germani, *Marat*, 53.

35 The same speech, as quoted by Albert Mathiez, *The French Revolution* (1922; New York, 1964), 356. Mathiez is typically enthusiastic about Robespierre's *coup de théâtre* (and following *coup de force*).

36 *Le Publiciste de la république française*, no. 224 (23 June 1793); in Auguste Vermorel, *Oeuvres de J. P. Marat* (Paris, 1869), 311: "Qu'a-t-il gagné à la Révolution?"

37 See Augustin Cabanès, *Marat Inconnu: l'homme privé, le médecin, le savant*, 2nd ed. (Paris, 1911), 251–52; cited by Bowman, "Le «Sacré-Coeur» de Marat," 166.

38 See Bonnet, "Les formes de célébration," 102. Compare the accounts in Guérin, *La Lutte de classes*, 284; and Soboul, "Sentiments religieux et cultes populaires," 206–10.

39 Petition of the Mennecy *société populaire* to the Convention on 19 Brumaire, quoted by Bonnet, "Les formes de célébration," 120.

40 See Paul Fassy, *Marat, sa Mort, ses véritables funérailles* (Paris, 1867), 23; quoted by Bonnet, "Les formes de célébration," 117.

41 See Bouloiseau, *La République jacobine*, 200–01.

42 Quoted in Stanley J. Idzerda, "Iconoclasm during the French Revolution," *American Historical Review*, 60 (1954): 17. The ceremony is dated by Bonnet, "Les formes de célébration," 120.

43 See, for example, Ballin's *Marat du séjour des immortels aux français, 26 juillet 1793, l'an premier de la constitution française* (Paris, n. d.), which warns against those engineering Marat's deification, "so that they can denature his Doctrine, as the debased Senate of Rome wished to place Jesus at the level of the Gods, in order to halt the progress of his doctrine . . . That is to say, to bend the principles of 'Holy Equality' under

the principles of Priests, Publicans, Monopolizers, Intriguers, and false Doctors of all times"; quoted by Germani, *Marat*, 76. Compare this updating of the gospels' *dramatis personae* with the Cordeliers orator's.

44 See, for example, the *Discours prononcé par Sauvageot, maire de la commune de Dijon, à l'assemblée des sociétés populaires de la Côte-d'or, tenue à Dijon, le 25 brumaire, l'an deuxième de la république, le jour de l'inauguration du buste de Marat* (Dijon, 1793), quoted and discussed in Bowman, "Le «Sacré-Coeur» de Marat," 162–63. And compare the letter to the Cordeliers orator from the sans-culotte Jean-Baptiste Vingternier, repeating and amplifying Brochet's arguments, presented in Cobb, "Marat comparé à Jésus," 313–14. Herding's "Davids «Marat» als *dernier appel*," 99–105 contains a full discussion of the to-and-fro of argument in the Marat-Jesus comparison.

45 Letter of 5 August 1793, quoted by Jean-Claude Bonnet, "Les images négatives," in Bonnet, *Mort de Marat*, 170.

46 Speech at the Jacobin Club, 1 Frimaire, in Robespierre, *Oeuvres*, 10: 196.

47 See Soboul, *Les Sans-Culottes*, 977.

48 Quoted in ibid., 820, with other connected material from this time: "Si Marat existait encore en ce moment, il eût été inculpé et peut-être guillotiné."

49 Quoted by Jacques Guilhaumou, "La Mort de Marat à Paris (13 juillet–16 juillet 1793)," in Bonnet, *Mort de Marat*, 61.

50 David's speech to the Convention, 15 July; Wildenstein, *Documents*, no. 463: "La veille de la mort de Marat, la Société des Jacobins nous envoya, Maure et moi, nous informer de ses nouvelles. Je le trouvai dans une attitude qui me frappa. Il avait auprès de lui un billot en bois sur lequel étaient placés de l'encre et du papier, et sa main, sortie de la baignoire, écrivait ses dernières pensées pour le salut du peuple. Hier, le chirurgien qui a embaumé son corps m'a envoyé demander de quelle manière nous l'exposerions aux regards du peuple dans l'église des Cordeliers. On ne peut point découvrir quelques parties de son corps, car vous savez qu'il avait une lèpre et que son sang était brûlé. Mais j'ai pensé qu'il serait intéressant de l'offrir dans l'attitude où je l'ai trouvé, «écrivant pour le bonheur du peuple»."

51 Speech to the Convention, ibid., no. 466: "Il a été arrêté que son corps serait exposé couvert d'un drap mouillé qui représenterait la baignoire et qui, arrosé de temps en temps, empêcherait l'effet de la putréfaction."

52 David's formal presentation of the picture to the Convention; ibid., no. 674. The following quotes are from the same speech.

53 Letter of 14 Floréal; ibid., no. 1190: "C'est en vain que vous vous enveloppez des ténèbres; je porterai la lumière dans les replis les plus cachés de votre coeur, je découvrirai les ressorts secrets qui vous font mouvoir, et j'imprimerai sur vos fronts le caractère hideux des passions qui vous agitent." I discuss this aspect of David's aesthetic in Timothy J. Clark, "Gross David with the Swoln Cheek: An Essay on Self-Portraiture," in Michael Roth, ed., *Rediscovering History: Culture, Politics, and the Psyche* (Stanford, Calif., 1994), 285–91.

54 See *Éloges, Discours, lettres et vers addressés à la section de Théâtre-Français, dite de Marseille, sur la mort de Marat, assassiné dans son bain, sur les sept heures du soir, par Charlotte Corday, le 13 juillet 1793, l'an 2ème de la république française une et indivisible* (Paris: n.d.), quoted in Guilhaumou, "La Mort de Marat à Paris," 77.

55 Walter Benjamin, "On Some Motifs in Baudelaire," in W. Benjamin, *Illuminations*, trans. Harry Zohn (London, 1970), 190.

56 Walter Benjamin, "The Work of Art in the Age of Mechanical Reproduction," in *Illuminations*, 225.

57 Among recent treatments of the picture by art historians, see Jorg Traeger, *Der Tod des Marat, Revolution des Menschenbildes* (München, 1986); Herding's "Davids «Marat» als *dernier appel*"; and Willibald Sauerländer, "Davids «Marat à son dernier soupir» oder Malerei und Terreur," *Idea, Jahrbuch der Hamburger Kunsthalle*, no. 2 (1983).

58 See Musée des Augustins, Toulouse, *Ingres et ses Maitres, de Roques à David* (Toulouse and Montauban, 1955), 37. On Desbarreaux, see Lyons, *Revolution in Toulouse*, 160–61, 174–75. Desbarreaux was the quintessential "popular" politician made good, beginning as a badly paid local actor/playwright and ending his days as "propriétaire et directeur d'une manufacture de fayence."

59 Saint-Just, *Esprit de la Révolution et de la Constitution de France*

(1791); in Saint-Just, *Oeuvres Complètes* (Paris, 1984), 307, ch. 12, "Des Femmes."

60 Saint-Just, report to the Convention on 26 Germinal, in *Oeuvres Complètes*, 809–10: "L'homme révolutionnaire est intraitable aux méchants, mais il est sensible . . . Marat était doux dans son ménage, il n'épouvantait que les traîtres."

61 See Ferdinand Brunot, *Histoire de la Langue française*, 13 vols. (Paris, 1937), 9: 690 and 689. The second quote is from Voltaire in 1733.

62 See Soboul, *Les Sans-Culottes*, 656 and n. 44.

63 See Marie-Hélène Huet, *Rehearsing the Revolution: The Staging of Marat's Death, 1793–1797* (Berkeley, 1982), 74, n. 4.

64 Speech reported in the *Journal de la Montagne*, 22 Brumaire; quoted in Brunot, *Histoire de la Langue française*, 9: 691: "On sait bien que le vous est absurde, que c'est une faute contre la langue de parler à une personne comme on parlerait à deux, à plusieurs, mais aussi n'est-il pas contraire à la liberté de prescrire aux citoyens la manière dont ils doivent s'exprimer? Ce n'est un crime de parler mal le français."

65 On the identity of the copyists, see Musée du Louvre and Musée national du château, Versailles, *Jacques-Louis David, 1748–1825* (Paris, 1989), 282.

66 *Le Publiciste de la république française*, no. 231, 2 July 1793, quoted in Alfred Bougeart, *Marat l'Ami du Peuple*, 2 vols. (Paris, 1865), 2: 259. An extract from the 14 July issue, which sounds much the same note, is given in Vermorel, *Oeuvres de Marat*, 318–19. Hébert made much of this aspect of Marat's last days in his speech to the Conseil général de la Commune de Paris on the evening of the assassination (see Bonnet, *Mort de Marat*, 444–46). Presumably much to Robespierre's annoyance.

67 François Furet, "Michelet," in *Critical Dictionary*, 984.

68 Both quotes from François Furet, "Quinet," in *Critical Dictionary*, 997.

69 François Furet, "Jacobinism," in *Critical Dictionary*, 709.

70 I am not saying here that Matisse's paintings do not successfully give pleasure, any more than that the Marat completely fails to instantiate the concept "of the People." What is at issue in modernism is the means by which effects are achieved or connotations

mobilized. My argument is that the means are most often discovered to be unstable, maybe dysfunctional, and that this discovery becomes part of painting's dealing with its world. I should say a crucial part. But that does not mean that I see all Matisse's work as consumed by doubt about Nature or sensation, or even that I am interested only in the work that is (the rigorous naivety of the paintings done at Collioure in 1905 is a touchstone for all that follows in Matisse; and I do mean touchstone, not foil); still less that I think I am offering an account of doubts Matisse might have entertained on any other level than that of practice. "Can't possibly have *pleasure* in the twentieth century, now can we? . . . Must do something about that . . ."

71 See Michel Bruguière, "Assignats," in *Critical Dictionary*, 426–36. Unless otherwise indicated, the facts in the following discussion are drawn from him, though he is even less impressed by the financial achievement of the Terror than I am (see 432–33).

72 Quoted in Guérin, *La Lutte de classes*, 1: 150. Guérin's whole chapter, especially the sections "Le soutien de l'assignat: la solution «autoritaire»," and "La victoire de l'assignat," 146–54, is basic to my interpretation.

73 See, for example, Wildenstein, *Documents*, no. 452 (David as *commissaire* for a new plan to combat forgery); no. 511 (forced replacement of coin by *assignats*); nos. 568, 588, 600, 628, 643, 648, 657, 697, etc. It may well be, to repeat, that my account of the *assignat* in 1793 is too sanguine. Guérin, as usual, wants his Jacobins ruthless as opposed to out of their depth. Not everyone was as impressed as the American ambassador. The figures I use are all disputable, and even the best of them hardly suggest that the Jacobins had much of a hold on the country's finances. All I want to establish is that the struggle to stabilize the currency was still going on in summer and fall, that it did not seem an utterly lost cause, and that David was personally engaged in it. Given his temperament, he would have been as likely as the ambassador to have lived in hope. (Again, I am not saying that signs of impending disaster were lacking in 1793. The *vérificateur en chef* supervised the burning of 10 million *assignats* just five days after the Museum procession, on 30 Vendémiaire.)

74 Anonymous "Variétés," *Feuille de Salut public*, no. 120, quoted in part

in Jean-Rémy Mantion, "Enveloppes à Marat David," in Bonnet, *Mort de Marat*, 217, n. 38: "L'assignat de 5 liv. qui faisoit toute la fortune de Marat, a été placé par David, sur le billot représenté près de la baignoire. Cette idée est vraiment un trait de génie, et une réponse éternelle à tous les sots qui accusoient l'ami du peuple de vendre sa plume. Eh, qui donc auroit pu la payer!" The sentences are all the more interesting when one realizes that the *assignat* is the only feature of the picture this critic singles out for particular notice, and therefore, as far as I can discover, the only feature of the picture singled out by *any* writer in 1793. The critical notice copied out in Deloynes, vol. 54, no. 1584 is also enthusiastic, and gives a hint of the picture's reception in the world of art: "Quoique ces deux tableaux [the Marat and Le Peletier] soient chacun dans leur genre ce que l'on peut concevoir de mieux, les artistes admirent plus particulièrement le tableau de Marat. Il est effectivement difficile d'en soutenir longtemps la vue, tant l'effet en est terrible."

75 Edmund Burke, *Thoughts on French Affairs* (1791); in R. Smith, *Edmund Burke on Revolution* (New York, 1968), 190; quoted in Lynn Hunt, *Politics, Culture, and Class in the French Revolution* (Berkeley, 1984), 125. In the *Reflections*, Burke puts immense stress on the *assignat* as symbol and instrument of the new "burgher" regime: "A paper circulation, not founded on any real money deposited or engaged for . . . must put the whole of what power, authority, and influence is left, in any form whatsoever it may assume, into the hands of the managers and conductors of this circulation . . . The whole of the power obtained by this revolution will settle in the towns among the burghers, and the monied directors who lead them . . . All these considerations leave no doubt on my mind, that if this monster of a constitution can continue, France will be wholly governed by the agitators in corporations, by societies in the towns formed of directors of assignats, and trustees for the sale of church lands, attornies, agents, money-jobbers, speculators, and adventurers, composing an ignoble oligarchy founded on the destruction of the crown, the church, the nobility, and the people. Here end all the deceitful dreams and visions of the equality and rights of men." Edmund Burke, *Reflections on the Revolution in France* (1790; Harmondsworth, 1982), 307, 311, 313.

The last two sentences would do as an epigraph for Guérin's *La Lutte de classes*.

76 See Richard Andrews, "Social Structures, Political Elites and Ideology in Revolutionary Paris, 1792–1794: A Critical Evaluation of Albert Soboul's *Les Sans-Culottes parisiens en l'an II*," *Journal of Social History*, 19, no. 1 (Fall 1985): 79.

77 Ibid., 77.

2 WE FIELD-WOMEN

1 Some biographers say the show opened on 23 January, but Pissarro's letters make clear it is still being hung several days later. See Pissarro to Julie Pissarro, 27 January 1892, *Correspondance de Camille Pissarro*, 5 vols., ed. Janine Bailly-Herzberg (Paris, 1980–91), 3: 194. (Hereafter cited as *CP*. I shall not cite correspondents and date of letter if they are indicated in my text. Translation has inevitably involved repunctuating Pissarro's informal, devil-may-care French.) One or two critics at the time say specifically the show will open on 1 February. It certainly closed on 20 February.

2 See, for example, Jules Antoine, "Critique d'art," *La Plume* (15 February 1892): 102, and Georges Lecomte, "M. Camille Pissarro," *Art et Critique* (6 February 1892): 49. The latter is a revised version of Lecomte's introduction to the exhibition catalogue, Galeries Durand-Ruel, *L'Exposition Camille Pissarro* (Paris, 1892). Bibliographies of the 1892 criticism are given in Hayward Gallery catalogue, *Camille Pissarro 1830–1903* (London, 1980), 253, and Martha Ward, *Pissarro, Neo-Impressionism and the Spaces of the Avant-Garde* (Chicago, 1996), 327. The following should be added: Anonymous, "Les Expositions. – Camille Pissaro [*sic*]," *L'Art français* (13 February 1892): n. p.; Anonymous, "Beaux-Arts. L'Exposition Pissaro [*sic*]," *L'Intransigeant*, 8 February 1892, 3; Anonymous (probably Georges Lecomte), "Carnet de la Curiosité," *Art et Critique* (30 January 1892): 47 [announcing the show's opening on 1 February]; Paul Bluysen, "Chronique – Les Petits Salons," *La République française*, 3 February 1892, 1–2 [paper founded by Gambetta: an unfavorable review]; Alfred Ernst, "Camille Pissarro," *La Paix*, 3 February 1892, 1–2 [substantial review by independent-minded critic]; Gustave Geffroy, "Chronique Artistique. L'Exposition de Camille

Pissarro," *La Justice*, 2 February 1892, 1 [substantial review in Clemenceau's newspaper]; Joleaud-Barral, "Un Maitre Impressionniste," *La Justice*, 2 February 1892, 2 [a "background" article, with interview]; Pierre Louis (Maurice Denis), "Pour les Jeunes Peintres," *Art et Critique* (20 February 1982): 94 [brief mention of Pissarro, as an artist who changed his whole temperament and vision as he grew older]; Pierre-M. Olin, "Les XX," *Mercure de France* (April 1892): 341 [response to Mirbeau's *Le Figaro* article]; Alfred Paulet, "Les Petits Salons – Camille Pissarro," *Le Jour*, 5 February 1892, 2–3. My thanks to Martha Ward, Robert Herbert and Howard Lay for their help in tracking down, and thinking about, the 1892 criticism. Martha Ward's book discusses the 1892 criticism (see my response in n. 128 below), and has a fundamental treatment of the previous five years.

3 18 January 1892, *CP*, 3: 191: "Une exposition à peu près générale de mes oeuvres."

4 See Pissarro to Lucien Pissarro, ibid., 188, and Pissarro to Joseph Durand-Ruel, 19 January 1892, ibid., 192.

5 See Charles Saunier, "L'Art Nouveau: Camille Pissarro," *La Revue indépendante* (April 1892): 33; Félix Vallotton, "Beaux-Arts. L'Exposition Pissarro," *La Gazette de Lausanne*, 24 February 1892; Georges Wulff, "Les Expositions d'Art," *Le National*, 7 February 1892, 3. Wulff uses *Bords de l'Oise* as a basis for criticizing Pissarro's recent work, especially his pointillism.

6 See Geffroy, "Chronique Artistique": "ces deux femmes, à l'ombre des verdures, dans un paysage d'une soudaine perspective." This sounds as though it could be *Two Young Peasant Women*, but that picture is described later in the sentence: "et ces deux autres encore, toutes récentes, vues à mi-corps, en avant d'un coteau." The 1892 catalogue mentions a *Paysannes assises* dated 1881. The picture I illustrate is dated 1882, but the catalogue was not strictly accurate about dates, especially from the 1880s.

7 Pissarro to Esther Isaacson, 5 April 1890, *CP*, 2: 345.

8 See Ludovic Rodo Pissarro and Lionello Venturi, *Camille Pissarro. Son art – son oeuvre*, 2 vols. (Paris, 1939), 1: 49. (Hereafter cited as *PV*. Catalogue raisonné numbers will be given as PV 100, etc.) *The Rocquencourt Road* is PV 118.

9 See Pissarro to Octave Mirbeau,

17 December 1891, *CP*, 3: 168. The pictures are PV 183–86.

10 See Everett Fahy, *Paintings*, vol. 5 of *The Wrightsman Collection* (Greenwich, Conn., 1973), 152.

11 Félix Fénéon, "Exposition Camille Pissarro," *L'Art moderne de Bruxelles* (14 February 1892), cited in Félix Fénéon, *Oeuvres Plus que complètes*, 2 vols., ed. Joan Halperin (Geneva and Paris, 1970), 1: 209. I see Fénéon's hand also in a brief notice of the exhibition's closing in the anarchist journal run by Zo d'Axa, to which Fénéon was a regular contributor. See Anonymous, "L'Écho Public," *L'Endehors* (21 February 1892): 3: "...une centaine d'oeuvres d'un art juvénile et savant, belles de lumière et d'arabesque."

12 22 November 1892, *CP*, 3: 149. Compare previous discussions in John House, "Camille Pissarro's *Seated Peasant Woman*: The Rhetoric of Inexpressiveness," in John Wilmerding, ed., *Essays in Honor of Paul Mellon* (Washington, D.C., 1986), 165–66, and Joachim Pissarro, *Camille Pissarro* (New York, 1993), 160 and 298.

13 Octave Mirbeau, *Correspondance avec Camille Pissarro*, ed. Pierre Michel and Jean-François Nivet (Tusson, 1990), 63.

14 Fénéon, *Oeuvres*, 1: 209.

15 Besides Fénéon, only Clément-Janin, "Chronique: Camille Pissarro," *L'Estafette*, 18 February 1892, 1, Ernst, Lecomte, Saunier, and Vallotton have any serious discussion of the recent work. Several critics are hostile. See, for example, Paul Gsell, "La Tradition Artistique Française, 1, L'Impressionnisme," *La Revue politique et littéraire*, 49 (26 March 1892): 404: "ses derniers essais sont contestables et la chinoiserie de la facture y nuit l'intensité de l'émotion." Kalophile l'Ermite (Alphonse Germain), "Chroniques: Camille Pissarro," *L'Ermitage*, 4 (1892): 117–18, mounts a full-scale attack on the recent work from a Symbolist point of view – one of the few times Pissarro was directly attacked from this quarter. The dreaded Aurier was respectful: see G.-A. A, "Choses d'Art," *Mercure de France* (March 1892): 283.

16 *PV*, 1: 62.

17 Fénéon, *Oeuvres*, 1: 209.

18 François Thiébault-Sisson, "Puvis de Chavannes Raconté par Lui-Même," *Le Temps*, 16 January 1895, 2. "J'ai condensé, ramassé, tassé" is hard to put into English.

19 See Jules Sion, *Les Paysans de*

la Normandie orientale (Paris, 1909), 370–72 and 390–400. Compare André Siegfried, *Tableau Politique de la France de l'Ouest sous la Troisième République* (Paris, 1913), 254–55, for a classic analysis of the property relations and politics of the Epte region. There was a mixture of small and larger-scale properties, but with one distinctive feature: *fermiers* were often richer and more powerful than the proprietors they rented from (they often rented from several). The preponderance of these large farms, and the weakness of clerical influence, went to make the region a paradigm case of Siegfried's famous "atonie politique," which he saw as one key to the Third Republic's stability. There is further discussion of Eragny's economy in Richard Thomson, *Camille Pissarro: Impressionism, Landscape and Rural Labour* (London, 1990), 46 and 51.

20 See Fahy, *Wrightsman Collection*, 152. Fahy believes the two earlier pictures show a field at Eragny, which the date on the latter makes unlikely. He therefore does not take the pictures as evidence for *Two Young Peasant Women*'s synthesis of earlier (absent) motifs.

21 Pissarro to Lucien, Georges, and Félix Pissarro, 28 September 1893, *CP*, 3: 374.

22 Pissarro to Lucien, 22 November 1894, ibid., 512–13.

23 Clément-Janin, "Chronique," 1: "Pour traduire cette nouvelle intuition de la nature, il fallait un procédé nouveau. Ce procédé... s'affirme surtout dans les dernières oeuvres du peintre, où les taches épaisses, étroites, pressées, saillissent hors de la toile, en des reliefs puissants. C'est un amas kaléidoscopique de couleurs, dont le maniement périlleux révèle une grande sûreté de coup d'oeil et une impeccable science des complémentaires.

"M. Pissarro n'emploie presque plus le pinceau, mais le couteau, non point par hâte, par *furia* d'inspiré, mais pour faire une plus large part à l'éclat du jour dans la composition du tableau. Les aspérités qu'il multiplie servent à accrocher et à retenir les rayons lumineux et, quand le soleil frappe, soudain les couleurs étincellent, comme une vitrine de joaillier."

24 19 February 1892, *CP*, 5: 417. As Bailly-Herzberg says, this is a rare example of Pissarro going into technical detail.

25 Pissarro to Lucien, 25 April 1896, *CP*, 4: 195.

26 Félix Fénéon, "Le Néo-Impressionnisme," *L'Art moderne de Bruxelles* (1 May 1887), cited in Fénéon, *Oeuvres*, 1: 73: "une propension à faire grimacer la nature pour bien prouver que la minute était unique et qu'on ne la reverrait jamais plus." The verdict is applied to the Impressionists in general, but Monet in particular is meant.

27 See in particular, for my purposes, the treatments of Millet in Fried, *Courbet's Realism*, 40–45, and of Legros in Fried, *Manet's Modernism*, 186–97. Michael Fried's comments on an earlier version of this argument were crucial: they got my thinking and looking out of a rut.

28 My thanks to Eric Schmidt for pointing this out, and to participants in a Pissarro seminar I gave at Berkeley in 1996 for help with many aspects of this chapter.

29 Proverbs from Gascony and Val d'Aosta, quoted in Martine Segalen, *Love and Power in the Peasant Family*, trans. Sarah Matthews (Chicago, 1983), 107, 108. Segalen's book in general is useful on attitudes and division of labor between the sexes in peasant society.

30 Élisée Reclus, *À Mon frère, le paysan*, new ed. (Netherlands, 1894), 55–56 and 54 (I have reversed the order of paragraphs). The pamphlet was probably first published in Geneva in 1893.

31 Ronald Blythe, *Akenfield, Portrait of an English Village*, new ed. (New York, 1980), 39–40. Thompson later became an activist in the Agricultural Labourers' Union.

32 William Wordsworth, "Preface," *Lyrical Ballads* (Bristol, 1800). I have preferred the punctuation of the 1800 version, quoted in John Barrell and John Bull, *The Penguin Book of English Pastoral Verse* (Harmondsworth, 1974), 452.

33 Pissarro to Lucien, 30 March 1891, *CP*, 3: 50.

34 Émile Verhaeren, "Chronique Artistique: Les XX," *La Société nouvelle* (February 1891): 253–54.

35 Pissarro to Lucien, 23 March 1891, *CP*, 3: 48.

36 Octave Mirbeau, "Vincent van Gogh," *L'Écho de Paris*, 31 March 1891, 1; reprinted in Octave Mirbeau, *Combats Esthétiques*, 2 vols., ed. Pierre Michel and Jean-François Nivet (Paris, 1993), 1: 440–43. The article marks the beginning of van Gogh's wider reputation.

37 1 April 1891, *CP*, 3: 54.

38 Émile Verhaeren, "Le Salon des Indépendants," *L'Art moderne de Bruxelles* (5 April 1891): 112: "Sorti, ainsi que Gauguin et Bernard, des rudes impressionnistes Cézanne et Guillaumin, il a exagéré leur vision fruste et saine." Verhaeren's February review had a first attempt at sorting out van Gogh's pedigree.

39 Georges Lecomte, "L'Art Contemporain," *La Revue indépendante* (April 1892): 15–16: "Sous prétexte de synthèse et de décoration, on couvre les toiles de teintes plates qui ne restituent point les lumineuses limpidités de l'atmosphère, ne donnent point l'enveloppement des choses, la profondeur, la perspective aérienne... Les protagonistes de cet art un peu déconcertant se réclament des interprétations synthétiques, expressives, de M. Paul Cézanne...

"La constante invocation de ce nom tutélaire nous ferait croire volontiers que ce qui séduit les peintres idéistes dans l'oeuvre de Cézanne, ce ne sont pas les toiles belles par la logique ordonnance et les très saine harmonie des tons, ...mais bien d'incomplètes compositions que chacun s'accorde, avec l'assentiment de M. Cézanne lui-même, à juger inférieures, en raison de leur arrangement déséquilibré et d'un coloris vraiment trop confus. Jadis, au temps héroïques du naturalisme, on se plaisait à exalter la bizarrerie, la fortuite construction de certaines toiles de ce peintre. On admirait ainsi, sans y prendre garde, l'une des très rares défectuosités de son talent. Aujourd'hui ce sont des imperfections de couleurs qu'on admire, au nom d'autres principes... Ce que nous devons retenir de son art sincère, si simplificateur, c'est la synthèse de lignes et de tons en vue de l'ornementation, son respect de valeurs, son dessin caractéristique." The whole passage (I have left out other interesting sentences) seems to me by far the best discussion of Cézanne at this date, and distinctly better than Lecomte's 1899 *reprise*, which is what usually gets discussed in the literature: see Georges Lecomte, "Paul Cézanne," *Revue d'Art* (9 December 1899): 81–87.

40 Lecomte's story "Sic Vos." was published in *Entretiens Politiques et littéraires* in 1890, then republished in *La Revolte*'s literary supplement in January 1891. His play, "La Meule," was produced by the *Théâtre Libre* in March 1891, with a program illustration by the anarchist neo Maximilien Luce: see Anonymous, "Théâtre," *La Révolte, supplément littéraire* (14–20 March 1891). The letter from Fénéon

introducing Lecomte to Pissarro, dated 30 January [1890?], is in the Bibliothèque Doucet, Paris, "Correspondance à Camille Pissarro." He published a lot in 1891 and 1892, particularly in *Revue de l'Évolution sociale* and *Art et Critique*. He also did various writing jobs for Durand-Ruel, including a book in praise of Durand-Ruel's private collection. He eventually became secretary of the Académie Française, and his later essays condescended to his and Pissarro's bygone politics.

41 A. Andrei, "Les Petits Salons: Camille Pissaro [*sic*]," *La France nouvelle*, 23 February 1892, 1. Compare Auguste Dalligny, "Expositions Particulières: Pissaro [*sic*]," *Journal des Arts* (12 February 1892): 1, which again complains about Lecomte's prose style. Pissarro was stung by Andréi's review, as is clear from his mention of it in Pissarro to Lucien, 26 April 1892, in John Rewald, ed., *Camille Pissarro: lettres à son fils Lucien* (Paris, 1950), 281. A section of the 26 April letter is omitted from *CP*, because apparently it is no longer in the Ashmolean files. But the section is clearly genuine – Lucien replies to specific points in it in his letter of 5 May 1892 – and contains crucial evidence of Pissarro's response to Ravachol. See below for further discussion. It is common knowledge that "belles pages" from the letters were at one time removed and sold.

42 Pissarro to Lucien, 7 May 1891, *CP*, 3: 76. See Émile Bernard, "Paul Cézanne," *Les Hommes d'aujourd'hui*, 8, no. 387 (presumably late April 1891). To make matters worse, the issue used Pissarro's 1874 etching of Cézanne as frontispiece.

43 See Pierre-Louis (Maurice Denis), "Notes sur l'Exposition des Indépendants," *La Revue blanche*, no. 7 (1892) and Gustave Geffroy, "Les Indépendants," *La Vie artistique* (28 November 1892), cited in Zurich Kunsthaus catalogue, *Nabis 1888–1900* (Munich and Paris, 1993), 119.

44 Pissarro to Lucien, 20 April 1891, *CP*, 3: 66. Compare Georges-Albert Aurier, "Le Symbolisme en Peinture – Paul Gauguin," *Mercure de France* (March 1891): 155–65. Pissarro's furiously annotated copy survives: see Belinda Thomson, "Camille Pissarro and Symbolism: Some Thoughts Prompted by the Recent Discovery of an Annotated Article," *Burlington Magazine* (January 1982): 14–23.

45 See Boussod, Valadon et Cie catalogue, *Exposition d'Oeuvres récentes de Camille Pissarro* (Paris, 1890), n. p. The last page has the entry: "Le bas-relief en bois sculpté et les objets en grès émaillé, qui sont exposés dans la salle, sont de Paul Gauguin."

46 Lucien to Pissarro, 6 July 1891, *The Letters of Lucien to Camille Pissarro, 1883–1903*, ed. Anne Thorold (Cambridge, 1993), 247–48. The articles referred to appeared in *L'Écho de Paris* from 3 March on, and then were published as Jules Huret, *Enquête sur l'Évolution littéraire* (Paris, 1891). The question of Symbolism versus Naturalism was central to many of the interviews, including those with Mallarmé, Maeterlinck, Aurier, Gustave Kahn, Mirbeau, and Charles Henry.

47 8 July 1891, *CP*, 3: 102.

48 5 March 1891, ibid., 40. The lithograph had been on the cover of *Le Père Peinard*'s 1 March number. On the paper and its editor Émile Pouget, see Jean Maitron, ed., *Dictionnaire Biographique du mouvement ouvrier français*, 15 vols. (Paris 1964–73), 4: 299–301, and Richard Sonn, *Anarchism and Cultural Politics in Fin de Siècle France* (Lincoln and London, 1989), 95–114 (which makes heavy weather of the paper's imitation of street slang).

49 Paul Signac to Jean Grave, ca. 1893, in Robert L. and Eugenia W. Herbert, "Artists and Anarchism: Unpublished Letters of Pissarro, Signac and Others – 1," *Burlington Magazine* (November 1960): 519. The letter congratulates Grave on having built solid and habitable monuments in the Kropotkin landscape. Presumably *The Conquest of Bread* was meant.

50 Eugène-Melchior de Vogüé, "Devant l'Été," originally published on 4 June 1891, then in *Regards Historiques et littéraires* (Paris, 1892), 351–52 and 354. De Vogüé was a leading force in the Right-wing Société des Agriculteurs de France. In the 1891 debate on tariffs (see below) the government was regularly accused of giving in to the Society, and putting the state at the service of *gros producteurs*. See Pierre Barral, *Les Agrariens français de Méline à Pisani* (Paris, 1968), 86–87. For full discussion of de Vogüé's criticism, see Jennifer Shaw, *Nation and Desire in the Paintings of Pierre Puvis de Chavannes from 1879–1895*, Ph.D. dissertation (Ann Arbor, 1994), 259–69, and Margaret Werth, *Le Bonheur de Vivre: The Idyllic Image in French Art 1891–1906*, Ph.D. dissertation (Cambridge, Mass., 1994), 105–15. My view of Puvis is deeply indebted to Shaw's and Werth's work.

51 See Charles Saunier, "Exposition Charles Jacque," *La Plume* (1 December 1891): 448, which mentions the Puvis hanging in the same space as a Pissarro *Faneuses* in egg tempera and two *Coins de Village*, and a Monet *Soleil Saignant*.

52 To Georges, 12 January 1890, *CP*, 2: 325.

53 See Pissarro to Lucien, 17 May 1891, *CP*, 3: 86, reporting Luce's verdict on the Salon: "Beaux Puvis de Chavannes." Compare Pissarro to Lucien, 15 May 1892, *CP*, 3: 229, reporting on Puvis's accompanying mural *Winter*: "Superbe Puvis de Chavannes."

54 See, for example, Octave Mirbeau, "Puvis de Chavannes," *La France*, 8 November 1884. This was written while Mirbeau was still on the Right, but we know that Pissarro thought it "fort bien fait": see Pissarro to Durand-Ruel, November 1884, *CP*, 1: 319.

55 I have used the text in Lecomte, "Pissarro," *Art et Critique*, 50 and 51–52, whose changes seem to represent Lecomte's second thoughts: "Depuis longtemps d'ailleurs M. Pissarro avait cessé de travailler exclusivement en face de la nature, d'en rendre le momantané et l'accessoire détail. Après avoir fixé à l'aquarelle ou au pastel la physionomie d'un site, l'allure d'un paysan ou d'un animal, il se livre, loin du motif, à un travail de composition au cours duquel le relatif et le superflu s'élaguent: seuls demeurent les aspects essentiels concourant à la signification et à l'ensemble décoratif de l'oeuvre. C'est ainsi que M. Camille Pissarro s'est haussé à des synthèses de couleurs et de lignes du plus bel effet ornemental . . .

"Le souci d'ornementation, déjà sensible dans les oeuvres initiales du peintre, est plus manifeste encore en ses toiles récentes. Toutefois ses études restent éloquemment descriptives. Le style n'exclut pas la vérité. Ses rustres ont une gesticulation caractéristique de leurs fonctions, ses bouviers circulent nonchalamment à travers les saulées et les clairières; . . . Mais les croupes des animaux, les directions du terrain, les volutes des branchages, l'arabesque des frondaisons, les attitudes des hommes s'unissent en des ensembles de lignes qui, complétant l'harmonie décorative de la couleur, font de chaque tableau une oeuvre d'une rare beauté ornementale."

56 See Pissarro to Lucien and Mirbeau, 18 November 1891, *CP*, 3:

143, 145 and 146. One or two sources – for instance, Hayward Gallery, *Pissarro*, 126 – say the picture was reclaimed by Pissarro in 1891. Maybe he took it back finally at the time of the retrospective. On *Woman Breaking Wood*, see Ward, *Pissarro*, 163–65.

57 See Pissarro to Lucien, 1 April 1891, *CP*, 3: 53: "une *raideur* et une *solennité* (surtout) qui se rapprochent des Anglais."

58 Pissarro to Lucien, 18 June 1891, ibid., 95.

59 Félix Fénéon, "VIIIe Exposition Impressionniste," *La Vogue* (13–20 June 1886), cited in Fénéon, *Oeuvres*, 1: 37; and an unidentified critic quoted in John Hutton, *Neo-Impressionism and the Search for Solid Ground* (Baton Rouge and London, 1994), 122. My thanks to Shalon Parker for the latter reference.

60 Maurice Denis, "La Réaction Nationaliste," *L'Ermitage* (15 May 1905), reprinted in Maurice Denis, *Théories 1890–1910*, 4th ed. (Paris, 1920), 196.

61 Maurice Denis, "De Gauguin, de Whistler et de l'Excès des Théories," *L'Ermitage* (15 November 1905), in Denis, *Théories*, 208.

62 Friedrich Nietzsche, "The Case of Wagner," in Walter Kaufmann, ed., *Basic Writings of Nietzsche* (New York, 1968), 622.

63 The Jerez uprising took place on 8 January 1892. Part of its purpose was to storm the jail and liberate 157 anarchists who had been imprisoned the year before in struggles over the right of field workers to organize. May Day was a crucial catalyst. The uprising was defeated, and four of its "leaders" were garroted on 10 February. See Temma Kaplan, *Anarchists of Andalusia 1868–1903* (Princeton, 1977), 168–85. The French press in January and February 1892 covered the Jerez events on the front page, as well as a meeting of solidarity at the Salle du Commerce in the faubourg du Temple on 13 February. The press was eager to stress socialist complicity with the anarchists over the event: see, for example, *La Cocarde*, 12 February 1892, 1, which prints an anarchist circular sent to "tous les comités socialistes révolutionnaires." These events should be entered into an understanding of Ravachol, and Pissarro's reaction to him. *La Cocarde* is specific on 2 March: "La revanche de Xérès nous était promise."

64 In addition to Jean Maitron, *Histoire du Mouvement anarchiste en France (1880–1914)*, 2nd ed. (Paris, 1955), the best recent studies are David Stafford, *From Anarchism to Reformism. A Study of the Political Activities of Paul Brousse* (London, 1971), Marie Fleming, *The Anarchist Way to Socialism. Élisée Reclus and Nineteenth Century European Anarchism* (London, 1979), Caroline Cahm, *Kropotkin and the Rise of Revolutionary Anarchism 1872–1886* (Cambridge, 1989), plus the two crucial collections of documents: James Guillaume, *L'Internationale. Documents et souvenirs (1864–1872)*, new ed., 4 vols. (Paris, 1975), and Jacques Freymond, ed., *Études et Documents sur la première internationale en Suisse* (Geneva, 1964). General histories of anarchism get a lot wrong; Leninist histories are a study in themselves.

65 See Stafford, *From Anarchism to Reformism*, 323, for the paper's changing title and affiliation, and passim for discussion of its shifting politics. The fact that Joachim Pissarro, *Pissarro*, 298, thinks he can correct Richard Thomson's verdict on *Le Prolétaire* and *Le Libertaire* with "These two newspapers were anarchist, not Socialist," gives an idea of the general level of art-historical expertise in this area. *Le Libertaire* was certainly anarchist, and may have been read by Pissarro (there is no specific mention of it in the letters), but as the paper was first published in 1895 it is not of much help in sorting out Pissarro's allegiances in the early 1880s.

66 The first mentions of *La Révolte* in the letters crop up in 1889, but it is clear that by then the paper is an established point of reference for the family. Pissarro refers twice to Kropotkin's *Paroles d'un Révolté* in December 1885. There seems to be a distinct hiatus in Pissarro's reading of the political press, or anyway his willingness to discuss it, in 1886, 1887, and 1888 – the years of maximum neo commitment, and collapse in sales.

67 For instance, the issue is central to fly-by-night anarchist newspapers in 1890 such as *L'Anarchie* and *L'Arme*, and the Guesdists are the main target. Equally, there is already real debate within the anarchist movement about whether to downplay the notion of anarchy in favor of the general strike. See, for instance, *L'Anarchie*, 5 September 1890, 1: "Il y a une question qui divise presque les anarchistes. C'est celle de la grève générale."

68 To Esther Isaacson, *CP*, 2: 349.

69 See Pissarro to Mirbeau, 19 November 1891, *CP*, 3: 147: "Avez-vous lu l'article de Séverine dans *l'Éclair* du 18 courant sur l'élection Lafargue... la voilà anarchiste! c'est épatant..." Séverine's famous article was entitled "Lafargue et Cie." "Le socialisme et l'anarchie font des martyrs – le guesdisme fait des candidats."

70 See *La Révolte* (5–11 September 1891): 3, quoting a report in *L'Éclair*: "il considérait le congrès de Bruxelles comme très important: rien que pour avoir 'rompu complètement avec les anarchistes'!"

71 Anonymous, "La Mort de la nouvelle Internationale," *La Révolte* (17–23 October 1891): 1.

72 *Journal Officiel de la république française*, Chambre des Députés, 1891, 771 (session of 4 May, speech by Millerand, socialist deputy).

73 See Fleming, *Anarchist Way*, 230 and passim.

74 See Cahm, *Kropotkin*, 268.

75 Kropotkin to Paul Robin, 27 February 1877, cited in Stafford, *From Anarchism to Reformism*, 81. This is very far from being Kropotkin's last word on a tortured subject: see the full discussion in Cahm, *Kropotkin*, 92–151.

76 Bulot had asked for the death penalty, and used the Congrès de Bruxelles as an argument: "Les socialistes ayant expulsé les anarchistes de leur congrès, n'est-il pas juste que la société les rejette, à l'occasion, de son sein?": see Sébastien Faure, *L'Anarchie en cours d'assises* (Paris, 1891).

77 On Ravachol, see Maitron, *Histoire du Mouvement anarchiste*, 201–15, and Jean Maitron, *Ravachol et les Anarchistes* (Paris, 1964), 27–76. For press carping at the state's tactics, see, for example, Eugène Clisson, "Ravachol," *L'Événement*, 30 March 1892. The same issue has an article by Edmond Magnier, "La Nouvelle Terreur," making the point that the bombs threaten Paris's position as capital of the nineteenth century. "Le jour où son hospitalité sera définitivement empoisonnée, la grande ville sera frappé au coeur de son organisme commercial et industriel... Avec quelle joie profonde et cruelle l'Allemagne impériale ne va-t-elle pas triompher de cette recrudescence révolutionnaire?" etc. Press comment regularly makes the link between the anarchist bombs and approaching May Day – of course, partly in order to discredit the latter.

78 There were regular notices of the group's meetings in *La Révolte* in the summer, as well as a journal, *La Revanche fourmisienne* (which does not

seem to have survived). Jean Grave was imprisoned for an article on Fourmies, "Viande à Mitraille," *La Révolte* (16–22 May, 1891): one main theme of the article was the Guesdists' unwillingness to recognize that standing armies existed to do what had been done at Fourmies. Among various other post-Fourmies events, see the report "La Manifestation Anarchiste Place de la République," *La Justice*, 10 May 1891, 1: an attempt to place a wreath at the foot of the monument to the Republic, broken up by police. The article lists Michel Morphy and Lucien Pemjean as instigators, which points to a wider field of anarchist militancy whose personnel is hardly known. A mysterious Martinet, for instance, described by one paper as director of the anarchist paper *L'Arme* and the art magazine *Moniteur des Arts*, was also noted in the crowd. In early March 1892 Martinet got out to England on a fishing boat, having accumulated too much jail time as a result of anti-conscription activities. See untitled items in *La Paix*, 8 February and 15 March 1892: "sa mise, d'ailleurs, le ferait plutôt prendre pour le fils d'un millionnaire que pour l'apôtre des revendications sociales." Some anarchists were good readers of the life of Baudelaire.

79 For instance, Millerand in the Chamber on 4 May 1891: "Il y a des anarchistes, mais combien sont-ils dans la population socialiste de France? Une poignée, sans influence et sans action d'aucune sorte." See *Journal Officiel*, 1891, 772.

80 Jean Ajalbert, "Après Fourmies," *La Révolte, supplément littéraire* (13–19 June 1891): 56, reprinted from *L'Avenir dramatique*.

81 Bernard Lazare, "Nouvelle Monarchie," and Ludovic Malquin, "L'An-archie," *La Révolte, supplément littéraire* (28 November – 4 December 1891). The question of whether anarchism was only or merely a literary fashion is complicated. Certainly it became chic. Fénéon, reporting on an evening of Symbolist theater on 11 December 1891 (we know Mirbeau and Pissarro were present, mainly to see Maeterlinck's *Les Aveugles*) ironized on the lack of ushers and tickets, "ce qui permettait aux 'compagnons' de l'*En-Dehors* [*sic*] et des *Entretiens*, venus là pour fêter le symbolisme, de prôner – toujours drôles – les délices de l'Anarchie." See Willy (Henry Gauthier-Villars), "Soirée Parisienne – Au Théâtre d'Art," *La Paix*, 15 December 1891, 2. (For evidence that this is Fénéon hiding

behind Willy's pen-name, see Joan Halperin, *Félix Fénéon, Aesthete and Anarchist in Fin-de-Siècle Paris* [New Haven and London, 1988], 169.) Obviously there was an element of intellectual fashion in the anarchism of the early 1890s; but Fénéon is a good example of the thin line between fashion and real risk.

82 Pierre Kroptkine, *La Conquête du pain*, new ed. (Paris, 1975), viii–xi.

83 Cited in Fleming, *Anarchist Way*, 216. Fleming comments on Reclus's uncharacteristic optimism in early 1892. Part of that mood involved Reclus in planning a book of propaganda songs for distribution to peasants: see ibid., 202. Again, there was disagreement among anarchists. The anarchist militant Charles Malato complained specifically of Reclus's utopianism at just this moment. See Anonymous, "Les Anarchistes. Conversation avec M. Charles Malato," *L'Éclair*, 14 February 1892, 1: "En France, elle [l'idée anarchiste] a été trop propagée par des penseurs qui 'évoluaient mal' en face du parti ouvrier. Tel Élisée Reclus." Malato was right to stress anarchism's strength in the Latin countries (he points to the fact that the key delegates expelled from the Congrès de Bruxelles were Tarrida and Esteve, from Spain), and right to insist on relations with the working-class movement as the key, but his image of a tranquillized France was soon overtaken by events.

84 Anonymous (but certainly Kropotkin), *La Révolte* (16–22 January 1892), cited in Maitron, *Histoire du Mouvement anarchiste*, 209. Maitron has a good discussion of shifting anarchist attitudes to Ravachol in 1892. Again, Reclus's attitude to Ravachol is a good point of comparison for Pissarro's: "Je connais peu d'hommes qui le surpassent en générosité," he is reported as saying in ibid., 212.

85 *CP*, 3: 213.

86 Rewald, ed., *Camille Pissarro: lettres à son fils*, 281

87 7 May 1892, *CP*, 3; 222.

88 To Lucien, ibid., 223.

89 See Pissarro to Lucien, 5 May 1891, ibid., 73, and Pissarro to Paterne Berrichon, early March 1892, ibid., 203.

90 Anonymous (Jean Grave?), "Pourquoi Nous Sommes Révolutionnaires," *La Révolte* (16–22 May 1891).

91 This topic is sometimes treated in the socialist literature by pointing to the fact that the aging Kropotkin supported the war against Germany. See, for instance, Sassoon, *One Hundred*

Years of Socialism, 28 – the only reference to an anarchist in a 965-page book. This is a cheap way out of the main question: How would the history of socialism have been different if the movement in general before 1914 had gone in for militant action against conscription and the arms race, as the anarchists did and demanded?

92 21 April 1892, *CP*, 3: 217.

93 Pissarro to Lucien, 13 May 1891, ibid., 82.

94 Pissarro to Lucien, 13 April 1891, ibid., 62–63.

95 Pissarro to Esther Isaacson, 5 May 1890, *CP*, 2: 349. The train of thought runs on directly to May Day and the Guesdists (see above).

96 See George Crowder, *Classical Anarchism: The Political Thought of Godwin, Proudhon, Bakunin, and Kropotkin* (Oxford, 1991), passim. Many of the book's particular arguments (e.g. on anarchist scientism) seem to me less convincing.

97 Clement Greenberg, "Review of *Camille Pissarro: Letters to His Son*," in John O'Brian, ed., *Clement Greenberg, The Collected Essays and Criticism*, 4 vols. (Chicago, 1986–93), 1: 216.

98 Pissarro to Georges, 31 January 1890, *CP*, 2: 331.

99 And its contemporary positivist variants. See, for instance, the extract from Charles Letourneau's *Science et Matérialisme*, "Affection," *La Révolte, supplément littéraire* (13–19 June 1891): 1.

100 See for instance Olin, *Mercure de France*, 341, whose chief objection to Mirbeau's presentation of Pissarro (see Octave Mirbeau, "Camille Pissarro," *Le Figaro*, 1 February 1892, 1) was his suppression of the question of Seurat's influence on Pissarro. In general, the pointillist issue is still on critics' minds in 1892, and several attack Pissarro's recent work for its residual loyalty to the method – this in spite of the show's downplaying of works from the pointillist years (see below, n. 126). Wulff, in *Le National*, has a particularly hostile account; but compare Geffroy, *La Justice* (he dislikes the *analyse de laboratoire* flavor, but concedes it is not fatal); Paulet, *Le Jour* (a hostile broadside); and Charles Ponsonailhe, "Les Expositions d'Art," *La Grande Revue* (10 February 1892): 334–35 (a more balanced assessment of benefits and debits).

101 Stéphane Mallarmé, "Crise de Vers," (first published 1897) in Stéphane Mallarmé, *Oeuvres Complètes*, Pléiade

ed. (Paris, 1945), 366; and Arthur Rimbaud to Georges Izambard, 13 May 1871, in *Rimbaud*, ed. Oliver Bernard (Harmondsworth, 1962), 6.

102 Anonymous (certainly Paul Signac), "Variétés: Impressionnistes & Révolutionnaires," *La Révolte* (13–19 June 1891): 3–4: "... la représentation synthétique des plaisirs de la décadence: bals, chahuts, cirques, ainsi que le fit le peintre Seurat, qui eût un sentiment si vif de l'avilissement de notre époque de transition..." See Pissarro to Lucien, 18 June 1891, *CP*, 3: 96: "Je t'enverrai la Révolte de cette semaine qui contient un article sur l'art qui cloche un peu et n'a pas selon moi une portée assez élevée..." The article tries to mount a defense of an anarchism in art which would be rooted in style not subject matter, but, as the quoted phrase indicates, cannot in practice maintain the distinction. These matters were on Pissarro's mind in 1891, and to see them treated badly was upsetting.

103 E. Tériade, "Visite à Henri Matisse," *L'Intransigeant*, 14 and 22 January 1929, cited in Henri Matisse, *Écrits et Propos sur l'art*, ed. Dominique Fourcade (Paris, 1972), 99.

104 *L'Art français* (5 March 1892), has "Pissaro [*sic*] – *Le Déjeuner*" on its cover.

105 To Lucien, 3 April 1891, *CP*, 3: 55–56. The story is on Pissarro's mind and he repeats it to Lucien on 9 April 1891, ibid., 60.

106 See Tate Gallery catalogue, *Claude Monet* (London, 1957), 29, and compare Wildenstein, *Claude Monet, biographie*, 3: 42, n. 1042. Wildenstein counts Monet's 1891 income from Durand-Ruel and Boussod et Valadon as 97,000 francs – about ten times Pissarro's estimated earnings that year (see below, p. 104).

107 *CP*, 3: 72.

108 See, for example, Pissarro to Lucien, 23 January 1886, *CP*, 2: 19–20. He is well aware that he is being forced down "parmi des capitalistes de moyenne fortune": see Pissarro to Lucien, 15 May 1887, ibid., 166. This is the context for his bitter claim to proletarian status in a letter to Lucien, 5 or 6 June 1887, ibid., 183, which should not be taken as Pissarro's once-for-all verdict on his own class position.

109 See Pissarro to Lucien, 25 November 1891, *CP*, 3: 154.

110 Félix Fénéon, "Dix Marines d'Antibes, de M. Claude Monet," *La Revue indépendante* (August 1888), cited in Fénéon, *Oeuvres*, 1: 113.

111 To Lucien, 8 July 118, *CP*, 2: 239.

112 Pissarro to Lucien, 14 July 1891, *CP*, 3: 105.

113 On sales from the 1892 exhibition, see *PV*, 1: 59, and compare overall sales figures in Ralph Shikes and Paula Harper, *Pissarro: His Life and Work* (New York, 1980), 262, and Ward, *Pissarro*, 247. When the show closed, Durand-Ruel bought all unsold paintings for a total of 12, 770 francs. On the contract, see *PV*, 1: 60 and Pissarro to Mirbeau, 30 November 1892, *CP*, 3: 280. The letters of 1893 do not make the terms (or indeed the existence) of the new contract clear and are full of worries about how many of his works Durand-Ruel will now choose to buy.

114 See, for example, Pissarro to Lucien, 9 April 1891, ibid., 61: "À Paris c'est une vraie réaction depuis la mort de van Gogh."

115 Pissarro to Lucien, 2 January 1891, ibid., 9. Compare Pissarro to Lucien, 7 January 1891, ibid., 11: "Durand me paraît plus que jamais persuadé que mes derniers tableaux empêcheront de vendre les premiers."

116 Pissarro to Lucien, 13 April 1891, ibid., 62, which also discusses Monet's ability to maneuver between dealers.

117 See Pissarro to Lucien, 25 April 1891, ibid., 68. Among various other discussions of how to play off dealers against each other, see, for example, Pissarro to Lucien, 26 May 1891, *CP*, 5: 411.

118 Portier in particular worked hard for Pissarro throughout the year, but not to much effect. See, for example, Pissarro to Lucien, 18 November 1891, *CP*, 3: 143: "Pour le moment, l'argent est rare ici, bien rare, et je reçois de Portier qui était si chaud une lettre désespérante, me disant qu'il ne peut arriver à vendre mes petites toiles qui ne plaisent pas du tout à ses amateurs!"

119 Pissarro to Lucien, 26 January 1887, *CP*, 2: 124. This is part of the sequence of panic-stricken letters referred to in n. 108 above, but the ironic attitude to patrons and the art market is not restricted to the years of absolute crisis.

120 Pissarro to Lucien, 23 October 1891, *CP*, 3: 131. Compare the assessment of his market in the same letter: "il ne me reste donc qu'à préparer mes petits acheteurs parisiens qui vont, par le fait de leurs achats de Pissarro, contribuer à les faire monter; je sens qu'il y a une tendance à cela, je monterai mes prix petit à petit, et pendant qu'il est encore temps les petits amateurs vont joliment me seconder."

121 Pissarro to Georges and Lucien, 28 October 1891, ibid., 135. He said much the same thing to Mirbeau on 9 November 1891, ibid., 140: "... non, j'aime mieux l'amateur, quelque récalcitrant qu'il soit."

122 See Pissarro to Lucien, 9 December 1891, ibid., 162, which also contains the phrase (spoken by the Boussod et Valadon employee Joyant), "le moment était venu de me lancer." Part of the reason Pissarro finally opted for Durand-Ruel was that he could not be sure of success with the more mainstream "boulevard" clientele associated with Boussod et Valadon. See, for example, Pissarro to Lucien, 23 December 1891, ibid., 171: "Joyant est venu hier, il a été enthousiasmé de mes aquarelles, et de mes dernières peintures, mais c'est trop révolutionnaire pour les patrons..." Durand-Ruel was almost as unconfident, but at least had a market strategy to deal with buyers' resistance.

123 Pissarro to Lucien, 13 December 1891, ibid., 164. The same letter discusses the choice between Durand-Ruel, Boussod et Valadon, and Bernheim-Jeune, and breaks the news that the Pissarros would have to give up the idea of a group exhibition of father and sons. This idea, which had been much discussed in 1890, was still alive in October 1891: see, for example, Pissarro to Lucien, 20 October 1891, ibid., 127: "Je tâte Durand pour notre exposition, sera-ce faisable, ils sont si marchands."

124 See Pissarro to Lucien, 16 December 1891, ibid., 166.

125 Ibid., 184, reporting on a visit from the younger Durand-Ruel the previous day.

126 Out of fifty oils shown in 1892, there were none from 1886 and 1887, two from 1888, and one each from 1889 and 1890. Compare the six canvases from 1881, six more from 1883, eight from 1891, and five from 1892. Out of twenty-one gouaches, six came from 1886 to 1890: they were heavily outweighed by works from 1881 and 1883.

127 And beyond. See Pissarro to Lucien, 26 April 1892, ibid., 220 for evidence of the *Vachère* and *Femme Assise* being altered on their return from Paris: "Je crois que ces tableaux ont beaucoup gagné au point de vue de l'unité." *La Vachère* seems to have been reworked yet again in 1894: see Pissarro to Lucien, 14 December 1894, ibid.,

521. I wonder if *Two Young Peasant Women* was also repainted.

128 Here I diverge from the interpretation of the 1892 show and its critical reception offered in Ward, *Pissarro*, 241–61. For Ward, Pissarro's anarchist admirers essentially did the discursive work of the market in 1892, perfecting the equation of "work" with "life." This is ingenious, but seems to me only incompletely true of the best anarchist critics that year (Fénéon, Saunier, Lecomte), who were struggling with notions of decoration, synthesis, Idea, even Peasant, as applied to Pissarro's work. That is, they were still trying for ways to construe Pissarro's paintings as public actions. Ward is right that the retrospective form offered the critic a ready-made autobiographical framework, and clearly some anarchist writers revelled in the "life=art=true individuality" equation. Mirbeau certainly did. But what seems to me remarkable in 1892 is the extent to which other anarchist critics refused to take the offer up – Fénéon, utterly – or hybridized the language of consistent "personality" with that of outlandish (symbolist/utopian) synthesis. What they wanted, and what they thought Pissarro might point the way to, was not so much radical individuality as alternative decor. They clearly (and rightly) regarded Mirbeau's writing as bourgeois individualism dressed up in anarchistic colors. (They particularly resented Mirbeau's collusion with the market in conjuring Pissarro's neo-impressionist period off stage.)

129 See *L'Art français* (23 April 1892): n.p.

130 Kalophile l'Ermite, *L'Ermitage*, 117. On the identity and attitudes of this critic, see Ward, *Pissarro*, 204–10.

131 Geffroy, *La Justice*, 1: "Les êtres qui vivent dans ses paysages ont été maintenus à leurs places permanentes. Il y a un accord de lignes et de colorations entre ces gens, ces animaux et le décor de ces verdures et de ces ciels. C'est une intimité du sol, de l'atmosphère, de la bête, de l'homme . . . Il [Georges Lecomte] a bien montré que ce n'étaient pas là des personnages surajoutés, posant devant le peintre en des attitudes de commande. En effet, ces paysans, ces paysannes, font partie de cette nature, on ne peut les imaginer ailleurs, et on ne peut supposer ces paysages sans eux." Geffroy had written the catalogue introduction for Pissarro's 1890 show.

132 Clément-Janin, *L'Estafette*, 1; quoted by Ward, *Pissarro*, 326–27, with French text.

133 Pissarro to Lucien, 16 May 1887, *CP*, 2: 169. "Ils n'ont pas eu ces coups de foudre devant les admirables *Delacroix, le Saint-Sulpice*! Quels brutes, c'est navrant!"

134 17 December 1889, ibid., 313. The underlined phrase is "*c'est trop entier de sensation.*"

135 See Pissarro to Lucien, early March 1884, *CP*, 1: 293.

136 Anonymous (Kropotkin), "L'Agriculture," *La Révolte* (12–19 December 1890): 1–2. Compare Kropotkin, *La Conquête du pain*, 249. The supplement to the following issue of *La Révolte* had a long extract from Reclus's *La Terre*, dealing with "l'influence de l'homme sur la beauté de la terre," part of which argued that the small peasant proprietor's subdividing of his land was one main form of the modern wreckage of the environment. See Élisée Reclus, "Le Pillage de la terre," *La Révolte, supplément littéraire* (20–26 December 1890). The question of socialist attitudes to the mass of small peasants was still unresolved in the 1890s. The Guesdist assumption that the immediate future lay with large capitalist agriculture was widely shared (Reclus shared it, basically), but was already a cliché and attacked as such. The playwright August Strindberg, in his study of the French peasantry published in Sweden in 1886, can be found arguing specifically against Marx on this: after Darwin, he says, we should take seriously the idea of the advantages of small-scale adaptability and differentiatedness, and learn to drop the regulation anti-Rousseau sarcasms at the very idea of a "return to Nature." See August Strindberg, *Parmi les Paysans français*, French ed. (Arles, 1988), 254–56.

137 See discussion in Fleming, *Anarchist Way*, 189–92.

138 Anonymous, "L'Agriculture," *La Révolte* (27 December 1890–2 January 1891): 1–2. Modified version in Kropotkin, *La Conquête du pain*, 257–58.

139 See Michel Augé-Laribé, *La Politique agricole de la France de 1880 à 1940* (Paris, 1950), 218, and compare ibid., 241–46 on the 1891–92 debates. *Le Figaro* (29 April 1891): 2, reports Edouard Lockroy as follows: "Vous faites du socialisme à rebours. Si le socialisme d'État a une excuse, c'est de mettre . . . le pouvoir de l'État au service du faible pour le défendre contre le riche, . . . tandis qu'au contraire vous mettez la puissance de l'État au service d'une classe privilégiée, de la classe des grands propriétaires."

140 See 9 May 1891, *CP*, 3: 78.

141 *Journal Officiel*, 1891, 832, quoted in part in Barral, *Les Agrariens français*, 87. The Deschanel speech is reported enthusiastically in the three mainstream papers we know Pissarro was reading; though not the passage I quote. My thanks to Marnin Young and Katherine Kuenzli for help in investigating the press.

142 Jules Ferry to Albert Ferry, 7 July 1890, in Jules Ferry, *Lettres, 1846–1893* (Paris, 1914), 523–24, quoted in Maurice Agulhon, "Les Paysans dans la Vie Politique," in Georges Duby and Armand Wallon, eds., *Histoire de le France rurale*, 4 vols. (Paris, 1975–76), 3: 380–81.

143 *Journal Officiel*, 1891, 855 (11 May 1891).

144 Ibid., 872 (replying to Raynal on 12 May 1891). Raynal's dreadful suggestion was reported in *Le Figaro*, 13 May 1891: 2, and in *L'Écho de Paris*, 14 May 1891: 2.

145 See *Journal Officiel*, 1891, 793 (Turrel on 5 May 1891) and 917 (Jamais on 16 May 1891).

146 For instance, Edouard Lockroy, opening the debate for the free traders on 28 April 1891, ibid., 717 and 723. The papers took up Lockroy's argument – that protectionism was the creature of Germany and its brand of "socialisme d'État" – with glee. See, for example, the report in *L'Écho de Paris*, 30 April 1891: 2.

147 On the late-nineteenth century as the golden age of folklore studies (in reaction to the perceived threat to the old ways of life), see Eugen Weber, *Peasants into Frenchmen, The Modernization of Rural France, 1870–1914* (Stanford, 1976), 471–84.

148 Bibliothèque Doucet, Paris, "Correspondance à Camille Pissarro": "Très honoré Maître, Je me suis chargé de donner ce prochain Février aux xx à Bruxelles et en d'autres cercles artistiques de notre Pays, une conférence sur le *Paysan en peinture*. Après l'avoir suivi dans son évolution depuis l'allemand Beham et le flamand Breughel je clos l'étude par celui que *vous avez créé*.

"Mais j'ai peur, maître, d'être trop peu renseigné sur votre oeuvre, n'ayant vu que celles qui figurent aux xx, il y a deux ans, et étant arrivé à Paris, ce Mars dernier, le lendemain de la fermeture de votre exposition au boulevard Montmartre.

"Je me souviens, que quand je m'y suis rendu, vous même m'engageant à y aller néanmoins, je n'y trouvai plus que peu de toiles.

"Pouvez-vous, maître, combler cette lacune, en m'indiquant par exemple, *si une étude a paru* sur votre oeuvre; *au point de vue spécial* surtout *d'où je veux l'envisager aujourd'hui* . . .

"Puis-je espéré [*sic*] *un prompt mot de réponse*? C'est qu'il m'a fallu du temps avant d'oser m'adresser à vous. Je notais exactement la distance qui séparait la place que vous occupez dans mes admirations et ma propre humilité."

149 On van de Velde's early career, see Susan Canning, *Henry van de Velde (1863–1957)*, exh. cat. (Antwerp and Otterlo, 1988). My thanks to Susan Canning for help with issues concerning van de Velde.

150 Henry van de Velde, "Du Paysan en peinture," *L'Art moderne de Bruxelles* (22 February 1891): 60–62, quoted in Canning, *Van de Velde*, 236–38. For the full text of the lecture in a later revised version, see Henry van de Velde, "Du Paysan en peinture," *L'Avenir social* (August, September, and October 1899): 281–88, 327–34, 378–82.

151 See van de Velde, *L'Avenir social* (August 1899): 282–84 (on Breughel), 287 (on Dutch), 284 (on blackface).

152 Van de Velde, *L'Art moderne*, 61, quoted in Canning, *Van de Velde*, 237. The 1899 text drops the paragraph on the two specific paintings, as well as three (by then embarrassing, and even in 1891 outdated) paragraphs on Pissarro's adoption of "la récente formule" of divisionism. Van de Velde makes the point, recently reaffirmed by Martha Ward, that divisionism and the effort at a new peasant type are coincident in Pissarro's work. "Coincidence étrange: ce n'est qu'au moment où la formule nouvelle lui met en main des moyens nouveaux, que le Maître songe à révéler le type qu'il aura créé."

153 See Pissarro to Lucien, 2 May 1887, *CP*, 2: 157, and Pissarro to Théodore Duret, 12 March 1882, *CP*, 1: 158.

154 Van de Velde, *L'Avenir social* (September 1899): 332–33. "L'apparition du Paysan selon Millet, est un fait tellement exhorbitant; le forage pour retrouver cette pure souche si gigantesque au travers la pourriture qui avait tout envahi, qu'on aime à déclarer aujourd'hui que Millet 'tâtonnait dans les épisodes de la Bible.'

"Est-ce assez loin chercher ce qui, au contraire, ne résidait pas plus loin qu'en son coeur! . . .

"Or, c'est l'espace que Millet avait rendu au Paysan . . .

"Et, pour la première fois, en Peinture, le Paysan s'acharnera-t-il réellement sur la Terre! . . .

". . . c'est bien la Haine qui fait se ruer si férocement le Terrien sur la Terre, cette formidable gueuse aussi âpre à vaincre que la mer, et plus amère!

"C'est de la Haine, cet à bras-le-corps qui sera éternel; l'interminable volée de coups mauvais qu'ils lui portent, la souillant dans ce qu'Elle a de plus beau: les fleurs, qu'ils abominent, et les arbres, qui sont leurs pires ennemis, et que sournoisement ils font mourir quand la joie leur est interdite de se ruer ouvertement sur eux, à coups de hâche . . .

"S'ils aiment la Terre, les patauds l'aimeraient à la façon de ces monstres qui aiment les femmes pour qu'elles leur donnent de quoi vivre!"

155 Van de Velde, *L'Art moderne*, 61–62, quoted in Canning, *Van de Velde*, 237–38.

156 Clement Greenberg, "Avant-Garde and Kitsch," in O'Brian, ed., *Clement Greenberg*, 1: 7–8.

157 See, for example, the conclusion to the paragraph on *Le Conquête du pain*, Pissarro to Mirbeau, 21 April 1892, *CP*, 3: 217, arguing against Kropotkin's *narodnik* idea that only those who lived as peasants could depict them and the landscape successfully: "il me semble qu'il faut être emballé par son sujet pour bien le rendre, mais est-il nécessaire d'être paysan? Soyons d'abord artiste et nous aurons la faculté de tout sentir, même un paysage sans être paysan." The interesting thing is that Pissarro seems to feel the implied argument of the first sentence needs the backing of the explicit (and less convincing) assertion in the second.

158 Adolphe Retté, *La Plume* (30 May 1896), quoted in Mathieu Robert, "Varia," *Le Réveil* (June 1896): 415. "En somme: maladivement amoureux de soi-même, se gargarisant avec les sonorités verbales qu'il déforme ou qu'il accole à son gré, pour lui seul, érigeant en système de raffinement la pénurie de ses facultés créatrices, blotti en un coin d'ombre loin du conflit social, portant pour blason un serpent gelé qui se mord à la queue sur fond de brume, Narcisse au trouble miroir où luisent à peine les faibles phosphores d'une décomposition d'art, prince de l'impuissance hautaine, tel apparaît le Décadent – tel apparaît aux intelligences sauves de son emprise M. Stéphane Mallarmé."

159 For a full-scale reply to the Symbolist attack on materialism, see

Georges Lecomte, "La Renaissance Idéaliste," *Revue de l'Évolution sociale* (April 1892): 169–73.

160 Pierre-Louis, "Définition du Néo-Traditionnisme," *Art et Critique* (23 and 28 August 1890), quoted in Denis, *Théories*, 1. Marnin Young points out in an unpublished paper that the long career of rehashing this quote began as early as 1891: see Willy, "Artistes Indépendants," *Le Chat noir* (21 March 1891): 1. The article is staged as an interview with Fénéon, and may well have been written by Fénéon himself. Typically, Willy/Fénéon argues that the dictum applies best to the neos, not the Symbolists.

161 Clement Greenberg, "Review of an Exhibition of School of Paris Painters," in O'Brian, ed., *Clement Greenberg*, 2: 88.

162 Saunier, *La Revue indépendante*, 39. For Saunier it is specifically the fans that speak to Pissarro's potential as a large-scale decorator.

163 Lucien to Pissarro, 19 April 1891, Thorold, ed., *Letters of Lucien*, 209. Compare Lucien to Pissarro, early February 1891, ibid., 184, and Lucien to Pissarro, 19 April 1891, ibid., 207–9, quoted in part above.

164 Pissarro to Lucien and Georges, 4 October 1891, *CP*, 4: 414. The admiration for Maeterlinck's simplicity and compression runs through the letters of late 1891. Compare Pissarro to Mirbeau, 28 November 1891, *CP*, 3: 156. Hence Pissarro's attendance at the *Aveugles* evening in December. Naturally Denis and Pissarro would have disagreed in their interpretation of *Les Aveugles*'s allegory of man without God.

165 Joleaud-Barral, *La Justice*, 2. "–Voilà, nous répétait l'artiste, hier matin, en nous montrant ses dernières toiles, mes préférées. Ce sont elles qui représentent le mieux ma pensée artistique, celles où j'ai réalisé le plus complètement mes théories . . .

"Ce sont là mes tableaux favoris. J'ai tenté d'y allier la division des tons à une grande exactitude de modelé et d'y réaliser l'harmonie synthétique des couleurs . . ."

166 Gsell, *La Revue politique et littéraire*, 404: "Il me dit encore: 'Je ne peins pas mes tableaux directement d'après nature: je ne fais ainsi que des études; mais l'unité que l'esprit humain donne à la vision ne peut se trouver que dans l'atelier. C'est là que nos impressions, disséminées d'abord, se coordonnent, se font valoir réciproquement pour former le vrai poème de la campagne.

Au dehors, on peut saisir les belles harmonies qui s'emparent immédiatement des yeux: mais l'on ne peut suffisamment s'interroger soi-même pour affirmer dans l'oeuvre ses sentiments intimes. C'est à la recherche de cette unité intellectuelle que je mets tous mes soins.'"

167 Paul Cézanne to Émile Bernard, 1905, John Rewald, ed., *Paul Cézanne: correspondance* (Paris, 1978), 314.

168 Émile Bernard, "Paul Cézanne," *L'Occident* (July 1904), quoted in P. Michael Doran, ed., *Conversations avec Cézanne* (Paris, 1978), 32.

169 See Theodore Reff, "Pissarro's Portrait of Cézanne," *Burlington Magazine* (November 1967): 627–33.

3 FREUD'S CÉZANNE

1 Sigmund Freud, "Project for a Scientific Psychology," in Sigmund Freud, *The Origins of Psycho-Analysis, Letters to Wilhelm Fliess, Drafts and Notes: 1887–1902* (New York, 1954), 355. For the Project's debts to the nineteenth century and the persistence of its concerns in Freud's later work, see Ernst Kris's introduction and the notes to the text.

2 Émile Bernard, letter to his mother, 4 February 1904: "J'ai vu de ses tableaux, entre autres une grande toile de femmes nues, qui est une chose magnifique, tant par les formes que par la puissance de l'ensemble et de l'anatomie humaine. Il paraît qu'il y travaille depuis dix ans." See Émile Bernard, "Une Lettre inédite du peintre Émile Bernard à sa mère à propos de sa première visite à Paul Cézanne," *Arts-Documents* (November 1954), reprinted in P. Michael Doran, ed., *Conversations avec Cézanne* (Paris, 1978), 24. This is backed up by R. P. Rivière and J. F. Schnerb, reporting on a visit made in January 1905: "À cette époque se voyait dans l'atelier du chemin de l'Aubassane un grand tableau de baigneuses avec huit figures presque grandeur nature [that is, the Barnes picture], auquel Cézanne travaillait encore. 'J'ose à peine l'avouer, disait-il, j'y travaille depuis 1894. Je voulais peindre en pleine pâte, comme Courbet.'" See Rivière and Schnerb, "L'Atelier de Cézanne," *La Grande revue*, 5, no. 24 (25 December 1907): 817, reprinted in Doran, *Conversations*, 91. Rivière and Schnerb were not the only witnesses to suggest that the *Bathers* project was linked in Cézanne's

mind and conversation with a return to his first Realist allegiances: compare Bernard in the same letter to his mother, 4 February 1904: "C'est un brave homme, une sorte de seigneur de la peinture qui retourne d'épais empâtements comme une terre grasse. Il professe les théories du naturalisme et de l'impressionnisme, me parle de Pissarro, qu'il déclare *colossal*." The Bernard letter is important as being the document from this key witness least subject to secondary revision.

3 This is my summary of a difficult body of evidence. We know for sure that there was a picture called *Les Baigneurs; étude, projet de tableau* in the 1877 show, and that it was often singled out by critics for abuse. Usually it has been thought that this was the *Bathers at Rest* in the Barnes. Richard Brettell, "The 'First' Exhibition of Impressionist Painters," in *The New Painting: Impressionism 1874–1886* (San Francisco, 1986), 189–202, argues that the picture shown was the smaller study, Venturi 273, now in the Musée d'art et d'histoire, Genf. His arguments are good but, as he knows full well, inconclusive. For what it is worth, I still feel the criticism of 1877 is most likely directed at the Barnes picture. The importance the critics give the work argues for a fairly large scale, I think, and once or twice, when the critics seize on an actual visual characteristic to attack, it seems to me they are pointing to features more prominent in the larger work (for example, Léon de Lora, *Le Gaulois* (10 April 1877): 2: "Je verrai longtemps les ventres bleus de ces baigneurs et les nuages d'un blanc de faïence qui flottent au-dessus de leurs têtes"). From my point of view, the fact that the 1877 picture was called an *étude, projet de tableau* only points forward to its revival in 1895. The large picture begun then was the tableau itself at long last.

Scène au Bord de la mer is the title Georges Rivière gave in 1877 to the picture until recently on loan to the Metropolitan Museum of Art, New York, now usually called *The Fishermen* or, even better, *Scène Fantastique*: it was exhibited *hors catalogue* in 1877, but Rivière's description is for once detailed enough for there to be no doubt that he is looking at Venturi 243. See Georges Rivière, "L'Exposition des Impressionnistes," *L'Impressionniste, journal d'art* (14 April 1877): 2. Rivière can also stand for the avant garde's apotheosis of the 1877 *Baigneurs*. He quotes a friend:

"'Le peintre des *Baigneurs* appartient à la race des géants. Comme il se dérobe à toute comparaison, on trouve commode de le nier; il a pourtant des similaires respectés dans l'art, et si le présent ne lui rend pas justice, l'avenir saura le classer parmi ses pairs à côté des demi-dieux de l'art'"(3).

4 Vollard tells the story of his hanging the *Bathers at Rest* in the shop window of his gallery in 1895: it was already surrounded by scandal that year, as the government had singled it out from the Caillebotte bequest as unfit to be seen in the Luxembourg. See Ambroise Vollard, *Cézanne* (New York, 1984), 53. For the lithographs, see Joseph Rishel, *Cézanne in Philadelphia Collections* (Philadelphia, 1983), 84–86, and Mary L. Krumrine, *Paul Cézanne: The Bathers* (Basel, 1989), 112–14.

5 For discussion of these qualities (especially the roots of each figure type in "erotic" or "tragic" motifs drawn from the old masters), see Theodore Reff, "Cézanne: The Enigma of the Nude," *Art News*, 58 (November 1959): esp. 28–29, 68, discussing the Genf *Baigneurs au Repos*.

6 François Jourdain, *Cézanne* (Paris, 1950), 11, reporting on a visit to Aix in 1904; reprinted in Doran, *Conversations*, 84.

7 Ernest Jones, *Sigmund Freud: Life and Work*, 3 vols. (London, 1953–57), 2: 13.

8 For the evidence on dating, see Theodore Reff, "Painting and Theory in the Final Decade," in William Rubin, ed., *Cézanne: The Late Work* (New York, 1977), 38–39. Evidence about the London picture is especially thin and Reff works what little there is a bit too hard.

9 Émile Bernard, "Souvenirs sur Paul Cézanne et lettres inédites," *Mercure de France*, 69, no. 5 (16 October 1907): 611, reprinted in Doran, *Conversations*, 71.

10 See Krumrine, *The Bathers*, 106, 239, for further discussion of the *Bathers at Rest*'s role in the *Bathers* sequence. Krumrine in general provides an exhaustive treatment of the way Cézanne's large *Bathers* rework a quite restricted stock of figure types, most of which had first appeared in paintings done in the 1870s and 1880s. I should say that the final reworking often seems to me so brutal and extraordinary that I doubt if pointing to the typological fountainhead helps us much in understanding what the body images have ultimately come to mean. This is true

in particular of the striding and dreaming figures.

11 Émile Bernard, "Réflexions à propos du Salon d'Automne," *La Rénovation esthétique*, 6 (December 1907): 63. Compare Bernard's verdict quoted in n. 2.

12 Remy de Gourmont, "Dialogues des amateurs – peinture d'automne," *Mercure de France*, 70 (1 November 1907): 110. The remark is put in the mouth of one of the two speakers in the title, but it looks from the text as a whole as if de Gourmont largely agrees with what his *amateur* says here.

13 Jean Laplanche and Jean-Baptiste Pontalis, *The Language of Psycho-Analysis*, trans. Donald Nicholson-Smith (New York, 1973), 314.

14 Ibid., 332.

15 Ibid., 311.

16 Sigmund Freud, *Three Essays on the Theory of Sexuality* (1905), in *The Standard Edition of the Complete Psychological Works of Sigmund Freud*, ed. James Strachey (London, 1953–73), 7: 199; quoted in Laplanche and Pontalis, *Language of Psycho-Analysis*, 310. The phrase I quote is from a note added by Freud in 1924. The full-fledged notion of a "phallic stage" emerges in Freud in the 1920s, but it is foreshadowed, say Laplanche and Pontalis, in the *Three Essays*, the "Little Hans" analysis published in 1909, and "On the Sexual Theories of Children" of 1908.

17 My thanks to Virginia Spate for this suggestion.

18 See Theodore Reff, "Cézanne, Flaubert, St. Anthony, and the Queen of Sheba," *Art Bulletin*, 44 (June 1962): 117.

19 Sigmund Freud, *Beyond the Pleasure Principle* (1920), in *Standard Edition*, 18: 26. The editor, James Strachey, comments: "What is particularly remarkable is the closeness with which some of the earlier sections of the present work follow the 'Project for a Scientific Psychology,' drafted by Freud twenty-five years earlier."

20 See, for example, Roger Fry, *Cézanne: A Study of His Development* (New York, 1927), 81–82: "The point of departure is the pyramid given by the inclined tree trunks on either side. The poses of the figures are clearly dictated by this – too clearly, too obtrusively indeed do they adapt themselves to this elementary schema. In spite of the marvels of his handling and the richness and delicacy of the colour transitions he has not escaped the effect of dryness and wilfulness which so deliberate a formula arouses." Compare Meyer Schapiro, *Paul Cézanne* (New York, 1952), 116: "It is exceptional among his works . . . in the marked symmetry and the adaptation of the nude forms to the triangular pattern of the trees and river. There is here, I believe, a search for constraining forms, an over-determined order which has to do with Cézanne's anxiety about women."

21 Sigmund Freud, "The Dream-Work: The Work of Condensation," in *The Interpretation of Dreams* (1900), in *Standard Edition*, 1: 293.

22 Paul Souriau, *La Suggestion dans l'art* (Paris, 1893), 86–87. I am grateful to Jennifer Shaw for this reference, and for pointing me to the wider cultural sensitivity to questions of vision and suggestion at this time. Compare also Deborah Silverman, *Art Nouveau in Fin-de-Siècle France* (Berkeley and Los Angeles, 1989), ch. 5, "Psychologie Nouvelle."

23 Quoted from the terms of the Galton research fellowship, *Encyclopaedia Britannica*, 11th ed. (Cambridge, 1910–11), *s.v.* "Galton, Sir Francis."

24 Laplanche and Pontalis, *Language of Psycho-Analysis*, 332.

25 Cézanne on a portrait of his gardener Vallier, quoted in Rivière and Schnerb, "L'Atelier de Cézanne," 817, reprinted in Doran, *Conversations*, 91.

26 Jackson Pollock, statement for Guggenheim application, 1947, in Francis O'Connor and Eugene Thaw, eds., *Jackson Pollock: A Catalogue Raisonné of Paintings, Drawings, and Other Works*, 4 vols. (New Haven and London, 1978), 4: 238. For further discussion, see ch. 6 below.

27 Letter to Bernard, 12 May 1904, Rewald, *Cézanne: correspondance*, 260: "Le talent de Redon me plaît beaucoup, et je suis de coeur avec lui pour sentir et admirer Delacroix. Je ne sais si ma précaire santé me permettra de réaliser jamais mon rêve de faire son apothéose." By this time the identification of Cézanne with his hero was more or less complete. Painting Delacroix's apotheosis was thus painting his own, which maybe was why it never could be done directly. Bernard's photographs of Cézanne in front of the Barnes *Bathers* – in which, obviously, Cézanne was a sheepish and proud collaborator – were as close as the artist needed to go to spell out his own presence in the dreamworld he had made, and his confidence that the dreamworld would survive him. For discussion of the dating of the *Apotheosis* watercolor sketch see *Watercolour and Pencil Drawings by Cézanne* (Newcastle, 1973), 156–57, catalogue entry by Robert Ratcliffe. Bernard claimed to have been shown the *Apotheosis* by Cézanne: see his "Souvenirs," 609, reprinted in Doran, *Conversations*, 69.

28 See Bernard, "Souvenirs," 612, reprinted in Doran, *Conversations*, 72.

29 Ibid., 71.

30 Léon Larguier, *Le Dimanche avec Paul Cézanne: souvenirs* (Paris, 1925), cited in Doran, *Conversations*, 13–14. The titles are those enumerated by Cézanne on the final page of his edition of *Les Fleurs du mal*.

31 For Roger Fry's reaction, see n. 20 above. He makes no bones about his difficulty. Schapiro's entry on the Philadelphia picture is measured and humane, but (by Schapiro's own standards) lacking in detail. Krumrine and others offer a typology, not a description. The problems, as I have shown, seem to have set in right from the beginning. Critical reactions to the showing of the *Bathers* in the 1907 retrospective, when not openly bewildered or dismissive, were strikingly guarded or perfunctory. I could not find a single extended discussion in 1907; and these, after all, were the "masterpieces" of the avant garde's patron saint, rumors of which had been circulating for years. (Maybe a further search in the more than one hundred periodicals then being published would turn up something.)

32 Paul de Man, "Aesthetic Formalization: Kleist's *Über das Marionettentheater*," in Paul de Man, *The Rhetoric of Romanticism* (New York, 1984), 263–90.

33 Heinrich von Kleist, "On the Marionette Theater," in A. Leslie Willson, ed., *German Romantic Criticism* (New York, 1982), 239–41.

4 CUBISM AND COLLECTIVITY

1 See Judith Cousins, "Documentary Chronology," in William Rubin, *Picasso and Braque: Pioneering Cubism* (New York, 1989), 400. Some of the ideas in this chapter were first developed in two seminars, at Harvard in 1986 and Berkeley in 1991: I am grateful to the students in both, whose proposals and criticisms I have often incorporated.

2 See Moderne Galerie catalogue, *Ausstellung Pablo Picasso* (Munich, 1913), no. 76. Here and elsewhere I

have tried to stick to the original titles of Picasso's pictures, using the (often slippery) evidence of early exhibitions and Kahnweiler's archives, as presented in Pierre Daix and Jean Rosselet, *Le Cubisme de Picasso: catalogue raisonné de l'oeuvre 1907–1916* (Neuchâtel, 1979), as well as Rubin, *Picasso and Braque* and Isabelle Monod-Fontaine, *Daniel-Henry Kahnweiler: marchand, éditeur, écrivain* (Paris, 1984).

3 See Pablo Picasso to Georges Braque, 10 July 1912: "De par ailleurs ces aficionados de Nîmes. Je ne pense qu'à eux et j'ai déjà transformé une toile que j'avais commencé d'un bonhomme en un aficionado je pense qu'il peut être bien avec sa banderille à la main et je tâche de lui faire une gueule bien du midi." Cited in part by Cousins, "Documentary Chronology," 399, from a letter in the Laurens archive.

4 Pablo Picasso to Daniel-Henry Kahnweiler, 12 June 1912, quoted in Pierre Assouline, *L'Homme de l'art. D.-H. Kahnweiler 1884–1979* (Paris, 1988), 167: "Je crois que ma peinture gagne come robustesse et clarté enfin nous verrons et vous verrez mais tout ça ne est prêt de être fini et pour tant j'ai plus de sûreté."

5 Picasso to Kahnweiler, 17 June 1912, quoted in ibid., 167: "Vous me dires que Uhde ne aime pas les tableaux derniers de moi ou il a du Ripolin et des drapeaux peut-être nous arriverons à dégouter tout le monde et nous ne avons pas tout dit." The pictures must be the "*Notre Avenir est dans l'air*" series of spring 1912, though none of the catalogues mentions Ripolin enamel paint. See Daix and Rosselet, *Le Cubisme de Picasso*, nos. 463–65. Wilhelm Uhde, whose portrait Picasso had painted in 1910, had been one of Cubism's fiercest early promoters.

6 Georg W. F. Hegel, *Lectures on the Philosophy of World History, Introduction* (Cambridge, 1975), 84, with last sentence transposed from 83. (Translation slightly modified. I wanted as much Hegelian afflatus as could reasonably be managed.)

7 Fried's *Manet's Modernism* makes explicit the way Fried's later work connects with his writings from the 1960s, and how his questions and conclusions have changed since. Compare Michael Fried, *Art and Objecthood* (Chicago, 1998), especially the introductory essay. For a relatively early article which contains a brilliant outline of Fried's views of the issues confronting painting in the nineteenth century, see Michael Fried, "Thomas Couture and the Theatricalization of Action in 19th Century French Painting," *Artforum*, 8 (June 1970): 36–46, esp. 40–46.

8 William Rubin, *Picasso in the Collection of the Museum of Modern Art* (New York, 1972), 68. My leaning on this description so heavily will be understood, I hope, as a backhanded thank-you to a scholar whose work on Cubism puts us all in his debt. Just how much will be clear from the rest of my footnotes.

9 The chief interpreters of Cubism from a semiotic point of view are Rosalind Krauss and Yve-Alain Bois. Krauss's review article, "The Cubist Epoch," *Artforum*, 9, no. 6 (February 1971): 32–38, laid the ground for a series of treatments, notably her "In the Name of Picasso," in Rosalind Krauss, *The Originality of the Avant-Garde and Other Modernist Myths* (Cambridge, Mass., 1985), 23–40, and her "The Motivation of the Sign," in William Rubin, Kirk Varnedoe, and Lynn Zelevansky, eds., *Picasso and Braque: A Symposium* (New York, 1992), 261–86. Bois's main articles are his "Kahnweiler's Lesson," in Yve-Alain Bois, *Painting as Model* (Cambridge, Mass., 1990), 65–97, and his "The Semiology of Cubism," in Rubin et al., *Picasso and Braque: A Symposium*, 169–208. The last article in particular helped me sort out what I see as the strengths and weaknesses of the semiotic account of Cubism, and the ways it does and does not connect with previous "modernist" descriptions. I have learnt from it, and found myself arguing with it, all through the present essay.

10 See Daniel-Henry Kahnweiler, "Gespräche mit Picasso," *Jahresing*, 59/60 (Stuttgart, 1959): 85–86. "Cubism – the real Cubism [der echte Kubismus] was basically a horridly materialistic affair, a base kind of materialism [eine abscheuliche materialistische Angelegenheit, ein niedriger Materialismus]." Quoted from the translation by Orde Levinson provided in Bois, "The Semiology of Cubism," 170. The full text makes it clear that it was specifically the Cubism of 1909 to 1912 that Picasso had in mind. The conversation took place in February 1933.

11 "O Manon, ma jolie, mon coeur te dit bonjour," the first line of the refrain of a hit song of 1911 by Fragson and Frink. See Rubin, *Picasso in the Collection of MoMA*, 206, n. 6.

12 See Daix and Rosselet, *Le Cubisme de Picasso*, 276, for a history of the picture's titling, and Margaret Potter, *Four Americans in Paris* (New York, 1970), 171, for the reference to the letter from Picasso to Gertrude Stein.

13 Ivan Aksionov, "Polemical supplement," *Picasso i Okrestnosti* (Moscow, 1917). English translation in Marilyn McCully, ed., *A Picasso Anthology: Documents, Criticism, Reminiscences* (Princeton, 1981), 113–18. My thanks to Christina Kiaer for help in correcting the translation.

14 See Cousins, "Documentary Chronology," 375–76, cited from a letter in the Laurens archive. *La lumière* is particularly vague. Does he mean a lamp? Or a lightbulb?

15 Cited in Isabelle Monod-Fontaine, *Donation Louise et Michel Leiris: collection Kahnweiler-Leiris* (Paris, 1984), 168–69.

16 The other picture is *Bottle of Pernod and Glass*, Daix and Rosselet, *Le Cubisme de Picasso*, no. 460.

17 Gertrude Stein, "Picasso," cited from Carl van Vechten, ed., *Selected Writings of Gertrude Stein* (New York, 1962), 333–35. I have transposed the order in which the last two extracts appear.

18 Here and elsewhere, my attempts to characterize the Cubist grid are partly provoked by Bois's discussion in his "Semiology of Cubism." And also by the bland modernist functionalism that came to dominate discussion of the subject in the wake of Clement Greenberg. See, for example, Walter D. Bannard, "Cubism, Abstract Expressionism, David Smith," *Artforum*, 6, no. 8 (April 1968): 22–32, esp. 23–27, and Walter D. Bannard, "Touch and Scale: Cubism, Pollock, Newman and Still," *Artforum*, 9, no. 10 (June 1971): 58–67, esp. 60–61. Greenberg returned time and again to the moment of high Cubism in his writings, and what he has to say about it in his most extended essay on Cubism, "Collage," in Clement Greenberg, *Art and Culture* (Boston, 1961), 70–83 – the basis of much later modernist criticism – is by no means his last word. All the same, Greenberg's treatment of Cubism from 1910 to 1912 seems to me the Achilles' heel of his account of modernism as a whole. It is one of the few points in Greenberg where the deliberately technical, practical, "hands-on" emphasis of his writing, which is usually so helpful, utterly misses its mark.

19 Carl Einstein, "Notes sur le Cubisme," *Documents*, no. 3 (1929): 146–55, my citation is from 154. The Sorgues *Man with a Guitar* and *Aficionado* are two of Einstein's illustrations. The "Notes" are the centerpiece of

a great trio of articles on Picasso by Einstein in the magazine, starting with Carl Einstein, "Pablo Picasso: quelques tableaux de 1928," *Documents*, no. 1 (1929): 35–38, and ending with his contribution to the special Picasso number the following year, Carl Einstein, "Picasso," *Documents*, no. 3 (1930): 155–57. These articles, together with the best passages in Einstein's cantankerous (and often feeble) book on Braque published in 1934, seem to me to mount the most root-and-branch argument against the view of Cubism I am proposing. Cubist painting, in Einstein's opinion, succeeds in shattering the world of objects. In it objects are at last recognized as "des symptômes de dégénerescence de la constellation «homme»": see Carl Einstein, *Georges Braque* (Paris, 1934), 70. Picasso's art is understood as a long series of attempts to break the epistemological log-jam of bourgeois culture – that is, its mechanical distinction between subject and object – and to risk a real dissolution of the self. Pictures become in his hands "les carrefours des processus psychologiques": see Einstein, "Tableaux de 1928," 35. "La destruction des apparences d'une prétendue réalité, osée par les cubistes, exigeait en premier lieu une dissolution et un regroupement de la personnalité et de sa conscience. C'est là que nous saisissons l'importance du cubisme": see Einstein, *Braque*, 29. All of this *Documents*-type argument at least has the merit of posing the question of Picasso – particularly the question of selfhood and autobiography in Picasso's art – at the right level of seriousness. Einstein's Marxism is a help here: no fear of his missing a world-historical trick. Cubism, he says, lays the foundations of "la nouvelle utopie collective": see ibid., 32. There is a side of me that wants to believe this. The present essay explains why I cannot.

20 Jean Metzinger, "Note sur la Peinture," *Pan* (October–November 1910): 650: "Picasso dédaigne le jeu souvent brutal des prétendus coloristes et ramène les sept couleurs à la blanche unité primordiale." The Metzinger seems to me a key text in the critical response to Cubism, partly because it comes so early. It was written by a painter whose own Cubist allegiances had not yet crystallized, and at a moment before the normal terms of Cubist discourse were properly established. *Pan* was a typically eclectic late-Symbolist periodical. In its January 1910 issue Metzinger had published the kind of poem the magazine thrived on – "La

lune mourait sous des fusillades mahométanes," and so on – dedicated to Max Jacob. Primitive or liminal moments of criticism like this are useful: sometimes they give a glimpse of what it was in a new work of art that resisted incorporation (usually for a brief instant) into the mainstream modernist narrative. For further discussion of Metzinger's text, see below.

21 I assume in what follows that the picture was enlarged in order to "save" or improve it. William Rubin, "The Library of Hamilton Easter Field," in Rubin, *Picasso and Braque*, 66, has another explanation, more economical, though not necessarily contradicting mine: that the dimensions were altered so as to make it part of a set of panels being done at this time for an American client. The trouble with this explanation, as Rubin admits, is that we know the panels in question had a constant vertical dimension of six feet, and *(Wo)man with a Mandolin* is ten inches short of that. I am happy with the idea that the Field project raised the question of surface and complexity again for Picasso, and may have led him back to some of his previous efforts with these issues in mind, but it is not proven, and on the whole not plausible, that *(Wo)man with a Mandolin* was intended to hang in Field's library.

22 Daniel-Henry Kahnweiler, *Confessions Esthétiques* (Paris, 1963), 29: "Peu satisfait, il revient à Paris en automne, après des semaines de luttes douloureuses, rapportant des oeuvres inachevées." See John Golding, *Cubism: A History and Analysis 1907–1914*, 3rd ed. (Cambridge, Mass., 1988), 84–89, and Daix and Rosselet, *Le Cubisme de Picasso*, 81–84, 257–58, for representative accounts of Cadaqués.

23 The series of still lifes Braque had done over the winter of 1909 to 1910, culminating in the Guggenheim Museum's *Piano and Mandola* and the Basel *Violin and Pitcher* (see Rubin, *Pioneering Cubism*, 148–49) must, I think, have struck Picasso as exemplary, especially compared with the indirection of his own work at this moment. Cadaqués strikes me as issuing as much or more from *Violin and Pitcher* as from Picasso's own *Woman Sitting in an Armchair* (Daix and Rosselet, *Le Cubisme de Picasso*, no. 342), or even from his portrait of Fanny Tellier (no. 346) – to name the two largest and most imposing works of the spring. And as for the self-consuming clutter of *Woman in an Armchair* (no. 344) or *Young Girl in an Armchair* (no. 345)! Cadaqués seems

meant as a kind of corrective to pictures like these, in particular to their edge of violence and invasiveness.

24 Compare Leo Steinberg, "Resisting Cézanne: Picasso's *Three Women*," *Art in America*, 66, no. 6 (November–December 1978): 115–33. Steinberg in general insists that the aftershock of the *Demoiselles* never did die down, and that the whole model of Cubism with which modernism works – especially its picture of Cubism as increasingly focused on an inquiry into the means and conditions of representation – is too abstract and two-dimensional. Modernist criticism wishes to abstract "representation" out from the play of affect and make it a self-sufficient subject. Picasso, says Steinberg, never wished (or did) any such thing. Einstein was right, in his view: Picasso's pictures are always "les carrefours des processus psychologiques." None of this I exactly disagree with. I see Picasso's work from 1908 to 1912 as more analytical and experimental than Steinberg does, but we would agree, I think, that such an approach to painting did not come easily to Picasso, and that time and again "analysis" or "experiment" – especially with female bodies – is to be understood as a charged exercise. Sometimes violent, sometimes tender; and sometimes inflecting the relations of self and other in ways that elude any one psychological description or moralistic tag.

25 Manet and Ingres in 1905, Puvis in 1904, Courbet in 1906. These were part of a pattern of retrospective exhibitions at the Salon des Indépendants and the Salon d'Automne, and at the galleries of Bernheim-Jeune, *La Revue blanche*, and Durand-Ruel – of Seurat, van Gogh, Gauguin, Toulouse-Lautrec, Renoir, Redon, Morisot, and repeatedly Cézanne – in which a modernist history of the nineteenth century was put in place as part of the avant garde's organizing of its new art world.

26 In addition to the paintings illustrated, see the whole sequence in Daix and Rosselet, *Le Cubisme de Picasso*, nos. 134–54, as well as the culminant mask-heads in *Woman Holding a Fan* (no. 168), *Bust of a Woman Leaning on her Elbow* (no. 170), *Standing Nude* (no. 167), and par excellence *Three Women* (no. 131) and *The Dryad* (fig. 108, above). I agree with Rubin when he says that "appearances to the contrary notwithstanding, modern painting is in general more informed by Western illusionism than

by anything else, for its revolutionary changes *operate precisely on that body of received ideas.*" See William Rubin, "Picasso," in William Rubin, ed., *"Primitivism" in 20th Century Art*, 2 vols., (New York, 1984), 1: 263, Rubin's italics. Equally, neither of us would want to deny that part of the appeal of the "chasse aux nègres" – the phrase is a giveaway – had to do with the usual, dispiriting "heart-of-darkness" clichés that attached to the objects brought home. See on this topic Patricia Leighten, "The White Peril and *L'Art Nègre*: Picasso, Primitivism and Anticolonialism," *Art Bulletin*, 72, no. 4 (December 1990): 609–30.

27 See Rubin, "Picasso," 298. The context is not quite clear, but this looks to be Rubin's reminiscence of Picasso's conversation. It tallies with various casual references to "les nègres," meaning the sculptures, in Braque's and Picasso's letters of 1911 (see Cousins, "Documentary Chronology," 401–2, where the patronizing collapse of work into maker is silently amended in translation).

28 It is possible that Picasso saw Douanier Rousseau's *La Mauvaise surprise* when it was exhibited at the Salon des Indépendants in 1901. See Caroline Lanchner and William Rubin, "Henri Rousseau and Modernism," in MoMA catalogue, *Henri Rousseau* (New York, 1985), 46–47. In any case, as Lanchner and Rubin imply, it is an image that most likely became active in Picasso's imagination several years later.

29 Picasso to Kahnweiler, 12 June 1912, quoted in Monod-Fontaine, *Donation Leiris*, 168.

30 See the treatments in Golding, *Cubism*, 71–76, Daix and Rosselet, *Le Cubisme de Picasso*, 66–67, 241–47, or the fine discussions in Rubin, *Picasso in the Collection of MoMA*, 56–62, 202–4. Rosalind Krauss has different, and I think more searching, things to say about Horta in Krauss, "Cubist Epoch," 32–33, which she develops further in her "Motivation of the Sign." Her earlier remarks influenced my thinking, as did the pages on Horta in Steinberg, "Resisting Cézanne," 125–27.

31 The notion of Cubism involving the eye "turning around" the object seems to go back to 1911 and no further (hence, in part, my interest in what Metzinger wrote in 1910, especially as he is one of the first to float the ensuing idea of perceptual mobility). See Jean Metzinger, "«Cubisme» et Tradition," *Paris-Journal*, 16 August 1911, 1: "Ils

se sont permis de tourner autour de l'objet pour en donner, sous le contrôle de l'intelligence, une réprésentation concrète faite de plusieurs aspects successifs. Le tableau possédait l'espace, voilà qu'il règne aussi dans la durée," cited in Edward Fry, *Cubism* (London and New York, 1966), 66–67. Compare Albert Gleizes, "L'Art et ses Représentants – Jean Metzinger," *Revue Indépendante*, no. 4 (September 1911): 165–66: "Hanté par le désir d'inscrire l'*Image totale* il donnera un dynamisme considérable à l'oeuvre plastique en faisant évoluer l'artiste autour de cet objet à représenter, puis avec un tact qui sera de la mesure et l'ordonnance du tableau, il en écrira le plus grand nombre de plans possible: à la vérité purement objective, il veut ajouter une vérité nouvelle, née de ce que son intelligence lui aura permis de connaître. Ainsi qu'il le dit, luimême: À l'*espace* il joindra la *durée*." Gleizes is describing Metzinger's practice, but it is clear that both of them thought what they were doing was licensed by Picasso's work of two years before. The part played by the prestige of Bergsonism in all this was immense. It goes along with the universal assumption in the early texts (one which I generally agree with) that Cubism is to be understood as an art of exalted or completed resemblance. Everyone from Apollinaire to Raynal took this for granted, at least until Reverdy's frontal attack on it in 1917. I think they were right to do so; but the question is whether completeness of resemblance in Picasso is bound up with figures of mobility or duration. Not all writers thought so at the time. Kahnweiler did not. The German critic Fritz Burger argued explicitly the contrary in his *Cézanne und Hodler* (Munich, 1913): see the passage quoted in Assouline, *L'Homme de l'art*, 205. My reading of the "hidden shoulder" motif connects with some things the early German writers say, but even more with the view of Picasso's project in the Cubist years offered in Leo Steinberg's work, notably Leo Steinberg, "The Philosophical Brothel," rev. ed., *October*, no. 44 (Spring 1988): 7–74, and Leo Steinberg, "The Algerian Women and Picasso At Large," in Leo Steinberg, *Other Criteria* (London and New York, 1972), 125–234, esp. 154–73. I could not agree more that "[n]ever is a Cubist object apprehendable from several sides at once, never is the reverse aspect of it conceivable, and no object in a work of 'Analytical' Cubism by Picasso or

Braque appears as a summation of disparate views," (160) and I dare say that Steinberg is right in insisting that Cubism, in this respect, represents a turning aside from Picasso's "inmost obsessions – among them, the fantasy of an Argus-voyeur whose eyes see from a hundred points." (162) I think I do disagree with Steinberg about what fantasy of depiction replaced the Argus-voyeur from 1908 to 1912. I do not believe, for instance, that Cubism is to be understood "not [as] a study or symbolization of structures, but [as] a pictorial dispersion of random parts." (160) "Random" seems wrong here. When I read that "in a Cubist picture the here and there of divergent aspects is not designed to consolidate body surfaces, but to impress the theme of discontinuity upon every level of consciousness," (160) I go along with the first phrase but draw back from the (Joycean?) absolutism of the second. The second phrase, to put it another way, seems to me to smuggle modernist pieties in again by the back door, though Steinberg has done more than most to suggest the ways in which Cubism remains a scandal for the modernism that adores it.

32 Compare my reading of *The Reservoir* with Rubin, *Picasso in the Collection of MoMA*, 56–58. Not that my account of Horta can be disentangled from Rubin's: obviously his description of Picasso's depiction of solids around this time as "never appear[ing] to have backs" (48) anticipates mine, though his further description of the pictures as forms of "bas-relief" seems to me not to deliver on the point of his own insight (as Steinberg and Krauss have argued, from different points of view).

33 Jacques Rivière, "Sur les Tendances actuelles de la peinture," *Revue d'Europe et d'Amérique* (March 1912): 383–406. My citation is on 397, n.1: "Rien n'est plus hypocrite que la perspective. Car, d'une part, elle feint d'ignorer que le tableau est une surface plane et, d'autre part, elle imite la profondeur uniquement avec un système de profils, tous établis dans le même plan, celui justement du tableau. Pour représenter avec sincérité la profondeur, le peintre devra d'abord avouer qu'il travaille sur une surface plane: c'est ce qu'il fera en établissant tous les objets les uns à côté des autres. Ensuite, il devra tâcher d'imiter la profondeur avec quelque chose qui soit davantage de sa nature qu'un jeu de profils plans." This is, I should emphasize, a kind of limit-argument in Rivière's text, and its

importance is clearly not fully recognized by the text itself: the fact that one crucial part of the argument is relegated to a footnote is telltale. Rivière's reactionary brilliance was recognized first by Fry (see Fry, *Cubism*, 75–81), and seems to me to resist attempts to put it in its place: for instance, David Cottington, "Cubism, Law and Order: the Criticism of Jacques Rivière," *Burlington Magazine*, no. 126 (December 1984): 744–50. Cottington's demonstration that Rivière's response was "ideologically determined" is not unconvincing, but (1) the point could hardly be more obvious, (2) in general, the intellectual authority of the Right in 1912 and thereabouts is what needs to be explained not just demonstrated (and demonstrating that a text's constructions of its objects are determined by certain Right-wing commitments is not the same, unfortunately, as demonstrating that these constructions lack explanatory power), and (3) Cottington's analysis seems to me intent on not recognizing the ways in which Rivière's text exceeds or deconstructs its own neo-Kantian frame of reference. Even Paul Crowther, "Cubism, Kant, and Ideology," *Word and Image*, vol. 3, no. 2 (April–June 1987): 195–201, which (putting aside the usual silly-philosopher's stuff about the art of the 1960s) seems to me the best and clearest discussion of why the early Kantian explanations of Cubism are so uninformative, is not inclined to recognize the way threads of something like a materialist argument appear from time to time in Rivière's article, disturbing its idealist drift. He sees (199) that Rivière has, and depends on, a notion of a "true" purpose of painting; he does not, I think, quite recognize the way that notion is prone to double back on itself and present the text with really interesting problems.

34 Rivière, "Sur les Tendances actuelles," 397–98: "[L]a profondeur n'est pas le vide pur ... Le peintre pourra donc l'exprimer autrement que par la perspective, en lui communiquant un corps, non plus en l'évoquant, mais en la peignant, comme si elle était chose matérielle. À cet effet, de toutes les arêtes de l'objet il fera partir de légers plans d'ombre qui fuiront vers les objets plus lointains.... La profondeur apparaîtra comme une fuite subtile mais visible qui accompagnera les objets; ils auront beau se tenir sur le même plan: entre eux s'insinuera cet éloignement positif et l'écartement produit par ces petites pentes sombres. Ils se distingueront les uns des autres, sans avoir besoin de changer leur visage réel, uniquement par la présence sensible entre leurs images des intervalles qui les séparaient dans la nature. En s'incarnant en des ombres, l'espace maintiendra jusque dans le tableau leur discrétion.

"Ce va-et-vient, cette fuite et ce retour, en façonnant des creux et des saillies, finiront par donner à l'ensemble du tableau un certain volume, à peu près indépendant de la perspective. Le spectacle entier recevra, comme l'objet, un modelé géométrique; il se montrera avec sa solidité véritable, qui est tout autre chose que la sèche et fictive profondeur d'un décor. Nous aurons devant les yeux non plus la fragile et artificielle vision d'un instant, mais une image dense, pleine et fixe comme la réalité." The first paragraph is cited in Fry, *Cubism*, 77–78.

35 Metzinger, "Note sur la Peinture," 650: "Picasso ne nie pas l'objet, il l'illumine avec son intelligence et son sentiment. Aux perceptions visuelles, il joint les perceptions tactiles. Il éprouve, comprend, organise: le tableau ne sera transposition ni schema, nous y contemplerons l'équivalent sensible et vivant d'une idée, l'image totale. Thèse, antithèse, synthèse, la vieille formule subit une énergique interversion dans la substance des deux premiers termes: Picasso s'avoue réaliste. Cézanne nous montra les formes vivre dans la réalité de la lumière, Picasso nous apporte un compte-rendu matériel de leur vie réelle dans l'esprit, il fonde une perspective libre, mobile, telle que le sagace mathématicien Maurice Princet en déduit toute une géométrie."

36 I have said already that the first half of 1910 seems to me more than usually spasmodic and inconsequential in Picasso's work. If I were arguing that in full, a lot would turn on an understanding of what Picasso was aiming for in *Young Girl with a Mandolin (Fanny Tellier)* (Daix and Rosselet, *Le Cubisme de Picasso*, no. 346), and how seriously we are to take Picasso's own opinion, later, that the picture had been left unfinished. My view, which I shall just state baldly here, is that we should take it very seriously indeed. The *Young Girl* was clearly intended as a masterpiece (alongside its equally problematic partner, *Woman Sitting in an Armchair* [no. 342], of exactly the same size), in which the devices of mapping and disintegration explored over the winter would be reassembled, so to speak, and made to apply to a particular identity. It is important that *Young Girl* is a portrait, and that portraiture seems at this moment a necessary mode for Picasso's art, as if the demands of the sitting might (so he hoped) compel a kind of particularization – a motivation of the new sign language, if you like – which otherwise was proving difficult. The portraits of Uhde and Vollard (nos. 338 and 337) are not very happy episodes in this respect (particularization in them seems not very distant from kitsch), and likewise, in *Young Girl with a Mandolin* the laying out of Fanny Tellier's identity turns out to depend far too much on the laying on of Fanny Tellier's charm. Cadaqués's *(Wo)man with a Mandolin* seems determined above all to exorcize the ghost of charm for good and all, even at the expense of the ghost of resemblance.

37 The *Violinist* is Daix and Rosselet, *Le Cubisme de Picasso*, no. 393; the *Monk with a Mandolin*, ibid., no. 389; the *Table*, ibid., no. 402.

38 See Fernande Olivier, *Picasso et ses Amis* (Paris, 1933), 165, cited in Daix and Rosselet, *Le Cubisme de Picasso*, 259.

39 Compare Daix and Rosselet on this issue, ibid., 259–66, with Josep Palau y Fabre, *Picasso Cubism (1907–1917)* (New York, 1990), 179–213, some of whose reassignments seem at least plausible. (The *Glass of Absinthe*, incidentally, is often dated to the fall after Céret, though not on any very secure grounds.) One further dimension to this period, stressed in John Richardson, *A Life of Picasso*, 2 vols. (New York, 1991–96), 2: 167–72, is the effort expended on the decorative panels for Marshall Field, which left no trace, or only distorted traces, behind. But when exactly was the period of maximum effort on Field's behalf is anyone's guess; and in any case, the idea of big decorative projects running deeper and deeper into trouble at this moment rather confirms my sense of the period's flavor. Once again within modernism the question of the decorative looms; but in this case it does not seem to me possible to work out what specific effect, if any, the effort at decorativeness had on Picasso's work as a whole in 1910. Maybe it encouraged the general drift toward the empty and open. In any case, what matters is that Picasso finally decided that such a drift was at odds with Cubism's cognitive, "easel-painting" ambitions.

40 Metzinger, "«Cubisme» et Tradition," 1.

41 Guillaume Apollinaire, *Méditations Esthétiques. Les peintres*

cubistes, ed. Leroy Breunig and Jean-Claude Chevalier (Paris, 1965), 80. The text was written in summer 1912, corrected in the fall, and first published in 1913.

42 Gleizes, "Jean Metzinger", 168. The whole passage reads: "Dans la représentation plastique d'une figure, d'un portrait, Metzinger est convaincu qu'un écrivant, sur une même toile, le visage de face puis de profil, ces deux plans joints avec toute la sensibilité qui alors entrera en compte, on ajouterait singulièrement à la ressemblance: il est évident que cela serait fait avec une mesure qui sera le point commun de la tradition des maîtres aux tentatives d'aujourd'hui. En résumé, il veut développer le champ visuel en le multipliant, pour l'inscrire dans l'espace de la toile même: c'est alors que le cube jouera un rôle et c'est là que Metzinger utilisera ce moyen pour rétablir un équilibre que ces audacieuses inscriptions auront momentanément rompu." Once one realizes that by the word "cube" Gleizes intends the whole problematic of the grid, this passage becomes interesting: it finds words for the constitutive tension in Cubism between the multiplying, destabilizing effect of the first "writing" of an object, and the effort to "inscribe" that profusion of aspects "into the space of the canvas itself." The grid or the cube are two ways of describing that latter kind of inscription. Notice that already in 1911 Gleizes is clear that Cubism is all "writing"; but he thinks there are essentially two kinds in pictorial art: a writing of the object – a multiplication – and a writing of the picture surface. The latter is assumed (I suppose in a modernist way) to be a unity as opposed to a multiplicity.

43 Paul de Man, *The Rhetoric of Romanticism* (New York, 1984), 258. Among other passages in de Man's work that deal with painting, I would single out his discussion of eighteenth-century painting as the model for an aesthetic of presence (concreteness and stability), in his "The Rhetoric of Blindness," in Paul de Man, *Blindness and Insight: Essays in the Rhetoric of Contemporary Criticism*, 2nd ed. (Minneapolis, 1983), 123–25; the aside on "the metaphor of light" in painting in de Man, "Aesthetic Formalization," 286; and the pages on the trope of the "solar" in seeing, in his "Phenomenality and Materiality in Kant," in Paul de Man, *Aesthetic Ideology* (Minneapolis, 1996), 80–83.

44 Predictably, the closest Cubist criticism ever gets to glimpsing these de Manian problems is with Rivière, "Sur les Tendances actuelles." His discussion of Cubism's attempts to dispense with lighting is typically intense, and once again it leads him to some strange, only half-developed, restatements of the modernist case. The trouble with lighting in painting, he says, is that it concedes *too much* to painting's actual flatness: "l'éclairage n'est pas le seul ni le meilleur moyen d'analyser l'objet; il ne représente pas réellement, mais seulement d'une façon toute idéale et abstraite la différence de ses parties [interesting negatives for a neo-Kantian]; il la suggère simplement, il la propose, il l'indique. Il laisse se succéder *à plat* sur la toile les diverses faces et, par l'entrechoc des clairs et des ombres, il nous engage à penser qu'elles sont séparées; mais si nous arrivons à voir cette séparation, ce n'est que par l'imagination." (390) In other words, lighting cannot provide a set of truly powerful equivalents for the depth and separateness of objects as they really exist in space. The best it can do is lay on a kind of code for that spatial existence, a code of lights and darks. Space is a matter left essentially to the viewer's imagination. But supposing painting could find a way to materialize space, not just encode it! Again it is the extent to which the encounter with Cubism leads Rivière in the opposite direction from idealism that seems to me interesting; and certainly it is the seriousness of his engagement with the idea of a materialization of space (without light falling across it) that leads to the brilliant description of Cubist "faceting" on 390–91. This too is haunted by a modernist vision of a new kind of pictorial unity, one in which "la répartition brutale et injuste des lumières et des ombres" gives way to a new kind of formal equality: shadow will be "distributed impartially," the joints and joining of planes will matter as much as their division, contours will at last be "doucement solidaires." The whole passage deserves to be recognized as the quintessential (that is, quintessentially weird) statement of the modernist case for "all-overness."

45 Fernand Léger, "Les Origines de la peinture [actuelle] et sa valeur représentative," *Montjoie!* (29 May 1913), cited from Fernand Léger, *Fonctions de la Peinture* (Paris, 1965), 16: "Nous arrivons, j'en suis persuadé, à une conception d'art aussi vaste que les plus grandes époques précédentes: même tendance aux grandes dimensions, même effort partagé par une collectivité ... Si l'on peut mettre en doute une création isolée, la preuve vitale en est faite lorsqu'elle se traduit collectivement dans des moyens d'expression personnelle très distincts."

46 See Mark Antliff, *Inventing Bergson: Cultural Politics and the Parisian Avant-Garde* (Princeton, 1993), for an extended treatment of the complexities here.

47 Adolphe Basler, "Art Français, art européen," *Montjoie!* (29 March 1913): 6: "Jamais, *depuis les temps dits gothiques* on n'a vu un mouvement aussi unanime vers la spiritualisation des formes sensibles de l'art. Nous assistons à la naissance d'un style aussi universel que le gothique, qui, né lui aussi en France, pénètre les autres pays de l'Europe pour s'y différencier selon les aspirations des diverses races." For other recognitions of Cubism as the new collective style, see Roger Allard, "Sur Quelques peintres," *Les Marches du Sud-Ouest* (June 1911), cited in Fry, *Cubism*, 64 ("Les tenants attardés de l'individualisme seront grandement choqués – il le faut – de voir un *groupe* se constituer fortement ..."); Rivière's waspish passage on the end of individualism (Rivière, "Sur les Tendances actuelles," 400); Charles Lacoste's attack on the Cubists' sacrifice of their own sensibilities "pour se conformer à la réalité littérale ou à la tradition comme à des formules mathématiques", in Charles Lacoste, "Sur le «Cubisme» et la peinture," *Le Temps présent* (April 1913): 338; and Jacques Reboul, "La Révolution de l'oeuvre d'art et la logique de notre attitude présente," *Montjoie!* (29 May 1913): 5–6 ("Cette attitude volontaire si logique, si conforme à l'ambition secrète qui conduisit nos prédécesseurs il y a sept siècles à réaliser l'art des cathédrales ...").

48 Jacques Reboul, "Le Juif au théâtre," *Montjoie!* (16 May 1913): "En dehors de quoi [that is, the end of the reign of money and mediocrity] il ne peut y avoir de salut que dans un bouleversement que nous sentons proche. Mais ce bouleversement ne marquera-t-il pas la fin du théâtre, tel que nous le connaissons? Le juif, qui n'est pas pour nous un adversaire de tendance, mais le pilier principal des préjugés de «stagnation», parce qu'il croit flatter le sentiment ethnique de ceux qui l'entourent, le juif peut devenir un adjuvant précieux dans un milieu qui prend enfin conscience de son évolution. Seulement, toute *révolution* le déroute et le rejette du côté de l'attente physique. La question est de savoir précisément si le principe de l'art n'est pas

révolutionnaire." The equivocation (which of course is no equivocation) is worthy of de Man in *Le Soir*. On Reboul and *Montjoie!*, see Antliff, *Inventing Bergson*, 107–8, 129. Antliff's writing, and conversations with him, persuade me that any attempt to dispose of Reboul's avant-garde anti-Semitism by putting him and his journal firmly on the Right is to misread the – much more depressing – osmosis of political and philosophical positions which is characteristic of Parisian culture in this decade.

49 Dora Vallier, "Braque, la Peinture et nous: propos de l'artiste recueillis," *Cahiers d'Art*, 29th year, no. 1 (October 1954): 14: "On s'est dit avec Picasso pendant ces années-là des choses que personne ne se dira plus, des choses que personne ne saurait plus se dire, que personne ne saurait plus comprendre ... des choses qui seraient incompréhensibles et qui nous ont donné tant de joie ... et cela sera fini avec nous."

50 Françoise Gilot and Carlton Lake, *Life with Picasso* (New York, 1964), 76.

51 Georges Braque, "Against Gertude Stein," *Transition*, no. 23 (July 1935): Supplement 13–14. The word "anonymous" crops up in this text twenty years before its reappearance in the Vallier conversations, and thirty before Gilot's (she is supposedly harking back to things said in the 1940s).

52 Vallier, "Braque, la Peinture," 18: "Voyez-vous, quand nous étions très liés avec Picasso, il y a eu un moment où nous avions du mal à reconnaître nos toiles ... Je jugeais que la personne du peintre n'avait pas à intervenir et que par conséquent les tableaux devaient être anonymes. C'est moi qui décidai qu'il ne fallait pas signer les toiles et pour un certain temps Picasso en fit autant. Du moment que quelqu'un pouvait faire la même chose que moi, je pensais qu'il n'y avait point de différence entre les tableaux et il ne fallait pas qu'ils soient signés. Après je compris que tout cela n'était pas vrai ..."

53 Gilot and Lake, *Life with Picasso*, 75.

54 Ibid., 77.

5 GOD IS NOT CAST DOWN

1 El Lissitzky to Sophie Küppers, 1 August 1925, in Sophie Lissitzky-Küppers, *El Lissitzky, Life, Letters, Texts* (London, 1968), 65. Rather than repeat "translation modified" a hundred times in what follows, I shall say here that in the majority of cases in this chapter, particularly with Malevich, I have made changes in the standard available English version. Mostly this is a matter of making the undoubted meaning clearer, or the form of expression less awkward. In Malevich's case, where meaning is rarely undoubted and awkwardness of expression is part of the textual effect (and seems always to have been so), I have, as someone with no Russian, been as cautious as the case allows. Heroic as they are, the translations in Kasimir S. Malevich, *Essays on art*, 4 vols., ed. Troels Andersen (Copenhagen, 1968–78), just will not do on their own. The text they offer of *God Is Not Cast Down*, for example, is for large stretches incomprehensible, and a comparison with the versions in Kazimir Malévitch, *De Cézanne au suprématisme*, ed. Jean-Claude Marcadé (Lausanne, 1974) and Kazimir Malevitch, *Écrits*, ed. Andréi Nakov (Paris, 1986) makes it clear that it is Andersen's translators who are responsible for this, as much or more than Malevich in the first place. This is not to let Malevich off the hook. He is an abysmally unclear writer, but the French translators seem to have found ways of admitting this fact into their (necessarily creative) versions without descending into utter gobbledygook. I have leaned heavily on their solutions in what follows, though in the case of *God Is Not Cast Down* – a sort of *Finnegans Wake* on the level of the signified as opposed to the signifier – I have been forced to make my own proposals about what Malevich might have been meaning at various key points. Hereafter the three main translations of Malevich will be referred to as Andersen, Marcadé, and Nakov. I want to thank Melissa Frazier, Christina Kiaer, and Reginald Zelnik for their generous help with particular linguistic (and other) points, though they are not to blame for the general tactics I have taken with regard to Malevich's prose. Christina Kiaer corrected errors and made helpful suggestions at various stages of the text; Brigid Doherty's reading of the chapter made me rethink my treatment of *God Is Not Cast Down*; Reginald Zelnik gave me excellent advice on the literature of War Communism. This chapter sticks close to UNOVIS from 1919 to 1921, but I should like to acknowledge how much I have learned from the work of Christina Kiaer, Christina Lodder, Manfredo Tafuri, Paul Wood and others on art under NEP and Stalin.

2 Anon., "Bolshevism Balks at Bolshevist Art," *Art News* (5 April 1924): 3, cited in part in Donald Karshan, "Behind the Square: Malevich and the Cube," Gmurzynska Gallery catalogue, *Kasimir Malewitsch zum 100. Geburtstag* (Cologne, 1978), 257.

3 Kasimir Malevich, *On New Systems in Art* (Vitebsk, 1919), the book's opening sentences, in Andersen 1: 83, but compare Nakov, 323–24. For El Lissitzky's name-change, see Aleksandra Shatskikh, "Unovis: Epicenter of a New World," in Guggenheim Museum catalogue, *The Great Utopia. The Russian and Soviet Avant-Garde, 1915–1932* (New York, 1992), 55 and 63, n. 4. (I use the spelling of his name that quickly became current in the West: the Russian form is slightly different.) El Lissitzky was in charge of the graphics workshop in Vitebsk in late 1919, and supervised the printing of *On New Systems in Art*. Basic biographical materials on El Lissitzky from Lissitzky-Küppers, *El Lissitzky*, and Peter Nisbet's invaluable "An Introduction to El Lissitzky," in Harvard University Art Museums catalogue, *El Lissitzky, 1890–1941* (Cambridge, Mass., 1987).

4 Mystery (deliberately) surrounded the words hiding behind the acronym, which anyway took on a life of its own. Nakov, 319, and Shatskikh, "Unovis," 63, both lean on a Malevich manuscript of May 1924 for their unpacking, and nevertheless an abbreviation in the text allows them to disagree slightly.

5 Kasimir Malevich, "Concerning the 'ego' and the collective," UNOVIS *Almanac 1*, quoted in Shatskikh, "Unovis," 56. I am not saying that everyone within UNOVIS understood, or agreed with, the typical dialectical one-man-upmanship Malevich goes in for here – beyond the mere "collective" to a self-annihilating unity in the image – but it was certainly Malevich who called the shots in the debate on collective work in Vitebsk in 1920. Articles in UNOVIS *Almanac 1* refer more than once to a lecture he gave in May, from which "Concerning the ego" is drawn, as the touchstone for future work. And in general, I begin with the most extreme statement on collectivism from within UNOVIS because my whole picture of the group – and of the moment of modernism it represents – is of its constantly being impelled onward, maybe to its doom, by its master's intransigence. Unless otherwise stated, dates and facts about UNOVIS are from Larissa Zhadova, *Malevich. Suprematism and Revolution in Russian Art 1910–1930* (London, 1982), now supplemented and corrected by Shatskikh.

6 See Nisbet, "Introduction," 48, n. 33. The word crops up in El Lissitzky's contribution to UNOVIS *Almanac 1*.

7 Kasimir Malevich to Mikhail Matyushin, 1915 (n. d.), quoted in Zhadova, *Malevich*, 124, n. 34.

8 Vladimir Lenin, *Collected Works*, 45 vols. (Moscow, 1960–70), 31: 404–6.

9 Lazar Khidekel, "UNOVIS in the Studios," UNOVIS *Almanac 2*, January 1921, translated in *Malevich: An Art and Design Profile* (London and New York, 1989), 29.

10 M. Kunin, "*Partiinost* in Art," UNOVIS *Almanac 2*, translated in *Art and Design Profile*, 28–29. *Partiinost* is a Leninist coinage, dating back to 1905 debates on art and literature, meaning commitment to the Party and "freedom from bourgeois anarchist individualism." It is not quite true, as Catherine Cooke has it in her excellent "Malevich: From Theory into Teaching," also in *Art and Design Profile*, that Kunin "is not otherwise recorded in the available literature on UNOVIS." Marcadé, 2: 180–81, gives an edited translation of an article Kunin published a few months later, "About UNOVIS," in *Iskusstvo*, nos. 2–3 (Vitebsk, April–May 1921), and John Bowlt in his "Malevich and his Students," *Soviet Union/Union Soviétique*, 5, pt. 2 (1978): 260–61, likewise quotes from it. Bowlt appears to treat Kunin as simply "outside UNOVIS" and therefore does not get the measure of his or her (ordinary) apostasy from the group. The Kunin of "*Partiinost* in Art" has this to say, for example, on the subject of painting: "'To the old – the cemetery; to the new – life,' said K. Malevich, and rightly: aesthetic pictures were pretty empty and built on nothing, they were harmful to the proletariat and of no use to it. They were the accessories of the old, departed bourgeois world, of a somewhat Romantic sentimentalism, of individualism, of everything from which the psychology of the satiated, obese class derived": see *Art and Design Profile*, 29. By April this has become: "UNOVIS rejects and denies any pictorial culture; UNOVIS denies aesthetics, the theater, poetry, music, in a word, all aspects of art; UNOVIS tramples on and kills all sense of beauty and aesthetic perception in its adepts, by means of fantastic theories of 'the pulverization of space' and 'the movement of the supremes within that space'." See Marcadé, 2: 181. The apostasy is ordinary, as I say. No doubt what Kunin now envisages as substitute for UNOVIS, and guarantor of the aesthetic, is *Partiinost* pure and simple. An unsurprising conclusion in the circumstances of 1921. What is interesting is the fact of someone like Kunin having fellow-traveled with or within UNOVIS during the months before. It tells us something about the intensity of UNOVIS's negotiations with the Party line.

11 UNOVIS leaflet, "We Want . . . ," May or June 1920, in Zhadova, *Malevich*, 297.

12 See René Fülöp-Miller, *The Mind and Face of Bolshevism* (London and New York, 1927), 209.

13 For "Comrade Chagall," see "Comrade Chagall's Resignation," *Proceedings of the Vitebsk Provincial Soviet* (19 September 1919), quoted in Aleksandra Shatskikh, "Chagall and Malevich in Vitebsk," AICARC (AICA ARCHIVES) nos. 1 and 2 (1989): 7. My thanks to Molly Nesbit for helping me track down this article. For "Gubernatorial Plenipotentiary," see, for example, Marc Chagall, "Ot Vitebskogo pod'otdela Izobrazitel'nykh iskusstv," *Iskusstvo kommuny* (Petrograd, 30 March 1919), quoted in Bowlt, "Malevich and his Students," 259.

14 Apparently Ermolaeva was an *Izo Narkompros* appointment, sent to Vitebsk in 1919 to put a bit of Marxist muscle into the Chagall operation. See Evgenii Kovtun, "Wera Michailowna Ermolaewa," in Gmurzynska Gallery catalogue, *Women Artists of the Russian Avantgarde 1910–1930* (Cologne, 1980), 102–9. That makes her role as one of Malevich's most loyal adherents and protectors – from June 1920, when Chagall finally left for Moscow, she was director of the art school in Vitebsk – all the more striking. See below, n. 155, for her later fate.

15 See Vladimir N. Brovkin, *The Mensheviks after October* (Ithaca and London, 1987), 252–53, citing the Menshevik Grigorii Aronson, *Na zare krasnogo terrora* (Berlin, 1929), 38. The movement for Workers' Assemblies of Upolnomochennye ("delegates" or even "plenipotentiaries" is as close as one can get in English) had started in Petrograd in Spring 1918, under Menshevik and SR auspices. The assemblies were banned on 27 June 1918.

16 See Vladimir N. Brovkin, *Dear Comrades. Menshevik Reports on the Bolshevik Revolution and the Civil War* (Stanford, 1991), 222, citing a Cheka document of 14 November 1920.

17 The Vitebsk trial was a spectacular event, in a predominantly Jewish town, and is taken as a sign of the general hardening of Bolshevik policy toward the Jews. See Benjamin Pinkus, *The Jews of the Soviet Union* (Cambridge, 1988), 101, and Jerome Rothenberg, "Jewish Religion in the Soviet Union," in Lionel Kochan, *The Jews in Soviet Russia since 1917*, 2nd ed. (London, 1972), 164, n. 1.

18 See Franz Meyer, *Marc Chagall, Life and Work* (New York, n. d.), 269–70.

19 El Lissitzky, "Our Book," *Gutenberg-Jahrbuch* (1926–27), quoted in Lissitzky-Küppers, *El Lissitzky*, 362.

20 Even to assume that the building is a factory of some sort is to play along with the photo's (and the propaganda board's) illusion of direct address, as Christina Kiaer pointed out to me. But for present purposes it makes sense for me to do so.

21 *Encyclopaedia Britannica*, 11th ed., *s.v.* "Vitebsk." 28: 146.

22 See Meyer, *Marc Chagall*, 605, n. 40.

23 See Guggenheim Museum, *The Great Utopia*, no. 207, where it is listed as "oil and sand on plywood, 47 × 63.5 cm." It was bought by the Museum Bureau of Narkompros in August 1920 from a UNOVIS show in Moscow, under the title *Gorod* [Town], or maybe, according to Nisbet, *Suprematism (Town)*. See Nisbet, "Introduction," 48, n. 33, and Harvard Museums, *El Lissitzky*, 168.

24 See the UNOVIS propaganda leaflet quoted in Zhadova, *Malevich*, 302.

25 El Lissitzky, "PROUN. Not world visions, BUT – world reality," *De Stijl*, year 5, no. 6 (June 1922), quoted in Lissitzky-Küppers, *El Lissitzky*, 347.

26 El Lissitzky lecture, 1921, quoted in ibid., 21, but erroneously described and dated. My thanks to Peter Nisbet for pointing out the mistake.

27 El Lissitzky, "PROUN," *De Stijl* text, in ibid., 347.

28 Both quotes from Kasimir Malevich, "I/42 Non-Objectivity," manuscript of 1923 to 1925, in Andersen, 3: 103, 145.

29 Kasimir Malevich, "Futurism-Suprematism," unpublished MS, 1921, translated in part in Armand Hammer Museum of Art catalogue, *Kasimir Malevich, 1878–1935* (Los Angeles, 1990), 177–78. I have changed the order of the quoted sentences in order to point

up the text's relevance to El Lissitzky's practice.

30 Kasimir Malevich, "Non-objective Art and Suprematism" (originally published as part of the catalogue of the Tenth State Exhibition, Moscow, 1919), in Andersen, 1: 120–22; but compare Zhadova, *Malevich*, 57, which is more spirited.

31 The most serious argument for the specificity and effectiveness of the Prouns' version of flatness-versus-depth is that mounted by Yve-Alain Bois, notably in Yve-Alain Bois, "Lissitzky, Malévitch et la question de l'espace," in Galerie Jean Chauvelin catalogue, *Suprématisme* (Paris, 1977), 29–46; Yve-Alain Bois, "Metamorphosis of axonometry," *Daidalos, Berlin Architectural Journal*, no. 1 (1981): 50–58; and Yve-Alain Bois, "From −∞ to 0 to +∞. Axonometry, or Lissitzky's mathematical paradigm," in Van Abbemuseum catalogue, *El Lissitzky architect painter photographer typographer* (Eindhoven, 1990), 27–33. I have learnt a lot from these articles, and from a superb lecture Bois gave at a symposium held in connection with the El Lissitzky exhibition in 1987, some aspects of which are represented in Yve-Alain Bois, "El Lissitsky: Radical Reversibility," *Art in America*, 76 (April 1988): 160–81; but I still find myself disagreeing with the (largely implicit) aesthetic judgement that accompanies Bois's explanation of El Lissitzky's axonometrics. What Bois presents us with, I feel, is a framework within which the aesthetic limitations of El Lissitzky's sense of space – its too carefully plotted, too local and intricate quality – can be seen to be bound up with an intelligent and ambitious attempt to rethink the conventions of perspective. Here as elsewhere within modernism, ambition and intelligence are no guarantors of artistic success – sometimes just the contrary.

32 See William H. Chamberlin, *The Russian Revolution, 1917–1921*, 2 vols. (1935; reprint, London and New York, 1952), 2: 490–91.

33 See El Lissitzky, "PROUN," unpublished text, written in Vitebsk and Moscow in 1920 and 1921, and given as a lecture at Moscow Inkhuk in October 1921, translated in Gmurzynska Gallery catalogue, *El Lissitzky* (Cologne, 1976), 59–72. Nisbet has shown how pervasive was the influence of Spengler on El Lissitzky at this time, and how ordinary the enthusiasm was among the Russian avant garde – at least, until Lenin had his say on the matter. See Nisbet,

"Introduction," 29, 49, nn. 55, 56. The Malevich quote is from Kasimir Malevich, *The Question of Imitative Art* (Smolensk UNOVIS, October 1920), one of his Reddest and most "collectivist" texts. See Andersen, 1: 178.

34 Kasimir Malevich, *God Is Not Cast Down* (Vitebsk, 1922), thesis 30, in Andersen, 1: 218.

35 Nisbet suggests that the propaganda board was created in connection with the December 1919 anniversary of the Committee for the Struggle against Unemployment. See Harvard Museums, *El Lissitzky*, 181. I see it as geared more specifically to the Bolsheviks' push against absenteeism and lack of labor discipline, which is the central theme of the Ninth Party Congress from March to April 1920, and of the Congress of Trade Unions soon after. Trotsky's 18 April speech on the militarization of labor, with its call for poster and propaganda campaigns (see below), comes out of this conjuncture. Pilsudski attacked massively in late April, Vitebsk became a behind-the-lines center of military activity all through May to July, and presumably *Beat the Whites with the Red Wedge* came from this time. None of this is proof that the propaganda board (which obviously resembles *Beat the Whites* in formal terms) comes from the same moment or just before. I just feel the balance of probabilities tends that way.

36 See Chamberlin, *Russian Revolution*, map on 2: 299.

37 See ibid., 29, 315. Compare Orlando Figes, "The Red Army and Mass Mobilization during the Russian Civil War 1918–1920," *Past and Present*, no. 129 (1990), and Richard Pipes, *Russia under the Bolshevik Regime* (New York, 1993), 51, 59–60, for recent estimates of desertions and failures to show up at induction centers, as well as the huge disproportion between front-line troops and "reserves."

38 See Merle Fainsod, *Smolensk under Soviet Rule* (Cambridge, Mass., 1958), 41.

39 See Mark von Hagen, *Soldiers in the Proletarian Dictatorship: the Red Army and the Soviet Socialist State, 1917–1930* (Ithaca and London, 1990), 73, n. 18.

40 Victor Serge, *Conquered City*, trans. Richard Greeman (London, 1978), 135–36; originally published as *Ville Conquise* (Paris, 1932). Compare the chapter on War Communism in Victor Serge, *Year One of the Russian Revolution* (New York, 1992), 352–76.

41 Document from P. Arshinov, *History of the Makhno Movement* (Berlin, 1923), quoted in Chamberlin, *Russian Revolution*, 2: 234. It is typical of Chamberlin that he manages to give Makhno sober and straightforward coverage.

42 See ibid., 300, where Dzerzhinsky's appointment is taken as evidence of the seriousness of the threat to the Bolsheviks in Makhno territory.

43 See ibid., 332, and the story of the British reaction, 321. Pipes, *Russia under the Bolshevik Regime*, 134, gives a figure of 83,000.

44 See Orlando Figes, *Peasant Russia, Civil War. The Volga Countryside in Revolution (1917–1921)* (Oxford, 1989), especially 321–53. Compare Pipes, *Russia under the Bolshevik Regime*, 372–78, 386–88, who calls the pattern of resistance a "second Civil War."

45 See Figes, *Peasant Russia, Civil War*, 329.

46 Vladimir Lenin, "Report to 10th Congress of the Russian Communist Party", 8 March 1921, in Lenin, *Collected Works*, 32: 184, quoted in part in Figes, *Peasant Russia, Civil War*, 321. I have combined features of Figes's and the *Collected Works*' translations. Unsurprisingly, given the date, Lenin's point of departure here is the Kronstadt uprising and the threat of "petty-bourgeois counter-revolution and petty-bourgeois anarchism," but it is clear that he sees Kronstadt as one more in the line of the previous year's *jacqueries*, and he refers specifically to Samara as a point of comparison.

47 See Nisbet, "Introduction," 15–16 and Harvard Museums, *El Lissitzky*, 179–80. Nisbet is so concerned to show that in Kiev El Lissitzky was not yet making Bolshevik propaganda that I think he muffles the obvious point: in Kiev and elsewhere there was (as yet) no contradiction between working for the Commissariat of Enlightenment and putting one's energies into the Yiddish revival. On the contrary. For a while – perhaps until late 1920 – the Bolshevik cultural apparatus fostered these and other symptoms of Jewish emancipation, no doubt partly in the hope that Jews in general would follow the trajectory that El Lissitzky took, from Jewishness to Bolshevism.

48 See Chimen Abramsky, "The Biro-Bidzhan Project, 1927–1959," in Kochan, *The Jews in Soviet Russia*, 64 and n. 2. There are many other estimates, summarized by Pipes, *Russia*

under the Bolshevik Regime, 112. Pipes gives a full and horrible account of the pogroms, 104–12, and even he can find little to say on the Whites' behalf.

49 See Figes, *Peasant Russia, Civil War*, pl. 12. Perhaps the photos are fakes. Figes appears to trust them.

50 Serge, *Conquered City*, 154.

51 See Diane Koenker, "Urbanization and Deurbanization in the Russian Revolution and Civil War," in Diane Koenker, William Rosenberg, and Ronald Suny, *Party, State, and Society in the Russian Civil War* (Bloomington and Indianapolis, 1989), 81. Koenker cautions against being dazzled by the spectacular nature of the numbers. Urban life kept going somehow.

52 Figures from William Rosenberg, "The Social Background to Tsektran," in Koenker, *Party, State, and Society*, 372, n. 21. Rosenberg's article is as convincing a version of the "economic determinist" account of War Communism as one gets.

53 The one-day-in-three figure comes from a contemporary study of the Moscow region in late 1919, cited in Rosenberg, "Social Background to Tsektran," 359. Compare Daniel Brower, "'The City in Danger': The Civil War and the Russian Urban Population," also in Koenker, *Party, State, and Society*, esp. 65–77. Victor Serge paints a vivid picture of the struggle for survival in the factory districts, and Chamberlin makes many of the essential points about absenteeism and productivity in his fine chapter on War Communism: see Chamberlin, *Russian Revolution*, 2: 96–117.

54 Figures from Lev Kritsman, *The Heroic Period of the Great Russian Revolution*, 2nd ed. (Moscow, 1926), 184–85, 187, quoted by Leonard Schapiro, *The Origin of the Communist Autocracy* (London, 1955), 215–16. Compare more recent estimates in Pipes, *Russia under the Bolshevik Regime*, 138–39.

55 For railroad statistics and stories, see Rosenberg, "Social Background to Tsektran," 363–68, and compare Chamberlin, *Russian Revolution*, 2: 108.

56 See, for example, Rosenberg, "Social Background to Tsektran," 356: "the . . . collapse of industrial production, which reached its nadir in the first four months of 1920."

57 Quoted by Edward Hallet Carr, *The Bolshevik Revolution, 1917–1923*, 3 vols. (London, 1952), 2: 193.

58 Vladimir Lenin, "Report to 10th All-Russian Conference of the RCP(B)," 26 May 1921, in Lenin, *Collected Works*, 32: 412, quoted in Carr, *Bolshevik Revolution*, 2: 196, n. 1. I have used Carr's translation.

59 See Sheila Fitzpatrick, *The Russian Revolution, 1917–1932* (Oxford and New York, 1984), 71. Carr singles out "the optimistic mood which dominated the second congress of the Comintern in July 1920." See Carr, *Bolshevik Revolution*, 2: 197. We know that El Lissitzky attended the Comintern congress in July, and later worked in the Comintern publishing division. See Nisbet, "Introduction," 29, 48–49, nn. 39, 44, 55.

60 The first two sentences quoted and discussed in Carr, *Bolshevik Revolution*, 2: 197. Compare Nikolai Bukharin, *The Politics and Economics of the Transition Period* (London, Boston, and Henley, 1979), 90–91. I have combined features of the translation given here with that in Nikolai Bukharin, *Economics of the Transition Period, with Lenin's Critical Remarks* (New York, 1971), 57–59. Bukharin's italics have been dropped.

61 Kritsman, *The Heroic Period*, 78, quoted in Sheila Fitzpatrick, "The Civil War as a Formative Experience," in Abbott Gleason, Peter Kenez, and Richard Stites, *Bolshevik Culture* (Bloomington and Indianapolis, 1985), 63.

62 See Sylvana Malle, *The Economic Organization of War Communism, 1918–1921* (Cambridge, 1985), 396–465, for a devastating account. Malle's book is a detailed reply to the straight "economic determinist" approach to War Communism.

63 See Malle, *Economic Organization*, 501.

64 See Fitzpatrick, *Russian Revolution*, 73. On rationing in general, see Carr, *Bolshevik Revolution*, 2: 232–35, and Chamberlin, *Russian Revolution*, 2: 100–102. Item 9 of the Kronstadt demands in 1921 was equal rations for all workers.

65 Sporadic efforts have been made to suggest that UNOVIS came under more direct political pressure in 1921. Bowlt says the group "was expelled from the Institute at the end of 1921." See Bowlt, "Malevich and his Students," 264. For Rakitin's version, see below. Shatskikh is more cautious: "The Vitebsk teachers went unpaid for a considerable period [no very special fate in 1921]; neither the central nor the local authorities offered the school any support." See Shatskikh, "Unovis," 63. Times certainly got hard for UNOVIS,

and it seems that some sort of commission was sent to Vitebsk from Moscow "to clarify the situation" (an ominous phrase in Zhadova, *Malevich*, 129, n. 22; compare Bowlt's summary of an article in the local *Isskustvo* presumably about the same matter, "Malevich and his Students," 264). The evidence is fragmentary. UNOVIS students still graduated from the Institute in 1922. The group went on exhibiting. In March and April 1922 UNOVIS was prominent, some say dominant, at an exhibition of work from provincial art schools in Moscow. In May 1922 there was an UNOVIS exhibition in Vitebsk. In June UNOVIS figured in the Petrograd "Survey of New Tendencies in Art." In May 1923 the collective UNOVIS entry was the talk of the exhibition of "Works by Petrograd Artists Belonging to All Trends." No doubt UNOVIS fell out of favor with the local Vitebsk authorities. In such cases the economic sanction – particularly the rationing sanction – was very often enough.

66 Quoted in Chamberlin, *Russian Revolution*, 2: 291.

67 Quoted in Schapiro, *Origin of the Communist Autocracy*, 216.

68 See Chamberlin, *Russian Revolution*, 2: 97. For contrasting views of the nationalization program (that is, of the balance between ideology and expediency within it), see Carr, *Bolshevik Revolution*, 2: 172–98, and Malle, *Economic Organization*, 29–76.

69 See Chamberlin, *Russian Revolution*, 2: 102.

70 See Carr, *Bolshevik Revolution*, 2: 171–72, and Malle, *Economic Organization*, 501.

71 Quoted in Isaac Deutscher, *The Prophet Armed, Trotsky: 1879–1921* (London, 1954), 501. As Deutscher says, the speech's "historical interest lies in the fact that this has been perhaps the only frank attempt made in modern times to give a logical justification of forced labour."

72 Quoted in Deutscher, *The Prophet Armed*, 500.

73 Bukharin, *Politics and Economics of the Transition Period*, 163, 165. Quoted in part in Malle, *Economic Organization*, 5–6. I have combined features of both translations.

74 See Deutscher, *The Prophet Armed*, 493.

75 Quoted in Stephen Cohen, *Bukharin and the Bolshevik Revolution*, 2nd ed. (Oxford and New York, 1980), 96. Cohen says that Bukharin replied to Olminskii "in a light vein." Lenin particularly approved of the chapter from

which the quoted passage comes, "Non-Economic Coercion in the Transition Period": "Now this chapter is superb!" See ibid., 97.

76 El Lissitzky in UNOVIS *Almanac 1*, as quoted in his "Our Book," Lissitzky-Küppers, *El Lissitzky*, 362.

77 *Depot and factory* is a standard Bolshevik form of words at the time. See, for example, Lenin's "Report to the Eighth Congress of Soviets," 22 December 1920, in Lenin, *Collected Works*, 31: 511: "Let us improve our methods in every workshop, in every railway depot, in every sphere . . ." The two key words here are *depo* and *masterskaya*. The sentence occurs in a general review of production propaganda and efforts to increase output – the review was a standard feature of Lenin's speeches.

78 See Donald Karshan, "The Graphic Art of Kasimir Malevich: New Information and Observations," in *Suprématisme* (Paris, 1977), 56–60. Karshan and others do not quite understand the political significance of the congress. It represented a decisive retreat from previous, largely unsuccessful Bolshevik attempts to stir up class conflict in the countryside. Delegates of the Committees of Poor Peasants (*kombedy*) – a Bolshevik creation of a few months before – arrived in Petrograd ready to demand the transfer of all political power from the local Soviets, strongholds of the "middle peasants" and *kulaks*, to themselves. Lenin and Zinoviev thought otherwise. The congress was induced to pass a series of resolutions which, soon afterwards, put an end to the committees as an independent force. See Carr, *Bolshevik Revolution*, 2: 157–59. Whether Malevich was aware of his modest role in all this – his portfolio was a kind of last will and testament of the *kombedy* – is another matter.

79 El Lissitzky, "New Russian Art: a lecture," 1922 typescript, in Lissitzky-Küppers, *El Lissitzky*, 339.

80 Malevich reported in "Khudozhniki na dispute ob AKhRR," *Zhizn' iskusstva*, no. 6, 1924, quoted in Vasilii Rakitin, "The Artisan and the Prophet: Marginal Notes on Two Artistic Careers," *The Great Utopia*, 27.

81 El Lissitzky, "PROUN," 1920–1921 text, in *El Lissitzky* (Cologne, 1976), 65. Compare the treatment of the same issues in his 1922 "New Russian Art," in Lissitzky-Küppers, *El Lissitzky*, 338–39. No one as far as I know has come up with a convincing suggestion about the sources of El Lissitzky's (fairly chaotic) reflections on signing and naming at this point. The obvious suspects –

Saussure, Roman Jakobson, the Formalists, and so on – were just making their presence felt in intellectual circles in Russia at this moment, though the actual content of El Lissitzky's thought seems to have little or nothing to do with them. But *someone*'s semantics are being drawn on, or coquetted with.

82 Malevich, "I/42 Non-Objectivity," in Andersen, 3: 145.

83 Kasimir Malevich, "Declaration," 15 June 1918, published in UNOVIS *Almanac 1*, translated in Zhadova, *Malevich*, 304. But compare Nakov, 217, and his general remarks on translation of this text. The transrational manifesto is already passionately on the Bolsheviks' side: "here socialism has given the world its freedom art has fallen down before the face of creation." See Nakov, 219.

84 Malevich's title for a group of five of his paintings in the "Tramway 5" exhibition in Petrograd.

85 My guess is that to call Malevich a nihilist will be taken by many enthusiasts to be a way of belittling him – maybe because they do not share my opinion of the tradition of Russian nihilism from which, I think, Malevich came. To call him a nihilist is, of course, not to adjudicate on his view of the godhead and man's acquaintance with Him. I am quite happy with the picture of Malevich as a mystic of the kind Gershom Scholem reports as saying: "There are those who serve God with their human intellect, and others whose gaze is fixed on Nothing . . . He who is granted this supreme experience loses the reality of his intellect, but when he returns from such contemplation to the intellect, he finds it full of divine and inflowing splendor": see Gershom Scholem, *Major Trends in Jewish Mysticism* (New York, 1954), 5. These questions are anyway too difficult for art historians. We could do with a moratorium on studies of Malevich's "philosophy." I just think that part of his power, as master and practitioner, was that he believed he had been granted the supreme experience of Nothing, and was good at convincing others that he had.

86 One of the main UNOVIS slogans. See, for example, UNOVIS leaflet 1, quoted in Zhadova, *Malevich*, 299.

87 Malevich, *God Is Not Cast Down*, thesis 1, in Andersen, 1: 188.

88 Ibid., thesis 3, in Andersen, 1: 189–90 ("condition" for "convention" is typically off track).

89 Ibid., thesis 5, in Andersen, 1: 192 (Andersen has "porosity" for the

key word here, Nakov and Marcadé prefer "trou.")

90 Ibid., thesis 13, in Andersen, 1: 197–98.

91 See Chamberlin, *Russian Revolution*, 2: 235.

92 Carr, *Bolshevik Revolution*, 2: 258–59.

93 See *Finansovaia politika Sovetskoi Vlasti na 10 let. Sbornik statei* (Moscow and Leningrad, 1928), 4, quoted in Malle, *Economic Organization*, 172.

94 *Dva Goda Diktatury Proletariata, 1917–1919* (Moscow, n. d.), quoted in Carr, *Bolshevik Revolution*, 2: 259.

95 See ibid., 260, and Chamberlin, *Russian Revolution*, 2: 104–5, for the measures of 1920 and 1921.

96 Carr, *Bolshevik Revolution*, 2: 240.

97 Quoted in Chamberlin, *Russian Revolution*, 2: 103.

98 Quoted in ibid., also 2: 103.

99 Quoted in Carr, *Bolshevik Revolution*, 2: 261, n. 1. It looks as if Preobrazhensky's figures on the *assignat* were too gloomy.

100 See Malle, *Economic Organization*, 190–92, and Carr, *Bolshevik Revolution*, 2: 266–67, on these various proposals.

101 El Lissitzky, "New Russian Art," in Lissitzky-Küppers, *El Lissitzky*, 339. Variations on the formula occur repeatedly in Lissitzky's UNOVIS writings.

102 See Yve-Alain Bois, "Malévitch, le carré, le degré zéro," *Macula*, no. 1 (1978): 28–49 on this moment in Malevich's career.

103 Both quotes from El Lissitzky, "PROUN," 1920–21 text, in *El Lissitzky* (Cologne, 1976), 70–71.

104 Karl Mannheim, "Digression on Art History," in *Essays on the Sociology of Culture* (London, 1962), 33. The text seems to have been written in the 1940s.

105 Lev Trotsky, *Khozaestvennoe Stroitelstvo Sovetskoi Respubliki* (Moscow, 1927), 374–76. See the discussion of the speech in Chamberlin, *Russian Revolution*, 2: 294. My thanks to Melissa Frazier for translating this text for me.

106 Facts from Katerina Clark and Michael Holquist, *Mikhail Bakhtin* (Cambridge, Mass., 1984), 45–51.

107 Mikhail Bakhtin, "Art and Answerability," *Den' iskusstva* (13 September 1919), translated in Mikhail Bakhtin, *Art and Answerability, Early Philosophical Essays* (Austin, 1990), 1–2.

108 Malevich, *On New Systems in Art*, in Andersen, 1: 95.

109 See Sheila Fitzpatrick, *The Commissariat of Enlightenment* (Cambridge, 1970), 141.

110 Anatoly Lunacharsky in *Vestnik teatra*, no. 75 (30 November 1920), quoted in ibid., 155.

111 Quoted in Fülöp-Muller, *Mind and Face of Bolshevism*, 111, no source given.

112 See Leonard Hutton Galleries catalogue, *Ilya Grigorevich Chashnik* (New York, 1979–80), 10.

113 El Lissitzky to Sophie Küppers, 23 February 1924, about his progress with a projected book of Malevich translations, in Lissitzky-Küppers, *El Lissitzky*, 39. Compare a letter of 23 March, also to Sophie: "This Malevich thing is complicated – his Russian is not all it might be, the grammar is all the wrong way round, impossible word-formations, especially in the manuscripts . . ." See ibid., 47.

114 Clark and Holquist, *Mikhail Bakhtin*, 51.

115 See the design reproduced in Zhadova, *Malevich*, plate 155. A Malevich-type aerolith is offset by the words "Religion is the opium of the people." Zhadova does not make it clear whether the project ever went beyond the drawing-board stage. I have my doubts.

116 See Shatskikh, "Unovis," 56. *Victory over the Sun* was performed on 6 February 1920. Costumes and set were by Vera Ermolaeva. A Suprematist ballet by Nina Kogan was also part of the program. See *The Great Utopia*, pl. 151.

117 "For the Program," UNOVIS *Almanac 1*, in Zhadova, *Malevich*, 311.

118 El Lissitzky, "suprematism in world reconstruction," typescript of 1920, in Lissitzky-Küppers, *El Lissitzky*, 333. Disgust with the fact that "at present, we are scattered in college workshops which are divided and fenced off. We are split up into cells and work at art independently" ("We Want," UNOVIS leaflet, 1920, in Zhadova, *Malevich*, 298) is a constant theme of UNOVIS pronouncements.

119 See Nakov, 412–13, for evidence on the book's status within the group. Christina Kiaer kindly pointed out and translated for me a review of the book by the Marxist critic Boris Arvatov: see Boris Arvatov, "K. Malevich. Bog Ne Skinut (Iskusstvo. Tserkov'. Fabrika)," *Pechat' i Revoliutsiia*, no. 7 (1922): 343–44. The review is relentlessly hostile, entirely justified in its impatience with Malevich's obscurity, but in my view largely mistaken in its interpretation of the text's main arguments. At least it tries. Arvatov seems to have been particularly incensed by a remark Malevich made to him in person, that "Marxism is a 'guzzling' philosophy" (344).

120 See Yve-Alain Bois, "Lissitzky, censeur de Malévitch?" *Macula*, nos. 3–4 (1978): 196, n. 16, for discussion of the shifting of speaker-positions in the pamphlet: "La volute énonciative de Malévitch, dans l'ensemble de ce texte où le «je» change sans cesse de position, et défend tantôt les positions de «l'Art», tantôt celles de «l'Église», tantôt celles de «la Fabrique», n'est pas faite pour simplifier l'interprétation." Agreed – though I still think it might be possible to make sense of the text's overall drift, which up to now no commentator has really tried to do (one can see why).

121 See Malevich, *God Is Not Cast Down*, esp. theses 5, 6, 10 (for "sum" here read "totality"), and 23. But the polemic against totalization is pervasive. Compare n. 142 below. Here might be the beginning of serious textual debate with such as Boris Groys, *The Total Art of Stalinism: Avant-Garde, Dictatorship, and Beyond*, trans. Charles Rougle (Princeton, 1992), esp. 15–19, for whom the totalitarian future is written into the Russian avant-garde project, and into Malevich's theories in particular. At the level of generality on which Groys operates, the thesis is irrefutable (and uninteresting).

122 Ibid., thesis 6, in Andersen, 1: 192.

123 Ibid., thesis 5, in Andersen, 1: 191.

124 Ibid., thesis 2, in Andersen, 1: 188. (Andersen has "stimulus," Marcadé and Nakov prefer "excitation.")

125 Malevich, "Non-Objective Art and Suprematism," in Andersen, 1: 121.

126 Ibid., in Andersen, 1: 120.

127 See Troels Andersen, Stedelijk Museum catalogue, *Malevich* (Amsterdam, 1970), 98, cat. entry 65.

128 Kasimir Malevich, *The Non-Objective World*, rev. ed., trans. Howard Dearstyne (Chicago, 1959). I have preferred the translation given by Charlotte Douglas, "Beyond Reason: Malevich, Matiushin, and Their Circles," in *The Spiritual in Art: Abstract Painting 1890–1985* (New York, 1986), 190, but in my next paragraph I give Dearstyne's version of connected phrases from the same book, so as not to conceal the problems of translation involved here.

129 See Kasimir Malevich, "Monuments Not Made by Human Hands," *Isskustvo Kommuny*, no. 10 (9 February 1919), in Andersen, 1: 66.

130 Malevich, "Non-Objective Art and Suprematism," in Andersen, 1: 122.

131 "Address of 1000 young students who signed an appeal to the West," UNOVIS document (Spring 1921), quoted in Zhadova, *Malevich*, 8. Obviously there was dispute within UNOVIS about how literally to take the "end of painting / beginning of architecture" war cry. Chashnik talks of the architectural and technical workshop as "the crucible of all the other faculties of the UNOVIS school, to which every kind of creative personality must strive in a unified collective of builders of the new forms of the world." See I. Chashnik, "The Architectural and Technical Faculty," UNOVIS *Almanac 2*, quoted in *Art and Design Profile*, 30. Khidekel in a 1920 propaganda leaflet talks tough, but carefully allows space for painting to continue: "If comrades say they do not wish to be architects, but say that they do not thereby run counter to Cubism, Futurism and Suprematism, they deny their own essence. Because producing a canvas is now a spent task: we undertake it solely to develop on it a construction of the element – the sign – required to perfect the creative work of construction and invention which will be the actual basis of our culture." See L. Khidekel, "The New Realism. Our Modern Times," in Zhadova, *Malevich*, 301. Again the word "sign" crops up.

132 El Lissitzky, "PROUN," De Stijl text, in Lissitzky-Küppers, *El Lissitzky*, 348.

133 El Lissitzky, "PROUN," 1920–21 text, in *El Lissitzky* (Cologne, 1976), 60.

134 El Lissitzky, "suprematism in world reconstruction," in Lissitzky-Küppers, *El Lissitzky*, 334. Donald Nicholson-Smith pointed out to me that the last few lines seem a paraphrase of Malevich's argument in another text from this time, "Idleness as the Effective Truth of Man." See Kazimir Malevich, *La Paresse comme vérité effective de l'homme*, trans. Régis Gayraud (Paris, 1995). A passage on p. 27 is useful supplement to *God Is Not Cast Down*: "Having attained such perfection, we shall attain God, which is to say that image which humanity has predetermined in representation, in legends or in reality. Then a new inactivity will dawn, this time divine, a non-state in which

man will disappear, for he will enter into the supreme image of his own perfect predetermination." It will take several thousands or millions of years, says Malevich – all that is needed is for man to be all-knowing and omnipresent.

135 See, for example, the articles by Yve-Alain Bois already cited; Alan Birnholz, "'For the New Art': El Lissitzky's Prouns," *Artforum*, 8, nos. 2 and 3 (1969): 65–70 and 68–73; Donald Karshan, "Lissitzky: the original Lithographs. An Introduction," in *El Lissitzky* (Cologne, 1976), 25–33; Selim Chan-Magomedov, "A new style. Three dimensional Suprematism and Prounen," in *El Lissitzky architect painter photographer typographer*, 35–45.

136 Malevich, "Futurism-Suprematism", in *Kasimir Malevich 1878–1935* (Los Angeles, 1990), 177. This whole text is full of phoney atomic physics: "In Suprematism the mass of energy breaks down into individual color constructs on the two-dimensional plane – with the result that each plane or volume becomes an independent unit powered by its own motion," and so on.

137 Ilya Chashnik, "The Suprematist Method," in Hutton Galleries, *Ilya Grigorevich Chashnik*, 21.

138 Malevich, *The Non-Objective World*, quoted in Lissitzky-Küppers, *El Lissitzky*, 20.

139 Both quotes from El Lissitzky, "PROUN," De Stijl text, in ibid., 347, 348.

140 Kasimir Malevich to Mikhail Matyushin, n.d. (June 1916), cited in Zhadova, *Malevich*, 124, n. 39.

141 Malevich, *God Is Not Cast Down*, thesis 24, in Andersen, 1: 213 (another impenetrable translation, which Nakov and Marcadé help to unravel).

142 Ibid., thesis 24. Again, the polemic against Marxist materialism is central to this section of the book. See theses 22, 23, and 31. At the same time, what most of us mean by religion gets equally hard knocks. God is not cast down, but by "God" Malevich understands Nothing, non-objectivity. God is something man created, "as an object of representation," just as man made the world itself "from the nothingness of his own representation." See thesis 33. But that does not mean, in Malevich's view, that the representations "world" and "God" can ever be dispensed with – or not in any foreseeable future. Compare n. 134, above.

143 To say that because much of the best of El Lissitzky's work was done abroad in the 1920s, and designed to appeal to Western audiences, the epithet "Bolshevik" does not apply, seems to me to mistake what the Bolshevik propaganda system *was* in the interwar years. El Lissitzky's work was an arm of the Comintern. He knew that full well: he knew he had to strike a precise balance between modernist language and Leninist or Stalinist message. It is not a job many artists would have cared to take on. But for him, I believe, the constraints were productive. For these reasons, the criticism launched by Peter Nisbet, "Lissitzky and photography," in *El Lissitzky architect painter photographer typographer*, 68, of the article by Benjamin Buchloh on El Lissitzky's later work, "From Faktura to Factography," *October*, 30 (Fall 1984): 82–119, strikes me as wide of the mark.

144 El Lissitzky, "PROUN," 1920–21 text, in *El Lissitzky* (Cologne, 1976), 65.

145 See, for example, Nakov, 138; *Kasimir Malevich 1878–1935* (Los Angeles, 1990), catalogue entries, 208–10; Andrei Nakov, *The Suprematist Straight Line*, Annely Juda Fine Art catalogue (London, 1977), 24; and the careful discussion of the Guggenheim Collection's *Untitled* (ca. 1916) in Angelica Rudenstine, *Peggy Guggenheim Collection, Venice* (New York, 1985), 476–80. The Los Angeles catalogue seems over-cautious to me, and I am with Rainer Crone and David Moos, *Kasimir Malevich: The Climax of Disclosure* (London, 1991), 156–60, in taking the changes of orientation seriously.

146 Malevich, *God Is Not Cast Down*, thesis 5, in Andersen, 1: 192.

147 It is not, in my view, that Malevich had any theoretical hostility to the "iconic" as such – say, on Formalist grounds. Rather, that he thought for most of his adult life that he did not have the means to make icons of the subject he cared about. When later in the 1920s he thought he had another subject – the peasantry, the proletariat, taking possession of the material world – he seems to have believed he also had the means to portray it. And he did so, to the scandal of modernist orthodoxy ever since.

148 Kasimir Malevich, "Appendix From the Book on Non-Objectivity," 1924, in Andersen, 3: 348.

149 The exceptions are Bois, "Lissitzky censeur de Malévitch," which contains by far the best discussion of Malevich's politics (at one particular moment) that we have; and Donald Karshan, "Behind the Square: Malevich and the Cube," *Kasimir Malevich* (Cologne, 1978). The Lenin text makes a discreet appearance in Andersen, 3: 315–58, as an appendix.

150 See Nakov, 137.

151 See Rakitin, "The Artisan and the Prophet," 36, n. 40.

152 See Andersen, 1: 244 for the opinion that the group producing *Anarkhiya*, one of many such in the capital at that moment, stood while it lasted for limited cooperation with the Bolsheviks. Malevich's seven contributions in late March and early April, translated in Andersen, 1: 49–64, strike me as being about as orthodoxly anarchist as you can get, though Andersen and others want to assure us that "for Malevich the interlude with *Anarkhiya* was not so much a political engagement as an attack upon the conservative forces in the artists' union." See ibid., 244. Compare the standard art-historical line on the "real" content of David's Jacobinism.

153 See, for example, "On the Party in Art," *Put UNOVISa*, no. 1 (January 1921), partially reproduced in Zhadova, *Malevich*, 310. (Could this also be by Kunin?) The article is rambling and unimpressive, but the main point of it seems to be to argue against those (unnamed) "Party people" who resist the idea of Party organization and Party consciousness in *art*, on the grounds that one Party – the political Party – is all that is necessary. On the contrary, "a forcing house of culture has got to be built, so that the force of consciousness which will grow out of it can become the model and paradigm of our new age. They will try to convince me that the creation of such a forcing house should not be a Party phenomenon." But the writer will not be moved. "If any kind of particular, non-Party truth gets established as part of life, then at that moment it becomes a Party phenomenon, a world-view, it strives toward realization of its truth and begins the work of world-building. Thus all new world-building is a Party matter, and all materials, all science, all knowledge can be the means of transposing such Party world-building into life." My thanks to Melissa Frazier for translating this text. I have worked hard, perhaps too hard, to put the best face on its obscurities.

154 See "The Growth of UNOVIS (A Chronicle)," propaganda leaflet, 20 November 1920, quoted in Hutton Galleries, *Ilya Grigorevich Chashnik*, 28–29: "Among the problems of the

conference was the essential position of art in Russian culture in accordance with the resolution of the congress of the PROLETKULT." Compare the garbled translation in Zhadova, *Malevich*, 302.

155 Kasimir Malevich to the President of *Glaviskusstvo*, August 1929, in Andersen, 4: 217. By this time Malevich was fighting for his life inside the State Institute for the History of Art, and before long fighting for his life *tout court*. In 1930 he, Ermolaeva and Suetin were expelled from the Institute, and from September to December he was imprisoned and interrogated "about the ideology of existing trends." See Andersen, 4: 245–46, and *Kasimir Malevich 1878–1935* (Los Angeles, 1990), 18–19.

156 The Peretz Society letter, quoted previously, seems to be reacting to Puni's regime. Puni replied to the criticisms in an article in *Vitebskii Listok* on 9 April 1919, insisting on the need for control over public decorations. See Meyer, *Marc Chagall*, 270. The risk-taking character of Chagall's hiring of Puni tends to get forgotten in the light of his later troubles with Malevich – and also because of the enormity of Puni's retreat from his artistic positions in the years after 1919. What Chagall and others would have seen in spring 1919 was an astonishing previous three years of artistic work on Puni's part: in particular the paintings and reliefs done for "Tramway 5" and "o,10," the brilliant *Letters* and *Flight of Forms* paintings then under way, and some interesting contributions Puni had made to street decoration in Moscow. No one could have guessed he was effectively at the end of his productive career. Puni would have been thought of as Suprematism's second-in-command: almost as much of a powerhouse as Malevich, though lacking Malevich's doctrinaire streak. That Chagall and Puni borrowed from one another in Vitebsk – Puni in the whimsical townscape drawings and in some of the *Letters* series, Chagall in paintings like *Cubist Landscape* or *Profile at the Window* – has often been noted. And clearly this is what Chagall expected to happen when he brought in the ultra-Lefts: a bit of stylistic push and pull, some resisting and conceding, an aesthetic shot in the arm for all concerned. If only modernism worked that way.

157 Deutscher, *The Prophet Armed*, 504.

158 Lev Trotsky to Anatoly Lunacharsky, 14 April 1926, quoted in ibid., 504, n. 1.

159 See M. Gurewitsch, "Concerning the Situation in Russia and in the RSDWP," October 1918, quoted in Brovkin, *Dear Comrades*, 131.

160 See Raphael Abramovich to Pavel Axelrod, 30 May 1920, quoted in ibid., 194.

161 Menshevik Central Committee, "Persecution of Socialists in Russia in 1920," quoted in ibid., 221.

162 See Iulii Martov, "Krovavoe bezumie," *Volia Rossii* (29 December 1920), cited in Brovkin, *The Mensheviks after October*, 283.

163 Arpad Kadarkay, *Georg Lukács: Life, Thought, and Politics* (Cambridge, Mass., 1991), 215–16.

164 See Vasilii Rakitin, "El Lissitzky 1890–1941," in Oleg A. Shvidkovsky, *Building in the USSR 1917–1932* (New York and Washington, 1971), 41, n. 6, no source given. The Orenburg conference seems connected with a series of attempts in summer and fall 1920 to reorganize propaganda work as a whole, in particular to strike a balance between the Central Committee's Agitprop Section and Lunacharsky's new Glaspolitprosvet – and also the propaganda sections of the army and the Commissariat of Transport. See Peter Kenez, *The Birth of the Propaganda State: Soviet Methods of Mass Mobilization, 1917–1929* (Cambridge, 1985), 122–28. There was a UNOVIS group in Orenburg, headed by Ivan Kudriashev. El Lissitzky quotes from correspondence with "a railroad worker, A. Smirnov from Orenburg" in his "The Catastrophe of Architecture," *ISO*, no. 1 (March 1921), quoted in Lissitzky-Küppers, *El Lissitzky*, 371. Orenburg in summer 1920 was close to one of the key areas of peasant rebellion against the Bolsheviks (or close enough to be a staging post for the Bolsheviks' military action in reply). See Figes, *Peasant Russia, Civil War*, 340. El Lissitzky's *Stanki depo* propaganda board could, of course, be associated with his Orenburg visit as opposed to the moment earlier in 1920 that I favor. It might even be that the street corner in Lissitzky's photograph is not in Vitebsk at all, but Orenburg.

165 See Meyer, *Marc Chagall*, 268.

166 Kasimir Malevich, *Suprematism: 34 Drawings* (Vitebsk, 1920), in Andersen, 1: 124. For further "space satellite" posters by the Smolensk UNOVIS group, see Mikhail Guerman, *Art of the October Revolution* (New York, 1979), fig. 62 – the same image as the one I show, with a different slogan – and Angelica Rudenstine, ed., *Russian Avant-Garde Art: The George Costakis Collection* (New York, 1981), 430, fig. 973.

167 See especially Edward Herman and Noam Chomsky, *Manufacturing Consent: The Political Economy of the Mass Media* (New York, 1988) and Noam Chomsky, *Necessary Illusions: Thought Control in Democratic Societies* (Boston, 1989).

168 Malevich, *On New Systems in Art*, in Andersen, 1: 88.

169 Chamberlin, *Russian Revolution*, 2: 356. The interesting thing, in Chamberlin's case, is that knockabout anti-Sovietism of this kind (there is plenty more in the same vein) coexists with an extraordinary feeling for the historical texture of events. The same could even be said of the horrific Fülöp-Muller. But then, they were writing before the Cold War. For a recent assessment of Bolshevik propaganda's methods and effectiveness, see Kenez, *Birth of the Propaganda State*, 254: "Soviet propaganda [in the 1920s] may not have convinced the masses but it succeeded in reinforcing the commitment of the propagandists." Scholars tend to agree that the civil war was a special case. Orlando Figes counts "the tremendous effect of Bolshevik propaganda" as a real factor in the growth of the Red Army in 1919 and 1920. See Figes, "The Red Army and Mass Mobilization," 186. This echoes Kenez, at least in one of his moods: "The Bolsheviks won the Civil War because they proved themselves superior to their opponents in two crucial areas of struggle: organization and propaganda." See Peter Kenez, "Lenin and the Freedom of the Press," in Gleason, Kenez, and Stites, *Bolshevik Culture*, 131. All such verdicts are touch and go. Nobody much believes in the superiority of Bolshevik war organization any longer; and Bolsheviks at the time, speaking at the Tenth Party Congress in March 1921, were unanimous in thinking bourgeois propaganda more effective than their own – because less flagrant. See Kenez, *Birth of the Propaganda State*, 125–26.

170 Iain Boal et al., *All Quiet on the Eastern Front* (Berkeley, 1990), 5–6.

171 William Wordsworth, *The Prelude. A Parallel Text* (Harmondsworth, 1971), 424.

172 William Morris, "The Socialist Ideal," *New Review* (January 1891), quoted in Peter Stansky, *Redesigning the World. William Morris, the 1880s, and the Arts and Crafts* (Princeton, 1985), 68.

173 See Theodor Schieder, "The Problem of Revolution in the Nineteenth Century," in his *The State and Society in Our Times* (London, 1962), 1–38.

174 Michael Ventura, *Shadow Dancing in the U.S.A.* (Los Angeles, 1985), 80.

175 See Norbert Elias, *The History of Manners*, trans. Edmund Jephcott (New York, 1978), and his *Power and Civility*, trans. Edmund Jephcott (New York, 1982). These are volumes 1 and 2 of a book first published in German in 1939 as *Über den Prozess der Zivilisation*. In addition to the work of Foucault, compare Anthony Giddens, *The Consequences of Modernity* (Stanford, 1990), Anthony Giddens, *Modernity and Self-Identity: Self and Society in the Late Modern Age* (Stanford, 1991), and Anthony Giddens, *The Transformation of Intimacy: Sexuality, Love and Eroticism in Modern Societies* (Stanford, 1992), for reflections that connect with, and develop, some of Elias's ideas.

6 THE UNHAPPY CONSCIOUSNESS

1 Alfred Jeanroy, ed., *Les Chansons de Guillaume IX, duc d'Aquitaine 1071–1127* (Paris, 1927), 6. Translation in Paul Blackburn and George Economou, *Proensa: An Anthology of Troubadour Poetry* (Berkeley and Los Angeles, 1978), 7.

2 Clement Greenberg, "The Present Prospects of American Painting and Sculpture," in O'Brian, ed., *Clement Greenberg*, 2: 168. The article was first published in the English magazine *Horizon*, October 1947. Greenberg is paraphrasing Nietzsche on the qualities of Apollonian art, which in 1947 is still "the great and absent art of our age."

3 Gustave Flaubert to Louise Colet, 16 January 1852, *The Letters of Gustave Flaubert 1830–1857*, ed. Francis Steegmuller (Cambridge, Mass., 1979), 154.

4 On Ralph Manheim's (preponderant) role, see Ellen Landau, *Jackson Pollock* (New York, 1989), 169–77. For a slightly different account of Lee Krasner's recollection of the session, as one where "everyone [that is, Krasner, both Manheims, and Pollock himself] contributed, with Pollock vetoing or approving titles," see Judith Wolfe, "Jungian Aspects of Jackson Pollock's Imagery," *Artforum*, 11 (November 1972): 72. Ralph Manheim, a great translator (and later an exile from McCarthyism), was one of Pollock's most remarkable friends, and one of the few to refuse interviews.

5 See *Encyclopaedia Britannica*, 13th ed., *s.v.* "Alchemy."

6 Clement Greenberg, "Review of Exhibitions of Worden Day, Carl Holty, and Jackson Pollock," in O'Brian, ed., *Clement Greenberg*, 2: 202.

7 Various people have tried to dissuade me from my hostility to the *Vogue* photographs, warning me it will be read as Puritanical, misogynist, "high-versus-low," even homophobic. These smears come with the territory. I persist in thinking that high fashion's cocktail of artiness and classiness (unattainable elegance spiced with avant-garde risk) is deadly, and deeply woman-hating – at least, in its effects. It may well be that the tactical alliance of fashion and the avant garde in 1950 had more *style* than most moments before and after. I am not denying Beaton was accomplished, or that he got some things about Pollock right.

8 Mark Rothko to Annalee and Barnett Newman, 10 August 1946, in Barnett Newman papers, Archives of American Art. My thanks to Michael Leja for this reference, and for his generous help with the chapter as a whole.

9 Jackson Pollock to Alfonso Ossorio and Ted Dragon, late February 1951, in O'Connor and Thaw, eds., *Jackson Pollock A Catalogue Raisonné of Paintings, Drawings, and Other Works*, 4 vols. (New Haven and London, 1978), 4: 258.

10 Mikhail Bakhtin, "Discourse in the Novel," in his *The Dialogic Imagination*, trans. Caryl Emerson and Michael Holquist (Austin, 1981), 276.

11 Ibid., 331.

12 Ibid., 293.

13 V. N. Volosinov, *Marxism and the Philosophy of Language*, trans. Ladislav Matejka and I. R. Titunik, 2nd ed. (Cambridge, Mass., 1986), 86. The book, published in Leningrad in 1929, may have been written wholly or in part by Bakhtin, or by Volosinov under Bakhtin's influence.

14 Ibid., 93.

15 Bakhtin, *Dialogic Imagination*, 284.

16 Ibid., 282.

17 Jackson Pollock, application for Guggenheim Fellowship, 1947, in O'Connor and Thaw, *Pollock Catalogue*, 4: 238.

18 Both quotes from Jackson Pollock, interview with William Wright, 1950, in ibid., 251.

19 The views of the first are clearest in Manfredo Tafuri, *Architecture and Utopia, Design and Capitalist Development*, trans. Barbara Luigia La Penta (Cambridge, Mass., 1976) [the translation could do with revising], and his "U.S.S.R.-Berlin, 1922: From Populism to 'Constructivist International'," in Manfredo Tafuri, *The Sphere and the Labyrinth*, trans. Pellegrino d'Acierno and Robert Connolly (Cambridge, Mass., 1987). Foucault's argument, pervasive in his later work, is put most relentlessly in Michel Foucault, *The History of Sexuality. Volume 1: An Introduction*, trans. Robert Hurley (New York, 1978); which is not to say that Foucault ever decided on, or pressed home, the implications of what he was saying for *art*. From the remarks on Goya and Sade at the end of *Madness and Civilization*, to the page on "literature" in *The Order of Things*, to the intimations of art's place in constructing the new "economy of manifold pleasures" which haunt *The History of Sexuality*, is a tortuous, and deliberately two-way, path.

20 Greenberg, "Present Prospects," 166.

21 Clement Greenberg, "L'Art américain au XXe siècle," *Les Temps modernes*, 2, nos. 11–12 (August–September 1946): 350: "Cette oeuvre . . . fait penser à Poe et elle est remplie d'une sensibilité sadique et scatologique."

22 See, for example, Foucault, *History of Sexuality: Introduction*, 47: "Nineteenth-century 'bourgeois' society – and it is doubtless still with us – was a society of blatant and fragmented perversion." The equivocal scare-quotes here, followed immediately by an unequivocal parenthesis, are typical of Foucault's late tactics.

23 Ivan Karp, "In Memoriam: The Ecstasy and Tragedy of Jackson Pollock, Artist," *The Village Voice*, 26 September 1956, 8; Sam Hunter, "Among the New Shows," *The New York Times*, 30 January 1949, quoted in Francis V. O'Connor, *Jackson Pollock* (New York, 1967), 46.

24 J[ames] F[itzsimmons], "Jackson Pollock," *Art Digest* (15 November 1952), 17, quoted in O'Connor, *Jackson Pollock*, 66.

25 Frank O'Hara, *Jackson Pollock* (New York, 1959), 24. He is referring to *Number 1, 1948*.

26 R[obert] G[oodnough], "Rev-

iew," *Art News*, 49 (December 1950): 47. By the sound of it he is describing *Number 32, 1950*.

27 Robert Goodnough, typescript of article, "Pollock Paints a Picture," in Jackson Pollock papers, Archives of American Art, quoted in Michael Leja, *Reframing Abstract Expressionism: Subjectivity and Painting in the 1940s* (New Haven, 1993), 327.

28 Bernard H. Friedman, "Profile: Jackson Pollock," *Art in America*, 43 (December 1955): 49, quoted in O'Connor, *Jackson Pollock*, 73.

29 Tennessee Williams, *Memoirs* (Garden City, New York, 1975), 250, quoted in Landau, *Jackson Pollock*, 17.

30 Pollock, interview with Wright, in O'Connor and Thaw, *Pollock Catalogue*, 4: 248, 251.

31 Herman Melville, *Moby-Dick* (London, 1963), 272.

32 Stephen Greenblatt, "The Cultivation of Anxiety: King Lear and his Heirs," in Stephen Greenblatt, *Learning to Curse: Essays in Early Modern Culture* (New York and London, 1990), 89. Greenblatt also calls on Bakhtin here.

33 Georg W. F. Hegel, *Phenomenology of Spirit*, trans. Arnold Miller (Oxford, 1977), 455–56. Hegel is comparing the Unhappy Consciousness's anguished recognition of meaninglessness – "the statues are now only stones from which the living soul has flown" – with modern scholarship's complacent acceptance of exteriority to the objects it studies.

34 Greenblatt, "Cultivation of Anxiety," 89.

35 Greenberg's immediate reactions in 1949 go straight to the point: "It is as well contained in its canvas as anything by a Quattrocento master . . . [it] avoids any connotation of a frieze or hanging scroll and presents an almost square surface that belongs very much to easel painting." See Clement Greenberg, "Review of Exhibitions of Adolph Gottlieb, Jackson Pollock, and Joseph Albers," in O'Brian, ed., *Clement Greenberg*, 2: 285. The review first appeared in February 1949.

36 Ibid.

37 Longinus, *On Great Writing (On the Sublime)*, trans. George M. A. Grube (Indianapolis, 1991), 19.

38 Bakhtin, *Dialogic Imagination*, 294.

39 Ibid., 292.

40 Ibid., 282. This passage is singled out for criticism by Paul de Man in "Dialogue and Dialogism," in *The Resistance to Theory* (Minneapolis,

1986), 112. It is typical, he thinks, of Bakhtin's falling back at key moments into "a precritical phenomenalism in which there is no room for exotopy, for otherness, in any shape or degree," "a gesture of dialectical imperialism." The implied argument seems to be that Bakhtin (and any account of self and language) faces an all-or-nothing choice, between recognizing absolute exotopy, or having no room at all for otherness "in any shape or degree." This argument depends in turn, as I understand it, on a set of metaphysical commitments on de Man's part, which we might sum up by saying that for him the Unhappy Consciousness is entirely correct in its view of mind and its objects, and that any attempt to think the question of otherness and utterance further – further than its antinomies – is no more than dialectical sleight of hand. None of this, by the way, is meant to suggest that de Man's criticism is at all Duchampian or William-of-Aquitaine-ish. On the contrary, de Man's strength as a critic has to do with his ability to inhabit the Unhappy Consciousness, above all at its most inconsolable. He is as unaristocratic a writer on literature as you can get.

41 Bakhtin, *Dialogic Imagination*, 277.

42 William Baziotes to Christos Baziotes, 10 March 1947, in Christos Baziotes papers, Archives of American Art. I owe this and the next two references to Michael Leja.

43 Peggy Guggenheim to Clement Greenberg, 2 December 1947, Clement Greenberg papers, Archives of American Art.

44 Douglas MacAgy, in "A Symposium: The State of American Art," *Magazine of Art* (March 1949): 95. Greenberg also took part.

45 Phrases from Greenberg, "Present Prospects," 166; Clement Greenberg, "Review of Exhibitions of the American Abstract Artists, Jacques Lipchitz, and Jackson Pollock," in O'Brian, ed., *Clement Greenberg*, 2: 75; Clement Greenberg, "Review of Exhibitions of Marc Chagall, Lyonel Feininger, and Jackson Pollock," in ibid., 1: 165; Greenberg, "L'Art américain," 350.

46 Greenberg, "Present Prospects," 167.

47 Clement Greenberg, "Surrealist Painting," in O'Brian, ed., *Clement Greenberg*, 1: 226.

48 *Galaxy* is painted over the 1946 picture, *The Little King*. See Francis O'Connor, ed., *Jackson Pollock: A Catalogue Raisonné of Paintings, Drawings,*

and Other Works. Supplement Number One (New York, 1995), 78.

49 Clement Greenberg, "Review of the Whitney Annual," in O'Brian, ed., *Clement Greenberg*, 2: 118.

50 Clement Greenberg, "Review of Exhibitions of Jean Dubuffet and Jackson Pollock," ibid., 124.

51 Greenberg, "L'Art américain," 352: "À moins que l'art américain ne se réconcilie avec ce minimum de positivisme sur lequel repose, à mon avis, la continuité et la force de l'art moderne en France, à moins que nous n'intégrions notre poésie dans les dimensions physiques immédiates de l'art . . . nous demeurerons incapables d'établir dans notre art une continuité qui nous permette de satisfaire nos ambitions actuelles. Nous ne devrions pas nous laisser abuser par le fait que le sentiment gothique a été dans le passé au principe de la plupart des meilleures oeuvres de la littérature et de la peinture américaines et qu'il anime encore nos talents les plus vigoureux." Having made the admission, he goes on: "Le positivisme nous a donné les peintres Homer et Eakins et le romancier Henry James. À l'heure actuelle seule une attitude positive, abandonnant les interprétations freudiennes aussi bien que la religion et le mysticisme, peut faire entrer la vie dans l'art sans trahir l'un ou l'autre." This is the ultimate ground of Greenberg's hostility to Surrealism, stated in terms which his French readers could hardly have misunderstood.

52 Clement Greenberg, "Review of an Exhibition of Karl Knaths and of the Whitney Annual," in O'Brian, ed., *Clement Greenberg*, 2: 198.

53 Clement Greenberg, "Reviews of Exhibitions of Worden Day, Carl Holty, and Jackson Pollock," in ibid., 202.

54 Greenberg, "Present Prospects," 166.

55 Clement Greenberg, "Review of the Exhibition *A Problem for Critics*," in ibid., 30.

56 A qualification here. In one interview, Lee Krasner specifically contradicts the idea of there being a very high proportion of paintings discarded, saying that Pollock by and large worked on a painting until it satisfied him. Likewise (again in very general terms), she answers that the time spent on a painting varied greatly. See Barbara Rose, "Jackson Pollock at Work: An Interview with Lee Krasner," *Partisan Review*, 47, no. 1 (1980): 90.

57 Clement Greenberg, "The Jackson Pollock Market Soars," in

O'Brian, ed., *Clement Greenberg*, 4: 112.

58 Herbert Matter, interview, in Steven Naifeh and Gregory White Smith, *Jackson Pollock: An American Saga* (New York, 1989), 885. Naifeh and Smith's way with interview material has been rightly criticized. See, for example, the discussion of their treatment of the Krasner-Pollock relationship in Anne Wagner, *Three Artists (Three Women): Modernism and the Art of Hesse, Krasner, and O'Keeffe* (Berkeley and Los Angeles, 1996), 133–36. I have used their interviews only where what is being said can be backed up by other sources, and where the malice or self-promotion of the interviewee is not flagrant. (This rules out a lot of the book.)

59 Clement Greenberg, interview for *Life* magazine, Time/Life Archives, 9 November 1959, in Naifeh and Smith, *Jackson Pollock*, 535.

60 Jackson Pollock, soundtrack for Hans Namuth film, 1951, in O'Connor and Thaw, *Pollock Catalogue*, 4: 262.

61 Ben Wolf, "By the Shores of Virtuosity," *Art Digest* (15 April 1946): 16.

62 Clement Greenberg, "Review of an Exhibition of Willem de Kooning," in O'Brian, ed., *Clement Greenberg*, 2: 229. The following quote is from the same review, ibid., 230.

63 Greenberg, "Present Prospects," 166.

64 Jackson Pollock, manuscript in Pollock archive, reproduced in O'Connor and Thaw, *Pollock Catalogue*, 4: 253.

65 Pollock, interview with Wright, in ibid., 250.

66 Jackson Pollock, interview for *Life* magazine, Time/Life Archives, 18 July 1949, in Naifeh and Smith, *Jackson Pollock*, 591.

67 See Lee Krasner, conversation with Edward A. Carmean, quoted in Edward A. Carmean, Jr., "Jackson Pollock: Classic Paintings of 1950," in Edward A. Carmean, Jr., Elizabeth Rathbone, and Thomas Hess, *American Art at Mid-Century: The Subjects of the Artist* (Washington, D.C., 1978), 133–35. Compare Robert Goodnough, "Pollock Paints a Picture," *Art News*, 50, no. 3 (May 1951): 39–40, on Pollock's "deep contemplation of work in progress," "weeks, often months of work and thought."

68 Pollock, *Life* interview, in Naifeh and Smith, *Jackson Pollock*, 591.

69 Jackson Pollock, draft of statement for *Possibilities* magazine, 1947, in O'Connor and Thaw, *Pollock Cata-logue*, 4: 241. The published statement uses the "get acquainted" form of words that crops up again in the interview two years later.

70 Rosalind Krauss, "Reading Photographs as Text," in Hans Namuth and Barbara Rose, *Pollock Painting* (New York, 1980), n. p. Compare the expansion of this argument in Rosalind Krauss, *The Optical Unconscious* (Cambridge, Mass., 1993), 243–308, especially the interpretation of mark, horizontality, and *bassesse* in Pollock, to which I respond in the following pages.

71 Jackson Pollock, narration on soundtrack of Namuth movie, in O'Connor and Thaw, *Pollock Cata-logue*, 4: 262.

72 The *White Cockatoo* hanging is obviously an extreme episode, if not a stunt, and in conversation with me Rosalind Krauss recalled Lee Krasner blaming the gallery for it. I could not find evidence about this. But the new title, which Pollock obviously did approve, rather argues for Pollock's participation.

73 Jackson Pollock, notebook, ca. 1955, quoted in Bernard H. Friedman, *Jackson Pollock: Energy Made Visible* (New York, 1972), 229.

74 Krauss, "Reading Photographs," n. p.

75 The dimensions are right, and some of the marks round the edge of the picture in the photograph are still visible in *Phosphorescence*, especially at top right.

76 O'Connor suggests *Sea Change* as the new state of the painting in the *Alchemy* photo, though the evidence is not conclusive. See O'Connor, *Pollock Catalogue Supplement*, 78. Various other pictures have roughly the right dimensions, but none of them to my eye contains unequivocal traces of the earlier layer as it appears in the photo. *Number 5, 1950*, in the Cleveland Museum of Art, is almost certainly poured on top of a previous brushed painting (see Landau, *Jackson Pollock*, 260, n. 18), and its dimensions roughly correspond to those calculated by O'Connor for the lost work (see O'Connor and Thaw, *Pollock Catalogue*, 1: 132).

77 The out-takes, which contain material of great beauty and interest (much of it superior, I think, to the footage Namuth chose to use), are in the collection of the Pollock-Krasner House and Study Center, East Hampton, N.Y. My thanks to Helen A. Harrison for showing me them, and for helpful discussion.

78 Hegel, *Phenomenology*, 137.

79 Ibid., 127.

80 Jackson Pollock, poem-manifesto, in O'Connor and Thaw, *Pollock Catalogue*, 4: 253.

81 Michael Fried, *Three American Painters* (Cambridge, Mass., 1965), 14.

82 Hegel, *Phenomenology*, 131.

83 See Jonathan Weinberg, "Pollock and Picasso: the Rivalry and the 'Escape,'" *Arts Magazine* (June 1987): 47. Weinberg counts three *Ones*. I think he should include *Lavender Mist*, for reasons stated later.

84 Pollock, interview with Wright, in O'Connor and Thaw, *Pollock Catalogue*, 4: 250.

85 Pollock, poem-manifesto, in ibid., 253.

86 See Jackson Pollock, résumé for Guggenheim application, in ibid., 238, 240.

87 Jackson Pollock to James Johnson Sweeney, 3 November 1943, in ibid., 230.

88 Phrases from: Pollock, draft for *Possibilities*, in ibid., 241; Jackson Pollock, statement on *The She-Wolf*, 1944, in ibid., 234; Peter Busa, interview, in Naifeh and Smith, *Jackson Pollock*, 865. (Busa is one of Naifeh and Smith's favorite informers, but it is hard to share their trust. I think the general point he makes here, minus the "always," is plausible, given other evidence, but the actual phrases are obviously made up – and Busa, to be fair, hardly pretends otherwise. Pollock would probably have been less amateurish. Naifeh and Smith transcribe "censor" on their audiotape as "sensor," which gives a clue to their familiarity with psychoanalysis.)

89 See Leja, *Reframing Abstract Expressionism*, 176–91 and 141–42. The drawing is reproduced in O'Connor and Thaw, *Pollock Catalogue*, 3: 384.

90 Leja, *Reframing Abstract Expressionism*, 184.

91 Phrases from: Jackson Pollock, interview, in Selden Rodman, *Conversations with Artists* (New York, 1957), 82; Pollock, interview with Wright, in O'Connor and Thaw, *Pollock Catalogue*, 4: 249; Jackson Pollock, as reported by his homeopath, Elizabeth Hubbard, in O'Connor and Thaw, *Pollock Catalogue*, 4: 275; Pollock, interview, in Rodman, *Conversations*, 82; Jackson Pollock, reported by Lee Krasner, in Bernard Friedman, "Interview with Lee Krasner Pollock," *Jackson Pollock: Black and White* (New York, 1969), 9.

92 Lee Krasner, quoted in Francine

du Plessix and Cleve Gray, "Who was Jackson Pollock?," *Art in America*, 55 (May–June 1967): 51.

93 See O'Connor and Thaw, *Pollock Catalogue*, 1: 172 and 176, and ibid., 4: 242, and compare fig. 226, ch. 7 below.

94 Parker Tyler, "Jackson Pollock: The Infinite Labyrinth," *Magazine of Art* (March 1950): 93. See the discussion of the Tyler text and Pollock's reaction to it in Leja, *Reframing Abstract Expressionism*, 313–36. Tyler wrote to Goldwater on 11 May 1950: "As to Mr. Pollock's reaction, he writes me he is 'delighted' and adds that he usually 'points' rather than explains in words." A copy of the letter is in the Pollock papers, Archives of American Art.

95 Jackson Pollock, notebook, ca. 1955, quoted in Friedman, *Jackson Pollock*, 228.

96 Tyler, "Infinite Labyrinth," 93.

97 Jackson Pollock, interview, in [Berton Roueché], "Unframed Space," *New Yorker* (5 August 1950): 16.

98 Fried, *Three American Painters*, 13.

99 There are two sides to the question here. First, some of the finest drip paintings – *Number 34, 1949* and *Number 15, 1949*, for example – have an overall configuration and expressive aspect which in my view do not fit the terms Fried proposed out of his reading of *Number 1, 1948*. *Number 1, 1948* is Pollock at the height of his powers, for sure, but it shows us only one way in which the dripped field could effectively be made a unity. Second, there is the issue of appropriate viewing distance(s). Fried would now agree, I think, that too much of what he said about the materiality of pigment being "rendered sheerly visual" depended on a fiction of ideal viewing distance at which the tactile surface volatilizes. As a way of championing what Fried saw at the time as the most fertile reading of Pollock's treatment of surface – the reading implicit in the work of Jules Olitski, for example – this had its point, and still does. And it rightly resisted a notion of Pollock's surfaces as all dramaturgy or "process." But the balance between materiality and "opticality" in Pollock's work now seems odder and more precarious even than Fried thought it, and in need of new description. See "Jackson Pollock: A Conversation between T. J. Clark and Michael Fried" (Open University, England, 1994), television program.

100 Theodor W. Adorno, *Aesthetic Theory*, trans. C. Lenhardt (London and Boston, 1984), 21. (I have modified the translations, especially the longer passage, in the light of the recent retranslation, Theodor W. Adorno, *Aesthetic Theory*, trans. Robert Hullot-Kentnor [Minneapolis, 1997]. Clearly the new version is more faithful, but I found it impossible to let go of Lenhardt's sharper form of words.)

101 Ibid., 161.

102 Ibid., but compare Hullot-Kentnor's translation, 110.

103 Donald Judd, "Jackson Pollock," *Arts Magazine* (April 1967): 35.

104 See the useful discussion of sequencing and technique in Carmean, "Classic Paintings," esp. 129–42. The sequence of major paintings Carmean suggests is *Lavender Mist*, *Number 32, 1950*, *One*, and then *Autumn Rhythm*. This seems right, though I disagree with some of the conclusions Carmean draws from his findings.

105 See O'Connor and Thaw, *Pollock Catalogue*, 2: 86.

106 See Hans Namuth, "Jackson Pollock," *American Society of Magazine Photographers' Picture Annual* (New York, 1957), quoted and discussed in Carmean, "Classic Paintings," 133.

107 See the announcement folder for the Bennington show, in O'Connor and Thaw, *Pollock Catalogue*, 4: 269.

108 Compare above, n. 17. This side of the Guggenheim statement is sometimes dismissed as something foisted on Pollock – perhaps written for him – by Greenberg. The same ideas do figure in Greenberg's writing around the same time. It is possible that Greenberg lent Pollock a hand with his (unsuccessful) grant application. But the further "foisting" hypothesis is just one more variant on the usual slur about both parties and their relationship. The wall-painting-and-architecture interest is alive and well, for instance, in the Pollock interview with Wright three years later.

109 The model was shown in Pollock's 1949 show at Betty Parsons, and presented in an article by Arthur Drexler, "Unframed Space: A Museum for Jackson Pollock's Paintings," *Interiors*, 109 (January 1950): 90–91. A plan to collaborate with Tony Smith on the design for a Catholic church is referred to in passing by Pollock in a letter to Ossorio from January 1951, as if Ossorio already knew all about it: see O'Connor and Thaw, *Pollock Catalogue*, 4: 257. The project never got off the ground.

110 The relation to Picasso has been treated at length, for instance in Weinberg, "Pollock and Picasso," and Krauss, *Optical Unconscious*, 281–84, 301–3. Pollock's relations to the other three, and the way these complicated his dialogue with Picasso, have still to be treated seriously.

111 Clement Greenberg, "Feeling is All," in O'Brian, ed., *Clement Greenberg*, 3: 105.

112 Greenberg, "Review of Dubuffet and Pollock," 125.

113 Greenberg, "Review of Gottlieb, Pollock, and Albers," 286. Compare my description with that in Leja, *Reframing Abstract Expressionism*, 302–3.

114 See the tremendous account of the picture in Fried, *Three American Painters*, 17–18, on which mine is a kind of gloss.

115 See Serge Guilbaut, *How New York Stole the Idea of Modern Art: Abstract Expressionism, Freedom, and the Cold War* (Chicago, 1983), 184–85, and fig. 20.

116 See, for example, O'Connor and Thaw, *Pollock Catalogue*, 2: no. 201, *Number 22A, 1948*; no. 291, *Silver Square*; and no. 206, *Number 18, 1948: Black, Red, Yellow*.

117 Clement Greenberg, "Jackson Pollock's New Style," in O'Brian, ed., *Clement Greenberg*, 3: 106.

118 Clyfford Still to Jackson Pollock, 29 October 1953, in Naifeh and Smith, *Jackson Pollock*, 728. I have corrected the punctuation.

119 Clement Greenberg, "Avant-Garde and Kitsch," in O'Brian, ed., *Clement Greenberg*, 1: 19, n. 6.

120 Timothy J. Clark, "Clement Greenberg's Theory of Art," in William J. T. Mitchell, ed., *The Politics of Interpretation* (Chicago, 1983), 211.

121 Krasner's recollection, in Friedman, "Interview," 9.

122 Charmion Wiegand, "Mondrian: A Memoir of his New York Period," *Arts Yearbook*, 4 (1961): 59–60.

123 Colin Thubron, *Where the Nights are Longest: Travels by Car through Western Russia* (New York, 1984), 90.

124 Meyer Schapiro, "The Social Bases of Art," *Proceedings of the First Artists' Congress against War and Fascism* (New York, 1936), 36–37. What I go on to say does not mean that I find Schapiro's critique of modern art worthless. On the contrary, in many ways I prefer it to the oddly equivocal hedging

of bets that came a year later in his *Marxist Quarterly* essay, "The Nature of Abstract Art" (where a lot of the same rhetoric survives, but hemmed in now by historical sketches proving the artists had meant well). What is wrong with the Stalinist account of modernism – the same could be said of Lukács, largely – is not so much the nature of its hostile descriptions as the implied alternatives to what it dislikes, and above all the implied way forward to such alternatives. But of course the descriptions are bad, too. Any account that flattens and evacuates modernism as Schapiro does here, and refuses to see modernism's own struggle with the (social) conditions of its existence, is bound to end up bringing on the Party (or some other saving identity) to rescue the Unhappy Consciousness from itself.

7 IN DEFENSE OF ABSTRACT EXPRESSIONISM

1 Georg W. F. Hegel, *Aesthetics: Lectures on Fine Art*, 2 vols., trans. Malcolm Knox (Oxford, 1975), 1: 11.

2 Hubert Damisch, "L'éveil du regard," in *Fenêtre Jaune cadmium ou les dessous de la peinture* (Paris, 1984), 69. The subject is Mondrian, but much the same verdict and form of words are applied, by Damisch and others, to Pollock, Newman, Rothko, et al.

3 Alfred H. Barr, *Matisse: His Art and His Public* (New York, 1951), 214.

4 John Ruskin, *Modern Painters*, 5 vols. (1860; Boston and New York, n. d.), 5: 347–49.

5 Ibid., 344.

6 Parker Tyler, unedited typescript of "Jackson Pollock: The Infinite Labyrinth," in Archives of American Art, Pollock Papers 3048: 548–49. (The edited text was published in *Magazine of Art*, March 1950.) For full text and discussion, see Leja, *Reframing Abstract Expressionism*, 315–16, 368–69.

7 Clyfford Still to Sidney Janis, 4 April 1955, in Archives of American Art, Alfonso Ossorio papers, quoted in James Breslin, *Mark Rothko, A Biography* (Chicago and London, 1993), 344. Copies of the letter seem to have been circulated at the time, either by Still or Janis.

8 Theodor Adorno, *Introduction to the Sociology of Music*, trans. Edward Ashton (New York, 1976), 62, translation slightly modified. For a reply to an earlier version of this chapter, using Adorno's frame of reference, see Jay M. Bernstein, "The Death of Sensuous

Particulars: Adorno and Abstract Expressionism," *Radical Philosophy*, no. 45 (March–April 1996): 7–16.

9 Clement Greenberg, "Review of an Exhibition of Gustave Courbet," in O'Brian, ed., *Clement Greenberg*, 2: 275. A month later Greenberg reviewed Gottlieb and Pollock. "I feel that Gottlieb should make the fact of his power much more obvious," he wrote, though he welcomed the painter's *Totemic Fission* – my choice for the quintessential Abstract Expressionist title – *Ashes of Phoenix,* and *Hunter and Hunted* as pointing in the right direction. Greenberg's review of the Pollock show at Betty Parsons is the one in which he took *Number 1, 1948* – "this huge baroque scrawl in aluminum, black, white, madder and blue" – as final proof of Pollock's major status. The words "baroque scrawl" seem to me to be feeling for the qualities in Pollock's work that I am insisting on here. See Clement Greenberg, "Review of Exhibitions of Adolph Gottlieb, Jackson Pollock, and Joseph Albers," in ibid., 285–86.

10 Obviously there are difficulties to making, and sustaining, a distinction between "bourgeois" and "petty bourgeois" as terms of class analysis. But I believe the distinction is real, and I do not want my talk in the text of class "cultures" and "formations" to give the impression that I fail to see the distinction is ultimately one of economic power. A bourgeois, for me, is someone possessing the means to intervene in at least some of the important, large-scale economic decisions shaping his or her own life (and those of others). A bourgeois, for me, is someone expecting (reasonably) to pass on that power to the kids. A petty bourgeois is someone who has no such leverage or security, and certainly no such dynastic expectations, but who nonetheless identifies wholeheartedly with those who do. Of course this means that everything depends, from age to age and moment to moment, on the particular forms in which such identification can take place. The history of the petty bourgeoisie within capitalism is therefore a history of manners, symbols, subcultures, "lifestyles," necessarily fixated on the surface of social life. (Chs. 3 and 4 of Timothy J. Clark, *The Painting of Modern Life: Paris in the Art of Manet and his Followers* [New York, 1984] were intended to begin such a history for the late nineteenth century. The material on "Modern Man discourse" in Leja, *Reframing Abstract Expressionism*

strikes me as providing some of the elements for a parallel description of the 1940s and 1950s.)

No need to be oversubtle about these things. Sometimes symbols and lifestyles still have class inscribed on them in letters ten feet tall. What could be more disarmingly bourgeois, in the old sense, than the First Class section on an international airflight? And what more dismally petty bourgeois than Coach? (Those in Business Class – or what one sardonic airline calls Connoisseur – would take a bit more ad hoc class sorting, some going up, some going down. A lot depends in this case on particular styles of corporate reward to middle management, which vary from country to country and phase to phase of the business cycle.) Anyway, the rough balance of numbers on a 747 over the Atlantic seems to me instructive for the balance of numbers in the world at large.

11 You could apply the same rule of thumb to Jorn as Greenberg was fond of doing to abstract painting in general: most Jorn paintings from the 1950s and early 1960s are considerably worse than most from the same period by Gottlieb, Still, Hofmann, de Kooning, Kline, even Tomlin; but a very few Jorns are better than anything by any of the above – in my view, decisively better. (I leave Pollock out of it, mainly because he painted so little, and, by his standards, so badly, after 1951.) A short, though certainly not exhaustive, list of the Jorns I have in mind would include, besides the ones I illustrate: *La Grande Victoire: Kujafski, Lodz* (1956), *Shameful Project* (1957), *Alcools* (1957), *Le Canard Inquiétant* (1959), *The Abominable Snowman* (1959), *Dead Drunk Danes* (1960), *L'Homme Poussière* (1960), *Faustrold* (1962), *Les Pommes d'Adam* (1962), *Triplerie* (1962), *Deux Pingouins. Avant et d'après David* (1962), *The Living Souls* (1963), *Something Remains* (1963), probably several other *Modifications* and *Défigurations,* if I could get to see them, and one or two late works, like the great *Between Us* (1972). This list is skewed and limited by accidents of availability, but I have a feeling that even if my knowledge of Jorn was more comprehensive it would not swell enormously.

12 It would be too easy to catalogue the more flagrant phrases here ("His emotion starts out pictorially; it does not have to be castrated and translated in order to be put into a picture," and so on), and the result would

inevitably have the flavor of Freudian "now-it-can-be-told." Whereas the point is the obviousness of the verbal love-affair, and the fact that the obviousness (which is integral, I think, to Greenberg's insights and descriptions from 1943 to 1955) was only allowable, or manageable, when it went along with a no-holds-barred, take-it-or-leave-it tone about everything – the tone Greenberg perfected as a writer of fortnightly columns and occasional aphoristic surveys. In a book – even one as brief and essayistic as Greenberg's on Miró had been – there would have been too obvious a seam between the documentary mode (Greenberg, understandably, was more and more anxious to disinter Pollock from a mountain of biographical filth) and awe at Pollock's energy and maleness.

13 Clement Greenberg, "'American-Type' Painting," in O'Brian, ed., *Clement Greenberg*, 3: 230–31. For reasons not given, but not far to seek, Mrs. Clyfford Still refused me permission to reproduce any of her late husband's paintings. This strikes me as a happy arrangement. Still, I now realize, will do best as this chapter's invisible ghost, sulking and shrieking in characteristic fashion from beyond the grave.

14 See Clement Greenberg, *Art and Culture* (Boston, 1961), 223–24. Part of the reason for the changes was the vehemence of Still's and Newman's reaction to Greenberg's original form of words. See Greenberg's reply to a typical blast from Clyfford Still (dated 15 April 1955, which suggests that Still's original letter may have been sent off at much the same time as the one to Sidney Janis on Rothko), quoted in Clifford Ross, ed., *Abstract Expressionism: Creators and Critics* (New York, 1990), 251–53. The term "buckeye" was one of the main bones of contention. Still suspected that Greenberg borrowed not only the term from Barnett Newman (which Greenberg acknowledged), but also its application to his work. Greenberg said No. "Barney was the first one I heard name a certain kind of painting as buckeye, but he did not apply the term to yours. When I, some time later, told Barney that I thought there was a relation between buckeye and your painting, or rather some aspects of it, he protested vehemently and said your stuff was too good for that." Since Greenberg regularly gets told off these days for being, in later years, waspish and superior about the Abstract Expressionists (as conversationalists and letter-writers), it is worth

pointing to the well-nigh saintly patience of his 1955 dealings with Still on the rampage. For more in the same vein, see Barnett Newman to Clement Greenberg, 9 August 1955, in Barnett Newman, *Selected Writings and Interviews*, ed. John O'Neill (Berkeley and Los Angeles, 1990), 202–4. "Buckeye" was again the offending term.

Marnin Young points out to me that in his spirited 1964 attack on Still, Max Kozloff seized on Greenberg's comparison to "Greenwich Village landscapists" (he quotes a few sentences from the *Art and Culture* text) and went on: "Critical attempts to portray [Still] as an artist who bursts forth into a new freedom, or as an exponent of the 'American sublime,' overlook his terribly static, one ought to say, vulgar, exaltedness." See Max Kozloff, "Art," *The Nation* (6 January 1964), 40. But is not the vulgar exaltedness what *makes* him an exponent? (Of course – especially given the date Kozloff was writing – one sympathizes with his distaste.)

15 *...And Thunderclouds Pass* comes from a poem by the Austrian Romantic Nikolaus Lenau, *And Out of the Caves* from Rilke's *Sonnets to Orpheus*.

16 On Still's McCarthyism, see Susan Landauer, "Clyfford Still and Abstract Expressionism in San Francisco," in Thomas Kellein, ed., *Clyfford Still 1904–1980. The Buffalo and San Francisco Collections* (Munich, 1992), 93. Greenberg's verdict on Pollock's politics was given in a 1981 interview with me. I think he meant it seriously.

17 Auguste Renoir to Paul Durand-Ruel, 26 February 1882, discussing participation in that year's Impressionist exhibition. See Lionello Venturi, *Les Archives de l'Impressionisme*, 2 vols. (Paris and New York, 1939), 1: 122. (The sentence occurs in a rough draft of the letter, and was omitted in Renoir's final version.)

18 Mark Rothko to Herbert and Mell Ferber, 7 July 1955, Herbert Ferber papers, in Archives of American Art, quoted in Breslin, *Mark Rothko*, 352.

19 This defense is not intended as a covert attack, and these sentences do not claim to characterize what was most productive (and genuinely excessive) in the art of the 1960s, especially from 1967 onwards. But I let them stand, because I do think that part of the history of the 1960s is bound up with art's withdrawal from Abstract Expressionism's impossible class belonging – its dreadful honesty about art and its place.

I do mean "part." Because ultimately I believe that the project of "returning art mainly to normal avant-garde channels" was and remains a hopeless one in the United States. The grounds (always shaky) for an enduring avant-garde autonomy, or even the myth of one, simply do not exist here. In the later 1960s and early 1970s in New York, the project imploded. Frantic efforts have subsequently been made to reconstitute avant-gardism around some "new" technology, or set of art forms, or refurbished critical discourse; but what is striking is the way these efforts cannot in practice escape the gravitational pull of the later 1960s. And I am saying that the later 1960s are a satellite, or a form of anti-matter, to the preponderant black star of *Coalescence* and *Memoria in Aeternum*.

A final thing I do not want to be taken as saying, or implying, is that art could make Abstract Expressionism a thing of the past by imitating it, or trying to go one better than it in the vulgarity stakes. That has been a popular, and I think futile, tactic in the last two decades.

CONCLUSION

1 Cesare Pavese, *The Selected Works of Cesare Pavese*, trans. Richard W. Flint (New York, 1968), 59. (*The House on the Hill* first published 1949.)

2 I know that strictly in terms of plot the last shot belongs to the young boy, Luca, who is maybe going home. But nonetheless, structurally, metaphorically, the final longshot is Ciro's, and "home" is a thing of the past.

3 Italo Calvino, *The Path to the Nest of Spiders*, 1964 preface, trans. William Weaver (Hopewell, N. J., 1976), x–xi.

4 Ibid., xvi.

5 Primo Levi, *If This Is A Man* and *The Truce*, trans. Stuart Woolf (London, 1987), 96.

6 Pier Paolo Pasolini, *Selected Poems*, trans. Norman MacAfee with Luciano Martinego (New York, 1982), 18–21, translation slightly modified.

7 My final pairing is made all the more unbearable, I recognize, by Pasolini's having chosen some phrases from Pound's Canto XCIX as a voice-over in his film *Salò* to the vilest images of agony and rape. "Poetry Corner," Pasolini calls the moment. But of course he selects Pound's phrases as his image of Fascism's dream of rectitude just because he too felt their power.

8 Pasolini, *Selected Poems*, 22.

Photograph Credits

Copyright Credits

Index

Figures in *italics* indicate references to illustrations.